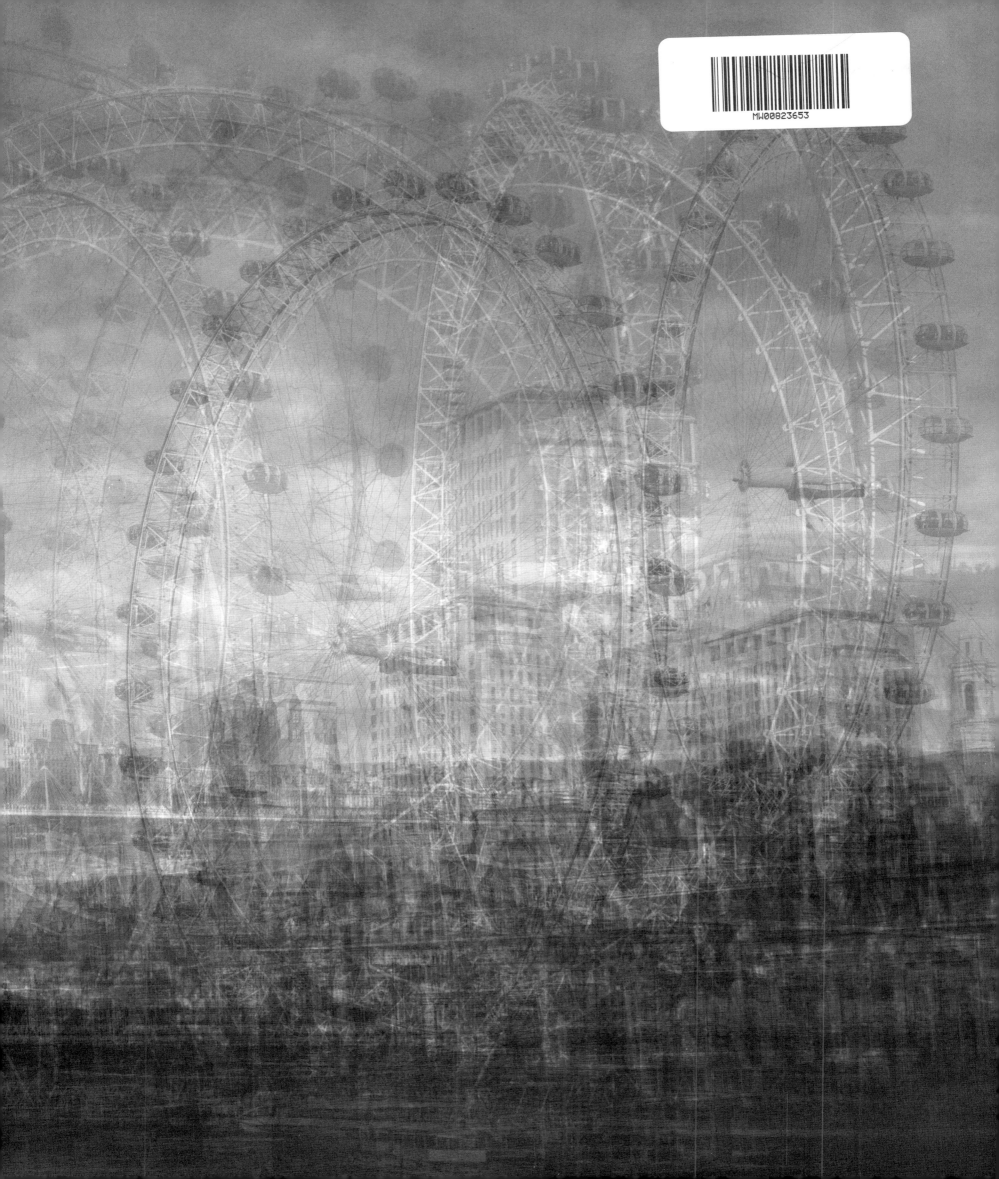
MW00823653

London
Burning

Portraits from a Creative City

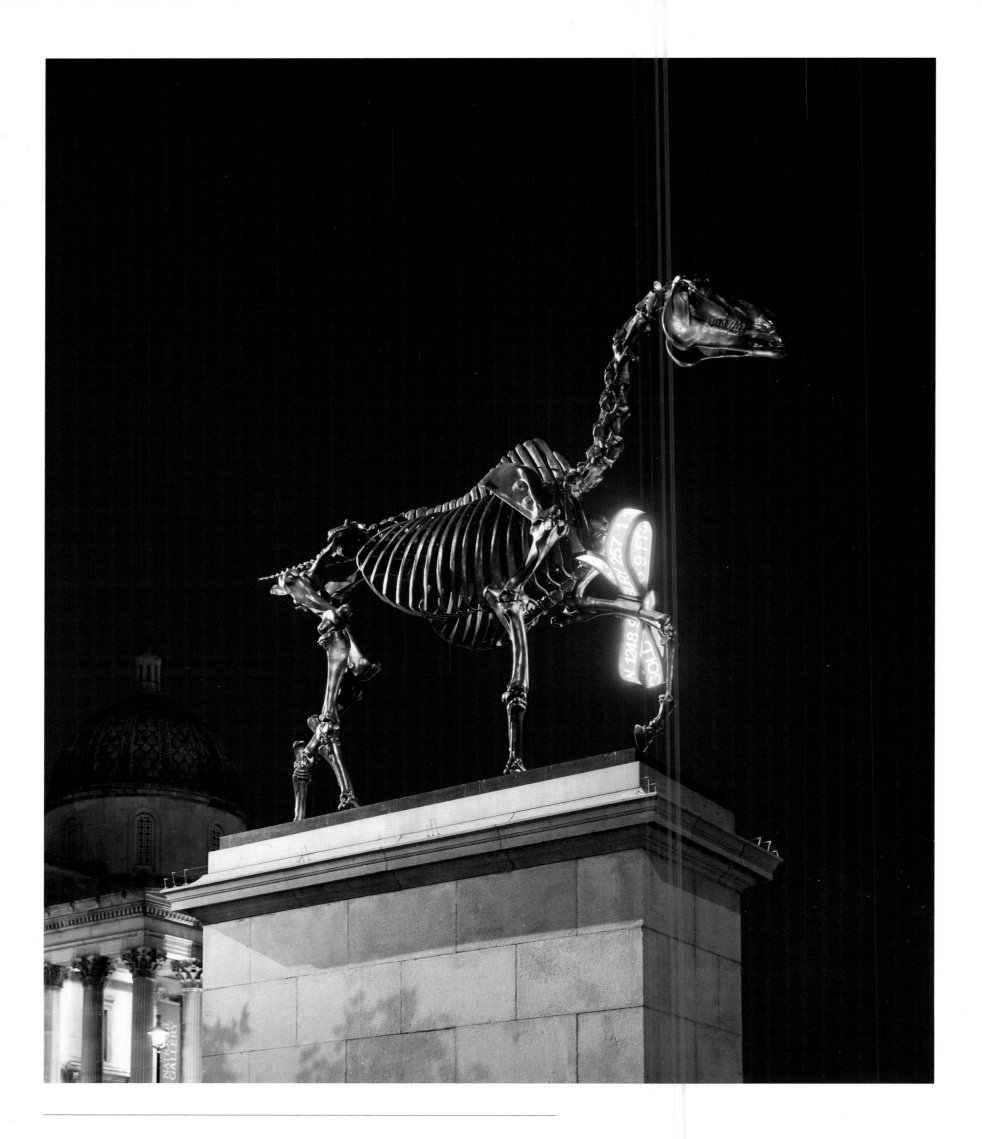

London
Burning

Portraits from a Creative City

Editor/Interviews
Hossein Amirsadeghi

Executive Editor
Maryam Eisler

Managing Editor
Andrea Belloli

Contributor
Gregor Muir

Photography
Robin Friend
Andrea Hamilton
Kate Martin

Additional photography
Hossein Amirsadeghi
Maryam Eisler

Thames & Hudson

First published by TransGlobe Publishing Ltd
in conjunction with Thames & Hudson Ltd

First published in the United Kingdom
in 2015 by
Thames & Hudson Ltd
181A High Holborn
London WC1V 7QX

www.thamesandhudson.com

First published in 2016 in hardcover
in the United States of America by
Thames & Hudson Inc.
500 Fifth Avenue, New York
New York 10110

thamesandhudsonusa.com

Text and captions
© 2015 Hossein Amirsadeghi
All works are reproduced courtesy of the
artists unless otherwise noted

Photography
© 2015 Hossein Amirsadeghi, Maryam Eisler,
Robin Friend, Andrea Hamilton
and Kate Martin

TransGlobe Publishing Limited
6 New Street Square
London EC4A 3LX
United Kingdom

www.tgpublishingltd.com
info@tgpublishingltd.com

All Rights Reserved. No part of this
publication may be reproduced or transmitted
in any form or by any means, electronic or
mechanical, including photocopy, recording
or any other information storage and retrieval
system, without prior permission in writing
from the publisher.

British Library Cataloguing-in-Publication Data
A catalogue record for this book is available
from the British Library

Library of Congress Catalog Card Number
2015937877

ISBN: 978-0-500-97071-3

Designed by Struktur Design Limited
Colour by XY Digital
Printed in China

Photography credits:
Robin Friend: 2, 23–4, 26–9, 31–7, 60–67,
80–87, 96–9, 104–5, 107–11, 123–9, 139–45,
172–83, 198–209, 211, 220–25, 237–41, 268–73,
275–9, 286–91, 295, 298, 320–29, 350–51, 353–7,
381–5, 436–41, 484–91, 505–9, 513–17, 519–21,
526–31, 537–41, 543–7, 557–61, 569–73, 576–9,
589–597
Andrea Hamilton: 50–59, 68–79, 88–9, 91–3,
98, 112–21, 131–7, 152–61, 168–9, 184–5, 193–7,
210–13, 226–7, 252–3, 260–61, 266–7, 280–85,
292–3, 307–11, 344–9, 359–63, 366–9, 378,
386–91, 406–15, 417–22, 424–35, 442–51, 453–7,
457–8, 460–61, 500–03, 510–11, 534–5, 562–4,
566–7, 574–5, 580–1, 583–4, 586–7
Kate Martin: 19, 20–21, 26–7, 39–45, 95, 100–
03, 149–51, 162–7, 214–17, 229–35, 242–3, 245–7,
249–51, 255–9, 282, 315–19, 331–41, 375–7, 379,
393–7, 399–400, 402–05, 463–7, 469–79, 493–5,
497–9, 553–5
Hossein Amirsadeghi: 16–17, 46–7, 49, 51, 55,
146–7, 157, 170–71, 186–7, 189–91, 225, 263–5,
285, 296, 299, 301–05, 312–13, 342–3, 349,
372–3, 423, 480–3, 523–5, 549–51, 585
Maryam Eisler: 11–13, 51, 74, 190, 365, 371–2, 533
Camilla Greenwell: 109
Tasos Gaitanos: 147
Roger Fawcett-Tang: 218–19
Quintin Lake: 598–9

(previous spread) Originally intended to hold an equestrian statue of William IV, the Fourth Plinth, raised in 1841, remained unoccupied for 150 years while debate raged over its appropriate use. (The three other plinths in Trafalgar Square are occupied by statues of Henry Havelock, Charles Napier and George IV, all 'dead white men', as former Mayor Ken Livingstone described them). The Royal Society of Arts conceived the Fourth Plinth Project in 1998 as a rolling programme of temporary installations, since which time artists like Mark Wallinger, Rachel Whiteread, Marc Quinn, Thomas Schütte, Elmgreen & Dragset and Antony Gormley have been featured. German-born artist Hans Haacke's 13-foot-high *Horseplay*, shown here, is a provocative gift horse, a subversive critique of the City of London's financial shenanigans and a nod towards the power of money in the contemporary art world

(endpapers) *London Eye* and *Tower Bridge* (2012) by Idris Khan. Digital bromide prints mounted on rag board, the images reflect the artist's take on London landmarks seen a million times a day, intended to create a feeling of 'stretched time'. Khan says, 'I try to capture the essence of the place reflected in the mind of the viewer – something that's been permanently imprinted on someone's mind, like memory'

Contents

Genius Loci

Hossein Amirsadeghi

The making of *London Burning: Portraits from a Creative City* has been quite a challenge in terms of both book-making and trying to encapsulate the essence of such a vast and diverse metropolis in a single tome. Various iterations of thinking preceded the actual commencement of work on the project after two false starts. While the contentious title remains as it has been from the beginning, the dynamics of the project have changed to accommodate the vagaries of process and creation. 'It's not until we're done' (my Managing Editor laments) 'that we know what we're doing.'

Ignoring the criterion of strict relevance is an essential part of the creative process for me. 'History is a pattern of timeless moments,' T. S. Eliot once said; *London Burning* is an attempt to capture moments in the timelessness of history in a city steeped in tradition and culture. So, a conundrum from the off. Frequently having initiated or spearheaded great movements in thought, politics (the Mother of Parliaments), industry, trade and finance that have hugely affected the progress of humankind, London has been a handmaiden to the modern world.

The urge to make something distinctly different was therefore a prerequisite necessitated by the commands of history and the wealth of material we had in play, some of which is locked away under layers of this pre-eminent city's creative history. Given that I'm not one to plan, the book reflects ideas in flux matched by creative motion. There is some wandering, and not a little awe, evoked by settings for a first-time visitor to admire, just as I did as a young boy straining with incredulity to see the top of Nelson's Column in Trafalgar Square, or the real Big Ben after movies I'd watched portraying its surroundings as rather intimidating. Reaching up to peer over the Embankment wall into the Thames, going to the Empire Theatre in Leicester Square to watch *Lawrence of Arabia* ... It's still a whirlwind of wonder all these years later.

Undertaking an exposé of the city through a creative rambler's perspectives, we moved from period to costume, from place to public space, seeking out histories of neighbourhoods and the pleasures of time travel, trying to recapture the delight of my boyhood discoveries. The resulting volume is not an attempt at an historical romp nor a desire to capture a city's mere façade. Rather, the overriding concern has been to capture the often extraordinary lives of creative people who live there. These are Londoners going about their everyday routines, yet they are special, different, and in the meandering process we've tried to shed some true light on the question of how and why one city can be creatively outstanding while another struggles. Just look across the Channel at London's millennia-old metropolitan foe. Paris is undoubtedly one of the world's most beautiful cities, with an equally striking and at times vibrant cultural heritage. Despite Parisians' constant gripes against their ancient rival and sometime nemesis, 400,000 French people choose to live in London. There may be some truth in descriptions of the city as a rich, smug, self-satisfied place swollen by hype. But then, who can argue with success?

History's Burden

What makes a city great in today's world?

Among cities that have survived the vicissitudes of time, London stands above most in terms of historical continuity and its powers of regeneration. Paris has been in decline (tumbleweeds in the Tuileries) for some years, while Rome still burns strong but on the embers of her past glories. Berlin is on the rebound, blessed as it is with a grand master plan

and unlimited public-development funds sucking talent from distant climes. A few Scandinavian capitals can still claim civilised continuity matched by sensible urban planning. But none can tick all the boxes that London can.

London is two thousand years old. Not just *old* because of fragments of history representing cultural and political interregnums – a bit of ancient wall here, an underground burial site there, ecclesiastical monuments or triumphal arches denoting fealty, whether in the name of God or of Mammon. London is old because of the city's ongoing historicity connecting Place to Past. You can trace contemporary life to its very ancient roots in linear fashion, dialling up a century by simply walking through different neighbourhoods. Take Clerkenwell (explored in these pages in the company of Peter Ackroyd), redolent of the Crusades, the twelfth-century Order of St John Priory's crypt still there for all to see in the midst of the new. The area has been a nodal point for agitation for many centuries. Clerkenwell Green, where Wat Tyler's Peasants' Revolt began in 1381, was also a hotbed of Communist activity, with Lenin working on the *Iskra* newspaper during his London exile. May Day parades start there to this day. The Tolpuddle Martyrs were hung there, and the Chartist movement began in the space presently occupied by trendy cafés.

You can take a Tube ride and tunnel through the city's physical and cultural antecedents. Cross Bones Graveyard (also featured in the book) is another case in point. Now a small plot of land in Southwark sought after by developers, the post-medieval disused burial ground's rusty iron gates sport a plaque with the inscription 'The Outcast Dead, R.I.P.' The site is mentioned in John Stow's 1598 *Survey of London* as the burial ground for 'single women', i.e. prostitutes who plied their trade outside the city gates in the pleasure grounds of Bankside, working the theatres (including Shakespeare's Globe), taverns, bear-pits and brothels under licence from the Bishopric of Winchester. Excluded from a proper Christian burial, thousands of young women historically referred to as Winchester Geese (after the eponymous pimp-bishop) were laid to rest on top of each other at the Cross Bones site. Acting on ordinances signed by Thomas Becket, the bishops allowed 'stews' (brothels) to operate within the Liberty until the 1640s. When they finally closed, along with the theatres and bear-pits, it sent Bankside's fortunes tumbling until London's Big Bang of the 1980s, which replaced sixteenth-century bear-pits with twentieth-century variants.

London is no newcomer to history's accolades or jibes. Ptolemy made reference to Londinium in the second century AD. In the twelfth century, Richard of Devizes observed, 'Whatever evil or malicious thing that can be found in any part of the world you will find in that one city.' Ralph Waldo Emerson saw nineteenth-century London as 'the epitome of our times, and the Rome of today'. And although Benjamin Disraeli described the capital as 'a modern Babylon', a century earlier Samuel Johnson's response to a doubting questioner had been: 'Sir, when a man is tired of London, he is tired of life!'

Londinium was established in AD 47 on the site where the City of London is today, an area no larger than Hyde Park. It guarded the Roman bridgehead on the northern banks of the Thames, and the subsequent imperial road nexus made the city into a communications hub. By the latter part of the first century, London's population had grown to sixty thousand people. When the Emperor Hadrian visited in AD 122, the city was at the height of its powers, having replaced Colchester as the provincial capital. Areas such as Bishopsgate, Aldgate and Ludgate, today

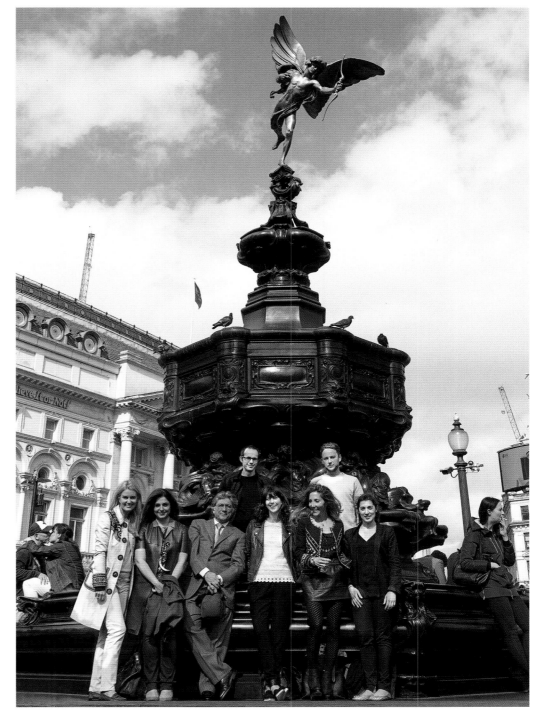

major global financial real estate within the City, originated as mere gateposts on the Roman bridge spanning the Thames, remnants of which were discovered in 1981 close to the site of London Bridge.

London grew over the centuries, with its population swelling to two hundred thousand by Elizabethan times, bursting the confines of its fortifications. The Thames was the source of its prosperity, feeding the poor with abundant oysters, and opening its harbour to merchantmen plying their trade to the far corners of the globe, bringing back new ideas. Yet the river was also a menace, its banks constantly bursting to sweep away entire neighbourhoods. Shakespeare's Globe had to be rebuilt at the end of the sixteenth century due to the spring floods, an annual event that was not brought under control until the Embankment was built in the nineteenth century.

The uneasy mix of cultures and increasing presence of people of colour (slaves freed from Spanish galleys) gave cause for considerable prejudice and agitation from early times. In 1601, the black population was officially designated a nuisance, with UKIP's earlier brethren calling for deportations. One way or another, London's culture was always a vibrant mix. Southwark, where the Globe was located, drew twenty thousand

London Burning's creative team gathers in Piccadilly Circus under the watchful eye of Eros, sculpted in the image of his mythical brother Anteros, the god of selfless love, in 1893. From left to right: Andrea Hamilton (photographer), Maryam Homayoun Eisler (executive editor), Hossein Amirsadeghi (editor/publisher), Kate Martin (photographer), Dorian May (project stylist) and Anne Field (project coordinator). Roger Fawcett-Tang (creative director) and Robin Friend (photographer) stand above their peers, while Andrea Belloli (managing editor) is absent in search of better climes

people a week to its theatres. The cost of a ticket was the equivalent of a penny (the price of a loaf of bread at the time) for access to the stalls.

It was the Edwardian age that ushered in twentieth-century London with a bang. The Victorian city had witnessed the apogee of the British Empire. Sedate and sombre, the great achievements of the Victorian period transformed the urban landscape. Britain led the world in trade and commerce, and London was the globe's undisputed financial centre. The city's prosperity was highly visible, as were rising political dissent and the transforming role of women. London's *belle époque* not only brought Art Nouveau with its unique architectural styles but such modernist writers as Somerset Maugham, Joseph Conrad, Rudyard Kipling, D. H. Lawrence, George Bernard Shaw and H. G. Wells, reshaping the world of literature and unleashing a bohemian renewal of thought that continues to shape London's literary skyline. The performing-arts scene highlighted people's continuing preference for live drama, the cinema still too young to affect the masses. Shaw, Henrik Ibsen and Maugham showed the way, their plays breaking attendance records. Sports meanwhile were divided by class, with soccer the favoured pastime of the people. The 1908 London Olympics sealed the city's pre-eminent stature globally at the same time that scientific strides kept Britain at the centre of industrial innovation. Architectural styles changed as well. Edwardian Baroque was a throwback to Christopher Wren's London of the seventeenth century, with notable figures like Edwin Lutyens and Charles Rennie Mackintosh paving the way for a design revolution at variance with eclectic Victorian tastes. In 1931 London's population peaked at eight million, not to be surpassed until 2011.

The romantic notions of Edwardian times reflect a nostalgia that grew out of the beginning of the loss of empire and the catastrophe of the First World War. As New York was barrelling ahead as the global financial pole, with America's power and wealth growing exponentially, World War II nailed London's imperial coffin firmly shut. The eclipse of the war-ravaged city and a near-bankrupt state continued until the advent of Thatcherism in the 1980s. Today's London lords it over the global cultural and financial sweepstakes. Several trillion pounds pass through its virtual fingers each day, and there were more films made around London in 2015 than in Hollywood. Dance, music, theatre, literature and media are fed by London's creative momentum, leaving the rest of the UK feeling eclipsed. The city's economy has become the country's powerhouse. Knowledge-based clusters are mushrooming; technology-driven companies are multiplying; just try reserving a table at a good restaurant on any day of the week. Meanwhile nineteen million tourists are expected this year, disbursing some £14 billion to London's economy.

Where did it all begin?

Creative Journeys

I first set foot in London as a young boy in the autumn of 1959 on the way to a Kent boarding school, my father's words ringing in my ears: 'Be careful, son! The English cut people's heads with cotton wool!' My first memories of the country are the smells of carbolic acid and fresh-cut grass, plus the meagre fare just five years after the end of rationing.

From such beginnings did my journey originate: London University in the late '60s, then a long hiatus followed by life in exile starting in the early '80s. Minimal qualifications for attempting *London Burning*, one could say. But the fascination goes beyond surface living or urban presence. Let's be grand and quote William Blake: 'I behold London; a Human awful wonder of God.'

Beholding we have done aplenty. But how do you go about measuring the visual presence of a metropolis like London? The city is home to

8.6 million people, the largest number of Londoners ever recorded. War and uncreative peacetime planning both contributed to the city's decline over half a century. Bombing destroyed a million homes, displacing 1.4 million residents, who were mostly dispersed to new greenbelt towns. Counties like Essex and Hertfordshire were drawn into Greater London's orbit. The city's 1945 master plan saw the population decline dramatically, bottoming out at 6.4 million by 1991. Restrictive laws, enlightened (socialist) planning and the power entrusted to local boroughs succeeded in holding back growth for forty years. The clearing of inner-city Victorian slums combined with new planning rules managed (fortuitously) to leave London as one of the world's least densely populated urban centres. Hence its high housing costs. Margaret Thatcher's social and economic revolution in the 1980s led to the loosening of restrictive planning controls and the unleashing of an entrepreneurial storm, for better or worse.

Unbridled capitalist forces have caused their own problems, though, compounding the social distress that has manifested itself in periodic riots (Brixton, 1981; Tottenham, 2011) and an ever-widening gap between rich and poor. London is not alone in facing this conundrum; the international jury is still out as to how to redress the dire social and economic consequences of rapid, lopsided urban development in first-world cities. The biggest threat to London's creative renaissance is a lack of affordable housing, which threatens to drive out professions whose existence is key to the capital's continued prosperity.

Even London's frenetic rate of development cannot keep pace with its growing population, projected to be eleven million by 2050. Liminal lands on the periphery are being developed at such a pace that (just for instance) previously featureless Nine Elms is now referred to as 'Dubai on the Thames'. The 2012 Olympics showed what could be achieved when political will and financial muscle join forces, changing the face of East London by turning a huge underdeveloped area into the Olympic Park. Similarly neglected areas like Barking, Park Royal, White City, Wormwood Scrubs and Finsbury Park are attracting the attention of major development consortiums, most of which are funded from overseas. The socio-political and aesthetic refrains are something else entirely, with battle lines drawn and redrawn between architects, urban planners, politicians and the common good.

These issues are not merely linked to redevelopment criteria. London's sense of English identity is all but gone. Walk down Knightsbridge on any given day and you hardly hear a word of English spoken; you're likely to hear nothing but Arabic on a summer weekend. London has lost its industry and transformed itself into a free market for humanity. It has more in common with major European capitals like Berlin, Paris or Amsterdam than with Glasgow, Cardiff and Nottingham. The strength of the capital's economy (bigger than Sweden's), the cosmopolitan nature of its inhabitants, and its internationalist-minded and plutocratic élites could easily declare themselves independent from the rest of the country. Forty per cent of the city's present population were not born in Britain, and one third are not white. The thirty-two boroughs plus the City of London Corporation represent demographic and class divisions that might as well describe countries, towns or villages (i.e. ghettoes) separated by degrees of wealth, colour, ethnicity and social electricity. Quarrelsome and querulous politically, riven by agenda-driven bureaucracies and local planning restrictions, urban land use remains one of the prime reasons for high-cost housing and office space. Land-use regulations in the West End inflate the cost of office space by 800 per cent (according to recent academic surveys) while residential purchasers can look forward to paying upwards of £60,000 per square metre in Mayfair.

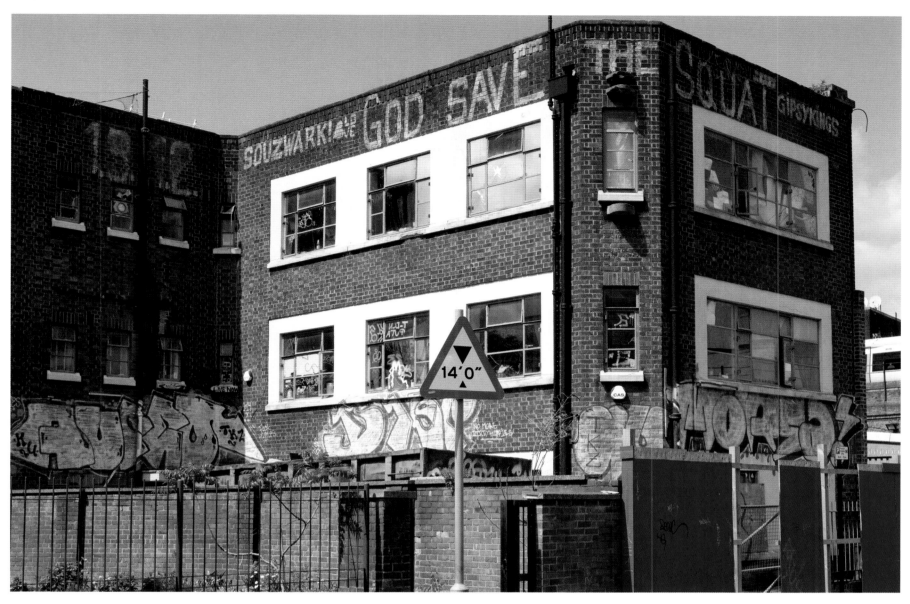

London's boroughs are still predominantly white even though the city has seen massive change in its ethnic composition during the last fifty years. While Kensington and Chelsea has a 70-per-cent Caucasian population, Brent and Harrow are equally divided between whites and Asians. Newham's white residents (29 per cent) are swamped by its Asian (46 per cent) and black (20 per cent) residents, while Richmond's whites (86 per cent) drown out Asians (7 per cent) and blacks (1.5 per cent).

If one were to trace the city's cyclical property values, demographic maps seem to determine price variations better than any other social barometer. Traditionally rich areas like Mayfair, Chelsea, Kensington and Hampstead have been challenged by newer, hipper neighbourhoods like Notting Hill, Islington, Fulham and Battersea as the cost of housing continues to push younger professional classes out to the south and east. The fast-gentrifying boroughs of Shoreditch and Hackney feature multi-million-pound apartments cheek-by-jowl with 1960s social-housing dystopias, some of which can at times be no-go areas for the police.

The 2011 Tottenham riots shocked Londoners to the core. The world watched parts of the capital burn with raging racial and class divisions. In fact, the threat of social menace is never far away, however removed genteel areas are from violent, crime-ridden neighbourhoods. The spectacle of £100-million homes a cab ride away from inner-city slums remains a jarring spectacle, political kindling waiting for a social match to ignite.

So, how to reconcile today's rosy picture of London as the world's creative capital with stories of emigration from the centre to the suburbs? Artists are moving inland and to coastal cities, especially individuals who can no longer squat, rent or survive their city's increasingly harsh demands. Given this fact, how is the capital's creative heartland continuing to contribute to its economic dynamic?

Zeitgeist

The essence of this book is wanderlust in search of the creative geography of a city seen through the eyes of a hundred souls who live and work there. Chosen from a wide field of specialities and backgrounds, the book's eclectic narrators become mirrors of their neighbourhoods, reflecting emotions, filtering history and refracting some of the ideas that are changing London before our very eyes.

London is an assemblage of villages and small towns, more tribal than people care to admit; the personalities featured in the book are drawn from such creative enclaves, milieux that hold people's imaginations. Art, literature, fashion, design, architecture, cinema, dance, theatre, food … all are seen through the knowing eyes of people as different in experience and background as Nicholas Serota and Beeban Kidron. Interactive players, each of whom has helped in their own way to fashion London's creative veneer, along with those lesser known who inhabit its urban-jungle fringe – all have ideas and opinions that, taken together, form the crucible within which any solutions to the city's future travails may arise.

For reasons of aesthetic, practical and logical arithmetic, *London Burning*'s various strands were sequentially designed around the seasons: we started in March 2014 and closed in May 2015. The chronology and appearance of the narrators are therefore more to do with the luck of the draw than anything planned. The result is not so much an exercise in cultural mapping as an attempt to seek out the archaeology of today's creative landscape.

And what landscapes we have covered, what people we have met, what arguments we have had, what good food and wine we have consumed in the name of creative exercise! I for one am filled to the brim at last with London trifle.

A derelict squat behind Southwark Tube station, emblematic of the many rundown buildings across London's centre and periphery that have (reluctantly) become homes for artists and others of a certain disposition. Squatting, a means of finding rent-free housing in the capital since the Peasants' Revolt in 1381, was accentuated by the housing crisis of the 1960s. Though criminalised in 2012, squatters remain a colourful threat to the fabric of property ownership in the capital

Downtown

Gregor Muir

In 1949, the photographer John Deakin observed that 'London is an atmosphere, a state of being.' Deakin wrote this shortly after the war, to accompany his photographic essay *London Today*, a publication capturing the sultry mood of a near-empty city, from a Sphinx on the Embankment to the Albert Memorial in early-morning sunlight. This *was* London, an austere city steeped in tradition. Deakin's book reminds us of the distance between his city and ours, and of how much that atmosphere has changed over time. Slings and arrows aside, London lives on. Yet for all its tradition – its protected areas, listed buildings, listed landscapes even – the city refuses to settle down. London cannot abide stasis. A fairly moderate position upon which to base this text would be to underline with much excitement how the city remains in a state of perpetual flux. But London merits more than that. It warrants an exploration of what makes it so creative. Why is it one of the leading artistic centres in the world? And isn't it about to change for ever?

The main protagonist of the story is Crossrail, which continues to cause traffic paralysis, having rendered large swathes of central London out of bounds, notably Tottenham Court Road, Hanover Square and Bond Street. To make way for vast underground tunnels connecting east to west via a high-speed link, entire blocks have been demolished in the heart of the West End. Construction sites will eventually give way to brand new ticket halls and access routes, with the promise of retail units and office space to come. All this is taking place under the watchful eye of Soho, one of the city's oldest neighbourhoods, whose distinct identity is about to be tested. For decades, Soho has been synonymous with seedy clubs and bars, cosy patisseries like Maison Bertaux or memories of Francis Bacon stumbling home drunk. This is where London's gay and Chinese communities mingle with the local media industry. The visual effects for the film *Gravity* were recently produced there. We are told that this single square mile is responsible for 10 per cent of the country's creative turnover; a quarter of Soho's workforce is employed by its creative industries.

'In the last four years Soho has lost 30,000 square metres of office space and gained twice that amount in residential. The creative clustering that makes this such an extraordinary economic and cultural engine is under threat as a result. There is a very real danger that we will erode the creative fabric of Soho past the point we can ever rebuild it'
Stephen Fry

Aside from its ominous undertones, what Stephen Fry's statement brings into view is the concept of 'creative clustering', whereby an area becomes so densely populated with creative individuals that it takes hold in the public imagination. Fleeting gatherings have marked many an artistic movement across London, such as the Bloomsbury Group (which can be traced back to the Clapham Sect) or the Young British Artists who roamed Shoreditch. Only once in a blue moon, however, do artists, fashion designers, film-makers, television companies, art students and restaurateurs conspire to produce somewhere as creatively lively as Soho. While we might look to Dalston or Peckham as emerging artistic quarters, Soho holds the patent on creative London.

From his Soho tower block, the journalist Jeffrey Bernard once observed, 'Never ever have I seen anything quite so stunningly beautiful as the rotting fruit and vegetables in Berwick Street Market just outside the front door of this block of flats.' Having passed away in 1997, Bernard would have baulked at the recent gentrification of Berwick Street, now streetscaped with Yorkstone paving and aged granite setts. (At the time of writing, nearby Broadwick Street, between Berwick and Poland streets, has been demolished.) While Soho struggles to retain its identity, Tottenham Court Road – a mere stone's throw away – has already given up the ghost. Imagining pound signs at the imminent arrival of Crossrail, landlords have squeezed out their former tenants and effectively closed down the computer and electronic shops for which the area had become known. Similarly, the bookshops that once lined Charing Cross Road are close to extinction, while the musical-instrument shops on Denmark Street are expected to close in 2015. It is easy to guess what will happen next.

Such changes might be met with a heavy sigh, and the setting up of committees like Save Soho, but overall London remains a place where the concept of constant renewal is broadly understood. Having destroyed many a thing it loves through sheer speculative greed, its affection for scattershot development has nevertheless spared the city a prehistoric 'old town' surrounded by a 'new town', a thumping bore of a pattern often encountered in other European cities. In its approach to urban sprawl, London is far less binary, opting for one large jumble of time, rendering itself higgledy-piggledy in the process. Eluding petrification through the endless refurbishment of existing buildings and the occasional new build, the city inspires its exasperated taxi drivers to talk about it as 'a wonderful place' before delivering the punch line '… when it's finished'.

Even though the Thames has ceased to function as a fully integrated business tool at the heart of the capital, London somehow retains the mindset of an industrious port. Whatever the tide has brought in, London has traditionally dealt with: importing, exporting, with more coming in than going out. Acknowledging how its wealth has been founded on other people's riches sourced elsewhere, London is predisposed to ingratiate itself with the world. It has to trade; otherwise it becomes landlocked and regressive, succumbing to a form of cabin fever. In recent decades, flickering images of Docklands, with its steamers and cranes, have given way to airports, with increasing talk of expansion across the South-east. Air-freight depot, tourist destination, business hub – London seeks a future in the skies. Meanwhile, on the ground, there is talk of silicon roundabouts, a term once only applied to the proliferation of web-based companies around Old Street. But, for all the new bars and trendy bakeries, it's the banking sector that remains ever-present, employing over three hundred thousand people in the City alone.

Trade continues to shape London, its ancient highways and boroughs determined by old tollgates and hunting grounds. Commerce and death have given rise to its form in much the same way that Mayfair-based hedge-fund companies have attracted Michelin-star restaurants and luxury-goods shops. Meanwhile, London's ad-hoc formation, come boom or bust, has played a critical role in defining its artistic identity.

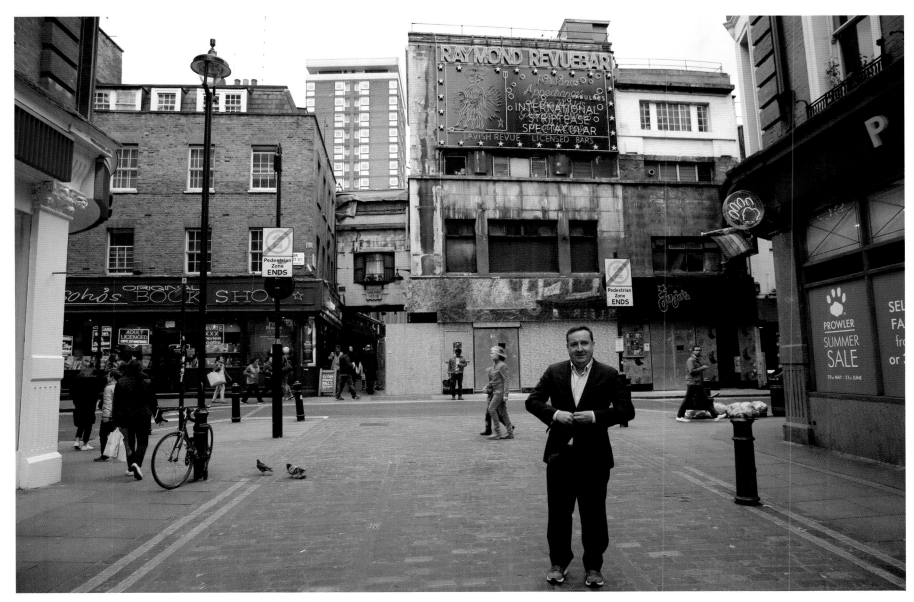

'For the bookish, London is a book'
Iain Sinclair

Unlike Los Angeles, a gridiron city, London has bends and circles. Roads tend to wind. London has crescents and squares, parks and gardens. It has trees. Moreover, London is a walking city; it's pedestrian-friendly. By contrast, North American cities have been created in haste, the need to lay down roads and railways, cost-effectively and at speed, overwhelming the desire for natural growth. Being an organic city, London meanders, with streets that come and go at random, and this is what lends it a poetic edge, with every street claiming a different history. The heritage blue plaques that adorn the façades of townhouses reveal a wealth of exceptional talent – Jimi Hendrix, Karl Marx, Horatio Lord Nelson, Florence Nightingale and Vincent van Gogh, to name just a few, the latter having spent a year in Brixton. London's history is by no means bound up solely with its official monuments or colonial edifices, allowing for a cultured past that goes beyond the incarceration of former rulers. Walking around the city, as the individuals featured in this volume do on a daily basis, it unfolds like a book.

London encourages difference. It's no small thing that so many people have settled here from around the world, adding to the city's heady blend of languages, cultures and ethnicities. While Londoners generally tend to mix, some lie low, owing to their extreme wealth. In 2014, the *Sunday Times* listed 104 billionaires based in the UK with a combined wealth of more than £301 billion; the Indian-born Hinduja brothers occupy the number-one slot with an estimated fortune of £11.9 billion. Of all the groups to epitomise the arrival of new money into London, the Russians have turned the most heads. In 2014, the *Guardian*

set the Russian-born population of London at 150,000, up approximately 900 per cent on 2001. The dominance of Russians in such exclusive areas as Belgravia, Kensington, Knightsbridge and Mayfair has resulted in new urban terminology, for example 'Chelski' or 'Londongrad'. The influx of wealth into the capital, not just from Russia, Siberia and the Ukraine but also from South Asia, China and the Middle East, has coincided with rising property values and city-wide rent increases. Throw in a strong pound and it's little wonder that London recently overtook Hong Kong as the most expensive city in the world, thus begging the question: Who can afford to live there?

'There's nowhere else like London. Nothing at all, anywhere'
Vivienne Westwood

London needs to capture creativity by somehow making it possible for aspiring artists and other creatives to live there; it should inspire people in such a way that the attention of the world is returned to the capital. For many years this is what it achieved, especially during the last half of the twentieth century. What seemed to attract people to the idea of London was the number of people who played with its image, plucking ideas from the urban ether. In fashion, Malcolm McLaren and Vivienne Westwood created a distinct identity for punk by synthesising images of royalty and the Queen with paraphernalia associated with kinky sex. The artist Trojan and performer Leigh Bowery (who modelled for Lucian Freud) created an iconic fashion collection that fused glam rock with images of Hindu gods, having sourced Asian accessories on their East End doorstep. Alexander McQueen spent his youth watching kestrels soaring above the Stratford tower block where he grew up as one of six children. Set against a scene

Gregor Muir on Rupert Street outside the former Madame Jojo's nightclub, whose recent closure has made it a symbol of Soho's resistance to rapid gentrification. Having had its licence revoked by Westminster Council in 2014, this much-loved subterranean haunt has since fallen into disrepair. Standing at the heart of Soho, its façade still supports the iconic 'Raymond Revuebar' neon blast. In the background looms Kemp House, a Westminster Council tower block, once 'home, sweet home' to the hard-drinking Soho columnist Jeffrey Bernard

of urban desolation, this image of the Cockney McQueen spying hawks preempts the highly tailored, plumage-laden couture that followed.

Gilbert & George have pretty much spent their entire lives observing the changes on Brick Lane in the heart of London's Bangladeshi community. Once home to waves of immigrants, from Eastern European Jews to Maltese settlers, the area surrounding the artists' home on Fournier Street is now a mishmash of cocktail bars and startups, new trends in the face of London's oldest bagel shop and a street market that dates back to the seventeenth century. Brick Lane continues to reflect the times, its social makeup determined by events elsewhere. As Gilbert & George once noted, 'Nothing happens in the world that doesn't happen in the East End.' Further west, Mark Leckey, winner of the 2008 Turner Prize, has produced several works inspired by Fitzrovia, the area surrounding the BT Tower. His film *LondonAtella*, credited to him and donAtella (a collaboration by Leckey, Bonnie Camplin, Enrico David and Ed Laliq), captures the Old Smoke being destroyed, adding to a rich seam of films including Norman Cohen's gritty portrayal of a city in decay, *The London Nobody Knows* (1967), which shows the abandoned music halls and meth drinkers who once inhabited the East End.

When it comes to music, London has a longstanding reputation for inventing entire genres. Of late, it has given rise to the drifting hypnosis of shoegaze and the urban sound of grime. The city's musical influence continues to resonate throughout the world partly due to a number of radical online radio projects, among them NTS Radio based in Dalston. And it continues to play an innovative role, especially in the area of pop. Take, for example, Tottenham girl Adele, winner of multiple Grammy awards, or the multicultural genius that is M.I.A. (aka Mathangi Arulpragasam), who once described what it's like to be an artist in the metropolis this way: 'In London the people are just more real, more human. There's wit and sarcasm. The weather's shit, too, so you produce better work because you're at home all day. In London it's easy to turn feeling pissed off into a place where you can generate something positive'. Perhaps this is why Thurston Moore of Sonic Youth now lives in Stoke Newington.

Indie music truly finds its roots in London, largely thanks to vinyl outlets such as Rough Trade, who also represent bands including Pulp. In 1995, Jarvis Cocker, Pulp's lead singer, swept back his fringe to deliver the hit anthem 'Common People': 'She came from Greece, she had a thirst for knowledge. She studied sculpture at Saint Martin's College'. Cocker, Gilbert & George, M.I.A. and Alexander McQueen are all alumni of Saint Martin's School of Art, from the time when it was located on Charing Cross Road in Soho. In 1989, the college amalgamated to form Central Saint Martins before moving, in 2011, to King's Cross, where it presently resides in a converted granary store behind the mainline station. Before the merger, Saint Martin's taught a variety of creative courses under the same roof, including fashion, film, painting and sculpture.

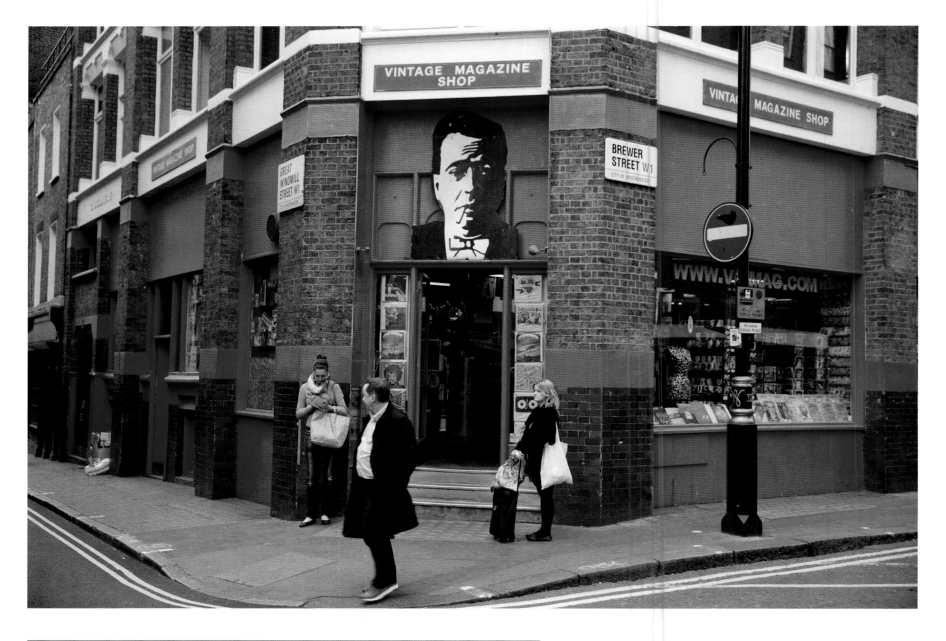

Gregor Muir

'That was the great thing about going to Saint Martin's. It wasn't just your painting peers looking at the way the painting was made. There were also lots of other people commenting on the subject and the content and even the humour of the work. It was very useful that there was definitely a lot of interaction between the different departments, particularly a group of painters and some brilliant fashion students. We were all in the same building, and the fashion students were often hanging out in the painting department. John Galliano was best friends with one of my friends David Harrison, and most days he would be in the painting studios at some point. We all went to the same cafés at lunchtime and nightclubs at night'
Peter Doig

If it were possible to create a microcosm of London's artistic potential and attempt to show how it works, it would resemble what Peter Doig (presently one of the world's leading artists) describes here: the casual, unforced interaction between idea-driven people. Perhaps this is what is meant by the now common phrase 'creative clusters': a meeting of minds across disciplines, where ideas are freely exchanged and take on new significance. That artists shared the same space as fashion designers, composers, writers, musicians and architects, and that they actually got to meet, was what traditionally set London apart from more segregated cultures. Of course, this observation is based on a description of a defunct art school based in Soho, now revealed to have been the arts equivalent of a model village. Is it possible to associate London with 'creative clustering' and artistic interaction anymore? Do art schools still encourage interdisciplinary exchange? While the hope is that Saint Martins' new digs in King's Cross will continue to offer similar creative connections, the reality is that arts education has become increasingly unaffordable to those who stand to benefit from it the most.

Ironically, the Royal Academy of Arts – located in the heart of Mayfair – can claim to be one of the first art schools in the country, and quite possibly the last, to not charge a fee and to offer studio space. In recent years, the RA Schools have launched the careers of Eddie Peake and Turner Prize-nominee Lynette Yiadom-Boakye. As the speculative heat surrounding the annual degree show begins to resemble the excitements that once surrounded Goldsmiths in south London, it's worth noting how few people now are in a position to opt for an artistic career. In turn, this leaves the sustainability of London's creative drive in question. The problem may have been answered by a former library and community centre to the east of Islington in De Beauvoir Road. Open School East was set up as a direct response to spiralling tuition fees and student debt, as well as increased bureaucracy in arts education. Successful applicants can study free for a year, with courses led by curators, writers and artists such as Ed Atkins, Marvin Gaye Chetwynd and Richard Wentworth. It's a new initiative (just a year old at the time of writing) and so too young to have proven itself as yet, but it does create a novel dynamic when set against the existing structures.

As younger generations attempt to dig in, artists find themselves looking to areas of London previously deemed way off the beaten track, such as New Cross, Seven Sisters and Walthamstow. These movements will inevitably be watched with great interest by property speculators attuned to the idea that artists are the stormtroopers of gentrification. Pushed to the city limits, creative people increasingly talk of affordable overspills such as London's satellite cities Birmingham and Croydon or the Cinque Ports of Margate and Folkestone. The idea that a studio visit once entailed hailing a cab and spending a short while in the East End starts to fade as Londoners realise that if they want to discover fresh talent they're going to have to jump on a train. The fact that the creative classes are being priced out of the capital is exacerbated by the erosion of state support for those with little or no income. Creatives from the '80s have a habit of referring to a time when they 'weren't doing it for the money' (making art, clothes, music etc) – a moment made possible thanks to the safety net of housing and unemployment benefits. By contrast, we cannot expect recent graduates, already saddled with student debt, to embrace enterprise and risk-taking in quite the same way.

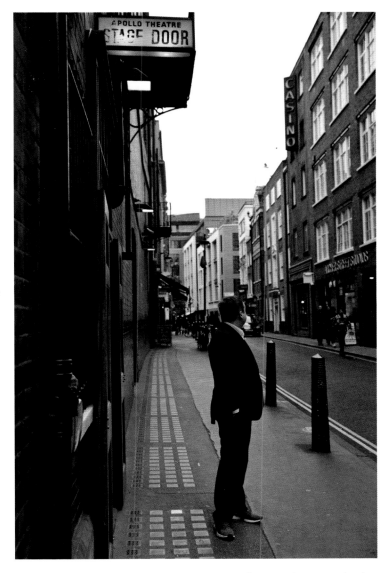

Muir, at the stage door of the Apollo Theatre in Archer Street (right), surveys the former site of Charlie Chester's Casino, its façade once adorned with flamboyant neon playing cards and rolling dice. Only a single inoperative sign remains. Artist Francis Bacon, once a regular visitor, described himself as 'perfect compost' for this notorious Soho gambling den

Muir passing in front of another odd Soho landmark, the Vintage Magazine Shop on Brewer Street (opposite), which has been catering to an international clientele of collectors, picture researchers and publishers since 1974

As the LA-ification of South-east England continues apace, another way to interpret London's place in the world is how it sits between New York and Berlin, New York being at the market end of the spectrum whereas Berlin has positioned itself as the studio of Europe thanks to its promise of cheaper rents. London, meanwhile, represents something in between. All business on the one hand, it continues to reserve a place at the table for more creative and less profitable practices, but only just. What if this balance were to tip? What if London's orientation – left in the hands of developers – were to become increasingly uniform and dull? Unable to turn back the clock and pretend to be Berlin, with its spacious apartments and reasonably priced workshops, how does London compete? Certainly it can never claim to be New York, with that cultural capital's insatiable appetite for art and commerce; just consider the Big Apple's Spring 2015 art auction results, or Ronald Lauder's $1.1 billion gift to the Metropolitan Museum of Art. In answer to the question, Who can afford to live in London? the answer is: A fairly turgid mix of bankers and rich kids.

What, then, of London's creative identity?

Curator and art historian Hans Ulrich Obrist has described the city as a 'megaphone'. Whereas in other parts of the world no-one can hear you scream, this unique city has the potential to broadcast artistic vision and creative thoughts far and wide. The recent move of the world's biggest contemporary-art galleries to London is likely because of this, not just for the pursuit of money alone. One can only hope that creative people continue to come to London and that the city proves perpetually inspiring. Let's also hope that those interested in overseeing the city's creative wellbeing might do so responsibly rather than harnessing its powers for speculative and/or political gain. If lessons have been learned in recent years about London's artistic potential and its significance in the wider world, they must surely be to acknowledge the circumstances under which creativity can flourish and then let it be.

The quotations appearing in Gregor Muir's essay are from the following: John Deakin, *London Today* (Saturn Press, 1949); Stephen Fry & others, 'Save Soho', Open letter to Chancellor George Osborne/ Communities & Local Government Secretary Eric Pickles, 2015; Jeffrey Bernard, in *Spectator*, 1991; Vivienne Westwood, in *Time Out*, 2008; Iain Sinclair, *London: City of Disappearances* (Hamish Hamilton/Penguin, 2006); M.I.A., in *Time Out*, 2008; and Peter Doig, *No Foreign Lands* (Hatje Cantz, 2013)

Delilah

Eddie Peake

Miles Aldridge

R

Ron Arad Be
Alan Rusbridger Ig
Matthew Freud Azzi Glass
Mary Portas Hassan Hajjaj
Melanie Rickey Antony Gorn
Alexandra Shulman Catherine Lampert
Sarah Mower Alis
Jackie Wull
Matthew Slotover Celia Pau
Charlotte Olympia Dellal Lauren Cuthbertson Peter A
Bella Freud André Balazs Vicken Parsons
Paul Simonon Elif Shafak Kevin O'Ha
Alan Yentob Guy Ritchie Norman Ro
Charlotte Tilbury Joseph Corr
Solange Azagury-Partridge Anthony d'Offay
Tom Hooper Dylan Jones
Saffron Aldridge Thomas Heatherwick
Deyan Sudjic Hans Ulrich Obrist Duro Olowu
Nick Foulkes Julia Peyton-Jones India Hicks
Charlie Siem
Natalia Kremen
Edmund de Waal

Henry Hudson

Tinie Tempah Richard Rogers Nicholas Serota
Ruthie Rogers Emilia Wickstead
Gordon Watson St
Tim Marlow
Flo Bayley
Alidad Mahloudji Gemma Arterton
Josh Berger
Johnny Coca
Camil
Zac Goldsmith DSDHA
Studio Voltaire
Emma Sayle Robert Van Helden
Clara Farmer
Lynette Yia

Sean Bidder

Olu Michael Odukoya

Idris Khan
Annie Morris

Xiaolu Guo

e Kicks

yson Perry
n Kidron Lyall Hakaraia Caragh Thuring
Toronyi-Lalic Christopher de Vos
Peter Pilotto NTS Radio Simone Rocha Fabien Riggall
thew Bourne Jonzi D
Chloe Aridjis Jason Shulman Laura Oldfield Ford
Michael Morris Celia Hempton
Spalding Alex Turnbull Prem Sahib
lager Mark Hix Blaize Simon Gilbert & George
Kate Prince Rohan Silva Adrien Victor Sauvage Polly Staple
oyd Victoria Siddall Courtney Boyd Myers
than Laura Wood Rudimental Romilly Saumarez Smith
nthal Emma Gladstone Kate MacTiernan
rgus Henderson Alice Rawsthorn
amara Rojo Roksanda Ilincic Sister Christine Frost

ude Kelly
Munira Mirza
Daisy Jacobs
Vayne McGregor
Ilse Crawford
vid Chipperfield
Julie Verhoeven

en Bayley

Raqib Shaw
Coco Bayley
atmanghelidjh Hannah Barry
Nathan Cash Davidson

n-Boakye

(following spread) The London skyline in angry mood, seen from the Greenwich Observatory on a May afternoon. Greenwich Palace (also known as Bella Court, the Palace of Placentia or the Palace of Pleasaunce) was built in 1443 by the Duke of Gloucester, then Regent to Henry VI. Henry VII rebuilt the palace between 1498 and 1504, and it remained London's principal royal residence until it was demolished by Charles II in the seventeenth century. It was then replaced by the Greenwich Royal Hospital for Seamen, designed in 1694 by Sir Christopher Wren and now the Royal Naval College. Two of England's greatest rulers, Henry VIII and his daughter Elizabeth I, were born at Greenwich

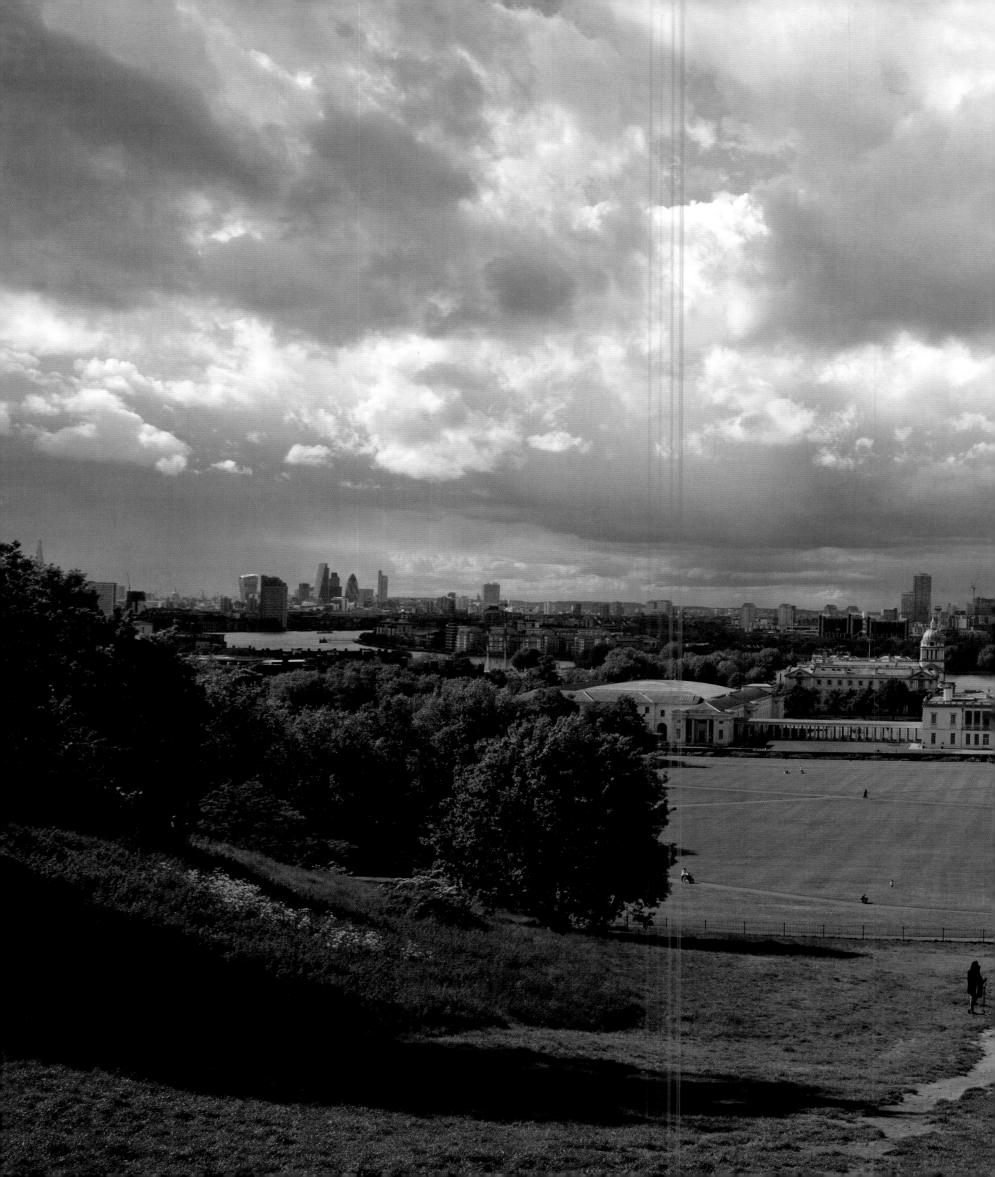

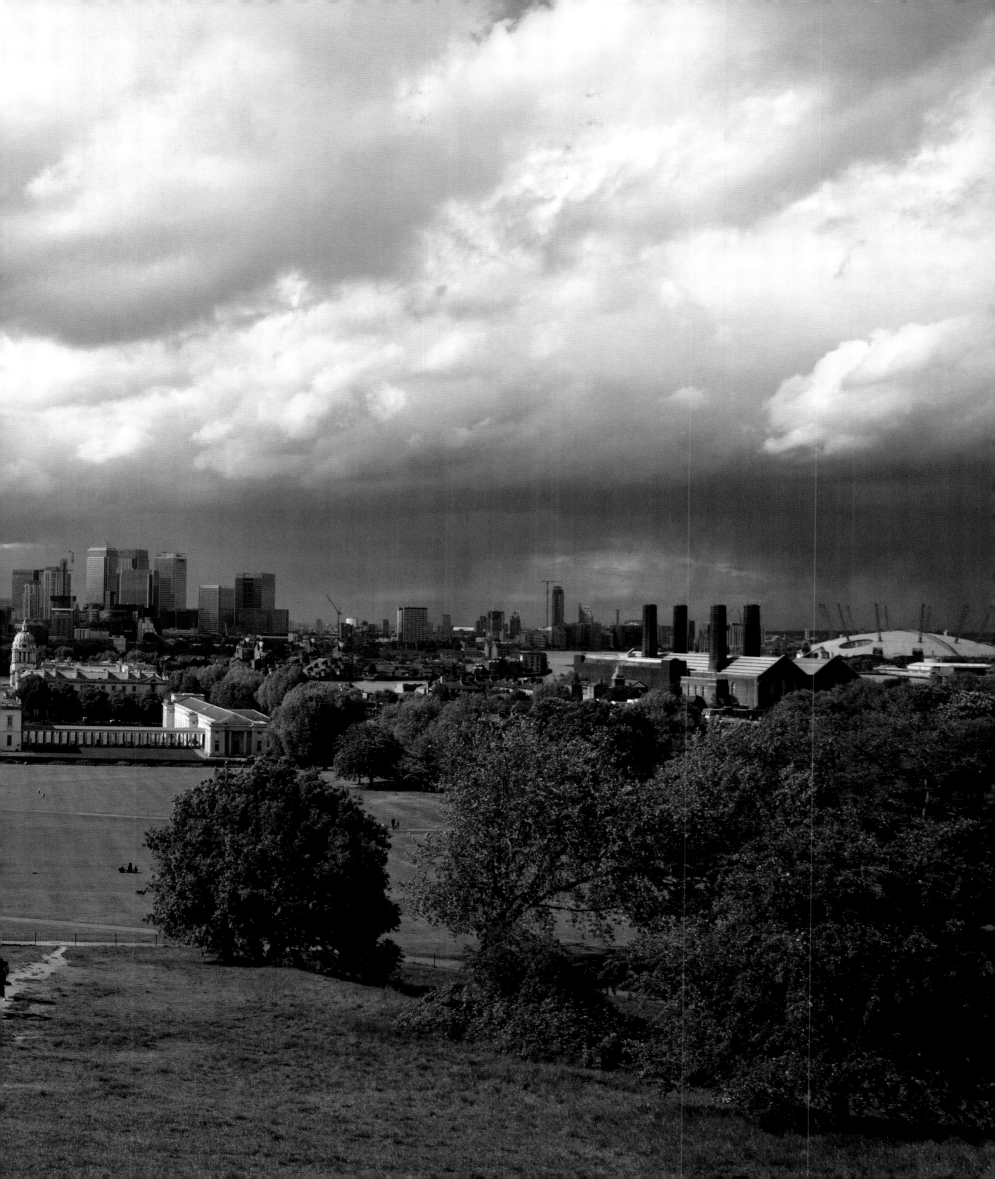

Bethan Laura Wood
Designer
Barbican/Spitalfields

What is particularly interesting about design in London? Or is it comparable to other leading design cities like Milan?
What's great about London is that it is such a melting pot of disciplines. What I fell in love with was that if you worked hard, found out where people were and went out to have a pint with them, you could become part of this strong creative world. In many ways it's very open if you are willing to be part of it and you work and you've got something interesting or exciting to say.

If you determine that you have something interesting to say, whose tracks do you follow in?
I came to London from studying in Brighton; I'm originally from the Midlands, from Shrewsbury. It's a beautiful place of black-and-white buildings and cream teas and old ladies. For a long time I would get panicked if I had to go back home because I knew that that wasn't where I needed to be to make the work that I wanted to make. I had a burning desire to come to London from the age of about sixteen.

And you ended up in East London because it was cheap, right?
Partially because it was cheap, but partially because everyone I knew in London was there. Also it seemed to be where a lot of things were happening at the time. When I first moved there, I produced my own jewellery line and teacup range, I worked for a glassmaker in exchange for workshop space, and I worked in a bar at night. That allowed me to find lots of avenues to new people.

You really mixed it up. Does that help your creativity?
Definitely. When I came to London, it was a very dressed-up period in terms of nightlife. This was 2007 maybe. With the new rave scene that was coming through, and neon, which was sometimes very fashion-y, I was happy as Larry that there were other people that wanted to dance themselves silly. It wasn't about who you were, but about how well you could put together a giant disco ball in your head. That was a great way to meet people from different disciplines. And that's partially why I did a jewellery range at that time; it was an object I could make small in the garden or in the kitchen, and then I could go out, wear it, and that was a way to start conversations with people.

So it was a bit of a performance?
A bit. I've been dressing up a long time, and I used to not like the association between how I looked and my work. I didn't like having pattern or colour in my furniture, and I wasn't comfortable having people think I was a fashion designer. As I've grown older, I've come to terms with that fact that I'm happy with what I like to do, and I'm comfortable in the way I am able to express myself.

Does how you dress affect the way you think creatively?
Sometimes I'm dressed up and it's a completely different zone to when I go into the workshop. Other times, I'm exploring how to work with a new palette of colours or, like when I went to Mexico, there were a lot of hot colours that I tend not to use. But when I started to dress more in those colours and understand them more, I was happy to use them in my work. When I did a lot of pattern design just out of the Royal College, I could make some work cheaper by just printing fabric, and then I started to wear some of those things, partially because I wanted to, but it was also a good way to introduce my work to other people. I had a dress that matched the furniture I made. I do what I want to do, based on what I want to look like that day.

Is it the same in your design work, or do you work to the client's needs?
It's mixed. I work quite a lot with the Nilufar Gallery in Milan, so I obviously listen to my gallerist. But at the end of the day, I'm a designer, and I make furniture which is about someone else being able to interact with it, to open the cabinet, to sit on the chair, to eat their dinner off the table top. I want them to be at the right height so that that function can happen and users can enjoy a piece both as an everyday object and as an object of beauty. I often have a direction for the work that I like to follow, but I also like to make work that is accessible to people for their homes.

Is it not ironic that you are represented by a gallery in Milan as opposed to a gallery in London? Are there galleries that represent designers in London?
There are some. I did residencies at the Design Museum in London and, after that, in Venice and one in Vicenza, after which I showed at the Milan furniture fair. That gave me a connection to Italy. I enjoy working in Italy because they have a lot of artisans and people with specialist skills. We still have amazing skilled people in the UK, but it's not always as easy to work with them. We have fewer knife specialists, for example, and they have so many requests for their knives that they don't have time to train an apprentice. Some crafts are out of fashion in the UK, which makes it harder to keep them going.

What I'm trying to get at is the depth of the British design scene versus the craftspeople you have worked with in Milan. Where is Britain in the universe of design-centred places in Europe?
If you look at a lot of the designers that have come out of the Royal College in the last ten or twenty years, what you see is an element of humour or dryness. And we have a lot more of a critical base in the UK.

Why didn't you choose Milan, then, as an artistic base?
Probably because my Italian is rubbish!

Bethan Laura Wood with Oscar Wanless at Spitalfields Market (right). Wanless, one half of Silo Studio, is a fellow RCA graduate with whom Wood shares ideas. Wood regularly visits the Thursday market in search of visual stimulation to incorporate into her pieces and signature outfits

Wood at the Bermondsey home of one of London's leading textile and fashion designers since the 1970s, Zandra Rhodes (opposite left)

Wood at a Barbican Centre show of work by French couturier Jean Paul Gaultier, a favourite designer (opposite right). She says of the Barbican, 'It's a nice marriage of fashion and architecture when I see shows here'

But if you were fluent in the language, would you move to Milan?
I wouldn't say never, but I love London, and I would be sad to leave.

Why?
In Clapton I love that you walk down the street and find, somewhere like Dalston, an amazing African market, and then you can go by Brick Lane or Aldgate East and there is a much more Indian influence. I love it that there are places where different cultures mix and make new cultures.

Does the friction affect creativity?
I wouldn't say it is friction in a bad way; it's a mixing of cultures. There is a lot of young design coming through places like the Darkroom, for example, and they have a lot of influence from the African prints you find in Dalston.

Can you put your finger on something practical that, in London, supports, helps and inspires the career of a designer like yourself?
The art schools are a very strong force. When I went to the Royal College I met many British-born people, but also people from France, the Netherlands, all over. It was a melting pot of people from different places, but it also had different courses that allowed you to look at non-traditional things, like taking apart a radio and looking at why if you see a knob you instantly know to turn it one way or the other. Or how a button on a black box can change what you think the box is.

What places in London act as inspiration points for you?
I love being around the Hayward Gallery because I love that type of architecture. They also have fantastic shows. There are obviously the Tates. I like to take a Thursday morning and go to Spitalfields. I love that area because it has a history of changing with different types of skills or crafts that move in and then move out.

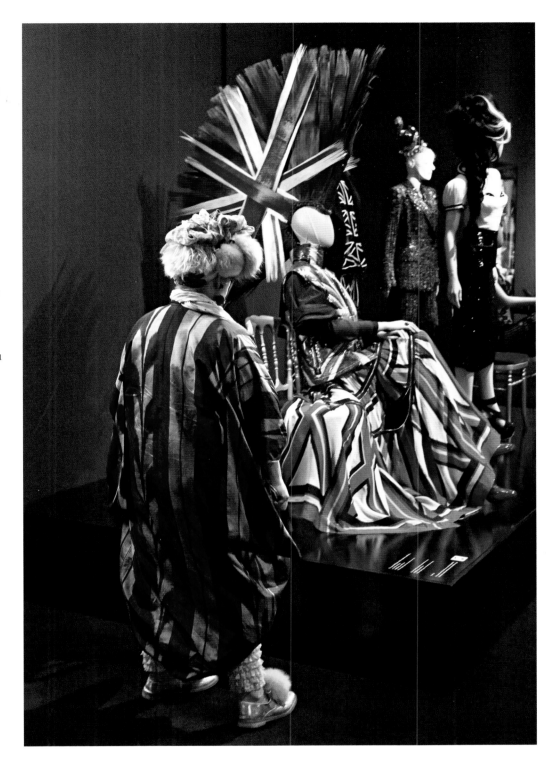

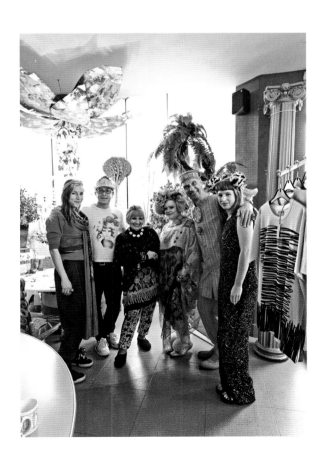

'What's great about London is that it is such a melting pot of disciplines. What I fell in love with was that if you worked hard, found out where people were and went out to have a pint with them, you could become part of this strong creative world'

Stephen Bayley
Author/Journalist/Design critic
Soho/Vauxhall

You've said that you were informally educated by the motorways, restaurants, cafés, bars and museums of mainland Europe. What did you mean exactly?
I went to a very good but very conventional English school in Liverpool, a place called Quarry Bank. Liverpool sort of made me. You can't grow up in Liverpool and not be influenced by architecture; it's got some of the most magnificent buildings in the world and some of the worst slums. Also there's something about the dynamic of Liverpool. Liverpool at the beginning of the twentieth century was one of the richest cities in the world, and then by the middle of the twentieth century it had become one of the poorest. The most shocking decline.

Which reflected the decline of the British Empire.
Absolutely. London is an international city, so London wasn't affected. But Liverpool was the great port of the Empire. So anyway, I just made it my business to teach myself about Europe. In those days I always used to drive everywhere; I spent a lot of time in cars driving around Europe. I started off with a Fiat 128, then a Citroën GS, then a break, then a Citroën Dyane, then a Ford Capri …

Were your automotive choices reflective of your personal aesthetics?
Yes. I've always liked the Fiat 'cause it's a superb bit of Italian design by a guy called Dante Giacosa, one of the great car engineers of all time. The Citroëns were in those days shorthand for 'I'm technically literate but also a little bit Bohemian.' And then the Ford Capri because I have a little dash of vulgarity about me, as you can see from my suit.

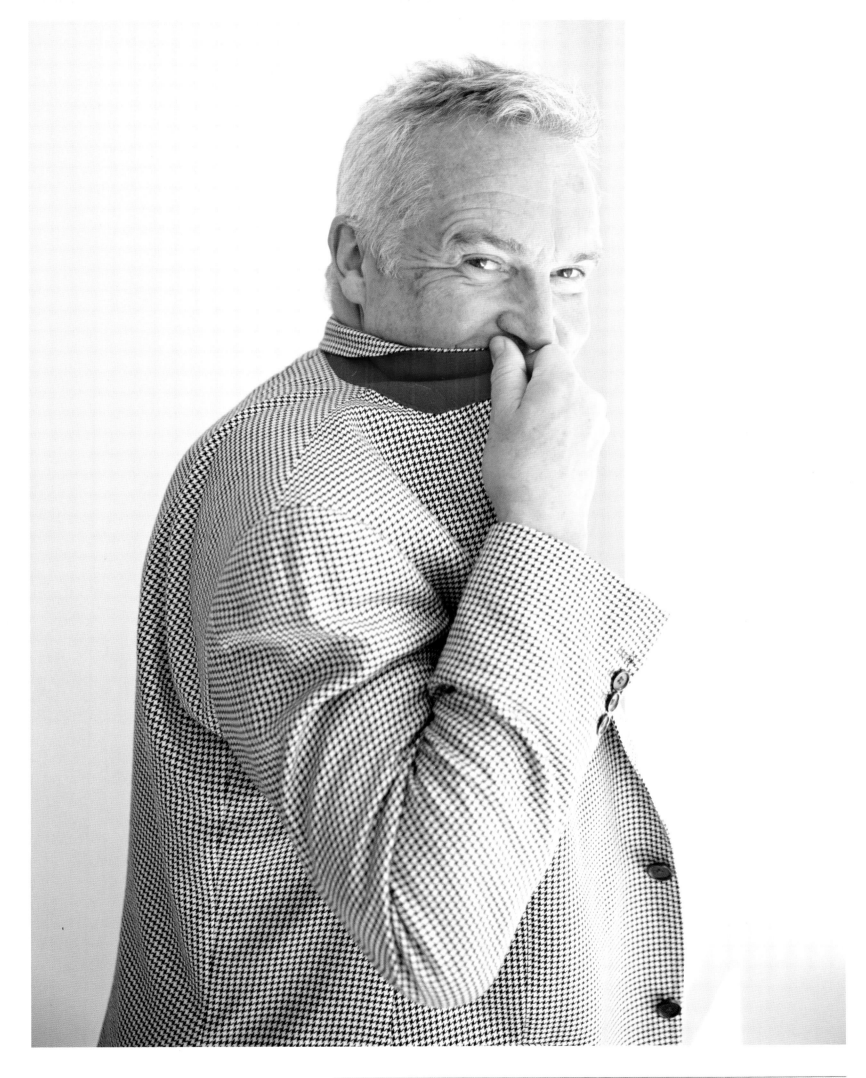

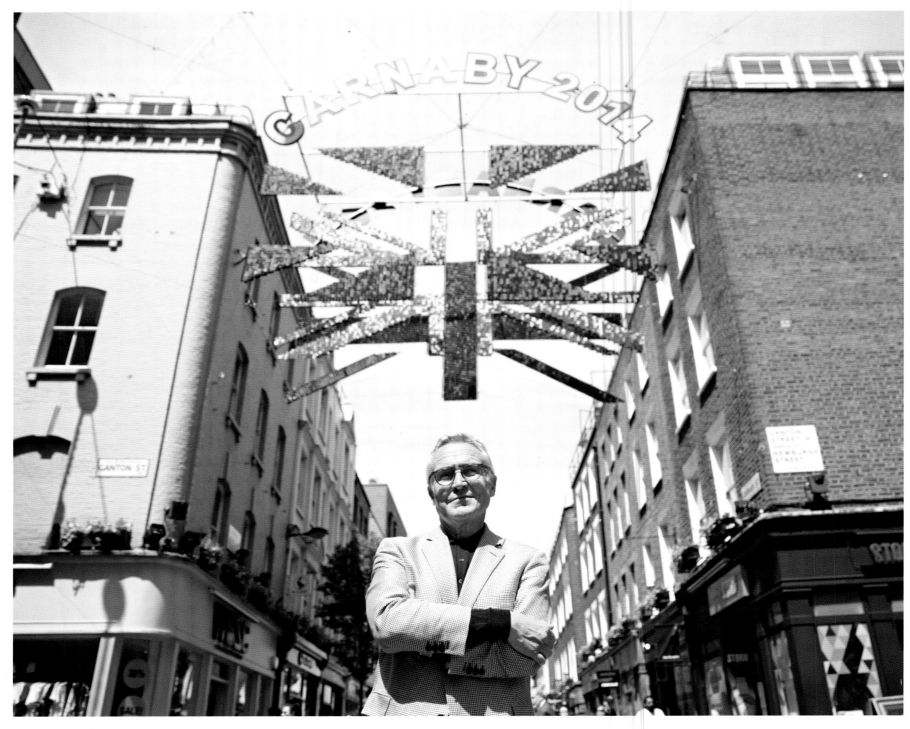

Stephen Bayley outside his office near Carnaby Street in Soho, London's quintessential fashion locale since the 1960s

'I was a pioneer of fear-of-missing-out syndrome. I always suspected that someone else was having a better time than me, so I was determined to make sure that I was having as good a time as possible'

Is it a put-on or does it come naturally?
I do have a slight inclination towards vulgarity.

Which explains your wanting to 'trade up', as in go museum-hunting around Europe?
Absolutely. The idea of social promotion fascinates me. Kurt Vonnegut, the American writer, said that you are what you pretend to be.

Did you prefer the M1 cafés or the *autoroutes* and *autostrade*?
The English, as you know, have refined the art of snobbery. We're all very Francophile; we don't like the French, but we like France. (It's an important distinction.) But no, I much prefer the French. Although it's a personal sadness to me when I go back to France to see that the French *autoroutes* are as bad as, if not worse than, the English. France has been an extraordinary presence in my life because I'm very interested in food and I spend a lot of time in France. Everything one likes about France is getting worse, I mean *everything*. The weather's getting worse, the food is getting worse, the people are no longer chic and elegant, the language is in decline, they no longer make great films or great books. France is in the most appalling state.

Social pretentions or adventures to one side, your own background is pretty modest, no?
It was quiet and provincial. I was brought up in relatively prosperous circumstances; my father used to sell undercarriage aircraft components. I was used to eating in good restaurants, staying in hotels … There's a term for it now: 'fear-of-missing-out syndrome'. I was a pioneer of fear-of-missing-out syndrome. I always suspected that someone else was having a better time than me, so I was determined to make sure that I was having as good a time as possible.

When did you end up migrating south?
I went to university in Manchester first, then Liverpool, and I came to London in 1974. I was a lecturer in the Open University, which was then quite a radical teaching institution. Then I got a job at the University of Kent. I started doing some journalism and wrote my first book, which was one of the first books about design in the modern sense, in the late '70s. Terence Conran discovered this book and plucked me from the obscurity of academic life and asked me to go and do his good works for him. He gave me enough money to build the Boilerhouse Project at the V&A, which became London's most successful gallery in the '80s. We put on design exhibitions and built the Design Museum. Since then I've been what I am now: a writer, consultant, international sex-god …

Where did your interest in design come from?
I read a book about taste. My interest in design was always something to do with my intellectual snobbery; being interested in design (as I had been since I was a child) was a way of learning about France, Italy, the US, places that seemed remote in those days. Knowing about design was a passport to a sophisticated milieu.

Is that still the case?
Absolutely. I passionately believe that everything we buy or make or use betrays, to an extent, the beliefs and preoccupations of the people who buy it or made it. This is what I mean by design. I'm not interested in the latest novelty. Design for me is how objects speak to us; it's the language of things. That's what I'm most interested in. One of the fascinations of the contemporary world is that there's no neutrality. Every choice you make tells a story about you. I'm interested in trying to understand what those stories are.

When was it that we chose, as the human species, to 'design up'?
Obviously people have been making things for ever. What we're talking about, the idea of taste, of how we choose objects to express our beliefs, that's a function of the Industrial Revolution, which brought us mass production, the first time in human history that anybody – well, almost anybody – could buy almost anything. The Industrial Revolution created choice, and with choice came taste. The Industrial Revolution democratised a version of luxury. Bernard Berenson had a wonderful line about taste; he said, 'Taste begins when appetite is satisfied.'

Back to this design addiction of yours …
I don't particularly like the word. 'Design' used to mean something precise; it doesn't mean anything precise now. It's not design, it's the world that interests me. I'm an aesthete. I believe in the visual. I always want to understand why visual things work.

Why has London come to play such an important creative role in your lifetime?
London's been a world city since the Romans; it's always been an international trading centre. But in the past twenty years it's become even more cosmopolitan. London, in my view, has the most organic vitality of any city on earth. New York looks quiet compared with London. The other thing is the economic factors here. We have a stable government, and we have got secure property laws and a tolerant tax system (which brings in lots of foreign money). The interesting thing about the English is that, while they have a reputation for being very conservative, which they are in some ways, they're always open to influence. The English language is an example. We take in new words from wherever suits us. The English language – I'm using this as a metaphor for London's creativity – is the most popular language in the world because it's the one with no rules. It's just a flexible thing that keeps on changing. The point is that these are all factors in London. There's also something about the sheer size and variety of London which is itself stimulating. It's one of the least boring places in the world – it's expensive and annoying, but it's never boring. Whatever you are – if you're a photographer, a writer, a publisher, a business – now you come to London. It's where everybody is.

You were once described by the *Guardian* as the second-most intelligent man in Britain. I want to know how to equate so-called 'chutzpah' with your creative verve.
Creative people always want to change things, like taking risks and don't accept the status quo. Paradoxically, creativity is usually about destruction. If you're creative, you probably want to destroy what went before. It's only brave people who are truly creative. Picasso is a paradigm of what creativity's about. I loved it when Picasso said, 'I'm always doing things I don't know how to do, so I can learn how to do them.' He also said that great artists don't borrow, they steal. That's chutzpah. Albert Einstein is another example. Creativity is not just about the arts, it's about science and business as well. Einstein said this wonderful thing about his relativity theory: 'If I knew what I was doing, it wouldn't be called research.'

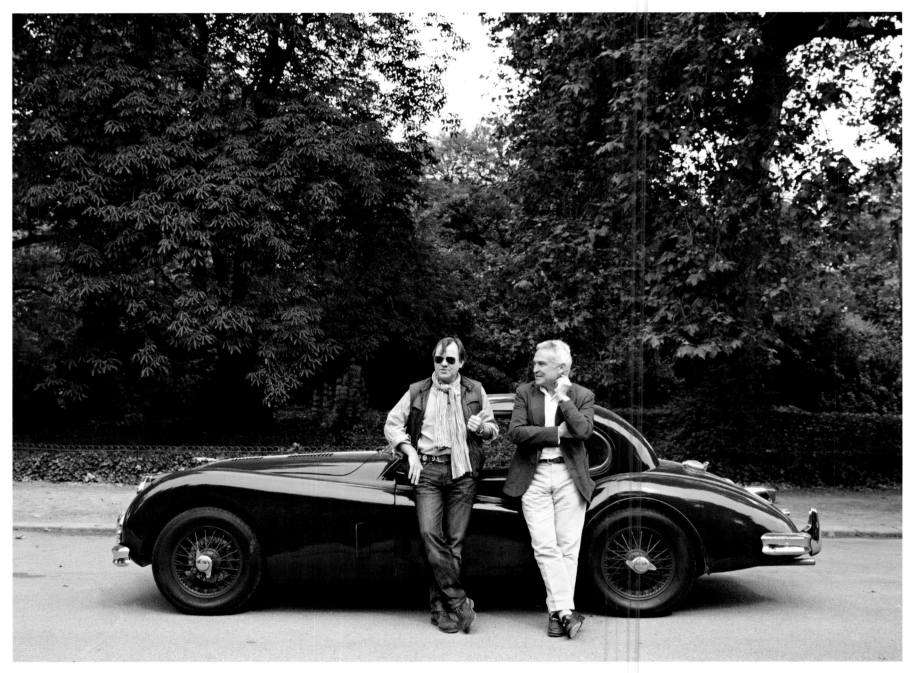

Bayley with his friend Robert Coucher, founder of *Octane Magazine*, an upscale car periodical to which Bayley contributes. Coucher, who has lived in Battersea for many years, says, 'It's like living in Surrey, but you are in London.' His 1955 Jaguar XK140 is taken for a spin most days. So passionate is the attachment that Coucher has joked of his final moments, 'Cremate me, throw me into the petrol tank, and I'll go for a last drive'

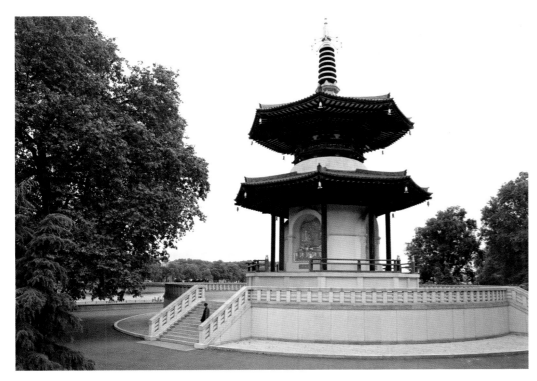

So creative intelligence should be force-fed to children at school?
No. You can't make people creative. What you can do is help create environments where creativity might flourish. Soho's a perfect example. Soho became the interesting place it is for straightforward economic reasons. In the seventeenth century a lot of French Huguenots came here and brought their watch-making skills and their skills with textiles. Like modern London, Soho always welcomed foreigners. The rents then were very low as well, because it wasn't very fashionable. Low rents mean that artists and middlemen and manufacturers can come here. This is why the film industry is just up the road. It started off with people who were doing scene-painting, and when the movies started, all the big American film companies came here to use the scene-painters. You can't teach creativity, but you can help create circumstances where creative people can flourish.

Do you think that London is a creative city due to its own indigenous force, or …
I think there are such things as national characteristics. There's more new building going on in London than in any other major city in the world. The Americans are much more protective of New York than we are of London. It's that strange English thing: we're conservative, but we're adventurous as well.

How much does the bottom line come into all of this?
I hate economists! Economists are always wrong. Anyway no-one cares what the Pyramids cost to build. No-one remembers the name of the accountant who was in charge of Westminster Abbey. We do remember the patron and the architect.

How would you like to be remembered?
I think it's reasonable to say that through the books and the exhibitions and the museums I've worked on over the past forty years, I have helped make people much more aware of design. It's as simple as that. Forty years ago when I started this interesting adventure, people would be mystified if you said, 'Did you know that somebody actually sat down in a studio in California and spent several years working out the shape, the colour, the details of that chair?' They thought it just happened. The revelatory force of this idea that for everything we have, somebody determined its shape – whether it was a person called a designer or an engineer, it doesn't matter what he was called … That was so shocking to so many people. I based my whole career on that revelation.

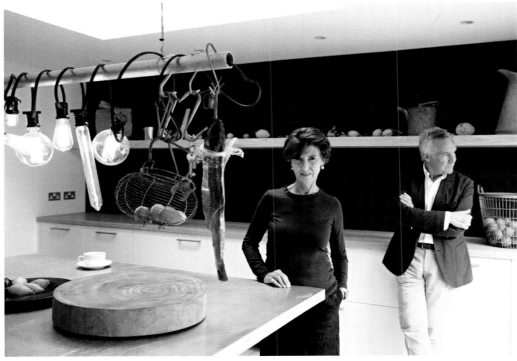

Flo Bayley (top) at the Battersea Park Peace Pagoda, a landmark not far from the Bayleys' Victorian home in Vauxhall (above), in whose kitchen the couple contend for centre stage

Flo Bayley
Product & graphic designer

Graphic designer Flo Bayley met her husband Stephen Bayley when they were both working for Terence Conran in the 1980s. Stephen has joked that he is 'the result of a great deal of styling from Flo – she may not be pleased with the attribution, but a lot of what is associated with me is in fact her inspiration' – praise indeed from an international design guru for a creative spouse. Mother of two children and coincidentally a descendent of Henry VIII, Flo lives in south-west London in a house she and Stephen bought about thirty years ago. She describes their domestic aesthetic this way: 'We want people to be comfortable, to come round and have supper, drinks, sit in the garden – whatever they feel like doing.' What the couple themselves do constantly is brainstorm, a pastime Stephen refers to as 'head-banging'.

Flo reads with passion; Stephen, who doesn't favour fiction, claims she gets through three novels a week. She is also an avid collector. The shelves of her home office are full of objects that 'would drive Stephen mad': old typewriters, dried leaves found on a beach, sketches, paint, scissors, an old camera. Her design company, Studio 176, is described this way in its mission statement: 'We aim for efficiency and economy without sacrifice of quality, intelligence and wit … Our proposition is simple: we can make you look better and feel smarter.' Aiming to quietly redefine

luxury, Studio 176 has included among its clients Boots, Delia Smith (for whom Flo designed the book *How to Cook*, which sold millions of copies), Goodwood Home Farm, Paperchase and Penhaligon's; a project for Perry Court Farm won a Design Effectiveness Award in 2013. The studio has also worked on brand identities for Nest, Designers Guild and Heal's. 'Luxury is simple things done very beautifully,' Flo avers. 'It doesn't have to be extremely expensive, it could be a very beautiful paper that has a wonderful smell and touch.' She attributes her interest in graphic design to a childhood fascination with type and packaging, adding, 'I went to the London College of Printing and then I went straight to Conran.' From there she started her own business. She describes London as 'the most vibrant and exciting city. I love the fact it's so cosmopolitan, I love the fact you can get completely lost … I'd hate to be somewhere where you've got to put make-up on to go to the farmers' market or to the shops … There are so many things to do, so many people that one knows here, but equally you can just be completely anonymous'. Vauxhall, where she lives, has 'been rather shabby for a long time; it's been very slow to come up, as they say, but it's incredibly central'. She especially loves being close to the Thames, which makes her feel 'happy and spacious … The walking: it's a daily delight'.

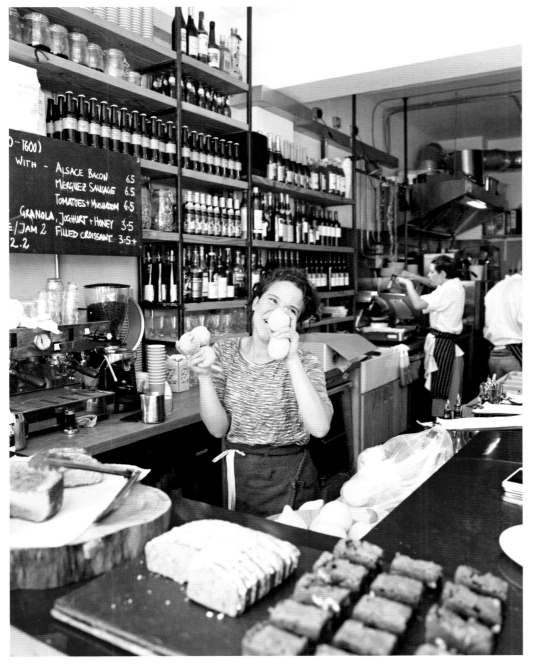

0 - 1600)
WITH - ALSACE BACON 6.5
MERGUEZ SAUSAGE 6.5
TOMATOES + MUSHROOM 6.5
GRANOLA, JOGHURT + HONEY 3.5
=/JAM 2 FILLED CROISSANT 3.5+
2.2

Flo Bayley takes aim with her son's slingshot at pigeons sheltering in the family's front-garden catalpa tree (opposite). London's pigeons inhabit every nook and cranny of the cityscape

Coco Bayley at the Peckham Refreshment Rooms (left). Born and bred in Vauxhall, she has worked in the up-and-coming south London neighbourhood for about six years. Coco with her father (below) pictured in Rye Lane, Peckham

Coco Bayley
Head Chef, Peckham Refreshment Rooms

Born and bred in Vauxhall, Coco Bayley, daughter of Stephen and Flo Bayley, is the head chef at Peckham Refreshment Rooms, an up-and-coming restaurant that has been described as serving 'small plates of European flavours in a pared-back modern space'. An Oxford graduate who earned an MA from the Sorbonne, Coco lives in Kennington, a disconcerting mix of near-perfect small Georgian squares and huge crime-ridden estate blocks built to fill in bomb craters after World War II. 'Peckham is hard work,' Coco observes, 'but it's quite fun.' Of her current career choice, her father has remarked, 'Disingenuously, she is learning the trade before deciding on a career in the food business or committing to medical anthropology ... I always lectured her on that sound principle from The Unwritten Laws of Engineering: it's better to do a modest thing well than an ambitious thing badly.'

Peckham Refreshment Rooms is part of a broader project to bring the arts to south London. Coco explains the thinking behind the Rooms this way: 'The concept was an unpretentious neighbourhood restaurant because there aren't many places around here. We're open from 8.00 in the morning until 1.00 in the morning so we get every different type of person who comes through Peckham – commuters, residents, artists, people clubbing, tourists, deluded party-goers I'd like to think it's quite unique in the London restaurant world in that I don't know that many places that are so small and yet so popular.' Coco's long-term plan is to open her own place south of the Thames.

Lyall Hakaraia
Fashion designer
Dalston/Barbican

You are Maori, I believe.
I'm half-Maori.

So you've travelled all the way from New Zealand to Dalston. From Kensington to Dalston is almost as long a distance socially. How is it possible in one city to have such a diversity of neighbourhoods?
Because they are like villages that have their own identities. People gravitate towards different villages. This one is quite African and Turkish, and you have people attracted to the energy that happens here. If you are east, you don't really go south-west or south; people stick to their areas.

I'm interested in your thoughts on identity in terms of the city.
I love travelling through London. London by night especially at the moment is great, with all the new buildings and the lights that have gone up. People gravitate towards different neighbourhoods because of what they offer. I love Dalston because there is a lively art scene and a lively gay scene. Gay, straight, is all here and gets on; everybody goes out. They have fun together and aren't really that bothered about what anyone else is up to.

Fifty years ago, where would this situation have existed in another part of London?
I have no idea. Probably Soho, Piccadilly, places like that. That element got pushed further out as it got more expensive.

So money drives out fun?
It pushes it to different places, and then it's about fun taking hold and making that area its own. But when rent goes up, there is not a lot you can do to hold on to places where artists can live easily.

You know a lot about rents because you lived in a squat, didn't you?
Yeah, for about seven years. I moved to London in 1990 and lived all over the place. It wasn't until I found this area that I really liked the absurdity of it, where you have amazing churches and lots of mosques and a rich Turkish culture. It was cheap to live here, and you contrasted that with the African communities as well. The conflict that happened between those two cultures was interesting.

Does that type of multi-ethnic mix create creativity?
I think so. That conflict was also good because it meant you could almost slip beneath the radar. You were so busy just surviving that dressing all in orange or green or spots or whatever you had on that day went unnoticed. It is only when it is obvious to people that things are going to change that people push against anything that is new.

So gentrification causes narrow-mindedness
It does.

If you were to take your gang out west to Chelsea or something, do you think you'd have people staring at you?
You probably would. I recently went with my daughter to Ireland, and she got very upset because everybody was looking at me. She doesn't notice it here, but over there it was much more noticeable; people wanted to take photos. Here you don't get that sort of intrusion. People leave you alone.

This exterior colour that you exhibit, is it art in motion?
Some people can express themselves through it like art. I think of it as some kind of performance. I do it on purpose so that it's something a little bit different, and people don't get used to seeing the same thing over and over again.

Do you do it on purpose to educate people?
I felt that it was important for people to sort of see something different, so that's definitely purposeful. I'm in my mid-forties now, so for me it is an everyday thing, something that I have assimilated into my life. You have people who are horrified by it, and you have people that come up and give you compliments as well. In Paris particularly, you get lots of people coming up and saying, 'Oh my God, you just made my day!'

But no violence?
No.

That surprises me.
I'm quite mouthy; I give as good as I get. I don't back down an inch so I usually don't get any of that kind of stuff. And when I'm out and I'm wearing a dress and heels in the street, I'm really proud to be who I am, and I'm really enjoying that moment. It's the same as anything else: as soon as you show any weakness, people are on you in a second.

In London fifty years ago, if you were gay you would have hidden yourself well off the social stage.
It was illegal fifty years ago.

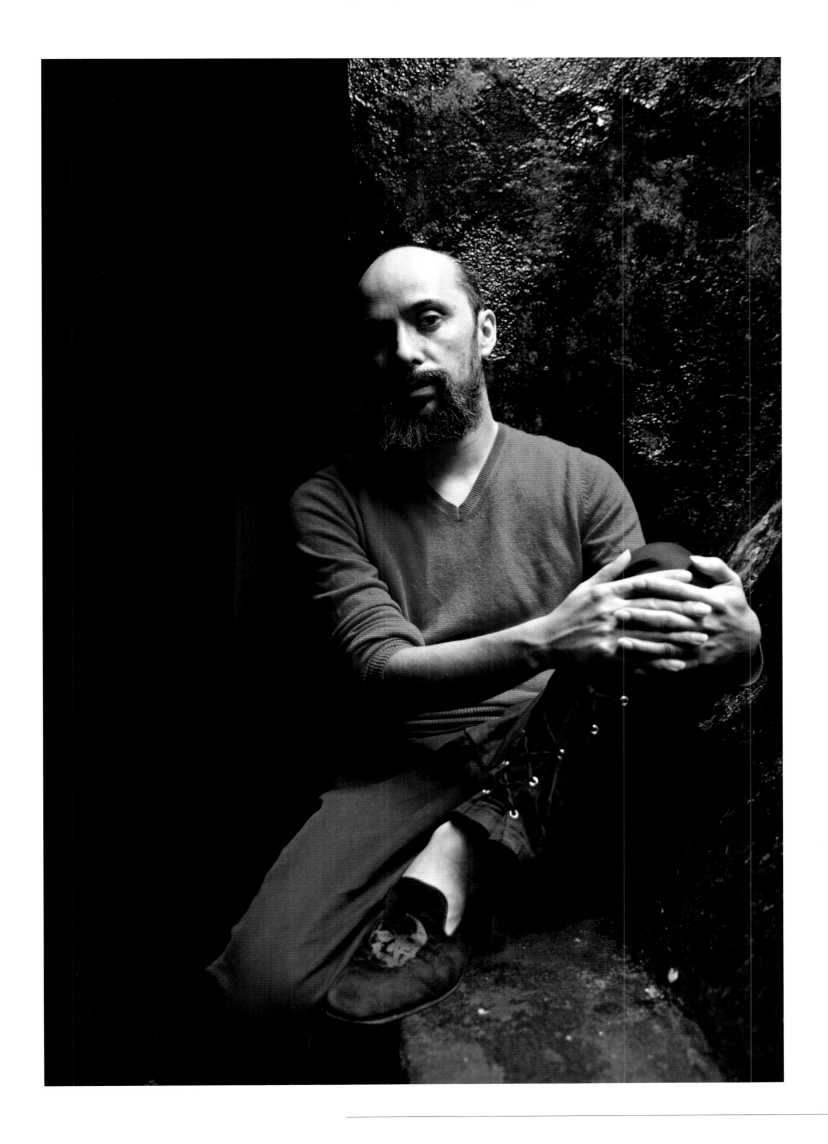

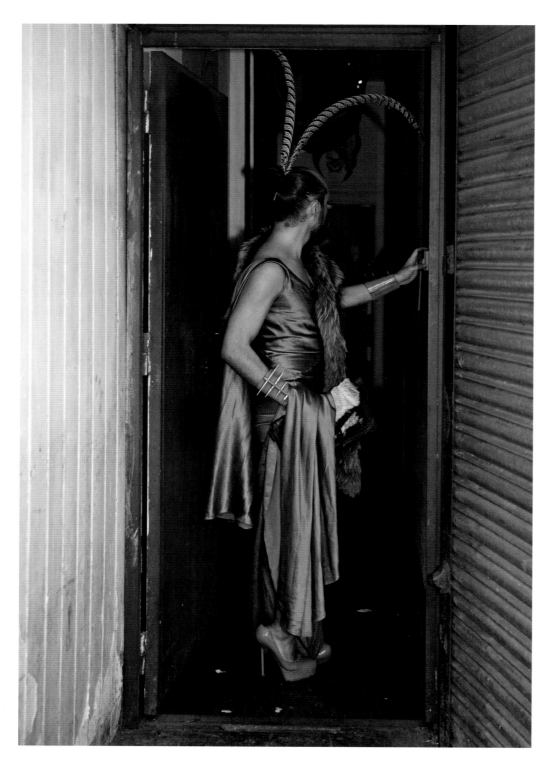

What has made London such an open place for extreme thinking?
Living in London we forget how lucky we are to be here, and in how many places around the world you can't express yourself. Over the years there have been a lot of people who have had the audacity to keep going at it and make sure that things change. There is a very liberal society here in England.

But *Lady Chatterley's Lover* was banned in the '60s!
I know. But what was once extreme is now taken as everyday. For example, when you talk to gay men who are in their fifties and sixties, they are very despairing of young gay men. They don't understand how they can be so flippant. They haven't had to go through that hardship; they haven't proven themselves.

You are part of the avant-garde, I suppose.
For me it is important that we keep on going, that we don't stop. There are still lots of groups who are unrecognised. I have lots of friends who are transgender so I work a lot with that community both in this country and internationally. It's one of the last things where there are still hang-ups because there is discrimination by society in general, but there is also discrimination within the gay and lesbian community. There are lots of lesbians who won't accept trans women. In the community itself things still need to change.

So the tables have turned?
They have. It is a sad thing that it is almost human nature to pick on the weakest, and it's sad that it happens within the community. For me it is an interesting thing, because surely if you are different you should be able to accept that there are lots of other people who are also different, and that their differences are equally as important as your own. Differences should be recognised and encouraged and supported.

The state can't do that, can it?
No. It's up to society at large.

Have you always felt this need to be right there in the thick of things?
I think so. I grew up in a very small town. It was black/white, gay/straight/lesbian, a small artists' community. I spent time with everybody's families; most of our parents went around naked. It was a hippy, free, nice society. Nobody was judged. As children we were all encouraged to be the most that we could be.

The outcome of which was what?
The outcome was that I found it very peculiar when I came to the rest of the world and people didn't think the same! As I got older and had my daughter, I wanted the world to be a better place and for her to understand that. Back to us being in Ireland again, she was really upset because she couldn't see why people wouldn't see that difference was okay.

What's the connection between being gay and creative, and being open-minded in the sense of the small community of free love and free expression you grew up in?
There is something special about the communities we have been speaking of, because they encourage you to express your otherness. An easy way of doing that is by being creative. You paint or you write or you make music. Always being a part of a community is a really important thing for me. Gay, I don't really think that is relevant. That universal thing you are trying to portray in your art will affect people whether they are a farmer or a banker or a doctor, straight, black, white. Great art has truth for everyone.

'When I'm out and I'm wearing a dress and heels in the street, I'm really proud to be who I am, and I'm really enjoying that moment'

(page 31) New Zealand-born Lyall Hakaria in repose in Dalston, where he runs the nightclub Vogue Fabrics

Hakaraia leaves his three-storey house (opposite), featuring his home on the top floor, his atelier on the ground floor and the site of the famed club Vogue Fabrics in the basement. Hakaraia outside the former Aziziye Mosque, now a shopping arcade (right)

Hakaraia arranges the window display at the front of his atelier (below left), where he creates designs worn by such celebrities as Madonna and Lady Gaga. Performance poet James stands outside, preparing to recite his work at Vogue Fabrics later in the evening

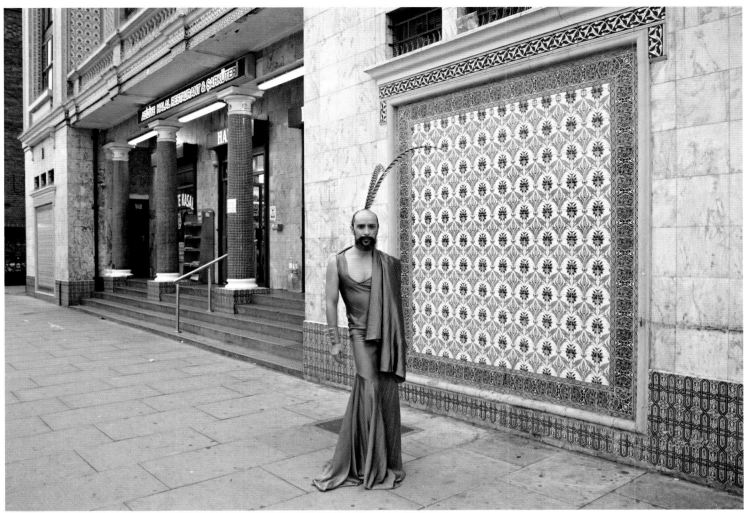

Hakaraia makes merry at his regular Dalston meeting spot, A Little of What You Fancy restaurant (right), with artists Jenkin Van Zyl (L) and Victoria Sin (R)

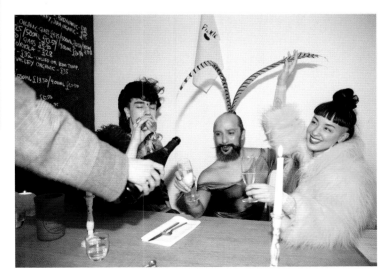

You've talked about having lived in the majority of boroughs in London. Where is your spiritual centre in this city?
My home. That's my spiritual centre.

Is that also where you find inspiration?
Definitely. Especially with a nightclub in your basement, there is a lot of inspiration to be had! My spirituality I suppose is about my home and inviting people into my house, talking to them and creating and making art in this space.

So now that you have some recognition and you are fulfilled in yourself, you feel that you can take that message out and help others.
Yes, definitely.

With a little profit along the way?
Well, I feel like I have been helped along my way in my life. There are people who have given me indicators and signals and helped me progress from one thing to another. I'm now of an age and in a position where I can do that as well. I have a spare room, and usually someone staying that needs help. I find them or they find me.

And you've never had any misunderstandings in such arrangements?
No. I'm used to working with the public. I used to sell my clothes from market stalls and I've done doors for clubs, so I'm really good at summing people up in three seconds. That's been my job for years! When you are working with celebrities like Madonna and Lady Gaga, you have to sum up what they are feeling and what they want from you in that moment, because if you get it wrong, you don't get that job. It's an uneven, interesting life, and I like that there is something always happening and catching me off guard. When you get comfortable, creativity starts going. If I can manage it, I try to go out four or five times a week, and I try to make sure that at least two of those places are things that I would never go to normally. You've got to do that sort of stuff to be continuously inspired.

Hakaraia and DJ Princess Julia celebrate the Barbican Genderf**k event (above), complete with a laser show in the conservatory (right), a tropical oasis featuring over two thousand species of plants and trees

Hakaraia and Victoria Sin (above) at Vogue Fabrics, where clubbers mingle in street gear and drag (right)

Victoria Sin, inspired by drag queens and porn, at Vogue Fabrics (opposite), where commissioned paintings by her (right) hang in the loos

Lyall Hakaraia

Alexandra Shulman
Editor-in-Chief, British *Vogue*
Queen's Park/Mayfair/Hyde Park/King's Cross

Do you think of yourself as the country's most important cultural trendsetter?
Definitely not. As the country's most important fashion-magazine editor, but not as its most important cultural trendsetter.

But whatever *Vogue* says determines the direction that is followed by others, no? How does it feel to have been at the top of that operation for more than twenty years?
I think of *Vogue* as something that has a life of its own; I am somebody who's nurturing it. I am passing through and it will remain. The period of my passing through is a great privilege, and it's a lot of work, too. It's a privilege to have the power of *Vogue* to enable you to say what you think is interesting, what you think is good, what you think is relevant. I see it as the power of *Vogue*, not the power of me.

How involved are you editorially?
I'm pretty involved, for instance with things like the page furniture, things like the headlines, and the introductions to the pieces, and the quotes that we pull out, and quite often the captions. I come from a features-editor background, so when I look at a page, probably the first thing I'll see is the pull-quote, and at least 50 per cent of the time I'll change that pull-quote. I'm far more likely to do that than I am likely to say, 'I think that's the wrong picture.' I'm very involved in the choice of the photographer, and pretty involved in what goes into making up a shoot. But what actually happens on the day is quite often entirely different from what I thought was going to happen. And mostly it's great. Sometimes it's veered off in a direction that I didn't want.

What happens then?
Sometimes I'll cut out the pictures. Our shoots are very expensive; it's quite hard to just dump a shoot.

It seems that you're very hands-on in every facet of the operation.
There are aspects that I'm not involved with. Through the day I just say, 'No, you make the decision; you do it.' I try and pick good people. It's my real talent: I'm brilliant at picking people. Once I've got good people, I do try and let them get on with it. But I need to be aware of everything.

And this brilliant aptitude that you have, whether developed or natural, is based on what?
Gut instinct.

So you like to mix it up?
Yeah. I'm always a bit disappointed if I hire the predictable choice.

But the magazine is pretty predictable.
It has a sort of agreed content, as it were.

Who agrees to that content overall? Is it an historical pattern, or?
It's historical, I think.

In other words, it's money-making, so why tamper with it?
It's money-making, it's admired. It's distinctive. People buy *Vogue* expecting it to be certain things, and although they like to see a surprise in it, they don't want it to suddenly all be shook up.

Given that sort of expectation, how do you do the unexpected?
Well, every now and again you can think of an idea, but you've got a kind of canopy of what *Vogue* is, and that's contemporary style, fashion, celebrity. Within those predictable categories, you might have somebody unusual doing something. Lots of times it's other people suggesting things. Or occasionally I'll read a writer and I'll think, They've never written about fashion, but it would be interesting to hear what they have to say.

You've said in the past that you wanted to be a hairdresser
or a musician ...
I never wanted be a musician; I wanted to work in the music industry.
I came to be in magazine journalism by default. Both of my parents were
journalists, so I was quite determined not to do what they did. And then
I ended up doing the same thing.

You have a dominant presence. Where does that come from?
I am quite clear. I am quite certain about things. What people who work
for me would say is that I'm quite good at making decisions, and they
appreciate that. Often it's the process of making the decision that's the
important thing. It may be the wrong decision, but at least you've let
something happen.

If you make the wrong decision, does anybody dare challenge that?
Oh God, all the time!

Your mother also wrote for *Vogue*, I believe.
She was Features Editor here in the '70s, I think.

So this is sort of your birthright?
Yeah, it's quite embarrassing. I've been in and out of this building since I
was about twelve. I've hardly gone anywhere else. I started working here on
Tatler. So really this is as much my home as my mum's flat in Eaton Square.

So Hanover Square to Eaton Square?
It's not a very long journey, is it?

Do you travel outside this dominion?
Sure. When I leave London, I tend to be more interested in being in the
countryside than I am in seeing a lot of other cultural activities, although,
if opportunity allows, I do.

(previous page) Alex Shulman
at home in Queen's Park,
and sorting through new
designs (above) at *Vogue*'s
London HQ, in preparation
for fashion shoots across the
globe, vestiges of which wait
in the corridor (right)

Alexandra Shulman

Shulman in her office (above), and reviewing the manuscript for her second book in her kitchen (right). British *Vogue*'s longest-serving editor, she has been at the magazine's helm since 1992

You've been quoted as saying that the fashion business 'is very much to do with smoke and mirrors; what designers sell is in part a fantasy'.
At its most basic level, you only really need two pairs of trousers, two T-shirts and a jacket, say. Everything else that you're buying is for desire or something. Designers have to make you want something that you don't need. The industry is very much to do with enabling that to happen. My fashion imagery in the magazine has a lot to do with two things. One is to inspire people to actually buy the clothes, but I would say it's more to inspire people to want to look a certain way. It's commerce, but it's also a dream.

Trying to sell the clothes, what relevance does that have?
Quite a lot, because the magazine is financed by advertising. The percentage of revenue that we make from selling the magazine is nothing compared to the amount that we make from advertising, and we wouldn't get that money from the advertisers if they didn't feel that they were making money out of it. They place advertising in an environment that encourages people to be interested in their brands, which is why they come to *Vogue* and don't go to some other magazines. People reading a different magazine might not be in the same frame of mind, might not be going to take in the subliminal message that the advertisers are putting out. You've got to be in the mood, you've got to be receptive, and you're looking at *Vogue* at a certain point for a certain reason.

So you're a facilitator for the creative fashion industry?
Yes. It's a collaboration. We all need each other.

When you were young, looking at and visiting *Vogue*, did you follow any of the fashions that were represented?
Definitely. I still remember so many images of *Vogues* I saw as a teenager. When you're a teenager, you remember the way a girl's scarf was tied and the colour of the eye shadow … I remember a girl in black lace, on a horse in a forest. She was a young blonde actress. That was such a memorable image for me.

In your years at the top here, have you noticed marked differences in the creative output of the British fashion industry, for one thing, and then in other parts of the creative world in London?
The British fashion industry has changed out of all recognition. There've always been some wonderful creative designers. Vivienne Westwood has been around for years; Mary Katrantzou is fantastic; you had people like Ossie Clark and Bill Gibb, and before that Hardy Amies and Norman Hartnell. So it's not like there weren't great designers. But now the actual business side works. People come to London to see British designers, to buy, to sell around the world. There are a lot of talented designers who've grown up in the last decade who now have real businesses. They're not a brand like Ralph Lauren or Armani, say, but there are no new Ralph Laurens or Armanis. It hasn't happened anywhere in the world that an individual has kept hold of and grown their eponymous brands to the same extent. It's now much more likely that you will be a talented designer who designs for a house that's owned by somebody else.

If you were offered the choice of heading *Vogue* Paris or *Vogue* New York, I suspect that you would stick with London.
Absolutely, no question.

Why is that?
Vogue Paris is a very different kind of magazine for a very different kind of city. It's a much smaller, more finely honed magazine, with one kind of Parisian aesthetic. It's concentrated and stylish and lovely, but it's not the culture I'm part of. I wouldn't know how to operate like that. New York's actually in some ways the opposite because it's massive. Because it's so big, it doesn't allow the same kind of creativity that we do. It has to appeal to a more middle-brow taste than we do.

As far as creativity is concerned, what is its main wellspring in London?
Is it because we are an island? All these people who come to London, who aren't British and who have homes here, or people who live here or are passing through, they love London because of the diversity and the range. The mix of cultures has helped London to be what it is nowadays. And yet at the same time, you've got everybody worrying about immigration …

A keen jogger, Shulman's favourite London spot is the Serpentine in Hyde Park (above)

A *Vogue* magazine highlight display adorns the corridor wall at Vogue House in Hanover Square (opposite)

'The mix of cultures has helped London to be what it is nowadays. And yet at the same time, you've got everybody worrying about immigration'

Shulman in the driver's seat, watching designer Mary Katrantzou's Spring/Summer 2015 show (left & above)

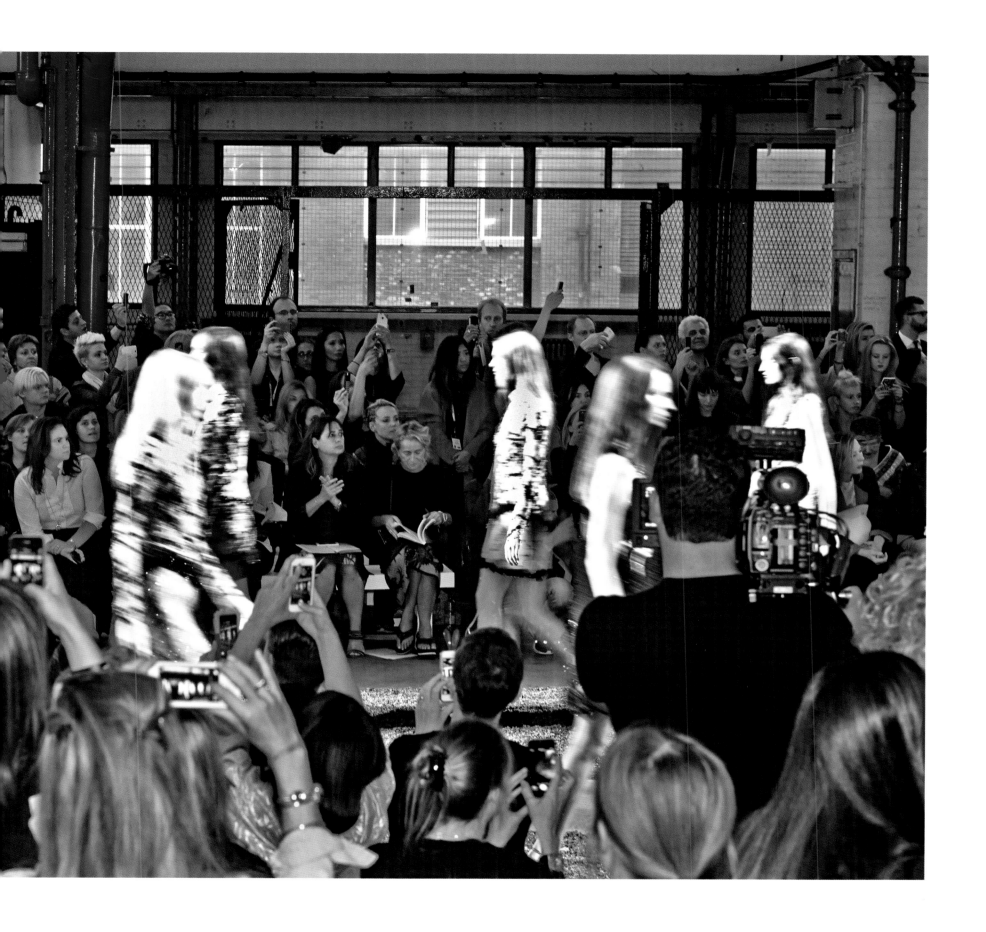

Jason Shulman
Artist

Alex Shulman's brother Jason, currently a painter, used to be (like his father and sister) in the magazine business. 'Everyone was very brainy in my family,' he says. Born in 1965, he lives in Hoxton with his wife, the author and critic Susan Irvine, 'no TV and some card-playing, booze-swilling red squirrels'. 'No-one lives in Hackney by choice,' he quips. 'Take me back to Belgravia; I've fallen far from the tree … Actually, I wouldn't necessarily want to go back there, but I do like the architecture.' By his own description 'misanthropic', Jason might well find Eaton Square, where he grew up, oddly appropriate, given that 'nearly everywhere is owned by someone who's away, so you're basically in a ghost square most of the time.'

Jason's father was a theatre critic, while his mother wrote etiquette guides. At one time Art Director at *Harpers & Queen*, Jason's work has been exhibited in London, Dallas and New York. He employs optics and other basic scientific tools in his work with the aim of exposing the falsehoods that underpin our experience of reality. Loss, pain and mortality are constant concerns. To create his key work *A piece of my father* (2006), Jason collected his deceased father's ashes from the funeral parlour, having 'remembered reading in some childhood book that there was lead in there to make four pencils, enough iron to make four

horseshoe nails, or some such … I poured out all of the ashes onto the table and I spent three months … getting all the iron out first of all, and then getting all the bits of bone that had oxidized in different colours …' He sums up the process as 'a catharsis. Most of the time you're oddly disconnected, you're just looking for bits of colour, but occasionally you'll find things like a filling or a gallstone, which would be a hideous kind of reminder of what you're dealing with …'

When asked if art qualifies as a kind of charlatanry, Jason replies, 'Definitely. Often you're trying to pull the wool over people's eyes, maybe just trying to show them the world up close … If you can get someone to see your world, that's a good day.' Place is irrelevant to his art; 'I don't need a view,' he explains. Having rented a monastery in Italy, he found himself 'crippled by the beauty and the art – famously, I followed a long procession of people who go to Florence and can't do any work!' London itself provides no inspiration as such. 'I don't in any way use it; I don't go out, I don't do theatre, I don't go to exhibitions, I don't bounce off its creativity in any way,' Jason claims. 'I go from here to home, or here to a bar to home.' His favourite drink? 'A vodka martini, which is basically a rich tramp's drink.'

Jason Shulman outside
his studio in Haggerston
(opposite), and enjoying
the spring colour and
gamboling squirrels in nearby
Stonebridge Gardens (above).
Shulman with his 2013 piece
Light Bulb, a play of light,
reflections and fire (left)

Anthony d'Offay
Art dealer/Collector/Curator/
Founder, ARTIST ROOMS
Dering Street

You've been here in Dering Street since, what, 1961?

No, 1969. We moved here and changed bank at the same moment, from Lloyd's to Hill Samuel merchant bank.

Was that a grading up, so to speak, from high-street bank to private bank?

Yes, because at that time galleries were considered a perilous venture. Our bank manager at Hill Samuel said to me, 'If you ever want to buy this house we'll help you.' I immediately wrote to the people who owned the house and said, 'Would you consider selling it to us?' They said, 'Yes, it's £60,000' – not bad. We bought it over three years, and it was a wonderful investment, and it was lovely to have a bank manager that helped us and lent us as much money as we wanted.

Isn't the crux of the matter that that bank manager, that local touch, that flavour of Englishness, has all but disappeared from London? The point I'm making is that the character of London has changed in the last forty years.

Yes. When we opened a big international gallery in 1980, we tried to do a couple of things. The first thing was to do exhibitions for the international art world and for young people in this country – for students. By saying to ourselves that we should be able to invite any artist to have a show in London and that we would have a reputation for showing the greatest artists in the world, we managed to persuade the public that here was something which nobody else had done. The idea of having a show outside New York in a very central place was attractive to American artists, and to have it in a place that spoke English. There are more people that come to London than any other European city. So the idea that if you had a show in London it would be seen by Japanese and Australians and people from South America, from the Continent and from Africa was extremely attractive. It worked incredibly well. One of the advantages of this place is that it takes five minutes to walk from Claridge's, and that's where all our clients, and all the people that came to visit us, stayed. The idea that London could change and become the most popular city outside New York was a very important one.

Important for the contemporary-art scene?

Exactly.

You were born in Sheffield and became a Londoner when, in the '60s?

I was born in Sheffield and brought up in Leicester. So what I saw, in terms of art, was pretty much what was shown in the museum in Leicester. London seemed a very, very long way away. Very expensive to get to, and you didn't know what to do when you got here at any case. It was only when I came to live here after studying at Edinburgh University that I learned what to go and see. The Leicester museum is a beautiful Victorian museum with lovely paintings, a whole floor of stuffed animals, some nice Egyptian mummies in the basement and a beautiful collection of paintings including amazing German Expressionists. And wonderful paintings by Stanley Spencer, and to my delight there was a great painting by Francis Bacon.

In terms of your journey from Leicester to taking art to the public, you've referenced the importance of 'the idea to get children involved at an early age … to get them looking at things; painting, sculpture, photography. If you get a child involved in culture early, it gets them for life'.

I think that's right.

And this has been the maxim behind both your professional purpose and your patronage?

Absolutely. You don't say, 'Oh, this is a regional museum and it's a small place; it isn't important.' You say, 'Every single person is important, and every exhibition is important.'

You're a bit of an anomaly because what I see in the world of contemporary art in London is that it's a dog-eat-dog business.

That was something that we saw coming, and we closed the gallery in 2001. But then something wonderful happened: many great galleries came to London from all over the world. Hauser & Wirth, for example, in Savile Row, creating a sort of heart in London, and now all the great galleries have come back to Mayfair.

But they follow the money, and that's a trail which you blazed, essentially, you and your kind, right?

We were very lucky that we did it when we did it. When we closed we had hundreds of letters from people saying, 'I saw such-and-such a show when I was eight years old, when I was fifteen years old, and I decided to be an artist, to go into design.'

When exactly did you put on your backpack and walk down here from Leicester?

I remember moving to London and thinking, In three months I should either be destitute or things will begin to look up. In the first three weeks I was lucky to have some successes, and I never looked back. When I was twenty-five, we opened a little gallery, and even in the first five years we had some big successes. We did a show, *Drawings of Hokusai*, and got a half-page review in *The Times*, so everybody was looking for our gallery in Vigo Street. It was this tiny, tiny series of three rooms on top of each other in a little old house.

From what I understand Vigo Street became Art Central in the '70s.

The fact that it was in the centre of Mayfair was very important, and people were very kind and encouraging and incredibly helpful.

You seem immoderately modest, and too nice to be in the business ...

I'm not in the business any more!

You've said, 'I was an unhappy, lonely, melancholy child ... and I was interested in culture.' Do people need to be a little dark and moody to become acculturated?

Lots of children, and everybody at puberty, has a rough time. My dad sort of ran away and I had to leave school a little bit early ... To be able to go to the museum and be quiet and on your own and feel strengthened by art, that's a wonderful thing. My mother used to go shopping but would drop me at the museum and say to the chap at the gate, 'This little boy will behave himself. I'll come and collect him in two hours' time.' That experience of being with wonderful works of art, being on your own, and having the time and the situation where you can be quiet and listen to them speaking ... Because if you're with a great work of art, it speaks to you if you're quiet.

Or does it open a little cubbyhole somewhere in which you find some understanding or space to speak back to that piece of art? Because art is not intended to speak to anybody except the artist ...

No, no, no, no, no! Great works of art are complete when they change hands and especially in public ownership, when they can be shared by other people. I don't think that works of art are there simply for the pleasure of the person who creates them. And the meanings of works of art change with time. The late works of Andy Warhol looked very banal at the time. Now they look prophetic and can be immediately read by young people.

The gallery that you opened is considered by many to have been a vital catalyst for the renaissance of contemporary British art. Is that how you see it too?

We represented some great British artists, but the greatest strength we had was to show artists who didn't show here before, like Joseph Beuys, for example, and Gerhard Richter. We showed all the famous German artists because, apart from anything else, they felt that they could in some way control the show. As if when they had a show in New York it was make or break. So it was a much safer thing for them to show in London. And you could get on an airplane in the morning, spend five hours with them and come back again.

So would you say that the creative environment in London is much more friendly and conducive to nurturing than in New York?

The idea of having a show in New York is frightening to people because they feel it has to work. What we tried to do was to encourage artists to do things that they might not otherwise have the confidence to do.

How did London particularise your métier? Or would you have done the same things in, say, New York or Paris?

It would have been completely different anywhere else.

What makes London so great creatively?

Do you think that it's just by chance that the two great auction houses in the world – Christie's and Sotheby's – come from London, and that the best art fair – Frieze – comes from London? It isn't a coincidence.

On another subject, in 2008 the *Guardian* suggested that you're known more for your shrewdness than for your warmth. Would you agree with that assessment?

I don't think of myself that way. To make ARTIST ROOMS was probably a shrewd thing, but my God, it took a bit of courage to give away a hundred Andy Warhols or a hundred drawings by Joseph Beuys. The collection was valued at £150 million at the time, in 2008.

And you just gave it away for the love of country?

In one sense the collection is owned by two museums and cared for if you like by the rest of the country.

Now, back to London. You've not moved out of the city; you've stayed the course.

Yes. It's a good central place to be, although I'm in Scotland a lot.

Is there a particular place that holds some special resonance for you, emotionally/artistically/creatively or otherwise?

Nick Serota has done an extraordinary thing by bringing about Tate Modern. I think it has just about the highest visitor numbers of any museum of modern art in the world: five and a half to six million. And it's free. You see plenty of young people spending hours there, hanging out there, meeting their girlfriends there, sitting down and being quiet there. That's an incredibly important thing for this country.

Do great works of art open up dimensions beyond the self in the sense of connecting with something larger than individuals?

Great works of art certainly have some aura which accompanies them. As a child this beautiful painting by Francis Bacon in Leicester was so powerful. I couldn't really put together that fact with the way that it seemed to be made, and I couldn't resolve the problem of its being badly drawn. The colours are wrong, but it's so powerful. So I just gave in and said, 'It's wonderful.' The only way I could understand it was at a deep level. It's like what Joseph Beuys said: 'Intuition is the higher form of reason.' That is to say, you don't try and understand everything in terms of your intelligence; you try and understand it at a deeper level.

At that deep level, is there a particular piece of art in London that you would propose as the most important work of art in existence?

Well, it's quite easy. There's the most wonderful sculpture by Eric Gill called *Mankind* in the Victoria & Albert Museum that I go and look at occasionally for inspiration. And when I go to the Tate I always look at the Mark Rothko Room.

(previous page) Anthony d'Offay at his Dering Street offices. D'Offay, who has occupied the seventeenth-century building since the 1960s, jokes that it once served as 'a house of ill repute'. The ground floor, previously his gallery, now serves as a shop selling speciality teas from small farms; the premises belong to his son Tim

D'Offay with American artist Alex Katz at Tate Modern (below). After retiring as a gallerist, d'Offay launched ARTIST ROOMS in 2008 to allow the Tate and the National Gallery of Scotland to jointly own and acquire 725 contemporary works from his collection. The latest items on display at Tate Modern from ARTIST ROOMS are by Katz

'To make ARTIST ROOMS was probably a shrewd thing, but my God, it took a bit of courage to give away a hundred Andy Warhols'

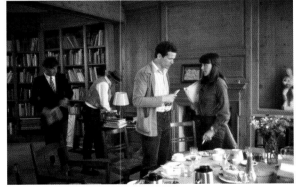

D'Offay enjoys tea from Tim's shop with his colleague Clare Jane Morris and Peckham gallerist Hannah Barry (top). Painter Lucian Freud had a habit of jumping up and down on the old floorboards in the gallerist's office. Regardless, the room has stayed largely the same since 1969, when German artist Joseph Beuys (above) would stay for weeks before opening a show. D'Offay marked his gallery's move into championing the international avant-garde with a landmark exhibition of work by Beuys. D'Offay (right) arranges papers on his mantelpiece next to an Andy Warhol portrait of the German artist

Hannah Barry
Gallerist/Founder, Bold Tendencies
Peckham

How is it that we find ourselves in Peckham, an unexpected base from which to promote creativity?

I came to Peckham for the first time with Shaun McDowell, a young painter, in 2006 as a sort of adventure. I came here once, I came here every weekend, I came here every day, and now my life is here. Peckham is like a no-man's land, a playground for opportunity. I'm interested in creative entrepreneurships, an entire system of opportunities, people interested in running their own restaurant, their own bar, their own shops, their own galleries, artists who were doing their own thing. To me it seemed that this was all possible in this place.

When you walk down Peckham High Street, it's like the United Nations of Nowhere. Every race and creed seems to be brushing against each other.

Actually, the high street runs from Peckham Rye, the large area of green space where apparently William Blake had his first vision. In my life to date, the world of poetry has always played a big part. So the idea that William Blake was up the road and at the bottom is Will Alsop's Peckham Library … you have poetry, you have architecture, and then you have this vein running up and down full of Africa, but also many, many make-or-break characters.

What about the earlier part of your journey? You were schooled in Croydon, right?

No, in Dartford. I'm from very south London and Kent, another no-man's land.

And you went to Cambridge. How did you integrate back after university?

I was working while I was in Cambridge 'cause I had to pay for my university. Then I came to London; I knew I couldn't live in London without having a job. I was involved in the world of culture through PR and consultancy, I was learning a lot about museums and galleries, I was interested in this idea that you could have a not-for-profit organisation and a for-profit organisation at the same time, and I was very interested in this idea of the spirit of generosity, in what it means to be philanthropic, because that was a real buzzword. So when I came to think about doing something, I thought, We've got to do a for-profit project, because we've got to make money and we've got to live, but on the other hand, why should one wait? I still don't know if I'm ever going to be wealthy or able to give money, so why not try to create another way of giving back, and do it earlier, because it actually is to do with a state of mind. Then, one day, I was attacked on the King's Road, and my entire life turned in on itself. I stopped thinking in the way I'd been thinking, and out of it came this clarity about what I should be doing. At the same time I met Shaun McDowell, and for the first time I saw art of my own time that I could relate to. I was able to come to Peckham and throw myself into a world where nobody knew who you were or what you stood for, and you could totally invent yourself.

So you'd been living life in the fast lane, and you came here to find soul. Is it redemption you're looking for, or something more?

I'm still seeking redemption. Once you see something in the fledgling stages of progress, you become committed to the realisation of that thing. First we were doing one exhibition in a house where Shaun had his studio; that became ten exhibitions. At the end of that cycle was the first-ever sculpture project. Now that sculpture project is an annual activity on its eighth year.

So you've changed Peckham into an artistic destination.

One of the great achievements is that we have been able to make other people believe that it's possible to do your own thing. When we set up the sculpture project, after a year or two we thought, How can we get more people to come to this project? What most people want to do is sit down and have a drink or a piece of cake when they visit an exhibition. So we set up Frank's Café, and within that organisation I put together the architects Paloma Gormley and Lettice Drake, the food-and-drink operators Mike Davies and Frank Boxer, and then there was myself and Sven who used to work together, providing administrative support, doing work with the Council. Out of that came Practice Architecture, which is now a fully functioning architectural practice with six to eight major projects under their belt, off the back of doing their first-ever commission, which was Frank's Café. Frank Boxer has two restaurants in London, very successful; Mike Davies just opened his own restaurant in Camberwell. And so on. That's a clear example of the trajectory of encouragement.

Is there a specific route for fulfilment, a path that you're mapping, or have things just evolved?

The system and entrepreneurship and other successes and people's organisations are all very well, but at the end of the day, when you see the progress of the artists at the core of all of this, that is what makes you happy.

Getting back to Blake, which of his poems is your favourite?

For sure, *Songs of Innocence and Experience*.

Which suggests that you do believe in what you described at one point as a 'mystical aspect to art'. This mystical aspect sounds quite religious, or perhaps like an awakening.

I do sort of believe in the transcendental experience of art.

Moving out to the larger context, there's a lot of talk about how art can regenerate an area. You've made this Multi-Story Car Park ... What is the draw there?

Frank Boxer talks about this in an interesting way. Audiences, broadly speaking: what do they want in the twenty-first century? They don't want *just* an art gallery, they don't want *just* a bar, they don't want *just* a concert. They want what they would call an 'experience'. What the Car Park project, taken as a whole, can provide is a unique and interesting experience. What the Car Park is large enough to provide is a choice. We've always talked about the problem of arriving at Bold Tendencies: sometimes people don't realise what they've come for. If they've come to have a drink and some food, they can go this way, but they might happen to come across a Stravinsky concert at the same time. Also here they are in an art exhibition. That's all fine. The cross-pollination of the arts and experience and architecture and, for that matter, food and drink is very twenty-first-century.

So this transformative element to art, especially contemporary art, does it extend to civilising muggers and the like? Is there a change in perceptions and attitudes at all levels? Do people out on Peckham High Street give a damn?

When we have the gallery open on Saturday and Sunday, we have visitors from all walks of life, including people who are native to Peckham. Pretty much everybody is able to look at a painting or sculpture. They comment about it, and hopefully they leave with some memory, however short-lasting that is, of what they just saw. And people react in very different ways to different things. We used to have a gallery over at Copeland Road and we were surrounded on all sides by shipping units, shipping televisions to Nigeria or whatever. The kids of the parents who were working in the shipping units, over the three or four years that we were there, would come in to visit. First they were running around being crazy, and then after a while they would give their opinion on the paintings. That's not me going out there to transform how they experience art, that's them coming across it. It is a very long process; it's not like here I go to the Tate Gallery, I've never seen a work of art, I look at a Gerhard Richter and my life is changed. But if you start off at looking at something totally new, unlike something you've seen before, then it can be transformative.

Talking of transformation, what about the final chapter? Where would you like to be buried in London?

Difficult question. Probably in the Chelsea Physic Garden.

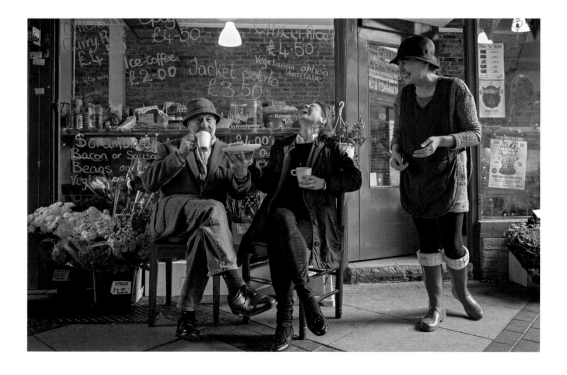

(previous spread) Hannah Barry, founder of Bold Tendencies, on the roof of the Peckham Multi-Story Car Park, a disused Brutalist construction that has become the venue for some of London's most happening cultural events. 'I've been arrested for the gentrification of Peckham,' Barry jokes, having worked there for the past decade

Café owner and longtime Peckham resident Barry Jenkins with Hannah Barry and barista Samantha Charles at Barry's Coffee Shop (opposite), which the gallerist frequently visits as it is near her workplace. Barry walks to work along Rye Lane (below). Named by the *Independent* in 2009 as one of fifteen people who would define the future of the arts in Britain, Barry works with artist Shaun McDowell in her gallery (right) in a converted warehouse near Peckham Rye Station (bottom right)

Bold Tendencies' first solo commission for the Peckham Multi-Story Car Park venue was James Bridle's 2014 work *The Right to Flight* (top)

Frank's Café & Campari Bar on the car park roof (above & right), designed by Lettice Drake and Paloma Gormley (daughter of artists Antony Gormley and Vicken Parsons). Bartender Frank Boxer and chef Michael Davies created the menu for the popular eatery

The Multi-Story Orchestra (above) premieres a piece by young composer Kate Whitley with words by poet Hollie McNish. Two hundred children from local primary schools joined with three local orchestras for the concert. The Multi-Story Orchestra has been based in the Peckham Multi-Story Car Park since 2011

(following spread) London as seen from the Peckham Multi-Story Car Park in winter and summer

Hannah Barry

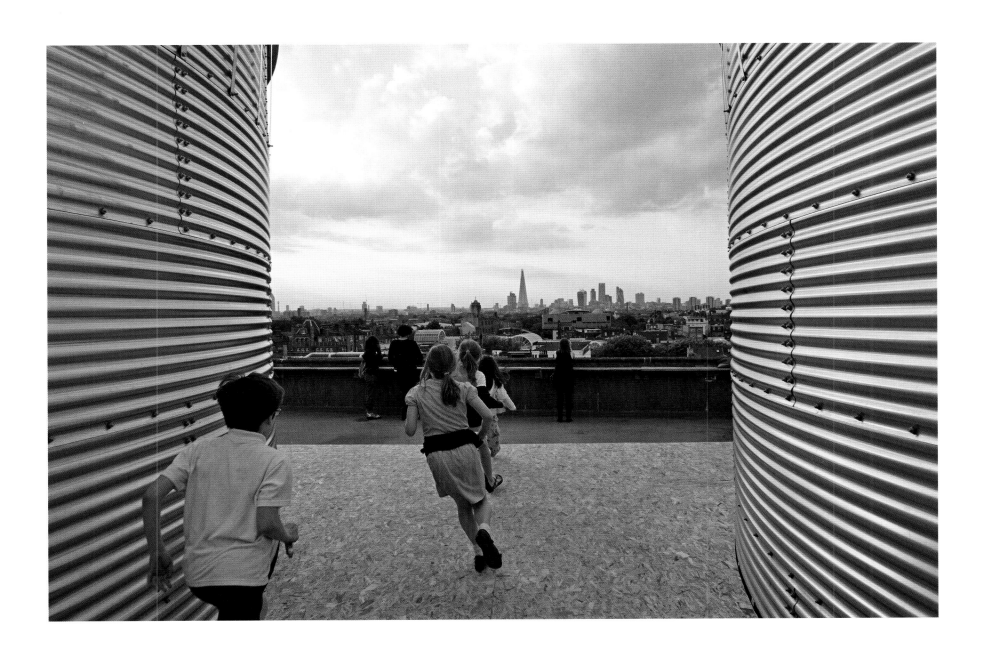

'Peckham is like a no-man's land,
a playground for opportunity'

Hassan Hajjaj
Artist
Arnold Circus/Camden

Where were you born?
In Larache, Morocco; it's a small fishing port.

And you landed here at the age of thirteen?
In Angel, in 1973. I came with my mum and my sisters. My dad was here from the '60s. My mum and my dad had no education so they can't read or write. My dad came here to work in a kitchen, because then it was easier to get a contract for foreign people to do day jobs. My mum also worked in a kitchen in a hotel.

Close your eyes and think back to age thirteen. What do you remember of London?
Grey, depressing, sad, lonely. I didn't speak English. We lived in one room, seven of us, with no bathroom. Also, coming from Morocco where it was all sunshine, I grew up by the beach, barefoot, had all that freedom … To have that taken away and be put somewhere else at that age was a bit difficult. Everything was new.

Not friendly?
No. This was back in the '70s; it wasn't as easy as it is now. London wasn't as mixed, and people made you feel you were a foreigner.

Are you still a foreigner after all these years?
I feel I'm not British, but I'm a Londoner.

What does it mean to you to be a Londoner?
We had to create our own village within a city. My first friends were foreign and coming here they had the same journey as me. So we had to create a place where we were gonna hang out, the music we wanted to listen to, the kind of food we wanted to eat. Which became, I suppose, a melting pot. Now the influence from my background and my friends' background lingers in music, fashion, food, art, because we were the first generation that came at a young age.

So you made a home and a life out of creativity?
Well, by the time I got to fifteen I stopped going to school. I didn't take exams so I got zero qualifications. That was hard. So I was coming out from school and trying to find my path in life.

Did you get into trouble back then?
A little bit. I had a problem with my dad, I moved out of the house, I had problems with drinking and experimenting with drugs, lived on the street. It was a strange time. A lot of my friends got in trouble with the police; some went to prison.

Did you get stopped by the police?
No, touch wood. I learned at a young age that I can be invisible to the police.

There's a great deal of talk about racism being tackled or addressed in London. Do you feel that is actually happening?
Racism is always going to exist.

How did you end up being an artist?
I left school, I worked in Woolworths, I worked in a timber yard, I worked as a gardener on Hampstead Heath – that was probably my favourite job – and then I was unemployed for about six years because I couldn't find anything

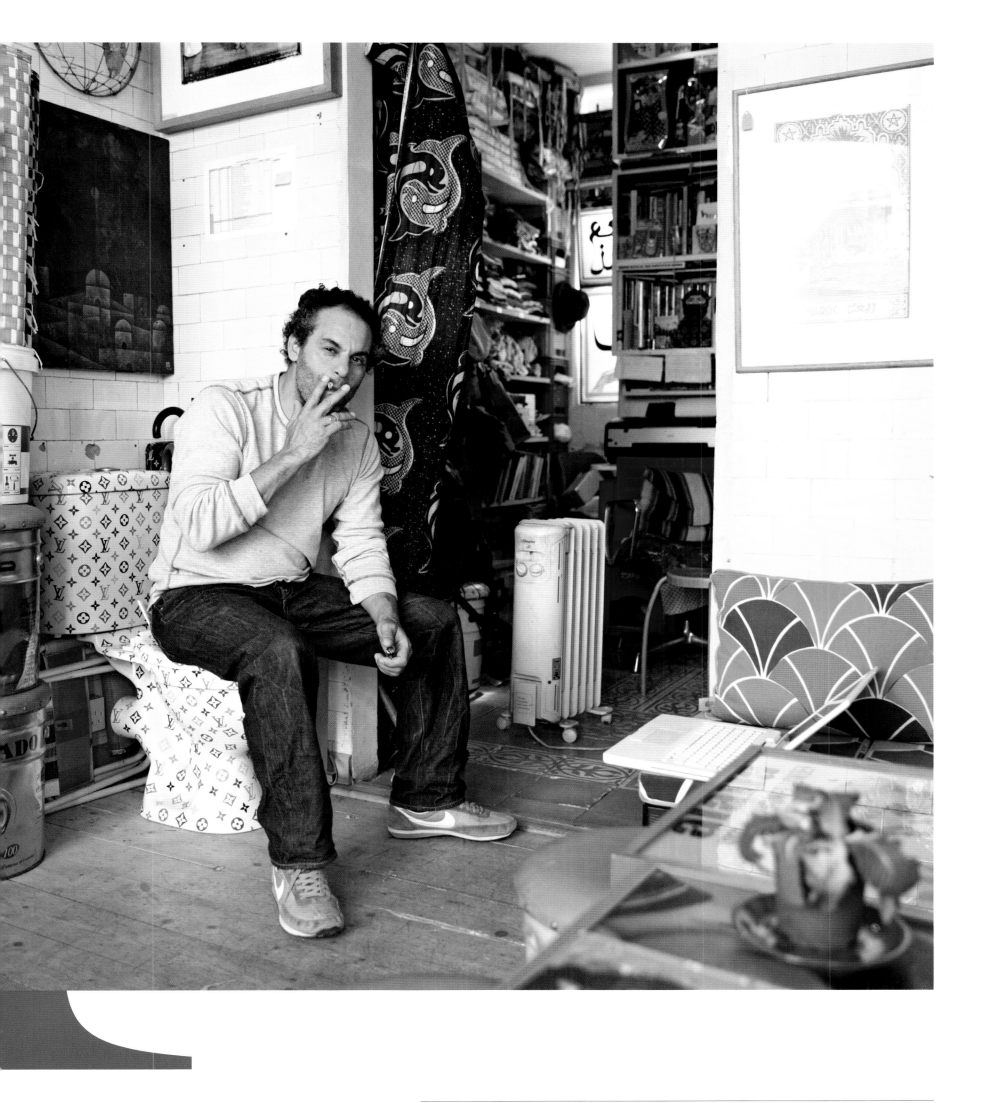

(previous spread) Hassan Hajjaj at his shop near Arnold Circus, an area buzzing with musicians and artists who might drop in for a chat or some Moroccan tea

Hajjaj at the Arnold Circus end of Calvert Avenue (left), near his shop on the Boundary Estate. The estate, dating from the late nineteenth century, was one of London's earliest social-housing schemes, intended to convert slums into model developments with four-storey mansion blocks, tree-lined streets radiating from a central garden and shops (but no pubs or off-licenses)

Hajjaj with friends and locals (above), including Johnny Vercoutre, the 'King of Shoreditch', and his Brindle Great Dane, Tiger

Hajjaj out and about in Camden Lock (opposite), the neighbourhood he thinks of as home. Having arrived in the area in 1976, Hajjaj, who is from Morocco, has always lived near markets. 'It is chaos,' he says, 'and I've been attracted to that'

'I feel I'm not British, but I'm a Londoner'

I wanted to do. Within that six years I started doing Camden Live at the weekends. That's when I started getting involved with the underground clubs, organising parties. Then I planned a store in Camden, and from there I found a shop in Neal Street in 1983, just before it became trendy.

What role did creativity play in that process?
When I was doing clubs, it meant I had to find an empty space, I had to redecorate it to make a backdrop, I had to put the DJs on, audio equipment, do the doormen, the cloakroom, so that was teaching me production and also to work in a team. Then when I got a shop in Covent Garden, Ron Arad had a shop two doors away, and then you had the hat shop, the bead shop, the music shop, the card shop, the comic shop, which meant people came from all over England for this street. I was the first fashion shop there, before it became trendy. That period of time was my university.

How did you get into the music, art and fashion scenes?
I started designing a label of my own, R.A.P., in 1984. The first person who came to borrow stuff was styling a shoot. I started assisting him for catwalk shows and photo shoots. My friend Zak Ové had just started to do videos, so I would do locations and get people, working behind the scenes. Then I started doing art shows in my shop. I had a record shop in the basement. It was in this golden time when London became a club culture. I was at the forefront with the rest of the people that started around that time.

In '92 the recession came. I closed the shop; then I had a warehouse, then another shop, and then I started going to Morocco regularly in '93, and my daughter was born. There was that kind of bridge to what I'd left behind. My idea was to do a body of work, so I was also going to New York and fusing New York with London. I wanted to show something from my culture, I suppose Arab culture, in a cool way to turn my friends on. I'd done this body of work thinking this was gonna be a one-off thing, and it was the first time I signed my own name; that was a bit difficult. My first show was in Marrakesh in 2000. Pino Daniele (he's a big singer in Italy)

bought a piece, and about six or nine months later he called me up and said, 'I want to use your image for my album cover.' I made a deal with him, so then I went to Italy to do a launch. When I was sat there I thought, Hold on. This has been about a year, I've done so many pieces, I'm here in Italy, maybe I should start this a bit more seriously. So I've worked hard to prove to myself first that I could be comfortable to say I'm an artist.

What is it about London that makes it special as a place for germinating creativity?
London is a place where foreign people feel freedom. They can be anybody, and they feel like everybody else. If you took everything away of what foreign people put here, London would be a sad place. Obviously for me the city's changed; it's become a bit harder, and sometimes a bit unfriendly.

How so?
Well, it's bigger, it's divided a bit, it's more rich and poor, it's lost that village feel. I call it a 'grinding city'. As soon as you step out of the house, it's expensive.

As a creative crucible, how would you promote this place? We're talking about creativity as being a kind of explosive force, right?
I'll give you an example. Look at fashion. We have a big industry here, but all the designers have had to go to Paris because the government don't back up the arts. So for somebody from Morocco, to fight to be part of London and to be accepted in the establishment, that's even harder. The government are trying to take more from people than help out.

Recently you've had some success in New York. If you were offered a lot of money, would you move there?
No. I could go and spend time there, but I don't know if I could live there. I'm Moroccan, a Londoner. I'm a misfit in both countries; I'll always be a misfit to a certain degree.

Alex Turnbull
Musician

Hassan Hajjaj describes his friend Alex Turnbull this way: 'He's a hip boy, he's a pioneer, he's the man.' Son of Scottish sculptor/painter William Turnbull, Alex's mother Kim Lim, who was born in Singapore, was also an artist. 'She was doing it before Chinese people were supposed to do contemporary art,' Alex remembers. 'She was doing it in the '50s and '60s when it was unfashionable. I think being married to my father, who's always been in the British art scene – a kind of quite powerful, influential figure – I think people tended to discount her because she was married to him.' Alex co-directed, funded and produced a film about his father in 2011; before that, he was a successful DJ with his own record label (primarily producing hip-hop), a member of the industrial band 23 Skidoo and a big skateboarder (he was British champion as a teenager). Involved in the punk scene beginning in the 1980s, Alex describes his music as having been influenced by Asian beats, his band becoming known for their avant-garde cassette-tape looping and the use of scrap metal as instruments.

Alex cites as his main influences anti-commercialism, his father (to whom he attributes his enthusiasm for 'anti-establishment practices') and skate culture. His band, he says, was 'very influenced by William Burroughs ... Commercialism was a dirty word for us'. Having started out using conventional instruments, he remembers 23 Skidoo's time as 'press darlings', adding that 'we did everything to confound that. Shaved our heads, wouldn't play our albums at gigs, confounding everyone's expectations of what the music/audience relationship was ... We didn't really care if people liked it or not.' The beginning of the X-Factor era marked the end of Alex's involvement with the music business. 'The thread of my story is style,' he explains. 'Street style – everybody wants a bit of that now – but at the time it was a very elusive thing, it took years to earn your stripes. Now you Google it, you buy it, you see somebody head-to-toe in hip-hop gear, and you talk to them and they don't know the first thing about hip-hop. They don't understand the culture at all ...' He cites Bob Marley's comment about historical awareness: 'In this great future you can't forget your past.'

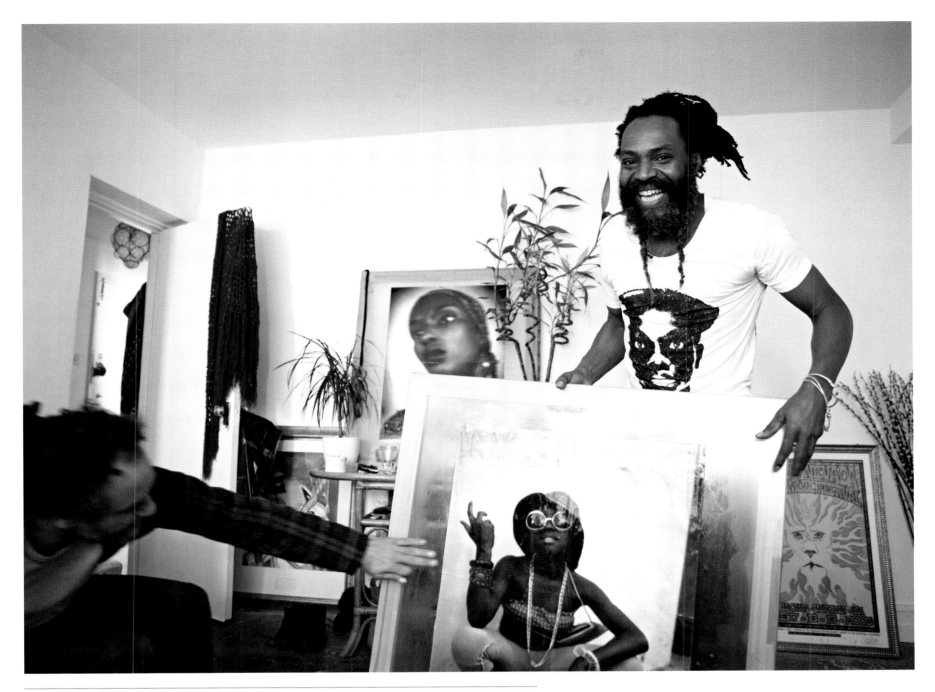

Blaize Simon
Artist

Hassan Hajjaj's neighbour and friend Blaize Simon specialises in hand-printing black-and-white Polaroids, sometimes mounting them on glass or PVC. Born in London, Blaize lived and worked in New York for a number of years. Photographing both on the street and commercially (his clients include Sony, Phillips and Pepe Jeans), he creates fashion and celebrity portraits, as well as reportage and mixed-media works employing found objects, glass, clothing, wood and metal. Blaize's photographs have appeared in *Dazed & Confused*, *Vibe* and other magazines; his 2008 exhibition *Blaize Simon on Calvert Avenue* (in Shoreditch) took over the whole of one street and included a mobile portrait studio. He also does workshops with local children and in schools, a kind of creative outreach that is critically important to how he thinks of himself as an artist.

Blaize's studio in Bow began its life as a commercial space; his home is conceived as a blank canvas that he 'blitzes' with his work. Describing himself as an artist rather than 'just a photographer', he confesses to craving 'instant gratification, so I became a mark-maker... I draw, I'll take anything, I recycle it really quickly so I get a hit'. Blaize wants his likenesses to *evoke* rather than *reproduce*, explaining, 'If I did your

portrait you would say, "Oh, it don't look like me, but it feels like me."' He chooses materials to recycle that have what he terms 'an energy'. Meanwhile the Polaroids he creates painstakingly go through a process of deep transformation in the workshops he does with kids. Blaize explains the process this way: 'The Polaroids are beautiful fibre-based, old, traditional-style printing. But then I deconstruct them and try to make children be inspired by my work. So I put them together very cheaply, but the image still holds its quality.' Speed and ease are critical so that the kids 'realise that you can make beautiful pieces of art from anything'.

Blaize's approach to recycling materials is instructive. 'When I come out of a darkroom or come out of anywhere making a piece of art, I collect everything because everything looks like a piece of art to me,' he says. 'I mount things, I burn things, I reconstruct things, so little things become something bigger and they're beautiful. You give them to people and they're like, "Oh!" I realised that there is freedom in art, and what I do anyone can do; they've just got to let go if they want to do it. So I just let go and everything becomes art.'

Hassan Hajjaj with musician, film director and hip-hop pioneer Alex Turnbull (opposite) at his Shoreditch studio off Kingsland Road

Hassan Hajjaj with Blaize Simon (above), looking over new work at the artist's home near Columbia Road

(following spread) Camden Lock, part of historic Camden Market, a favourite tourist haunt overflowing with artisanal, designer and clothing shops, as well as knick-knack merchants, food vendors and local oddballs

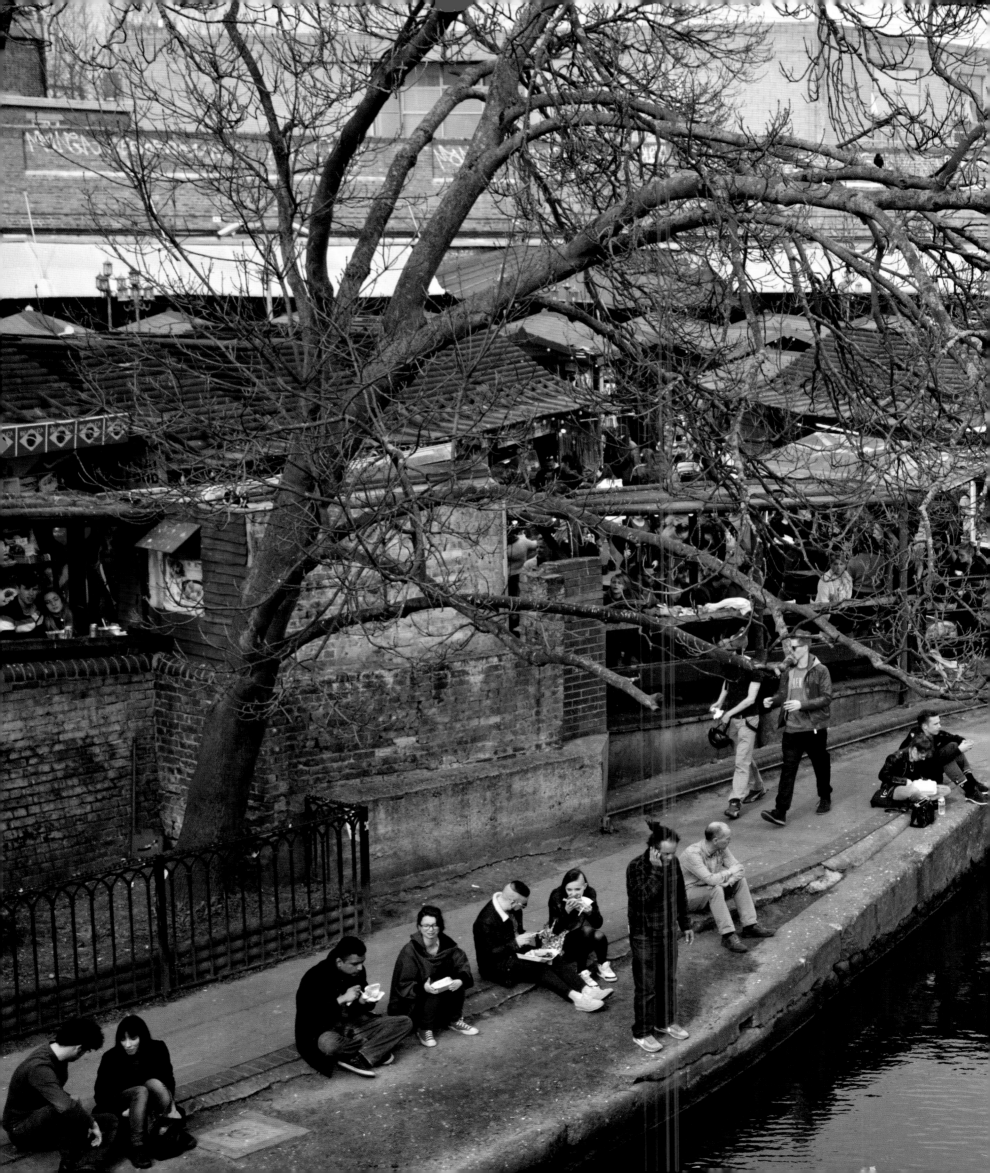

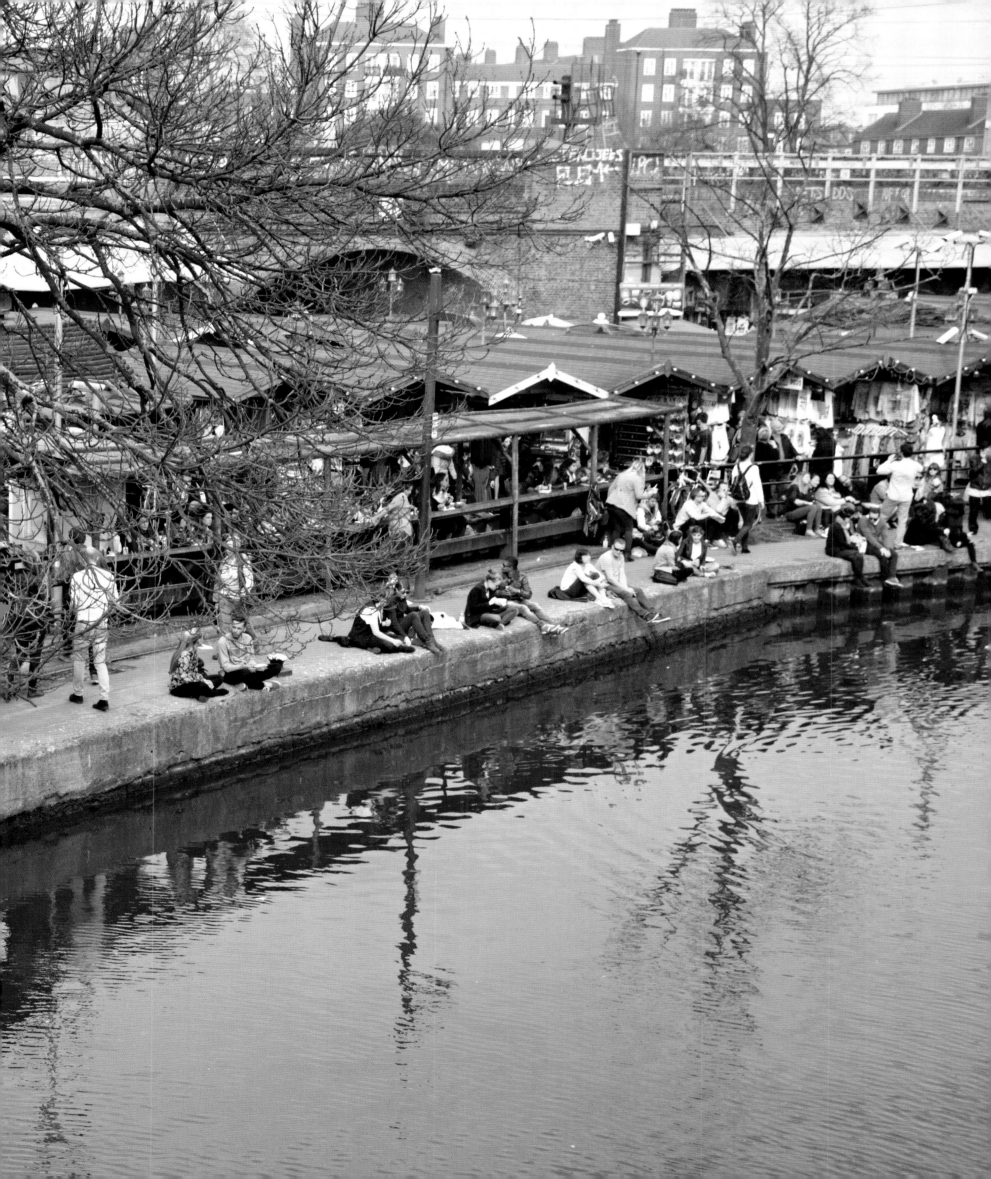

Camila Batmanghelidjh
Founder, Kids Company
Southwark

How would you define being a Londoner?
I define London by black cabs and double-decker buses. It's very stereotypical, but it's nice because of it. They're the real Londoners; they've got the networks of London in their hands. If you want information about London, find either a black-cab driver or a red-bus driver.

But will that give you an insight into the soul of the city?
Into the soul of the city as well. People think the city's soul is, let's say, its art world or its fashion world or its food world, but the real soul of the city is in the day-to-day bustle of the general public going about their normal business. The rest is decoration.

Decoration or not, what makes this city so creative?
I think London is an optical illusion. You can look at one bit of London and think that's the whole of it. The rich travel in a particular layer of London, the poor travel in another layer, and very few times do the two genuinely meet. So what happens is, often people want to describe London, and whatever they see and they like is London, but it's not all of it. London is never one thing. It's always in motion, and it has layers and layers of existence, and it would take you a very long time to be able to define it. Some of it you don't really come into contact with.

Are you talking about a Berlin Wall type of divide between rich and poor, or is it more subtle?
No. The British do things more subtly. I would call it the divide of politeness. It's the way you don't acknowledge the existence of something by being so polite as to ignore it completely. It's an unspoken language.

You yourself have broken through that divide with your creativity; your presence cannot not be noticed.
Yeah, I'm one of those characters that can travel through both those spaces. I can be in a crack den dealing with the survival issues of a child, and literally within twenty minutes I can be at Buckingham Palace or wherever. That's the beauty of London.

Would you not define that as a kind of creativity? To have been able to bridge the gaps to some degree, or to announce your presence and the existence of this subculture?
The one thing that bridges this divide is emotions. The rich have emotions, but their defence mechanisms are different. You know, human beings need to belong to a group and be valued in a group. The rich do that by wearing expensive clothes, by being seen at the right parties, by having the right memberships of clubs and so on. The poor do it by having a reputation for violence and aggression, because the power currency in the ghetto is violence. The more violent you are, the better you survive in adverse conditions. The common emotion in both these groups is the need to belong. If you understand that, you get to travel the path of commonality between these two groups using your emotional life. That's what I did.

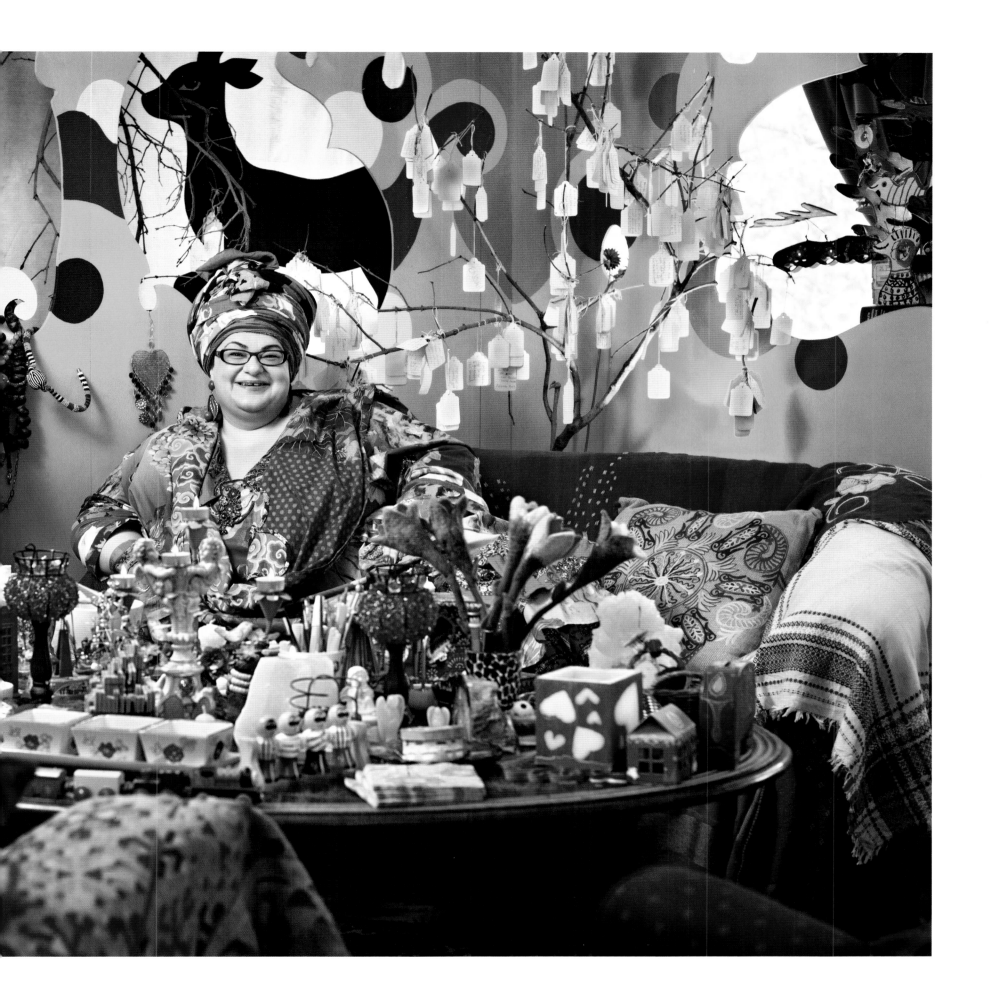

(previous spread) Camila Batmanghelidjh in her riotously fanciful office at Kids Company, the charity she founded in 1996. Nicknamed the 'Angel of Peckham', Batmanghelidjh's charity supports thirty-six thousand children and provides three thousand meals a week across London, Bristol and Liverpool. 'This room is like the inside of my head,' she jokes. Known for her equally colourful garb, Batmanghelidjh's fashion inspiration comes from sources as varied as Persian Qashqai tribal garments and bedspreads. 'I'm wearing a duvet today,' she says. 'It was too nice to be on a bed so I decided to make it into a dress'

And brilliantly so, as in an event you had at Sotheby's promoting the sale of designer handbags for Kids Company. But those people come for the fun and the frolics, and when they leave in their cabs or limousines they forget that connectivity, don't they? They've paid their dues for the year.

Yes and no, because I get to give a speech, so I will take stories of the children I meet in the ghettos to recount them to people who would otherwise not get to hear about it. That's why events like that are so important. The sale of those bags will result in me being able to buy beds for the children that I care for that don't have beds. A third of my under-14s are sleeping on the floor.

Granted, that is a compromise necessary to expand your...
It's more than a compromise. It's a bridge, a worthwhile bridge.

You're in a manner of speaking the last line of defence against people that have the anger and the ability to come and burn the city down. Do the people who support you do it to prevent that happening?
I have got incredible support from the rich, the politicians and the people I work with; otherwise I couldn't do what I'm doing. I have to raise £24 million a year. This is a big organisation; it has six hundred staff, eleven thousand volunteers, and involves thirty-six thousand children. I couldn't do that on my own. A system's mobilised to help me deliver, and it's made up of complete strangers' kindness. I've seen genuine philanthropy; I've also seen manipulative philanthropy. I always think that I'll try and engage with that as best as I can.

Do you ever push the bullshit button?
Yes. There was a man who was giving us £500,000 and he wasn't behaving appropriately. I returned his money to him. It was hard, but it was the correct thing to do.

Principles are as important as money, then?
People, if they seek it, it's because they have an understanding of it within themselves. But what happens is that people don't feel brave enough often to live by those principles, because they feed into their sense of insecurity. They think that if they don't engineer their lives under their control, they will end up devastated and destitute. What they don't understand is that if you endeavour to do the right thing, to do the emotionally authentic thing, eventually things fall into place.

So you have a belief in nature, in an actual order in life ... The other week I was listening to Radio 4 talking about canonisation and somebody called in to propose you as a saint.
That was very nice of them!

Are you a saint?
No. Sainthood suggests you've arrived at a point of excellence, whereas I think you continuously strive to the point of excellence, but you don't necessarily arrive at it.

You arrived in Europe as an Iranian who'd been stranded at an early age. You lost your country, lost your family, lost your support ...
Yes, and lost my sister.

But didn't lose your mind.
No.

Was the path you eventually followed imprinted on you before that, the idea that you needed to ...
To serve, yes. I had it as a child.

Even when you still had money and your family intact?
When I was a child I told my parents I wanted to open an orphanage; I knew I had this in me.

Did that have anything to do with possessing a creative gene, do you think?
It's something you tune into, yeah. I definitely have not changed since I was a child. There's something that stayed with me, and it's very powerful.

Why didn't you do this somewhere else?
The British gave me political asylum. I was at school here.

But was there anything particular to London that allowed your project to flourish?
London loves eccentrics. The beauty of London is that no-one really notices what you look like or what you do. I have this incredible sense of freedom in London, which I like. It just so happened that I was here, and wherever you are there'll be children who are in need, and that was what I wanted to do.

Would you be able to do the same thing in New York, say?
Yeah. Wherever you plunk me, I'll be able to do it, because these things have a particular principle you have to follow, and wherever you follow it, it will work.

And where is this grand principle leading you?
What happens to personalities like me is that we come along, we get something done up to a point, and then we're gone, and someone else comes along and takes it a bit further. So we're sort of catalysing characters.

How many of you are there in this city?
There are probably a lot of us.

Why do you figure you've become known? Is it your creatively dressed, flamboyant character?
Yeah, I think it is.

Is that consciously crafted?
No. Women in Iran in the mountains used to wear layers of clothes. I saw that as a child and thought, That's a much more interesting way of dressing. That's where it started.

In a related vein, you have been quoted as saying, 'I am one of God's metabolic mistakes. You'd think I'd be miserable, but I'm not.' Why would one think you're miserable?
Because the line normally is: If you're big, you must be very unhappy. I haven't been.

Have any of 'your' children gone on to become creatively important?
We've got kids who are writers at the Royal Court, we've got kids who are neuro-scientists, we've got children who have trained as nurses, who are satellite engineers for high-security organisations. So yeah, I've got really bright kids.

If you weren't living in London, where would you settle?
I love snow, so I'd go somewhere where I could ski every day.

The five-storey Kids Company central office, previously an old Social Security building, was transformed by kids and volunteers into a homely, colourful space. The building houses an exhibition space used by children and artists-in-residence alike (above). A work by a teenager called Frederick, *In Cold Blood* (left), says it all: 'This is my past. I lived a cold life and I saw a lot of blood.' The installation titled *The Pink Room* (opposite), created by a group of children, depicts the psychological and sexual abuse endured by many youngsters who find sanctuary at Kids Company

'I can be in a crack den dealing with the survival issues of a child, and literally within twenty minutes I can be at Buckingham Palace or wherever. That's the beauty of London'

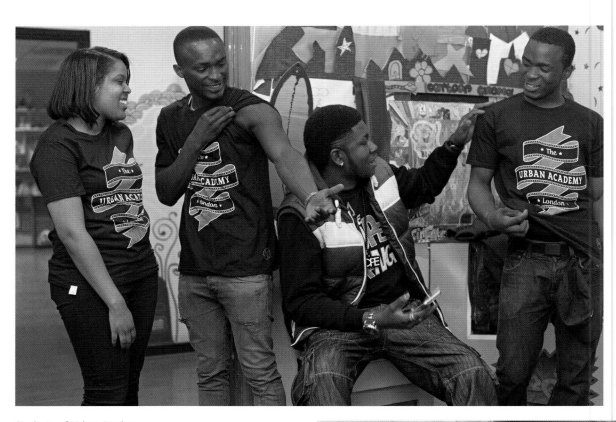

Students of Urban Academy Jenelle, Moshood, Alfie and TK (above) help raise funds through T-shirt sales for the Kids Company post-sixteen education and life-skills programme. Moshood launches into the air outside Kids Company headquarters (top right); he is a member of Dance United, a charity committed to transforming lives through dance, and has performed for the Duke and Duchess of Cambridge. Urban Academy students play chess in the weights room (right)

(following spread) Iron gates at the Cross Bones Graveyard in Southwark bear witness to the long-dead with a chilling plaque that reads 'The Outcast Dead, R.I.P.'. Overlooking an unconsecrated graveyard in which tens of thousands of prostitutes and paupers from as early as the sixteenth century were interred, the gates are adorned with ribbons, faux jewellery and other emblems, creating a people's shrine as well as a sort of communal artwork

Established in 1892 and housed in an old bathhouse, the Lynn Athletic Boxing Club (above) is the oldest amateur boxing club in Europe. Former world heavyweight contenders Frank Bruno and Danny Williams trained with the club. Boxing gloves await use by the 150 boys and girls who train there weekly (top)

Twenty-year-old TK (right) has taken part in Kids Company's Urban Academy for a number of years. 'I wasn't going to school, uni or college,' he says, 'and I didn't want to stay at home, so I decided to get involved so I would stay out of trouble.' A keen amateur boxer, TK trains every week at the Lynn Athletic Boxing Club in Burgess Park in Southwark, and competes nationally

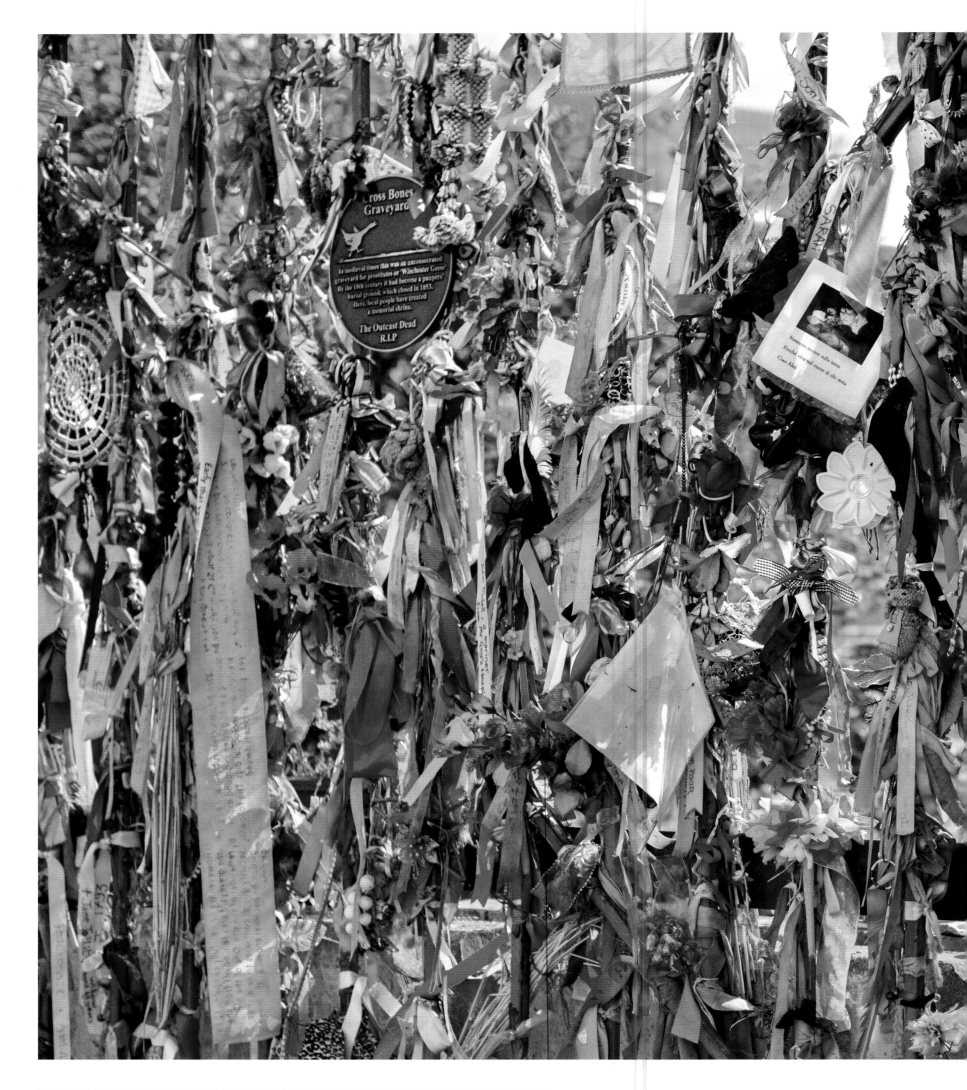

Cross Bones Graveyard

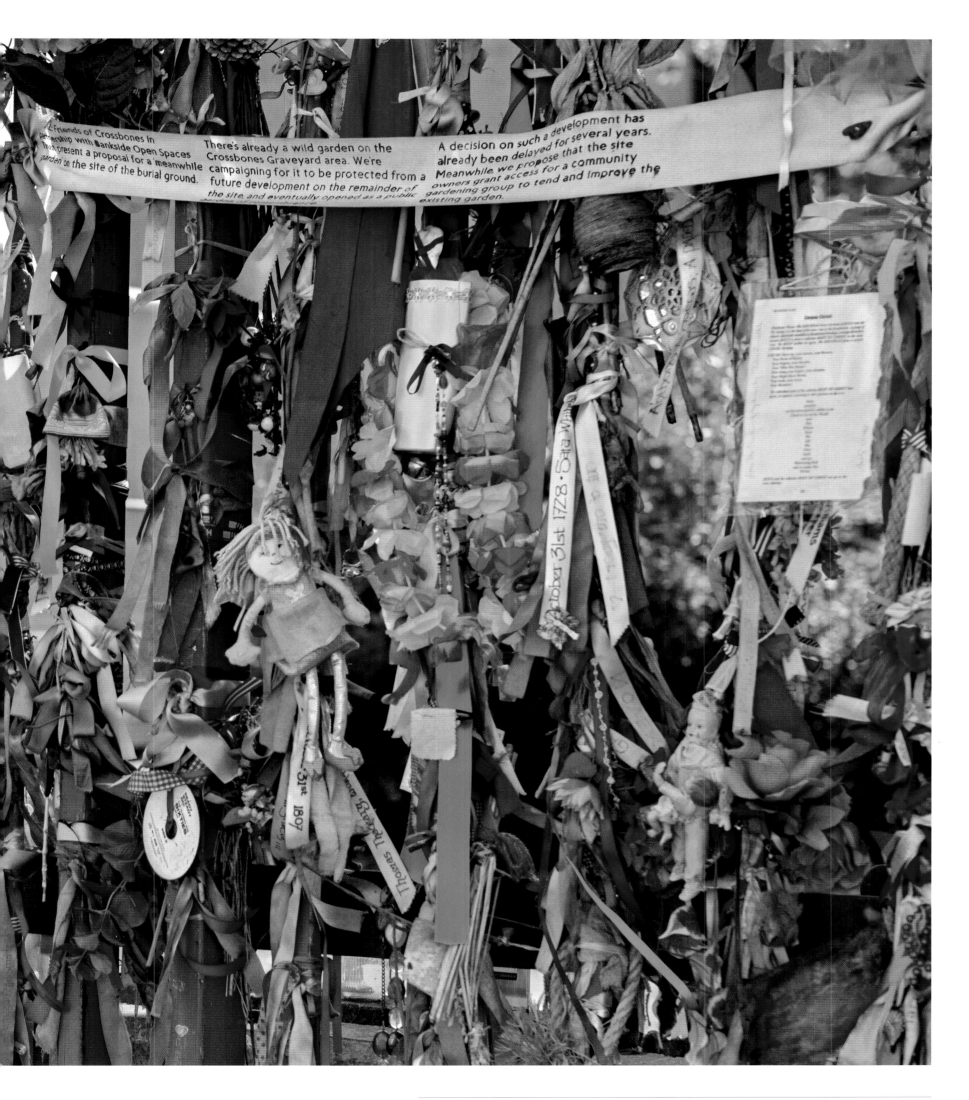

The Friends of Crossbones in partnership with Bankside Open Spaces Trust present a proposal for a 'meanwhile garden on the site of the burial ground.

There's already a wild garden on the Crossbones Graveyard area. We're campaigning for it to be protected from a future development on the remainder of the site, and eventually opened as a public

A decision on such a development has already been delayed for several years. Meanwhile, we propose that the site owners grant access for a community gardening group to tend and improve the existing garden.

Robert Van Helden
Floral designer
Clapham/Battersea

Why are you up to your neck in flowers?

Because flowers bring happiness. Being Dutch helped; I grew up with flowers. My dad used to come home every Friday with flowers for my mum, and when we kids started earning pocket money we would bring flowers home for Mum every week. I was from a business family; I didn't really know what I wanted to do. Weekends I used to help out in a local flower shop owned by friends of my parents, sweeping up and doing deliveries. Then I was given the opportunity to come to England for a year's exchange. I did intensive business school, and then I was placed in Selfridges for a management course for a year.

Wasn't that a roundabout way to bloom?

And bloom I did. In that year my last department was the flower department, which I asked for. I was supposed to go to New York next, but they asked me to stay on because of my Dutch connections with flowers. So I was Assistant Manager on the shop floor, then Manager, and then I got sick and tired of having to wear a suit and a shirt and tie every day, so I asked if I could go into the design team. I started there just helping out, not having any confidence that I could actually arrange flowers. Then on a big job they said to me, 'We're running out of time! Please do one of these urns!' And they all stood back saying, 'Wow!' It was like a confidence boost.

So that was the turning point?

It was a moment as such. I did that for a year and half, and then somebody asked if I would run a flower shop they were going to open in the Fulham Road. I left my good job and stood on the flower stall. I met all kinds of people. After three months it came to Christmastime and I thought, This is not getting anywhere. So I left. My father was still alive then and I had to ring him and say, 'I've left my job' and he said, 'Well, you can come back to Holland now and open up your flower shop' and I said, 'No. I want to stay here.' London was The Place. So I started up on my own, doing flowers in people's homes, in 1986.

Now you're the king of the flower world in London, doing the grandest things possible. How does that make you feel?

I still, after twenty-eight years, pinch myself. All the people I've met … I've been very lucky to travel the entire world to do my job, and my job is my hobby; it's a huge part of my life. Every day is different, every person you meet is different. It's a love affair.

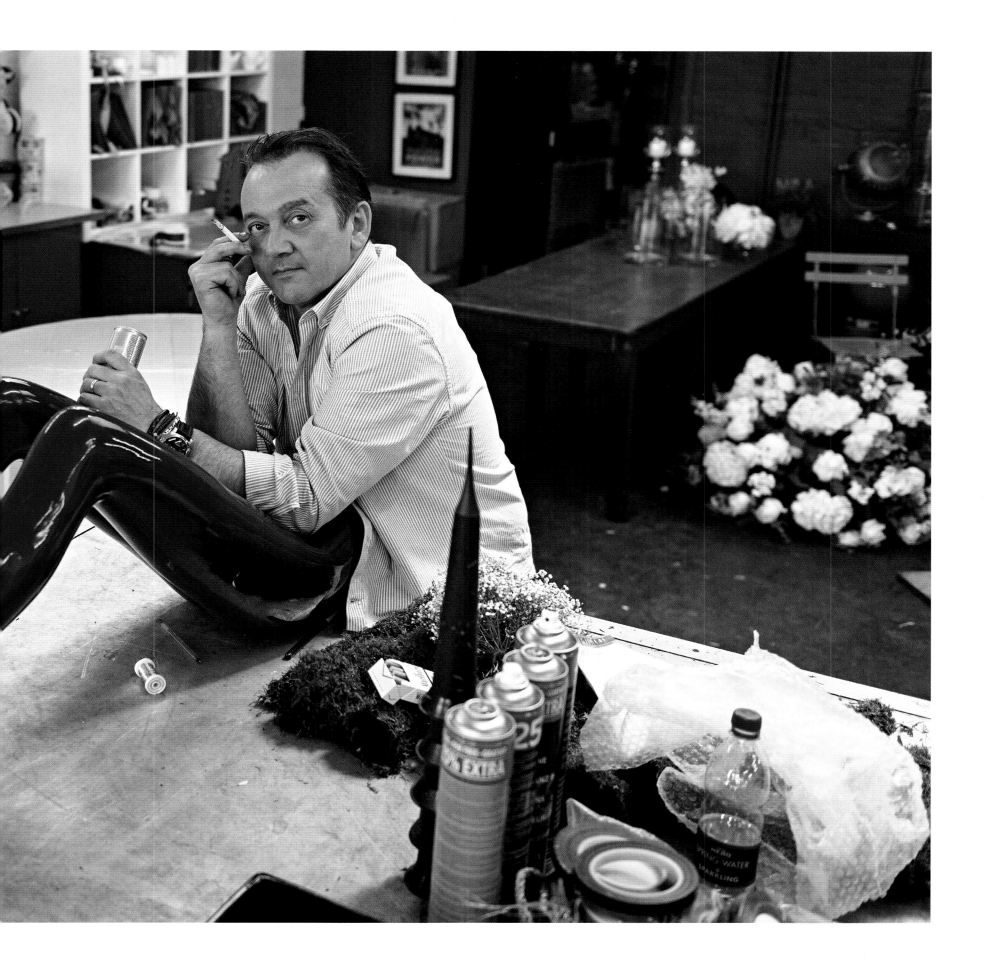

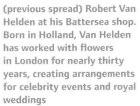

(previous spread) Robert Van Helden at his Battersea shop. Born in Holland, Van Helden has worked with flowers in London for nearly thirty years, creating arrangements for celebrity events and royal weddings

Van Helden is to be found each working day at 5.00 a.m. in New Covent Garden to select his day's needs. He is seen here (above left) inspecting the fresh flowers trucked in regularly from Holland. The florist in a playful mood in his studio/warehouse (above) while his assistant Ian Maine (left) hugs a bunch of hydrangeas. The original Covent Garden, which dated back to medieval times, moved to its new site in Nine Elms, Vauxhall in 1974 leaving behind a very colourful history. Cinema great Alfred Hitchcock spent time at Covent Garden working with his father, a fruit importer

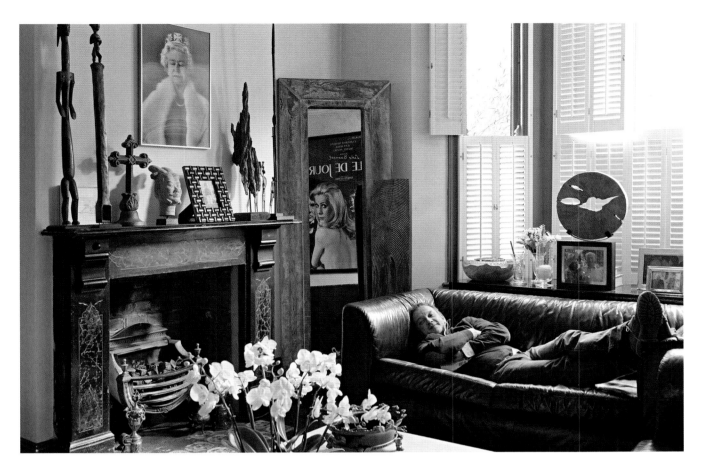

Don't you think that there's a culture of excess in London, given the phantasmagorical flower arrangements that you sometimes do for the city's élites?

Yes. In twenty-eight years we have been through the ups and downs, recessions and everything. When I first started, one bar mitzvah had to be bigger than the other one. Then it all was cut back. I remember my mum coming over years ago; roses were costing £7.50 already; she was almost having a heart attack, coming from Holland.

Has it been hard work getting to the top?

If you work hard, it's easy to get – well, it's not easy, but if you get to the top, to stay at the top. As for me, people say to me, 'Why do you still go to the flower market every day? Can't somebody else go?' I love it. And I meet every client that walks through the door myself.

Your position is interesting because you straddle the full spectrum of society, from your salt-of-the-earth suppliers to palatial homes and places like Blenheim Palace, many of whose residents have become your friends.

As long as you remember who you are … At the end of the day we're all human, but you don't get too full of yourself. I'm from a family where we weren't shy of work. I like the good things in life, and they just don't give themselves to you. You work for it.

What about social extravagance? Is that a characteristic particular to London right now?

We've got a huge influence from the Arabic world, the Russian world, and they like excess to the point that sometimes it can be garish. I like to keep it tasteful …

So how do you deal with that creatively?

It doesn't always work. I like to stick to my signature, and I do give the time. If you don't get it right then I'm not the right person for them. It's like going to buy a dress at Valentino or going to buy a dress at Dior; it's whatever suits your style. You like to teach people that there is another way, but sometimes the excess is too garish, so I can't put my heart into it.

When you're doing one of your artistic 'installations', how does the germ of the idea spark in your head?

I don't know. I can wake up in the middle of the night, or when we get home I love pottering around, and ideas come. You walk around and think, Oh my God, I haven't used that! What else can I do with it? I buy props that I like and would have in my home; it's what you do with them.

Tell me why London is so important to you creatively.

I came here thirty-two years ago, and it was like my dream holiday. London becomes smaller even as it expands in all directions because you get to know so many people. And there are so many opportunities here. I've been very lucky to have been given this chance and to have made something out of it. What's happened in this period is incredible: shop openings, clubs and bars, it's so cosmopolitan. And different to New York or wherever. It's come to feel like a gigantic village. Anything is possible.

You're known as the florist to the stars, am I right?

I've been very lucky to have been Elton John's florist for the last twenty years, having done all his big parties. One of the highlights as well was Nelson Mandela's ninetieth-birthday charity dinner. There's a picture on the wall that Nelson signed; it's like gold dust to me. These things wouldn't have happened in Holland as such. And yes, London has made me who I am today.

Van Helden at home in Clapham Old Town (above). 'A lot of people see a Dutch influence in this house,' he notes. The African sculptures are from his visits to South Africa

'London becomes smaller even as it expands in all directions because you get to know so many people'

Tim Marlow
Director of Artistic Programmes, Royal Academy
Piccadilly/Mile End/Stamford Bridge

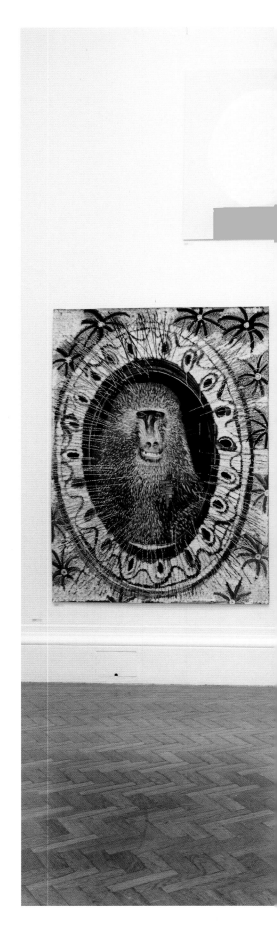

As the man who represents the face of contemporary art in London, suddenly you've ended up in this old-school institution. How did that come to pass?

I am an art historian by training. I think it's essential to do art-historical exhibitions in a contemporary way. I don't think that the two are mutually exclusive, contemporary art and historic art. The exhibition programme here is at the centre of it all, but it's not the only aspect of this place. At the real heart of the Academy are artists. It's the only organisation of this stature internationally that was founded by and is run by artists, and that physically has an art school at the heart of it. The Academicians are a great sounding board. If you can't take them with you, you're doing something wrong.

What made you leave White Cube and do this instead?

I'd been with Jay Jopling for ten years, so probably I needed to do something different. I love White Cube and had a wonderful time there. I'm not sure, though, that the old model of 'vanguard' and 'cutting edge' applies any more. Increasingly it's a more pluralistic, multi-faceted, slightly shattered model where commercial galleries are leaner, nimbler, financially more able; consequently, they do some of the most radical artistic projects. The thing I like about the Academy is it's not hamstrung by public accountability because it's privately funded. You'd think calling it *Royal* Academy would mean this is the most Establishment institution of all, and in a way it plays with and on that. But by definition it's anti-Establishment because there's no orthodoxy among the artists here. There's this in-built creative tension, this conflict, that I love. I'm not trying to deny that the Royal Academy has an Establishment twist to it; it was founded with royal assent. But it has a flexibility that belies its name.

The Royal Academy is reputed through Norman Rosenthal to have been one of the principal instigators of the contemporary-art scene.

To a certain extent that's true. Norman is a visionary and a genius, and I consider him to be one of my mentors. But as he pointed out when we had lunch not so long ago, when he began here in the late '70s, bar the British Museum, nowhere was really doing major exhibitions. It was more the exhibition landscape that Norman changed in London than the contemporary scene. *A New Spirit in Painting*, his first major show in '81, changed the way that contemporary painting was perceived. As for *Sensation*, no-one denies that it was cleverly opportunistic. There was a gap in the programme; Charles Saatchi had offered his spaces so that the large *American Art in the Twentieth Century* exhibition could be shown there as well as here. So it was a natural filler. You can't say it was strategic vision on behalf of the Royal Academy to plan *Sensation*, but they had the opportunity and ran with it. And they were the engine behind the conditions that led to London finally being able to rectify the disgrace of not having a museum devoted to modern art. Tate Modern, I've always said, is a symptom rather than a cause of the changes that went on.

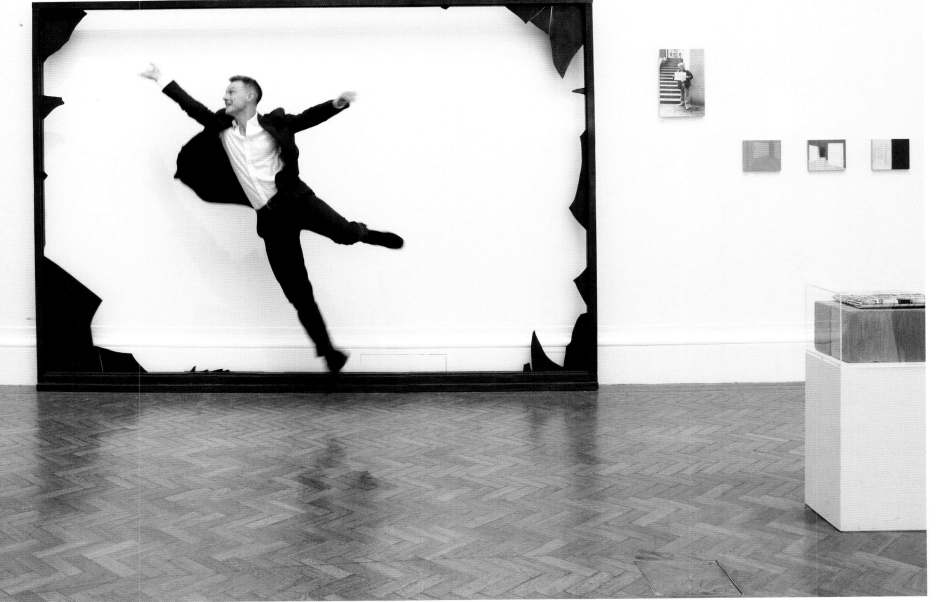

(previous spread) 'The Royal Academy is the best cultural playground in the world,' declares Tim Marlow, playfully framed amongst artwork in the 2014 Summer Exhibition. The Summer Exhibition, held since 1769 and the world's largest open-submission show, historically included works by such British masters as Gainsborough, Reynolds, Turner and Constable

Typical Palladian interiors at the RA (right & below). Once Lord Burlington's mansion, the house was sold to the British government in 1854 and has been home to the RA since 1874

'People are looking for history to repeat itself, but we're in such an expanded and pluralistic landscape that the ways that differences are made are more subtle and more networked'

Has London always been a city of cultural momentum?
No. London was underrated. The British cultural establishment was fundamentally literary-dominated. In the last twenty years, the visual has moved much more to the centre. As a society we're less suspicious of the visual arts. Kenneth Clark, when he was Director in the '50s of the National Gallery, was airily dismissive of British art. He said that we don't really have a visual tradition, that we're a literary nation. That's pretty amazing, for the Director of the National Gallery to be saying that. Now our self-image is much more visually confident. That momentum gained pace in the '90s.

Was there a connection between the rise of London as a major financial centre in the '80s and the sudden explosion of the contemporary-art scene? Did money drive it, at least to an extent?
No. I'm not saying money had no role in it, but I don't think it drove it. What drove it fundamentally were artists, successive generations but particularly the generation at the very end of the '80s. That's how the commercial galleries evolved so successfully. Artists came from different parts of the country to London, but it was that creative melting pot that led it, and that's where the institutional and financial interests coalesced.

So what happened, did a meteor hit Earth?
No. It was built on the momentum of what happened before. People like Sarah Lucas say that she was very interested in the sculptors who came to prominence in the early '80s: Bill Woodrow, Richard Deacon, Tony Cragg. Other factors … what the Royal College did in relationship to Pop art … David Hockney … the teaching at Goldsmiths in the '80s, people like Jon Thompson, Michael Craig-Martin, Richard Wentworth. But you've got to commend the receptiveness, in the end, of institutions.

Who were the key individual players?
With a certain distance you realise that there were many people playing a role. I like the group ethos of the YBAs in the sense that there's very little that binds their work together, but there's still this sense of supporting each other. I suppose the key player without doubt would be Damien Hirst. He was the visionary who set up exhibitions. Michael Craig-Martin played a great role as a teacher and guru. Nick Serota's cultural acuity, driving London, using that momentum, seeing it was now possible to open a museum of modern art … of course Nick's a major player. Norman in his way played a role. Andrea Rose at the British Council did a huge amount. You can't understate what Saatchi did. The spaces that Saatchi provided up on Boundary Road, artists love that; they'd seen very little like it. He had the vision to bring the best international art on that scale.

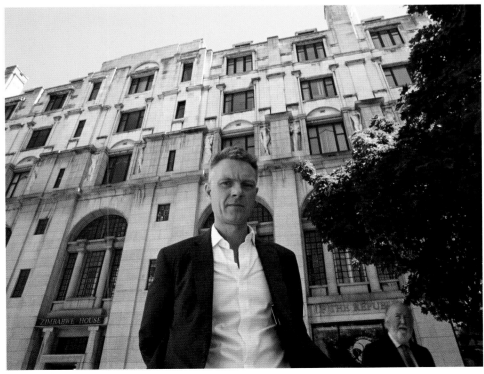

Commissioned in 1908 to decorate the façade of the British Medical Association Building (now Zimbabwe House) on the Strand (left), Jacob Epstein sculpted 8-foot-high nudes intended to symbolise the Ages of Man. The statues prompted accusations that the laws of beauty and of sexual propriety had been transgressed; eventually the statues' hands, faces and genitals were hacked off. 'It became a site on which moral hypocrisy was allowed to have free reign,' Marlow explains. 'I find this place moving because it is a monument to something that's been destroyed. I like British skepticism, but moral hypocrisy is never far away in this city, and we need to keep it at bay'

Marlow in Postman's Park (above), where posties used to enjoy their breaks from work at the General Post Office. It was the Victorian painter George Frederic Watts who created this memorial in the public gardens and former churchyard, erecting tablets evoking touching tales of heroism, often involving children, fires, drownings and train accidents. 'These are very humane monuments,' Marlow reflects. 'It's great that this is tucked away in the shadow of St Paul's, not far from the Law Courts; it's really quiet, like a refuge'

What of today's scene?

It's a different landscape now. People are looking for history to repeat itself, but we're in such an expanded and pluralistic landscape that the ways that differences are made are more subtle and more networked. So I'm not thinking about authoring great things. I want this place to be as good as it can be, and I don't care if I'm seen as the frontman for that or not. If the whole thing was an ego trip I'd be doing something slightly different, because you don't fundamentally have control of an organisation like this. In the mixed ecology of the contemporary-art world in London, there's roles for all sorts of people, but I'd much rather be arguing with a governing body made up of artists than dealing with a governing body made of the great and the good.

Why did Tim Marlow end up in London to begin with?

I went to university here. I've travelled the world in the last ten years, and I never feel depressed coming back to London. This is a place of immense possibility. It's the pivotal city in Europe. It's home. There's a scepticism in British culture, a sceptical dimension that I like. The English laugh at themselves. I also like the fact that London's always been this melting pot. Without sounding colonial or post-colonially arrogant, you don't always have to go round the world 'cause a lot of the world comes to you here.

Do you think that's one cause of this ferment of creativity?

Yeah. Creativity has been dominated, assisted, inspired partly by people from outside coming to London.

You mentioned the group enterprise of the YBAs in the late '80s. Now it's very much individualist-driven, underpinned by the power, the pockets, of the galleries that they're associated with. Or am I wrong?

Yes and no. Some art has been a lonely enterprise; for others it's been a group enterprise of studio practitioners and assistants and apprentices. When cornered, the arts tend to be supportive. Having said that, I think one of the tragedies in the last few decades is how (wittingly or unwittingly) governments have managed to divide the arts and then to rule them. The arts maybe should be a more collective enterprise when it comes to dealing with politicians.

What places did you visit when you first came to London?

I grew up in Derbyshire and we had a holiday house in Norfolk. Every summer, either from Chesterfield or from Norfolk, we would come to London for a day. That was the thing I looked forward to the most. I first came here when I suppose I was seven or eight, to the National Maritime Museum. I was obsessed with Nelson, so I wanted to see his uniform with the bullet hole in it. Carnaby Street, where I remember coming quite a bit, was way past its heyday; this was in the '70s. Stamford Bridge … to come up for a [Chelsea football] game was fantastic. And I used to also come up every summer for the Test Match at Lord's. So it would be for sporting events, but also for exhibitions. I came to see a Stanley Spencer show here at the Academy on a school trip.

You've been everywhere, you're fifty-one. Fast-forward: you're on your last legs. Where would you like to be buried?

Under the penalty spot at Stamford Bridge would be a pretty good place.

Marlow crosses Waterloo
Bridge (above), which he
sees as dividing East and
West London. 'I'm very split
between east and west,' he
says. 'I like the east. I like
its slightly seedy history, I
like the fact that it's close to
where a lot of artists have
lived and worked in the last
two or three decades, I like
that there's still a hidden
aspect to East London. It
has earthiness and energy,
and it's also changing with
the Olympic Games and
rejuvenation. West London
has always had an airy
glamour and swagger to it'

Marlow and his son George at
The Morgan Arms in Mile End
(opposite). Father and son go
to the pub for apple juice and
chips every Friday

Tim Marlow

Marlow at Stamford Bridge in Fulham, home to Chelsea Football Club, of which he has been an avid fan since childhood. When asked where he would like to be buried, he replies, 'Under the penalty line at Stamford Bridge'

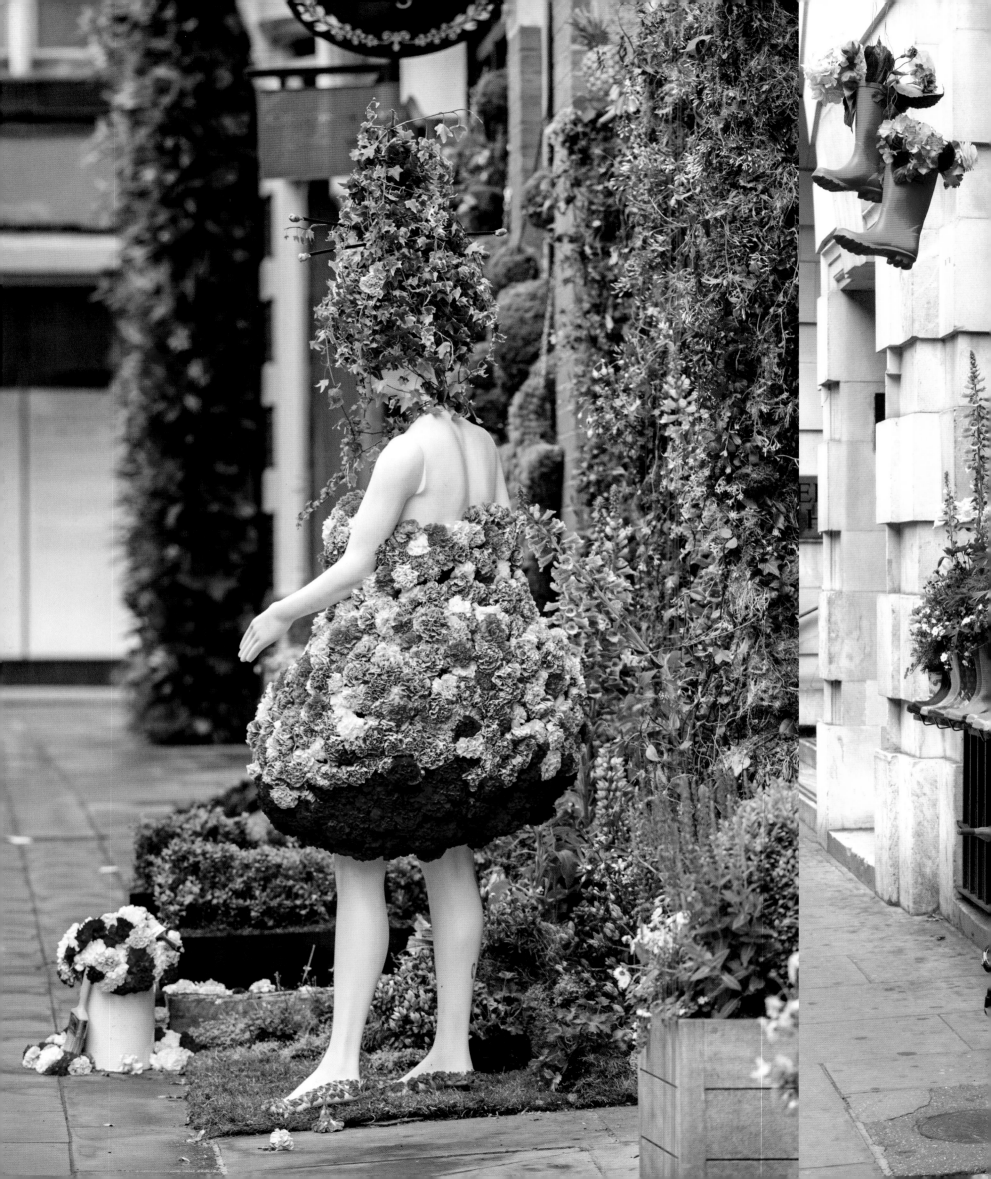

Bloomin' London

O Spirit of Spring
Whose strange instinctive art
Makes the bird sing,
And brings the bud again
from Richard le Gallienne, 'An Ode to Spring'

Spring brings a bounce back into London's step, its parks bathed in colour, gardens bursting with blossom, and the many trees lining the city's streets shouting with natural delight, including more magnolia explosions than any other urban centre in Europe. Chelsea storefronts celebrate the season as spring quickens the pace of social life, heralding activities as diverse as the Chelsea Flower Show, the Oxford and Cambridge Boat Race, the London Marathon, and various chocolate and coffee festivals.

The Chelsea Flower Show remains the most English event in London's social calendar, never mind the vagaries of multiculturalism and the economic and political upheavals of the past century and a half. Established in 1862 in the Royal Horticultural Society's gardens in Chiswick, the event moved to Temple Gardens in 1888, finally settling in the grounds of the Royal Hospital Chelsea in 1913. Nothing seems to have dented the show's significance for the country's bourgeoisie, who flock from all over Britain in their tens of thousands to navigate overcrowded stands and endure long queues for pretend Chelsea tea parties.

From modest beginnings in a single large tent, today's Chelsea Flower Show boasts a Great Pavilion that alone could accommodate five hundred London buses parked end to end. It takes nine hundred people more than a month to construct the edifice, and just one woman, the Queen, to declare the jamboree to be open. Although gardening is a long-held English passion with quirky traditions all its own and is largely class-blind, aspects of the Flower Show remain evocative of hierarchy and privilege – in contrast, for example, to Columbia Road's flower market, which remains, despite its increasing popularity among the city's middle and creative classes, East London-focused.

Chelsea has a ball during the final weeks of spring, indulging in all forms of *folies des fleurs*, and dressing up its splendid squares and shop-window displays to herald the advent of the London Season. Classic events which have become magnetic draws for the international jet set include Ascot, Guards Polo, the Henley Regatta, Wimbledon, the Royal Windsor Horse Show, cricket at Lord's and the infamous debutantes balls. Meanwhile, the Proms unfold for the masses in Albertopolis.

Social hypocrisy, backed by obscene wealth, continues to characterise parts of Chelsea and Kensington in spite of resistant pockets of social housing that blight its polished veneer. The area's manicured squares and garden plots house larger numbers of the global rich than there are colours festooning its springtime streets. Celebrities and media types mingle with oligarchs of all persuasions who find London amenable to their needs to either flaunt or hide their wealth, leading some to style the city as the Capital of Bling. Despite the vagaries of fashion and finance, the political map of London is invariably red, however, blue being a permanent minority in parliamentary elections.

In search of bling, the present volume features one of London's leading society florists, Rob Van Helden, as he assembles a floral extravaganza for a Kensington-and-Chelsea non-dom's million-pound birthday bash. Twas ever thus. A village in medieval times, Chelsea became fashionable in the sixteenth and seventeenth centuries as a magnet community for the rich, among them Sir Thomas More, its most famous political non-dom of the age, who moved there in the 1500s before losing his head in a fugue of religious bling-slinging, trying to best Henry VIII's unquenchable thirst for more. An historical moment that chimes perfectly with today's Chelsea scene.

Emma Sayle
Founder, Killing Kittens
Richmond

Tomboy, daughter of an army colonel, mixes with the tough crowd and becomes the sex kitten of London. Is this a tale of transformation?
Not really; that's just business. I'm still a tomboy. I'm much more comfortable in a tracksuit than I am in heels and dresses. What makes you sexy isn't the dress you wear; it's the whole package. There is nothing sexier than a confident female.

Is Killing Kittens a feminist statement?
It's feminist in that it is for women, and for empowering women. If women want to try things out, they can; if women want to sleep around, they can. It's their choice. As long as they aren't doing anything because they are being made to do it, or expected to do it, it's great.

But God took that right away from women …
Religion took it away. Women have always been persecuted on the religious front, because you've always had men that were slightly intimidated and scared of women.

Slightly or totally?
Very! Look at burning witches at the stake. I mean, I would have been burnt at the stake! A female with an opinion back then was a witch.

So you've taken it upon yourself to reverse the cycle of history?
Well, if boys can do it, then girls can do it. The sex industry caters to guys. For a female, it has to be ambience and touch and feel and smell. The brain has to be turned on; we are complicated creatures. When it comes to sex for a girl, it's not as easy and straightforward. If you are not in the mood, then that's it. Whereas a guy can be in the mood in about a second.

Was it London that made you into a sex kitten?
I think it was growing up abroad. I spent a lot of time in the Middle East. London has always been pretty liberal, but elsewhere there was this massive suppression. That drove me more into creating an environment and a platform where women are in control and doing what they want to do. We lived in Kuwait for four years. There were massive underground parties being run in palaces; you had everything from prostitutes to Czech air hostesses to diplomats to the Kuwaiti royal family. Everything and anything went on at these parties, but it was very disrespectful to the females. They would be treated like pieces of meat.

Does London's liberalism mean that it inclines towards a libertine view that encourages creativity?
The minute you give people a platform and say that it is okay to think this way and do this, that encourages creativity. If you allow people to be themselves, and it's their choice.

You are quite an entrepreneur …
Yeah, I was always a wheeler-dealer. Killing Kittens is wheeling and dealing in stuff that you can't get anywhere else.

Did the idea not shock your family?
My family know that if I have an idea, I'm going to do it; they know not to try and stop me. They also understood it. My parents have lived abroad; that makes you a lot more open-minded. They knew that it wasn't a case of me just going off the rails and wanting to sleep with everyone. They knew this was business. Actually my mother thought it was a very good idea.

Have you made a success of it business-wise?
Yeah. We do six events a month, and we've just launched in America. We are launching in Ireland soon.

You don't find that social or political or legal regulations interfere with what you're doing?
It depends on where we want to launch. I don't think we could launch in the UAE. In Europe and in the States, it's completely fine. As long as it's private parties, with private members, and you are doing it in private houses, you can do whatever you want.

You are also a writer, aren't you? Are you acting out your fantasies with Killing Kittens to get material?
I'm not acting out my fantasies because it's business; it's not like I'm there naked at the parties. The parties have given me a lot of material to write about, but I've always written massive diaries. I've always had a very active imagination. What I've always done is organise events, and I've always done stuff for girls. The sports stuff I do is aimed at getting girls together to reach their potential.

(previous page) Emma Sayle, founder of Killing Kittens, a members-only club hosting sex parties initiated by women

Sayle (left) also founded The Sisterhood, a fundraising group of women in London and Cape Town who participate in international triathlons, adventure races and dragon-boat regattas. The group holds a world record for crossing the English Channel. Sayle meets friends from the Sisterhood in Richmond every Sunday to row down the Thames and catch up over drinks at a local pub

Does confidence have anything to do with free sexual expression for women?
Confidence has a lot to do with exhibiting your inhibitions. A confident female can achieve anything. That's work, that's sex, that's sport. I've grown up with lots of controlling males around me, and seen lots of friends in controlling relationships. You see what they are like when they get out of it and you see that, even somewhere as liberal as London, in what looks like a normal relationship, there will be a voice in there saying, 'You shouldn't do that.'

You've said that these are not swingers parties, that they are orgies? Is that really the case?
Well, it is what it is. Though about 50 per cent of people that come along don't get naked and don't get involved; they just like the atmosphere. It's sexually charged, and it's good-looking, and it's candlelit. We set the scene, and then it is very much like experiential theatre. America seems to be more behind than we are here. Europe, on the other hand, is ahead of us. They've got these things left, right and centre.

'There is nothing sexier than a confident female'

So do you think you are making a contribution to gender politics?
I'm definitely pissing off a lot of men. What keeps me going is that we get people emailing; I see them after every party, and they say, 'Thank you very much!' We get a lot of girls just leaving relationships, and they realise what they were putting up with and that they shouldn't be putting up with it.

You've said that your parties 'are very elitist, and women are always in control'. Doesn't this kind of elitism exclude certain classes?
It's nothing to do with class or ethnicity. We've got an age range, and then people have to submit photos. It's not that everybody has to be a supermodel.

But they're from a certain class, a certain income bracket.
It's more about hedonists that all have the same sort of drive. They feel that they've got one life and that they need to go and live it.

You've said that alpha men have the worst reaction to you, and yet you were a daddy's girl …
I was a daddy's girl until I realised that he was an asshole. He was in the army and very outdoorsy, so I went everywhere with him and camped. But he was also very, very controlling of my mum, and very old-school, as in 'Woman, know your place.'

How do you think you will be remembered?
I don't know. I don't know where Killing Kittens is going to go.

But you have already established a little footnote in the social history of London.
In terms of female sexuality, I suppose. Sometimes when I stop and think that it's been nearly nine years, I can't believe it. It's only when I take a look back that I realise it's a much bigger entity than I thought. In my head it's still a little thing.

Although she has lived around the world and grew up mainly in the Middle East, Sayle thinks of Richmond as home. 'I've been coming here since I was born,' she explains. 'I've always had uncles and aunts who lived around the park.' Sayle takes a break at the site of her grandfather's summer birthday picnics (above), and walks the towpath (right) with her Working Cocker Spaniel Rex

Eddie Peake
Artist/DJ
Hackney Wick/Hampstead Heath/
South Kensington

How worrying is it to be a superstar at such young age? You're thirty-five, right?
I'm thirty-two.

Thirty-two is a young age to have achieved international acclaim …
There are artists I know who are younger than I am who are much more successful. And I don't feel that young, especially because I've been showing my work for about ten years now, though only in the last three or four has it become known beyond my immediate peers and friends and family.

How does it feel to break out?
There are some aspects of it that I've found difficult to acclimatise to. In the main I'm just doing what I was doing already, but on a slightly magnified scale.

But surely it puts much more pressure on you to come up with the goods?
It does. There's a much more intense level of scrutiny. I would even say that there's a level of eagerness among some commentators to see me fuck up. But it's one of the little idiosyncrasies of an artist's career that you have to have this mental strength to be able to disregard the noise.

Do you ever lose sleep over it?
I do, actually. I'm affected by the responses that people have to my work. There are some people who are a bit better at it than others, at just letting things roll off them like water off a duck's back.

Does having money pouring in not make a difference?
I don't know if it does, actually.

You're also aware that you're living and working in one of the richest, most expensive cities in the world, where money is everything.
I'm aware of that. I'm born and raised in London, so to some extent I feel exotic here, because most people I know in the art world have come to London. I in some ways envy people who come to London and get to enjoy its rich and diverse culture; I've never felt that great sense of excitement about it. I mean, London is a place where you have to work really hard in order to be able to tap its cultural juices and benefit from them.

You've never lived anywhere else?
I lived for two years in Rome and for half a year in Jerusalem, and I spent a bit of time when I was at university in America doing an exchange.

You wouldn't chuck London in for Rome?
I would, absolutely! But Rome is impossible to sustain oneself in. There's no jobs even for Italians.

But now, at your stage of success, you could go back to Rome.
Yeah. I am in a very fortunate position where I would be able to do that now, it's true. But part of me also feels like, Well, that was then. I do want to leave London again, much as I love it, and I'd like to go somewhere I haven't lived before. It's enriching to live somewhere where you're a foreigner and a stranger and learning new things. These little banal things that make day-to-day customs a bit more difficult are actually incredibly generative. Maybe degenerative to begin with, but then it becomes constructive.

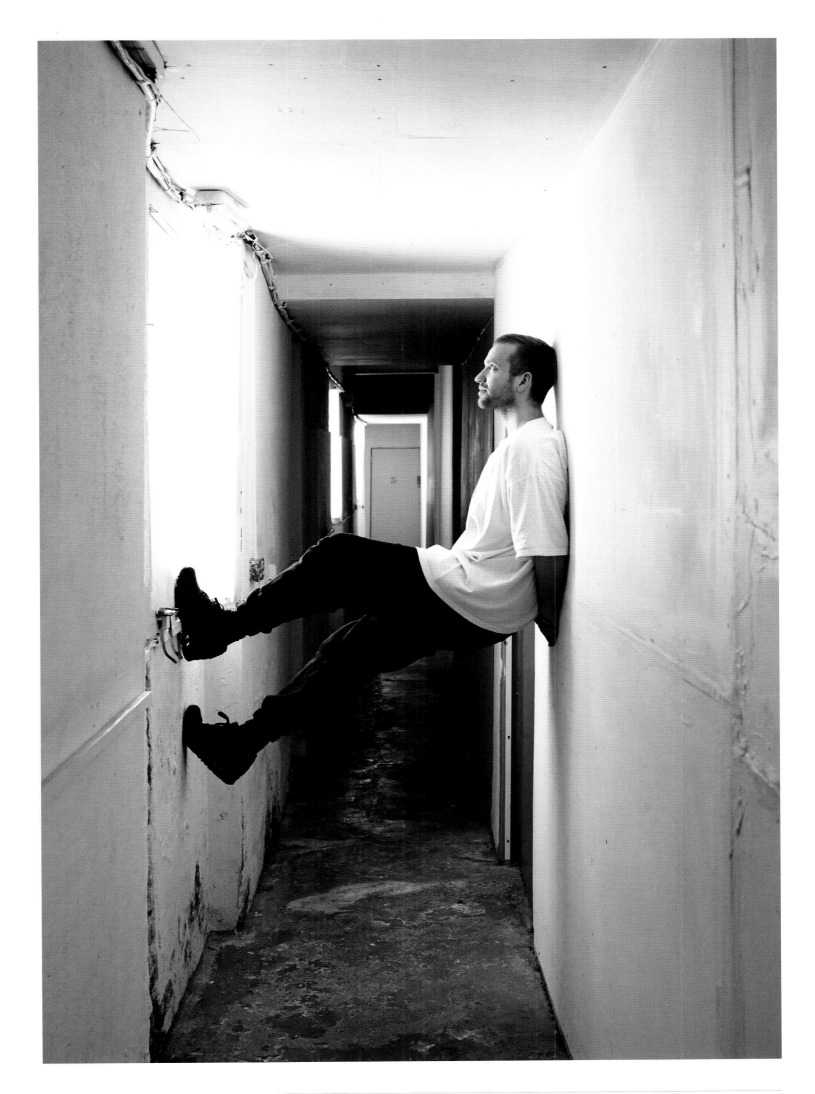

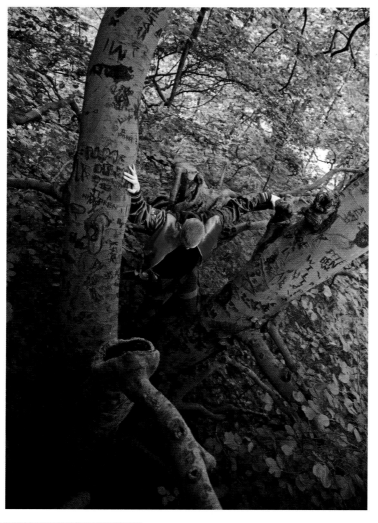

(previous page) Eddie Peake outside his studio in Hackney Wick

Peake on Hampstead Heath (opposite), and climbing the Beanstalk (above), a beech tree on the Heath near his childhood home. Peake, who would sometimes climb the tree while out walking his Staffordshire Bull Terrier, carved his initials in the trunk (left) as a teenager. Urban legend has it that Jimi Hendrix and Led Zeppelin visited the Beanstalk in their time

What is it that set up this creative umbilical connection between you and London?
London is one of those cities that functions as a microcosm of the rest of the world because it has so many cultures within it.

How do those social dynamics factor into your creative output?
They're a significant factor in my thinking across the different ways in which I work.

And which aspect of your art is related to or derived from London as such?
For example, I like to work with text, and sometimes I use slang that is directly lifted from the jargon and slang I used to hear or use when I was a teenager going to a state school.

In which neighbourhood did you grow up?
Finsbury Park. Now I live in a house about ten doors along from the infamous mosque in Finsbury Park where Abu Hamza was doing his thing.

Have you ever drawn inspiration from Park Lane as against the gritty parts of the city?
I identify myself to a larger extent with the 'real' areas of London. That's where I'm from. Having said that, I went to the Royal Academy, so I spent three years every day in Mayfair.

Did Mayfair inspire you at all? What I'm trying to trace is the urban and inspirational archaeology here. Has there been a specific neighbourhood that has got your record label going? One that has got your DJ'ing going? One that has got your spray-painting going?
Definitely: Finsbury Park. And I went to secondary school in Tufnell Park. I spent my teenage years in Dalston – I'm talking about Dalston before it became hip, when you'd get mugged walking through it. Those are the kind of areas that I think about when I'm thinking about the context for my work.

What is it that you find appealing in a particular area? Is there a specific road, a building, a clump of trees in a park that gets your creative juices flowing? And what about Hampstead Heath? What's the special relationship there?
My parents would often take me, my siblings and our friends to Hampstead Heath to run around and play football and just do whatever kids do. Tufnell Park is a short walk from Hampstead Heath, so me and my friends would go and do whatever teenagers do, like smoke weed and get drunk and climb trees. It almost sounds like something from an Enid Blyton story, but it felt very different to that, quite an urban experience.

Hampstead Heath to one side, the work you make is urban art, right in the heart of the city. You couldn't produce it out in the Yorkshire Dales, could you?
This came up the other day … I actually feel quite ignorant about the rest of the country; I don't feel that connected to it. It's funny when you go to America and people refer to you as 'British'. I really don't feel British. I don't even particularly feel English. I am a Londoner, yeah.

Final question: Is London male or female?
Good question, and a very complicated one … Hermaphroditic, maybe … It's a very sexualised city but in a kind of suppressed way. A fascinating question, and one that I want to think about. But I don't know the answer to it.

'London is one of those cities that functions as a microcosm of the rest of the world because it has so many cultures within it'

Peake spray-paints limited-edition scarves at White Cube Bermondsey (left), and looks over his series inspired by the Fibonacci sequence (below). The works were shown and then auctioned off (above) at the end of the performance *Eddie Peake: Möbius Strip Shaped Triangle*, on the occasion of the Institute of Contemporary Arts' 2014 gala fundraising dinner

Peake at the Victoria and Albert Museum, studying one in a series of fifteenth-century tapestries depicting aspects of the hunt (opposite). 'I really like that the V&A is determinedly eclectic,' Peake says of the place where he finds some of his inspiration. 'I don't think creatively in terms of a single discipline or medium. I have an abundance of ideas, and I want to do them all'

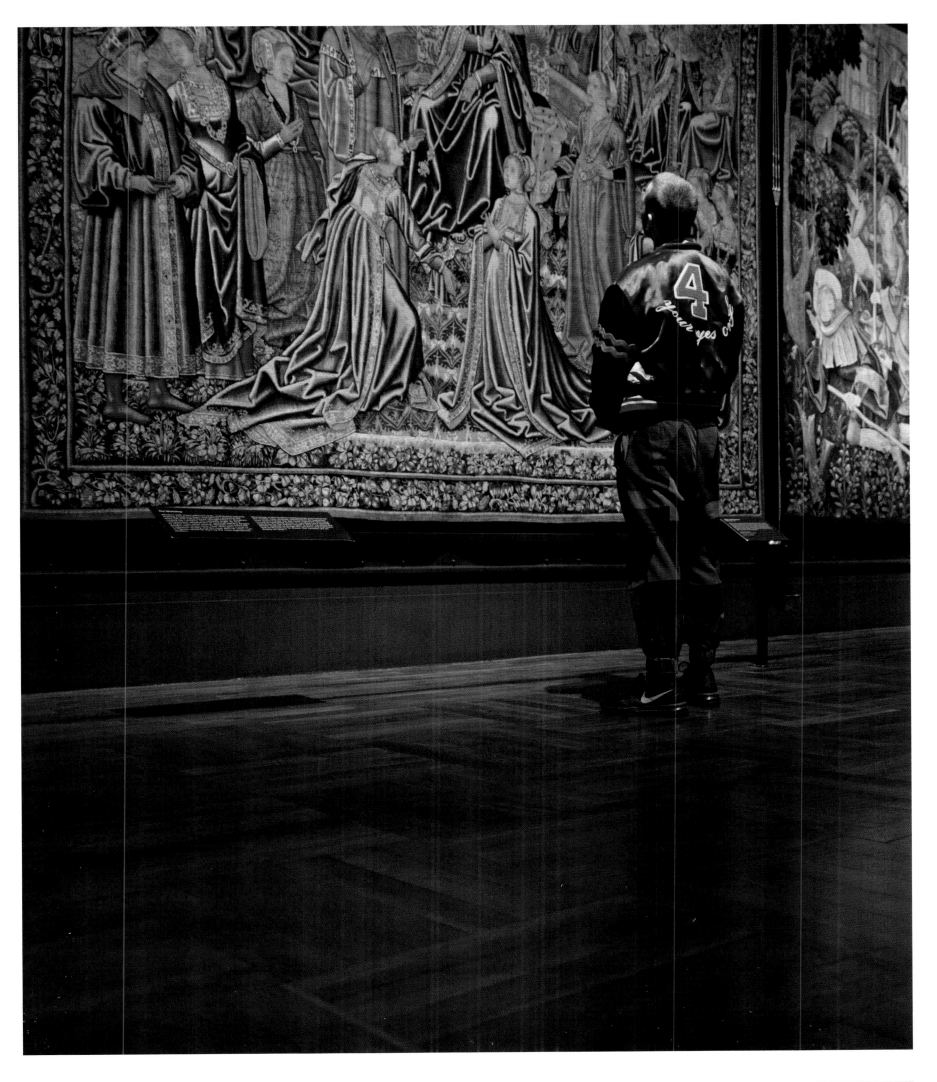

Celia Hempton
Artist

Most of the paintings by Celia Hempton, Eddie Peake's girlfriend, are sexual in nature; indeed they have been characterised as possessing a sense of 'detached voyeurism'. Born in 1981, Celia received a BA from the Glasgow School of Art and an MA from the Royal College of Art in London. In 2013 she was awarded a fellowship that allowed her to work in Umbria; prior to that she spent two years on a Sainsbury Scholarship in Painting at the British School at Rome.

Celia's work explores contemporary questions around privacy and intimacy, seeking to define the significance of such concepts in a world in which traditional norms of modesty, prudence and discretion are constantly being provoked and redefined. Using friends and models as sitters, her small canvases focus on 'private parts' of the body, and are juxtaposed with large wall paintings referencing landscapes. Her aim, she explains, is 'to provide a difference in tempo and atmosphere' between the two, making the canvases seem 'more vulnerable'. In order to create some of her works, she has randomly connected chat-room users via webcams, thus creating images with 'a sense of wilderness or indifference' about them. Her paintings recall Courbet, Schiele and the Brücke artists Max Pechstein and Ernst Ludwig Kirchner.

Celia cites as 'a consistent interest' the fact that she can trace back to her childhood what she terms 'an awareness of a spectrum of gender and sexuality' within herself. Having been 'very much a country girl', she came to London after studying in Scotland with 'a kind of obsession with the idea of a city and big structures'. Glasgow was where she became 'city-wise'; she found the Scottish metropolis 'much rougher in a way than London … It was a good learning curve for me'. Her experience of London has been coloured by her friendships with 'people like Prem [Sahib] and Eddie, and especially the gay scene, which is very open and liberated'. Particularly important have been conversations she has had with friends 'about what it means to be a woman, what it means to be a man, and whether those two conditions are binary or whether they're fluid … That wouldn't be happening anywhere else'. Italy, by contrast, represents the upholding of tradition and conservativism. Musing further on the city/country contrast she has explored in her work, Celia adds, 'I like the idea that, when I hang these very clean, brightly coloured paintings of nudes, they're sometimes on these much dirtier-looking walls or swathes of colour … At the same time, there's something of the country about it and there's something of the city about it.'

'London has a history of being very open,' observes Celia Hempton in her Cell Studio space in Hackney (opposite). Hempton with friend and collaborator Eddie Peake in the rooftop garden outside her studio (left). She credits Peake, whom she met while on an artist's residency in Rome, and another friend, Prem Sahib (below), with influencing her work

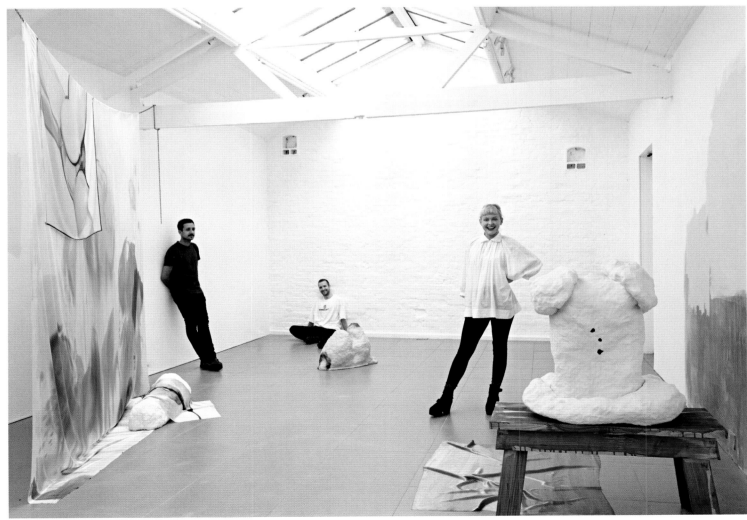

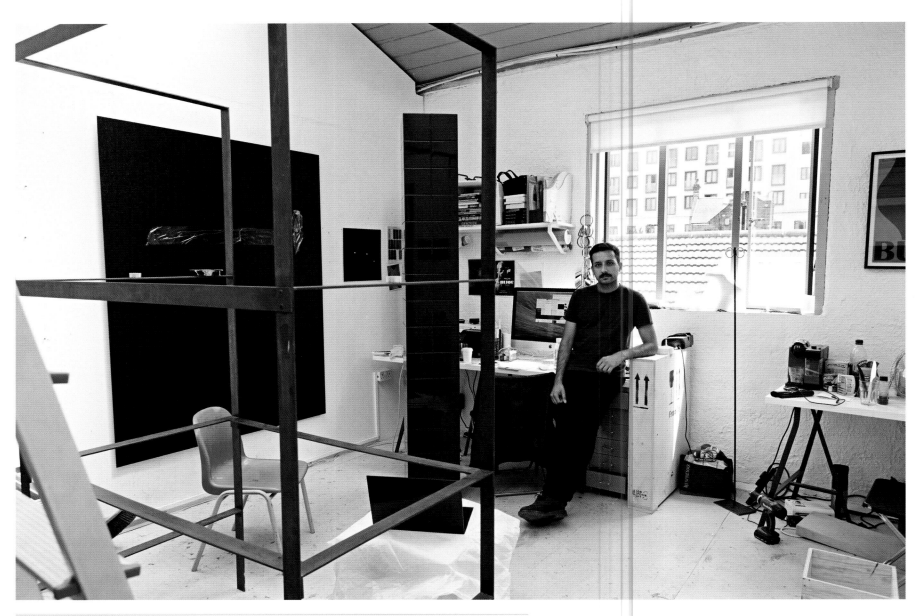

Prem Sahib
Artist

Prem Sahib, like Eddie Peak a graduate of the Royal Academy Schools, regularly DJs with Peake at, among other venues, Vogue Fabrics. Prem also creates minimalist sculptures, of which he says, 'I like letting the narrative emerge; there is one, a lurking presence.' Born in London in 1982 to an Indian father and Polish mother, Prem learned some of the techniques he employs in the fabrication of his sculptures from his uncle, a labourer, and his father, who has done spray-painting. These pieces, along with his installations, employ a sparse palette to explore abstract and autobiographical themes. Critics have noted that they 'evoke certain gendered spaces where the body is alternately exposed, honed and celebrated (the changing room, the gym, the public toilet)'; despite their seeming coldness, they explore sexual identity and queer culture, including themes of desire, intimacy and community.

Prem observes that there was no single moment when he decided to become an artist, although there was a point when he discovered that he enjoyed making art. He finds the pressure of creating exhibitions challenging, musing, 'I sometimes feel that galleries do not understand the working process of artists.' About his childhood in London, he notes, 'I grew up in an area that was very Asian, and I completely identified

with that in some ways … I was going to central London a lot and exploring the fact that I lived in this amazingly diverse space.' Soho was a neighbourhood he especially liked, but he feels that it has become less 'exciting' in recent years.

Prem doesn't 'consciously have an idea of being an artist as a job somehow. It's something that I just fell into through an interest I had in expressing myself. Maybe when I did my foundation course I started to realise I had strength in a particular area'. As long as he has a studio (his current one is located in Bethnal Green), he has everything he needs, he adds. He describes his sculptural work as 'quite biographical … People can engage with it in ways that aren't just about knowing about its references. Sometimes the references are highly obscured or abstracted, so there's kind of multiple readings.' Being a gay man in London has, Prem believes, given him 'a lot of impetus' to think about his own place in the world. In fact he credits the city with providing more of an artistic education than any formal schooling, saying, 'The nightlife in London has probably been more moving to me in some ways than a particular painting I might have stood in front of.'

'London always fosters and creates opportunities to think about your experiences in a creative way,' notes Prem Sahib in his studio, which is close to Celia Hempton's (opposite). Sahib on his studio roof overlooking the neighbourhood (right), and at Hackney Bureau (below), the café he visits regularly with Peake and Hempton (following spread) Fabien Riggall rests beside the Regent's Canal, beneath Mare Street in Hackney. The iconic gasometers are leftovers from the Haggerston Imperial Gas Company. Soon to be replaced by highrises, they inspired Riggall to use them for a Secret Cinema showing of Ridley Scott's iconic film *Blade Runner*

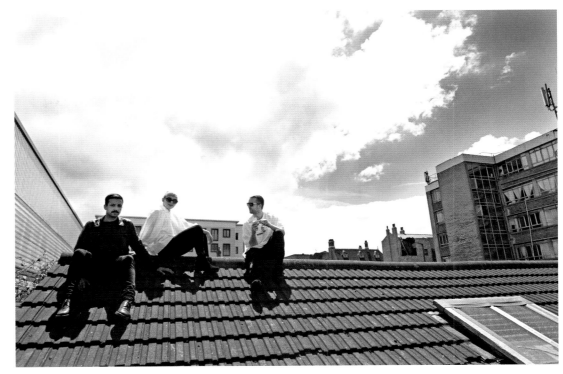

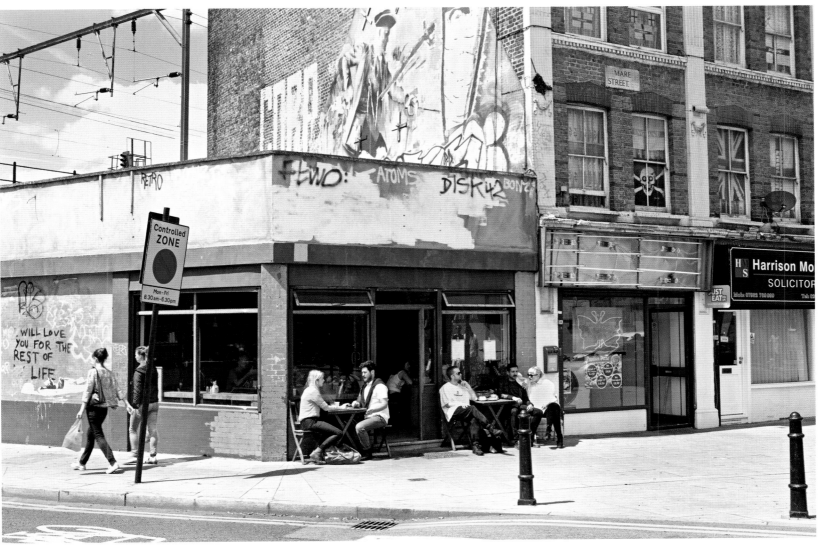

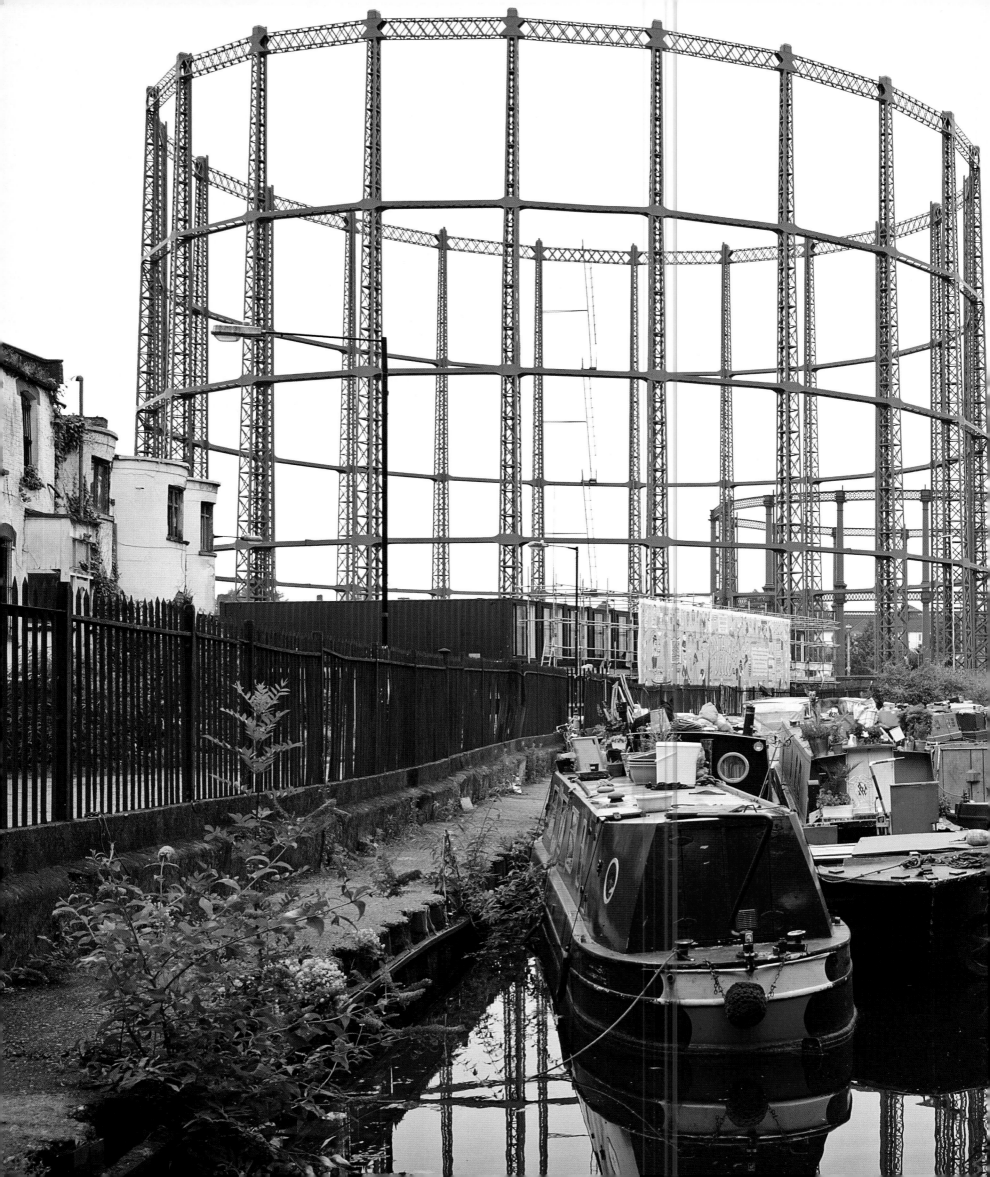

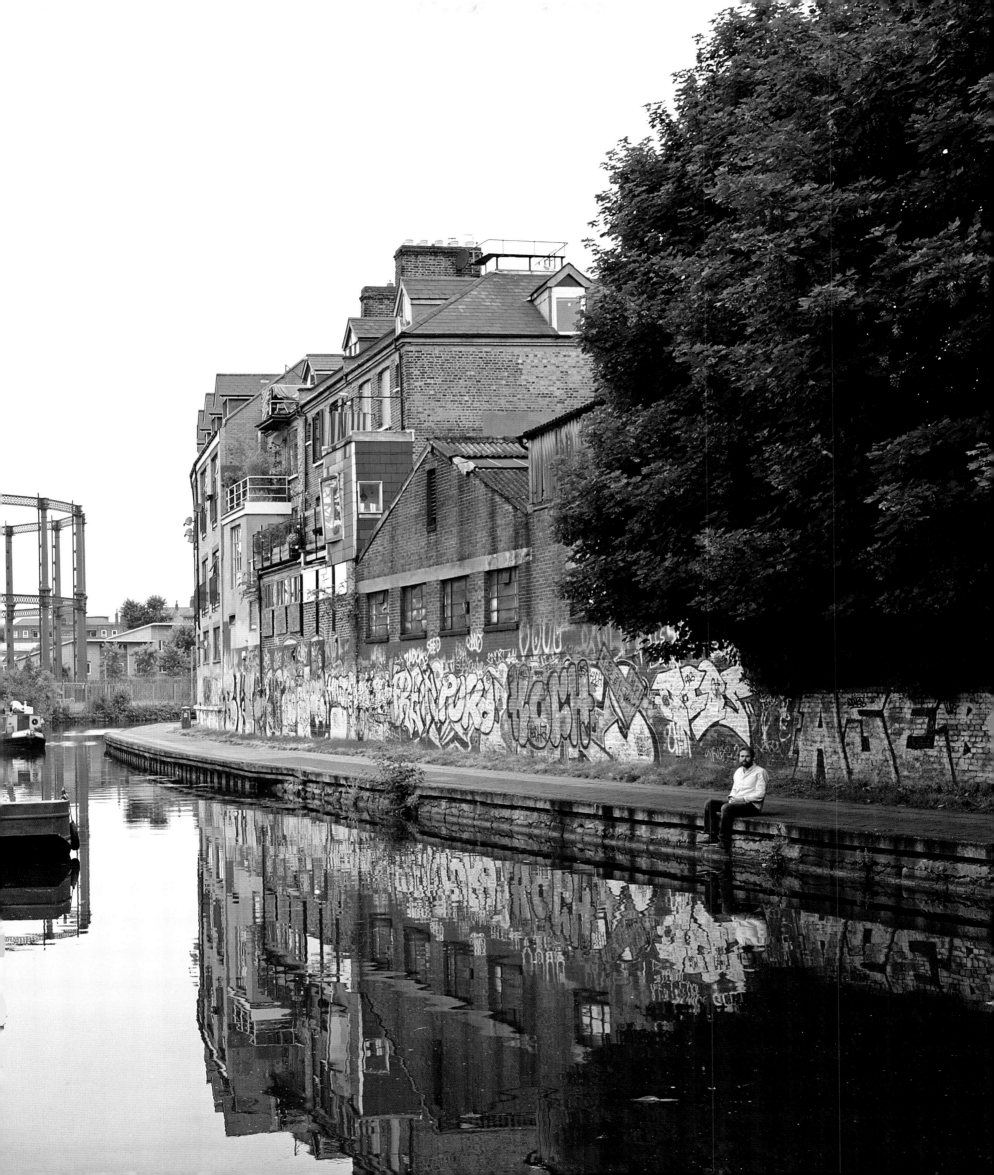

Fabien Riggall
Founder, Secret Cinema
Regent's Canal/London Fields/Olympic Park

We are sitting in the Laundry in Hackney, which used to be the biggest laundry in all of London. Now it's a washing-house of ideas.
Yes. It's owned by Ed O'Brien; he's curated the building with a series of organisations. What I like about his plan is that it's like the old Hollywood studio set-up where you have all of the artists under one roof and you can create amazing work. Next door you've got Young Turks. The bassist from Mumford & Sons has a studio here. Underneath it all is a venue with a capacity of six hundred in which we are going to have a cinema.

In essence it is a hen house of activity …
It's a brothel of creativity.

Do these libertarian ideas actually feed into creative output?
As much as possible.

Why is so much happening now in East London from a creative point of view?
What is happening with creativity is that everything is happening so fast, and artists are working much more quickly than they used to. We are living in our own worlds. I built an organisation around Secret Cinema in which we are collaborating with lots of different artists. In reality it was a utopian idea. We are all still as busy as we used to be, and I hardly know my neighbours.

So essentially, it's just real estate here in the Laundry.
It's just real estate. This area is interesting and full of young, creative organisations. There is a community in Hackney that doesn't exist in lots of other parts of London.

What are you, nearly forty? And you are reinventing the experience of cinema.
We have invented something that is in between theatre and cinema. I am interested in disrupting every single thing. There is always a battle between those that want to keep systems going to try to fuel mundane corporate existence and those that want to challenge and change. I think the world is automated and slightly dull, and that those who can change, change it. The world must constantly change. I want to build something that celebrates those that constantly challenge and change.

How are recent times different from past times?
There is an opportunity now because people are taking less drugs than in the '60s. Creativity is currently owned by four big companies: Facebook, Google, Apple and eBay. They own the data and are basically going to start controlling us. Every single time I click on an article which is left-field and talking about control, they know. With the snooper cameras they are working on, they are going to be able to monitor all of our Facebook feeds. That scares me. What I'm interested in is building a group that can disrupt media and politics with culture.

They'll absorb you; they'll buy you out in a few years.
No, not at all.

That's what power does.
No, *we* are going to buy *them* out.

Okay, then when you buy them out, you'll become a church as well.
No. I want to build a culture that is open and free.

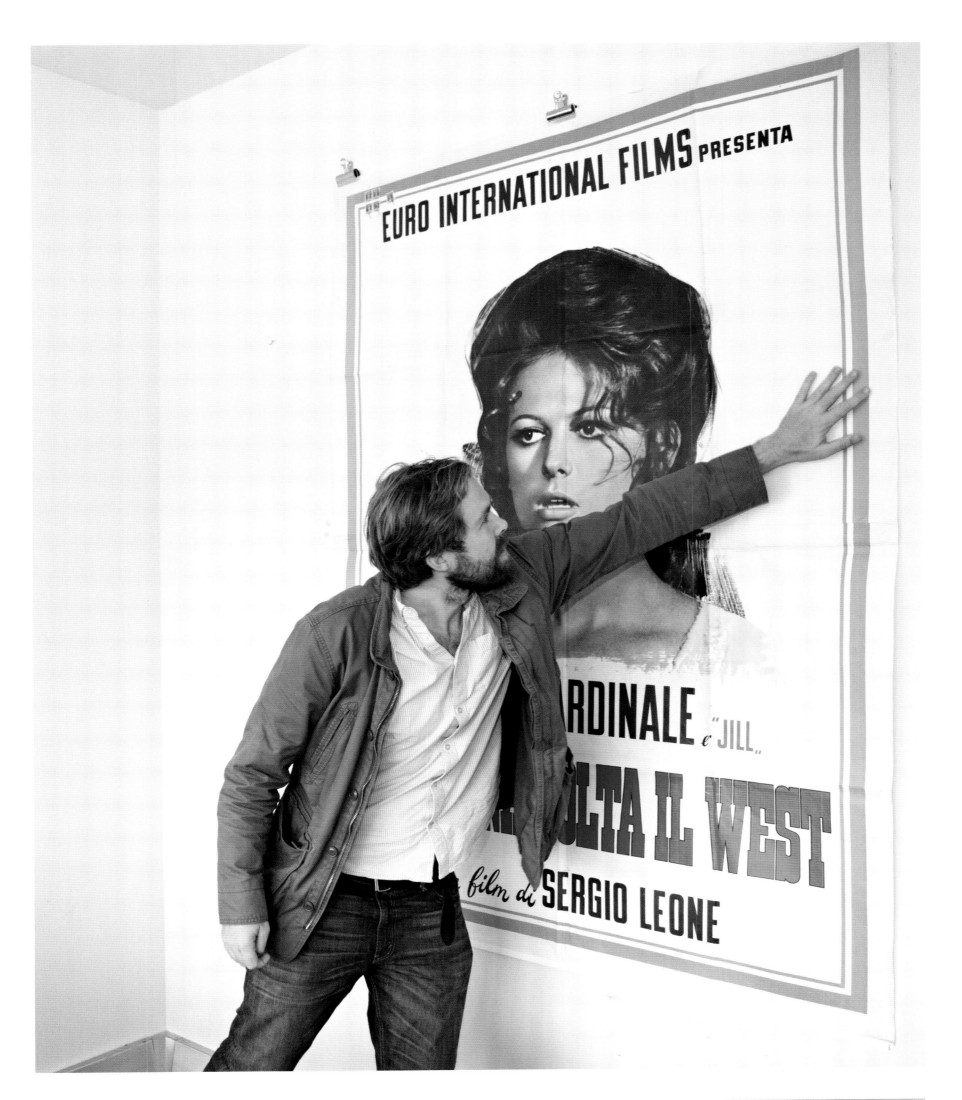

'London is a tough city, but I don't think there is anywhere else like it. It gives you the tonic you need as long as you can stay off of the drugs'

(previous page) Fabien Riggall in the Secret Cinema offices at the Laundry, a renovated 1950s building in the heart of Hackney. Riggall sorts out Claudia Cardinale on an Italian poster for *Once Upon a Time in the West*, Sergio Leone's 1968 spaghetti western, one of Riggall's all-time favourite movies. He first saw the film as an eleven-year-old in a Moroccan cinema shrouded in cigarette smoke. A self-described 'hopeless romantic', Riggall never forgot the experience, which became one of the reasons that he tries to recreate magical connections between films and their audiences

Everybody wants that!

Sure, but I've been going ten years and I'm still battling it, and now we have a quarter of a million people a year at shows and they are still as out there as they always were. I'm about to launch in America, and we are very much going to keep the same ethic and spirit. There is an opportunity here because some of these organisations are starting to become so big that they can't move as fast. From an artistic point of view, people think about cinema, music, art, fashion and food. I don't think it's going to be that way any more. It's going to be these universes where you won't just release an album, you are going to release a world.

That's rather ambitious, isn't it?

What I mean by 'a world' is that I don't think albums or films have the same value as they used to. The idea is to release an album that is actually a building, so that to listen to the album you go to the building. If you release a film, you don't go to the cinema, you go to an experience like ours. You go to a house to see a new fashion line and there are models there, live, in the house. Basically, people need shit that is much more extreme now.

Yeah, but that still only grants access to a limited number of people.

It's about capturing the spirit of it. The idea of a local cinema is where you go to the manager and he knows your name and introduces you to other people in your community and it's a friendly experience. What we do is a sort of extreme version. For example, yesterday I had a meeting with a landowner who owns the space under the railway arches in Britain. They've got all of this space under the arches where they want to make cultural spaces. I said to them, 'I can make the same commercial offer to you as a bigger brand could because I've built a market out of something that is this left-field. There is a whole world of things that are really secret and unusual.'

Why does it have to be secret to be different?

I see secrecy as a form of truth that allows you to do what you want.

So you're interested in disrupting the most important type of social medium, which is cinema. I was thinking on the way here that what you are doing is trying to replicate what Aldous Huxley was idealising in *Brave New World*, the idea that you plug into the cinema and fly into the movie.

Well, there are no seats and there is no stage. You become the movie. There are tons of politicians that are laying down the rules and then breaking the rules. Most media reporting on what is happening is actually not telling the truth. I feel this is the time in which everything needs to be turned upside-down.

And you're the prophet.

Not at all. I'm just a player. I'm just fooling around.

But you are not fooling around.

No, it is quite serious. I'm basically playing the fool. Going to studios like Warner Bros., they may think that I'm just nobody, but now they are starting to realise that I am doing something so they are getting all of their lawyers out.

You know the old adage about David and Goliath … You can't really beat the big guys.

Yes you can. You just have to confuse everyone. Secret Cinema isn't a gimmick. It's what cinema used to be where you had an organist, and dancing, and people were shouting and throwing things at the screen, and everyone was going crazy. There would be riots. There was an atmosphere. Now it's all very quiet and no-one says anything. The world has become boxed in.

The Secret Cinema showing of *Back to the Future* being set up at Queen Elizabeth Olympic Park in 2014 (opposite). Over sixty thousand people experienced the film's live re-enactment, including a famous scene where lightning hits a clock tower (far left). Riggall visits Ruth's Frock Shop, a pop-up shop on Hackney Road themed around *Back to the Future* (left), and gets ready to take off in a reproduction of the DeLorean car used on the set, with Doc Brown (actor Andrew Lawden) looking on at Earls Court Exhibition Centre (above)

You want more theatre in the cinema essentially.
More theatre everywhere. The government should have a team with
artists, musicians, performers everywhere. There should be constant
culture. All the money is going to the wrong people; it's going to artists
that are safe and tick a box. They need to invest in making people happier
through culture.

**What is it about London that inspired you to make something you can
use to challenge the likes of Warner Bros.?**
I don't want to challenge Warner Bros., I just want them to respect what
we have created. If you can defeat London, you can do anything that you
want because it has such an open attitude towards ideas. There is also a
massive cultural mix here, so if your idea works here, it explodes. London
is a tough city, but I don't think there is anywhere else like it. It gives you
the tonic you need as long as you can stay off the drugs.

**You are almost talking about a religious experience as against just
letting your hair down.**
No. I think the religious fanatic is Mark Zuckerberg, who's taking over
our minds.

**In terms of practical aspects, of financial support, I've heard a lot of
big names mentioned. I've heard that Ridley Scott is a fan of yours.**
He's allowed us to use three of his films and build a world around them,
so he trusts us from an artistic perspective. And we are working with
Bob Gale, the writer of *Back to the Future* …

Do you have an organisation, a group of people that work 9.00 to 5.00?
There is an office here with twelve or fifteen people, and we have a
costume department and production design. Each time we show a film
we build a set just like a theatre production. We usually have about 160
people working on it.

Where do the day-to-day financial resources come from?
The audience. It's a very dangerous way of working! We put the tickets
on sale, the money comes in, and then we build a show. We budget, put
more tickets on sale, pay the debt off, and that's what I've been doing for
four years. Now I'm getting more serious and more organised. I'm going
to get some investors and build a business model.

Isn't that the antithesis of creative?
Yeah, but I need help.

You just want your fingerprint, your own input, on a production, then?
Yes. I met Spike Jonze for the first time the other day. My interest is in
actually writing the script with the film-maker and writing something
that starts as an event or a building and then becomes a film. I'm trying
to get in touch with the creators to see if it's possible. The idea is that for
his next show, we would design something that would be taking place
all around London, so a restaurant might open up, a nightclub, a police
station, something that was fictitious but also real. And when you are
watching the series, I like the idea that the audience is written into the
script, so the main character will interact with the audience. That would
be kind of interesting.

Riggall, who never misses an
opportunity to swim at the
London Fields Lido (above)
in order to clear his head,
founded a Secret Swimming
club for fellow enthusiasts.

Built in the 1930s and closed
in 1988, the lido was saved
from demolition after an
eighteen-year campaign led
by local activists. Restored to
its former glory, it reopened
in 2006

Nicholas Serota
Director, Tate/Chairman, Turner Prize
Pimlico/South Bank

N

You've been described as the most important person to change the face of contemporary art in Britain. Is that a valid proposition?
Journalists are always looking for easy solutions, for an image that they can make and then destroy … I certainly wasn't responsible for what happened in the '60s. Think about the '90s; that was really fuelled by a group of artists. I created a platform for some of them by the way in which we reorganised the Turner Prize, the way in which we started looking outwards, but these things are aided by groups of individuals in conversation, in debate. A bureaucrat like me can only help a little.

You are infamous for being modest. Tate Modern has done more than a little to influence twenty-first-century art. You are part of a template that has been sought after around the world.
Britain had been waiting for a modern-art museum for a long time. The Tate was trying hard to fulfil the responsibility fulfilled in New York by the Whitney Museum and by the Museum of Modern Art, but all in one building. We needed dedication to British art and dedication to international modern art. Peggy Guggenheim suggested creating a museum of modern art in London in 1938. It took another sixty years to make it.

And you.
And possibly me.

How does the individual affect cultural birth in a city like London, which has a great cultural history all its own?
We have to create conditions in which young people encounter brilliant minds. That means having good art schools, putting young people in contact with brilliant designers, brilliant engineers and brilliant artists. Artists and designers don't just emerge out of nowhere. It's that conjunction of interests that makes a difference. We all learn from teachers, we all learn from mentors. We learn from example, and then we create something else.

Is it an incremental process?
It can be. But there are situations where three or four, five or six, individuals come together and spark off of each other, which is what we saw in the late '80s around Damien Hirst.

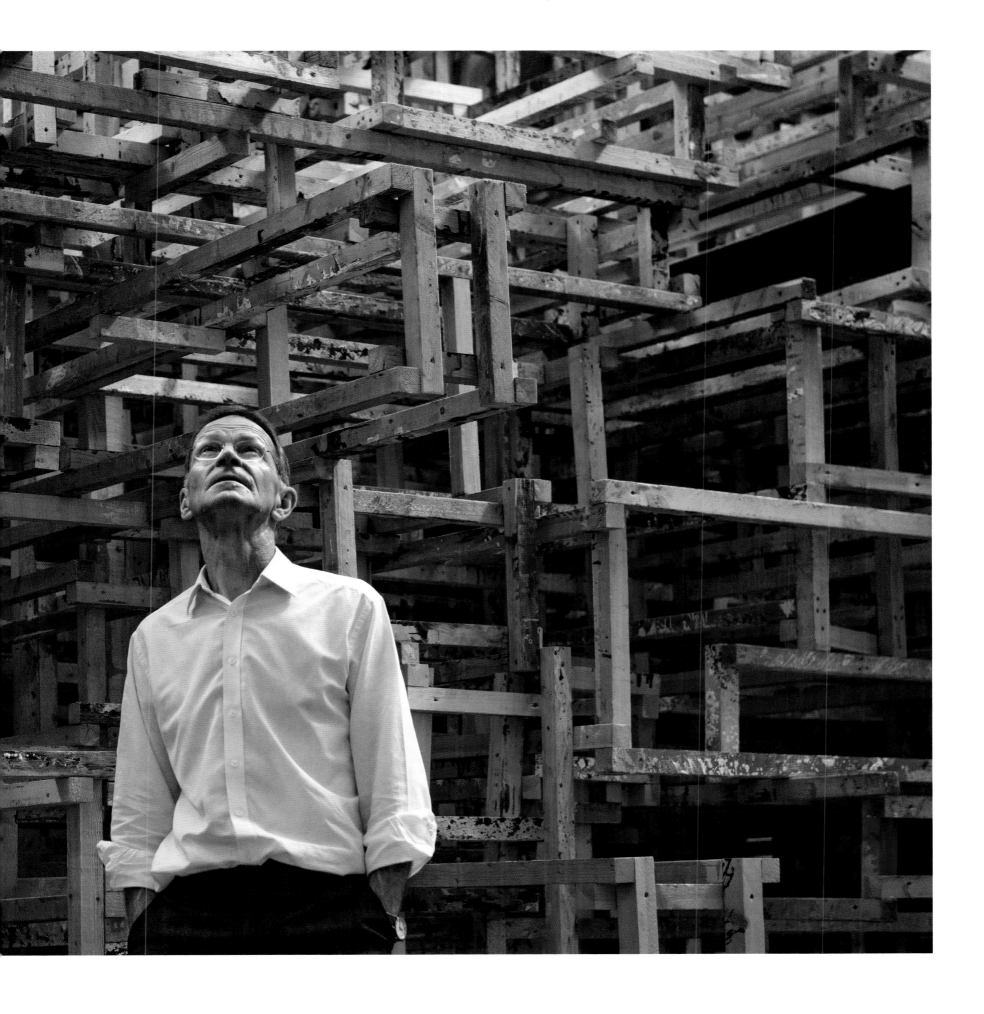

(previous spread) Nicholas Serota in Tate Britain's Duveen Galleries in front of *dock*, the 2014 Tate Britain Commission by artist Phyllida Barlow (the mother of artist Eddie Peake). A 1937 addition, the Duveen Galleries were the first public galleries in England designed specifically for the display of sculpture. Barlow's commission was her largest and most ambitious installation piece to date in London

Visitors rest outside the Duveen Galleries (top right), bathed in the summer light streaming through a window designed by the 2009 Turner Prize-winner Richard Wright. Launched in 1897 on the site of a former prison, Tate Britain began as a single site with a small collection of British art. Today Tate has four major sites and nearly seventy thousand works by both British and international artists. Serota has been responsible for much of that expansion. He keeps plans for building projects in his office (above) along with records of acquisitions and exhibitions for both Tate Britain and Tate Modern

An institution like Tate Modern not only acts as a platform but also as a place of education and inspiration. Did you have any preconceived ideas about how you were going to transform the Tate, or was it an organic process?

My ambition was to connect London to the rest of the world. I grew up in a situation in which I watched important exhibitions being made in small museums in Continental Europe. I also watched major exhibitions being made in Paris and New York. Very few of those exhibitions were avant-garde; all were important, large historical surveys. I set up originally in Whitechapel to make a place in the UK that was the equivalent to any of the small museums (particularly in Germany, Belgium and Holland) that have a commitment to showing artists as they are emerging and to do so in a consistent way. Then you grow a public, and they grow an audience, and then you grow an influence. Then you provide a repository of knowledge and information and energy that is appealing to young artists. When I came to the Tate, people had been saying, 'The great exhibitions pass London by.' I had the ambition that the Tate should be the place that had the expertise to make such shows, but that could also become part of a world that can command such shows.

So you effectively internationalised the London art scene?

Yes. I was fortunate because I was working at a time when Norman Rosenthal was being very ambitious at the Royal Academy. What he did there was in some way a precursor of this activity.

Serota by the spiral staircase designed by Caruso St John as part of a £45 million renovation of Tate Britain (above). Travelling regularly between London's two Tate museums, Serota and his team persuaded Transport for London to build a pier at Millbank to service the riverbus (left); the pier was completed in 2003

You've been described by journalists as tall, thin and austere, with craggy, animated features and piercing eyes. It's a functional look essentially. Which of these characteristics have helped you move the mountains that you have moved?

I probably have to keep my cards a little bit closer to my chest in order to achieve what I want to achieve. If I tell everybody before I begin, there are plenty of people in this country who will say, 'Oh, we don't need that' or whatever. People look back on what I did at the Whitechapel as a success, but at the time, it wasn't regarded by the Establishment as a success. I was never invited to join an Arts Council committee. I was actually once invited to go to an exhibition committee, and I went to the meeting, and then about three weeks later I was informed that they had made a mistake. There wasn't enough space on the committee and they had not really intended to invite me. Most of the time when I was at the Whitechapel, and then early on at the Tate, I received enormous criticism. I mean titanic.

Were you a bit like Samson knocking down the Temple?

I've always loved the Tate; I've never wanted to knock down the Temple. What I wanted to do was create a space that artists had respect for and an engagement with. You could say that in terms of contemporary art, the Tate had kind of lost its way. I just wanted to recover that.

Making institutions seems to be something that you have mastered to a T. An old power station, a derelict gasworks ... Are renewal and regeneration significant factors within the culture of a city?

There are two things I'd say to that. The first is that, until very recently, most contemporary art has been on the margins of British society. I don't think it is at all a coincidence that the original Tate was created on the site of a prison in a marshland. Why? Because when Henry Tate proposed giving his collection of modern British painting to the nation, they said to put them in Trafalgar Square, at the National Gallery. Then there was a suggestion that they should go to South Kensington. But the directors of the V&A and other museums in that area said, 'No, we don't want that here.' So he was offered this redundant prison site in 1892. When we went to St Ives, it was a redundant gasworks. When we went to Liverpool, it was a redundant dockyard. When we went to create the Tate Modern, we found an abandoned power station. We are always at the margins.

When we first announced that we would go to Bankside, no-one knew where this was in London. Even ten days before the opening, there were trustees asking how people would get there. It was a part of London that had been neglected over many years. The Tate has gone to these sorts of sites because it has always had a shortage of resources. It uses its resources in the most creative way that it can, and it gets much better value for money onsite. But of course, in choosing that site and having the confidence to know that it would work, there were two factors that made a difference. One was the realisation that most artists preferred showing their work in converted buildings. The second reason was that it was an effective part of the city, a part that still had potential. By going there, we could improve the city, add something to the city.

What do you think it has added to the city in economic and social terms?

Partially because we have encouraged Southwark to take a part in our planning and some of the wealth, some of the benefits are starting to make their way slowly into the borough. The area immediately south of Southwark Street is changing. It's a place where small creative industries and businesses can congregate, and it's become a centre for creative ambition.

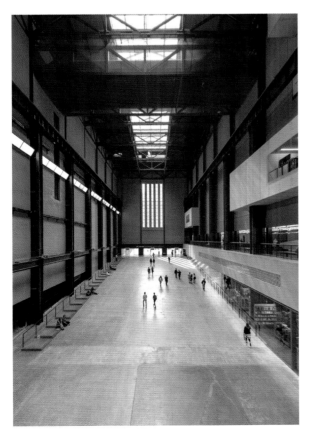

Construction underway for Tate Modern's extension (opposite) designed by Herzog & de Meuron, the architects responsible for Bankside Power Station's original conversion. Master of all he surveys: Serota on the terrace of Tate Modern (top) with the Shard, Europe's tallest building, in the background. The bridge (above) links the new wing to the Turbine Hall (left) at the heart of the current museum

What in your opinion distinguishes London from Paris or New York as a cultural and creative hub?
It is different now than it was in the 1960s; London is in a lot stronger position than it was. I think that culture is created when you mix cultures, when you bring people together that don't necessarily have a shared view of the world. London is a much more exciting city now than it was in the 1960s. The creativity that was here in the '60s in some way ebbed because it was monocultural and heavily influenced by what was happening in America. Well, it was British, but how do you define British? It was a certain kind of British that was strongly connected with American culture. Now (and it is something that the Olympics in some way have helped us to develop and maintain), London is a much more diverse city than it was. London has been incredibly helped by its geographic position in comparison with New York because of the move east in terms of economic wealth and the direction everyone is looking in. I can remember in the late '80s people sincerely asking if London would survive as a financial centre with Frankfurt developing in the way that it was. I don't think anybody would ask that question today.

You pre-empted my next question, which is to do with the financial strengths of London. Would there be the same backing for contemporary art and culture in terms of sponsorship and patronage without this financial muscle?
The presence of people in the city who come from elsewhere and who see the city as a place in which they want to live, can live, socialise, engage in culture and engage in commerce obviously makes a big difference within the market, and obviously makes a big difference within public institutions, because many of those people have been extremely generous in helping those public institutions advance their programmes.

You've taken it upon yourself to raise a large amount of money …
Too much, yes, for Tate Modern.

A quarter of a billion pounds. Is that process ageing you by the minute or is it an enjoyable task?
It's an enjoyable challenge more than an enjoyable task. It's a good cause; it has to be done. As the building slowly emerges, we see that there will be all kinds of opportunities within it that are not present in the existing Tate Modern. We can create a new model for museums of contemporary art as platforms for discussion and exchange of ideas.

Built by the rich.
Funded by people who care about society.

The rich.
In some instances, yes.

There is an essential dichotomy, isn't there, in all this? You are basically taking from the rich to feed the minds of the masses, if that is a fair but crude interpretation of the process. You are fundraising by means of your platform-creating, your ability and your power. This enables you to centralise these resources and pass them on to a general public.
The great thing about Britain is that we have this tradition of free public museums. It's supported by the state, but also supported by individuals. They are fundamentally situations that serve the public rather than serving the rich individuals that you are describing. That is one of our great strengths, and if we can co-opt people and get further cooperation for that framework, those are the terms in which we take the money. You can give a lot of money to the Tate, but you don't immediately become a trustee. Trustees are appointed by the Prime Minister. We are a national institution, and we will remain as such, I think. That is one of our strengths, that independence. We don't belong to the public sector. The same is true of the universities; they are highly dependent on a combination of private and public funding. They have been over a long period of time, and again, it's one of our strengths.

But education is a basic social duty. Do the same principles apply to art as well?
Art is education. It is opening our minds to the world, and it doesn't begin or end at the ages of fifteen to twenty-five, it continues right the way through. These are educational institutions. What is education? It is opening yourself to different kinds of experience. That's what museums do at their best. When you go to Tate Modern, you are experiencing another culture's point of view. You are understanding how that person is seeing the world.

Do you feel that art education should be more systemic than it is currently in the curriculum, national or otherwise?
Well, it's a left-brain, right-brain kind of argument, isn't it? Should you build muscles in your legs rather than your whole body? It's about the whole person, and that whole person has to express themself through art and culture as much as through language. We probably have completely understandable reasons, but we place too much stress on the command of language rather than of images or the command of visual strengths or capabilities. Recently, Richard Rogers had an eightieth-birthday celebration at the Royal Academy. There was a report from his first year as a member of the Architectural Association, saying that he could barely express himself, he couldn't string sentences together, and various other complaints of this kind. It was all about language. This is a man who has made some of the most remarkable and beautiful buildings in the last forty or fifty years; leaving the Association, he was already noted as an important and talented architect. In spite of his dyslexia and his inability to use language, he uses language in a very beautiful way.

You once were quoted as saying that you would die at the Whitechapel. How much was that institution dependent on you?
You can't see it now, but there was a little mural painting that showed a portrait of one of the early directors of the Whitechapel, and underneath it said that he had been killed in action in the First World War. One of my daughters, at the age of about six, asked if I would die at the Whitechapel, and I said, 'No, I'll probably be killed in action.' I didn't die at the Whitechapel, and I don't think I'll die at the Tate. I hope. You never know.

Serota on the terrace of Tate Modern's Members Room overlooking St Paul's Cathedral (above). Crowds cross the Millennium Bridge, the first pedestrian-only Thames bridge constructed in more than a century (opposite). Designed and engineered by Foster + Partners, Sir Anthony Caro and Arup, it links St Paul's to the Globe Theatre, the Bankside Gallery and Tate Modern

(following spread) The Tate & Lyle Sugars factory at Plaistow Wharf, opposite Greenwich. The wharf dates back to the 1880s. Corporate benefactors have always been the backbone of London's cultural regeneration. Henry Tate, nineteenth-century scion of the sugar dynasty, funded Tate's original Millbank building in 1897, donating his collection to the museum

'A bureaucrat like me can only help a little'

Polly Staple
Director, Chisenhale Gallery
Tower Hamlets/Victoria Park

Did you wake up at age ten or eleven and say, 'I'm going to be a curator?'
When I was at school, I was always in the art room. I liked English Literature and Geography, but I was an arty kid. I grew up in London, studied Art History and also went to art school, which was a perfect combination for learning to be a curator. I feel an affinity with a community of people offering new perspectives on how we think about the world. I like artists as well. That's what keeps me going: artists.

How does art open a new window on perceptions of the world?
If an artist has a job, it is to think about new ways of thinking about the world.

Many folk here in the East End must have little interest in being involved with or understanding what you're trying to do here, what you want to explore historically, or am I wrong?
Some people are very interested and some people are not. Here at the gallery, we talk to different audiences in ways which recognise their knowledge of art. We also have audiences who might only go to a gallery once a year, so when I'm talking to them I might give them some background information in a different way.

This space was formerly a Spitfire propeller factory, I believe.
Yes. Where we are now is a space originally established by artists, and a lot of artists live in this community. We have a partner – a primary school across the street – and we work quite actively with that school and other partner primary schools in the borough, because there's very limited access to art for schoolchildren. We also have projects with secondary schools, and we do a project with Victoria Park. The art world is made up of many different players, many different constituents, and we as a public space in the East End have a responsibility to our local community which is about dealing with matters of class and trying to break down those barriers. But we also have a direct line to an international art world.

How much of a difference does this space make to the heart of the East End?
This area has seen an intense amount of regeneration in the past ten years. You have a very mixed community of people living here. You have a housing estate, but you also have quite good architecture where there's desirable accommodation. You have a strong mix of people and classes and races. It's an example of a good, strong civic society, and we as a gallery play a role in that.

What distinguishes this part of London in terms of creative output?
Tower Hamlets, because of the docks mainly, has been a site of many shifts in communities and migrations. There were first the working-class white Irish. You then had the Jewish community coming in; anyone who made money moved to north London. You then had the Bangladeshi community come in. A lot of the white Irish moved out to Essex; you now have a big Bangladeshi community. In the '90s you also had the creative, artistic community move here because the rents were cheap. The history of this building was artists being able to take over a semi-derelict building and do it up. It's rare that you would still find a building like this.

Your background includes Frieze Projects, editing magazines, a high-end education, Goldsmiths, Chelsea. And yet you parked yourself here.
You know what I have here? I have autonomy. We don't have any heating and we don't have very much money, but we can do really interesting things.

You recently received the Genesis Prize, the citation for which described you as an 'outstanding mentor of artistic talent'. What makes for an outstanding mentor?
I will tell you what I told them, which is that the way that I work with artists (but also with my staff) is to support people, talk things through, be the critical friend, challenge people, have a strategic plan for supporting an artist, for example on developing a project.

Why is London so important in terms of the art scene today?
Cities have particular moments, don't they? I think London is having a particular moment. There are probably economic factors in there. London never features on those city lists where they nominate 'The Best Place to Live' … Apparently the nicest place to live right now is Vancouver or somewhere …

Portland, Oregon.
Exactly. But I'd go mad if I lived in Portland. There's an energy to London which is the old New York energy; it's multi-cultural, which is really important.

So if you didn't have muggings and murders and knifings, there would be no creativity.
Maybe there's a tension that happens in cities. It's bred partly from competition, I think.

If you were to paint a picture of London as a creative centre twenty years down the line, what would you hope to see?
Property prices are the thing that's going to stifle London. My staff can't afford to live in Hackney any more. Artists can't afford to live in London.

(previous page) Polly Staple arranging *The Bottom Line (to Kathrin Boehm)* at the Chisenhale Gallery, part of Céline Condorelli's first solo exhibition in London. The work formed part of *How to work together*, a major three-year joint initiative organised by the Chisenhale, the Showroom and Studio Voltaire

Staple at the entrance to the Chisenhale Gallery, a renovated 1930s veneer factory (above), and carrying a ladder (right) with a colleague past *baubau (to James Langdon)*, another Condorelli installation. *Like The Bottom Line (to Kathrin Boehm)*, *baubau* formed part of *How to work together*. Staple regularly visits the Pavilion Café in neighbouring Victoria Park (opposite bottom), in conjunction with which the Chisenhale runs a residency programme. The first project (in 2013) was the mural *Dome* (opposite top) in the skate park

So how do you subsidise art?
I don't know. Shall we ask Mr Cameron?

But what would you do yourself? Have a revolution, a socialist intervention?
I don't know. If people aren't going to live in the country and are just buying for investment, do we need to think about whether there should be a certain rate on those kinds of purchases as opposed to purchases by people who are going to live in the city?

If the money didn't come in, then all of this wouldn't be happening. That's the paradox, but it's the paradox of the living city.
One final question. Where would you like to be buried in London?
I went to a very beautiful funeral of a friend last year, on the Essex-London borders. It was a non-religious burial in a funeral ground where you had a view of the Essex salt marshes on one side and you could look to London on the other. I'd quite like to be buried there.

On the borderlands ...
Yeah, the borderlands. In a cardboard coffin.

What is it about the periphery?
The margins are where all the interesting things happen.

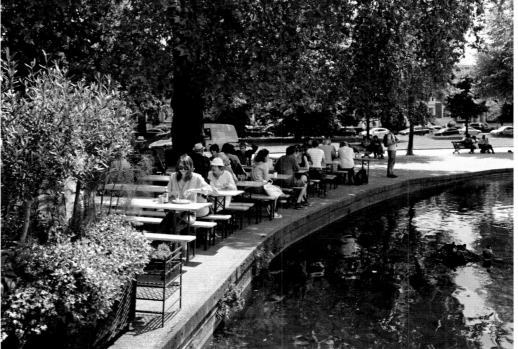

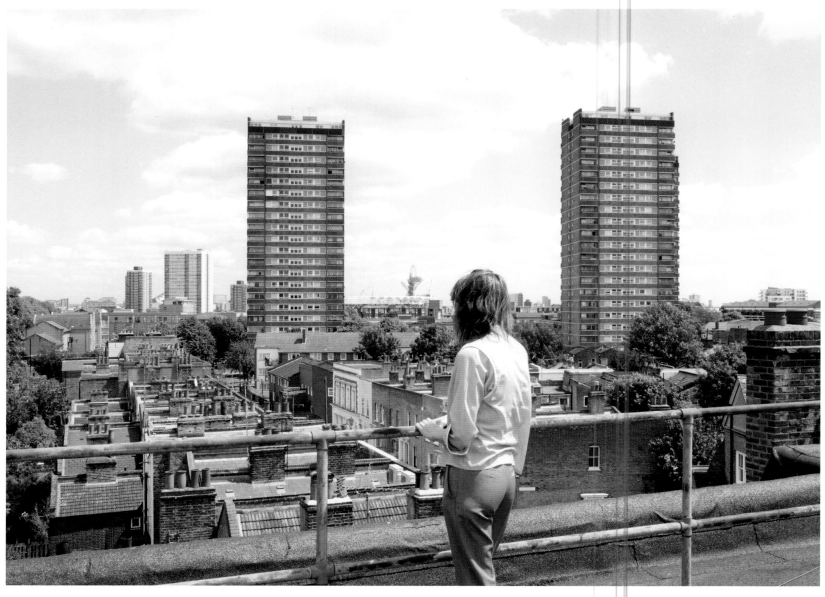

Staple looks across
Tower Hamlets from the
Chisenhale's roof (above),
and works through ideas
(right) for a new show
with Caragh Thuring

'Property prices are the thing that's going to stifle London. My staff can't afford to live in Hackney any more'

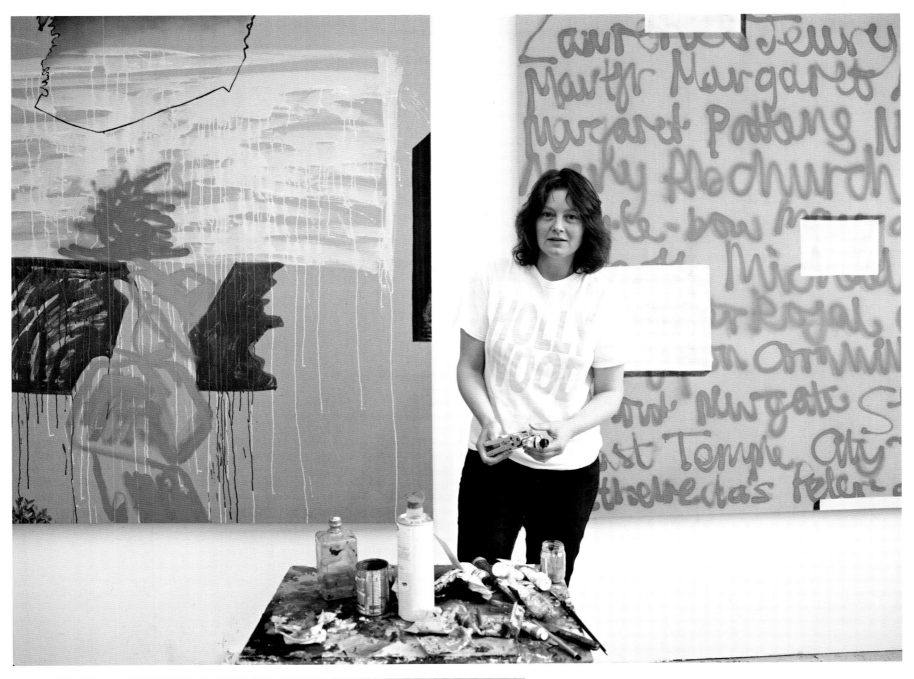

Caragh Thuring
Artist

Born in Brussels in 1972, Caragh Thuring enjoyed her first solo exhibition in a public space (Chisenhale Gallery) in 2014. She has worked in the same studio in Hackney Wick for eighteen years. 'I happened to land in London at a time when galleries were opening in the East End and everything gravitated towards that area,' she explains. 'The landscape changed because there was a lot of industrial building and post-war building; it's an area that been developing ever since … Every week it's different – there's a new restaurant, a new building going up – whereas the rest of London is very stationary.' The area's 'anonymous' quality appeals to Caragh, creating an atmosphere in which 'you can just do your work.'

A painter of mostly abstract compositions, Caragh co-ran a gallery in the East End for a time. When the Tate purchased one of her paintings out of the Frieze Art Fair in 2012, she acknowledged the honour by saying that it was 'nice to be a part of a lineage'. Thus she joined some of her favourite artists (among them David Hockney, Lucian Freud and George Stubbs) in one of London's foremost arts institutions. Another significant moment in Caragh's budding career was a stint as artist-in-residence at Suvikunta on Sarvisalo, the artists' colony in Finland owned by collectors Anita and Poju Zabludowicz.

Caragh, who paints on unprimed, often brown linen, is intrigued by the fragmentation of landscapes, objects and figures. She 'thought a lot about sculpture and about buildings and spaces' when she first began painting, and does a lot of research before beginning her pictures, looking, as she puts it, 'at a lot of old art'. Individual works are completed quite quickly, and ideas are explored and resolved as they unfold. She calls the act of painting 'the freest thing you can do, in that you're dealing with nothing, and you have to construct something out of that nothing'.

Caragh notes that 'everything is hidden in London; it's very higgledy-piggledy … You can go anywhere and find something interesting'. She notes that for her, the city is 'the most conducive place' in which to live and work, citing the fact that 'there's no system … to how the art world operates, how artists operate. It's just a big mess and you just sort of muddle through the mess. I really enjoy that.'

'There's nothing tying me here except that I like living here,' says Caragh Thuring of London. The Belgian-born painter, who has a studio (above) in Hackney Wick, is a long-term resident of the East End

(following spread) The Hertford Union Canal, better known as Duckett's Canal, flows behind the Chisenhale Gallery. Opened in 1830, it links the Regent's Canal to the Lee Navigation, passing through Victoria Park on its way and providing splendid vistas of London's waterways, poor cousins to the waterscapes of Venice

Jackie Wullschlager
Literary & art critic/Author
Southwark/The Strand/Euston

Would it be accurate to describe you as first among equals when it comes to art criticism in London?
Every critic has their own line. You have to have a vision; any art critic on a good paper will have that.

Are major art critics gatekeepers in a sense?
Our power is diminishing because art is more about money than it ever was before. On the other hand, there is much more art around now than there ever was. It's such a bloated, hyped scene, and that is where perhaps we have a use because we can point the way.

That gives you enormous power without responsibility, I suppose.
To whom is one's first responsibility? I've often wondered about that. I think it's equally to the artists and to the reader. In the end if you're writing what you believe and you've got an eye, it comes to the same thing. It's about the truth.

If you had to choose between the artist and the reader, which would it be?
I don't think it comes to that. I always think of Matthew Arnold, who said that the thing about a critic is to spread the best that has been said and thought. In the end, you owe it to every artist to try and see the world through their eyes. There are people who leave me completely cold, and I've learned that it's fairer to suggest that another critic goes along and does them. Nobody wants to read something saying that you don't get it. The exception to that, I suppose, is when a major museum mounts a big show. Museums are publically funded so they are accountable in that way. Your loyalty in the end is to the world of culture, in which we are all a little speck.

And you never doubt yourself or what you write?
Self-doubt is not a problem for me. Occasionally I'm wrong and I admit it. It actually makes it more interesting. The classic case was Peter Doig, whom I just didn't get in the beginning; I thought it was just pretty and not very serious. Since then, I think I've written three pieces saying I'm sorry and this is a serious and exciting artist. Certain problems I have with him remain; they were the things that alerted me in the first place to be slightly wary of someone who was being so hyped so soon. *Criticism* is a funny word, isn't it, because a lot of it is celebration and commentary.

You mentioned Matthew Arnold earlier ... Is there continuity in art over the *longue durée*?
Hugely. It's one of the most optimistic, fantastic things about art. There is always something the links go back to. I can absolutely see how it unravels. Nobody who is radical doesn't also look to tradition, and that is a fantastic thing about continuity, about the human spirit, about everything being building blocks to where we are now.

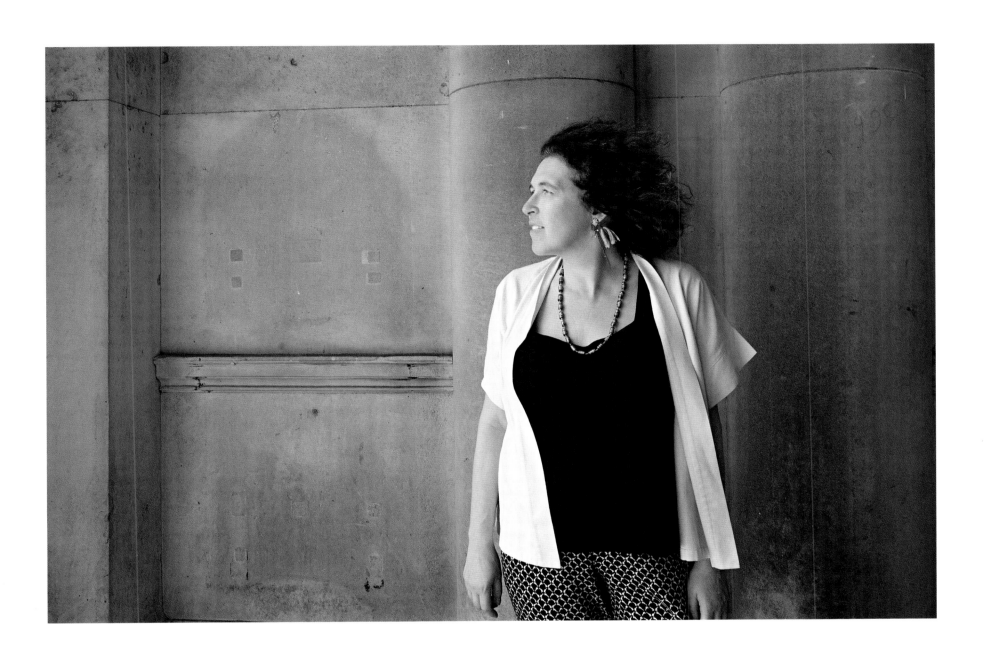

'There is much more art around now than there ever was. It's such a bloated, hyped scene, and that is where perhaps we have a use because we can point the way'

Talking of building blocks, you started writing criticism around the time the YBAs came on the scene. Do you remember that moment?
My trajectory is slightly different, because I was a book and theatre critic for most of that time, and I lived abroad through the '90s. When I came back to this country in 2004, London was transformed beyond anything you can imagine, from a rather grey and insulated place into this sort of blaze of money. I came back to be this paper's chief art critic, and I started the same week that Gagosian opened on Britannia Street. I always think that that was the beginning of London becoming so global; you know, everybody came here.

This whole movement in the '80s, did it go counter to culture by making itself outrageously noticeable?
What we always find is that things go counter to culture and then they become the Academy.

How much in counter-cultural artistic movements leads to creativity on a wider national, even international, level?
I think that will be the really good legacy of the YBAs. I was talking to Simon Fujiwara, and he said, 'God, I was a teenager lying in bed, and I turned on the radio and someone says, "This woman called Tracey has made art out of her bed," and I was electrified.' That is really important, the fact that art is a long story of democratisation, isn't it? Tracey Emin gave voice to underprivileged female experience in a way that had never had a voice. You probably had to go back to Charlotte Brontë to find something as dramatic.

What are the main components driving today's art scene?
It's a combination of money and thinking, but the economic factors are dominant. I think the opening up of art is a terrific thing; I wouldn't want to turn the clock back to the '70s, when there were two contemporary-art galleries in this country and hundreds of people who were interested rather than millions. I suppose, as a commentator, as a critic, one is just trying to be a corrective voice to say that actually there is no time in history where there were more than a hundred great artists. There are not a thousand great artists at every art fair!

You've referenced the early twentieth-century Russian collector Sergei Shchukin, who said something to the effect that if you feel a psychological shock in front of a painting you must buy it without further ado. Is that your basic maxim?
It is. I want to respond emotionally.

Does art criticism stand equal to literary criticism?
John Ruskin elevated writing about art to an absolute art form. I do find that consoling and appropriate when I justify what I'm doing.

On another, related subject, do you collect yourself?
I do, but at a tiny, tiny scale. It is a conflict of interest, of course, but on the other hand, life is very boring if you're disinterested and neutral. I would be surprised by someone who wrote about art and didn't want to live with it.

Are the items in your collection part of your life journey? Do they reflect nostalgia, focus thematically, function spatially?
No. They give me confidence and faith that these things can be made.

Why do you think London is such a vibrant city these days?
Because of the fusion of the most creative people in it, and because it has become very global, which it wasn't. You walk along the streets and you hear twenty languages going past you. I come from a European background, but I was brought up here, and I've always thought that a mix of cultures is a very wonderful, sort of incendiary thing. That's why I wanted to go and live in Europe in the first place. I was in New York a couple of years ago, and I thought, How interesting! Of course it is also a fantastically vibrant city, but it struck me that it had become more like a museum. There was the 'New York time' from the '20s to the '50s and '60s, and there it was: the architecture, everything, had fossilised it. I loved it and thought that was a nostalgic holiday, whereas London just moves all the time.

So within this creative flux, can you put your finger on one particular person or institution that has been especially instrumental?
Tate Modern – I mean, nobody would deny it – is fantastic. I don't agree with everything they do, but they are ahead of the game. They bring things in from everywhere, and I don't think that London would be London without Tate Modern. There is probably no other institution of which one could say that.

And where in London do you find your own inspiration and solace?
At home.

Behind your desk?
I'm afraid I do find joy, but also it can become too much of my job. I'm seeing things all the time, galleries all the time. Anyone creative would say that we don't do holidays; there is no space between work and leisure. It's the same thing because you live your thoughts. I spend a lot of time at artists' studios, I spend a lot of time in museums, and sometimes that visual overload of which everyone talks happens to me. I love being at home in my garden or in my study, where I have three paintings that I love. They steel me and I just love them.

And where is home?
Highbury, north London.

In Highbury is there a particular place where you walk?
We walk through Highbury Fields a lot. My mother lives up in Hampstead so I suppose our standard thing is to walk through Highgate Cemetery.

Do you mix it with Marx when you go out there?
I do think that the twentieth century was shaped by the thinking of Marx and Freud.

When you have to check out yourself one day, where would you like to be buried?
Probably Highgate Cemetery, with the thinkers.

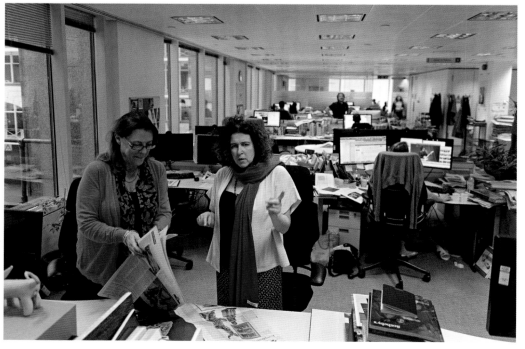

Jackie Wullschlager

(page 131) Jackie Wullschlager outside the Courtauld Gallery at Somerset House, which she visits weekly. She is particularly fond of the Courtauld 'because it's a small and absolutely exquisite collection'

Wullschlager reviews the latest issue (opposite) in the FT's offices with Arts Editor Jan Dalley. Wullschlager is in charge of scheduling reviews of major exhibitions by the paper's team, a job she describes as 'a huge pleasure'

Wullschlager at the British Library (above), where she does most of her writing twice weekly. The old British Library was housed in the British Museum before it moved to St Pancras in 1997, becoming the UK's largest (and costliest) public building constructed in the twentieth century. The library's holdings include over 150 million books and manuscripts, among them two copies of the Magna Carta and Leonardo da Vinci's Codex Arundel

Wullschlager rounds the stairwell of the Courtauld Gallery (left), and inspects her favourite work there, Manet's A Bar at the Folies-Bergère (above). 'Samuel Courtauld was collecting in the 1920s; he was one of the first people to bring French modern art to this country. His eye was extraordinary, so every work is a choice work,' Wullschlager explains.

The gallery, founded by Courtauld in 1933, occupies Somerset House. Originally a Tudor palace, the building was renovated by Christopher Wren and Inigo Jones, fell into disrepair and was remodelled in the eighteenth century. Having witnessed the death of Oliver Cromwell in 1658, it escaped the Great Fire of London in 1666

Nathan Cash Davidson
Artist

Young artist and rapper Nathan Cash Davidson describes his studio as a 'portal to the future'. Nathan found a huge fan in Jackie Wullschlager early on in his career; one of his paintings, *Judith's Room*, resides on the mantelpiece in her study. When Wullschlager saw *Judith's Room* in a 2006 exhibition (Nathan now refers to it as his first grown-up painting) she 'absolutely went for it. It seemed to me to be a new way of painting, and it reminded me of Matisse'. She describes Nathan as 'a unique talent because he doesn't let anybody else's vision touch him'.

Born in London in 1988, Nathan lives and work south of the Thames. Educated at Wimbledon School of Art, he graduated in 2010. As a rapper he writes and performs his own compositions; his visual artwork is often described as surreal. In the manner of several early French modernists he finds titles for his works by cutting up newspapers and rearranging the words. Inspired by historical figures, Renaissance costume, Old Master paintings and video games, his subjects have ranged from Henry VIII to George W. Bush and Ali G. His paintings often include family members as well. 'I just like anyone who looks like they could be from the past,' he explains. 'For example, if I saw a film where everyone was dressed

up like they were from the 16th century, I could pause that and use that. Our faces haven't really changed much, so anyone could potentially look identical to someone from that time if they dress up in the same clothes.' He credits his parents with taking him to the National Gallery when he was a child, as well as to 'lots of houses that had old master paintings in them. When I paint, it reminds me of going on holiday and walking round the old houses. It also reminds me of going to see pantomimes'.

'To get into the past I have to go into the future first,' Nathan quips. 'I always had these opposing worlds in my head, but never considered putting them together as it feels like them swearing at each other.' Wullschlager finds in this mix of old and novel 'a new sort of movement in art – which I suspect comes from kids who have looked at the Internet a lot and had lots of diverse overlapping and merging images'. Nathan, she believes, 'is absolutely inventive. Nobody will be making painting like that at any other time – it comes out of now'. His relative youth unnerves her slightly. 'I've rarely seen that sort of talent declared so young,' she muses. 'It's just unquestioned, and there is nothing to negotiate.'

Nathan Cash Davidson predicting the future (opposite) with the help of a homemade Ouija board in his studio in Peckham's Bussey Building. Originally built by Bussey and Co for the manufacture of cricket bats, the early twentieth-century reinforced-concrete structure (one of the area's tallest buildings) is now a part of Copeland Park (above), a group of warehouses transformed into a creative quarter

Cash Davidson, one of Wullschlager's favourite artists, speaks about work at various stages of completion in his studio (left & below left). 'He's an absolute genius for compositions as well as the handling of paint,' says Wullschlager

Celia Paul
Artist

Celia Paul's flat-*cum*-studio is located in Bloomsbury, within viewing distance of the British Museum. Entering the lair of this seemingly delicate, shy individual feels like stepping into a world divorced from the bustling one immediately outside her door. Formerly represented by Marlborough Fine Art, Celia has recently been taken on by Victoria Miro, a move that appears to have given a new impetus to her public persona.

Celia was born in 1959 in Trivandrum in India. Her father, a missionary, moved his family back to Britain during the 1960s, eventually becoming Bishop of Bradford. A painter of figures and landscapes, Celia attended the Slade School of Fine Art, where she met British artist Lucian Freud, for whom she frequently modelled during the 1980s. Student and tutor also had a romantic relationship that resulted in the birth of a son. Of her painting technique Celia says, 'My arms connect with my insides in a way that's so very different than, say, writing. With watercolours, when I paint, I let the watercolour just drip vertically because it justifies the beauty of the surface of the paper, whereas with oil paints you kind of build, it's more like a stage set ...' Working from studies and limiting herself to a narrow range of subjects, Celia explores themes of identity and individuality; for many years her main subjects were her mother and sisters. Sometimes she paints the view from her window. She thinks of her studio as a 'secret, female space' from which it is possible to observe the iconic 'male' architectural creations of her immediate surroundings: the British Museum, the BT Tower, St George's Church.

'My mother has always spoken about "all of you", and I think I've always been searching for a sense of identity, a sense of who I was amongst all these daughters,' Celia says of coming to terms with her relationship with her four sisters. 'When I was eleven my father became head of this religious community in Devon, and I was then sent to boarding school ... The combination of being both at a religious community, living there, and going to boarding school meant that I didn't really have any privacy. So painting became a way of controlling my inner world.' Jackie Wullschlager describes Celia as not being 'someone to push herself, and those are the kind of painters I like ... There aren't that many artists that I find exciting, but I'll see a show that I didn't expect to find riveting and I'll want to understand where that work comes from. I'll say, "Can I come to see your studio?" Very few artists say no – in fact they don't – because artists like you to understand and they like to talk about their work'. Commenting on her initial awareness of Celia's change of galleries and all that implied in terms of London's highly competitive art scene, Wullschlager continues, 'I knew her work, but it was the first time she showed at Victoria Miro. She used to show at Marlborough; its glory days were in the '50s, '60s. She was somehow, for me, catapulted into a new being of our time.' Wullschlager characterises Celia's work as 'intimate and introverted ... and yet it is about that connection with the Other, so it's generous as well. She's just a very fine painter'.

Celia Paul in her studio in Bloomsbury (opposite), where she has lived and worked for thirty-five years. Layers upon layers of paint cover the floorboards, chairs and walls, on which Paul writes and tests her pigments (right & below). She hates seeing paintings leave the studio, saying, 'They don't look like themselves all wrapped up.' An oil of a tree seen from Great Russell Street leans on an easel along with portraits of the artist's sisters, niece and mother. 'There's something of a reflective and meditative quality in the paintings,' Wullschlager states during a visit to Paul's studio (bottom right)

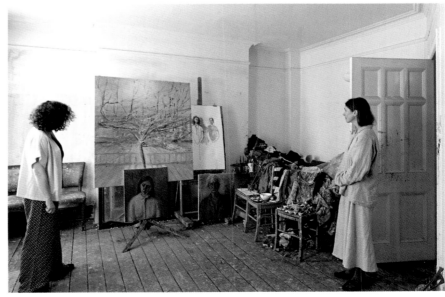

Rohan Silva
Tech entrepreneur
Brick Lane

You're, what, thirty years old? You've attended the University of Manchester, the London School of Economics, Cambridge University, Massachusetts Institute of Technology. You've been an adviser to a Prime Minister, set up Tech City, been a trustee of some of the biggest organisations of art and culture in the country, and were named a Young Global Leader at Davos. What do you do in your spare time?
I'm lucky that things I enjoy doing are things I'm passionate about, that things I find fun and creative are things that I've been able to do as my day job.

You use the word *creative*. What do you mean by that?
For me creativity is about making something happen that wouldn't otherwise have happened. I'm always excited about starting projects, about conjuring up an idea. Often creativity is about connecting the dots between things. A lot of the policy-making I used to do in government was in a sense a creative act, but typically was about importing an idea into a different field.

Is there a viral quality to creativity?
Certainly there is something contagious about creativity, something interesting about how ideas spread. In government I saw a big part of my job as trying to weaponise ideas. It's quite easy to have a new idea; the hard thing is to make it happen. That's partly about winning people's buy-in and creating a structure for delivering on the new proposal. In politics and policy it's slightly simpler because there are a limited number of newspapers, of think tanks, of people that really matter. The entrepreneurial world is much bigger. How do you get a new idea off the ground? How do you create a new type of institution?

In the case of weapons of war, weaponisation involves the releasing of force to existing, deliverable mechanisms. In the case of ideas, how do you go about that exactly?
In the case of ideas, the objective is impact; the objective is making change happen. An example is Tech City. The initial impulse came from an entrepreneur called Matt Webb, founder of a company called BERG. I'd fought to get three young creative companies on a trade mission we were doing with the Prime Minister to India. The only companies typically invited on these kind of trips would be BP and British Aerospace. I said, 'Why don't we take some small, growing companies too?' One of them was BERG. At the end of the trip, Matt Webb said to me, 'There's something interesting going on with tech in East London, but the scene is fragmented; there's a whole set of policy obstacles in the way of growth, and no-one takes the cluster seriously, no-one knows it's happening globally.' So I started exploring, started thinking about …

… how to weaponise it?
How to weaponise it. That was a multifaceted challenge of making sure the Prime Minister and the Chancellor understood the opportunity, but also ensuring the buy-in of Google and venture-capital firms globally and locally, as well as the community. You can have a kernel of an idea and it would be easy to stand up and make an announcement, but to turn that into a living, breathing thing, to actually support an ecosystem over several years … this is what we live for, right?

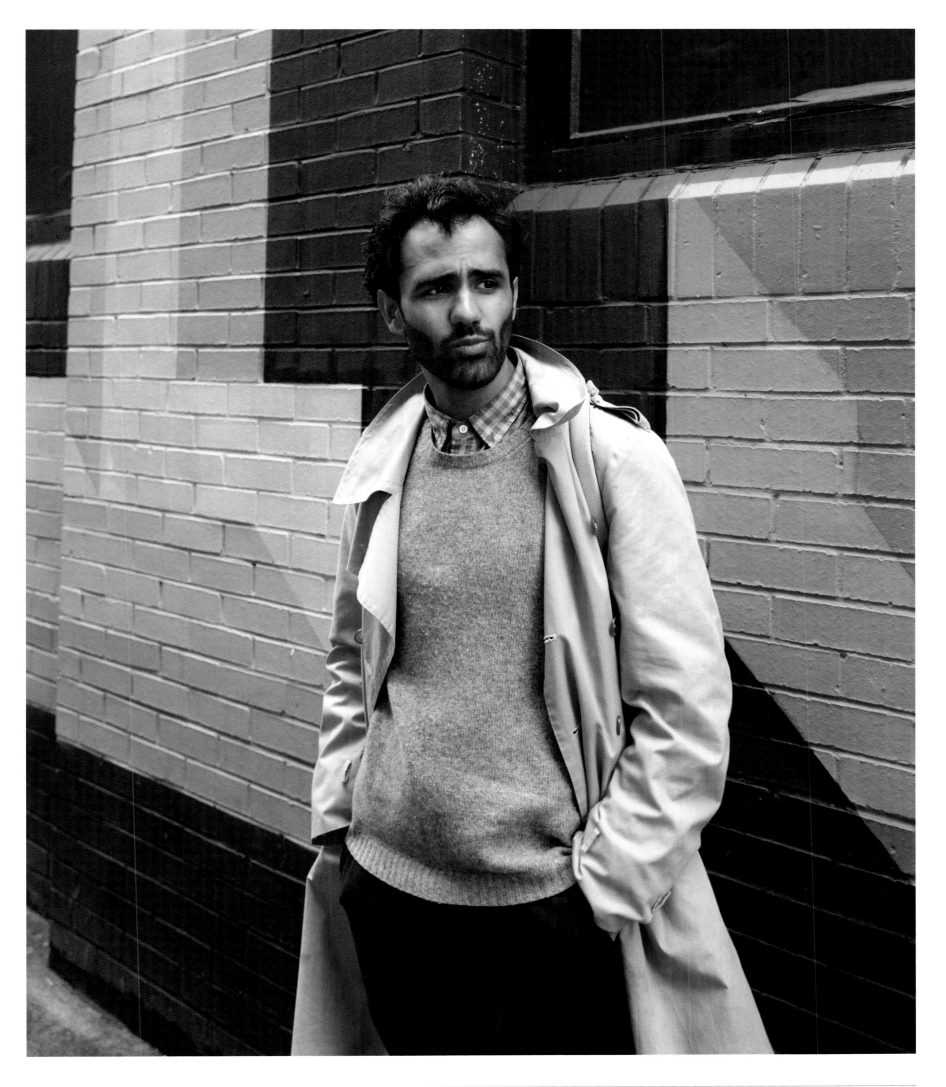

(previous page) Rohan Silva in Shoreditch – an area he admires for its vibrancy and creativity – in front of lettering by graffiti artist Ben Eine, who is known for his alphabets around East London. The passageway reads 'Extortionists' on one wall and 'Protagonists' on the opposite wall. Ebor Street, which hosts Shoreditch House, a members-only club opened in 2007 in a converted warehouse, is said to have been instrumental in the transformation of Shoreditch. Founded by Nick Jones as part of his Soho House Group, Shoreditch House is internationally known for its rooftop pool and selective membership of creatives

Silva with Courtney Boyd Myers on Hanbury Street near Brick Lane (above), an area famous for graffiti art and its many Bangladeshi curry houses. Brick Lane has hosted immigrants from around the world since the fifteenth century, including French Huguenots, Irish and Ashkenazi Jews. The mid-twentieth century saw a major influx from South Asia and Bangladesh, with the area becoming one of the early hothouses of Anglo-Indian cuisine. The Black Eagle Brewery, commonly known as the Old Truman Brewery, towers overhead. Once London's largest brewery, it now hosts a range of creative businesses, restaurants and shops

From start to finish, how long did that process take?
I started working in earnest in July 2010. The Prime Minister announced the tech-industry initiative in November 2010. At the time there were two hundred digital and tech companies in East London; there's well over five thousand today. It's far and away the fastest-growing tech cluster in the world. We worked hard to generate the virality that you're talking about, partly by banging the drum, by shining a spotlight on the area, by bringing the Prime Minister here, every single government minister. We did events around the world with Prince William, did events at Buckingham Palace. You can only do that if you've got logic on your side.

What was the kernel of the idea given the global competition?
Tech City was based on a set of understandings, or at least views, about how the world was changing (in particular the growing importance of clusters and proximity) and this fascinating paradox which is that technology might be obliterating distance, but proximity and clustering matter more than ever. People bought into that idea and saw it as a national strategic imperative that we get behind our best clusters. The people in power right now are real believers that you shouldn't try and drop something out of the sky; instead you should go with the grain of what is emerging. I always saw Tech City as a sort of Trojan Horse for policy. Policy-making is a funny business; it's often driven by politicians needing to make announcements, so it's quite backwards in that sense. I always thought that if Tech City got going, ministers would want to come and visit. And any time a minister visits a place, they generally want to be able to announce something. But how do you channel that for good? People can criticise politicians, but they are responding rationally to a set of incentives created by the media and the political cycle. The role of a good policy-maker is to understand the politicians' mindset and support it. So I was able to drive through entrepreneur visas, tax breaks for investment, entrepreneur relief, a whole set of government contracts to small businesses, a review of the intellectual-property framework for the digital age – all of that through the prism of Tech City. They're all national policies I hope will support entrepreneurs in Birmingham and Leeds as much as they do entrepreneurs in East London.

I'd like to touch further on the question of creativity and politicians. Politicians cannot be creative by nature; they would be out of a job.
Creativity requires permission to fail, and politicians don't have that permission unfortunately. If they ever say something wrong, the media are all over them. They lose their jobs. It creates a culture in which people are very risk-averse. I'm lucky to have had permission from George Osborne and David Cameron to be innovative. That is a creative act because it's them imagining and understanding the potential future benefit of doing this thing that might be unpopular.

How did you manage that?
By joining government. I thought that joining the Treasury would be great way to make a difference. It was the powerhouse of British policy-making at the time. But it was incredibly frustrating because Gordon Brown ran the Treasury in a terrible way; it was a closed cabal of his people at the top. History has proven that he wasted so much money and got so little done. I hope that every future Chancellor and Prime Minister pay heed to that lesson.

Talking of lessons, you've said you were a utopian leftist at the LSE, no less ...
That's where it all fell away. I was introduced to Isaiah Berlin and others, most critically Karl Popper. Popper's work is focused on how to drive change and reform. Popper was critical of what he described as utopian social engineering, i.e. this idea that you can just pull one big lever and try and change everything. Generally where people have tried that in the past, it's led to the most awful outcomes and unintended consequences, the reason being that life and people and societies and economies are vastly complex. The right way of operating is to distribute decision-making to localised power and to experiment, to be open and transparent.

Silva, looking every bit the nerdy entrepreneur, at Google's Campus London (above & left); he was instrumental in persuading Google to set up the campus as part of Tech City. 'There have only been two occasions in the last thirty years where the government, in a very concerted way, has gotten behind a single "cluster". The first was Michael Heseltine with the Docklands and Canary Wharf for the financial services in the mid-to-late '80s, and the second is Tech City,' Rohan explains

'In government I saw a big part of my job as trying to weaponise ideas. It's quite easy to have a new idea; the hard thing is to make it happen'

Silva at Second Home (above), the entrepreneurial/event space he co-founded with Sam Aldenton. A former carpet factory on Hanbury Street, the space was transformed by Spanish architects José Selgas and Lucía Cano, creators of the 2012 Spanish Pavilion for the Venice Biennale and the Serpentine Gallery's 2015 Pavilion

By 'transparency', what do you mean exactly?

In opposition, I created an open-data agenda. Baroness Noakes sent me an email back in 2006, 2007, saying, 'Have a look at this.' This young senator called Barack Obama that none of us had ever heard of, together with another senator, had proposed legislation that would make all items of US federal government spending transparent. So you could, in their words, 'Google your tax dollars'. I thought this was incredibly radical, because after all it's the public's money. One of the reasons I hated the Treasury was there was this cavalier attitude about other people's money. So I said to George Osborne, 'We should do this.' And George said, 'Yeah, looks great.' And so we did.

That set me off down this rabbit hole of 'What other data does the government have that, if it's published in the right way, could help citizens better understand what was going on in government, could help people create apps and tools?' And also unlock economic value, because a lot of this data's very valuable. So I created this whole agenda, and the UK's now seen to have the best open-data agenda in the world. Barack Obama became President Obama; he started a global organisation called the Open Government Partnership, which is a network of countries committed to open-data principles. President Obama chaired it in his first year because he started it, and the second year the chair was David Cameron, in recognition of the fact the UK is a world leader in this. We wouldn't have that agenda if I hadn't read Karl Popper at the LSE.

So creativity is basically friction between ideas and the application of ideas?

The creative act is often painful, and if you're pushing different worlds and ideas together, that's often painful too. When you present a new idea, it's often laughed at, mocked, and that creates friction. So this stuff is often very hard.

You recently observed that the role that civic space plays in driving growth is incredibly important. What did you mean?

The reason I say that is that creativity needs space, and it sometimes needs to be unhurried. There's a reason that coffee shops played such a big role in artistic and scientific and cultural change all the way back in the seventeenth and eighteenth centuries. It was this place to just talk and think and not be under pressure. When I was thinking about doing Tech City, one of the bits of feedback from the community was that there weren't enough places and spaces for people to come together. So I went over to Mountain View and sat down with Eric Schmidt, who was then CEO of Google, and tried to persuade them to create what at the time I was describing as an innovation hub in East London, i.e. a place to come together. Essentially a civic space. Google has more money than the government right now, so I thought they'd be better placed to help. And also, Google is good at delivering things in a way that government generally isn't. And there is a real skills deficit between the public and private sectors. The civil service hasn't paid enough attention to people development and management over the years. It's still very amateurish. You could definitely describe it as uncreative. Policy-making should be grounded in reality, and all too often it's not.

Does it get in the way of public space or creative enterprise?

Historically in the UK, if you've tried to start a creative business, accessing the capital to get going has been very hard. The money would often be described as coming from 'friends, family and fools' because it was so risky. For too long, the only people that got to start creative businesses were people whose friends and family had wealth. That's fine. No-one chooses where they're born, but we've got to make sure that everyone gets that opportunity. That's why, for example, I worked so hard and fought for so long for tax breaks. Hopefully that has spread happiness. (Unhappiness, too, because starting a business, as I'm learning, is bloody hard work!)

Would you describe yourself as a man of the people?

I care deeply about the city that we're blessed to live in. It's the brightest city in the world. The ancient Athenians had an oath that we should try and leave our city more beautiful than when we found it. That is partly about design and aesthetics, but it's also about social justice. That is a responsibility that we should take incredibly seriously. It's as relevant for Londoners today as it was for Athenians way back in the day. And that is about thinking about people.

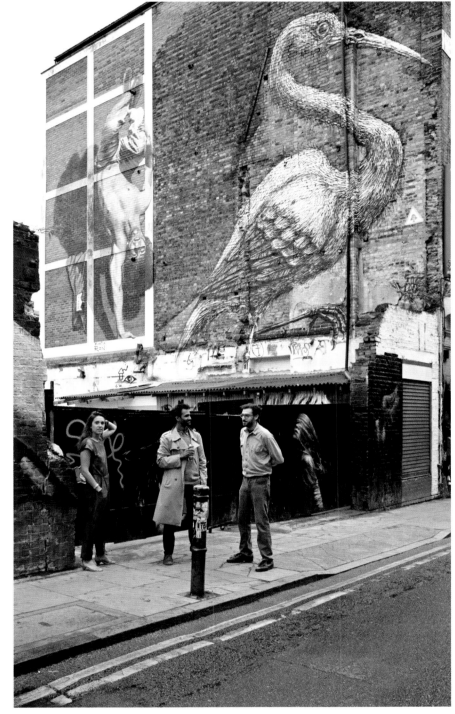

Silva walks along Chance Street (left), passing Belgian graffiti artist ROA's omnipresent neighbourhood hedgehog. ROA has covered a number of London walls with large animals, including a four-storey-high stork on Hanbury Road (above), where Silva catches up with Courtney Boyd Myers and Igor Toronyi-Lalic

Courtney Boyd Myers
Entrepreneur

Courtney Boyd Myers outside the Albion Café, which is located in the Boundary Building, a Victorian warehouse in East London. The American-born Boyd Myers spends most of her time at the Albion, working, networking or socialising. 'We've had a lot of support from the government, which is something I've found almost bizarre,' she observes, adding how astonishing she finds it 'to see David Cameron show up at startup events and invite startups to 10 Downing Street'

American entrepreneur Courtney Boyd Myers made a big impact within six months of arriving in London in 2012. Voted one of the most influential people in Tech City, she was asked to join Number 10's tech advisory panel. Described in *Forbes Magazine* as a '21st century Sherpa of intrepid international startups' and by Betabeat as the 'blogger everyone knows', Courtney began her career in journalism, focusing on the finance sector. Finding it an increasingly unhappy subject after the financial crisis of 2008, she asked her editor whether there was something more positive she could write about. He suggested that she do a piece about robots. 'So I did,' Courtney remembers, 'and I loved it.' She continued to write about the technology sector for *PC Magazine*, *Huffington Post*, PSFK and *IEEE Spectrum* before launching The Next Web, one of the world's leading tech and business blogs, and co-founded 3460 Miles, a biweekly newsletter aimed at connecting tech startups in London and New York.

'I've been moving between New York and London for the last three years,' Courtney muses, 'and there is just so much that the two cities have in common. I was always getting requests for contact details for investors in London or the best co-working space in New York or a great bar to host a launch party. So I decided to turn it into a business.' During her first month in town, 'everyone in the community reached out – from the adviser to the Prime Minister to a young woman who followed me on Twitter. In London, I've experienced men and women working to elevate women in tech with equal passion.' What inspires her, she says, are 'the faces that surround me both online and in real life; they are the leaders of the maker's movement, the Internet artisans, and the digital craftspeople who are pushing the boundaries of innovation on a daily basis'.

Courtney is keen to maintain a healthy work/life balance both for herself and for the people with whom she works. 'Managing a global team means long hours and checking email and Skype before bed and when you wake up in the morning,' she observes. 'But I also make time every day to go to the gym or yoga, cook healthy meals, and spend time with loved ones.' Like other creatives whose work takes them back and forth across the ocean, Courtney loves both cities in which she spends most of her time. 'When it comes to hot summer nights, serendipity and pure energy, New York is the greatest city in the world,' she enthuses. 'But in London, it's light until 10.00, and when I go to sleep, I hear the sound of raindrops and the wind between the trees. Why have one when you can have both?' She admits to finding London 'dreary, cold, and that kind of sucks, but the people are more creative'. Why is that? 'New York is a melting pot; London people maintain their individualities, where they're from and their cultures. So you get this great cross-cultural education living here.'

Igor Toronyi-Lalic
Writer & commentator

'I love booing,' says fiercely opinionated critic, curator and cultural commentator Igor Toronyi-Lalic. Born in London to parents who emigrated from Hungary and Yugoslavia around 1970, Igor believes that central government should stay out of policy-making in the arts. 'The best art is that which triumphs as art. Art that attempts to triumph on other grounds – social, economic, political – is likely to fail,' he asserts. Co-Director of the London Contemporary Music Festival, Igor writes on the arts for a variety of publications, including *The Times*, the *Sunday Telegraph*, the *Economist*, *Gramophone* and *Building Design*, as well as acting as Arts Editor for the *Spectator*. He is also the author of a biography of the quintessential English composer Benjamin Britten. Igor's report on public art entitled *What's That Thing?* controversially claims that a recent boom in the number of installations and sculptures in public spaces has left the public with nothing better than a 'mountain of mediocrity'. Too much public commissioning of this kind, he argues, 'disenfranchises people threefold. The people who – by and large – pay for it: money is taken from them without their consent; art is commissioned without their consent; and the pieces are then installed without their consent'.

When questioned specifically about music in London right now, Igor describes a sort of *Gesamtkunstwerk* moment-in-the-making, expressing his belief that 'there's something going on … that's different from anywhere else. It's partly the way things are being done as much as the type of music that's being made. People are trying to put together music that hasn't necessarily been put together before, and branching out, making links with the art world, with performance. Everything is coming together. If you look at art or opera or even elements of theatre, it's all the art forms moving together; I think London has pioneered that.' His enthusiasm for the city in general is, he says, not about particular places but 'about the people. I hang out with people who don't have any interest in following how things have been done … The key thing is following whoever has counter-intuitive ideas …' Igor plays intriguing word games with political stereotypes, observing, 'I think we're in a conservative moment. There are two types of conservatives: there are the conservatives who are still conservative, and then there are conservatives who are capitalist radicals. That's where I posit myself. I'm a capitalist Bolshevik of some sort. I love the destructive force of capitalism. Change is everything.' And, resolutely in counter-intuitive mode, he cites bankruptcy as the source of London's particular energy, evoking a thought-provoking link between financial failure and 'creative thinking'.

Igor Toronyi-Lalic at home in Islington. Passionate about music, writing and the other creative industries, his domestic environment encapsulates many of his interests. 'I like all of London,' Toronyi-Lalic muses. 'It's the idea of stuff going on in a classically capitalist way: stuff being built and stuff being destroyed'

Kate MacTiernan
Architect

Born in 1985, Rohan Silva's Australian wife Kate MacTiernan received her BA in Architecture from Melbourne University and studied at the Architectural Association in London. Kate met her husband while travelling in Europe; having known him for just five days she made the decision to move to London to be with him. Described as having 'boundless energy, sudden convictions and impeccable contacts', Kate founded Steinbeck Studios in 2011, a design company dealing with socially transformative projects to address the lack of quality housing available in London.

In 2012 Kate fell in love with St Clements, a Victorian workhouse, infirmary and mental institution, and determined to convert the site into flats and community homes. The building, donated by the Mayor of London to the East London Community Land Trust, is held by a foundation. As St Clements is in the process of being reimagined, it is being used as the venue for the Shuffle arts festival, founded by Kate as 'the expression of the vision of what this type of development could be' and curated by Danny Boyle. Shuffle is 'about place-making', Kate explains. 'Mile End … hasn't got its own identity, and yet it's got this incredible character … It feels quite brutal and non-place-ish when you first come here. The road is busy and there's not much sanctuary. We're trying to help Mile End have a stronger identity.' She finds the area's

densely populated, intensely busy atmosphere attractive; the contrast with St Clements – 'this secret garden and world that had been locked off for ten years' – was startling. 'No-one had been in there for ten years, and there was all this human misery pent up in there, and all these poetry books and everything that we found, and this patients' social club … You can't just let this history die out. It can't just be another set of flats. It has to be something about how we treat people and what being part of London is.' Kate connects the community land-trust housing model (which consists of housing linked to what people earn rather than to market prices) to 'a model from the civil rights movement in America', adding, 'It has never happened in the UK, or only in country towns where a farmer would give some of his land. It's never happened in a city.' When asked how she came to adopt this unusual approach, she replies, 'Sometimes it takes an outsider to see things that other people can't see.'

Kate believes that 'the next mass human thing to happen' will be mass urbanisation; thus her interest in novel housing models and ways of organising stronger urban communities. She is hopeful that others will follow in her footsteps. 'All those cranes and everything are chasing after a model they think works,' she muses. 'It's only when you prove another model that works better that they'll switch to that.'

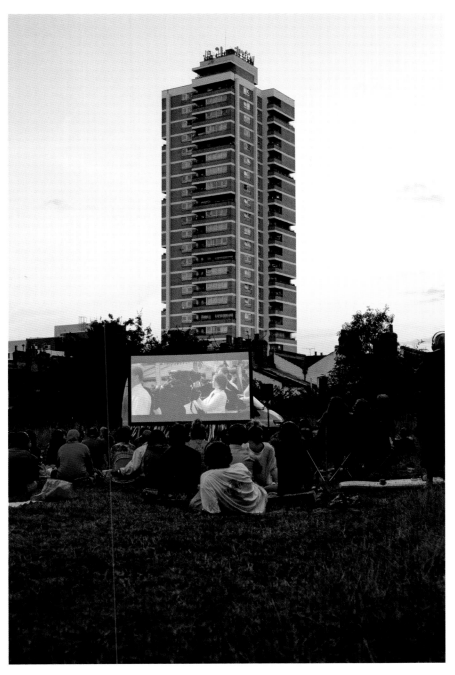

Kate MacTiernan (wife of Rohan Silva) outside an old lodge used as a base for the Shuffle Festival (opposite) in Tower Hamlets Cemetery Park. One of London's 'Magnificent Seven' cemeteries (below right), Tower Hamlets Cemetery (or Bow Cemetery as it is known by locals) opened in 1841 and was closed to burials in 1966. Transformed into a nature reserve, the park is an urban woodland beneath which are buried some 380,000 bodies of former patients of St Clement's asylum. Built as a workhouse in 1849, St Clement's was saved in 2013 and reopened as the site of the film festival, which is organised by MacTiernan and Danny Boyle (below). A Mile End resident for over thirty years, Boyle would peer down onto the workhouse from the tower block where he lived before he became a film-maker and impresario. The annual Shuffle Festival includes film programmes (left) as well as performance, art and architecture installations, comedy, music and storytelling. Ticket revenues fund the Community Land Trust, which provides sustainable housing and other long-term neighbourhood projects

Emilia Wickstead
Fashion designer
Chelsea/Marylebone

You were born in New Zealand, moved to London and have become a famous, very English designer. Your clients include the Duchess of Cambridge and Diane Kruger, and you started out with £5,000 borrowed from your husband.
My then boyfriend.

Your then boyfriend! Did that seal the deal?
Yes. Then it became a real relationship.

How did you feel when you arrived in London to study at Central Saint Martins College of Art and Design?
I'm an only child. My mother had her own business in New Zealand when I was growing up. So when I was starting out at Saint Martins, I had that experience of growing up within the fashion industry, or at least the New Zealand version. Starting up my own brand was my aspiration. It was a combination of being hard-working and never giving up and also being incredibly naïve. I was twenty-three when I started the business – it worked in my favour.

What was the inspiration behind such perspicacity?
When I was fourteen, my mother married an Italian and we moved to Milan. That was the first time I had gone to a big city. I am very much a New Zealander at heart – I like walking around with bare feet – but I would walk into shops in Milan and just couldn't believe it. Rather than finding it daunting, I found it inspiring. My mother was always my backbone of support, so I always had a person to fall back on who had worked in the industry. I learned a lot at Saint Martins, but I could always ask her a question. I was excited by London and nothing was going to stop me.

So you'd been eight or nine, sitting on her lap while she was doing stuff?
When she first started out, I was a baby. She would work downstairs late at night, so it's been in my blood since day 1. My earliest memory was when she had a shop and I would go there every single day after school. Everyone who came in would laugh because she would be doing a fitting and I would be sitting there waiting to go home. I guess that is how we do things in New Zealand; it was very down-to-earth. My father was a talented artist, and I guess this artsy background was in my blood. I remember wanting to study Fine Art. My mother said she would definitely not help fund a degree in Fine Art so I should think of something else. Then when I arrived in Italy I was fascinated by Milan's world of fashion, 'cause it was in its heyday then. She said, 'If you want to study fashion, you can do it, but you must study marketing as well.'

Why did you choose Saint Martins?
Because it was the best school for fashion in the world. My mother said, 'If you want to do this, you need to choose the best place.'

How old were you when you came to London?
I was nineteen. It was liberating. Being in Milan was a wonderful experience, but at school everybody was kind of the same and it was about fitting in. In London, it felt like you could be anybody and do anything. I felt that the world was my oyster and I was at home again.

How did you fit in yourself?
Essentially I was experimental. I would only wear second-hand clothes, did everything crazy. I moved to Milan with short hair and realised I needed to grow it long. Then I got to Saint Martins and my creative flow came out again. In Fashion, Design and Marketing you spent a year out in industry. I went to New York and spent a year at Proenza Schouler, Narciso Rodriguez and American *Vogue*. I went from doing experimental things to realising what clothes actually sell and what was my vision as a twenty-one-year-old.

So that was a reality check?
A huge reality check.

Do you cater to a market or do you market your ideas?
It's a mixture of both. When I started the business, my designs were very much what I loved and wanted to wear. When starting with made-to-measure, I was aware of what the customer wanted.

(previous page) Emilia Wickstead at the Chiltern Firehouse wearing one of her bespoke 'Miranda' outfits. The wildly popular boutique hotel and restaurant opened in Marylebone in 2014. Wickstead was commissioned to design the uniforms for female staff

Wickstead in the Chiltern Firehouse's courtyard, where waitresses whirl around guests (above). Lithuanian Naurija Ziukaite is kitted out in a light blue Wickstead dress, while Egyptian Melanie Nakhla wears a dark blue pantsuit, also by the New Zealand-born designer

Wickstead on Cadogan Lane in Belgravia (above right), where her atelier used to be located. One of the world's most expensive neighbourhoods, Belgravia has had a number of notable residents, including Mozart, Chopin, Neville Chamberlain, Ian Fleming and Vivien Leigh. Wickstead occupied the elegant atelier (opposite) for five years before moving to Sloane Street

Hard work, or did it come easy?
The way that I grew up is that I've always worked. Even when I lived in Italy, I had to work every summer. Even when I started the business we started in a way that made money. That was part of our business model. The most wonderful thing today is that now, during London Fashion Week, I am able to experiment and be more fashion-forward as well as realistic. I've built a business that makes money because I sell my clothes as much as I design them. But the genes of my company, and my designs, are quintessentially wearable. They are feminine. You look at how I dress and you see an English rose, but there's always a little twist.

What was your first big sale?
I sold a 'Pamela' skirt, which I still make today, and a 'Marlon' top. I think the total sale was £1,500. I was so excited. My husband went out and bought a bottle of champagne and I screamed at him for spending the money.

New Zealand is considered to be one of the most creative societies in the universe. How would you explain that?
We're at the end of the world, far, far away. I don't know if it's naïve to say this, but we're almost untainted. Things are changing with social media, but we're very much untouched. Growing up there, you start a business and you have dreams and you work extremely hard. That's part of our culture. We're not handed things on a silver platter. No matter if your family has a little bit of money or it doesn't, everyone is the same. Every kid works in the corner store.

The question I'm trying to get at is: What are the components, civil, social, economic or political, that fashion a creative person?
It's the freedom to do what you want to do. I watched my mum do everything, every day, in front of her clients in a culture that is not materialistic and superficial.

You have been described as being determined, confident and very nice. Behind the mask, is there still nice underneath?
I think I'm bossy. I smile all the time and I wonder if it's a cover. There have been a lot of times in moving to Milan or London where people wouldn't give you the time of day. Things were hard so I just put on a smile and kept going. I also believe in being nice to absolutely everybody, unless someone is obviously rude.

You've been described as the first London designer to crack the arcane rules of British high-society formal dress. Is that an accurate description?
Every designer has a dream-world in their mind. I have dreamed up this world where I go to fancy parties, live this life where everybody is always dressed up, and I revert a lot to Old World couture. My inspiration when I started my business, and something I have always looked up to, is where women would go into a Christian Dior studio and look at fabrics and choose their colours. What was exciting to me as a business concept was to play on that but modernise it. It doesn't exist. There's a niche in the market.

So you're going back to the '50s, the debutantes, and to nineteenth-century St Petersburg, *Anna Karenina*, salons.
Exactly. I loved it when fashion designers' shows were for their customers, who were the royal family. Today we live in a completely different world where it's all press, all buyers, and unless you're a top VIP spender the dynamics have changed. I wanted to create something different, to add value and bring back what I feel doesn't exist.

You've said that you aspire to be your own muse. How does that work?
I do live a little bit in my mind. I remember a teacher at school used to say, 'Every day you feel like you're in a movie.' I do. I am my own muse.

Coming back to being in London, you live in Chelsea, right?
In World's End, on a main road.

Do you find inspiration there?
I am not necessarily inspired by the area that I live in. My office is in Wandsworth, and my offices, studio and shop are in Knightsbridge, so I'm in the middle.

Is London where you would stay even if your presence were demanded in Milan or Paris?
I would always stay in London. It's a very grounded place, and I love it.

'Starting up my own brand was my aspiration.
It was a combination of being hard-working and
never giving up and also being incredibly naïve'

Matthew Slotover
Founder, Frieze
Arnold Circus/Regent's Park/Camberwell

What is the significance of Arnold Circus for you as a Londoner?
What you see here is the first social housing in Britain, I think. It was the ghetto, the worst slums.

Art yuppifies neighbourhoods, doesn't it?
Artists find interesting neighbourhoods before anyone else, parts of the city that are not expensive but that have nice bones, parts that are not central.

Speaking of skeletons, what infrastructure is conducive to a creative environment?
A reasonably personal scale. Big roads, tall buildings are not inspirational for artists. Nice architecture helps. What's important to artists is the volume of space and good light. It's expensive to get that in a non-run-down area, so they end up in areas that are more edgy. They create amazing spaces out of what they have, and they are not snobby about who lives next door. What I love about here is this building itself. Three fantastic artists have studios downstairs, and there's a fashion designer, an architect, curators, a shoe designer. There's a great kitchen, and with it a great caterer.

Is this Frieze's original space?
No, we've moved many times. We started the magazine in 1991. Through the '90s and 2000s we moved further east; it's the story of London, really. As the rents went up, we moved to Clerkenwell, then to Islington, then to Shoreditch. Now we're slightly east of Shoreditch. This is my favourite office since Soho. It's the first time that I've felt you can go out in the street and bump into people you know are interesting. There's interesting little cafés, interesting little shops. If you want a bit of inspiration, you can just take a walk. Immediately seeing what people are wearing on the street or who's in the cafés or new things being built feels, for lack of a better word, creative.

What's the backbone of any creative enterprise?
Clearly you need to have an idea, a way of doing things that isn't necessarily what's happened before. What it's all about, really, is having the courage to do things slightly differently.

So when you transferred from a magazine to an art fair, what was so original about yours that has made such an intrinsic contribution to London's cultural outline?
The basic model is the same as art fairs have been for fifty years or even longer maybe. Galleries are combining in one space to meet each other's clients, attract people and create a sort of event. We did a few things that were different. Our ambition was to do less of a trade fair and more of a festival, the kind of thing where you walked in and felt uplifted rather than a bit down. The choice to do our fairs in tents in parks was key because people love parks; they feel ownership of them. You know there's not another event there a week before and another one a week after; it immediately gives you a different experience. What that did was allow us to work with architects to design a fair different ways each year, to bring in restaurants that we liked rather than using the house restaurant of the venue. The main thing we did was we commissioned projects through different artists (we have a not-for-profit company) …

Frieze Projects?
Exactly.

We're sorry:

We're sorry for the working conditions to which you have become accustomed, We're sorry to have made you believe that with study and commitment you would have found your own place in society, We're sorry for the disparity of wages, We 're sorry for having too often put relatives and friends in positions of power, We're sorry for having left you with an aging political class, We're sorry for not following up on many social issues, We're sorry for not having thought of culture as a common good, We're sorry for not having listened to you properly, We're sorry for having considered art an elite field, We're sorry to have had you believe that success was the opposite of failure, We're sorry for not never having made the museum a place of cultural exchange, We're sorry for the lack of clarity, We're sorry for the unequal distribution of goods, We're sorry for having lied, We're sorry for having used the media in our favor, We're sorry to have turned the News into a (sad) show, We're sorry for having often ignored you, We're sorry for not ever accepting the dissent you repeatedly manifested, We're sorry for Carlo Giuliani, We're sorry for having treated public matter as a private thing, We're sorry for speculating, We're sorry for having created unjustifiable taxes, We're sorry for having made it impossible to reach the end of the month, We're sorry for keeping you locked in your job, We're sorry for the reckless stock market gambling, We're sorry for allowing that nothing is ever changed, We're sorry for having spoilt Beauty, We're sorry for having you believe that failure is due to your personal deficiencies, We're sorry to have you believe that a lottery could change your life, We're sorry for having pushed consumers to consume recklessly, We're sorry to have made you believe that the latest SUV model is a necessary tool, We're sorry for having subjected you to our decisions, We're sorry for the plight of prisoners, We're sorry for the continuous airing of stupid reality shows, We're sorry for destroying thousands of trees just to print unnecessary glossy tabloids, We're sorry for the continued mythification of consumption, We're sorry for the billions spent in arms, We're sorry for having supported and armed the tribal wars in Africa in order to benefit from them, We're sorry for the new colonialism, We're sorry for not respecting the Kyoto Treaty, We're sorry for the wars, We're sorry for making you believe that occupying nations is necessary, We're sorry for the tons of useless concrete thrown at any time, anywhere in the world, despite the existing empty housing, We're sorry for having deceived you, We're sorry for the way we do politics, We're sorry for the way we do finance, We're sorry for continuing to lie to you, We're sorry for entering your private life, We're sorry for making you believe what we wanted you to believe, We're sorry for unjustified detention, We're sorry for privatizing, We're sorry for having deprived you of the freedom to decide for yourself, We're sorry for having censored, We're sorry for having produced unwatchable movies, We're sorry for not having provided an adequate and equal education for all, We're sorry for having forgotten the concept of democracy, We're sorry for the hundreds of different editions of "Big Brother", We're sorry for what we have not done yet, We're sorry for continuing to hamper the free circulation of culture, We're sorry for the restrictions of the Internet, We're sorry for "Jersey Shore", We're sorry for having put you against cultures different from your own, We're sorry for the xenophobic and populist politics, We're sorry for not having done everything possible, We're sorry for the homophobia, We're sorry for having forgotten our origins, We're sorry for having destroyed and rebuilt, then destroyed again, We're sorry for sitting on our Chairs for too long, We're sorry for having forgotten our role, We're sorry for the things that we have omitted, We're sorry for having put you all against each other, We're sorry for making you pay for our mistakes, We're sorry for making you hate politics, We're sorry for our legal system, We're sorry for keeping you thinking you can buy a common good, We're sorry for having wrongly persecuted the Anarchists, We're sorry for Tibet, We're sorry for Mohamed "Tarek" Bouazizi, We're sorry for not have changed what we promised to change, We're sorry for having kept you in the dark, We're sorry for the costs of education, We're sorry for the bureaucracy, We're sorry for the show trials, We're sorry for making you believe that we're truly sorry.

(previous spread) Matthew Slotover in his Frieze London office, an old schoolhouse that acts as the company's base. Formerly the Rochelle School, the building dates from the 1880s; Frieze occupies the old playground on the top floor. Slotover stands next to a proof-spoof of Frieze's reputation for selectivity, Danilo Correale's 2013 *National Anatema (We're Sorry)*. The work serves as an apology for the world's ills; its final line reads, 'We're sorry for making you believe we are truly sorry'

Slotover with Margot Heller (right), Director of the South London Gallery, in the gallery's Fox Garden (originally a workingmen's college), celebrating her being made OBE in 2014. The gallery's 2010 renovation and extension resulted in a doubling of visitor numbers

This choice of tents in parks in the heart of John Nash country, where the art sells, was that a case of necessity being the mother of invention?
Pretty much. There's not many spaces in London that can hold something that big.

Was it difficult convincing the Council?
To start with they said, 'No, we don't do commercial events in the parks; the parks are for getting away from that kind of thing.' Then about a month later they called back and said, 'We've been thinking … We did have a flower fair here last year and we also have outdoor sculptures that often sell, so maybe it's okay to sell art. Let's talk about it.' It was just at the point where they were beginning to want to raise money through events because their grants had been cut by the government.

How did you raise the money you needed?
We didn't have to raise much money because the costs and the revenue come in around the same time. We took a small loan with a bank.

And here you are, having not only changed, almost single-handedly, the face of the London art scene but replicated it in New York. Were you just lucky with your timing?
1991 was the ideal time to start an art magazine in Britain. Our first cover was the first-ever published interview with a young artist called Damien Hirst; it was just when he and that group were beginning. But that was totally accidental. With the fair, London became much more international in terms of the people living here. Galleries like Gagosian were moving here, Tate Modern opened in 2000, so that was exactly the right time to do it. We didn't know that 2003 to 2008 would have this huge boom in art, especially in London, but the signs were there. You get a gut feeling, don't you? You can feel when something is happening. You can have good timing, but you make your own luck as well.

Did you break even straightaway with the fair?
We lost money the first year, we broke even the second year, and then we started to make money. Deutsche Bank came in the second year saying that this might fit with what they were doing, so that was amazing. Also we expanded the fair from 120 to 160 galleries from year one to year two.

Did you already have good relations with most of the players in the art world through the magazine?
With the galleries and the curators we did. We didn't know any collectors, not a single one, when we were doing the magazine. We didn't know anything about the market, but we figured if we could get the best galleries and they brought the best art, then they would make that happen. That's still our philosophy. We have a committee who selects the galleries; we have about three times the number of applications of the number that we can fit …

Couldn't you just expand the space?
No, 'cause there are trees around the tents.

What would happen if Frieze said, 'We're packing up. No more London Frieze'?
Someone would go to the park and say, 'Frieze isn't happening. Please can I do it?' It's not such a complicated idea; it's the city, really, that drives it.

Going back to your own antecedents, you're a Londoner. Have you ever thought of emigrating?
I feel very unadventurous compared to friends I've got who have come here from other places or left here to go to other places. In the '90s we thought New York would be a lot of fun, but then we had kids and it never happened. London has changed a lot in the last twenty years, so it's been exciting to be here.

How would you encapsulate your appreciation of London?
It's a very civilised place, that's what I always feel when I come back here. It's a great mixture. Where we live in Camden it's very quiet; you can hear birds singing. In ten minutes you can be in town and you can have fantastic high-end food, great street food. There's wealthy and there's poor, but it's not too extreme, the differences between them, and it's still an amazing place for all of the art forms. We speak English; everyone in the world has English. In terms of time zone and transport it's very easy. You can get to Europe easily, you can get to America easily, get to the Middle East, Far East easily. It's pretty much in the centre. It's a very good place for doing business internationally. It's probably the most international city in the world now.

Slotover surveys freshly cut watermelon (top) at Leila's café and grocery in Arnold Circus. Celebrities Ralph Fiennes and Julie Christie are regular customers

Slotover en route to a meeting at Rochelle Canteen (above), a favourite eatery among locals, housed in a converted bike shed in the grounds of the former Rochelle School. 'The food is amazing,' Slotover enthuses. Founded by Melanie Arnold and Margot Henderson (wife of chef Fergus Henderson), the lunch-only venue has become a watering hole for creative types in search of quirky English fare

'We didn't know that 2003 to 2008 would have this huge boom in art, especially in London, but the signs were there. You get a gut feeling, don't you?'

Matthew Slotover

Slotover in the empty shell
of the 2014 edition of Frieze
London (opposite). Visitors
included artist Grayson Perry
(top left) and an assortment
of other colourful characters
drawn to the fair's bustle.
'Art attracts interesting
people,' Slotover says,
tongue-in-cheek

Victoria Siddall
Director, Frieze Fairs

Having launched Frieze Masters in 2012, Victoria Siddall was recently appointed Director of all the Frieze art fairs, taking over from Matthew Slotover and Amanda Sharp. Born in 1978 in Northern Ireland, Victoria lives in Bethnal Green. Her father was an army man, so the family lived in many different countries. Confident and gregarious around art-world folk, Victoria has a personal collection of works by unrepresented artists, the first one she purchased being a drawing by Hurvin Anderson. She remembers being moved by contemporary art at an exhibition of works by Wolfgang Tillmans at Tate Britain in 2003. 'It blew me away … I hadn't seen work presented like that before, or art about mundane subjects presented in a way that was indescribably moving and fascinating. That made me want to get more involved with contemporary art and learn more and understand more about artists, what motivated them and inspired them.'

Victoria curates booth locations at the Frieze fairs as one might a dinner party, with the aim of sparking conversations. She also collaborates regularly with architects and designers, liaises with curators on talks programmes and is responsible for financial oversight. 'The fairs all feel distinct, although in the best possible way,' she observes. 'A good art fair allows you to discover great art from all over the world, all under one roof. One benefit is that the galleries have been selected from a long list of applicants by a well-informed committee, so you should be seeing the best.'

Shoreditch, where the Frieze offices are located, is constantly changing, Victoria finds. 'The street that's deserted one week, a month later will be full of cafés and design agencies and hotels … It's very vibrant and very young.' Before joining Frieze, she worked at Christie's. Back then, she says, 'contemporary art seemed like an incredibly exciting area to be a part of.' After attending the first Frieze fair, she applied for a job, only to find herself working there a few months later. Understanding that the fairs must combine 'quality and seriousness and academic thought and curatorial innovation alongside an element of fun', she also recognises that fairs are not 'a party; the galleries are there to sell art'. Her main challenge is to create a 'balance between those two'. Of her personal contribution to London's creative scene, she notes, 'If anything, it's bringing a new perspective and new audiences to look at historical art, and to consider things that they might not otherwise have been interested in. If we can achieve that and broaden people's horizons – and also, from the commercial point of view, introduce new collectors to galleries, or Old Masters, or sculpture, or Impressionist art – we will have done something interesting.'

Victoria Siddall on Ebor Street in Shoreditch (above), and in front of graffiti by Ben Eine (opposite). Siddall often schedules meetings at Shoreditch House (top & bottom right), the members-only club opened in 2007 in a converted East London warehouse. 'London is uniquely open to things,' reflects Siddall. 'It says so much about the city that there is so much public interest in seeing art and discovering artists'

(following spread) A 32-foot-tall wooden sculpture, *SMALL LIE* (2013), by Brooklyn-based artist Brian Donnelly (aka KAWS), towers above a pushchair in Regents Park. Galerie Perrotin chose the New York-based artist's colossal work for the 2014 Frieze Sculpture Park

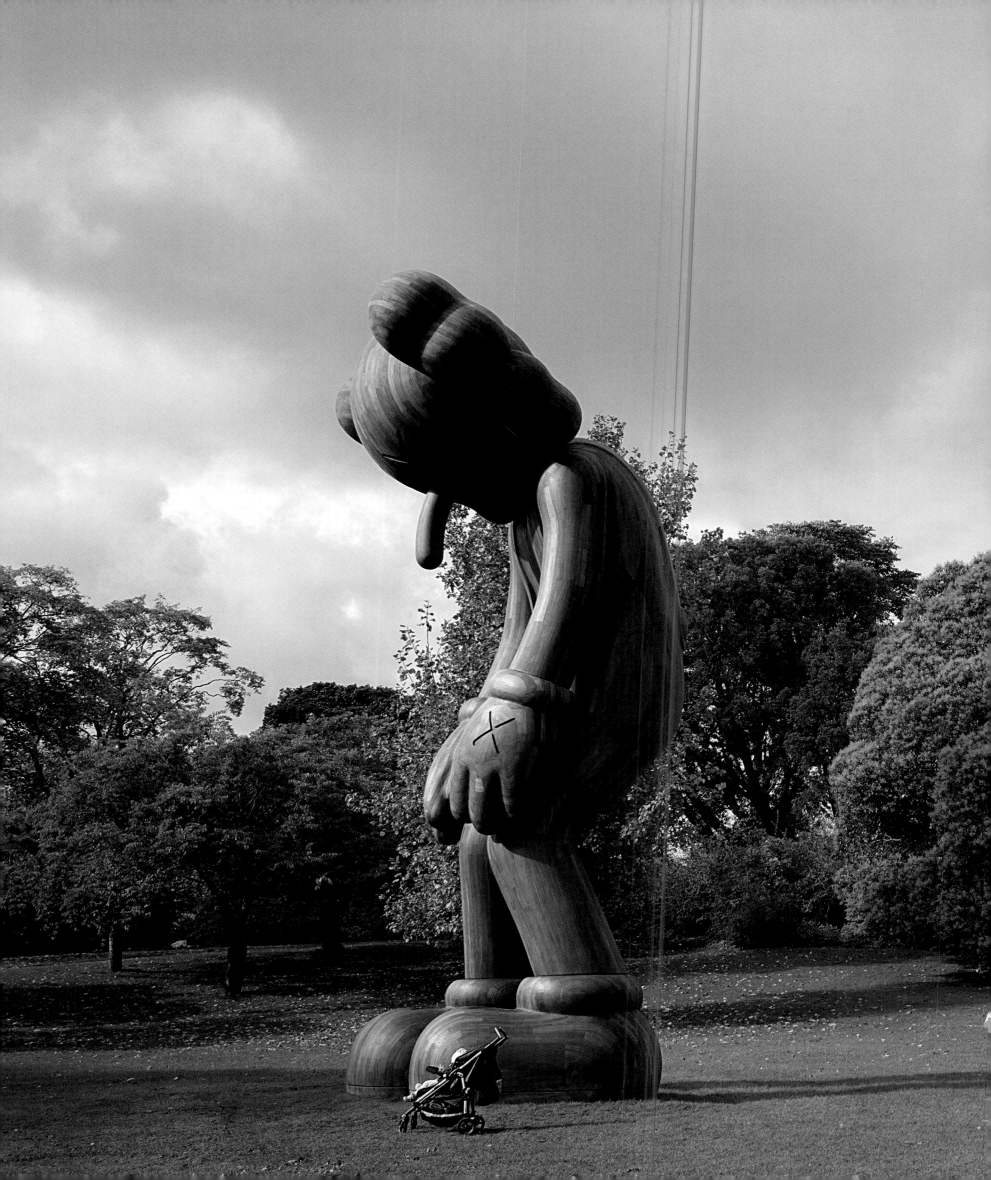

Nick Foulkes
Writer/Cultural commentator
Mayfair/Shepherd's Bush

Are we living in good times or grim times in London?
I'm probably by nature quite dysphoric. Nevertheless I would say that it's the best time to be bourgeois and living in Northern Europe. Things like healthcare are better now than in my parents' day. If I look at black-and-white footage of 1964, the year in which I was born, it seems like I'm looking at a grainy early Lumière brothers film. So yes, things have moved on a lot.

But have they improved? Because people have great nostalgia for those days.
Look at *Downton Abbey*. It's a tourist attraction. We have old buildings and stuff that the rest of the world believes are worth coming to have a look at. In terms of natural resources, Europe isn't overburdened with them, but it has always been able to add value. Have things improved? A lot of the charm has gone, but I would argue that people are nicer than they might have been in the past. There's a greater understanding of people's emotions today perhaps.

Is democracy, or socialism, responsible for the demise of civility, of gentlemanliness?
I don't necessarily know that it is over; I just think that it has changed. You could look at political correctness as a form of good manners.

When I came here as a young boy, the English gentleman was thought of as an exemplar of good taste. Was that stereotype a leftover from the Regency period?
The Regency was fairly barbaric, this great free-for-all. There was great social mobility. A man who was a boxer became one of the richest men in England by effectively founding bookmaking; his grandson wound up in the House of Lords. That culture of the English gentleman is very much a nineteenth-century invention.

Looking back, then, who were the gentlemen in that period?
Gentlemen obviously were the ones who could read and write ...

And where's the English gent hiding in London today?
It depends what you mean by 'gent'. If you look at the Chaucerian 'parfit gentil knight', that's a very different thing to these guys who could sneer in a particular way and knew not to wear brown shoes in town or whatever construct divided them from people who didn't know those things. They had money and they had power. Being a *gentleman* is different to 'being a gentleman', if you know what I mean. There are certain expressions that you can or can't use, and people who are actually quite nice and kind. Kindness is a hugely underrated virtue. I suppose the perfect gentleman is someone who recognises a *faux pas* but is simply too polite to mention it.

(previous spread) At home in Shepherd's Bush: Nick Foulkes on his favourite sofa, among his eclectic collection of art and books, including a Russian painting of Lenin proclaiming Soviet power. 'I've always liked things that no-one else was into at the time,' he observes. Originally pastureland, Shepherd's Bush became part of Greater London during the late nineteenth and early twentieth centuries. It was famously home to the Shepherd's Bush Empire, a variety hall where Charlie Chaplin performed

Foulkes at Hamilton's Gallery with owner Tim Jeffries (above), discussing art and design between a photograph by Guido Mocafico and a collaborative work by Jean-Michel Basquiat and Andy Warhol

How many generations do you need to create an English gentleman?
I think it was when Alec Douglas-Home was Prime Minister, Wilson would apparently heckle him, reminding him that he had inherited a title. I think Alec was the 16th Earl of Home. In the end he turned round and said something along the lines of 'Well, I am sure you are the 16th Mr Wilson' or something to that effect.

I do remember, though, the sense that a 'true gentleman' represented something beyond mere money. That's not particularly true in London today, is it?
No. London has got this wonderful capacity to reinvent itself. The era that you speak of was post-imperial, when they still had supreme confidence that their way was the best way. Now London has become a sort of ... I've heard it described as like Venice in the fifteenth century.

Almost like a trading port of yore?
Yes. You've got people coming here from all over the world to do business, but also it's a Monte Carlo with stucco. They are whole parts of London where, when I was younger, you would see people actually living year-round. Now they are, in effect, rather grand holiday houses.

But that's a tiny fraction of the population. We have a huge city here which is the HQ of global entrepreneurs, people of great intelligence and expertise who run mighty commercial and financial empires.
'Who *ran* ...' I often think what historical era you can draw parallels with today, and I really don't know. I would love to have seen it in Victorian times, when there was that confidence and a belief that man's progress was inevitable and that the future had arrived. It was the China of the world in terms of manufacturing almost everything; it was the Silicon Valley of the world in that it had people inventing stuff. And it was an amazing imperial power like America is today except bigger, better and more effective.

So what went wrong?
God knows! You have to ask clever people about that.

You're nothing if not clever yourself, with a history of eclectic interests: writing for magazines, for newspapers, books, a man-about-town, dare I say a dandy?
I like clothes; probably I spend far too much time thinking about clothes.

We know that the Parisian or Italian gentry were better dressed than the English were in times past. How did the English manage to project this air of taste and class?
It was that they happened to be running the world at the time.

That's no longer true, though.
A perfectly reasonable thing to say. I suppose we're quite good at winging it. And, in the way that America became the dominant cultural entity in the second half of the last century because they had the economic and military power, we were able in the nineteenth century to impose cricket, hunting and a sense of fair play.

Nick Foulkes

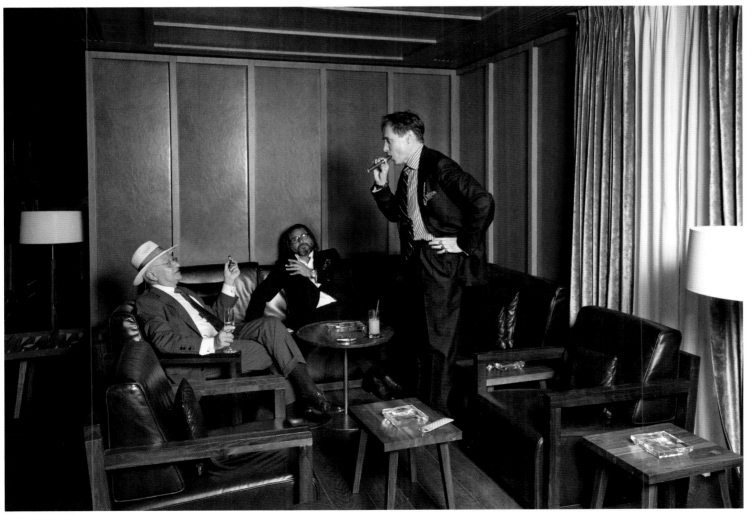

Foulkes at the London Library, a favoured haunt in St James's Square, with biographer, novelist and newspaper columnist A. N. Wilson (above). Founded in 1841 by Thomas Carlyle, the library is only open to members; rebuilt after the Second World War, when it was partially destroyed by a German bomb, it houses more than a million volumes. Eminent past patrons included Rudyard Kipling, George Bernard Shaw, Henry James, Virginia Woolf, Winston Churchill and its long-time president T. S. Eliot

Foulkes enjoys a smoke with cigar merchant Edward Sahakian and Hani Farsi, owner of the Bulgari Hotel, Knightsbridge (left), in the leather-panelled Sampling Lounge of the hotel's cigar shop. Iranian-born Sahakian is known to leave £50 notes in his suits before donating them to charity. Saudi-born Farsi's entrepreneurial spirit extends from hotels to IT, film and real-estate development, including the Soho House Group

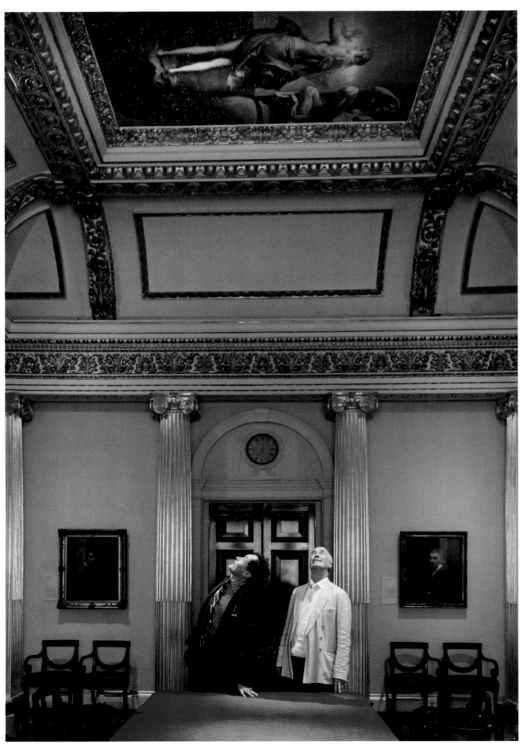

What is the future of London, given that, in economic terms, it's an independent entity that can almost afford to shear off its connections with the rest of the country?
I was only half joking when I said it was like Monte Carlo in that it is ludicrously expensive. If you're a reasonably sophisticated person living in London, you've got more in common with somebody, say, in New York or Paris than with somebody living in Wales, where I was born. The strength of London is to reinvent itself as something attractive. I love Boris Johnson. He's done quite a good job at promoting the city.

Is there a personality that fits today's London particularly well, and is that person in any way creative?
Yeah. London is a very, very creative city. And it is so diverse, ethnically and culturally. You can't have one overarching personality who is the embodiment of a city as culturally indigestible as London.

What about Ken Livingstone?
Ken Livingstone was the embodiment of a period in the militant '80s. The '80s are perceived as an era of economic liberalisation and materialistic culture and so forth. But actually the ideologies of the 1970s continued a long time into the 1980s. In those days, you'll remember, there were Enoch Powell and Tony Benn, who were the kind of Punch and Judy of British politics. Both of them were educated people.

Powell represented almost an imperial view of culture whereas today we're experiencing the fallout from the socialisation of culture. And London has succeeded better than most other great cities inasmuch as it's become a temple to attract foreign money.
Yes. If you look at descriptions of people visiting London in the early nineteenth century, they're amazed by the size, the industry, the round-the-clock activity, the sheer sense of energy. It may be a miserable day outside, but we are still in the greatest city in the world.

Going back to the idea of reinvention, how do you see yourself in twenty years' time?
I have no idea. I hope that I'm allowed to continue doing what interests me.

Which is writing?
It's writing and the finding out of things. I used to think it was a terrible burden to have to make a living. Actually it's been quite interesting because I'm probably naturally quite lazy, but I paradoxically like to keep busy. I get worried if I'm not working; somehow I think I'm wasting my life if I'm not doing something. But if I didn't have the need to feed, clothe, educate a family and all that, I probably wouldn't have done a lot of the things that I've wound up doing.

It has been said that your inspirations include such quintessentially English characters as David Niven, Cary Grant and George Sanders (a favourite of mine).
George Sanders I love because of the voice. James Mason I love because of the voice. They're people I like to watch in old films. I watch old films for the clothes.

Why have those clothes disappeared?
Because special effects-led movies probably don't call for beautiful tailoring. It's all become very commercial. People pay to have product placement. But there was a charm ... That was a different time.

You've been quoted as saying, 'My love of London comes, I suppose, out of two things: history and clothes.' Anything else?
You've got marvellous things in this city, and the beauty of it is that you can be with one of the most famous musicians in the world in the morning, with an artist in the afternoon, and then you're popping into the London Library and you go have a cigar. I often get caught up in the anxieties of the day and forget this, but it is a spectacular place to live.

Foulkes with Charles Saumarez Smith (opposite), Secretary and Chief Executive of the Royal Academy of Arts, admiring the ceiling painting by the eighteenth-century artist Sebastiano Ricci in the RA's General Assembly Room. Ricci's peripatetic life reflected the demand for his talents as well as his illicit love affairs. Originally a bedroom, the General Assembly Room now serves as the private chamber for the Academy's governing body

Foulkes outside the London Library in St James's Square (above), also home to the offices of British Petroleum, the East India Club, the Naval and Military Club and the Royal Institute for International Affairs (Chatham House). Foulkes has a word with the UK Chairman of Christie's, David Linley (right), in front of the auction house's HQ on King Street. Viscount Linley, the Queen's nephew and fifteenth in line to the British throne, has pursued a career in furniture-making, and took over the helm of the venerable auctioneers in 2006. Founded in 1766 by James Christie and located in its present building since 1823, Christie's is the world's oldest and largest fine-art auction house

'You can't have one overarching personality who is the embodiment of a city as culturally indigestible as London'

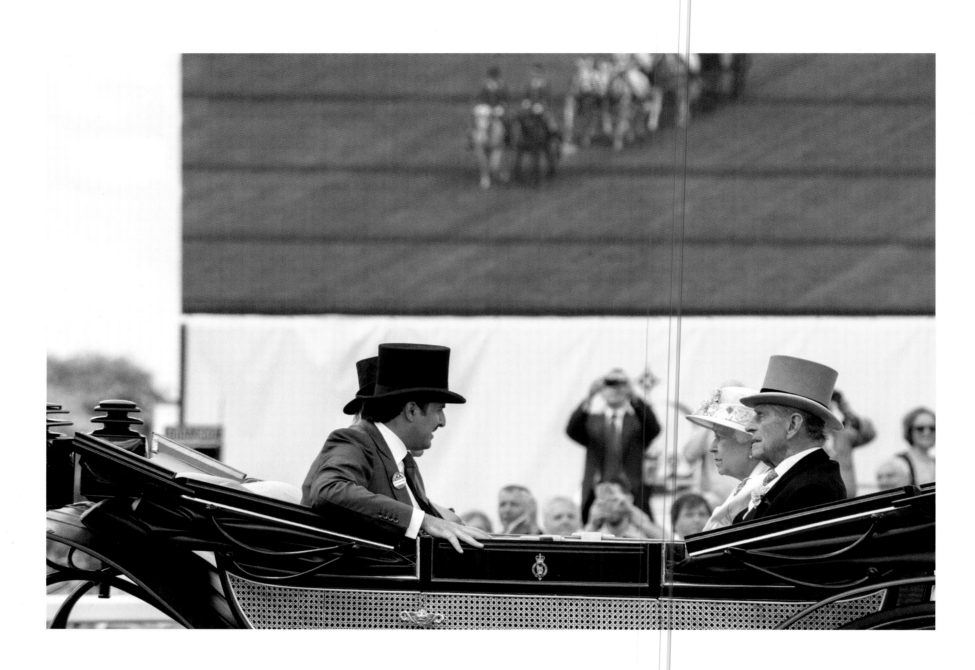

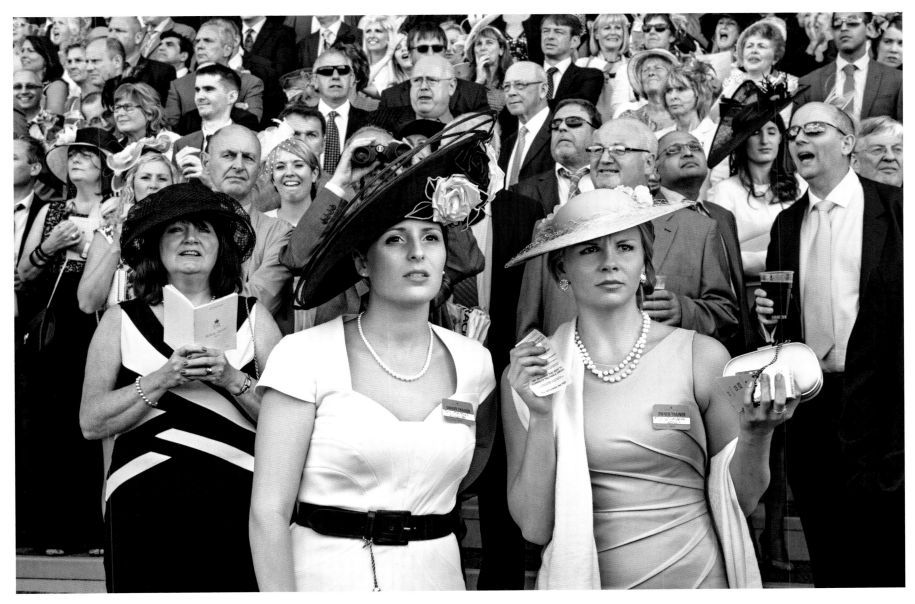

A moment of both capture and rapture at Ascot Racecourse, as fans anxiously grip their betting slips (above) at the climax of a race. The Queen and the Duke of Edinburgh arrive at Royal Ascot (opposite) accompanied by Sheikh Tamim bin Hamad Al Thani, the ruler of Qatar, and Lord Vestey, the royal household's Master of the Horse, to watch the Gold Cup and Diamond Jubilee Stakes. Founded by Queen Anne in 1711, Ascot is a fixture of the British social calendar, with over five hundred thousand race-goers attending each year

(following spread) Buckingham Palace framed by the trees of St James's Park on a somnambulant summer's afternoon. Purchased by George III in 1761 as a gift for Queen Charlotte, the palace has served as the London residence of Britain's sovereigns since 1837. St James's Park was known for its farms, woods and leprosy hospital before Henry VIII turned it into a deer park with its own hunting lodge. Today's public park is the result of 1827 designs by architect and landscape artist John Nash, while the local pelican population is the legacy of a 1644 gift to Charles II by the Russian ambassador of the time

Antony Gormley
Artist/Royal Academician
King's Cross

Your parents named you Antony Mark David Gormley. AMDG:
Ad majorem Dei gloriam, **'for the greater glory of God'. How did you live up to that?**
It was not a bad thing to be given if you were the seventh child of seven, because I came into this world at a time when family rituals were already established, and the room for me to contribute to this small nuclear tribe was limited. I could break the rules and challenge both the collective will of the household and the individual power of the father, which was quite a big deal.

Was your father a God figure?
In my mother's eyes, my father and God were indistinguishable.

Is it your view that the concept of patriarchy in the art world represents order and management, and is an important factor in stymying creativity?
Yeah. That's very beautifully my problem, if you like, with all authority. I'm unusual insofar as I had a traditional British education and went on to Trinity College, where a high proportion of the alumni are landed gentry, in other words kind of an old power. I have a problem with the sense of entitlement that comes with that, the degree of laziness that comes with established patterns of thinking and doing and human organisation that don't fit with the way the world works now, particularly with all of the tools that we have for cross-cultural and cross-class communication. I question it as a viable foundation for social justice or the distribution of resources. Having been through it, you could say that I was playing a double game. I've accepted a knighthood; why did I accept it? For two reasons. One was because there are few ways in which there is public recognition for something as marginal as sculpture; to get that recognition and to not accept it would be churlish. The second reason is that I can use it as a position to speak out about things, use the system to change it.

Do you believe that creative people like you have been a spur in bringing about change in British society as a whole?
The huge revolution that has happened in terms of our culture within the last quarter of a century is still not recognised by the majority of the population. What is that change? It is that, as a result of separating itself from Europe as a result of the Reformation, culture became bound by the word, not the image, and lost its embodied celebration of the physical. In the last twenty-five years that has changed; now we could arguably be leading the world in terms of visual creativity. So there is a lot to be celebrated and talked about, and positions to be argued and questioned.

You experienced a cultural revolution of sorts yourself as a young man, didn't you?
I have absolutely no regrets about being brought up by nuns and then monks. If one's life is determined by significant others, and the first significant others are one's parents and siblings, to then find that there were other people in the world who cared about one not because of achievements but as a total person – that is what I found at school. People who I still consider friends were remarkable guides for intelligence and the beginning of feeling and being. It was only coming out of that monastic environment and recognising the degree to which it was founded on a myth that I didn't really trust it anymore.

(previous spread) Antony Gormley checks his emails at the top of a galvanised-steel staircase outside his purpose-built studio. Architect David Chipperfield's seven-bay design took its inspiration from the industrial vernacular of the warehouses and rail yards nearby in King's Cross

An assistant at work in Gormley's 1,000-square-metre studio (top) among heavy machinery reflecting the industrial nature of the sculptor's work. Each of his assistants is involved in intricate discussions before a work or series is finished. Gormley descends the stairs to the studio's forecourt terrace (above). The floor was made of 140 tons of steel and reinforced concrete to support pieces which can rise to 10 metres in height

Gormley often begins new works with moulds of his own body (left), a process he describes as capturing a 'moment of lived time'. His 2007 project *EVENT HORIZON* featured life-sized casts of himself sited across London's rooftops, bridges and streets

To my mind, in fact, your figurative, imposing, simple style has monastic overtones …

I would say that is simplistic. What are the tools that you need in order to examine your life and give it worth? The monastic ideal – certainly in terms of the Carthusians or similar orders that related physical work to meditation or prayer and some creative activity (usually in the scriptorium, where you would illustrate manuscripts or write) – that balance is a good basis. So when you say to me that my art looks a bit monastic, I like the model of art that should not be about spectacle or distraction or decoration for its own sake. Art should be, hopefully, an instrument by which you become more alive.

Did your own journey in art have to do with being based in London, or could it have happened anywhere?

It was almost in spite of London. It wasn't until I left Hampstead and escaped to the North Yorkshire countryside and experienced weather and moors, heather and forests and deep winters, that I began to live properly. One lives one's life in the hope that they will become a whole person. London was my birthplace and it remains my home because it is this critical mix of comfort and disturbance, but it was by leaving London that I realised what London is worth. When you think about London, it's difficult to think about one thing. It is what its history tells you it is: a group of villages in the Thames Valley that slowly became an aggregate of cells. That's why it is impossible to talk about it in any definitive form, and that's where its richness comes from. London is an extraordinary place. It's a disease of a city, but once it gets you, you can't really leave it. It has more surprises than most places.

Since the last time we talked, three and a half years ago, there has been a total transformation around King's Cross. It's unrecognisable.

It's happening at the end of my street. Every week there is another floor going up.

How much is that operation gutting the city's creative soul?

I was saying to Roger Madelin and Peter Millican, the prime developers around here, 'Please keep studios and art spaces in the mix!' Peter really responded to that. Kings Place is a good example of enlightened development in which they built this wonderful auditorium and a gallery space so that art is integrated within the building. All new developments should be forced to put 1 per cent into the creation of artistic spaces.

But how much of that sort of tokenism is merely paying lip service to the arts?

It has got to be done for the right reasons, and you can see it when it is done properly.

I'm trying to explore how a creative city unfolds, or how some areas become creative and others do not. As a born-and-bred Londoner, what do you think the prerequisites are for a creative city?

The reason I'm here is that when I came back from India in 1974, I couldn't afford anywhere to buy or to rent. So I squatted a studio that has since been knocked down, literally half a mile away, between Caledonian Road and York Way. I was living on a boat that somebody gave me in Paddington Basin and cycling over here every morning. One morning this little kid said, 'Ay mate, don't you wan' a house?' I thought, That is exactly what I need, because the boat I was living on wasn't tall enough and I was constantly doubled over. We went to see the house and it was empty so we broke in and moved in about two days later. Eventually we swapped that one for a larger house down the road. Anyway, that was just to say that the first thing most artists need is space, space for free, space that nobody else wants. What that would mean in global terms is that the entire artistic community would move to Detroit! What you need is a balance between space that nobody wants and people that are interested in the products of what people might do in this otherwise unusable space. That's the alchemy that grew up in London. In the '70s we had a number of organisations like Space and Acme that were actively

searching out Council properties that weren't due for redevelopment because they said there wasn't enough capital and they would turn them into artists' studios. Those sorts of organisations are critical because they act as a bridge. Once you have a mass of creativity, an informed and interested public can start sharing the energy of that place.

Why is London perhaps the most creative city in the world now? Space alone doesn't explain it …

It's difficult to say. What would be the critical things? The rise of artist-led organisations, and then you need characters like Nick Serota, Charles Saatchi, ambitious individuals who absolutely identify with the energy of visual culture. The Turner Prize has to be in there somewhere. Would there be five million people visiting Tate Modern now or would Tate Modern itself exist had it not been for the Turner Prize and what the Turner Prize did as far as opening the general public up to the idea that visual art could be as fun as sport in terms of a betting opportunity? There were huge shifts in what people were prepared to be interested in. You could say that, whether the *Angel of the North* was a symptom or a cause, the

Pulleys suspend sculptures from skylights in the pitched roof of Gormley's studio (above). Since 2006 he has been experimenting with his bubble-matrix series, works based neither on architecture nor on human anatomy

fact is that a highly resistant northern population only interested in ball sports, particularly rugby and football, suddenly become interested in art. The fact that you could turn the Baltic Flour Mills into a contemporary-art venue is an example of a radical cultural shift. The transformation of an old power station into an art gallery was another key moment. The dialogue between the dome of St Paul's, the City, the Bank of England and the old Bankside Power Station: that says it all. In power terms, it shows the vision for setting up contemporary visual culture directly in relation to the established order of money and state religion. I don't know what happens when the whole of the core of the city becomes, in a way, cleaned up. King's Cross is one of the last central London areas to remain resistant to gentrification. But when it's all cleaned up, where is there room for the mess that artists make and feed off of? That's a good question.

From what you are saying, one could suggest that these cultural changes are somewhat engineered. But what is the initial spark, the key link in the chain, behind creative rejuvenation?
There is one factor that I haven't mentioned, and that is the degree to which the present state of artistic confidence in Britain is the result of the foundation laid by the art schools, all of those late nineteenth-century realisations and questioning about the nature of urban life. You've got to be careful with what's happened; the art schools have become administered, not inspired. There are a few that have resisted – Goldsmiths is still a great college. I've got postgraduate students who come from Central St Martins because I thought it was immoral for me to be so close and to not have them. It's great. They come here and get what they missed over there because they missed out on that tradition of learning through doing. You don't get a studio anymore, as you did twenty years ago. In the old days you were given a bunch of materials and a place to mess about with them.

You've been quoted as saying that 'most culture is a reaction to amnesia. Not just human memory, but the way old galaxies disappear.' What did you mean?
We are the society of the spectacle, and we are in a period of cultural narcissism of an extreme form because of the speed of the instruments of distraction. I'm not interested in tradition for its own sake. However, I do think it is important that everything that is made is conscious of the dialogue that it has with everything that has already been made. The danger of the society of the spectacle is that that dialogue never takes place because everything is so immediate, that history becomes the length of time between takes. The reason that I am passionate about sculpture and that I deeply believe in its value is that it stands outside of the nature of time.

Are you saying that sculpture is almost like an interrupter of time, an interloper between history's visual takes?
It does two things. One is that it insists on you stopping for a while, not as it were being entertained but having to do some work and walk around it and poke it a bit and make you see what you feel or think or do. The other is that it reinforces a bit that there is a thing in the world that isn't an image. It doesn't move or do very much; it's just there. With any luck, its 'there-ness' is enough of an impediment to a constant searching for new distractions. It can reposition you in your own space and time and allow you to re-lock onto what it is to be alive, aware, conscious, feeling. The tragedy in all of this is that in bringing everything to the surface and making everything so visually fascinating, we lose the sense that the human is the most evolved life form on the planet; the human mind-body complex is about the most complex and subtle instrument there is for life. I feel that we've become somehow obsessed with our own toys.

Materially or metaphorically?
Take the great standing stones on Orkney. Just the fact that they are there in rain and storm and light and dark, bearing witness to a time no longer remembered, but they were there then, forty-five hundred years ago, and they still mark a time and a place and command our attention. Through the very existence of those things, we sense something of the provisional nature of our own time, but we are also invited to join them in this elemental world. That is why I'm committed to sculpture. It doesn't need shelter, it doesn't need a wall or a roof, it doesn't need electric light, it definitely doesn't need a label. It *waits*.

What is it waiting for? An answer?
No. It's a question in itself that leads to other questions. I don't think there is any closure in this.

Where do you yourself fit into this elemental body that you have created and installed around the world, in various casts of your own shape? Do we have your physical representations registering symbolic emotions all over the globe?
It was for other people's emotions; I am still an empty vessel myself. Through trying to make these objective correlatives of a subjective state, I ask myself, 'What is a human being?' I take myself as a control case. You could see this whole project as some vast narcissistic exercise not dissimilar to Alexander the Great having sculptures made of himself, but I would be keen to argue the opposite. I used my body because it was the thing most available to me.

The artist (opposite) in front of pieces inspired by EXPANSION WORKS, a series exploring the expansion of the universe through 3.5-ton cast-iron forms. A giant crouching figure fashioned by the artist overlooks Brown Hart Gardens in Mayfair (above); Gormley designed it as an architectural extension of the Beaumont Hotel. Influenced by Eastern philosophies, Gormley was attempting to 'sculpt darkness', with the intention of encouraging hotel guests to engage in a meditative pause. Jacob Epstein's *Pieta* (1956), one of Gormley's favourite London landmarks, graces the courtyard of Trade Union Congress House on Great Russell Street (right). 'Epstein created this incredible Pieta of a mother with the broken body of her child,' explains Gormley. 'In the context of the Trade Union headquarters, this is about acknowledging the unspoken toil of everyone who made London – all of the unsung, unspoken heroes that constructed this extraordinary city'

'London is an extraordinary place. It's a disease of a city, but once it gets you, you can't really leave it'

Gormley beneath the Hardy
Tree amid tombstones
outside St Pancras Old
Church. The writer Thomas
Hardy was tasked with
relocating the graves while
serving as an apprentice
architect in King's Cross
in the mid-nineteenth
century. With fragments of
Roman material and parts
of the church dating from
the late twelfth century,
the churchyard contained
thousands of human remains,
including those of victims
of the Black Death. Mary
Wollstonecraft, author
of *The Vindication of the
Rights of Women*, and Sir
John Soane are among the
notables buried beneath the
ash tree. 'It has become the
most powerful and beautiful
memorial,' Gormley notes.
'These were tombstones
brought together eternally by
the hand of man, and are now
held together by living roots'

Antony Gormley

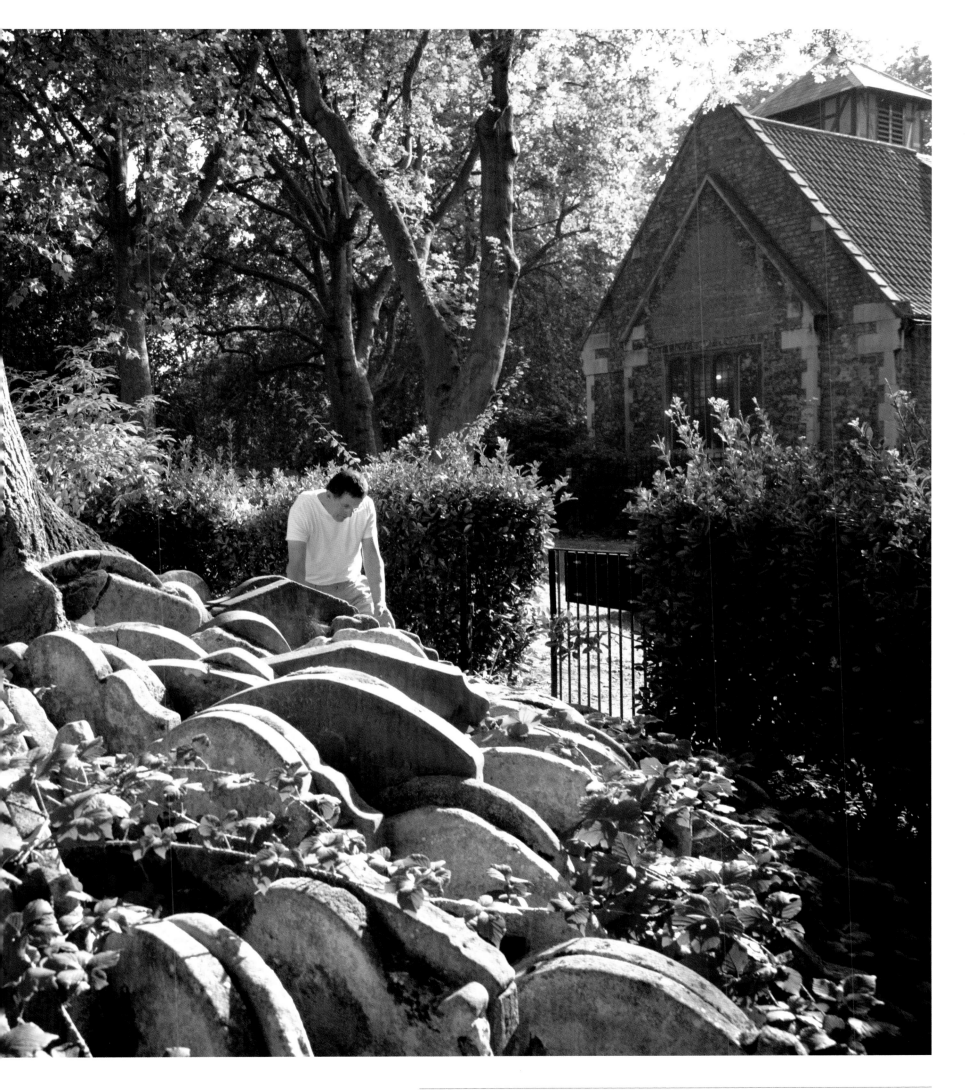

Vicken Parsons
Artist
Leicester Square/Bloomsbury/Soho

Artist Vicken Parsons met her husband Antony Gormley in the 1970s when they were both studying at the Slade School of Fine Art in London. She loved the way he 'got on with stuff', the fact that he was 'very energetic and focused. There was no barrier to him doing what he wanted … He would work day and night. It was challenging and inspiring and fun'. Born in 1957 in Hertfordshire, Vicken has three children with Gormley, whom she married in 1980. In the early days the couple lived in a squat in King's Cross. Now, their spacious, side-by-side studios occupy a custom-built complex designed by David Chipperfield in the same neighbourhood, which has changed almost beyond recognition in the intervening decades thanks to a massive urban redevelopment scheme. Did she mind putting her career on hold while her husband's prospered? 'Yes, but I also knew that we had to feed the kids and pay the mortgage.' She helped him in the early days, sealing him into the casts that left him blind, able to breathe only through his mouth. Was she ever frightened by the process? Apparently not. 'But he was sometimes.'

Vicken's father was an actor-turned-farmer; her mother, whom she describes as 'a really, really good potter', worked in a boatyard during World War II. Vicken and her four siblings were all sent to art school. When asked if she received encouragement from her parents to pursue her studies, she replies, 'Oh, lots and lots and lots! There was no expectation to make money. It was all quite idealistic, although my dad must have worked incredibly hard. You never knew it because he made it seem fun.' Coming from a family 'that didn't really have anything', Vicken's time at the Slade was gruelling nevertheless. The squat she lived in lacked gas or electricity, and her daily diet revolved around homemade bread and cabbage.

Some commentators have cited Vicken's self-sufficiency as a reason for her comparative detachment from London's contemporary-art scene. Known for her paintings of interiors and landscapes rendered at a small scale, her tutors included the abstract artist John Hoyland. Bucking the trend for video, performance and installation, Vicken chose to focus on the most traditional of media, and has been rewarded with solo exhibitions on the Continent as well as in the UK. She paints on thick wooden board or glass in a characteristic palette of muted colours, and finds inspiration in personal experiences derived from memory and sensation rather than direct observation. 'I like the contradiction of making a large space in a small thing; within the small thing, the space opens up again,' she observes. 'But it's not a real space, obviously; it's a suggested space – and sometimes it is a cancellation of that.' In the 1980s, when some painters began to work on an enormous scale, Vicken briefly followed suit. Around the time she had her second child, however, she turned to working small. 'And there was no turning back,' she remembers. Speaking of the vast scale of some of her husband's work, she observes wryly, 'I hugely admire what he does … I do the opposite. I could fit a whole exhibition into a carrier bag!'

Vicken is most interested in 'going down into a place which is hidden. Trying to get down to the unconscious, I suppose'. What she calls 'all the life stuff, getting married, having a family' has, on occasion, pulled her away from painting. 'I always felt guilty when I wasn't working, and guilty when I was,' she muses, encapsulating many parents' frustration when it comes to creating a satisfactory life/professional balance. 'I always kept my own work going, although I didn't show so much for quite a long time because it was difficult to make sound commitments and know that I would be able to make enough work.'

The image bears the handwritten inscription:

D.D.D

Jean Cocteau
*
1960

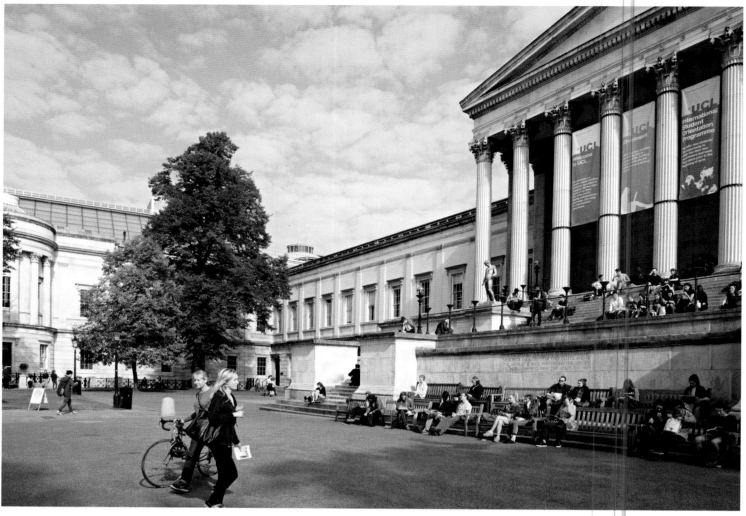

(previous spread) Vicken Parsons transfixed by Jean Cocteau's 1959 mural in Notre Dame de France in Leicester Square. The church was founded in 1861 for the city's French community. *Crucifixion*, one of three panels Cocteau painted in the chapel dedicated to the Virgin Mary, takes centre-stage; the artist's self-portrait is visible to the left of the altar. 'There's something beautiful about the fact that it's tucked away; you wouldn't even know that the church is there,' muses Parsons. 'It's stunningly quiet, peaceful and yet joyous at the same time'

Parsons with her bicycle (above), outside the Slade School of Fine Art, where she was a student in the early 1980s. Parsons credits the Slade with allowing her to discover her full potential as an artist; it was also where she met her husband Antony Gormley. The school, founded in 1871 by Felix Slade, played a key role in the introduction of women to the University of London, offering female students education on equal terms with men

Vicken's first memory of London is 'probably trips to the dentist, and then after the dentist we would go out for a treat to the old patisserie in Marylebone'. She says this of the city: 'What I like, I suppose, is having been here for such a long time … At first we would go to openings, and it felt like everybody was slightly competitive. Now it's more like family because we've known these people, a lot of them, for such a long time. That's just a very, very lovely, proper community.' Of her experience as a student she adds, 'We were incredibly lucky and the art schools were fantastic and so many practising artists were teaching … The Slade was just brilliant for going to exhibitions and being in the middle of London.' Squatting continues to be an option for students living on next to nothing in the metropolis, of course, especially given stratospheric housing costs. 'They're probably a lot better organised than we were, and more clever at it,' Vicken points out. 'There are organisations who provide studios, but it's increasingly getting difficult to find a space to work …' About her own method, Vicken cites struggle as being key to productiveness, adding, 'You don't discover new things, do you, unless you're going beyond what's comfortable … It's also about finding your way of working, finding your other artist-friends and people to grow with, and then … people who might represent you buy your work …' The reward, she says, might be described as 'an emergence of a feeling of calm … There is that tension of trying to make something happen. Then you have to fight with it. Every time you make something it's sort of an unknown thing, an anxiety that it's never going to be a brilliant thing or even what you'd like it to be. But then, if you stay with it, there is, not always but sometimes, a clarity, a transformation that happens, that makes you feel good and whole and okay'. She is pleased to be achieving recognition, saying, 'I just want to make good work, and I do want it to be seen, and that's happening increasingly, which I always thought it would … I always believed in it.'

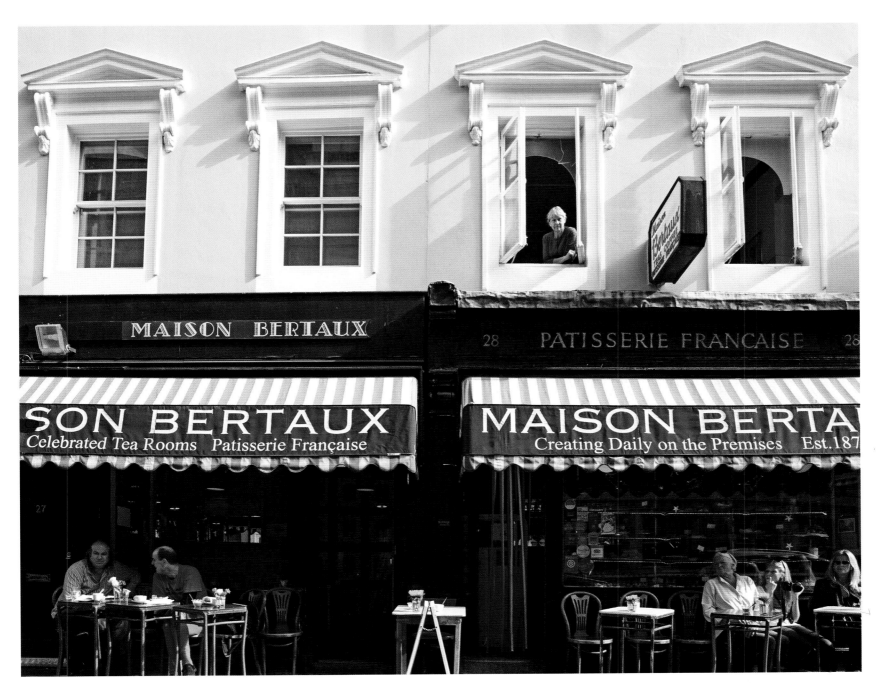

Black-cab drivers enjoy a break from work outside the Russell Square Cabbie Shelter (left). Parsons' great-great-grandfather Lieutenant-Colonel Sir Edmund Henderson was involved with setting up the shelters while serving as Commissioner of the Metropolitan Police. Between 1875 and 1914, sixty-one shelters were erected at a cost of about £200 each. Only thirteen remain today, preserved and maintained by the Cabmen's Shelter Fund

Parsons enjoys the sunshine at an upstairs window at Maison Bertaux, her favourite London indulgence (above). The city's oldest French patisserie, Maison Bertaux was founded in 1871 on Greek Street in Soho. Current owner Michelle Wade, who runs the shop with her sister Tania, started working there at the age of seventeen

Antony Gormley

QUANTUM CLOUD, designed by Antony Gormley in 1999 (left), creates geometry with a passenger jet overhead and the cable car on the Greenwich Peninsula, next to the Millennium Dome. Gormley's 30-metre-high sculpture questions whether the body is emerging from a chaotic energy field, or the field from the body

The Thames Barrier (above), one of the world's largest moveable flood barriers, spans 520 metres across the Thames at Woolwich Reach. Run by the Environment Agency, the Barrier protects central London from the flooding that has threatened the city throughout its history. The Barrier's five-storey-high gates have been raised 174 times since its inauguration in 1984

Summer Wine

The London trees are dusty-brown
Beneath the summer sky;
My love, she dwells in London town,
Nor leaves it in July
from Amy Levin, 'London in July'

The onset of summer in London heralds a time of hazy sunlight and lazy afternoons spent in the city's parks, communal gardens and pubs. There is no more English sight than a group of people of all ages gathered together among centuries-old walls sipping pints of London's best. With picturesque names like The Nag's Head, The Dog and Duck, Lamb & Flag, Ye Olde Cheshire Cheese, The Jerusalem Tavern and The French House, London's pubs have played a crucial role in the capital's social, political and literary life for many, many years.

The Jerusalem Tavern in Clerkenwell (featured by Peter Ackroyd in this book) is a case in point. A haunt of David Garrick and, later, of Charles Dickens, the Jerusalem at one time belonged to the satirist William Hogarth's father Richard, whose unwise investment in the Latin-only St John's Coffee House in the 1720s bankrupted the family and sent the old man to debtor's prison.

William Hogarth's paintings and etchings are themselves a grim reminder of Londoners' historical infatuation with the demon drink. The capital's drinking history can be traced back to Stone Age beer jugs used for imbibing fermented juice; nothing new there, then. It was the Romans who introduced the delights of the vine and more sober drinking habits earlier picked up from the Greeks. Sobriety to one side, drink (yesterday's Gin Lane, today's teenage binge drinker) remains one of the city's seemingly intractable problems: it is claimed that more children recognise the names of beers than they do brands of ice cream.

Wandering back through time, one can also drop in on The Dog and Duck, a well-known Soho watering hole claiming landscapist John Constable and novelist/journalist George Orwell as regulars. Lamb & Flag in Covent Garden had the seventeenth-century poet John Dryden as a regular, with Dickens dropping in from time to time when not patronising the Jerusalem. The French House, another Soho institution featured in these pages, lays claim to the ghost of the hard-drinking bohemian journalist Jeffrey Bernard and is where General Charles de Gaulle penned his famous resistance pitch to his countrymen after the collapse of France in World War II. Less worthy but equally colourful plans were hatched in the early 1960s by the Great Train Robbers in Belgravia's Star Tavern, a haunt of such well-shod visitors as Peter O'Toole and Diana Dors. Another Belgravia destination, the Grenadier, is said to have hosted the Duke of Wellington, while the four-centuries-old Seven Stars behind the Royal Courts of Justice is a rare survivor of both the Great Fire and the Blitz. Lenin was a regular at the Crown Tavern in Clerkenwell; rumours have him secretly rendezvousing there with Stalin.

There are reportedly seven thousand pubs in London, not to mention the increasing number of wine bars, a symptom of the nation's yuppified drinking culture, represented here by the Anglesea Arms in Fulham. Henry Hudson's *The Rake's Progress*, featured as the book's final profile, is a brilliantly updated parody devised by the artist and his friends, young creative types on the up and on the make. Hudson's work is reflective of London's present boom psychosis, the implication being that money can buy you love, art and more. The morality of this modern-day cautionary tale hinges around the innocent's ascent in society and subsequent descent into depravity. Our book concludes appropriately with the innocent's naked body lying next to William Hogarth's grave.

Norman Rosenthal
Independent curator/Art historian
Soho/Holborn/Regent's Park

You were described in 2008 as 'having helped turn London into the art miracle of the world'. Is that an exaggeration, or would you concur?

Well, I worked at the Royal Academy and I maybe helped turn it around a little bit. I don't think one can talk about oneself in that way. As curators, I suppose three people have been very decisive and maybe I'm one of those three, I don't know. Obviously, Nick Serota has done incredible things. And I'm very happy that the Serpentine has become a rather amazing place thanks to Julia Peyton-Jones, her energy and her aura as much as anything else. Julia has reinvented that very tricky location. It was a kind of boring place for years and years; it was sort of worthy, you know what I mean? There are institutions that are worthy and institutions that are exciting. The Tate is exciting; sometimes it's a bit worthy. Because of its sheer size, it comes off like some sort of huge Ministry of Culture. Particularly the exhibition side is exciting because Nick keeps a strong eye on it. Nick is, in the end, a bit of an impresario, almost in spite of himself. And I am a bit of an impresario too. But I'm only a curator, I'm not an artist. I'm just somebody who tries, as Shakespeare says, to 'see a church by moonlight'. See what's in front of you, in other words.

You haven't mentioned Charles Saatchi …

Of course Saatchi did a huge amount as well. Saatchi was also an impresario in his own way. He's a complex individual, Saatchi, and I love him. At his greatest, he was fantastic.

Talk to me about 1997, the *Sensation* show …

Sensation was an important show, but I like to think I was the driving force behind the show called *A New Spirit of Painting* back in 1981, the first big contemporary show I did. It brought all the German painters, but also people like Julian Schnabel and lots of other artists, world attention. I remember the opening when the whole art world descended on the Royal Academy just for one night. The people at the Royal Academy were so amazed! Now, we have our art fairs and what I call the perpetual caravan of the art world. But that caravan had never ever been seen, if it existed at all. It had never, ever been seen in London. Nick Serota was a co-curator of that exhibition because I knew I could not sustain the show by myself. I'm now the great Sir Norman and all that bullshit, but in those days I was little Norman, the young upstart. I knew I needed somebody like a battering ram to get it through. The exhibition almost wasn't allowed to open by certain members of the Royal Academy who said we were in the pockets of all sorts of dubious forces in Germany … It was no joke. I put my head on the line. If Nick hadn't been there, I would have lost my job. He was only Director of the Whitechapel, but he gave just enough muscle power for me to hang in there.

In the early '80s, London wasn't throbbing with art in any sense of the word, was it?

In the '60s and '70s, there were *two* contemporary-art galleries in London, the Lisson Gallery and Nigel Greenwood. That was it. There was no scene.

What happened, then, to build the momentum that resulted in London becoming the creative centre of the universe?

I don't think it is. It's quite wrong to say that. London is a very creative place, but the whole world has changed in a big way. Like in *A New Spirit of Painting* there were only male artists. That would be unthinkable today. It was also a very small world. Now it's a huge world, with a kind of art scene. I went to see a perfectly respectable art exhibition a few years ago at SOAS, called *Art of Saudi Arabia*. And it was not stupid. There is an art scene in South-east Asia and China and South America. In the '80s, the art world just consisted of New York, which still in my opinion is the supreme place, both creatively and in terms of mediation, whatever people may say about London. In those days, it just happened as a subculture in New York, a little bit in Los Angeles, in Paris a tiny bit, as part of what I call the Düsseldorf/Cologne thing, a tiny bit in Berlin, a bit in Turin and Milan and Rome, and a bit in Switzerland. Now it's a sort of world industry, which is both good and bad. We're talking about this global industry where hundreds of thousands of young people everywhere try to make it, just like in music.

And why do they do that?

It's the way things have turned out. It's what has happened. It has to do with communications and with the marketplace.

You mean, with money.

Yeah. The markets have suddenly taken up art, and so lots of kids think that art is a way to keep going. But there are just a handful. I still think that New York is the world capital of art. That's where reputations are made. London is nice and good, but still provincial.

I was talking about creativity in all senses of the word …

I know what you mean. London is an amazing place for music, for design, for all sorts of things. And London is very much in the centre of the geopolitical world, so that gives it certain advantages. We're part of the Eurasian continent, as Joseph Beuys would have put it.

You said once, 'The only thing that embarrasses me is mediocrity.'

I'm not embarrassed by it, I'm just quite bored by it. Mediocrity is *boring*.

And do you think of yourself as being 'flamboyant and controversial', which is how you've been described?

I don't want to be controversial. So far as I speak at all, I just want to speak my mind or write my mind. What's the point of doing anything else? As I say, it's all about seeing what's in front of you. If I like it, then I want to stand up for it.

You're the son of Jewish refugees from Germany who settled in London. In fact you've described yourself as 'a nice Jewish boy from a modest background taken into this glamorous world of art'. Is the art world truly glamorous?

Of course it's glamorous! I mean, imagine being a bank manager or a trader on the stock exchange! What a boring thing to be. I don't even know what a trader is.

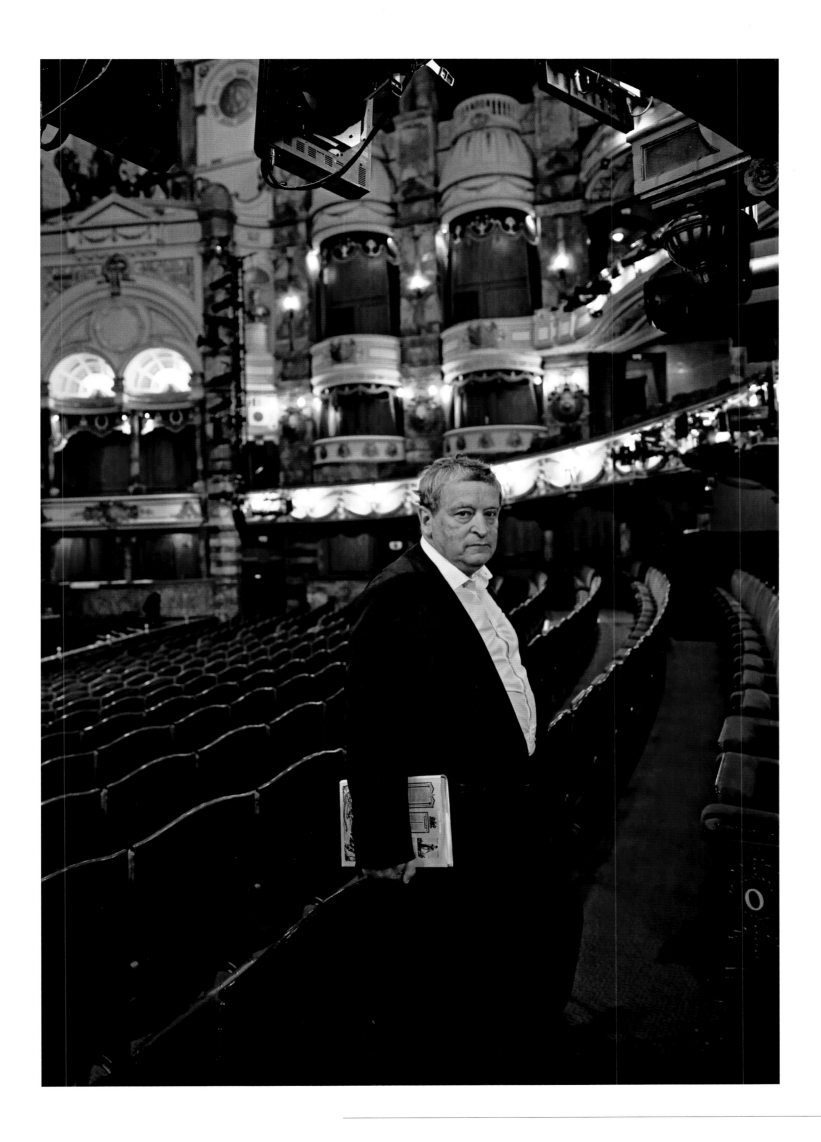

(previous page) Norman Rosenthal at the London Coliseum, home to the English National Opera since the early 1970s. An ENO Patron, he is as passionate about opera as he is about visual art

Rosenthal at home (left) in Soho. His house, built in 1710, is jam-packed with works by emerging as well as blue-chip artists. Soho has claimed a number of famous residents since the 1600s, including composer Franz Liszt and artists John Constable, Francis Bacon and Lucian Freud. Deriving its name from the ancient hunting cry 'Soohoo', the area began to grow in the late seventeenth century, its narrow streets becoming home to Greek, Italian and French Huguenot immigrants. Rosenthal has lived there for over twenty-five years, enjoying the area's seedy reputation as London's red-light district. 'My life is sexy enough without having to spend money in sex shops' is his response to the area's reputation

Rosenthal shops for books in Cecil Court (above & left), a passage he has been visiting since childhood. Cecil Court served as the first London address for Mozart and his family, and was the likely site of the creation of the young composer's first symphony. Today it is a tourist haunt visited by *Harry Potter* fans – keen to discover Diagon Alley – and bibliophiles. 'I spend a lot of my life in places like this,' Rosenthal says

'I'm just somebody who tries, as Shakespeare says, to "see a church by moonlight". See what's in front of you, in other words'

There's a lot of trading in art right now, though, isn't there? It's almost become a commodity.

Up to a point. Lots of money has been made out of it by lots of people, and that's just fine.

Doesn't the huge amount of money that surrounds it have a corrupting influence?

You can't make generalisations about these things. You can talk about individual moments which may seem not very happy, you know what I mean? Nothing is perfect. Because the market has very positive functions, both in terms of mediation and spreading the word, and it also keeps things alive. Why do people take such great care of art, even in museums? Not just because it's valuable. It's a mechanism for sustaining what is happening and what has happened. On the whole, there is a kind of amazing mechanism for keeping things going from generation to generation. And it's also a great sorter. The 'now' art also sorts things out, not necessarily perfectly. The art market is a preserver.

What sort of city will London turn into in the far future, do you think?

I can't answer that kind of question. The main thing is to look after the past, try and recognise the present, and let the future take care of itself. Suppose we become like Pompeii ... I don't know what will survive. Do you want the beautiful paintings by Titian in the National Gallery to survive more than paintings by Damien Hirst? What survives survives. People will have to add up what they find and draw their own conclusions. I don't know what's next. I don't know if I'm going to be alive tomorrow morning!

Which leads me to my final question. You've been quoted as saying that 'everything runs its course. That's what I find fascinating about life.' What did you have in mind when you said that?

I mean, the YBAs are now MABAs: middle-aged British artists. There are no YBAs any more; that's gone. The Pop generation was fantastic too. But there were more people participating in the YBA world, so that was good. You know, when you go to these big openings, at the White Cube or wherever, and there are thousands of young people and they're drinking Becks beer and all this kind of thing, it's all good news. It's not dead yet.

Does the showmanship and hoopla surrounding art today add up to vibrant artistic production?

I don't see a great deal that is amazing coming out at the moment frankly. A generation like Damien's has to pass even more into history before something is born again. It's the luck of being born at the right place and the right time. I was very lucky, like Nick. We were there to invent. It's quite difficult to invent now in the same kind of way. So we were the lucky ones, we were not just the talented ones, because we were there to make something which didn't quite exist before. At some point, a generation will come along, probably quite soon, and stir it all up again, as Damien and his mates did at that time, and Michael Craig-Martin and all those sorts of people. They'll reinvent the wheel, you know?

Rosenthal wanders through the Secret Garden (above), also known as the Garden of St John's Lodge, in Regent's Park: a very English refuge designed to be a place of meditation away from the area's madding crowds

Alice Rawsthorn
Design critic/Author
Hackney/Broadway Market/Whitechapel

You've said that design is frequently treated as if it didn't matter by being trivialised and misinterpreted. What did you mean?
The popular stereotype of design is that it's a styling tool, when actually that's only a tiny fraction of what design does. Design is one of the most powerful forces in our lives; it can help us to manage change to make our lives better.

Is design a mass event or an élite construct?
Design is an ubiquitous force, so for everybody, wherever they live and in whatever circumstances, the design of their surroundings will affect their sense of well-being, their ability to succeed or to fail.

Can you cite an example that particularly stands out here in East London?
One example from this area, which was very poor, is Booth's Poverty Maps, one of the most inspiring historic examples of data visualisation, which is an increasingly important area of design now – in other words, how we use design to distil huge quantities of complex information in ways that can help us to understand the world. Charles Booth was a shipping magnate from Liverpool who concentrated his charitable work on anti-poverty campaigning. In the late nineteenth century the squalor of the London slums, particularly around East London, was a national scandal. Booth assembled a group of economists, social scientists and statisticians, most of them volunteers, and they literally walked every street, spoke to residents, to the police, to local priests and vicars, to schoolteachers, to identify the socio-economic status of every street. Booth's brilliant design decision was to present the data not in the form of a huge, inscrutable series of papers, but as maps in which he colour-coded streets to signify their socio-economic status.

How was that helpful?
It meant that anyone, even if they couldn't read or write, could look at the map of, say, Whitechapel and recognise that the black streets were the poorest streets, inhabited by the 'viciously criminal', and that the navy-blue streets were probably slightly less vicious and slightly less criminal and slightly less poor. The yellow streets, like the one that Booth lived in in Kensington, were yellow; they were the plushest and most prosperous streets. He actually discovered that the national press had understated the level of poverty, so there was a huge political outcry and so much pressure on the government that they cleared the slums and built decent housing for what they called the industrious poor. That was an extraordinary example of information design which changed the lives of millions of people for the better.

What about a more recent example?
If I had to choose a contemporary example, one of the most popular and rapidly expanding areas is social design, the application of design to address complex social, economic and political problems. For example, the social-design group based in Bermondsey called Participle is working with local authorities to redesign the provision of care for the elderly.

You've referenced London's great design heritage. What contemporary examples would you identify as iconic?
In the early years of the twentieth century there were many wonderful examples of public-sector design in London. Harry Beck's Underground map was part of a series of initiatives by London Transport that has defined London, not only for foreign visitors but also how Londoners see the city. A recent reinvention of London's design heritage that I feel is very successful is Thomas Heatherwick's redesign of the Routemaster, a classic, mid-twentieth-century double-decker bus that was foolishly lost to London by a succession of political decisions. Interestingly, it's one of those examples of product design that benefits from multiplicity. When you see them all together they look fantastic; they're almost like this élite army of insects marching forwards. During the World Cup, Adidas paid (I presume) a fortune to repaint some of Thomas's buses black because it suited the hard-core campaign they had around their World Cup sponsorship. Again this was a very powerful way of using (I hate the word *icon*) an iconic example of design and twisting it in a way that suited their marketing objectives so it was a sensible commercial exercise but also fun for Londoners.

You always make a splash: well-dressed, polished, aesthetic 'inside'. Where did that image originate?
I was a complete tomboy as a girl, always climbing trees. I refused to wear skirts and dresses, but I was always particular about the jeans and T-shirts I wore; I can remember them vividly. Of course part of London's great design heritage is a wonderful fashion heritage, and that's an aspect of the city I enjoy. As a teenager I was obsessed by fashion, art, style, and pop culture and music. I see fashion as part of a broad perspective on contemporary culture and an enjoyable and dynamic element of it.

(previous page) Alice Rawsthorn looks over the display at Donlon Books in Broadway Market, a shop she describes as 'an East End treasure'. A rare example of an independent bookshop continuing to thrive in London, Donlon Books is favoured by arty types and offers an idiosyncratic selection of publications covering many creative fields. 'I always spend far more money than I intend to when I go there,' Rawsthorn jokes

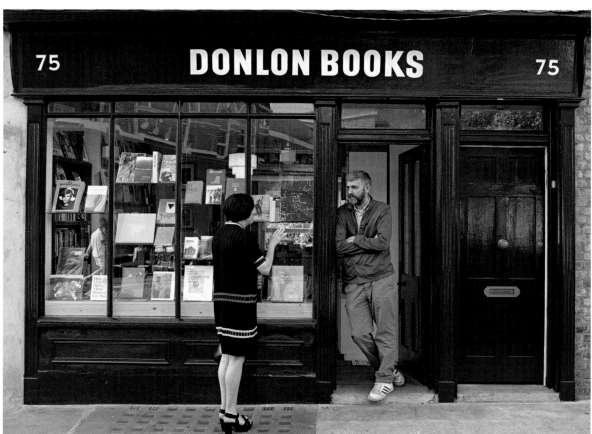

Rawsthorn with bookshop owner Conor Donlon (left). Born in Ireland, Donlon came to London to study Fashion Design at Central Saint Martins and assisted artist Wolfgang Tillmans

A venerable icon, an old typewriter (above), with its colourful companion adorns a neighbourhood shopfront. With the decline of Soho as London's bohemian quarter, the area around Columbia Road is becoming home to young creatives seeking cheap places to live

Rawsthorn visits the Whitechapel Gallery (below), of which she is a trustee. Founded in 1901 to bring great art to East London's immigrant populations, the Whitechapel was one of the city's first publicly funded spaces for temporary exhibitions. Picasso's *Guernica* was displayed there on its first (and only) visit to Britain in 1939, and the gallery has presented the first major shows in Britain of work by Jackson Pollock, David Hockney, Gilbert & George and Richard Long, among many other greats

'I spent much of my time memorising the Tube map in anticipation of moving to London'

Having been born in Manchester, when did you move to London?
I left Manchester when I was eight, but my heart is very much still there!
I moved to London when I left Cambridge after I graduated. Before I went
to university we were living in a tiny hamlet in East Anglia, 2 miles from
the nearest shop, and I spent much of my time memorising the Tube map
in anticipation of moving to London. I wanted to work in the media and
had a place on the *Times* graduate training scheme.

**You write both for the general reader and for specialist magazines.
How do you toggle between the two?**
Obviously the *New York Times* is a paper for the general reader. I've
recently started a column in *Frieze* magazine because I did want to write
about design within a cultural context. I don't believe any writer can be
convincing or interesting or persuasive about their subject unless they're
absolutely passionate about it. I spent the first half of my career as a
general journalist; I wrote about politics, economics and corporate issues
for the *Financial Times*. But when I was about forty, I reached a point
where I decided I did want to specialise in something I was absolutely
passionate about. I've been lucky because I decided to write about design
at a time when interest in it has risen significantly.

**Where do you believe London ranks as a design centre at this
moment in time?**
London's standing is very high because we have produced so many
extraordinary designers in so many different areas. Unfortunately,
though, because of public-sector funding cuts in the education system,
there is a real risk that London's standing will diminish. When I talk to
people who run art and design schools in London and teach in them,
they are very concerned. They're having to take more foreign fee-paying
students, many of whom are very talented, but not all of whom are
perhaps as gifted as the students would be if they were able to accept
them on merit. That's a tragedy. If I do crits at the top design schools in
Europe now, there are bright British students who chose to go to those
schools rather than design schools in Britain because they knew they'd
get a better education. That's heart-breaking.

**To what do you attribute the current revival of the London
fashion scene?**
First of all, the British Fashion Council has done a fantastic job. They
have professionalised the way fashion shows are run in London, their
relationship with international buyers and with the international media. I
remember going to fashion shows in London and they were always about
two hours late. Passionate as I am about fashion, I don't have two hours
to waste waiting for fashion shows! Now the schedules run like clockwork.
They've also introduced a fabulous bursary system to help young designers.
Also, before the cuts in public-sector funding, colleges like Central Saint
Martins were attracting the cream of the world's fashion students.

**Leaving aside the draw of talent, surely its money that talks in the
fashion industry, no?**
The structure of fashion retailing has changed dramatically here,
particularly for designer fashion. The growth of websites like Net-a-Porter
has helped young independent designers phenomenally because typically,
they would have taken a decade to get a tiny rail of clothes in Barneys
and then maybe Bergdorf Goodman would take them on, and that would
be their only way of reaching customers in the United States. Because
sites like Net-a-Porter place such large orders with them, suddenly their
collections are accessible to consumers all over the world. That structural
change in fashion retailing has been of huge benefit particularly to
small-to-medium-sized independent designers with a distinct vision.

**You are a trustee of many arts and other institutions. How does that
work for you?**
I do a lot of pro-bono work in the arts, and I enjoy it immensely. It
wouldn't be appropriate for me to be involved in the governance of design
institutions in Britain, given that I write about design for the
New York Times.

Rawsthorn outside Violet,
her favourite Dalston bakery
(above). Californian Claire
Ptak started her organic
bakery/café in 2010 after
running a market stall in
Broadway Market for several
years

(following spread) Graffiti
art at the corner of Ada
Street and Broadway Market,
home to young Londoners
intent on new horizons and
affordable housing. Alas, as
with elsewhere in the capital,
moneyed interests drive out
creatives, who often leave
their artistic expressions
behind in mural form

London Borough of Hackney

Ada Street E8

FISH & CHIPS

BOE
+ IRONY

Alistair Spalding
Chief Executive & Artistic Director, Sadler's Wells
Clerkenwell

Does being made CBE hang a noose around your neck?
Well, I certainly count as part of the Establishment …

Yet your father was a steelworker.
That's right. My parents are Scottish but moved to England to seek work.

And you've always felt yourself to be on the side of people who don't usually get included in things.
That's right.

The question is, does that make you a revolutionary or does it just make common sense?
I'm certainly not a revolutionary in my political views. England is very class-ridden, and I always did feel separate. Thinking about Sadler's Wells, it had that ethos that Lilian Baylis put into the DNA of the building about being a place for people from all walks of life to come to. Perhaps I came here because that ethos resonated with me. It's really a belief that everybody should be able to access and enjoy the arts, just as they should be able to enjoy other aspects of society.

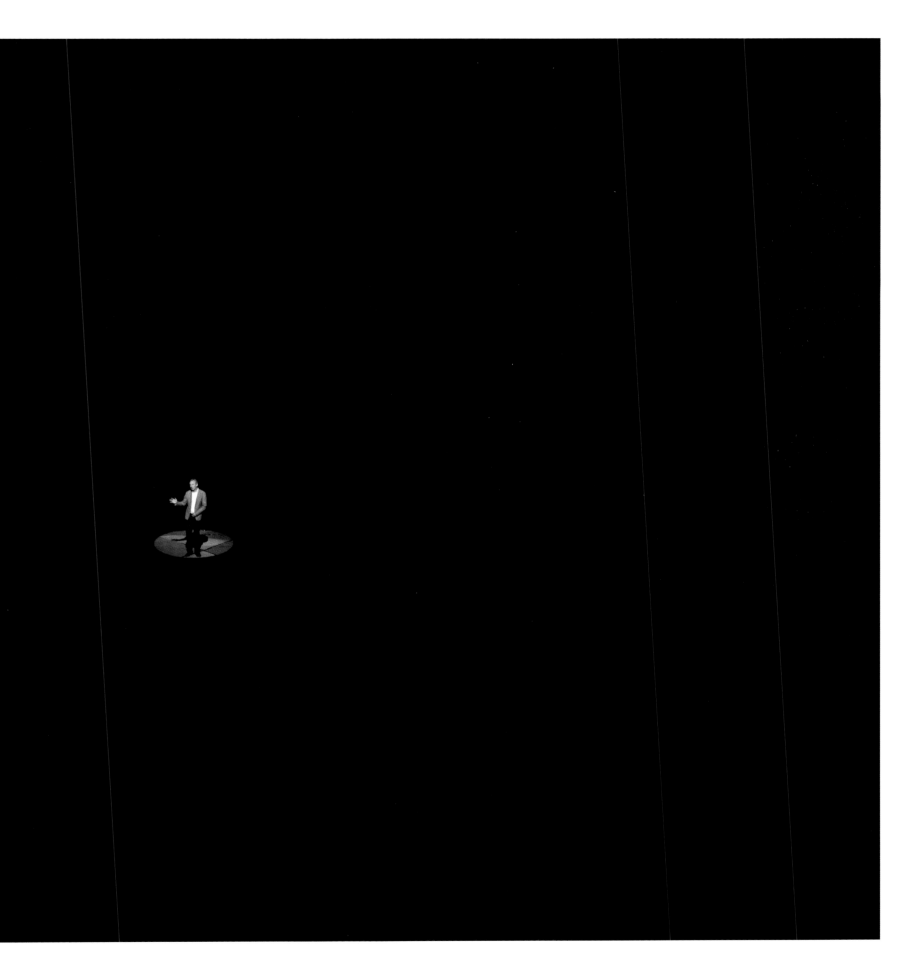

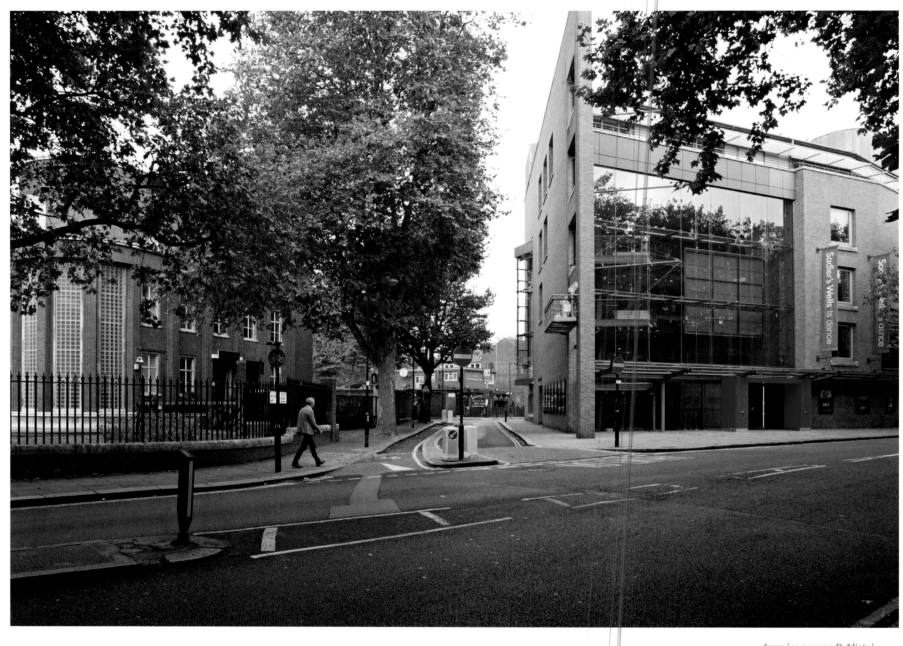

'The next stage is to get creativity coming
from the grassroots'

(previous spread) Alistair
Spalding onstage at
Sadler's Wells. Spalding has
essentially recast London's
second-oldest theatre as
the city's principal home for
contemporary dance. Sadler's
Wells has existed as a theatre
since 1683, when Richard
Sadler discovered a mineral
spring on the site and built
an establishment intended
to entertain fashionable
Londoners sampling its
'medicinal waters'

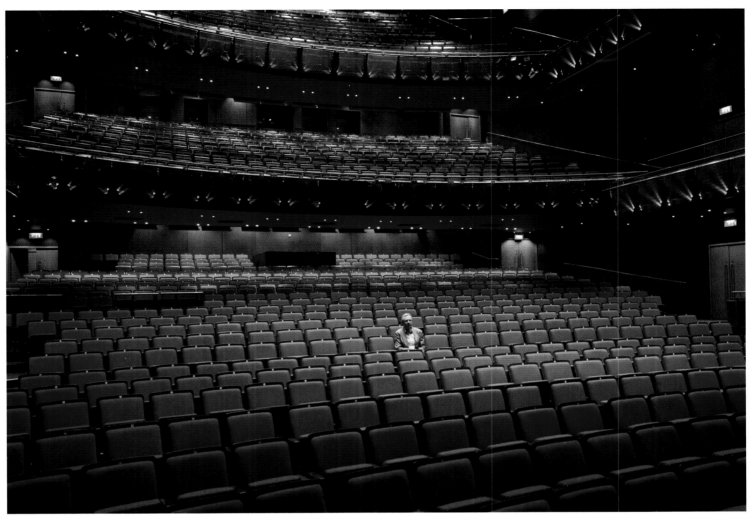

How do you go about that in practical terms?
We have a very unusual economic model here; 9 per cent of our income is subsidy. So there's a big need to bring people in anyway. We need people to come to the theatre, so we're very outward-looking. Dance has so many different facets. Ballet came from the noble classes; Louis XIV invented it and it was all about the court. Recently dance has become much more democratic. The rise of hip-hop is a good example. You get it coming at you literally from the street, a form of which then goes onto the stage. The only way you can run a year-round dance house is if you embrace a broad definition of what dance is.

Has the invitation to the unwashed to walk in off the street always been a progenitor of creative flux?
Shakespeare was the first to do it, really. His audiences were real people, and, in a way, he was also running a theatre.

So you've got to be tuned in to the street.
I think that if, at the heart of what you do, there lies a respect for those around you, that's a healthy thing, and makes the work you present relevant.

Does that not just make you a bean-counter?
Yeah … I come in and look at the daily sales and say, 'How much are we taking on this show and how much on that show?' We count the money, we really do. I do that first thing in the morning, and the rest of the day is about Art. I'm joking! It's okay to be thinking about ticket sales because money is power – to invest in more art and to take risks. Every time an organisation gets into trouble, you become weak and you can't do ambitious things.

You've spoken about New York and Paris having been the centres of dance for ever. Now you, single-handedly, are transforming London to fit into that slot. What is it that makes London a viable centre of creativity right now?
The French always had dance at the centre of their culture. In England, the Royal Ballet was only started after the Second World War. The Royal Swedish Ballet celebrated its 240th anniversary in 2013, and Johannes Öhman, its Director, explained to me that the reason they are one of the world's oldest ballet companies is that their royal family has French origins, while the British royal family has German roots. So historically we've had a much stronger connection with the world of theatre, music and opera; we're not a dancing nation. Having said that, it is changing quite rapidly. I suppose it's about having the opportunity to give artists a platform. The next stage is to encourage even more creativity coming from the grassroots. There are other creative industries, but there's a strong commercial-finance sector here that is also very creative. London has those two things going; lots of people don't recognise that.

In the process of balancing money and public support, you've set up the What Next? lobbying group, is that correct?
David Lan, Artistic Director of the Young Vic, and I were part of the small group that set up the movement.

What is its purpose?
It's to get the public to engage with the arts and to understand their value. If we get to the public, which I think we haven't ever done properly, that will affect politicians and the decisions they make about culture and arts education.

What is the difficulty connecting with the greater public?
Some people unfortunately see culture as not for them. They see it as something you need to know a certain amount about before, for instance, coming into a theatre or seeing an exhibition.

Spalding walks to work past the Laboratory Building on Rosebery Avenue (opposite), next to Sadler's Wells. The modernist structure, now converted to flats, was constructed around Sadler's Spring in 1936 by the Metropolitan Water Board. Spalding enjoys a quiet moment in the theatre's fifteen-hundred-seat auditorium (above), where half a million people attend performances each year. Five different buildings have occupied the site since the seventeenth century; today's design has kept faith with Frank Matcham's 1931 iteration

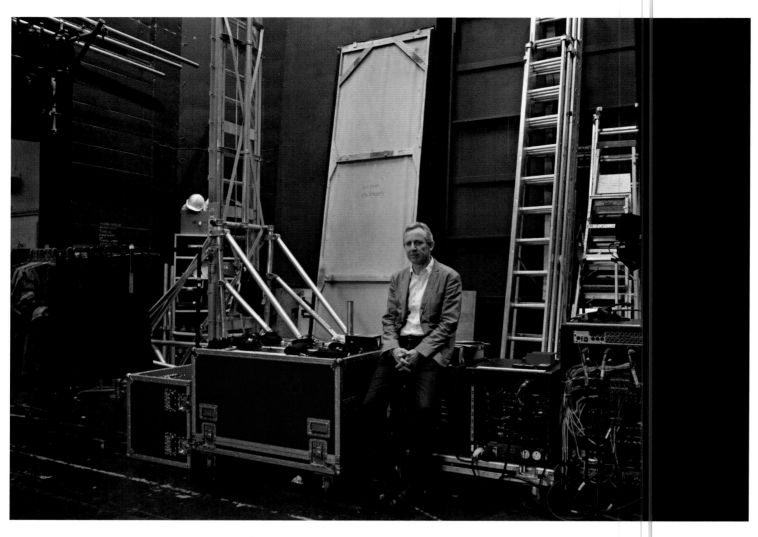

Spalding backstage (left).
Once a venue featuring
jugglers, wrestlers, dancing
dogs and even a singing
duck, today Sadler's Wells
hosts a wide range of
international contemporary
dance, including tango,
hip-hop, ballet, Bollywood
and flamenco

**But everyone's a dancer! Why is it that dance just kind of blooms?
Even little babies, if you put on some music, start ...**

... start dancing, start spinning. They start doing all the things that you
see on the stage. It's absolutely within us, part of us, that we want to
move and express feelings through movement. Unfortunately as we get
older we become more self-conscious and less engaged with that side
of things because there's so much emphasis on what's going on in your
brain. And our society also is becoming less about the physical. That's got
a lot to do with some of the problems that we have, obesity and some of
the illnesses that occur because people aren't active. I'm not saying they
all should be dancing, but they should have some connection with their
physicality. It even affects me; I'm aware I should do something every
day to be active. I swim, I cycle, or I run. Dancers have this alertness, this
power, because they have this constant connection with their physicality.
A lot of us have lost that.

**You engage a lot of acts from exotic places. How much inspiration
does English dance get from outside?**

Oh, it's huge because, as I said, dance is not really a tradition here. One
of the strands of Sadler's Wells' work focuses on presenting outstanding
work by international artists and companies. So for example we had
a show in 2013 by this extraordinary Danish choreographer, Mette
Ingvartsen, where the dancers were more like workmen setting materials
into motion. That piece would never have been made in this country.
Never. That sort of work is important for artists here to see because it's a
different way of approaching the art form.

**You look the epitome of English sanity and correctness. And yet you
set off this little revolution in English dance.**

I know. That's what people can't really get their heads round. That's years
of being taught to be English, even though I'm Scottish. You're right; it's
a completely crazy world to be in. I didn't even study or train in dance,
so it's kind of weird that I ended up doing this. It's an obsession in a way.
And yes, if you wanted a stable, more predictable life, you certainly
wouldn't go into this business!

What keeps you sane in difficult situations?

What keeps you going is that you know that there's a long-term mission
for the organisation and vision for the art form as a whole.

**In your dreams, what would be the ultimate rung, the final curtain,
if you will?**

With my team, I'm currently working on a new project – to open a
new six-hundred-seat theatre in Stratford, East London, as part of a
new culture and education quarter. Our plans for the space will enable
us to offer development opportunities for artists and to train the
choreographers of the future. That's my ultimate goal.

Spalding often visits Exmouth Market, a short walk from his office, for lunch or meetings (above). The market has hosted food stalls, pubs and restaurants since the 1890s. A hip place for young professionals to meet, it is also a must-see tourist destination

Spalding and Michael Morris, Co-Director of Artangel, walk past Royal Mail's Mount Pleasant Sorting Office in Clerkenwell (right). Opened in 1889 and covering 7.5 acres, the postal centre was one of the world's largest sorting offices, reputedly having 23 miles of underground train tunnels. Although the tunnels are no longer in use, part of the sorting area is being converted to luxury housing – a contentious issue for locals concerned about a shortage of affordable accommodation

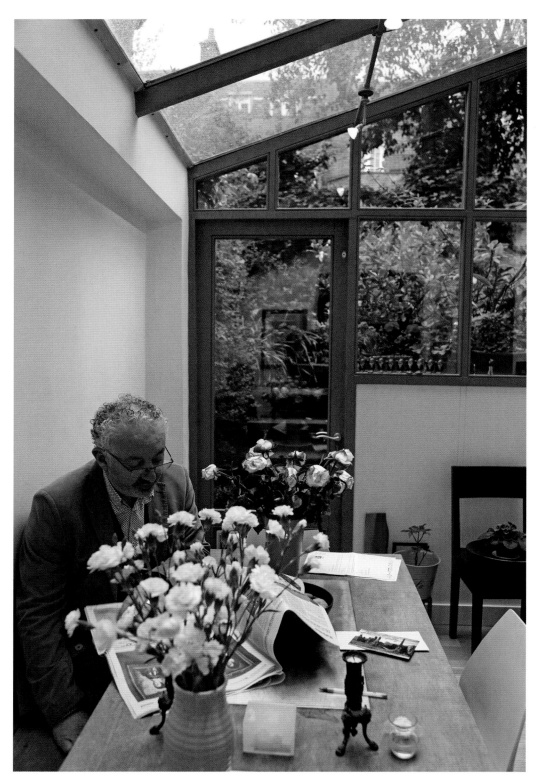

Michael Morris
Co-Director, Artangel

Co-Director (with James Lingwood) of Artangel since 1991, Michael Morris was previously Director of Performing Arts at the ICA and founder of the production company Cultural Industry. Michael and Alistair Spalding, with whom he shares a deep love for the work of the German dance company Tanztheater Wuppertal Pina Bausch, meet up regularly in Exmouth Market to exchange thoughts and ideas.

Morris and Lingwood took on the directorship of Artangel with a view to reinventing what an arts commissioning agency might look like with ambitious new work created and presented outside traditional cultural spaces. Michael explains their collaboration as having been motivated by a shared desire 'to explore uncharted territory'. Landmark works Artangel have produced include Rachel Whiteread's *House* (1993), which won the Turner Prize, and Michael Landy's *Break Down* (2001), in which the artist destroyed all of his worldly possessions in an empty department store in Oxford Street. A member of Tate Modern Council and Artistic Advisor to the Manchester International Festival, Michael specialises in producing innovative, site-specific events, often free of charge to the public. These ambitious projects are financed by a mixture of public investment from Arts Council England and the private patronage of the Company of Angels, some two hundred benefactors who contribute to Artangel each year.

Location is critical to Artangel's success. 'All our work in London is produced in relationship to particular places within the urban environment,' Michael explains. 'We try to animate places which are not the usual breeding ground of arts and cultural events.' London, he feels, has changed beyond recognition. 'When I began working, it wasn't so easy,' he remembers. 'Little by little, the city has opened up and is now one of the most vibrant places to work in the world, whereas when I began my career in the 1980s, the city was far more insular – it was at times a real challenge to generate attention for the untried and untested.' Referencing the transformation of particular neighbourhoods, he describes Shoreditch in the 1980s 'as a place you would not have gone unless you wanted to find a spare bath tap. Now it's incredible – Shoreditch, Whitechapel, King's Cross – just look at how King's Cross has changed. That was something that could never have been predicted back in the 1980s. It used to be a station … Now it's a destination.'

Artangel's Michael Morris and Alistair Spalding, friends and collaborators, enjoy a tea break (left) in Exmouth Market, where they meet regularly to take the city's creative pulse. In Spa Fields Park (above), the two men admire the Tuscan-style Our Most Holy Redeemer church, built in 1887 by J. D. Sedding. Morris reading the morning paper (opposite) in the conservatory kitchen of his home in Islington, fresh cut flowers a constant feature

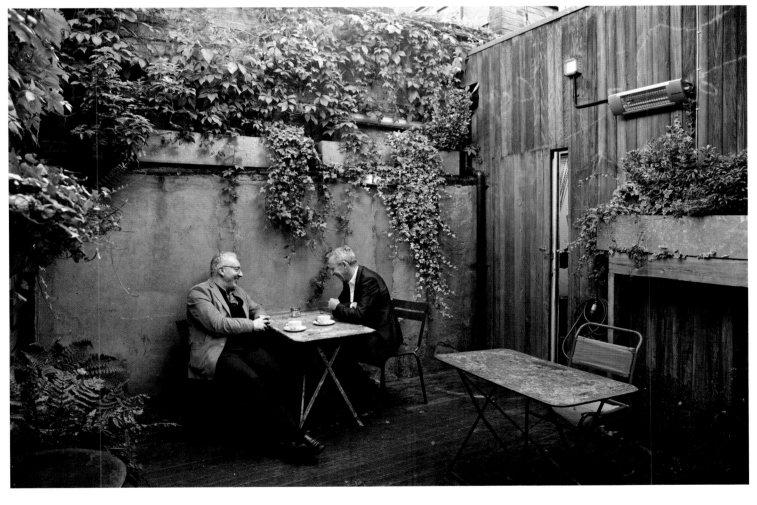

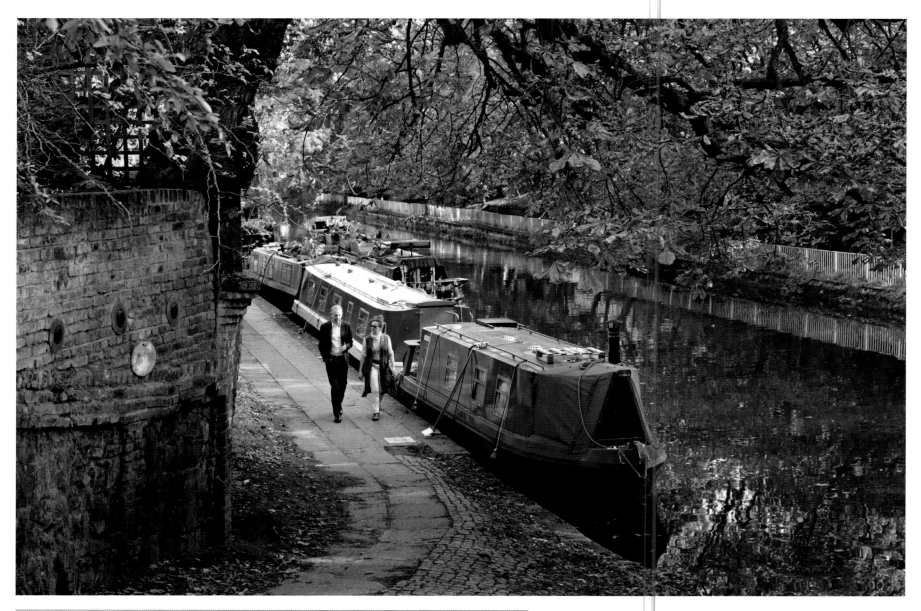

Emma Gladstone
Artistic Director, Dance Umbrella

As Artistic Director and Chief Executive of Dance Umbrella, Emma Gladstone runs London's most established dance festival and commissions new work. Her previous job was as Artistic Producer and Programmer at Sadler's Wells, where she developed partnerships with Latitude Festival, Tate Modern and several other projects. Of her former colleague Alistair Spalding she says, 'He dreams big and it's been fun riding along those dreams with him.'

Emma, who lives in south London, references St Paul's as one of her favourite places, along with Hampstead Heath. 'I love being in the city but totally surrounded by green,' she notes. She studied History at Manchester University before post-graduate studies at Laban (now Trinity Laban Conservatoire of Music and Dance), who made her an Honorary Fellow in 2014. Having studied with Arlene Phillips as a teenager, she stopped dancing at thirty-seven. Citing 'self-motivation, dedication and collaboration' as the characteristics she injects into her own work, Emma's forte is bringing people together to collaborate. 'I call it cultural dating,' she jokes. 'It's a nice way to get fresh blood into the art form.' She believes in working with people she likes, in not taking no for an answer 'on things that matter' and in being 'generous on things that don't'. In the 1980s, together with choreographer Matthew Bourne, Emma co-founded, ran and danced in Adventures in Motion Pictures. She has lectured internationally for the British Council and recently stepped down as Chair of Candoco, a company that works with both disabled and non-disabled dancers.

When choosing new dance pieces to feature in Dance Umbrella's programme, Emma is on the lookout for 'something articulate, brave, personal and distinctive'. Though she is optimistic for dance's future in Britain the poor economic climate does worry her. 'It is going to be harder and colder out there for artists, especially young artists,' she muses, 'because a lot of regional venues are struggling with cuts *and* council cuts, which means that there are fewer venues to perform in.' She reflects interestingly on the British commitment 'to words and logic and narrative', saying, 'I am keen to find ways to help people talk about other things, things that dance deals in, such as moods, emotions, images, intangible and evocative sensations ...' What she terms 'the weight of theatre' and 'the stress on the academic' are unavoidable in the context of British culture generally, she believes, and what she hopes to achieve is 'to make people open their eyes and bodies to looking at physical work'. About the London dance scene in particular, she observes that it has changed 'hugely, hugely, a lot because of Alistair. Sadler's has done an extraordinary job in helping get dance out to people and in making it inviting to bring people in. It's changed the whole game.'

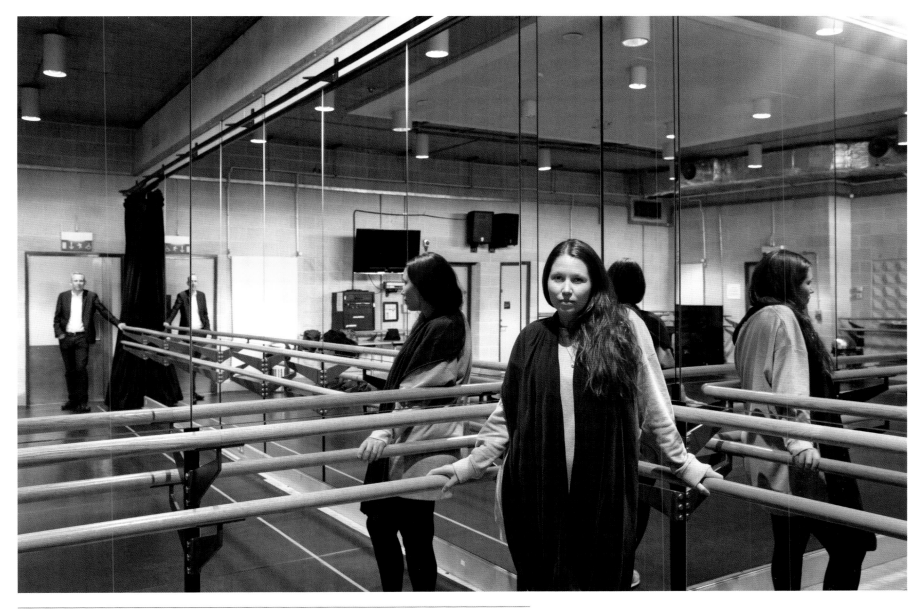

Kate Prince
Choreographer

In 2002 choreographer Kate Prince started ZooNation, a group that combines hip-hop with musical theatre. She also set up ZooSkool, a programme for kids. 'We are very careful about the music we use,' she says, 'and which moves we teach them; we focus on all the good, positive elements of hip-hop.' Lacking formal training, Kate did not take dance seriously until she was an adult. Having been convinced by her mother to submit a tape to Breakin' Convention, her group was among those featured in the festival's first edition. An Associate Artist at Sadler's Wells, in 2008 she choreographed both the Beijing Olympic hand-over ceremonies and Nelson Mandela's birthday celebrations.

Born in Southampton in 1974, Kate first saw hip-hop on MTV. At the age of twelve she became a boarder at Bryanston public school ('Bryanston taught me to do what I wanted to do, and find a way of doing it'). After attending the University of Edinburgh, Kate created work for the Fringe, going on to train in hip-hop in London, Paris and the US. Having returned to the UK, she taught hip-hop in stage schools; her other jobs have included being a runner at the BBC, making films, writing lyrics and directing. Kate found her way into choreography through teaching and working on festivals. The award-winning *Into the Hoods*, which she produced in 2006, became the first-ever hip-hop production in the West End, where it went on to become the longest-running dance show. Kate has been nominated for numerous awards and is on the board of Dance UK.

Citing as influences Aaron Sorkin (she has watched *The West Wing* five times), Steven Soderbergh and Harper Lee's classic coming-of-age novel *To Kill A Mockingbird*, Kate's ideal achievement would be to reimagine the dream dance sequence in *Singin' in the Rain*. About establishing her credentials, she says, 'I do think it's been harder as a woman, and a white woman at that, to get people to take me seriously.' Difficulties aside, she remains open-minded about the transformative potential of dance, noting, 'I operate under the principle that every single one of us is a dancer. When we were tiny, we all danced without any inhibitions – it's only as we grow up that dancing gets relegated to something we do when we're drunk, or at a wedding.' Kate worries that too few young people go to the theatre due to high ticket prices and the fact that there 'isn't enough work created with a young audience in mind. But we shouldn't forget that the young people of today will be running things one day, and if we don't work harder to create genuinely accessible and engaging work ... in the not too distant future it will die out completely'. Society, she asserts vigorously, needs its artists: 'Imagine the world with no Mozart, no Shakespeare, no Michelangelo … no Fred Astaire! That's not a world I would like to live in!'

In *Angel*, Emma Gladstone and Alistair Spalding (opposite) walk along the Regent's Canal, built in 1820 by architect John Nash

Alistair Spalding and Kate Prince in one of Sadler's Wells' rehearsal studios, surrounded by mirrors and Harlequin sprung floors (above). 'Sadler's Wells is great for recognising young talent,' Prince notes

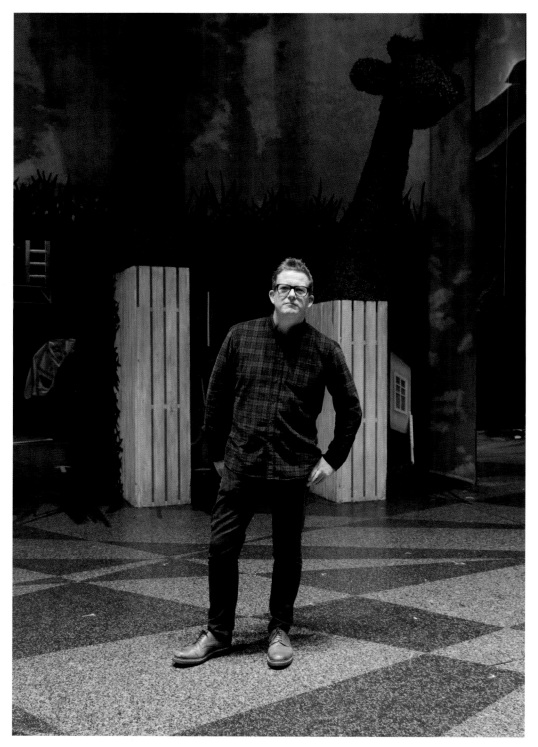

Matthew Bourne
Choreographer

Hailed by the *New Yorker* as 'the most popular choreographer of theatrical dance in the western world', Matthew Bourne was born in Hackney in 1960 and lives in Islington in an old grave-digger's cottage. He remembers as a child re-enacting shows he had seen in the West End: 'I loved singing and dancing. I'd charge old ladies from down the street to come and watch. I'd give them a cup of tea, but they'd have to pay. I've always had one eye on the business!' An Associate Artist at Sadler's Wells, Matthew created the world's longest-running ballet production, his production of *Swan Lake*, and is a five-time Olivier Award winner and the only British director to have won Tony Awards for both Best Choreographer and Best Director of a Musical. Matthew's company New Adventures sometimes employs as many as 130 people and has a repertoire of twelve rotating productions; his groundbreaking *Swan Lake* has toured internationally. In 2008 he set up Re:Bourne to increase opportunities for young people, particularly young men, to participate in dance; two years later he created the New Adventures Choreographer Award to showcase emerging choreographers.

'I do think of the audience when I am choreographing a show,' Matthew says. 'Some people have never been to the ballet before, and I'm trying to make it as simple and as accessible as possible.' The way he focuses his work has changed over time. 'When I first started out, I wanted to make people laugh,' he recalls. 'I put nods and winks in, as it were. Now I want there to be some emotional truth.' He cites the suspense of Alfred Hitchcock's films as an influence, 'but also entertainment, glamour, comedy … all these things you don't think about as Hitchcock things'. His creative process can, he says, 'begin with many sources', music being the most obvious one. 'My process would be doing lots of research around the idea before I actually get into doing any kind of staging or movement and working with my designer … Then I workshop with a few dancers that are very quick and very creative, and … work out a few ideas.'

Matthew's early interactions with Sadler's Wells involved passing the theatre on the 38 bus from Walthamstow, where he grew up. 'I came when I was eighteen to see *Swan Lake*, right at the top of the upper circle,' he remembers, 'just because I had never seen a ballet before and I thought I should see one …' Dance in London has changed a lot since then, he feels. 'When I first started out, there was a thriving group of young choreographers who were starting their own companies … I don't see it as much now. London has definitely become the dance capital of the world, though.'

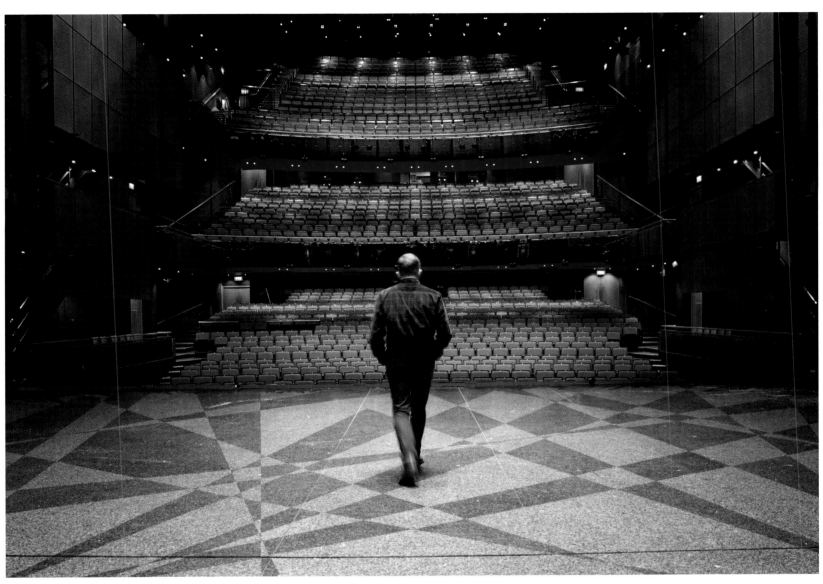

Matthew Bourne onstage at Sadler's Wells (opposite) for his adaptation of Tim Burton's *Edward Scissorhands*. 'I came here when I was eighteen to see *Swan Lake*, right at the top of the upper circle,' Bourne remembers (above). The two men admire an installation by Shezad Dawood, which covers three levels of the theatre's exhibition wall (right). Dawood's work is the first commission created in an ongoing partnership with the Tate

Jonzi D
Choreographer

Dancer and choreographer Jonzi D was one of the first performers to transfer hip-hop into a theatre setting. Alistair Spalding first met Jonzi D at the Southbank Centre. Out of their discussions came Breakin' Convention, an annual international festival hosted by Sadler's Wells, where Jonzi D is Associate Artist.

Born in 1971, Jonzi D's parents were from Grenada. He treasures early memories of his father's and uncle's African-style dance 'battles'. It was his brother who introduced him to hip-hop culture, however. Calling himself a 'true Cockney', Jonzi D quit school but went on to complete a course in Dance at Lewisham College, and in 1993 he graduated from London Contemporary Dance School. Described as 'gregariously charismatic' and 'an excellent mimic', Jonzi D (who started breakdancing when he was twelve) has been cited by Spalding as 'raising the profile of hip hop dance theatre to a whole new level'.

The 'original hip-hop values are education, empowerment, peace, love and unity,' Jonzi D explains. The genre, he adds, 'is something from nothing, and that something is an explosion of creativity, individuality and form'. Covent Garden in the 1980s was the nucleus of hip-hop culture, with Brixton an exciting place to be south of the Thames: 'The front line, and the energy, and a really strong Caribbean presence were there'. The West End was another magnet for kids making their own entertainment.

'It's a lot to do with the fact that there was no Internet and we did have to define our own selves,' Jonzi D muses. 'London at that time was amazing for that.' He also remembers the Trocadero, where 'there was a free dance space where people would jam together.'

These days the hip neighbourhoods have moved east, with Jonzi D citing Shoreditch as a major creative centre. At one time he had a 700-square-foot warehouse in the area; it was where he created his first works. 'It's really important that artists have got space to make work,' he asserts, explaining that he had to move into more affordable space himself. But Jonzi D remembers East London when it was not so hospitable. 'Growing up in the '70s … I was very aware of the relative apartheid that existed there … My sister told stories of being kicked down the street … A lot of these racially charged scenarios over the years have definitely chilled out. Right now in East London you wouldn't know the ethnicity of someone speaking. Everybody sounds the same …'

In 2011 Jonzi D refused the MBE. Asked why he did so, he replies, 'For me it's obvious. I am not going to accept a badge that says I'm a member of the British Empire. My forefathers were victims of the British Empire. I am diametrically opposed to the idea of empire. Man, I'm a *Star Wars* fan – empire is bad.'

Jonzi D arrives on his bicycle (above) to mentor members of the London-based dance crew Unity (opposite) and Hereford-based TrashDollys (right) in studios at Sadler's Wells. 'These buildings,' Jonzi D says, 'have often promoted an artistic apartheid by saying something is "high art". As soon as you use the term "high art", you are saying there are people below you; I've always had a problem with that.' Alistair Spalding and Jonzi D overlook an empty lot in Queen Elizabeth Olympic Park (top), where they are planning to create another venue in London's new Culture and Education Quarter

(following spread) The Old Red Lion Theatre above the pub of the same name in Islington. The fringe theatre was founded in 1979, while the pub is one of the oldest in London, having been built in 1415. It has boasted an illustrious list of visitors and is the subject of William Hogarth's 1736 painting *Evening*. Samuel Johnson used to write there, and Thomas Paine is reputed to have penned *Rights of Man* in the shade of its forecourt trees

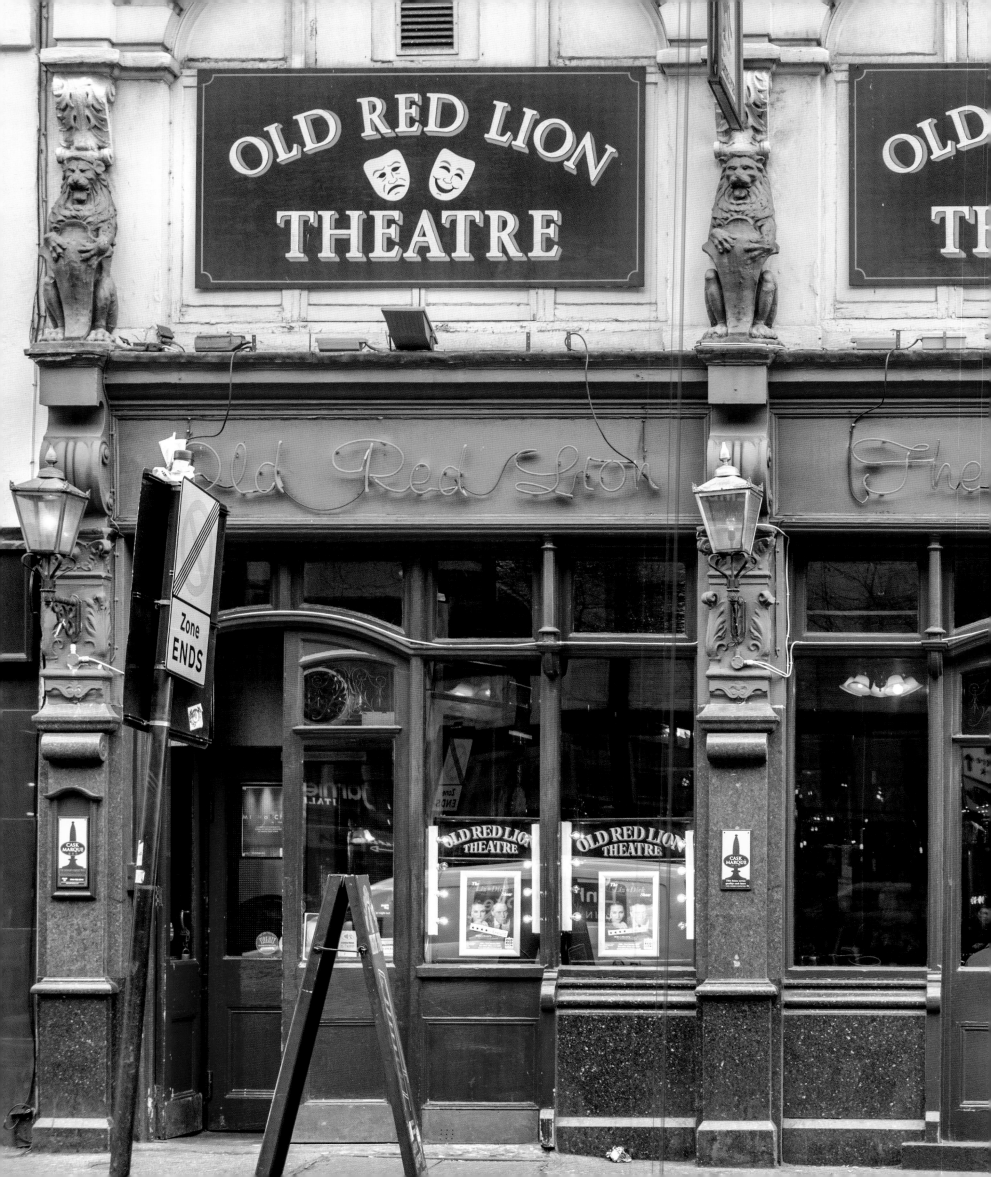

Delilah
Musician/Songwriter
Hampstead Heath/Camden/Piccadilly Circus

Sitting here in Kenwood House, at the heart of Hampstead Heath, I'm wondering what the significance is of this particular location for you?
I literally grew up in the park; every day after school I was here for hour upon hour, climbing trees. Having that rural upbringing is important for a child, but still being an inner-city girl. That helped give me a bit of brain space.

You were never really fond of school, were you? Why was that?
I don't like to conform; I don't like feeling confined or institutionalised; I like to be free; I like to have an informed opinion. If I don't know something, I will try and self-educate as best as I can or ask someone who might be more knowledgeable. I'm not anti-education or school; it's just that it's uniform and everyone has to be the same. Children should be free to express themselves and create within whatever limitations they set themselves or their soul sets them.

In terms of your own experience, how important is creativity?
Creativity is such an important part of your emotional health. It's therapy.

Can you give me an example from your childhood?
I had a kingdom in that forest over there, and I built a castle in that tree, and I was a princess when I ran around here. I created a fantasy and became whoever I wanted to be. Creativity is imagination; it's that freedom to explore.

You've described yourself as a pessimist; what did you mean?
Signing a major record deal at seventeen, signing into another institution …

What was the effect of that? Was it very regimented, very controlled, very demanding?
Exactly. That moulded me into a bit of pessimist, whereas before I had been this girl full of imagination and excitement.

Which record company did you sign with?
Warner Bros.

So they sent all these grey-suited people over to clear your head of thinking that would run counter to their own intentions …
I think they saw a seventeen-year-old who they could mould into whatever they wanted.

Did they manage to achieve that?
No! That was why I had such an unhappy time. The whole thing was a battle of the wills and me saying, 'No! I won't conform.'

How long did that battle last?
Five years? Only this year have I started to experience what pure happiness feels like again and to feel excited.

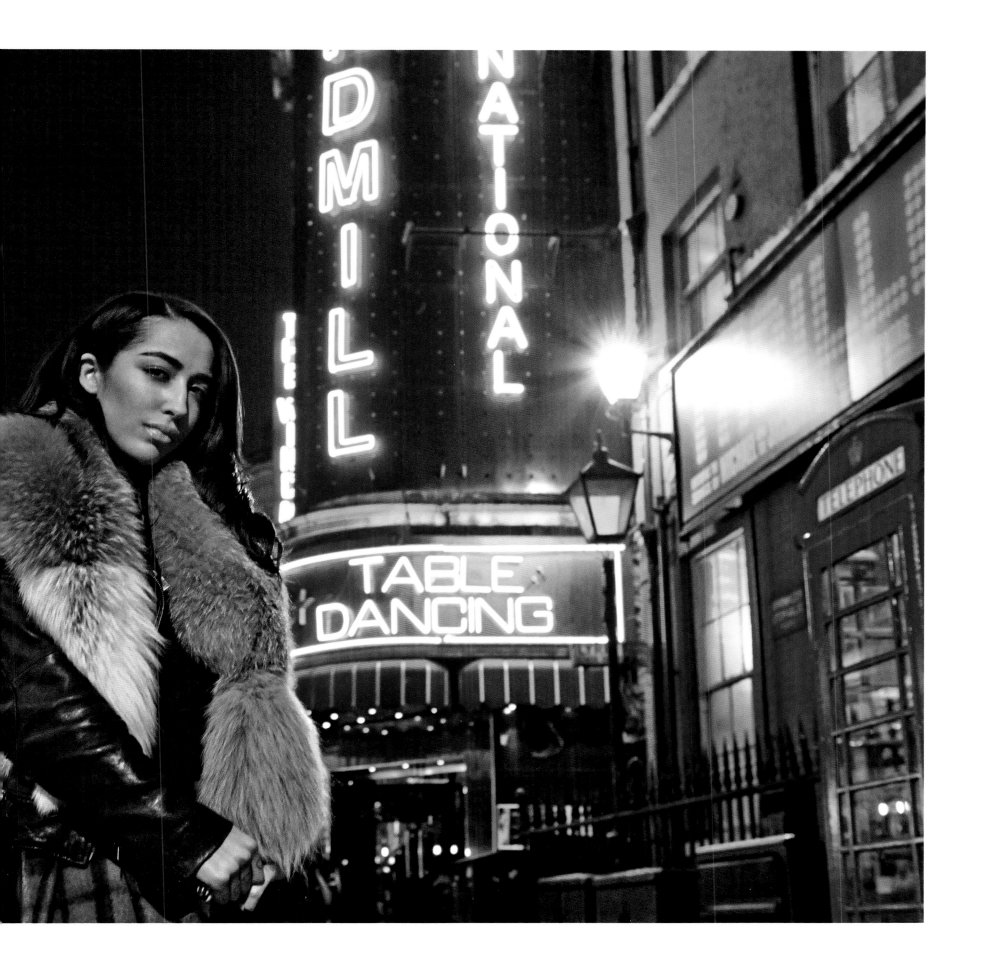

(previous spread) Delilah in front of the Windmill Theatre, a Soho landmark with a racy history, having tested the capital's prudish attitudes to sex since the 1930s. Built in the 1600s on the site of an actual windmill, it was a variety theatre known for its _tableaux vivants_ before becoming a cinema in the 1960s, and now back to form again

Describe pure happiness to me.
It's having a team of people that I love and that want to see me grow and I want to see them grow, and each time we achieve or succeed it's like we're all high-fiving each other, you know? Succeeding and being surrounded by people you don't like is the most horrible feeling. It's when I feel comfortable and safe that I'm most productive and creative.

Do you not need friction to encourage your creative side?
I used to think so. But a huge amount of my favourite artists were, for lack of a better word, method actors, and they weren't happy people. They were amazing artists, wrote incredible songs, but were miserable. A lot of them died young.

Whom are we talking about?
I was a big fan of Amy Winehouse. My best friend was her best friend, and I saw the effect that watching his best friend destroy herself had on him.

But surely the 'system' can't be blamed for Amy Winehouse's demise.
No, but she too started really young, and I do think there is something in signing too young. I know that the pop-music industry is based on how young and beautiful you are, but it's quite damaging to take somebody who hasn't quite formed into the human they're meant to be and try and mould them into something they're maybe not.

Who has had the most profound impact on you spiritually, emotionally and professionally?
Definitely Prince, because I spent the most time with him. He's one of the few living legends of pop music. He has a lot to teach and he surrounds himself with the most creative of people. Being at Paisley Park, full of people flying in and out who were amazingly talented, was incredible because none of those people have ego when they get there; they can't out-ego him! So you lose that at the door. Everybody's just there to learn from one another.

What is the single element intrinsic to creativity that sparks and ignites young talent?
The first thing is luck.

And you're saying the big labels stand in the way?
I don't want to make the industry sound like this awful black hole of negativity … The record labels are a bank. If you buy a house, you look at the house for its beauty and its fireplaces and its windows and how you're going to decorate it; this is the place where you're going to raise your family. But you've got to get a mortgage, and at the end of every month you might be stressing to pay that mortgage, so it's stressful to keep yourself in that place. That for me is the music industry. There are the beautiful rugs inside it, and your family may live there and grow there and you'll make some memories, but it's fucking expensive to be in that area, and your Council tax goes up every year, and some months you don't know how you're going to pay your mortgage. That's how I look at it.

Has family been important in your life?
Yeah, incredibly. I have a crazy, mix-match, multi-coloured, couple-of-wives, lots-of-children-with-each-of-them family.

Your natural dad disappeared from your life quite early, didn't he?
He completely disappeared when I was six going on seven. My stepfather was my sister's dad. He was with my mum since I was two years old, taught me how to ride a bike, taught me how to swim, played Barbie dolls with me. He was my father. He passed away in a car accident when I was eleven.

So this is the father who saw talent in you, went and found a little piano, fixed it up, that sort of father. You were lucky.
Yeah, very. I was his daughter from the moment we met. I think I blocked out how I felt about his passing for quite a long time, in order to just cope.

How much did that loss affect your creativity?
It was the reason I became a songwriter. I've always wanted to be a singer. There are videos of me at five years old, standing on a chair at someone's birthday party, insisting everybody listen to me sing.

You were born in Paris but you've said that, first and foremost, you're a Londoner. London seems to be in your very soul.
There's something about French culture and the Parisian lifestyle that I'm drawn to. But we moved here when I was two, so I grew up here. I have made friends here, I went to school here, this is where I'm from. I could see myself living in Paris, I could see myself living in LA, I could see myself living in New York. I keep going on about the park, but this is the one thing that separates London from those cities. I could have a beautiful home in any of those places and go to great restaurants and hang out with friends. But when I come here with my dog, I just switch off. I could be in the middle of nowhere.

It doesn't inspire your music, though, does it?
No, but it keeps me happy. It keeps me breathing deeply and calmly and circulating the oxygen and the blood around my body. I find sometimes I'm on stage and I haven't actually taken a breath other than to sing a note, so it keeps me from passing out!

But where you live is nothing like this …
Camden, where I grew up, is the polar opposite. It's punky and gritty and dirty and loud. It's buzzing with energy, and that definitely spawned my creativity, even down to what I used to wear. I do feel that people have judged me or judged my music based on how I chose to present myself to the world: dressing up, wearing girly clothes or fancy shoes, or putting make-up on and having my hair done. That made a lot of critics take me less seriously and not even listen to my voice. There were certain opportunities I wanted to be offered and they didn't happen. The message relayed back to me was that they didn't happen based on my exterior. I was judged, just like you are most of the time in life. It happens.

So are you a little more happy now, content, at ease with yourself both inside and out?
Yes. I am genuinely happy. Stressed, which is normal. I'm trying to branch out into America and the rest of the world as an independent. I have never multi-tasked this much in my entire life. But it's rewarding. I can see what I'm trying to achieve rather than having to call someone to say, 'Excuse me, could you get me that thing over there?'

Delilah in the grounds of Kenwood House (opposite), where she regularly walks her Great Dane Pelé. 'The Heath helps give my brain space,' she says. Delilah and family at play in front of the eighteenth-century Neoclassical villa (above) built on the edge of Hampstead Heath by Scottish architect Robert Adam

Delilah at Cottons Rhum Shack in Camden (left), owned by her family since 2008. The eatery was a favourite haunt of the late singer Amy Winehouse

'I do feel that people have judged me or judged my music based on how I chose to present myself to the world'

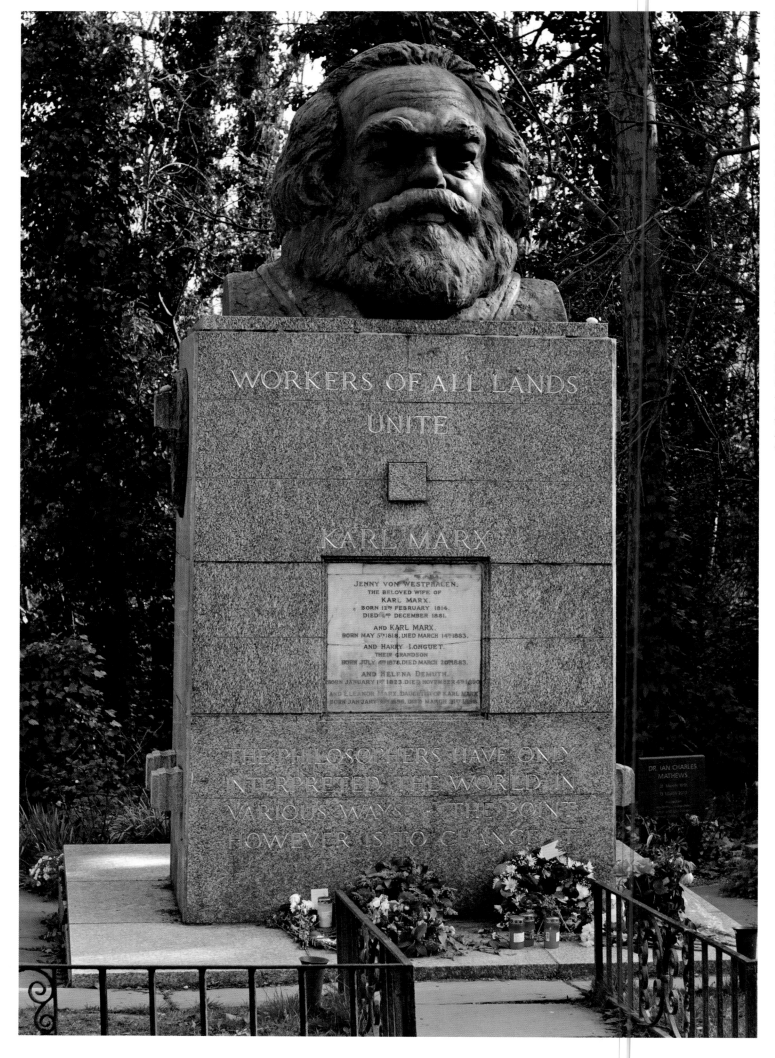

Karl Marx beds down with Malcolm McLaren in Highgate Cemetery. This vast track of greenery in north London is home to some 170,000 souls, most without headstones or mention in the history books. A designated nature reserve, Highgate is one of the 'Magnificent Seven' cemeteries known as sites of both cultural and natural beauty, overseen by their local councils while their occupants wage eternal war between Commie Reds and Pink Punks. Consecrated by the Bishop of London in 1839, fifteen of Highgate's acres were intended for Christian burials, with the remaining two given over to dissenters of all stripes. The list of names vying for attention for ever include George Eliot, Jean Simmons, Eric Hobsbawm, Sir Ralph Richardson, Henry Gray (author of *Gray's Anatomy*), John Galsworthy and numerous unclaimed martyrs, the most recent being Alexander Litvinenko, victim of poisoning by polonium

Miles Aldridge
Fashion photographer/Artist
St James's/Hampstead Heath

You are known for your obsessions with women and colour. How does obsession translate itself into creative endeavour?

Well, the women are usually the medium of the idea; they are the actresses. The colour is used in an advertising way to sell the idea, so that when the viewer sees the picture, they are drawn into exciting colours that stimulate the eye, and then they are drawn into an idea centred around women. I tend to use women to communicate how I feel about the world, so they are filled with anxiety, filled with uncertainty, filled with questions about who they are, where they are going. I'm not judging women and saying, 'You guys don't know what you are doing with your lives.' I'm saying that none of us do. That's really my view of the world, that all of these things that we have been sold, through advertising mostly, but also through our parents and the church, will never make you happy. Happiness is a drug to suspend our questions, for an afternoon maybe.

So if you didn't follow your creative urge, would that make you unhappy?

Yeah. You are very lucky if you are an artist and you can create. The idea that a thought can be translated into an image and that that can be exposed to the public is an incredible luxury for someone to have as a gift that you can share.

Where did this gift come from in your case?

When I was five, I would be sitting on my father's lap, he'd be smoking a big cigar, and he'd be drawing on a gigantic piece of white paper a psychedelic image of possibly a butterfly or a beautiful bird. He was a famous illustrator, Alan Aldridge. So from a very young age I was privy to this idea of something being born on white paper, out of the blankness of an idea. His ideas were incredibly – I mean, to call them imaginative is to almost undermine them. His imagination was unbounded.

Where did your creative relationship with your father lead?

He seemed to work very hard, and then he left very suddenly when my parents divorced. He left a gigantic bookshelf of books behind which I studied and found fascinating in his absence. It was an interesting exchange: a father for a library. There was on that bookshelf Bosch and Brueghel and Warhol and Lichtenstein, but also there were a lot of books on comics. It was a whole visual lexicon that he left me to play with. Rather tellingly, I moved into his studio as my bedroom, so I kind of camped out in his history. Of course I missed him immensely. For a young boy, waiting for your father to come back, wondering if he is coming back, is incredibly upsetting. That certainly has fed into my work. The second big hurt of my life would have been my mother dying a few years later.

"For me, a picture works best when there is a mysterious, inexplicable quality to the narrative suggested in it"

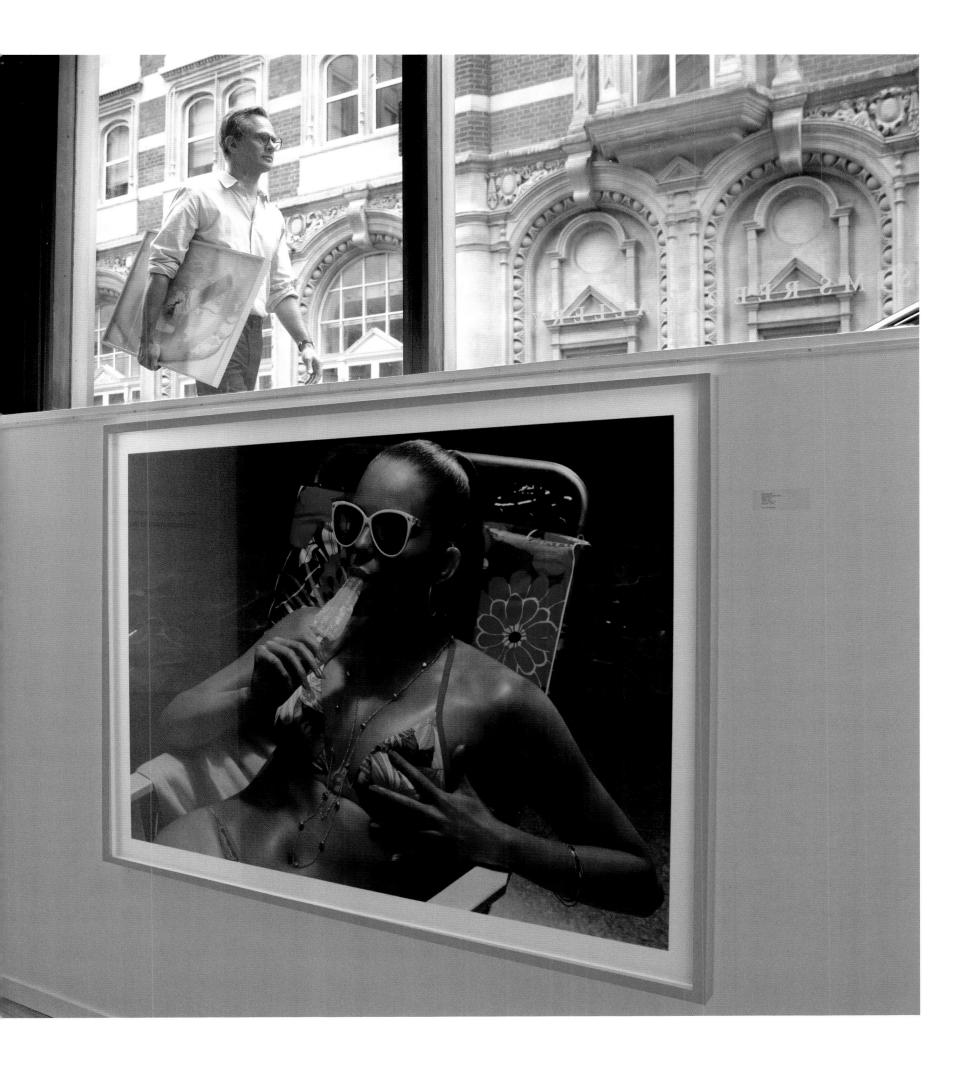

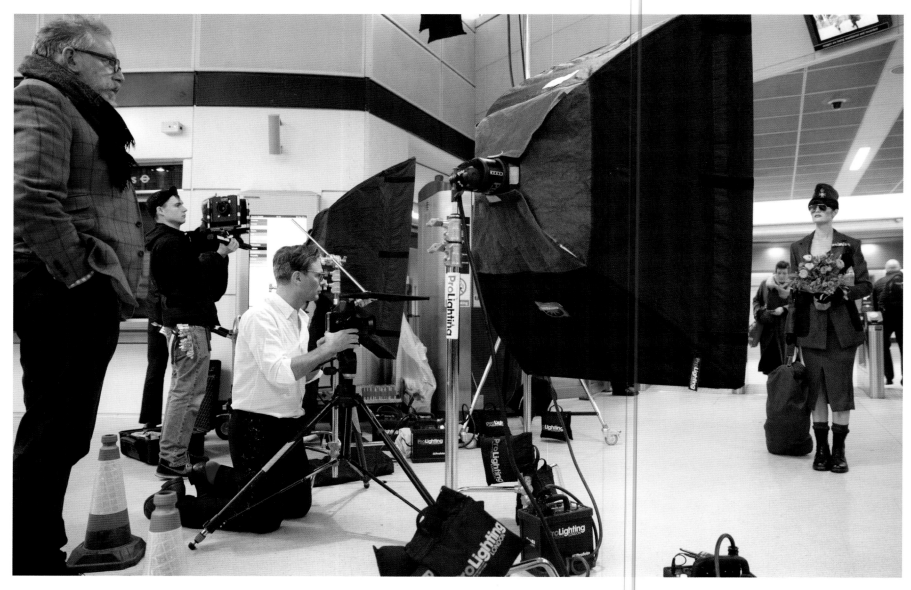

(previous spread) Miles
Aldridge ferries a lithograph
past Sims Reed Gallery in
St James's

Aldridge on a photo-shoot
for *Vogue Italia* with model
Sam Rollinson and a team
of twenty stylists and
production assistants at
Blackfriars Tube station
(above) and a garage in Soho
(opposite)

You seem to have had a charmed life while your dad was around, being collected from school by Eric Clapton, photographed by Snowden, and John Lennon was a family friend …
John Lennon was my dad's friend more than a family friend. My father was as surreal as the Beatles; he was very much part of that London psychedelic coterie of groovy people. Sadly, my mum was not. The distractions of superstardom that my father went through were far too powerful for a conventional middle-class marriage to survive.

Your dad also made album covers for people like Elton John …
He did Elton John a very famous one called 'Captain Fantastic', which is sort of psychedelic Hieronymus Bosch. It's almost medieval; it has that intensity of detail.

It sounds like he didn't mind having you around while he was working.
He was very generous about that. He would typically draw with very loud music on. Me and my sister used to love jumping up and down on the sofa to Jimi Hendrix's 'All Along the Watchtower'. When me and my sister were in the studio he would turn it up very loud and we would play. Very sweet memories of that.

So your father was hugely instrumental in your creative development …
Undeniably, though I started to rebel and was fairly angry with him for having left the family house and made my mother so sad. Then I went to art school, and my mind was opened to Picasso, Matisse and particularly Egon Schiele. The spell that my father had over me started to dissipate. My father never wanted me to go to art school, actually. He was very much an East End kid who came from Romford, arrived in London and then just bluffed his way into the business.

After he left, did your mum struggle to keep the house together?
She did struggle, and she certainly was depressed. She seemed a very defeated figure to me. So in my teens, I had two images of women. One was my mother, struggling to make ends meet, to cook something, to wash up. Like a lot of women I have met since, she was very quiet about her situation. She was all taken inside, while the face was very beautiful and mask-like. This was undeniably something that I translate into the females that I photograph: the appearance of calm but, underneath, trauma.

Looking away from your family for a moment, what are your thoughts about London being a centre for creativity today?
In the '60s, London was an incredible fulcrum. My father used to take me to London because his studio was there, and you'd rub shoulders with Francis Bacon and Lucian Freud. It was a remarkable piece of history. The only foreign influence was Italian coffee, maybe Greek food too. Soho then was mostly ruled by artists.

So what killed Soho?
Capitalism, I would've thought. Bit by bit, Soho has been immensely transformed in the last twenty years. Brasserie after brasserie, it has become much more gentrified and doesn't have a sense of danger.

Is danger an important element in the creative mix?
It is different for different artists. Francis Bacon often spoke about the idea that he lived in the gutter and that's where he found his interesting subjects.

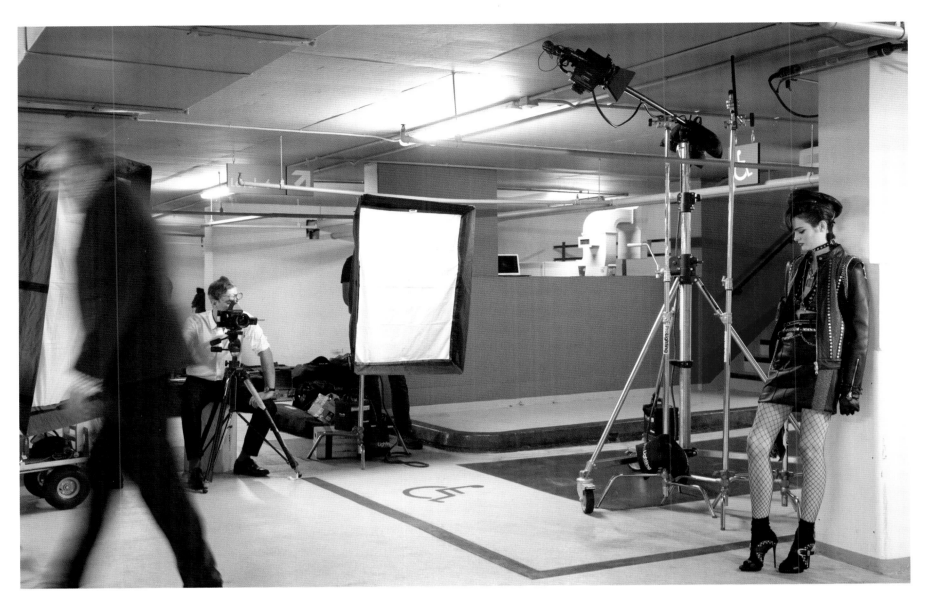

But that isn't where you've chosen to base your own work, is it?
I often think my pictures are about a real moment. My universe is neither the gutter nor the upper echelons of society; I'm probably somewhere in the middle. Through that I have a good vantage point to see the universe at play. I like to see my pictures as the real world viewed as if it were a Hollywood musical.

Fellini-esque really, not Hollywood ...
Fellini is a great guide because he, like Helmut Newton, another hero, was incredibly free with his eroticism.

In professional terms, though, it's the fashion industry that feeds you, no?
That feeds me monetarily? I'm not sure anymore. It used to. I began as a fashion photographer. It was interesting when I got to the point where people would say, 'But do you have any personal work?' I realised then that all my personal feelings – about my mother, about my wife, about my kids – was actually being put into the pictures. I started to understand that you can work in that business – like Helmut Newton, like Avedon – and tell your own story through your pictures even though they are published in a magazine. Of course, now the lines that were clearly marked for people like Avedon and Newton, the fact that you were either a photographer or an artist, have become blurred. The fact that I'm able to work in the fashion industry and produce what I consider art because it is personal seems totally fine.

'In the '60s, London was an incredible fulcrum. My father used to take me to London because his studio was there, and you'd rub shoulders with Francis Bacon and Lucian Freud. It was a remarkable piece of history'

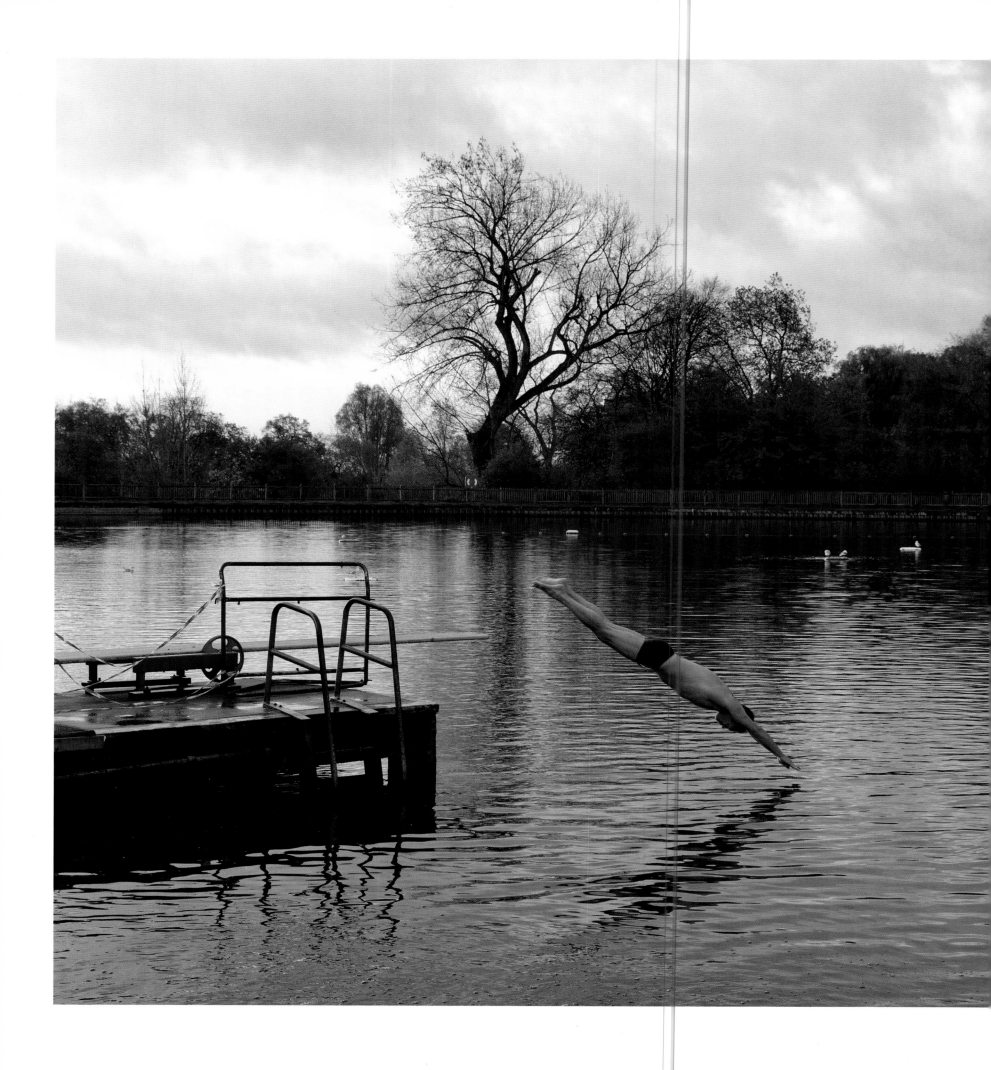

Miles Aldridge

Your oeuvre seems intrinsically entwined with mystery of some sort. Is that self-imposed?

I, like my father, thought that what I really wanted to do was make movies like Hitchcock or Lynch. Cinema became the ultimate art form. Rather like opera at the turn of the century, cinema seemed to take on so many aspects of art that in itself it was art.

In fact there is a sort of operatic quality to your work.

Absolutely. Operas want to be movies, but in the end they are almost more like paintings because they are static and laden with so many symbols.

It seems to me that in your photographs you ennoble your imagery; you imbue it with social, sexual, psychological, even violent attributes, almost as if you expect the viewer to become aroused.

Exactly. I learned that trick from Hitchcock. He spoke about the shower scene in *Psycho*; what he liked about it is that the viewer became a voyeur. What Hitchcock was really saying was, 'How dark are you? How weird are you that you are watching this?'

So your work is revealing to me, to the viewer, that hey, I may be a little bit more fucked up than I imagined myself to be!

That's great to hear!

But isn't this just pornography at a certain level?

Porn is a transitory medium, meaning that the requirements of porn you can probably work out in a few seconds. My images, I hope, are working in a more timeless way, where they linger and ask more questions of you. I've never seen a porn image that makes you want to think about your life, aside from asking yourself, 'Why am I looking at this bloody image?' I don't agree with photographs that are easy to read. The great photographs of our time are mysteries. That's what I'm after.

Do you not ever play with the notion of ugliness?

I don't. I'm guilty of being obsessed by beauty, I think. But what I've learned, by first of all being the brother of a very beautiful woman and then the husband of a very beautiful woman, is that beauty does not give them a free pass to life at all.

There's also an element of fakery in the world you inhabit; you've spoken very openly about it.

Yeah. I work for *Vogue Italia*, which is the greatest fashion magazine in the world. Luckily for me, the Editor-in-Chief understands that people who want to buy Prada and Dolce & Gabbana are not stupid. So they don't need a picture of someone in a dress being happy, because they know that the dress isn't going to make them happy. What they want is a picture of the woman in the dress being more complex. My pictures are trying to be powerful, not to be reportage. Reportage is always flawed because it is slanted from whoever is taking the picture. In the end it is propaganda. I don't use the camera and say, 'This is truth.' I say, 'This is a one-frame movie.'

A keen swimmer, Aldridge dives into the chill November waters of the Men's Pond on Hampstead Heath (left), the only lifeguard-attended swimming area in London open to the public year-round. Aldridge at work at home in Highgate (below) in the company of his cat Monster. He once devoted a *Vogue* editorial, entitled 'Cat Story', to stray felines

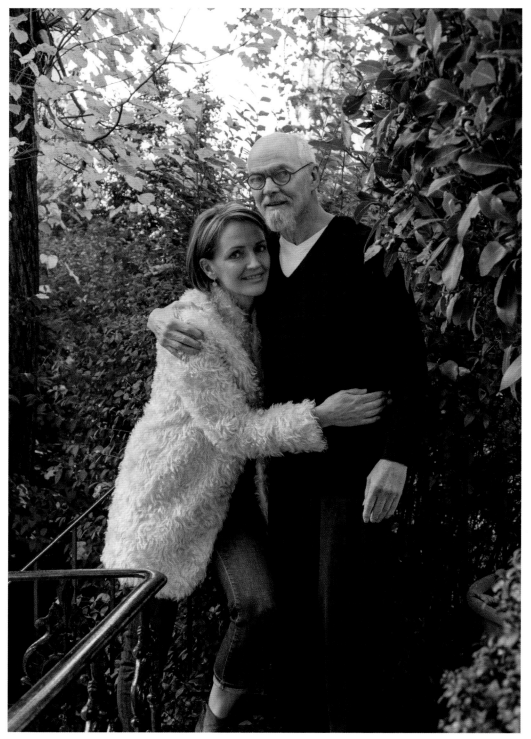

Saffron Aldridge
Model

'I don't like chaos,' asserts Miles Aldridge's perfectionist sister Saffron. Born in 1968 and brought up in Parliament Hill, London, Saffron is the third wife of financier Ian Wace, with whom she lives in Notting Hill. 'If I sit down, I like to look at things beautifully organised rather than a mess, because I like my eye to fall on things that look beautiful,' she adds. 'I think it's just growing up in a creative family, with my father's work and always being taught to see things. When he was drawing or doing air-brushing or doing illustrations for a book, I was seeing them build and grow, watching something beautiful happen ... If that mantelpiece was all a mess, it wouldn't look beautiful to me.'

Known for her 'sparkly emerald eyes and sexy laugh', Saffron (who likes to eat but not to cook) was described by Ralph Lauren (who gave her a modelling contract when she was only nineteen) as a 'latter-day Lee Radziwill'. 'My father always says to me, "You should have been short and unattractive because you would have been more successful,"' Saffron jokes. 'He believes in my business brain.' Saffron's first job was modelling jewellery for *The Field* magazine; she was approached by a scout at sixteen while flipping burgers on a stall in Camden Market. About being a Ralph Lauren model, she says, 'It was exciting and fun, but brave. I lived in Paris at seventeen. I didn't even have a phone in my apartment; they didn't let the models have phones in the apartments, and nor did you have mobile phones. So you were completely left alone, and you learned a lot.'

Today Saffron is a freelance journalist and Women's Editor of *GQ*, as well as being a dedicated fundraiser. 'To be successful,' she says, 'you have to put in the effort, be able to take knocks, and learn not to take rejection personally. If you can keep your head together and remain grounded, you can really make it work for you.' Oddly, given her great natural beauty, she confesses to never having had any confidence. 'Any job I did, I felt insecure,' she remembers. 'That's a horrible feeling to have every day.' Then how does she fit into the Aldridge family's creative mix? 'I can't draw and I'm not inclined to take photos, particularly, but do I have a creative head?' she asks rhetorically. 'I probably do, the way I see things. I love looking at art, I love being around artists, I love the whole process of art. I just can't facilitate it myself, but that's okay!'

Saffron considers her children to be her greatest achievement in life. 'Leaving them aside,' she says, 'I think it's managing to have dealt with a lot of chaos in an ultimately elegant way as I've grown up.' Perhaps experiencing the family traumas of separation and loss made her a stronger person, 'possibly too strong sometimes. I say I'd done the three Ds by the time I reached thirty: death, divorce and depression. Some people don't deal with those issues until way later on in life. Of course it makes you stronger, but it also makes you a fighter, and sometimes being a fighter is not always the good way. Softness is very attractive.' Despite having lived in many big cities, Saffron feels most at home in London. 'I'm not particularly adventurous, so I haven't really gone out and explored too much. I like being familiar,' she notes. Life is too short to argue about the little things, she believes. 'If you walk past a tree that is eight hundred years old and you figure yourself to be eighty, you're 10 per cent of the tree. We come and go so quickly compared to nature.'

Saffron Aldridge with her father (opposite), the famed '60s artist, illustrator and graphic designer Alan Aldridge, whose work embodied British psychedelic art of the time. He worked with everyone from the Beatles to Elton John, starting out as a freelance 'East End boy' and becoming Head of Marketing for Penguin Books. A flirtation with Punk in the '80s was followed by a move to Los Angeles. 'I never had a favourite artist,' he once said. 'I was always my own favourite artist'

Saffron Aldridge in front of Alice's Antiques on Portobello Road in Notting Hill (right). Originally a typical London food market, Portobello Road Market began expanding into antiques in the 1940s, and was made internationally famous by Richard Curtis' 1999 romantic comedy *Notting Hill*

Mary Portas & Melanie Rickey
Retail consultant/Broadcaster
& Journalist/Fashion editor
Primrose Hill/Bloomsbury

Mary, do you think of yourself as a pathfinder, a ground-breaker?
MP: I would like to think that's what I do, try and challenge the sea of thinking. There are lots of things that I've been first at doing.

Like what?
MP: When I was in Harvey Nichols putting young artists into windows, that opened them up as a gallery. I didn't do it commercially. If you stop people and they are connecting to something visually and emotionally, that becomes much more powerful than trying to sell it. I put on Thomas Heatherwick, who went on to design the London buses and the Olympic torch. At Harvey Nichols, we nearly got closed down because we put his sculpture coming out from the windows, this huge, snaking sculpture.

How many years ago was that?
MP: This was 1996. And we got the D&AD Gold! No-one had ever given a D&AD Gold to a window; it normally went to an ad campaign or whatever. That was beautiful because it was being able to think about fashion retail in a purely creative way. I've tried to put that at the centre of everything I've done since. But not all clients allow you to do that, so you have to connect with them and then try to get to that.

But success breeds greater permission to be creative, right?
MP: I would imagine that's right.

You talk about engaging rather than selling to customers. Isn't that just pulling the wool over their eyes? In the end, they have to put up the money regardless.
MP: I certainly wouldn't think of it like that. One of the things that I did was I redefined charity shops. Charity shops were the blight of the high street. So I thought, What if you put respect and love into a beautiful place where people wanted to be, that was connected to the community and run by the community and was a proud extension of what that community is? If you looked at a charity shop like that, would that work? Of course that works because what happens is that people then respect it and give you good stuff. Instead of selling it on eBay and thinking, I could get £50 for that, you think, It's going to be doing something good for someone who has less than me.

So have you been turning the high-street experience into a branding exercise all its own?
MP: Advertising isn't relevant the way it used to be. Now the messages that come to us from the way your hair is or what you are wearing will tell me what kind of person you are, as will the way you speak or connect with me. Subliminally, the way you are is expressed all the time in a way that is more powerful than an advert telling me why I need something. All through my career I've tried to do that, like in Harvey Nichols. When I saw those huge windows, I thought, Why do I have to put in stuff to make people buy it? Why can't I put in stuff that makes them happy? The by-product is that they buy it, that they come into a place that inspires them and that makes them feel like 'This is like me; I want to be in here; I want to be in a place that understands me.' You might call it pulling the wool over their eyes, but I do it from a place of respect.

Melanie, you are a fashion writer; you have a long career in major newspapers and magazines, and you were one of the founding partners of *Grazia*. Regarding the fashion industry, Google attributes £21 billion directly and £6 billion indirectly in revenues from this industry to the UK economy. How does that strike you?
MR: Well, the richest man in Spain has a fashion company, the richest man in France has a fashion company. That tells you a lot about the power of business, and therefore about the power of fashion.

We see a consistent pattern, whether psychological or social, of people needing to be seen as beautiful or aspiring to be beautiful through an accessory or a piece of clothing, so in effect trying to buy a dream, when life's realities are far from the Dior-esque ads thrown at the wider populace.
MR: That's the idea: brands want you to buy into their dreams. But you also need to look at what those houses generate for charity. We are starting to get a different conscience in the mainstream that is driven by a new youth group. I don't think we'll ever lose the beauty and the drama and the creativity, because they create the wealth for those businesses, but we will look more and more at what they are giving back. Anyway, should we ask why we celebrate art? If we stop art in that way, if we stop creativity in that way, we stop joy.

Where are we now in the history of fashion, Melanie?
MR: We are in a strange state of flux because fashion has suddenly become very global, through Instagram. If a fashion show takes place, the whole world can see it; items from the show can be sold immediately. The way that fashion is now being communicated online and via Instagram is moving power into different people's hands among the millennial generation.
MP: It's less elitist, isn't it, although the luxury brands will still have the upper hand for a very small percentage of people.

But then you have this perpetual game of Snakes and Ladders, don't you? Plus there aren't any characters today who equate to, say, Grace Kelly or some other big star.
MP: I don't think those idols ever go away. Idols are different now.
MR: Victoria Beckham is the wife of a footballer who was a pop star. Or take Kim Kardashian, a powerful figure who stands for absolutely nothing. She wanted to be fashionable, and now she is. She is accepted by the fashion people. That's what she has achieved, that's her contribution. She is an It Girl. And fashion needs It Girls.

If the world of fashion were to become one of total equality and everyone had access to everything, all fashion items would become mundane, boring, normal, non-aspirational, wouldn't they?
MP: Of course. Look at the behaviour of the brands. They will do anything to move upwards creatively and culturally. This is where the arts come in. You start to worry about the arts and how they will respond.

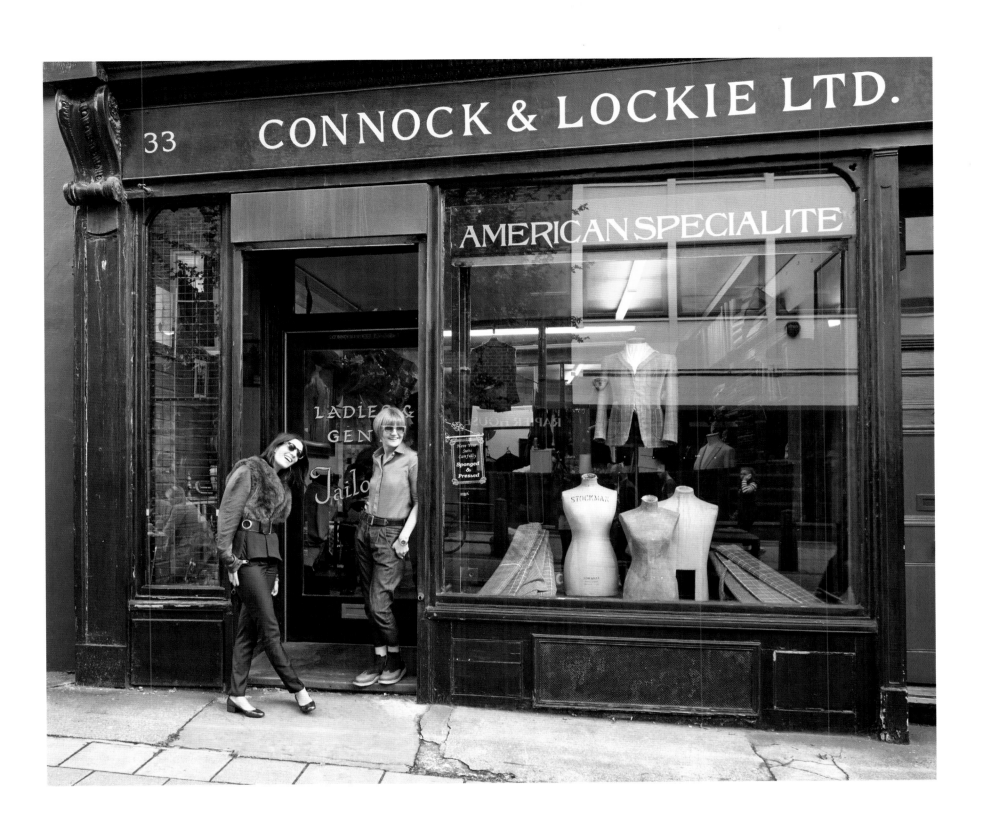

'If you stop people and they are connecting to something visually and emotionally, that becomes much more powerful than trying to sell it'

(previous page) Melanie Rickey and Mary Portas outside Connock & Lockie Ltd., bespoke tailors on Lamb's Conduit Street. Portas is a crusader for the preservation of high streets with independent shops, of which Lamb's Conduit Street, in the two women's words the 'premier menswear street in London', is a prime example

Rickey (above), always on the lookout for new talent, strikes a pose backstage after Ed Marler's 2014 London Fashion Week debut with Fashion East. A recent graduate of Central Saint Martins, Marler received business mentoring and a place in a top international showroom in Paris thanks to support from Fashion East

By selling their souls, basically.

MP: You could go on for ever about it … It's understanding culturally what it is that people aspire to. We've had some of the ugliest fashion possible, from UGG boots to Crocs, that have made fortunes out of being ugly. It's about understanding the flavour of the time and knowing how to lead that.

MR: Also, fashion changes the way it communicates with you all the time.

What are the creative elements that feed and inform those changes?

MR: When we started *Grazia*, we had a dialogue with our audience that we could build up; we could tell them things that they could not know themselves. The Internet grew, so they could find those things out on the Internet. We had to adapt the way we spoke to them because they could find information elsewhere.

MP: The truth about fashion is that most people do not feel confident about it.

But you are a very confident person, Mary.

MP: I am a confident person, but that's because I've spent years in the business and you imbibe it. Friends will say, 'Have I got this right? What's in this season?' Most businesses try to pick up on that. It's guiding and it's inspiring. People talk about their *faux pas* when they were young; having the wrong hair tie or the wrong socks made them feel that they weren't part of the right club. It never goes away.

In London today there is all this bubble and bustle around fashion. Mary, what is the potential for London as a powerhouse of fashion on a global scale?

MP: I have travelled to many fashion capitals and I think you'd be hard pressed to see people who are quite as individual as Londoners. What London is brilliant at is innovation. Some of the best designers in the world come out of London. When it comes to the big marketing and globalisation of fashion brands, we fall short. There is something in this where we don't like the idea of becoming too populist and big. We want to remain a bit kooky. We want to remain a bit left of centre.

MR: London is about originality.

MP: It's about originality, yes. When you look at the big-name American designers, Ralph Lauren and things, they want to be global. It's very commercial and it gets a bit boring.

They've become stylised and controlled.

MP: They are styled. They are stylists.

MR: Unashamedly, Ralph Lauren is about nice Americana, Tommy Hilfiger is about nice jeans and jackets, everyone is about very wearable things, whereas London prides itself on being original. McQueen started so much. Galliano, Westwood, these were designers who pushed the boundaries. Look at the next generation … They are doing not un-wearable clothes and are building strong businesses. People come to see their shows from all around the world.

MP: That's true, but if you said to a Chinese person, 'Have you heard of Peter Pilotto or Roksanda Ilincic?' they won't have heard of them. They *will* have heard of Ralph or Alexander Wang. We are not that great at doing that global thing; there's a part of us that just wants to do really brilliant and innovative work. At the core, that's what London is about. That's why people come from other sides of the world, to feed into that.

What is this engine that feeds the resulting multi-cultural, multi-faceted juggernaut?

MP: The engine is that it's hard and it's mad and it's fast. You've got to work London, you don't just get by in London. The creativity bubbles out of the sides; that is what is unique to this city. Look at New York. You do not see the fashion in New York that you see in London.

Portas and her dog Walter chat with shop manager Krissy Marton (above) at Mary's Living and Giving Shop in Primrose Hill. Portas pioneered a collaboration with Save the Children in 2009 to create a series of charity shops as both attractive retail destinations and community hubs

Regent's Park Road Bridge (above). Portas and Rickey bring their son Horatio (opposite bottom) to the bridge regularly to watch the passing trains. The couple stroll with Horatio and Portas' daughter Verity through Primrose Hill (opposite top). 'It's full of slightly mad English eccentrics,' Portas says of the area. 'Something which I hope to be one day!'

How will fashionable London change in the near future, Melanie?
MR: People *are* building global businesses. Give them three or four years … There is a very important growth period going on. There is a lot of investment, people in hedge funds wanting to invest in fashion brands.

So after collecting art, they will collect fashion houses?
MR: Yeah. There is a gold rush happening in London around fashion and fashion technology.

Let's talk a bit on a more personal level. Mary, you were brought up on the wrong side of the tracks.
MP: I had a working-class background but a very loving upbringing. My mother died when I was sixteen, which threw everything up in the air, really.

Were you close?
MP: She was the matriarchal constant, this strong, wonderful, loving woman who made our lives fantastic. My father was the typical working-class man, went to work, came home, that's it. Everything was looked after. When my mother died, my elder siblings had just gone off to university, one had gone to work, and I was left looking after my younger brother. I ended up running the household. That's when responsibility fell on my head for the first time. And then my father died. And then we were homeless.

So you went from becoming homeless to becoming the Queen of the High Street.
MP: Queen of Fuck Off, I think it was.

When did your aesthetic tableau start to appear?
MP: When I was at Harrods. I was going to be an actress and I got into RADA, not realising how difficult it was. I couldn't go because my father suddenly died and we had no money, so I did what was second-best, became this attitudinal, awful eighteen-year-old and went to college to do retail design. I hated every minute. I eventually got a job at Harrods and fell in love with fashion. This was in the '80s. I was able to start working with fashion to create the nearest thing I had to theatre.

Melanie, you also had a death in the family that shaped your life.
MR: I lost my sister to leukaemia when I was twenty. That was the turning point for me in terms of making a decision about the career I wanted to go into, working towards that, gaining an immediate foothold in the *Independent* and spending the next ten years going from newspaper to newspaper. Which was a wonderful and huge learning curve. Then I took all of that information into *Grazia*, which we built up to be very successful.

And you two are married, or you have a civil partnership …
MR: Civil partnership.

And you have three kids. Do they all live with you?

MP: Yes, and the ex-husband comes round for Sunday lunch.

MR: It's all very friendly.

MP: You know, when I went into the public eye in 2007, there were very few gay women there before me. I was even advised not to mention it. I'd like to think it's helped a lot of other people say, 'Hey, this is the way that I live my life.' I've realised that, even in our little playgroups, there are three sets of gay parents. And we have such a normal, vibrant family life, such a happy home. Our two-year-old is the happiest person you'll ever meet.

How do you think of your legacy, both of your legacies, to the fashion scene in London?

MR: Success is about having a solid base. It's about having a solid relationship, a solid home and home life, and that is like your trampoline to get out into the world and do what you do.

MP: Yeah. I used to describe it as being like those swing balls you used to play with as kids. If you don't have that centre, you can't swing. You can't go off and hit the ball. For us it's relationship and family, maybe because we both lost it so young. I have this enormous security at the heart of the way that I live my life, so if all else goes, that's still there. I hope that people will see that what we try to do is challenge the status quo but in a beautiful way, a good way. When you mentioned pulling the wool over the public's eyes, it's not what I would ever do.

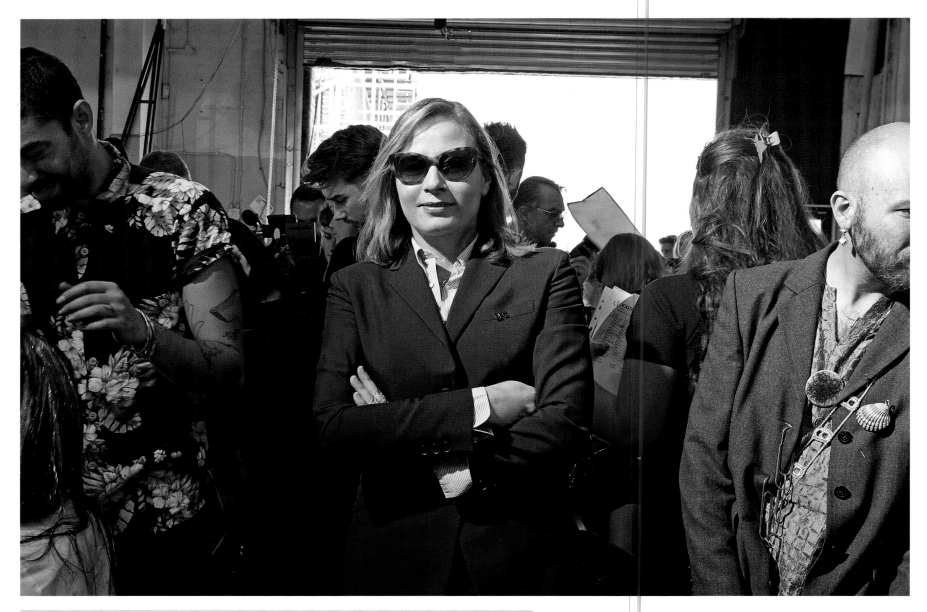

Sarah Mower
Fashion ambassador

The British Fashion Council's Ambassador for Emerging Talent and Chair of the NEWGEN selection panel (of which Melanie Rickey is also a member), Sarah Mower declares, 'I wear British designers on principle, but that's so easy nowadays because, frankly, all the best people are British!' The NEWGEN panel, which chooses young designers to receive sponsorship from the BFC, has helped such talents as Erdem and Simone Rocha achieve success. Also a founding member of London Showrooms, Sarah was brought up in Bath and lives in Hammersmith, where she finds inspiration in her early-morning runs with her dogs. Her first job in journalism was with Ms London Magazine; she has also served as Fashion Editor for the *Guardian* and done stints for *Harper's Bazaar* and *The Times*. Now a professor at Central St Martins and the Royal College of Art, she was made an MBE in 2011. 'What I realised a few years ago,' she muses, revealing the extent of her contacts as well as her imagination, 'is that if I don't know how to fix something, I probably know a woman who does.'

Sarah observes that most people would 'find it difficult to believe that the very streets where TV cameras recorded looting and burning' during the riots in the summer of 2011 are also home to 'the most impressive British small fashion businesses of the past twenty-five years'. She cites 'collective action, co-operation, generosity and camaraderie' as the factors behind London's success as an international fashion centre.

'Once the hopeless, ridiculed, self-lacerating underdog everyone wanted to abandon', the city 'has been transformed by a cultural shift that began about eight years ago: graduate designers started helping one another; the British Fashion Council rebooted and started looking outwards; the world around us opened up; and a group of senior professionals like me decided to stop moaning and get stuck in'. Sarah took the role of Ambassador for Emerging Talent because she 'was frightened. We had so much talent which was just getting started in the first half of the 2000s, but banks were crashing and I was afraid our designers would be swept away'. Early influences include her aunt, whom Sarah describes as 'a fashionable woman ... When I was old enough to go into town, I would go to the Bath Museum of Costume and started doing fashion drawings. My aunt swept in one day, saw them and gave me a subscription to *Vogue* ... When I was young we were always buying clothes from jumble sales, restyling them, but I never thought it could be a career!'

Sarah admires 'how colourful London is now' when it comes to fashion. 'There was a period in the '90s when people just wore black,' she remembers. 'But these kids are all about colour, all about exuberance, despite the fact that life is so tough. They have no fear about dressing up and enjoying themselves. That's the most amazing thing that fashion can give you.'

Sarah Mower, a force in new British fashion, backstage (opposite) at 2014 London Fashion Week. Melanie Rickey and Mower (below) keep track of emerging British talent while discussing the show (right) with Ed Marler and his models

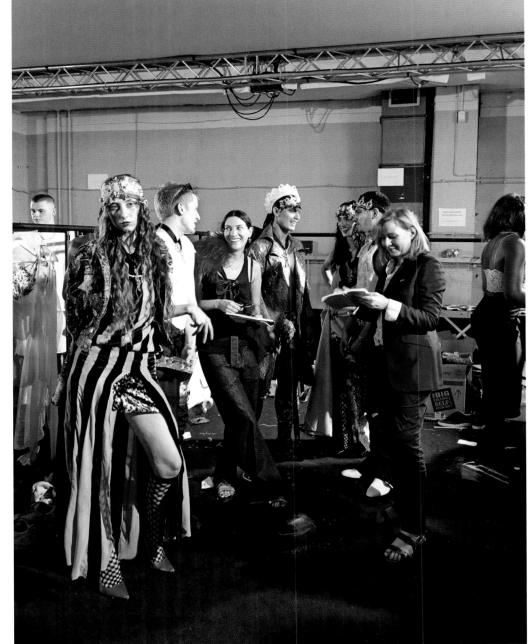

Gilbert & George
Artists
Spitalfields/Bunhill Fields

In a way, you two epitomise London's changing face in contemporary art and culture. You've become the cultural icons of your neighbourhood. For how long have you lived in the area?

George: Nearly half a century. We say that to take a walk around our neighbourhood is to take a walk around the world. The thoughts and feelings and visuals exist anywhere where there are people. What is happening in Brick Lane or in Spitalfields will almost certainly be happening somewhere else in the world tomorrow. It is sort of the beginning of things.

Gilbert: There used to be old Jewish factories here. They wanted to demolish everything, and some artists came here to live in one of the oldest parts of eighteenth-century London. It was restored and has become more and more the centre of the world, we feel. We used to say that Liverpool Street Station is where the rich and the immigrants and the artists are all mixing up together. The richest place in the world must be the City, where all the money goes through. Five minutes away is Brick Lane, which is famous in another way, and then all of the artistic culture ended up here in the East End. There is a certain freedom here. Here everything is boiling.

George: It's always moving. First it's Hoxton, then it's Spitalfields, then it's Dalston. We believe that it is super-modern, super up-to-date, but all of the history is here as well. All the great railway hotels are still here, all of the eighteenth-century buildings. This street was named after the Huguenots; the Edict of Nantes threw all of these people out of France. The next street is Wilkes Street, named for the man that invented freedom of the press. There is modernity and antiquity and the future side by side. Isn't it wonderful?

London has had more than two thousand years of history and was an imperial centre for more than two centuries. Aside from the military skill and acumen that transposed the Empire across most of the world, what role did English culture play?

Gilbert: Darwin was English, and so was Alan Turing, who invented the computer. They changed the world for ever.

George: The Empire had its own attractions.

Walking down the street here, you might meet someone from Pakistan who hardly speaks any English and other people from different cultures. Does traditional 'London-ness' or 'English-ness' exist anymore?

Gilbert: London's the new Babylon, don't you think? Nobody can understand each other, but it is all happening.

George: People are coming from all over the world. For years we used to get stopped by people on Brick Lane who would say stuff like 'I am concept artist from Bulgaria.' Now, they say stuff like 'I am curator from Slovakia.' All curators suddenly. The only English language we hear in the evenings is from Americans, Australians and South Africans. No Cockney person would go to our restaurant, no indigenous person.

What's happened to the Cockneys?

George: They are in Bethnal Green. We are their favourite artists. They are keen on us because they always thought that artists came from somewhere else. Finally they found some artists who were in their community.

So do you think of yourselves as London's Pearly Kings of Art?

George: The acceptance is extraordinary. A lorry driving through the docks at Commercial Street stopped us, and what did he say, Gilbert? 'Oy! My life's a fucking moment; your art's an eternity!' The ultimate compliment! Then he drove off.

This art that you speak of: would you describe it as art of the people, as representative of the street?

George: We always said, 'Art for all!' That was our earliest slogan, from '68.

Gilbert: We are searching for ways to live. I think that's what the artist is doing.

Has any component of your art informed the debate around the evolution of contemporary London culture?

Gilbert: Oh yes! It's not part of religion or politics, it's culture and freedom to be able to challenge boundaries and accept more, like with sexuality.

George: When artists and writers and poets and musicians say that fucking about is okay, politicians have to say that fucking about is okay. If not, they'll be voted out. No young person goes to the police station to check on how he should behave. No-one sees a priest to find out how they should behave. They go to a pop concert or a museum, a bookshop or something.

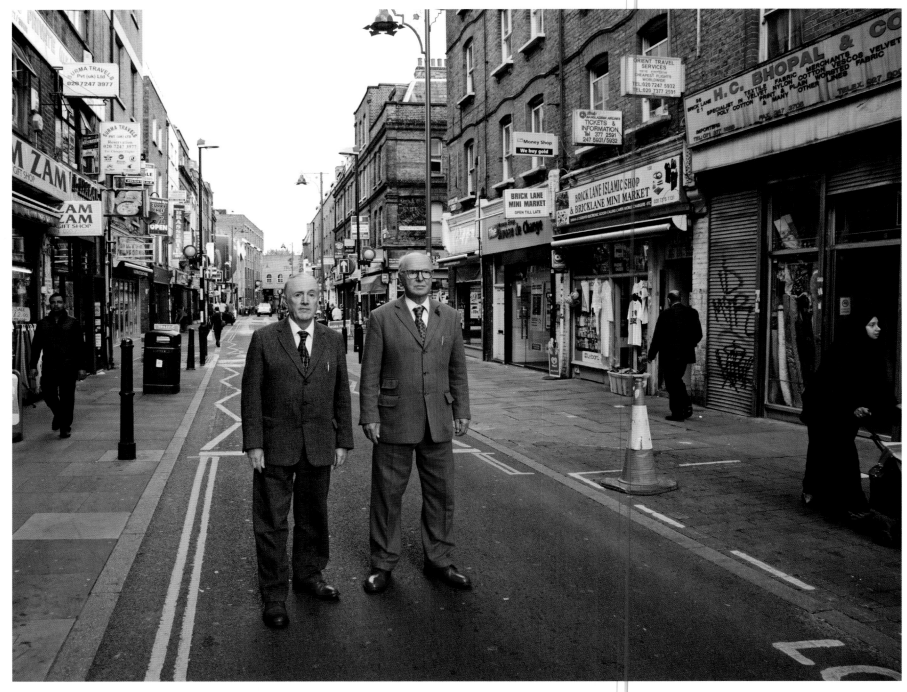

(previous page) Gilbert & George take an important call in Spitalfields, in one of London's famous red telephone boxes. Designed for the Post Office by Sir Giles Gilbert Scott in 1924, the 'currant-red' kiosks are as much a symbol of London as its red buses, though they remain prey to vandals and have become increasingly rare since the advent of mobile phones

The artists strike their trademark pose (above) on Brick Lane, once a site for the digging of brick-earth, now famous for its Bengali curry houses. The Brick Lane Jamme Masjid (just outside the picture) was formerly a synagogue for Jewish immigrants. Earlier still, from 1743, it served as a church for French Huguenot settlers escaping persecution. 'The question is, what will it be next?' George wonders

Gilbert & George's local graffiti-covered pillar box (opposite), the insignia of Queen Elizabeth II barely discernible among the competing signs and seals of local and itinerant royalty

But when you started out saying these things, you were thought of as oddballs ...

George: We said that we were conservative, and that was a big sin in the art world. Waiters, taxi drivers, with anybody else it's fine, but in the London art world, you're a Nazi child-molesting motherfucker if you're conservative.

Have you stayed true to that line despite other people's perceptions?

George: We believe in the individual.

Gilbert: There is a free market for art, and if you want to represent free people you should be able to make what you want and say what you want as well.

Enoch Powell predicted in the 1960s that unfettered immigration and the mixing of races would lead to rivers of blood. Fifty years on, do you see that happening or not?

George: It is part of an amazing celebration. We think everything is very positive in that way.

Gilbert: We are very optimistic about the future.

George: We like young people, we like what they are doing. We like it because we are in the middle of it. I don't know where we are going, but we are going somewhere.

One side of your street is bookended by a church, and on the other side is a mosque that used to be a synagogue. Do you experience these constructs as religious encroachments or ever feel intimidated in your own neighbourhood?

George: No, not at all! We think it is fantastic.

Gilbert: We are not frightened of anybody.

What I have in mind are the parts of the Middle East that are under the control of Isis. Three-thousand-odd Europeans are going out there to fight, with five hundred or so Britons among them. The fellow who is beheading Americans and Britons is known as Jihadi John from the East End ...

Gilbert: We are fighting for two values; that's the battle that is going on. It's medieval, what is happening out there, don't you think?

Given your success, you could have easily moved down to Chelsea or Mayfair. Why didn't you?

Gilbert: It's dead down there.

But there are artists who frequent those areas ...

Gilbert: Who? Give me names.

So you believe that your creativity is partially down to living where you live? If you were sitting in Mayfair you'd be twiddling your thumbs?

Gilbert: We feel the world here. We have to feel the world. Our emotions when we go for a walk in the street, what we feel, are so complex. It wouldn't be the same in Chelsea.

George: We are affected by London, but we have also affected it. We are making tomorrow.

Gilbert: We are helping to make people go to art galleries. Very few people used to go even to the Tate; going to a private gallery was unheard of. It was a place for posh people to entertain each other. Now everybody is going. They all want to see the new freedom that is brought about through art. That is a new religion, this freedom of thought, individuals who experiment in different ways with how we could behave.

George: A gallery in the '70s was like a posh jewellery shop or a posh furriers. You wouldn't go into a shop like that unless you were intent on buying something, right?

Gilbert: I remember the first gallerist we showed with. He went out to dinner with a posh lady and we were not allowed there 'cause we were poor artists.

This great churn, the powerful creative production house that has become this great city: are there any European parallels?

Gilbert: There is no other such city in Europe, not even Berlin. France is totally standing still; it's dead. All the other countries are so deep in recession that they don't know what to do.

George: So all the great artists from these places are here.

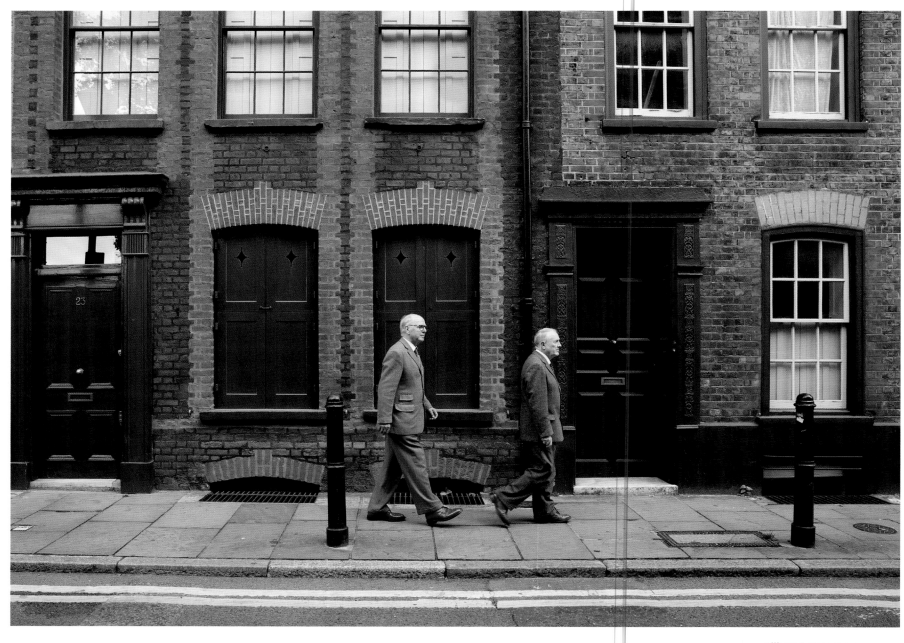

'London's the new Babylon, don't you think?
Nobody can understand each other,
but it is all happening'

Gilbert & George on Fournier Street (above). The neighbourhood was originally occupied by silk merchants, with many of the houses dating from the 1720s. Fournier Street became infamous in the 1880s due to the association of the Ten Bells public house there with certain victims of Jack the Ripper. 'Nothing happens in the world that doesn't happen in the East End,' George boasts proudly

In effect you are the East India Company of modern London. You have helped establish the new order while becoming part of the Establishment even as the system has spurned you and you've been sidelined by the critics.

Gilbert: We never won, but we never lost.

George: The late Michael Sullivan loved London because he said it was like a polished coffin. Which it was, but now Paris is the polished coffin. There are still brass rails in shops that have been there since the 1890s, still that same dark green paint all over Paris.

Is there no chance that they will drag you out of here except in a polished coffin, then?

Gilbert: We have already set up a foundation, the Gilbert and George Centre, and that is going to be everything that we have.

Did you do that with the intention of promoting your ideas of creativity?

Gilbert: No. We want a legacy and we want it to be examinable: our designs and how we made them. Like William Blake – he had a visionary idea. To show that it is beyond just painting … It is a vision of living.

Is there an artist or writer that you both particularly admire?

Gilbert: Obviously William Blake. He personified what you could call looking at the world in a different way.

George: He has an amazing follower in me. Bunhill Fields, where he's buried, was a cemetery for all of the people who weren't part of the Church of England. We visit the graves there. There's Daniel Defoe, the famous author, there's John Bunyan, the author of *Pilgrim's Progress*, and there's William Blake. Only one grave still gets flowers, and that's William Blake's.

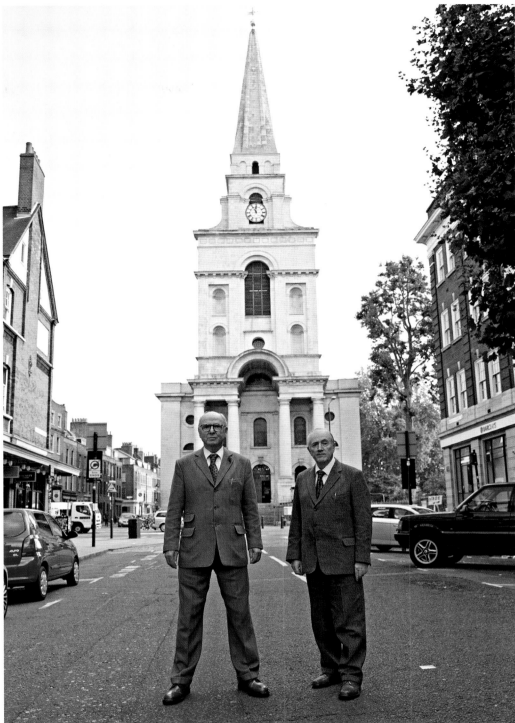

Gilbert & George pay homage to poet William Blake (left) in Bunhill Fields burial ground, a cemetery founded in the 1660s for Noncomformists, radicals and dissenters. Among the 120,000 people interred there are John Bunyan, author of *The Pilgrim's Progress*, and Daniel Defoe, who wrote *Robinson Crusoe*. Blake's and Defoe's headstones stand side by side, dissenters in the hereafter

Gilbert & George (above) in front of Christ Church, Spitalfields, completed in 1729 by Nicholas Hawksmoor, a student of Sir Christopher Wren. 'Christ Church was voted one of the most famous buildings in London, and we were voted one of the most famous couples in London,' the duo proclaim unabashedly

Jude Kelly
Artistic Director, Southbank Centre
Shoreditch/South Bank

J

Where do you live in London?
I live in an old coat factory that has become a fashionable set of flats. Opposite is what they used to call the Packington Estate, infamous for gangs, knife crime, really quite a dangerous area.

So it's been transformed within ten years, twenty years?
I suppose about fifteen years. Fortunately, it's retained some of its original communities. You've still got working-class people, you've still got social housing, you've still got some of these people who go back for generations here. This bit of East London that stems from King's Cross to Angel, then down to Hackney, has become one of the most coveted places to live. Also, anywhere that has reclaimed water, you'll find that anybody who has leisure time starts organising their life around it. Instead of people coming along here heads down, ready to go into factory work, the barges going along with the horses, now people have changed it into little houseboats with beautiful gardens.

How does this transformation occur when artists inhabit a place and then it becomes something else?
Regeneration is one of the most political and complex areas, whether inside yourself or inside a community or a city. One of the reasons it is so contentious is because if it happens organically, then it is the natural flow of change. It takes a long time. If you accelerate it through urban planning, then some of the things that were unexpected consequences of change get swept away. That's one of the areas where people really fear regeneration, because it's not really regeneration, it's engineering. It's very hard now to have subculture because as soon as a subculture starts arising, someone commercial spots it and turns it into a commodity very, very quickly.

Speaking of being quick, for five years now you've been the Artistic Director of the Southbank Centre, London's largest cultural institution, if not Europe's. You've talked about being dogged by creativity and observed that creatives have a certain sense of madness …
You have a certain destiny to follow for a place or an idea and you feel some urgency about helping that destiny to be realised. It is a sort of mission.

That mission isn't inherent in everybody. Even if people have it, it might not be tapped into.
It's interesting about how you discover early on a sense of urgency and desire for purpose and apply it to things or, when something hits you – perhaps an injustice or an excitement – it draws from you this sort of drive and motivation. When you see pictures of me when I was four, I probably would have had the same physical position that I have now. I've always been leaning forward with my hands on my hips saying, 'Let's go!' There is something genetic about the desire to see things happen. So much that has led me to succeed, I got from the values of my family and my neighbourhood when I was growing up.

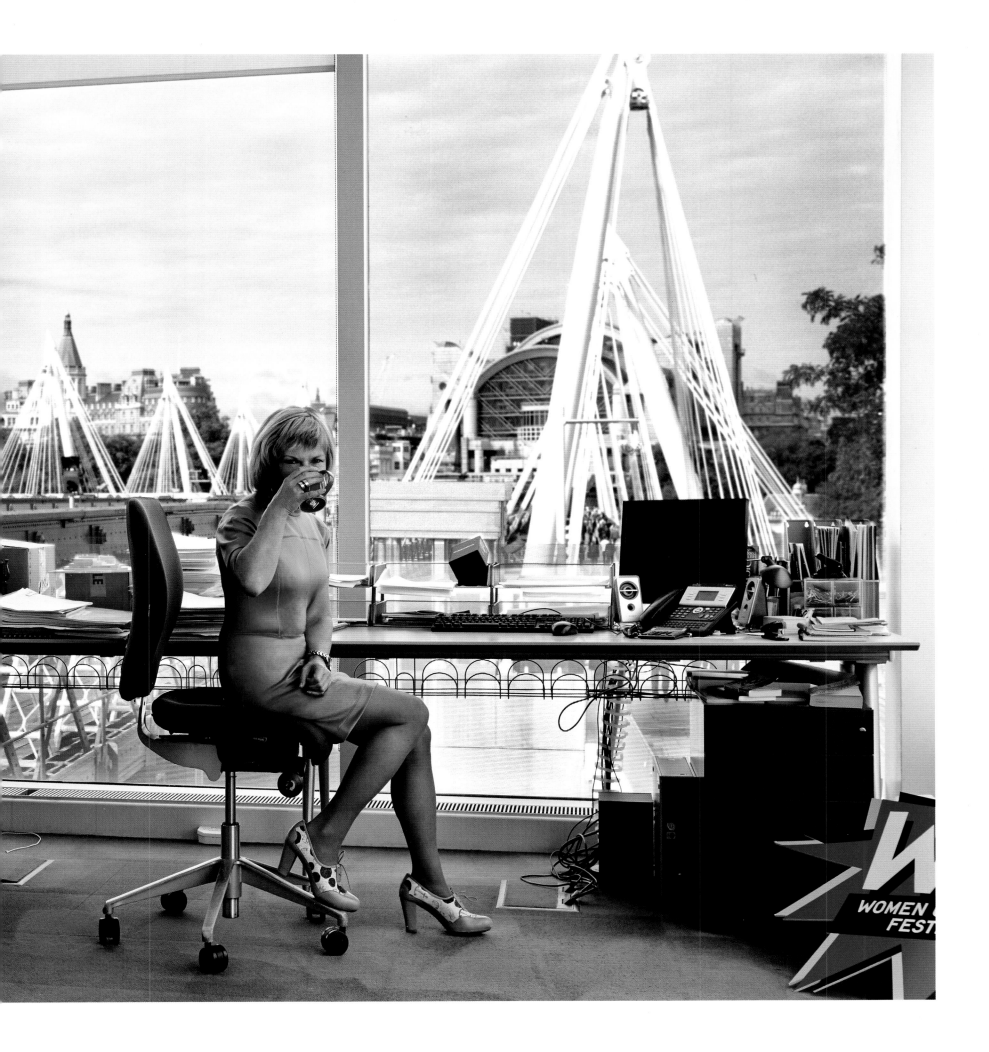

Like what?

That everybody should be included in the conversation. My father, one of ten children in Liverpool, was brought up as a second-generation Irish Catholic; my mother was Protestant at a time when those two communities didn't marry. But they did marry. We lived for the early part of my life in Liverpool on Parliament Street, where there was a Chinese community. The second community that moved in were African sailors, and the third community were the Irish. The idea that you lived in harmony with different voices that had different stories was really powerful. I've always been interested in stories and in making art, and I was always frustrated if the people who came to see the plays I put on in the garden were just the neighbours that looked the same as me.

You've observed that the Second World War democratised the world, so that within every class there was a hidden store of talent that could be utilised for social good or perhaps creative enterprise. Can you say more about this?

Trauma galvanises people to make changes. I was listening to Francis Fukuyama lecture the other day, and he was saying that the balancing act of a society is often allowing what could be without actually experiencing it. You can bring people to the brink of choices, some negative and some positive, and with any luck, you haven't got to live through the horror of the worst of those choices.

The Southbank Centre was a direct consequence of the war, wasn't it?

Yeah. There was going to be something called the Festival of Britain anyway; it was going to be the hundredth anniversary of the Great Exhibition of 1851. I'm sure the planning for the Festival of Britain was that it would be another celebration of colonial life. Then the war came along and completely changed what we wanted to value in our world. With tragedies like Hiroshima, you could see what the end of the world would look like. The young people coming back from the war said, 'We don't want a festival that focuses on Britain's past in that way; we want a festival that shows what a progressive future could look like.' Fifty per cent of the artists that made the Festival of Britain were refugees, and many of them were under twenty-five. Eight million people came out to the Festival of Britain and it was free. It was on the south side of the river, which was deeply unfashionable. It was the poor side, the side where the prison was; there was a mental asylum there at the time. People in north London never went to south London (you still hear it now!). This beacon of what it could be like if we all shared in the future of technology, the future of design … It was about culture, and that's what Britain was about. In the Royal Festival Hall, you can even see from the architecture (it's built like a ship) that it has so many different kinds of entrances because there is no front door and no back door. Anybody can come in from anywhere. There are all these glass rooms so you can see through it. It's emblematic of the idea of welcome and freedom.

So it evokes transparency, the accessibility of truth, which up to that point had been a privilege of the élite. Propaganda of the institution was replaced by propaganda of the imagination, with people not only desperate to try and see the progressive future but also desperate to avoid what they had just come out of.

Absolutely right. And the idea (I still deeply believe this) is that you have to keep falling back in love with humans. The thing that I was driven towards at the Southbank Centre was that the history gave me the opportunity to connect it to my own past and to my parents, and the things that they fought for and believed in. To have a space that was the place for the Festival of Britain, to have the Royal Festival Hall, to have these 21 acres in which to enact, over and over again, the compulsion we have to bring together many different types of people, or the need we have (perhaps it's more than a compulsion) … Is this a picture of peace? Is this a picture of human happiness?

So your transformation fifty years on from the Festival of Britain, your idea of a creative London, is yet again building on the idea of this great metropolis. What about Britain's other urban centres, for instance Liverpool, the great centre of the nineteenth century, or Glasgow? These days Liverpool is kind of dead and Glasgow is pejoratively described; it has some of the best music, but the mass of people have kind of been pushed to one side.

That could be hotly contended, what you've just said about Glasgow and Liverpool! But one of the great problems about regional cities is that they don't feel the urgency to get into international exchange. If they were a port city, as Liverpool was, or Newcastle, Glasgow or Cardiff, they benefited enormously from being international. That's why they became creative centres. If you take away that continuous interchange of ideas, any place, any person, starts to diminish. One of the things I always say about the Southbank Centre is that I want it to be like a bustling port city. Obviously, one of the questions about a place like London … well, London's unique, isn't it? Sometimes the incredible stickiness of London, people drawn to it and then staying there, means that it gets bigger and bigger, more intense and more self-intoxicating, and doesn't look out for the rest of its country. That is a tension.

Given your experience, expertise and activist involvement, from feminist causes to cultural vanguarding, where is London going with this mass of ideas, mass of money, mass of cultural output?

This is a really profound question now. It doesn't just relate to art obviously; it relates to the fact that if you live in a city where the symbol of inequality is money, not just money but the fact of inequality keeps growing. That is a society where the life-blood of democracy is beginning not to work. In London, one of the great things that has been happening over the past ten years in art and culture is that a lot more of it is free, is on the streets, so the idea of accessibility is a push that London has been leading on. The counter-push is that the people who are gravitating towards owning culture are finding themselves wanting to belong to a social milieu that doesn't accept everybody. For example, it really concerns me that there is very indifferent art education for state schools. You put that alongside the fact that you have a group of people who should be truly concerned about this – the value of art and of creativity – but children that are going to private schools are not having to engage with the paucity of choice on offer in state schools. Segregating society like that is a problem.

You've said that since you were little you wanted to make stories, roping neighbours' children in to put on plays in your back garden. Is creativity about making stories come true?

I'm not sure I can come down to one phrase about what creativity is. You have a hunch that you can make a shape that can contain meaning, and which might change a story or speak of a story. If you didn't think of a story as a narrative, then yes, I think that creativity is about making a story happen. Creativity isn't just about having an idea. It's about shaping that idea into something that emerges as a reality. We all have ideas; the real creativity has got to be how you apply them.

(previous spread) Jude Kelly in her Southbank Centre office overlooking the Golden Jubilee Bridge across the Thames. The centre, which includes the Royal Festival Hall, Queen Elizabeth Hall and Hayward Gallery, is Europe's largest arts complex. The British government had it built in 1951 as a 'Tonic to the Nation' intended to rejuvenate the capital in the aftermath of World War II

Kelly walks along the Grand Union Canal in Islington (above), an area once dominated by warehouses and derelict buildings. 'This is a total example of how London has reclaimed water and its canals,' she explains. The redeveloped Packington Estate now hosts social housing alongside private homes. 'If you can get a proper mixed community,' Kelly emphasises, 'it's much healthier for London's development'

Kelly outside Shakespeare's Globe (above) on the South Bank. A reconstruction of the Elizabethan playhouse that was demolished in 1644, the current theatre was rebuilt in 1997 through the initiative of American thespian Sam Wanamaker, using materials similar to those employed in the late seventeenth century. 'More than any other artist,' Kelly says, 'Shakespeare has affected English sensibility with his lyricism, his philosophy and his incredible sweep of society'. Shakespeare's Globe hosts some 370,000 visitors a year

Kelly on the steps up to the Southbank Centre complex (opposite), a layered concrete landscape composed of Brutalist buildings once described by the Prince of Wales as having the appearance of 'a nuclear power station'. The area, known in the Middle Ages for its theatres and prostitutes, drew twenty thousand people a week to its theatrical establishments in Shakespeare's time. Today the Southbank is a major entertainment destination with an estimated fourteen million visitors per year

'Sometimes the incredible stickiness of London, people drawn to it and then staying there, means that it ... doesn't look out for the rest of its country'

Rudimental
Musicians/DJs
Hoxton/Dalston/Smithfield

Piers, you once said, 'We are products of our individual musical journeys and of London.'

Piers Agget: Yeah, definitely.

Kesi Dryden: For the three of us growing up in Hackney, it was a very diverse, multicultural place. We had people from all walks of life living on one street. Next door I had a Jamaican family playing reggae music, on the other side there was an Indian family, and upstairs I had a sort of local English family. We were surrounded by different sounds, different music, different walks of life that all came together and created the people that we are now.

Leon Rolle: Growing up there were two or three options. You did music or you played football, and if you weren't good at those two, you'd probably dive into crime. We were lucky to have each other, from probably the age of five years old, and to go through this journey together. We had our own vibe going on as well, and that consisted of a pair of decks, musical equipment passed down from Piers's dad and brothers.

Was school important?

LR: School was definitely important, especially for our parents. My mum was a teacher; my dad was around but not really around.

PA: Being young and in London, there are so many scenes going on. Garage was just forming into grime, which were sub-cultures of electronic music and underground rave music. Our sisters would have had jungle and then house and garage. That brought people together. I might be middle-class and someone else might be working-class, but we'd come together through music and football. That's what's good about London. I might be white and someone else might be Indian or black, but you go to school, you meet people, and you get to share cultures and make friends.

KD: So wherever we go on tour, we always feel at home.

What was negative about growing up in London?

KD: There were so many estates where we grew up, and there was gang culture around all the time. A lot of it's from boredom. As Leon said, for us it was music or football, which was something to distract us from all the negative things where we grew up.

LR: I went to school in Bethnal Green; I went to three different schools 'cause of my behaviour issues. I used to say, 'I'm from Hackney' and everyone would be like, 'Whoa, stand back! Don't mess around with him!' There was that perception of Hackney that you had to be tough when you lived there.

So if you become super-successful and filthy rich, will you go out to LA or stay in London?

LR: We still stay in London. We still stay in Hackney.

PA: Yeah. There's no place like home.

Amir, can you say something about the blood-and-guts of the neighbourhood as it relates to your work?

Amir Amor: Well, we all come from different backgrounds, so we've all had our own struggles. I was an asylum seeker from Iran. We've all had our route to creativity and managed to make something together.

Kesi, your parents were from where?

KD: Mum's English, Dad's from Barbados.

PA: I'm a quarter Irish, a quarter Scottish, just English mixed.

LR: Mum's from Dominica; my dad was born in Trinidad and Tobago.

Is there a link flowing between all of these cultures?

KD: The link that brought us together was soul music, something that we all loved and our mums and dads loved.

PA: Marvin Gaye, Otis Redding, Sly and the Family Stone …

AA: Marvin's my favourite artist of all time. *What's Going On* was the first record that made me realise that whatever you feel, you're not the only one in the world.

So music is kind of a saving grace?

KD: I'd say solace.

AA: What we're doing, it's stopped us from doing stupid things, from becoming something that we don't want to be.

PA: We were all very similar in school; we weren't the best at doing exams maybe. When you don't excel, you feel a bit lost.

LR: I always knew I was never going to be a rocket scientist. I always knew that I wanted to do music or be a professional footballer; that's how narrowly my mind worked when I was in school. My teachers said that I would never get to do any of that, and –

So they gave you a lot of encouragement!

LR: They gave the worst encouragement! I wasn't dumb; I had common sense. I managed to scrape through my GCSEs by the scruff of my neck, only because my mum was a teacher. The one thing that I could always fall back on was these guys, as well as music. And music … I always say that it saved my life. Music and my son.

(previous page) Rudimental members Amir Amor, Piers Agget, Kesi Dryden and DJ Locksmith (Leon Rolle) frolic in front of Sh!, the women's erotic emporium off Hoxton Square, one of London's earliest garden squares, now dotted with galleries, bars and restaurants. Before the opening in 2000 of White Cube, one of London's leading contemporary-art galleries, the square was known for its heroin addicts and rough sleepers

Rudimental in front of the Hackney Peace Carnival Mural (left). Painted in the wake of the race riots of the early 1980s, the mural depicts a parade through Hackney streetscapes. As self-described keen Hackney boys, Rudimental featured the mural on the cover of their debut solo album *Home*, which was nominated for the 2013 Mercury Prize

'I used to say, "I'm from Hackney" and everyone would be like, "Whoa, stand back! Don't mess around with him!"'

The group walk along Rivington Street (above) in front of a notable Shoreditch watering hole, the Bricklayers Arms. The Borough of Hackney was transformed from farmland into industrial and urban landscapes during the Victorian era. It is currently one of London's most culturally diverse boroughs, and its demographically youngest, with a quarter of its population under the age of twenty. 'Growing up,' says Leon Rolle, 'there were all different walks of life and different cultures. That had a big part to play in who we are today, our music and our individuality'

You've said, 'We always keep it humble, otherwise our mums would slap us about.' Do your mums still play an important part in your lives?
KD: Definitely. I grew up with a single mum. My brother and sisters all had a very strong relationship with Mum, still do now. She always kept me on track, and any time I might have been doing something that I shouldn't have been, I didn't worry about anything else but what my mum would think if I got caught doing it. That was what drove me along the right route. When I told her I wanted to do music, whereas some parents might have said, 'Are you sure? There's not really jobs' she was like, 'This is what you're into. Go for it.'

For every one of your groups that succeeds from neighbourhoods like Hackney, how many don't? There must be thousands of kids doing music.
PA: It's a good point. I didn't realise until I got to uni that's there's lots of different job roles and you don't necessarily have to be an artist, a singer.

In musical terms, how powerful is London compared to, say, LA?
PA: Very powerful.
AA: It's the most powerful place in the world for music.

You guys, through your music, and others since the Beatles in the '60s, have virtually transformed social preconceptions, because ironically, most of the bands, most of the music, has come from people from less privileged backgrounds.
AA: Actually, the majority of the music industry is …

Run by toffs?
AA: Yeah!
LR: I hear what you're saying, though if we're looking at our own experiences, what have we really come from? Not having money, having to work extremely hard.
PA: My mum came from a working-class background. I wasn't at the bottom, and that definitely helped give me the opportunities to try musical instruments. My dad supported me. A lot of musicians are successful because they did have money, but you can also break through that. I'd say we're a mixture, that's what we are.
AA: It takes a lot of power to be able to do that, coming from poverty or a working-class background, because social confidence is what you get if you come from a middle-class background or if you have privileges. I'm not talking about crazy privileges, having a yacht or …

Just a stable household?
AA: Yeah, stability in your household. For people that don't come from privilege, it takes a lot more stubbornness.
KD: It might have happened a lot earlier for us if we didn't have to worry about money, 'cause we were doing 9.00-to-5.00's, then coming home and going to the studio in our spare time, and then the holidays we'd have from work were basically ourselves funding studio time.
LR: I did negative stuff to put clothes on my kid's back. Luckily we got signed three, four months later.

How does it make you feel if you have to break rules to get clothes for your kids? Does it make you bitter?
LR: It doesn't make me bitter. I had to do what I had to do. But now that I'm here, I value every moment.
KD: Before Rudimental happened, we were working in schools and youth projects, so people used to look up to us. It was good to see people that they could relate to in a positive environment. Now that we are even bigger, when I go back to a school, everyone's like, Wow, you were here and now you're there and you're a person I relate to. You're just an everyday person! If you can do that, I can do that.

Do you guys fear major success?
PA: Every time something huge happens like playing Glastonbury or winning a BRIT Award or having a Number 1 album or having two Number 1 singles, you just want more success and it just gives you more dreams.
LR: I still don't understand what success is. That's my God-honest opinion.
AA: There's a big difference between success and popularity. We've got success without popularity at the moment. No-one really knows what we look like, who we are, and that's perfect, that's what we want. At some point people will start recognising us, maybe, but if you're asking if we fear that, then yeah.
LR: Eighty thousand people came to watch us at Glastonbury and I could probably walk past them in a crowd.

Any regrets?
AA: Regret just means you feel like you haven't worked hard enough. I feel like we've worked pretty hard. I would change certain things, but I don't regret doing them the way we did them.
LR: No regrets from me.
PA: Every regret was a path to something else.
KD: I don't regret anything, but I can agree that I might have changed the way I'd done things growing up.
PA: We made a lot of mistakes in the last two years, and we've also made a lot of good decisions. In life you've got to make a mistake and learn from it, and move on to the right decision.

The group (above) trade ideas in Major Tom Studios. Rudimental's members took their name from Kesi Dryden's book of piano exercises, drilled into him as a young boy. Unusually for the music industry, the group decided against promoting a front man from the beginning, bringing in guest vocalists for individual tracks

(following spread) Julius Caesar arrived in Britain in 55 BC; it took another two millennia for César Ritz to build his eponymous hotel on Piccadilly. The height of lush and plush, the Ritz, which opened its doors in 1906, has witnessed royals and aristocrats of all hues coming through its front (and back) entrances. Irving Berlin's song 'Puttin' on the Ritz' is perhaps more relevant to London's former social grandeur than it is to today's common-or-garden reality, given the variety of people and costumes that pass the hotel's august doors. The city abounds in stark contrasts, from girls sporting Dolly-kei garb to shop owner Samm Stanley, originally from French Guiana, sweeping the pavement outside Eclectica, his bric-a-brac shop in Clapham

Solange Azagury-Partridge
Jewellery designer
Mayfair/Portobello Road

You were conceived in Casablanca but born in London, a little like ideas conceived in one place and enacted elsewhere. Nonetheless you've said that you are a Londoner through and through.
Yeah. It's quite typical for Londoners not necessarily to be English.

What is the component of London's DNA that flavours the city's creative output?
Maybe it's that combination of the English/British aspect combined with the energy from different cultures.

Do you sometimes travel back to Morocco?
Occasionally. I still have a cousin and an aunt there; we're Sephardic Jews. I discovered recently that on my mother's side we have Berber origins and on my father's side we are Spanish. It all informs my work.

How would you describe that informing process?
It's just what you're attracted to and what you see, how I translate things that I see. I can't really qualify it. For instance, I was in Sri Lanka and we visited a Buddhist temple and there was a fabulous Buddha sitting on a lotus leaf. I thought, Okay, that's a beautiful basis for a piece of jewellery. So I extracted the lotus leaf and turned it into a ring.

You supervise the production process through every level, don't you?
Yeah. I do a little sketch, and then I get a better drawing done by my experienced girls upstairs, and then we make a maquette.

You have quite a number of staff working for you.
Well, I'm not such a big brand; I'm an independent still. I have quite a few people working here, and a little shop in Paris and a little shop in New York.

But you've said that you prefer to be in a homely environment?
Yeah. I started working from home. The only reason I got a shop was because too many people were coming to my home; I needed to separate my work life. I had to have a workspace ultimately. But I made sure my workspace felt like a home environment. It also means that clients feel welcome and relaxed.

What is the importance of home to you?
It's everything. It's my rock; it's my stability. Without my home, I couldn't do anything. My home is my family, I suppose, and the environment I create to make myself feel good.

Would you live in another city if you were forced to do so by business circumstances?
I love living in London; it's such a human city. Just the fact that I can walk through the park to work and not see any buildings, just a vast expanse of green, is so unusual in a big city. And London has everything that you could ever want to keep your mind occupied. But Rome would be a lovely place, I think.

Jewellery and design were not what you had in mind as a young lass; you were planning to become a translator, weren't you?
I always had a creative side, but I didn't think that you could make a living from being creative. So I focused on the only thing I could do, which was languages. It comes in handy. I love learning other languages because actually you turn into a bit of a different person when you speak another language.

And you taught yourself design? At what age did you begin?
I suppose in my mid-twenties.

What was the first sale that really took your breath away?
It was when it was somebody I didn't know, a complete stranger. That's when I thought, It's not just my friends being nice; it's actually real.

At what stage does a creative feel empowered in the sense that they have no insecurities?
It takes a long time. That was a very empowering moment, when I felt that people who didn't know me were buying my jewellery. Another moment was when I was hired as Creative Director of Boucheron. There's one particular ring that they make all their money on these days ... I just felt, Okay, now I trust myself. I know what I'm doing.

(previous page) Solange Azagury-Partridge on the panelled staircase of her flagship store in Mayfair. The patchwork carpet, one of the shop's special features, was designed by her and sourced from her various showrooms. 'Floors and ceilings are always neglected spaces,' she explains. 'It's different here'

Where do you think it will lead you, this self-belief? Is there an objective at the end of the rainbow?
I have no objectives, actually. I just want to be happy! I've grown out of my ambitions; I think they're a waste of time. You know, I call this a kind of occupational therapy, what I do. It keeps me from going crazy.

Is the business side also taken care of by you, or do you have business managers?
Since I've become independent, I do it. I was part of an investment group for five years, and that knocked all of my ambition out of me! When all you think about is money, it destroys your soul.

Would you ever go back into such a relationship, for example if there was a big wad of cash on the table?
I doubt it, but I don't know.

I believe you've described yourself as a feminist. What exactly did you mean?
All being feminist is, is wanting to be equal to men. I want to be accorded the same rights and privileges as a man, and to be able to express myself.

Do you still encounter gender constraints in the business world?
You'd think jewellery would be a very feminised industry, but it's not. The upper echelons are totally male. And men do business in a very different way to women doing business. They suddenly put on their business persona; they suddenly leave their humanity behind. I don't know what goes on … It's just bizarre.

You seem very genuine; that's a rare commodity in the world of high-powered creatives.
I don't feel like I'm a high-powered creative.

Thinking in terms of your emotional transference into your pieces, do you have a spiritual side in fact? Maybe even a relationship with God?
I suppose so. It's just a kind of appreciation of the beauty of life.

In what way does London give you that momentary reflective, spiritual uptake, if you will? Is there a specific place or neighbourhood that gives you that?
Walking through the park does that for me. Every morning, when the sun is shining and it's beautiful, I just think, I'm lucky; I should be happy. No matter what perceived problems or issues I might have, it doesn't matter. Life is beautiful.

Azagury-Partridge designed each colour-coded room (above) in her boutique. The two-storey shop is filled with artwork by friends, as well as hidden doors and striking interiors. 'The intensity of the colours that I use is part of my DNA, I suppose,' she says (opposite), referencing her Moroccan origins. One of Azagury-Partridge's most popular designs features the words 'fuck off' (right)

Azagury-Partridge enjoys
a tea break at the Wolseley
(right), a Viennese-style
café-restaurant in St James's.
'The Wolseley,' she explains,
'is a little bit of London
glamour ... and it's always
delicious.' Lucian Freud, a
regular customer before his
death, had his own table,
and any number of London
literati can be found huddled
in meetings in the lap of
luxury lunches

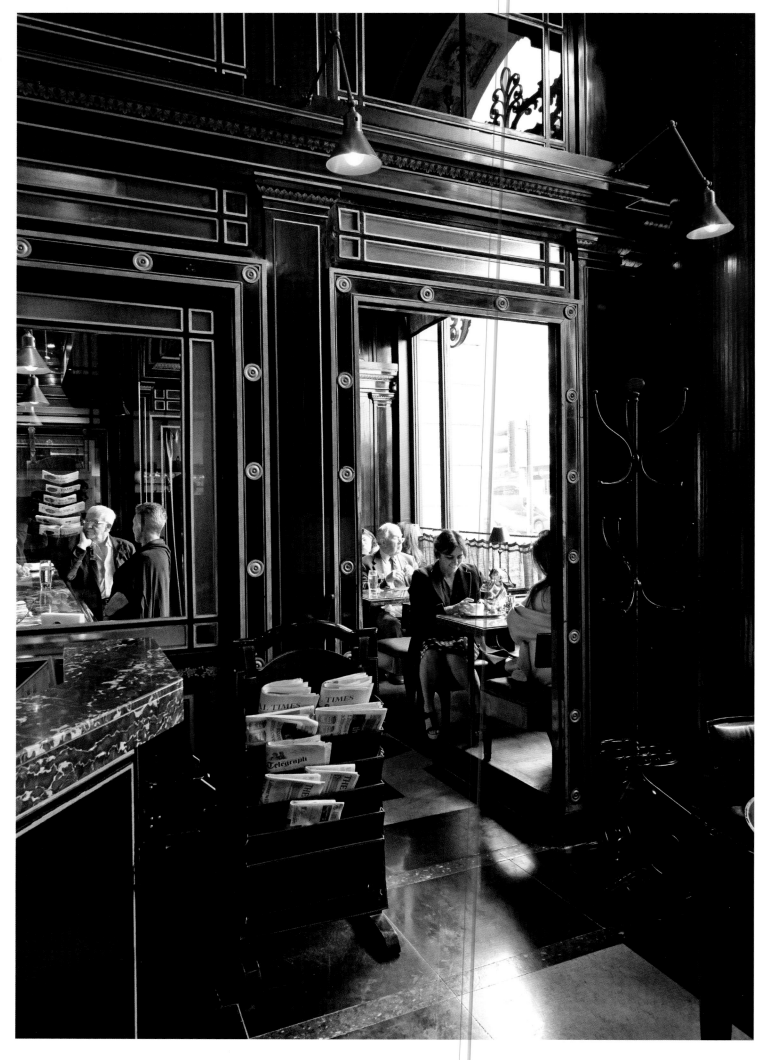

Solange Azagury-Partridge

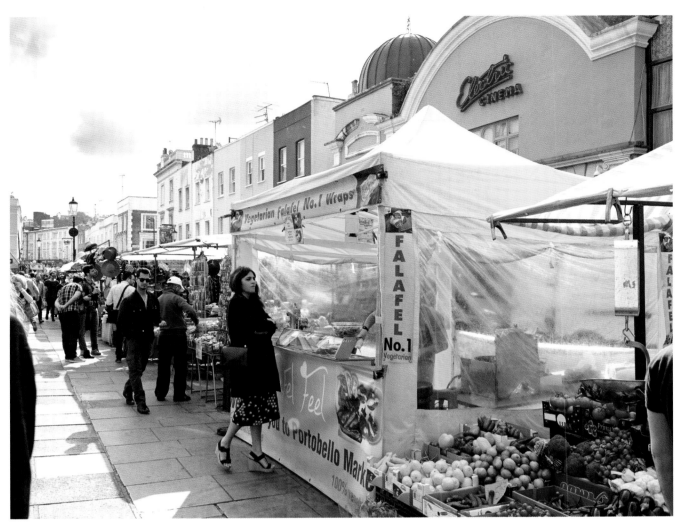

Azagury-Partridge on Mount Street (left) – one of London's fashion hubs, and a neighbourhood with some of the world's most expensive property prices per square foot – in front of *Silence*, with the Connaught Hotel as a backdrop. The fountain, which exudes water vapours every fifteen minutes, was designed by Japanese architect Tadao Ando in 2011. In the background, culinary artist Marco Pierre White can be espied walking on the opposite side of the fountain

The designer at another of her favourite London eateries (above), a falafel stand in Portobello Road Market, just outside the Electric Cinema, one of Britain's oldest movie theatres. Of falafel she says, 'It feels like a taste of my grandmother'

'London has everything that you could ever want to keep your mind occupied'

Gordon Watson
Decorative arts dealer

'London used to be the most extraordinary place,' remembers decorative-arts dealer Gordon Watson, 'because you could go anywhere from Portobello Road, which I used to go to every Saturday. I haven't been for five years – it's finished. You'd go down Kensington Church Street and it was filled, you'd go down the Kings Road and all the little auction rooms … It was absolutely a buyer's heaven … Sadly, that's stopping now.' The man in whose shop Solange Azagury-Partridge developed her interest in vintage jewellery was born in Hamburg and grew up in Manchester; since moving to London he has almost exclusively lived in Chelsea. 'It seems like I've been collecting all my life,' he muses. 'As a child I was never happier than when I was rummaging around local antique shops.' Calling himself a 'quite volatile character', Gordon jokes that he can barely remember his own name sometimes, 'but I *never* forget an object or its history.'

One of the world's leading authorities on twentieth- and twenty-first-century furniture, objects and lighting, Gordon began his career at Sotheby's in the 1970s. 'I quickly realised that, being the compulsive buyer I am, I needed to have a retail outlet,' he remembers. When advising young collectors to associate themselves 'with a reputable dealer or a member of an auction house' as a way of learning the ropes, he adds, 'Visit their premises, be charming, ask questions, buy from them, and gradually you will learn from their expertise. Then, when your knowledge is more firmly based, you will be able to add to your collection with great confidence.' The key thing, he believes, is to 'handle an object, examine it, get down on your hands and knees … Examine it inside out'. A proponent of the view that 'beautiful objects from all periods, when put together, can stand the test of time,' Gordon confesses to liking to shop, joking, 'It's what I do best.'

Gordon's home is a de-sanctified Methodist church that became a recording studio before being sold to a developer whose girlfriend, he explains, 'wanted to live in Notting Hill Gate, slightly grander, so I bought it'. The thought of following the artsy crowd and migrating to the East End fills him with disgust. To live in London was always his goal. 'I used to have a great girlfriend, a lesbian who had a Mini,' he recalls. 'She and I would come every weekend, age sixteen, down to London …We would hit the clubs and pray that somebody was going to invite us back to stay. If not, we slept in the Mini or took a tiny little room … So the whole of my teenage life to adult life was to get to London. I had no other wish.' He was already a practiced salesperson, having sold 'faulty raincoats' in Manchester with huge success. 'What I'd do with the money was go to the local antique shops and the local junk shops and I'd put deposits on things … I remember buying a very early Russian Constructivist plate … It was probably the best thing I've ever bought, but that disappeared!'

Gordon Watson in the window of his eponymous shop (opposite), where he deals in some of the most sought-after twentieth-century design objects in Europe. Long based in Pimlico, Watson opened his shop over thirty years ago and is known for sourcing high-quality furniture, objects and lighting

Watson relaxes at home (left) with a Glen Ligon neon work that reads 'I sell the shadow to sustain the substance' (2005). 'The only reason I sell is to facilitate buying,' explains Watson

Watson in the doorway of his home (above), a converted Methodist church in Chelsea. 'It was desanctified in the '60s and became a recording studio,' he explains. 'The Stones and various bands used it, and then Marc Almond, the pop singer from Soft Cell, bought it. He sold it to a property developer, a great party boy, who spent three years redoing it, and then I bought it'

Sister Christine Frost
Member, Order of Faithful Companions
of Jesus/Community activist
Poplar/Canary Wharf

You were born in Ireland, in Limerick, and you trained as a physiotherapist at Guy's Hospital in London ...
I had an interview at Guy's with a possible place, but I was toying with entering a convent. I know that sounds crazy now, because nobody enters convents; you don't even use phraseology like that any more. You had to have six pairs of shoes and six of everything to last you more or less the rest of your life, and I was seventeen going on eighteen, and I remember being so ashamed, going into shops looking for six pairs of shoes. I don't know how a girl would feel today to say to her friends, 'I'm thinking of being a sister.' That's a shame because it's a fantastic life, actually, if you get your finger on the right pulse, if you get direction, and if you get enough leeway to go where you need to be.

Who was directing you, some force from above?
I suppose you could say God was, in some way. But nature played a part.

So you were seventeen, going to the movies, going to parties ...
Of course. I was perfectly normal. I was naughty actually.

Is that the naughtiness that drives you to redemption?
Probably. Probably gives you that bit of mischief. But not maliciousness.

Talking of mischief, you've been quite a troublemaker, haven't you, within the St Matthias community?
Well, on Canary Wharf I remember Eric, what was his name?, he was quite important, he referred to me as 'that bloody woman'. I've been in Poplar for forty-five years; I was sent here by my superiors. I made three vows: obedience, poverty and chastity. When I entered, of course, I was told my superiors knew what God wanted of me. I've learned that it isn't always so.

How would you convert me to your cause? What would attract me to it?
What drives me here is a sense of justice, that's all. That's in the Old Testament, it's in the New Testament, it's all Jesus ever stood for: being just, being fair, taking care of everybody regardless of who they are. That's a difficult thing to do 'cause sometimes you don't like people. You see these people coming along with their clipboards and telling you in their pinstripe suits, 'Life is going to be so good! You'll all be employed, you'll all have double-glazed windows!' And you think, Okay, that sounds good ... I can still see the guy from Canary Wharf sat there in front of us, slouched out, chewing gum, and I'm thinking to myself, There's no way that guy's going to do anything for any of us. He doesn't give a damn about us.

So did you riot and string him up?
No, I think we got Leigh Day, which was a big law firm.

How did you do that? They're expensive.
We didn't pay a penny.

Why, did they do the job pro bono?
Yeah.

Who sold the idea to them?
People like me. There would have been maybe half a dozen of us who really, really felt this wasn't going to be right, 'cause we were all going to end up moved out. Maggie Thatcher talked about the trickle-down effect. There was never any trickle-down. There still isn't.

So you would build a church spire while Canary Wharf built what, a hundred storeys?
But how many of them will be in Heaven? If they have willingly, wilfully, made loads and loads of money for themselves on the backs of people who are being paid £6 an hour, God will say to them, 'You were irresponsible! Why did you do that, 'cause that was unjust?'

So do you feel that you have made a contribution that honoured your denial of a personal life in favour of chastity, of poverty, and straightened out some crooked timbers of humanity?
You can only do what you can do; it's a matter of putting a few little drops into the ocean. It's got to be about inclusion. I do get scared … I remember reading about Bosnia and Serbia, and I look at my local community and I think, If we're not careful, if we continue to set one group against another and allow kids to be angry on the street, the neighbours who maybe looked after me yesterday might well turn on me. It's happening in Syria. To me it's all about building mutual understanding, mutual co-operation, mutual getting on and doing things together.

Let's go back forty-five years. What was it like here in Poplar, which communities lived here?
It was English and Caribbean. Brilliant. And the Irish. Forty-five years ago, I would be in a classroom on a Friday in a big mixed comprehensive, and on a Monday I would have new kids in my classroom who'd just landed in England on the Friday to live with some uncle or aunt they'd never met before.

(previous page) Sister Christine Frost contemplates the world through the traceried window of the oldest building in Docklands: the former church of St Matthias in Poplar, now St Matthias Community Centre. The church's beginnings can be traced back to the outbreak of the English Civil War. The building was revived under the patronage of the East India Company, whose coat of arms can be seen on the chapel ceiling and in the windows. The property became a victim of theft and vandalism until its conversion into a community centre

Frost (above), who was made MBE for her services to the community of Tower Hamlets, regularly challenges the encroachment of Big Money into the living space of London's poorer classes. 'Rent should be appropriate for genuine working-class people, not just the people in Canary Wharf,' she protests. 'Developers are buying up properties and taking them away from us'

Frost has spent forty years working on the Will Crooks Estate, a five-block complex that includes Wigram House (right), where residents have devoted a mural to their local hero Will Crooks, the early twentieth-century trade unionist, Fabian politician and Labour activist. Kids from the estate (opposite) get a talking-to from PCs Cherifi and Imrie of the Isle of Dogs Police Station

From where?
From the Caribbean, mostly from St Lucia or Dominica. We built up tremendous rapport; they're still my friends. We'd take groups to Margate in the summertime. I'd fill five coaches on Poplar High Street – that's three hundred people. They'd all have their chicken and their bottles of rum, and they'd be swigging away.

In the intervening years how have the local demographics changed?
The Caribbean community have largely disappeared.

Where have they moved to?
Hackney and further out. Everybody moves out, which is a shame.

And they have been replaced by whom?
The Bengali community.

I understand that Poplar has the highest population of Muslims in England per capita.
Probably. They come from Sylhet, which was really strange for all of us to grab a hold of. Culture is a very strange thing, because you don't realise it until somebody maybe is doing something different.

Isn't the bottom line that someone in the West End of London may have a Bengali cleaner or may visit a kebab house or a curry takeaway, but otherwise they don't want them around?
That's what I would challenge around here; I've challenged it for years. I was called a 'Bangalover', which was meant as an insult, by some of our white community.

Politics apart, is there any resolution to the problem of ethnic strife in cities?
You do the next best as you see it, and the next best as I see it is to build a cohesive community. I live on an estate where we're all mixed, which is fantastic.

But haven't recent events proven that the expression of fundamentalism is a sign of anger, or a sign of frustration, like all these kids going out to Syria to fight?
Hold on! We've done exactly that! We had the Inquisition, we made people become Christian! So don't be getting on your high horse!

In the late '60s, Enoch Powell gave a famous speech, the 'Rivers of Blood'. Do you remember that?
I do.

In a manner of speaking, we have arrived there, haven't we, at least in some ways?
I would hope that that, please God, will not happen. I see people being angry and being anti- and not trying to understand. That's why some people haven't liked me, because I haven't forgotten where I come from, and I'm thinking, I'm an immigrant as well, and if you don't like 'them' here, I'm going to go too. 'Oh no, no, we don't mean you!' Well then, what do you mean? We had CNN here and they were talking to some of the old ladies here, and as I passed by I could hear them say, 'Well of course, you know, they don't integrate, they don't want to integrate.' And I knew perfectly well what they were talking about: they were talking about the Bengali community.

But that's true in some ways, isn't it? They hardly learn the language, they stick to their own neighbourhood –
Come on! That is a lot of badness because their menfolk had their wives and they were scared stiff that they would go by Western ways, so they kept their wives indoors. That's why forty- or fifty-year-old women haven't got a word of English, which I think is an absolute disgrace.

It's the bloody men again, isn't it?
Of course it is!

Gender-benders aside, are you a creative soul as well as a spiritual one?
I'd say so, yeah, probably.

And your creativity is embodied in your ability to adapt to change?
Yeah. I'm very lucky 'cause I don't feel tied by rules and regulations and stuff. I hope that when I meet Jesus he says, 'Hmm, you have tried to follow the Book … Okay, come home.' That would be the best I could hope for.

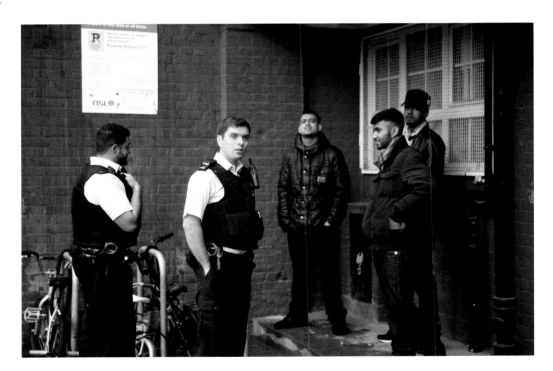

'You do the next best as you see it, and the next best as I see it is to build a cohesive community'

Sister Christine Frost

Frost in the stairwell of a cable-stayed footbridge on the infamous 'Bridge to Nowhere', built as part of the Docklands Light Railway in Poplar with no destination. The railway system was put in place to meet the increasing transport needs of Canary Wharf, London's second-largest financial district and one of the largest in Europe. Home to a number of major bank headquarters and professional-service firms, Canary Wharf, which employs 105,000 people, was an initiative of Margaret Thatcher's government in the late '80s. It resulted in the destruction of a large number of Council houses and the rejuvenation of a derelict part of the city

Sean Bidder
Creative Director, The Vinyl Factory
Hayes/Soho

Marshall Street appears to be a mixture of rent-controlled and high-end loft development.

Yeah. There's a very old public swimming pool that is part of the fabric of Soho and which the local community uses, called Marshall Street Baths. Maybe ten years ago, it shut down. It's a Victorian-style swimming baths with an arched roof. There was a substantial amount of money required to get it up and running again, and that was done as part of the Vinyl Factory development, which is a mixture of public works and private/residential. It's mixed-use creative space, so we have a gallery space, a record shop, a fashion PR company and a political corporate PR company, and within our offices we have the mixture of companies under the Vinyl Factory umbrella. These are the music-and-arts magazine *FACT* and the Vinyl Factory record label. We have curators working with us, and then we have the small property team that oversees the acquisition and development of these industrial spaces. The DNA of the property side of the company is that most of the buildings are industrial buildings with a heritage to them. They're always developed for mixed-use spaces. Within the Vinyl Factory there's a music-and-arts company that at its core is a producer. So it's almost like the Bauhaus. We work with different craftspeople – screen-printers, box-makers, specialist artisans – to develop the limited editions and projects that we do.

Within this group what exactly do you do?

My job title is Creative Director. I run the record label and work in close collaboration with all the creative aspects of what we do as a company. I'm quite hands-on with the musicians and the artists in a) finding them and talking to people about collaborating with us, and b) developing projects. Some of those projects are music releases, some are broader than that; they involve an installation or an exhibition or a live event of some kind. We may then create some kind of documentation, so we have a website. We believe in a kind of aesthetic of what the artist's trying to convey and in presenting that in the purest way possible. One thing we find is that a lot of musicians want to be artists and a lot of artists like the idea of bringing out music.

Why do you think that is?

I think it stems from the fact that most people, when they're teenagers, are interested in pop culture. Music's a strong driver for everyone. When people develop a career as such, they don't generally lose their passion for music. We present them with an opportunity to re-engage with that in some way.

When did you start up your music label?

We started the label in 2008; the Vinyl Factory itself started in 2001.

And the Vinyl Factory bought out …

… EMI's pressing plant. That's basically the cornerstone of the British recording industry. It's over a hundred years old; it's where they made all the records of the Beatles, the Rolling Stones, Pink Floyd, Sex Pistols. All the classic British records came out of Hayes, Middlesex. The last serious upgrade of the EMI machines happened in the early '70s. We still use those. It's like a classic car: you've got to know what you're doing, there's no manual, you've got to have experienced people. It's a craft, to be honest. We don't sign people up to long-term deals because we feel like that would stifle them creatively.

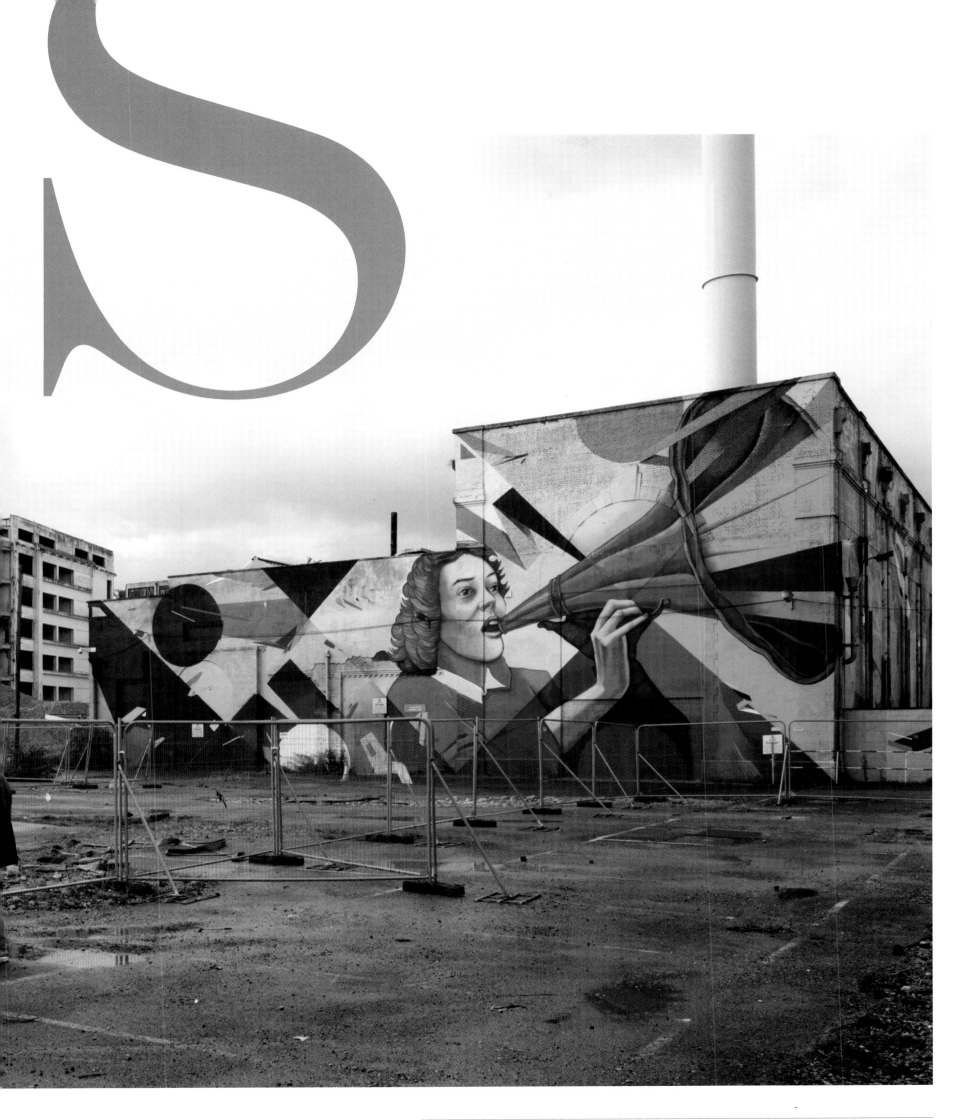

(previous spread) Sean Bidder in the grounds of the derelict EMI factory in Hayes, home to Britain's vinyl-record production beginning in 1907, and including the Beatles among its many musical greats. The 1930s saw the complex employing seventy-five hundred people across an area totalling 58 acres. Converted to munitions manufacture during the Second World War, the site produced components for radar, a critically important British invention. The property is being redeveloped into 'The Old Vinyl Factory', thus injecting hard-nosed commercial considerations into the creative process – a common ploy among twenty-first-century property czars

The Vinyl Factory produces records using machinery from the early '70s (below), acquired after the closure of the EMI facilities

How did the art part of the business mix come about?
The artist side of it didn't really happen till I was doing a project with Franz Ferdinand, and one of the guys said, 'Oh, I'm friends with Martin Creed. Why don't we get Martin to do the artwork for the record?' My immediate thought was, Great! Let's meet. He came in and he was really enthusiastic. He loved vinyl and he loved what we were doing. From that point it was obvious to me that there would be lots of visual artists that I could approach about projects.

How many imprints were made of that particular record?
A hundred. It was a white record and the labels were hand-painted.

And how much did they sell for?
Twenty pounds?

Not even a hill of beans, was it, considering the scale of the music industry?
Most digital-music sales are declining; vinyl's actually growing. The biggest market growth is with people aged eighteen to thirty, kids who grew up with digital music. People are asking, 'Why are you buying vinyl? Is it a fad, is it a trend, is it a reaction against the uniformity of digital music?' You can always come up with an answer, whether it's right or not I don't know, but what I do know is that they're buying records. In America, where there's a real boom, the demand is higher than the supply right now. To get a record made you have to wait three months.

As Creative Director within a group enterprise, are you able to argue your corner at board level?
Yeah. I'm one of the directors and effectively I'm in charge of running that side of the operation. It's a profit-making company; we're in joint venture with all the artists that we produce. We're quite nimble. I'm always looking for new ways and new models and new structures.

The reason I asked that question is to tease out exactly how creativity has imbued and informed this entire enterprise.
A lot. It's at the centre. Essentially we're creating a piece of art …

So is art the main source of revenue?
Every company that's under the umbrella has its own operations, its own P&R, its own profit-and-loss, its own annual accounts, so at the centre of the Vinyl Factory group, obviously there's creative drive. The record label is run as a business.

And that is a self-sustaining business, has a profit and is growing?
Yep.

Where will all of this lead within the changing context of the music scene?
Hopefully we're helping to enable artists to find a market. There will never be a shortage of creative people in London, so it's a great place to operate. It's an international city now. There's lots of people passing through, there's always a support network for young talent here, and there's a kind of infrastructure in place as well, which there isn't in other cities. And music for the last forty years has been the central thrust of youth culture in this country. I don't see any sign of that changing.

But hasn't the music world changed beyond recognition in the past forty years?
The Internet and the way that people are able to some extent make music and art, and to create an audience, have changed the playing field completely. The power structures that were in place previously, whether it was the music industry or the art world, wanted to control those elements, to be able to sign the artist, own the rights, and then be able to dictate the market value and the price. All that is changing. It's changed irreversibly in the music industry already.

Why is that?
Because, in addition to being able to build their own audiences, people can have their own distribution model. So really, why do you need someone else? You only need someone else if a) you want to get paid in advance, or b) you want a certain level of investment in you, in building you up. But you don't necessarily need that; that's a choice you're making. If you look at some of the most interesting artists today, they're not really multi-media artists, they're just artists operating in the twenty-first century. They do everything and they put their own work out there and they're so far ahead of the galleries, I don't even know why they have galleries. They're moving at a different speed and they're engaging broader audiences. We can help facilitate some of that.

Bidder with artist Conrad Shawcross (left) and his 2014 installation *The Ada Project*, displayed at the Vinyl Factory's Brewer Street Car Park in Soho – another mix of bricks and artwork

'Record collectors are quite passionate about vinyl,' Bidder remarks. Special long-play records (left & above) sport limited-edition covers produced for the Vinyl Factory by such leading artists as Eddie Peake, Jeremy Deller and Martin Creed

On a rainy day in London, Bidder hurries to work past Beak Street in Soho, where the Italian waterscape maestro Canaletto lived and painted between 1749 and 1751. Lexington Street's nineteenth-century warehouses have all been redeveloped as luxury flats and office space

How dramatic and irreversible will this so-called 'evolutionary' process turn out to be over the longer haul?

It's hard to say. I don't think it is reversible. The reality is that technology's only going to grow and develop, isn't it? At the same time, what we're finding is that people still want to come together in communal spaces, physical spaces, and share ideas and experience things together. You can obviously experience a lot virtually on the Internet, but people still want to go to concerts, they still want to go to an exhibition. What we're going to see is a growth in those experiences and how they're presented. As long as we're tactile human beings, we'll want to interact with other people.

Part of what I'm getting at is this: How much does money push out old-style tradition or creative talent, forcing it to relocate elsewhere?

Cities change; London is changing. It's always been a huge city, it's always been growing, and artists generally go through stages themselves if they're successful. You saw that with East London and now you're going to see it with Peckham. Probably going to see it with Tottenham; there's a bunch of other areas.

Is that a good thing, in your opinion?

I don't know if it's good or bad; it is what it is. I suppose what you're getting at is whether there will come an endpoint when there's literally nowhere left. There might, but I can't see that happening just yet. Ironically, artists have probably done more to speed up the development of London than almost anyone else. I mean, developers are led by art. There's no way that Hackney would be what it is today without artists. Same thing with Peckham. I was in New York last week, and you see how intense some of the building and the structure is in Manhattan. We're nowhere near that. Do I want London to become Manhattan? I don't.

Turning the spotlight back on you, how best would you describe yourself?

As a kind of creative, almost like an enabler, someone who's good at bringing people together, basically. Good ideas.

And where does this talent come from, in your case?

I don't know. My dad's a writer. It's good to have encouragement when you're younger to be interested in the arts; both my parents were quite encouraging in that regard. They never set any expectations on what I should or shouldn't do. Being encouraged to explore that side of your character when you're younger is a good thing, because it constantly challenges you, which is great. You feel alive, you're constantly working with people that have different ideas and different perspectives, and some of those perspectives are not following the herd, so that's always refreshing. Hopefully you're adding something to the experience of being on this planet. That can only be a good thing.

'As long as we're tactile human beings, we'll want to interact with other people'

Sean Bidder

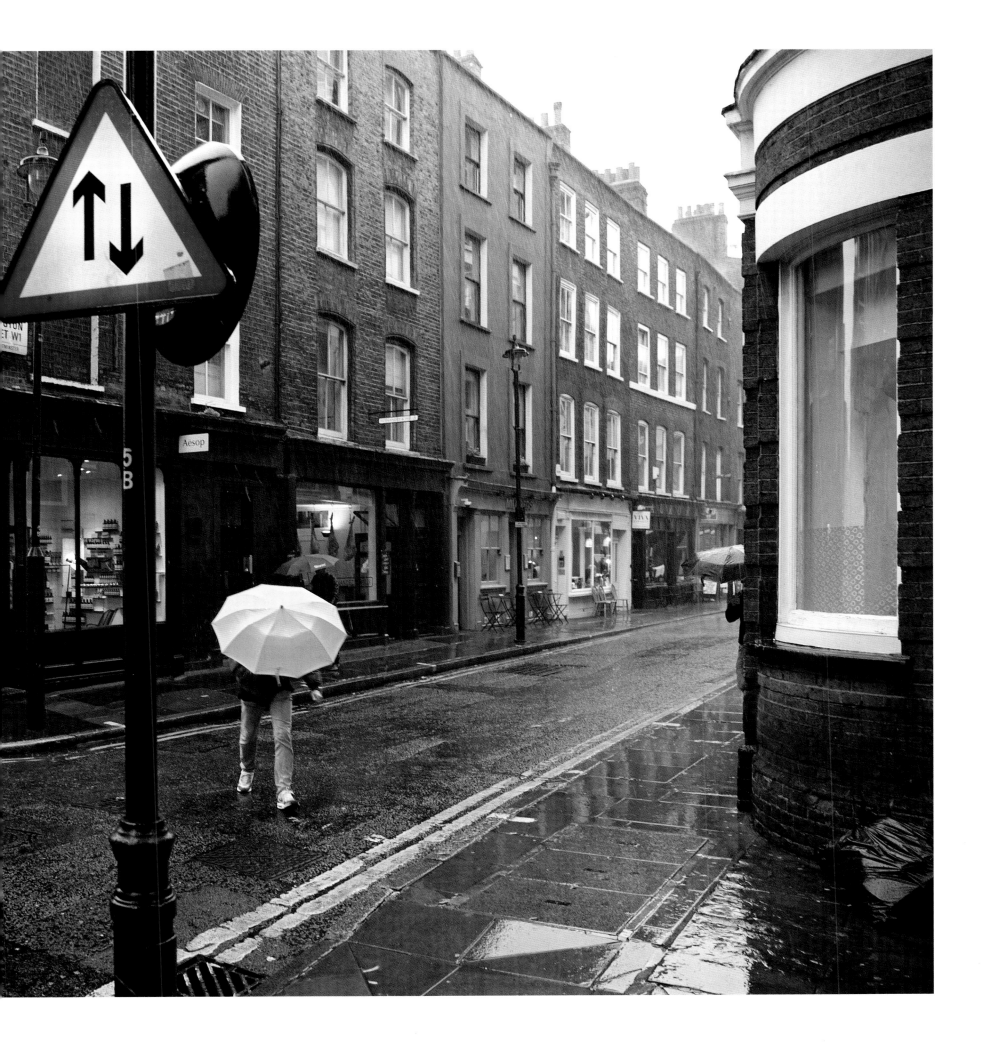

Fergus Henderson
Chef/Restaurateur
The City/Smithfield Market/Soho

Would you agree with the claim that you've had a profound impact on London's restaurant scene?
The whole nose-to-tail thing has caught on. It's hard for me to see my own impact.

Have you accomplished what you set out to do or are you still searching for something – some magic pig trotters, perhaps?
Always searching for magic pig trotters – the Holy Grail – but that's something else. It wasn't meant to be a cause or a teaching. It was meant to be a good lunch. It's all taken on some momentum and become something else.

You've attributed your success in some degree to your parents, both of whom were keen cooks. You've said that having a white tablecloth 'kept us together as a family' …
Yes. We were a gutsy family; we all enjoyed eating and sitting at the table. So I learned a lot from my parents. I learned to be a chef from eating and drinking the best.

You lived in Covent Garden, which you've described as an historically gruesome place of gin and prostitution. Now, of course, it's a yuppie, unappealing tourist trap.
Yes, it's sad. Bring back the prostitutes … Maybe it's cyclical; maybe it can all come back in future years.

I've always been fascinated by this on-the-boil atmosphere of ne'er-do-wells and artists on the peripheries who seem to feed off the same scene. Soho is changing as well but has retained some of that atmosphere.
Chefs, rogues and artists have the same timekeeping.

Are we putting potential artists out of business by pushing them out of such neighbourhoods?
Obviously the centre just grows and grows. I'm not sure how people – how my staff – carry on. London is so expensive (not like Berlin). But when we first moved here, Sarah Lucas and Angus Fairhurst had a studio down the street. Now they've all moved out.

You were friends with the YBAs in the '80s and they ate at your restaurants. How could they afford to do that? Were they given free lunches? Did they give you paintings to hang on the wall?
No, no paintings on the wall. Luckily they had been fairly successful so they paid. We were struggling so they were very helpful.

But why would they come to your place in particular? What was the appeal? Isn't your restaurant just a hospital for food with its white walls and plain decor?
Yes, but it's comfortable. It's an eating place and they felt comfortable. There is no art on the wall so they didn't have to have someone they don't like to look at.

Was St Johns modelled on eateries that existed in previous centuries?
No, it wasn't really modelled on anything. The building is what gave us the shape. We painted it white because it was covered in pork fat and smoke, what with all the chimneys.

So the character of the restaurant became informed by the nature of the building?
Yes. It's an extraordinary space. It runs in a kind of strange way – there are no right angles.

(previous page) Fergus
Henderson pigging out in
the cold store of his St John
Street restaurant, made
famous in the 1990s as their
eatery of choice by artists
including Tracey Emin and
Damien Hirst

Henderson (above) on his
morning jaunt through
Smithfield Market, Britain's
largest wholesale meat and
poultry mart, which has
been in continuous use since
medieval times. Destined for
redevelopment, the building
has listed status. True to its
bloody function, Smithfield
was a site for the execution
of heretics and political
rebels such as William
Wallace, the fourteenth-
century Scottish nationalist
leader, who was tortured,
hung, drawn and quartered
with his parts left on public
display. Wat Tyler, who led
the Peasants' Revolt in 1381,
met a similarly gruesome
fate there

You are very dismissive of supermarket-food culture. Don't many people have to depend on cheap food for daily sustenance?
Yes, well, the reason that there aren't any more butchers is that people haven't been going to them. They should be going to the butcher, hugging the butcher and letting them know they love them. Then the butchers would stay. The supermarkets give you what they want you to eat. Which is sort of perverse: apples that are crunchy two months later, and oranges that are perfectly orange and round and plastic. It's a strange perversion of what real food is about. People only shop there because they need loo paper and milk; people go to the supermarket and then they get caught. They go to the supermarket for their household needs.

But you've also said that eating that sort of food does not produce creativity in the afternoon. Are you of the opinion that food can be inspirational?
Lunch.

Not breakfast? Not dinner?
No, lunch. Breakfast, I find, is an espresso and a cigarette. By 11.00 I am ready for my seedcake and a glass of Madeira.

Does good food inspire good companionship?
Very good!

How much does the booze component influence the timescale?
Good wine slows things up a little bit.

Going back to the nose-to-tail concept, you've said that 'it's only polite to use the whole beast once you've knocked it on the head.' The whole carcass? Every bit of it?
Yes. Also because it's delicious. You get all sorts of tastes and flavours. The heart is an extraordinary part because it has the essence of the animal it comes from.

So what do you say to the great British public who eat beans on toast?
We all eat beans on toast sometimes. Beans on toast is good on Sunday night. When you've had enough, beans on toast is great. But you should probably also enjoy other things.

I remember in the '50s there wasn't a single decent restaurant in London. What happened? What triggered this enormous change?
I'm not sure. It's hard to say why things went so wrong and why it came back. Strangely we have got fantastic seasons. Very short, marvellous moments where something is delicious and you eat lots and then you wait till next year. Like English asparagus or gulls' eggs or grouse.

But wasn't all of that really for the élites and not so much for ordinary folk or even the working middle class? The question I want to pose is: What's class got to do with eating?
You can have lamb neck and have a broth, which is a wonderful thing. So you can still eat well without spending too much money. Eating within your means is always a good thing.

In the same vein, you've said that no-one in London understands perfect cabbage. What did you mean?
Some would say it's all changed here with the food press and television so that now consumers know all their food. But in Rome, those who are fashionable all talk about puntarelle, or Roman chicory. London is a million miles away from a young trendy person saying, 'Ah, the cabbage represents London.' It has a long way to go.

If you were to choose a food or vegetable to represent London, what would it be?
It's hard to say. London is troublesome because it's so big …

If you could choose one restaurant in London, Paris or New York (not your own!), where would you go?
That's tricky. I might choose Le Rubis in Paris. It's in the Marché St-Honoré. It's a little wine bar, but they serve food. It's a wonderful place to go and things happen there that just don't happen in restaurants today. You usually have to wait at the bar for a table and you have a glass of wine. These old boys are around and they are happy to have a glass of wine, and there's the lady who runs the tables … There was once a plasterer, head to toe covered in plaster … In most restaurants people don't like people coming in covered in plaster, but she said, 'Please, come, sit.' They gave him some wine and he left. It was such a civilised approach.

Are English eating habits as civilised, even in London?
It has a little way to go.

Following a more civilised English tradition, Henderson (above) enjoys elevenses at St John's. He pauses (bottom left) on the doorstep of his restaurant, a former smokehouse that he converted before opening its doors in 1994

'… *We have got fantastic seasons. Very short,*
marvellous moments where something is delicious
and you eat lots and then you wait till next year'

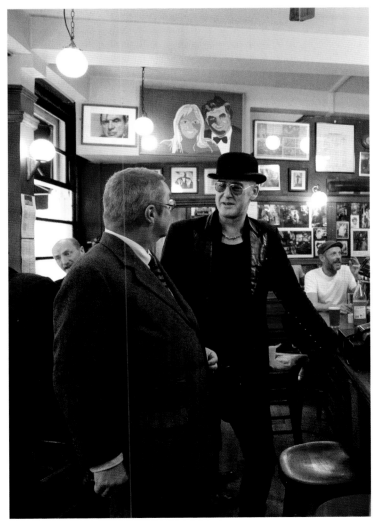

Henderson at Sweetings (opposite), a very English establishment dating back to 1889, which he has frequented for the past thirty years. Describing London's oldest fish and oyster restaurant as an example of working chaos, Henderson adds, 'This place is magical' as he sips a Black Velvet, the restaurant's trademark drink (half-Guinness, half-champagne, served in traditional pewter mugs). While an architecture student, Henderson spent several days studying the restaurant as a working environment

Henderson takes coffee at the Bar Italia (above) on Frith Street, his favourite place for espresso. Henderson at the French House in conversation with Phil Dirtbox (left), a legendary Soho figure from the '80s whose illegal drinking dens were famous for their parties. The French House, a post-war landmark, was frequented by the likes of Dylan Thomas and Francis Bacon. An apocryphal account has Thomas losing the original manuscript for *Under Milk Wood* at the bar pictured here, while the Free French leader Charles de Gaulle penned his speech '*A tout les Français*' there, inviting his countrymen to repel the Nazis

Tamara Rojo
Artistic Director, English National Ballet
Aldwych/Kensington

Here we are in Jay Mews, right next to the Royal College of Art. Does this space or proximity of places have creative significance for you?
Definitely. It represents what London is right now: a centre of art. Everywhere you look, there is a theatre, a college of music, a college of art, a college of design, a theatre, a museum, a gallery. It's really, in my opinion, a cultural centre of the world.

You were born and trained in Spain. At what age did you come to London?
I was twenty years old.

And why did you come?
Because I wanted to be part of the London ballet companies, first English National Ballet, then Royal Ballet.

Is that an aspiration for ballerinas all over the world?
Very much so. Britain has a great reputation for ballet companies. They are serious, they are well managed, they have a very important history, important repertoire. In different moments they've had directors that have been incredibly inspiring. There was a moment that London Festival Ballet (now English National Ballet) was directed by Peter Schaufuss. Suddenly every young dancer was looking at this company because of the repertoire and the stars they were creating. Then there's moments when the Royal Ballet, thanks to MacMillan and Ashton, were creating masterpieces. So the companies based in London, but also Birmingham Royal Ballet, Northern Ballet, Rambert contemporary company, all of this makes Britain a very attractive prospect for any dancer.

And a very competitive environment.
Very competitive, which is also very good.

Ballet has always been a rather élitist construct, no?
When it was first created, it was of course the ballet of the court mainly. But very soon it was absorbed by the middle classes and later by the working classes, especially during the French Revolution. If you look through history, professional ballet dancers have always been from very humble backgrounds. Of course in Russia ballet became the big artistic achievement that the Revolution could show off. So it is a British perspective to think that it is an élitism. Maybe it's in part because it has been embraced by the Royal Family and they have been patrons.

Being a successful dancer would seem largely to have to do with dedication and physical ability, no? One might think that intelligence has very little to do with it.
Intelligence is the most important thing a ballerina needs. When you're confronted with the art of ballet, it is an ideal aspiration of what you want to achieve with your body. But then you have reality, which is your body. And each body is completely different. So you need intelligence to be able to understand your own limitations or your own qualities and see how you can use them for your best advantage to achieve this ideal. It's an intellectual reflection, even things as simple as remembering the steps. Steps are mathematical equations so anyone who doesn't understand mathematics is not going to understand how to remember steps.

How many hours does this training for your mind and body take?
I read that book *Outliers* which said it's ten thousand hours and I realised that I did ten thousand hours by the time I was fourteen. I've probably done sixty thousand hours by now. When I was a student, I would start at 9.30 and finish at 6.30. Today I start very often at 8.30 and finish training about 2.00. Then if I have a performance, I start at 7.30 and finish at 10.30. And then you have to do your own study, to watch videos, to read books.

Where does that leave you in terms of the other things in life?
I love fashion, but I love even more literature and theatre and looking at art. I'm constantly in search of emotion.

(previous spread) Tamara Rojo in Aldwych, the heart of London's Theatreland. 'I love that it has two lives,' she says of the area. 'It has the everyday life with normal people, and then suddenly, when night is about to come, theatre happens and it's completely different.' During dark nights in a different time, Aldwych Tube station and its tunnels sheltered treasures moved there from the British Museum for safekeeping during World War II

Rojo leaves the Kensington headquarters of the English National Ballet (right), and practises (below) as part of her gruelling daily schedule

Some ballerinas look so cold; emotional is the last thing you would expect them to be.
I disagree. If you go to see *Manon, Carmen, Romeo and Juliet*, all you see is emotion. The steps in themselves have no meaning. It's like words. If you take words and put them out of order, they have no meaning. The same thing with steps. You can put steps together to break someone's heart.

Do you feel emotionally naked when you're performing?
Completely. That's the point. You're there to share, you're there to open your soul and hopefully to allow people to feel something. The only way to achieve that is with complete honesty. For that honesty to happen, all the things around you have to make you feel safe.

So in essence you're oblivious to the audience?
As a group of individuals, you're oblivious to it. As an energy, you're very much aware of it. You feel it straight away. You have five thousand people looking at you, waiting for you; of course you feel it straight away. You even feel the energy of the audience in terms of whether they are empathetic or alienated.

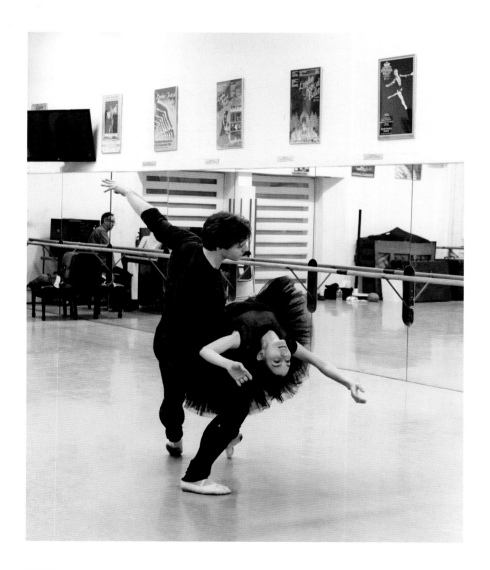

Do you perform for the audience or for the dance?
That is something I still don't know. It's almost like we're all there for something else, and because I am an atheist I find it difficult to say what that something else is. It's almost like when primitive human beings got together round the fire to connect to whatever universal energy there is. Dance is the most primitive of all the art forms. That's why it's the most emotional. Dance is the most essential way of communicating our inner feelings when we don't know how to communicate them by words.

Is that how you felt right from the beginning as a dancer?
You start out of instinct. I was five years old, so all I knew was that I wanted to be in that room doing whatever those children that I was watching were doing. I wouldn't go home! My parents didn't want to put me into ballet so I cried for six months every day until they said yes.

So you got your way with your parents, you get your way with your troupe as Artistic Director … You must own the spirit of the space!
No, the opposite. As Artistic Director I'm here to enable other people to achieve that. I'm here to open doors, and I'm also here to challenge their perceived limitations.

But you're not just an enabler, you're a transmitter of present and past emotions, aren't you? You carry the torch for generations of dancers.
I do, but actually now the more satisfying part of my job is the enabling.

Besides London, which are the world's other top ballet centres?
Today it would be Russia, Paris and London. The thing about London is that you don't only find this excellence in dance. You find excellence in music, in theatre, in art, not just infrastructure but cross-fertilisation.

Going back to your own personal journey, you've described yourself as 'a great self-abuser'. What did you mean?

I am not so much anymore, thankfully. What I meant was that there is a moment in the beginning of your journey as a dancer when you're trying to find the truth. You dig at everything that you feel, and you dig at everything that you're convinced of. You question everything. I did it to an extreme that I wouldn't recommend to everyone to do. I would do it physically as well. I would say, Okay, how long can I go before I break?

Does all of this physical work and psychic exploration not lead to a rather lonely life?

It does and it doesn't. It does in that there is part of your mind that is constantly searching, constantly looking inside and outside. But of course we dance in ballet companies so you spend most of your day surrounded by people. If you talk to a musician, a great pianist or a great cellist, they spend days on their own practising. Our practice is always public, it's always shared. That's really good because it means you have a family feeling; you go on tours around the world with this family, you get very close. Some people marry each other, some people have children with each other. So it is a dichotomy that your search is individual, but the way you practise it is within a community.

Rojo looks south (above) from the roof of the ME Hotel in the Strand. 'I love looking at the South Bank and seeing how it has transformed from an area where no-one wanted to go to one of the trendiest areas of London,' she enthuses. 'Seeing the Southbank Centre, the National Theatre and Tate – all of that has transformed the south of the city'

'If you take words and put them out of order, they have no meaning. The same thing with steps'

Natalia Kremen
Ballet instructor

Natalia Kremen, who left the English National Ballet just as Tamara Rojo was arriving, founded the Natalia Kremen Ballet School in Kensington in 2012. Having trained at the Bolshoi Ballet Academy and Leonid Lavrovsky's Ballet Academy, Natalia found herself settling in London after meeting her future husband, dancer David Makhateli, while she was on tour. Following an audition, English National Ballet offered her a permanent contract. In fact, Natalia always wanted to have a 'much wider repertoire'. 'I wanted to get the opportunity to dance in ballets by MacMillan, Ashton, Nureyev, Lifar and other great choreographers,' she explains. And, she adds, her teachers told her that 'your feet should speak when you dance.'

Reflecting her commitment to her profession, Natalia's favourite quote is from Emile Zola: 'The artist is nothing without the gift, but the gift is nothing without work.' Her favourite roles were Giselle, Raymonda and the *pas de deux* from *Romeo and Juliet*. The most testing of these was Giselle, because 'you have to control each centimetre of your body, be strong inside so it looks effortless, light and weightless for the audience'. The fact that her father was a ballet dancer meant that she began going to performances at the age of three. But her father didn't want her to follow his footsteps 'because he went through all the difficulties of a dancer's life, and he didn't want me to know about aching pain in muscles, tears,

toe blisters, competitions between classmates, injustice, injuries, jitters and all the rest'. The turning point came at an audition at the Bolshoi Ballet Academy. 'My parents decided to try,' Natalia remembers, 'and I was lucky to be chosen.'

Natalia offers the following advice to young ballerinas: 'Learn, research, watch, read and analyse all ballets, dancers, technique, ballet history and traditions,' adding that 'ballet is not a sport. It's not just about high legs, big jumps and a hundred pirouettes. You should have charisma and dance with your soul.' Having left the stage herself, she feels that she is 'slowly becoming more normal', all the stress and strain of performance put behind her. Big stars, she notes, 'live their life through ballet. They don't really go to pubs after the performance; they focus. For example, Tamara Rojo and Alina Cojocaru don't do those things. They stay in the studio longer than others, they work more hours than others. That's what makes them so special'. London, she believes, 'gives opportunity to anyone to try to do new things. Then it's up to you if you can make it or not. In Russia, there are very strict standards … For example, if you're not certain height, you can't dance *Swan Lake* … In London it doesn't matter how tall you are, how small you are, how skinny, how fit, or how masculine you are. You can dance almost anything as long as you have individuality and charisma'.

Natalia Kremen (opposite) is whimsical at a bustling junction on Kensington High Street, contending for attention from a grumpy passerby and bemused rush-hour pedestrians. Kremen, who has danced the lead role in *Swan Lake* many times, tends to some real swans in Kensington Gardens on a winter's day (above), and, on a cold night, shows off the prowess of her young students by the Serpentine (left) in Hyde Park

Ron Arad
Artist/Designer/Architect
Chalk Farm/Pentonville

For how long have you been in this neighbourhood?
About thirty years?

What drew you here in the first instance?
We used to be in a great place in Covent Garden, which is our original playground. Then Covent Garden started changing. There used to be a big hall that was sort of a people's park there; it was the end of hippie-dom. And there were creative people there. There was Details jewellery and there was a young guy from Nottingham called Paul Smith. He had his first shop there, and every night he used to project slides on the window. Everyone knew each other; it was really good. Then the chain stores took over and we were forced out. I saw a 'For Sale' sign here, and I walked in and I loved it. It was a sort of oasis. I thought, This time I won't spend any time or energy on designing the place like I did in Covent Garden. I didn't keep my word. We had an accountant and he said, 'If you do this, I'm not your accountant anymore.' So that was that.

So your Covent Garden experience was seminal in terms of your early London years?
Absolutely. When I walked into Covent Garden, there were people who worked on theatre sets there and initially I shared a studio with them. My studio was very much in the open; people came in and out. Once I had a group of Japanese people come to the studio and say that they'd heard that we had good parties, which was true. They were sent to photograph one of our parties. I said, 'Give me your card. We'll call you when we have a party.' 'But we're leaving on Friday.' I said, 'We can't have a party between now and Friday!' They said, 'But our editor said we have to have a party here. We'll pay (this is over thirty years ago) £50 to every guest.' 'Well, actually, we do have a party on Wednesday!' I started calling all of my friends. They said, 'We'll do the drinks and the food.' They wanted an English thing, so we had triangular cucumber sandwiches. And they asked everyone, 'Where did you get your shoes from? Where did you get your jumper from?' – that sort of magazine thing. We still didn't know how serious they were, but there was someone at the door with a wad of £50 notes. So we all went to the pub, and it was a problem for whoever was going to be the first to break the £50 note to buy a round of drinks. £50 was a lot of money back then.

When was this, 1984?
Yeah.

So you got chased out of Covent Garden because of money, because of development. What's it like there now?
Look, I'm not a judge of creativity, but I believe there is more feeling in Soho than in Covent Garden. Covent Garden is a good place to see people that paint themselves white and stand like statues, a good place to buy socks.

Speaking of creativity, where do you get your inspiration?
Ideas are cheap. The big problem is not ideas but to know which ideas you give time to, which ideas you invest in.

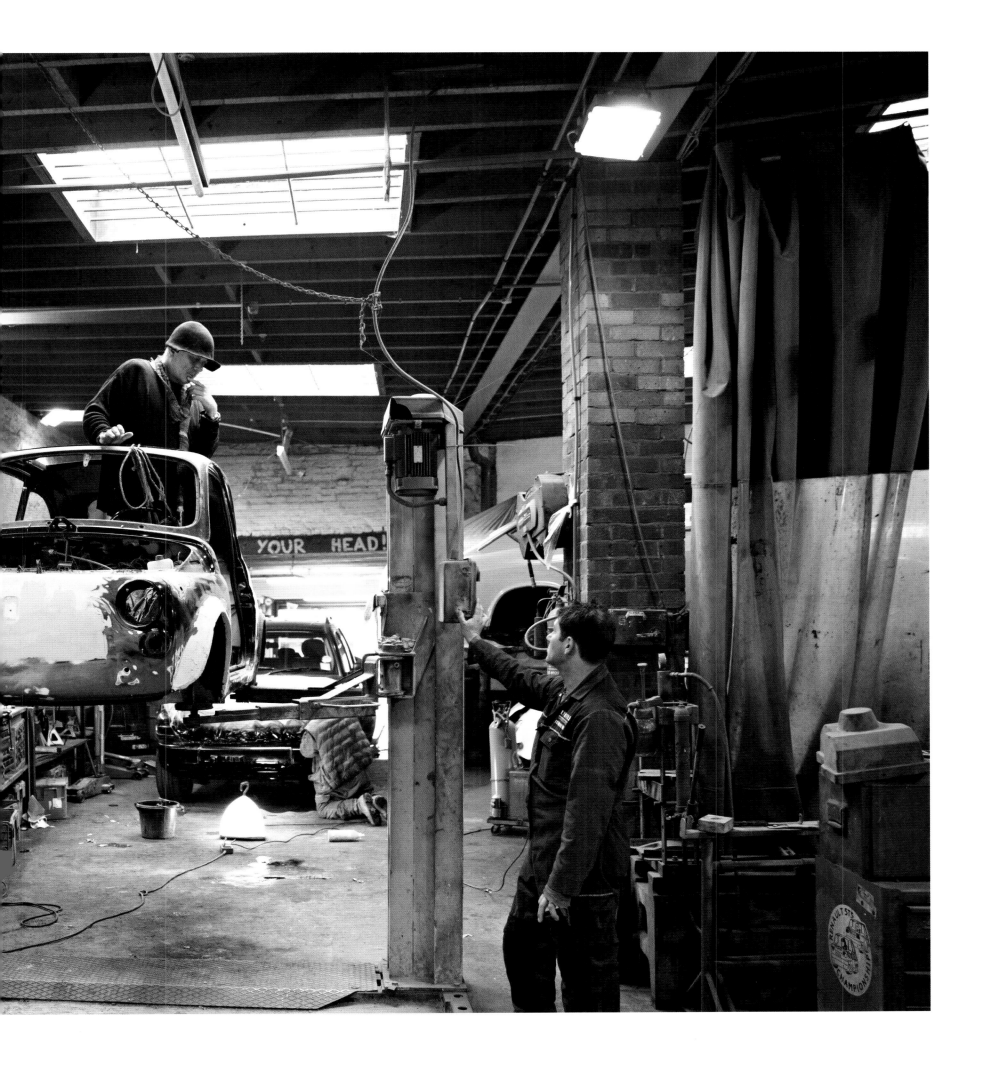

(previous spread) Ron Arad works on a restored FIAT 500 similar to those in his 2015 exhibition at New York's Paul Kasmin Gallery, where six cars were crushed flat. FIAT later released the limited-edition FIAT 500 'Ron Arad', created by the eccentric designer

Arad (below) at the entrance to his Chalk Farm studio. He strikes a typically quixotic pose (opposite) in front of a series of iPad sketches by his friends Ai Weiwei, Antony Gormley and Christian Marclay. Arad's electronic device (he is also a computer geek) etched their sketches onto glass with a diamond drill-head; the results were mounted on light boxes

Some of your work is quite impressive artistically, but it's impractical in terms of everyday living. How does that come about?
Every project has a different objective, a different vocation, wants different things. The success of a chair can be measured not just by how many they sell but how many companies in China copy it. I visited some of the companies in China that specialise in doing copies of my work. This is what I call success, unfortunately… I'm more upset by people around here that copy than people that create factories with three hundred people working, livelihoods … There is something pleasing about that.

You used to be a professor of Design at the Royal College of Art. Why did you give that up?
Because I did it for twelve years, and they deserved someone new to take the course. I also left because the Director, in those days Christopher Frayling, was progressive, liberal, cultured, interesting, and every idea you tried on him, he said, 'Yes! Let's do it!' I wanted to stop while he was Director. He said, 'But you promised me not to leave until I leave!' 'Yes, but you promised to leave two years ago!' In my opinion, the college went downhill. Once again, they let the bureaucratic, the commercial, side take over.

'*You can become a Londoner without becoming English. So I guess I'm a Londoner*'

Are you able to teach creativity, or is it something that people are born with?
You don't teach creativity. If you say it about someone who is creative and is older than eight, it's an insult. Working at the Royal College wasn't about giving students tools, because I didn't know what they should do. I really liked the things that they didn't understand, you know? Because it was post-graduate, it was about helping people do better what they were good at. It wasn't about helping them join a professional world. Even Christopher Frayling used to be worried when I said publicly that we took perfectly employable people and in two years made them unemployable. I mean, it's not so bad because the unemployable people later employ people.

When did you first find yourself employed?
I was employed when I finished studying architecture. I found it difficult to work for other people, most often after lunch. You know, when you work in an office, you go out and … I don't know. One lunchtime I walked from this place I was employed by up in Hampstead to a scrapyard behind the Roundhouse and picked up my first two Rover seats and made a Rover chair that became an '80s icon.

And this happened just because you were bored with working? As what?
As an architect. I once said in an interview that boredom is the mother of creativity. It's been tweeted and re-tweeted and re-tweeted, and I get the credit for saying it.

So it was creative boredom that sparked the new life that led you to where you are now?
It allowed me to make a living without doing things I don't like doing.

But not everybody can do that, right?
I don't know. Everyone can try.

Okay, back to the beginning. You were born in Tel Aviv and moved to London in 1973. Why London?
First of all, I thought I could speak English, but when I got here I realised that what I thought was English was almost American. And I thought London was an exotic place. I grew up thinking everything English was high-culture compared to crass Hollywood. It's not true, of course, but as a teenager that was what you taught yourself to think.

So you became an Anglophile?
No. When I came here, I realised that there's no connection between the London I imagined and the London I found.

How long did it take you to acclimatise?
I'm still working on it.

Is it a depressive place?
No. It's my favourite place to live. You can become a Londoner without becoming English. So I guess I'm a Londoner.

What exactly did London do for you?
It's what London could offer you. Also, there's a benevolent indifference in London, I found. You could do what you wanted here in NW1 and no-one would care. Also, being an outsider was important because I didn't have my aunts to satisfy; you know, no-one was watching over you … I started my business when I was an illegal immigrant. At one point I was given twenty-four days to leave. Someone introduced me to some old guy who was the head of the Design Council in those days …

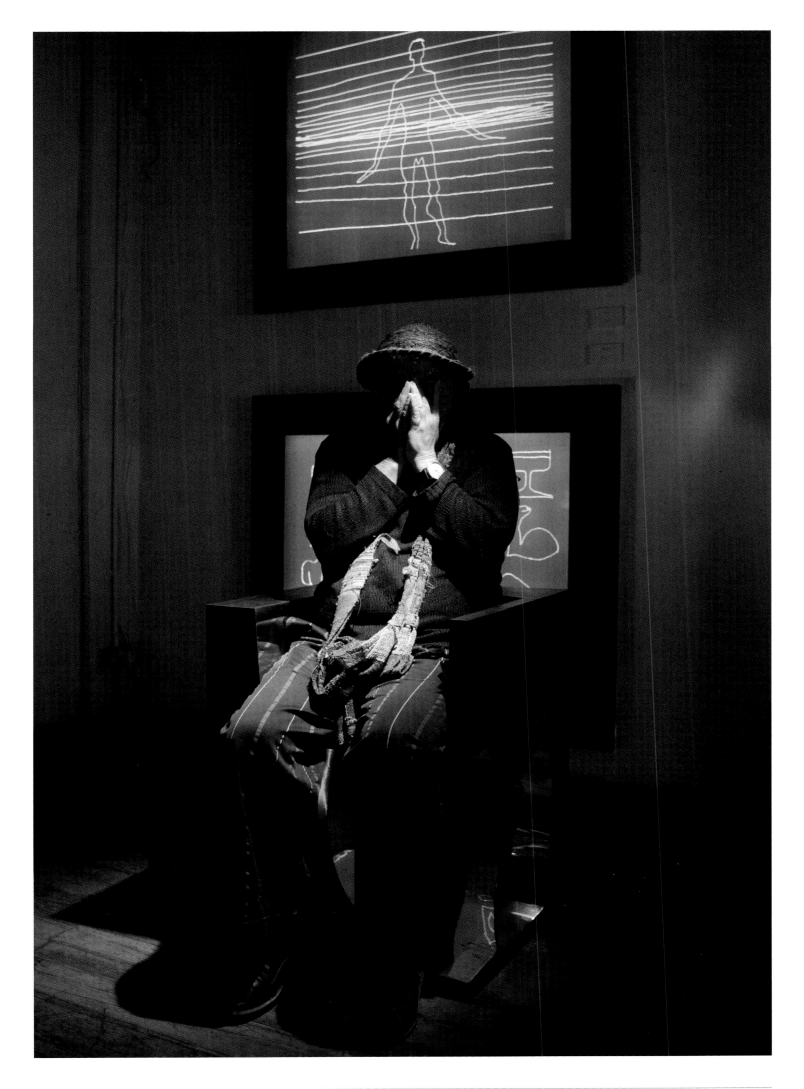

When was that, the late '70s?
Something like that. I showed him the letter that gave me twenty-four days or else, signed by some David Waddington.

He was a Minister.
How do you know?

Because I remember.
That was a great lesson in English letter-writing because the Design Council guy wrote, 'Dear David, I've just seen a letter signed by you. But I don't believe that you wrote it. You're asking Ron Arad, an asset to this country, to leave?' For me it was a lesson in …

Political wit?
Yeah. This David Waddington recommended that the magistrate that was looking at my case would … Anyway, I am here, and I became British, and I became, without me wanting anything, a professor at the Royal College, and I'm told that I'm a Royal Academician. I think I was selected as an architect. But it was my sculptor friends that, without me knowing, nominated me, and after that, when I had been to some selecting sessions of new members, I couldn't for the life of me understand how I went through it. It's medieval, the whole process.

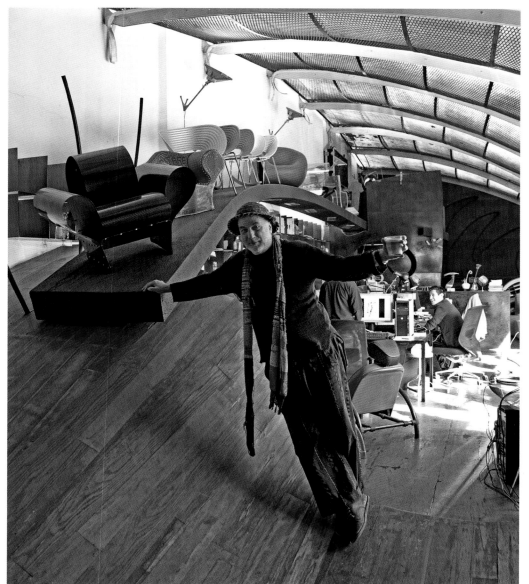

How do you contrast this traditional air about London with the city as a fantastic maelstrom of new ideas and vibrant people?
I don't know. When I go to the annual dinner at the Royal Academy and it says 'dress code', I simply don't read it.

Thirty or forty years ago they would have thrown you out.
But I wasn't thrown out of anywhere.

Do you attribute changing social mores to creatives like yourself bending the rules?
You can watch the changes. You can find very good cappuccino here, which you couldn't before.

Changes for the better?
Some things for the better.

What isn't better?
Speed bumps. There were no speed bumps when I came here. The population of traffic wardens has multiplied. I once stopped and asked a traffic warden for directions in the centre of town and he gave me very precise directions. I said, 'You know what, why don't you get in the car and show me?' He said to me, 'You'll kidnap me!' I said, 'No, I won't!' He said, 'Seriously?' I said, 'Seriously!' So he got in. And I realised that this guy worked with cars and he had never been inside one. It was incredible. He was chuffed to bits.

You have a sense of wit about both your work and your life, am I correct?
I don't know. If that's what you think, I'm not going to argue with you.

In fact someone wrote of your work that it 'consistently reinvents the everyday object, transforming it into something daring, witty and provocative'. Would you not agree? And which of those terms fits the best?
All of the above.

You've also been quoted as saying, 'I'm afraid of boredom, fundamentalists, philistines, I'm afraid of the dark and of death. I try to avoid all of these things.' What is it about fundamentalists and philistines in particular that worries you?
Fundamentalism is the most dangerous thing now if you look around you, in any direction.

Do you mean that this creative city that has nurtured you and thousands of others, which has made you an international success, also nurtures crazies who strap bombs to themselves? Is there social tension in London today that makes that happen?
Mostly not. I think the mosque does it more. I think it is the result of all sorts of religion. Religion gives you an excuse to do things that shouldn't be excusable.

And how would you define a philistine?
The artistic, creative world is not so important. Culture is luxury; culture is surplus to requirements. Where I operate, I'm upset sometimes by philistine writers … It's not important. I can live with that.

Would you ever consider moving out of London?
Where do you suggest? Where can one go? Nowhere is perfect. London is not perfect. But I prefer London to lots of places.

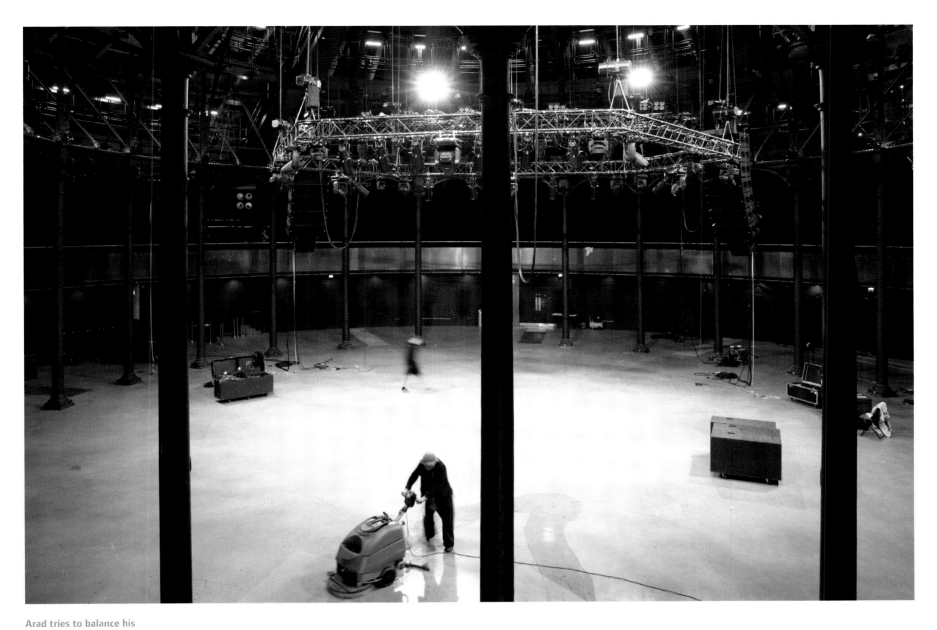

Arad tries to balance his coffee cup (opposite) while leaning against a curved wall in his studio, a piano factory that he revamped after buying the premises in 1989. Arad is an avid supporter of, and collaborator with, the Roundhouse (above), which was established in 1846 in Chalk Farm. Doing his bit, he polishes the stage floor while pandering to the camera. 'This is not only a theatre venue,' he says of the place. 'There are poetry classes, computer classes, even circus classes … It's philanthropy for the local youth.' In 2011, during the Tottenham Riots, he was trapped in the theatre until the early hours. Rioting kids spread the word on social media not to touch the place, describing it as 'a sacred location'

'Ideas are cheap. The big problem is not ideas but to know which ideas you give time to, which ideas you invest in'

Hans Ulrich Obrist
Co-Director, Serpentine Gallery
Hyde Park/Lincoln's Inn Fields/London Zoo

How have you managed, almost single-handedly, to drive the London art world's curatorial paradigm since 2006?
I have a practice that I've always done …

The word *practice* evokes something purposeful, medicinal, diagnostic. Does your work have a diagnostic purpose?
I don't know. In a way it is not a theoretical profession, not something that came out of academia. It is something that came out of practising, making exhibitions, working with artists. I've worked in the field since I was a teenager. When I started, the word *curating* was not used as often as it's used now. Often people didn't know what the word meant. This was pre-Internet, the '80s. When I told my parents that I wanted to become a curator, they thought that it was a medical profession. They were very excited. We didn't clear up that misunderstanding for a couple of years because it sort of created comfort.

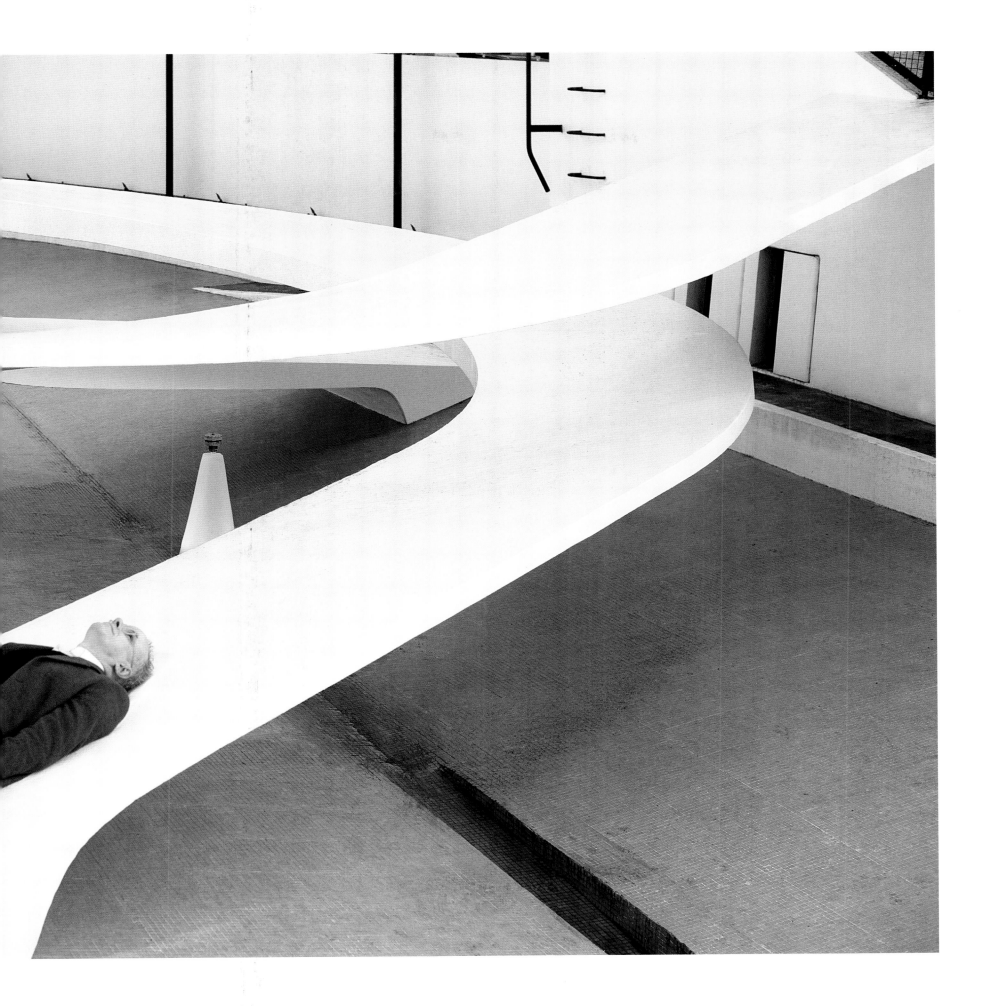

(previous spread) Hans Ulrich Obrist at rest in the Penguin Pool at London Zoo in Regent's Park; the pool was designed in the 1930s by the Russian émigré Berthold Lubetkin. While it has survived waves of architectural depredation, the penguins have been relocated to the zoo's duck pond, thus abandoning their impractical habitat

And today?
Today curating is everywhere. If Joseph Beuys said everyone is an artist, now everyone is a curator. The Internet has had an effect, but so has globalisation. A recent article in the food section in a New York newspaper said that Chinatown feels like a museum where Chinese crab is being curated. Musicians and DJs are invited to curate music festivals and radio shows and playlists. The sociologist Mike Davis criticised Barack Obama by describing him as the chief curator of the Bush legacy. Through the Internet it has become obvious that something that has been occurring for the past hundred years is peaking. There is more and more data, the data is exponentially exploding, and there is also a shift between creating new objects and using what is already there.

So you are a manager of ideas?
That is one definition.

How do you ensure that 'curators' do not assume a mantel of self-importance?
The most important thing for me always has been that the most important people in the world are artists.

But people like you seem to be framing the institutional art discourse nowadays.
It's not only about me. Every morning I read Edward Lifson when I wake up, the poems and the novels of this man. I need him to give me strength to resist the homogenising thoughts of globalisation. It's a way of resisting the pressures of a more unified experience of time and space. That's what exhibitions do. They resist that homogenisation. In this sense it's important that we think not about 'fly in, fly out' curating but about curating which is a much longer-term commitment.

Some people would claim that, given globalisation and the art-fair mania current everywhere, artistic production is essentially being metered by galleries whose curators are only out for short-term gains.
Yeah, but my activity as a curator has nothing to do with the market.

That's an important point. You are off in a little universe on your own. Was that a purposeful decision?
Yeah. That was a decision I made early on.

You've never been a collector yourself?
No, no no. Collecting results in a system in which you have a lot of artwork. That's the opposite of what I do. It's not about ownership. What I *do* collect are recorded conversations with artists. That is not a collection but an immaterial archive.

You claim that artists are the most important people in the universe. Is this something that has happened recently, or has it always been so?
This is a very interesting question. What do we remember of previous centuries? Most of the politicians and the emperors have come and gone; art has staying power. It has a power to drive us through time. Artists are able to anticipate things in a way that a lot of us can't. That's why to be a curator is to be a utility for these artists. I want my profession to be useful.

You've been described as a junction-maker. Is that what you mean?
Yeah. J. G. Ballard mentioned the idea of the junction-maker. You can say that as a curator you make junctions between objects. You say, 'This is an artwork that can be installed here,' and then we make a decision about how artworks are placed or assembled. An exhibition needs to invent a new rule of the game. There is not only the rule of the game, there is craft involved in how it's composed. You can also say that bringing together people is a form of making junctions. I, for example, bring together an artist and an architect, or an artist and a scientist, or a composer and an artist, and they do an opera together. That's also curating.

It's almost the role of an impresario.
Yes. I'm not an art curator. I curate literature, I curate music, I curate science. That's what I learned from Diaghilev, the great multidisciplinary impresario with the Ballets Russes. He curated painting shows and got bored. In a way, with the idea of being a painting curator, there is a feeling that you need to go beyond that and do something that appeals to all of the senses. That is the core of my work, and it creates a permanent kind of surprise, hopefully.

You are located in the middle of one of the biggest parks in the world, you are a tiny outfit, yet you have made such a hullabaloo. Is that debilitating or exhilarating?
For energy it is very good because we don't get overwhelmed by the really big things we do here.

And what of the architectural dimension to the Serpentine's ambitions?
I was interested in architecture and often curated architecture. Julia Peyton-Jones, who was Director of the Serpentine before I came, invented the Serpentine Pavilion. The model was to bring architecture and art together. That brought Julia and me together in an interesting way. We started to do this experiment where we ran an arts institution in tandem.

'It's also interesting that now all cultures are in London. It is the only city in Europe which has this cosmopolitan dimension'

Obrist at Sir John Soane's Museum (left) among faces and objects he remembers from the year he spent sleeping there as a young curator while working on the first exhibition of contemporary art to be held in the building. 'I used to retire to my room at night,' he recalls. 'It was so spooky!' (especially with the sarcophagus of the Egyptian pharaoh Seti I nestling in the basement). The museum, opened to the public in 1833, house's Sir John's collection of art and artefacts, from Roman antiquities to landscapes by Piranesi and Canaletto. Obrist, with the museum's current director Abraham Thomas (below) in the Picture Room, views paintings and architectural models unveiled from behind nineteenth-century hinged panels. William Hogarth's *Rake's Progress* is among the treasures

Obrist (above & top) alongside the Serpentine Gallery's 2014 Pavilion, designed by Smiljan Radić. Obrist (right) views the Albert Memorial, one of his favourite London landmarks. Unveiled in 1872 to commemorate the death of Queen Victoria's consort, the memorial bears witness to the surrounding area's transformation into a knowledge hub

You are distinctively different characters, and yet the arrangement has worked to good effect.
Yes, in a way, like Julia and I have said, 1 + 1 is 11. It's a wonderfully complimentary kind of collaboration, and it's very, very exciting. I would say also that because of globalisation it's much more complicated to run an arts institution than it was ten or twelve years ago. It's good to have two people.

So could you have done this if you'd stayed in Paris instead of coming here?
It is very specific to here. The way London connects to the world is so fascinating. It's within an archipelago, and that's another thing we can learn from Edward Lifson: the twentieth century was very much a quest for specialised centres. As he says, New York stole the avant-garde from Paris. You can't say that the avant-garde today belongs to New York, or Paris, or London; that would be an absurd claim. We can however say that London in this new archipelago condition is very important because it is also a time when Europe is in danger of again having nationalisms, which are poisonous because they are a reaction against globalisation. You have people who embrace globalisation blindly, and that's dangerous. Then you have people who reject globalisation and go back to nationalistic positions. We need a third way. That is our job. No matter what we do, we need to work on – there isn't a word in English really. *La mondialité* is the engagement with the Other. If you are from an island, you need to change with the Other, to develop with the Other. It doesn't mean that you lose your identity.

But why does London stand out in this connection?
It has many centres. It's not like Paris, where you have one centre and then the periphery.

How much does technology have to do with this fusing of archipelagos? Because you've said that with new information technologies the human condition has been reshaped.
Absolutely. It will be interesting to see how information technology enters the world of exhibitions.

But if people have nothing to touch or own, will art continue to have value?
If you look at artists who work with the digital in a materialist way, they almost create a new form of materialism. There is such a verisimilitude in these avatars; you see every pore of the skin. It's very visceral to make the digital almost HD, very slick.

Do you believe that London will maintain its archipelago position in the future?
We should never predict the future. I think we are looking at a post-planning condition, and things can change so fast. The role of the futurist is the role of the artist. In London at the moment, there is no end in sight. It's much more central than if you were in the US; it's difficult to go to the Middle East from there, to go to Asia, Central Asia or Russia. From here it's relatively easy. It's also interesting that now all cultures are in London. It is the only city in Europe that has this cosmopolitan dimension. The only thing that endangers it is that real estate becomes too expensive. The real estate bubble prevents creative people from staying. Nevertheless, London has incredible resilience. It always bounces back.

Was it always thus?
When I moved here in 2006, I didn't find it as dynamic as it had been in the '90s, because when I worked here in the '90s, there were the YBAs, and there was this great energy. In 2006, art was good, but it was very global, and it was a bit more difficult to find a new generation of artists emerging. In the past two or three years, there has been a whole new generation of artists emerging who also work with digital media. Many of them are worth watching. It's not only that real estate is so expensive that everyone emigrates; we have a new generation that pops up.

You've described yourself as someone who rose up from travelling as a student on night trains to see artists to become the most public voice of new creating. Was that your greatest achievement, or is there more to come?
My greatest achievement is coming from such small beginnings, you know? I never want to look back on what was achieved. We are only as good as our next project.

'*I never want to look back on what was achieved. We are only as good as our next project*'

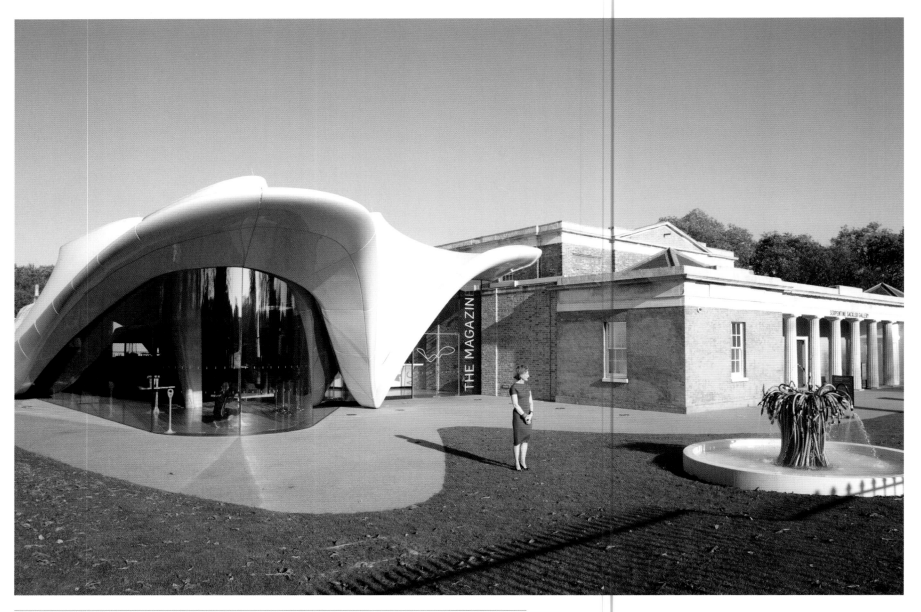

Julia Peyton-Jones
Co-Director, Serpentine Gallery

Former artist Julia Peyton-Jones, who runs the Serpentine Galleries together with Hans Ulrich Obrist, is the intense networker (although she hates the word) widely credited with turning the premiere venue's fortunes around. After exchanging emails regularly with him and speaking every day, Julia decided to offer Obrist a job. The rest is art-world history.

Although her grandfather was an art historian, contemporary art was not a part of Julia's upbringing; going to the Tate with her father was a special treat though. Educated at Tudor Hall, she went on to study at the Royal College of Art. Described by a friend as 'deeply reserved', colleagues find that Julia's 'single-minded focus can be intimidating' though 'unarguably effective'. She is known for working long hours. Her undoubted success as a fundraiser has a lot to do with her ability to focus on others as though they are 'the most important person in the world'.

Curator of Exhibitions at the Hayward Gallery from 1988, Julia became Director of the Serpentine in 1991. She well remembers the place when it was first set up by the Arts Council and only open in the summer months because it had no heating. Called 'one of the most powerful and successful women in the British art world' by the *Telegraph*, Julia went on to secure Diana, Princess of Wales as a patron in the 1990s, oversaw a major refurbishment programme in 1998 and inaugurated the annual Pavilion in 2000. The Serpentine Summer Parties – 'the hottest party of the year' (the *Telegraph* again) – are famous for their A-list attendees.

The Serpentine is also known for having the lowest ratio of public subsidy of any arts organisation in England; indeed Julia cites as one of her 'proudest achievements' the fact that admission remains free. 'I've always fundraised, always,' she says. 'I fundraised for myself when I was a student to pay my fees.' She is also something of a jack-of-all-trades, joking that she has 'done every job you can possibly imagine, and gladly so'. Gigs have included hand-colouring maps, doing architectural drawings, being a shop assistant and working in a nightclub. When she first started as a professional fundraiser, she recalls, 'it was a very unacceptable thing to do, because it was assumed that the government would fund all the arts. I took a rather different view: that it was more important for something to be done at the level that it needed to be done, and to raise the money to do it, than to worry whether it was fundraising or not fundraising. That was always my starting point, and that hasn't changed at all.' Going even further and describing fundraising 'a very honourable profession', Julia notes that 'many people have come into the arts as a result of supporting institutions, artists and individuals.' This construction of a wider community interests her greatly. When she first started out, 'there were no philanthropists, there were extremely few collectors, there were very few galleries ... It was a very different landscape. What's so exciting is that the landscape has changed and grown out of all recognition. That growth has produced something astonishing in terms of a cultural centre for Europe.'

Lacking an advertising budget, the Serpentine relies solely on word of mouth to promote its programme. Such a thing would simply not have been possible twenty or thirty years ago. For Julia the turning point was the YBAs, whom she describes as 'the impetus that really changed thinking … Up until that point, the late '80s, there wasn't the awareness of today. This country was so much about looking backwards, looking to the past, not living in the present. That was such a seismic shift; it was a revolution; it was more fundamental to the ethos, or the character, or the heart of this country than anything I can tell you. When I was growing up, if you wanted to be smart you'd buy something old. You'd never buy something new, never contemporary art'. In the early days of building support for the Serpentine, she regularly had people say to her, 'Oh, contemporary art! This is ridiculous, any child could do this!'

Julia, who serves on the Westminster Public Art Advisory Panel and who is an occasional attendee at the World Economic Forum in Davos, cites as her mentors the influential Joanna Drew (former Director of Art at the Arts Council, and responsible for the Hayward and Serpentine galleries) and curator and critic David Sylvester. 'David gave me my standards,' Julia says. She does not regret stopping being an artist herself; it remains 'something that informs what I do on a daily basis'. And the Serpentine's small footprint has turned out to be a blessing. 'I used to be tortured by the fact that people said the Serpentine was small. But now I love it,' Julia explains. 'You have to think laterally about how to keep your programmes fresh when you don't have space to help you … The scale forces invention in a way that's very interesting.'

Astonishingly, the Serpentine's annual Pavilion project draws twice as many visitors as the Venice Architecture Biennale. 'Surely,' Julia muses, 'part of the appeal is that its existence is so fleeting … It's a way for the Serpentine to build a new wing every year. Most people will do a new wing once in a lifetime. We say, "No – boring!"' About the Pavilions' fifteenth-anniversary year, she adds, 'I suppose anniversaries are of interest because it's a moment when you can look at a period of time and review the contribution you've made, see if it lives up to your expectations. But also it's an indication of the way forward and what you might do in the future. So, on both counts, I think it's an interesting opportunity for us, not least because the Pavilion was our way of exhibiting architecture not as an exhibition of drawings, models and photographs, but through the commission of a built space. The Serpentine's had a long history of commissioning from the day it opened in 1970. So it follows along the trajectory of that model …' Commissioned architects 'at the time of our invitation have not completed a building in England, but we also introduce artists who are younger and who are gaining an international reputation'. Smiljan Radić's 2014 construction was chosen by Mayor Boris Johnson as one of the images on a poster 'to talk about the things that London can offer. For a temporary structure that is only in existence for a four-month period, to be cited as a landmark of London is incredibly gratifying'.

Politics are kept firmly to one side, however. 'To lead a public institution, one must stay apolitical. But I am deeply committed to art for all,' Julia explains. 'What I do as an ambassador for the gallery is make connections with people, not just within the arts but from other fields too.' She cites the Serpentine's commitment from its earliest days to create shows with such 'unbelievably distinguished' artists as Giacometti, De Kooning and Jasper Johns. The rules of engagement have changed in the meantime. 'The term *curator* was not invented then,' Julia notes. 'They used to select artists and call it "co-opted by committee", which was an incredibly labour-intensive idea … There was a pairing between the Hayward and the Serpentine, through exhibitions called the Summer Shows, and that was an opportunity where tourists as well as the British public had the chance to see work by contemporary artists. On many occasions they would not be familiar with them … The Hayward and the Serpentine were two of the few places in London where you could regularly see contemporary artists' work.' That public interest in, and support for, contemporary art went from strength to strength had to do in part with the Princess of Wales becoming a Serpentine patron but also

with design magnate Terence Conran, by way of his influential shops Habitat and Heals. 'Habitat was major,' Julia observes, 'this idea that you could own an object which was designed by a living person, and you could afford to have it in your sitting room. It became cool and hip and desirable not to look to the past, but to look to today. Architecture followed very much later.' In this connection she credits Obrist with making an observation that stuck a chord: 'He was part of a panel at the Hayward, and he talked about what Eurostar had done to our national psyche. Of course Eurostar stopped this country being an island. It punctured the very essence of who we were, and that umbilical chord to Continental Europe psychologically was a massive change … The island mentality began to unravel, and by unravelling we looked outside this country and then received things. The rest is what we know today.'

Julia Peyton-Jones (opposite) in front of the Serpentine Sackler Gallery, designed by Iraqi-born architect Zaha Hadid. 'When I came into the art world,' Peyton-Jones remembers, 'the artistic community was very small.' Opened in 2013, the gallery is a tribute to her relentless drive in transforming a minor public space in Hyde Park into an internationally recognised contemporary-art platform. Peyton-Jones (above) on night duty near her office, with the V&A's cupola visible in the distance

Elif Shafak
Writer
Marylebone

You were born in Strasbourg to Turkish parents, and went on to live in Spain, Jordan and Germany. You now live in London. So you've travelled far and wide, causing trouble. At least your writing has caused trouble. Sometimes.

Has that been intentional? Is your writing meant to be political?
Not necessarily. As writers coming from countries like Turkey, Pakistan or Egypt, countries where democracy is not mature, I don't think we have the right to be apolitical. And I'm not an apolitical person. However, my main guide is always my imagination. So there is politics in my writing, but politics is not my guide. My guide is the art of storytelling. This is a nuance that I care about.

This art of storytelling, this big imagination that you own, seems to have blossomed early on.
I was a very lonely child, and I did not grow up in a typical Turkish patriarchal family. I was raised by a single mother, and because she was working, I was on my own for long hours. Because we lived abroad, in addition to that loneliness there was a sense of cultural alienation. As a result, I was very introverted, and books were my best friends from the very beginning. I started writing at the age of eight. But I was left-handed, and at the time in Turkey people thought it was wrong to be left-handed. So they forcefully converted me to right-handed. There were all these myths that the right hand is for good things, the left hand is for sin, or there are two angels sitting on our shoulders writing down our sins and our virtues, two notebooks on our shoulders. So these angels are constantly scribbling. You're constantly told off, constantly reprimanded. As a result, I was very late to learn how to write. Even today there's a gap between my mind and my handwriting.

Please describe your early travels.
First there was Strasbourg, then we went back to Turkey, to Ankara, the capital. Around the time I was ten years old, we moved to Madrid. Spanish at the time was my second language, and then English became my third language.

So when you were writing as a child, you were writing in Turkish?
I was writing poems in English. I love language; I pick it up fast. So I was writing in both languages.

Was this encouraged?
I was a curious child, I was an observer, and in a land such as Turkey, there was so much to observe and question. But at the same time I was always treated as an individual. That's an important distinction.

Was that because of your mother?
Yes. She was different; she was a divorcée first and foremost. When my parents got divorced, she had no diploma, no job, no money, and we came back to my grandmother's house. Usually in this Muslim, conservative neighbourhood what they would do automatically was find a suitable husband for such a woman, because she shouldn't be alone. Usually you married someone much older, because you're not very favourable in the marital market because you're second-hand. It was my spiritual, Eastern, traditional grandmother who stepped in. She said, 'Wait a minute! She's not going to get married again, she's going to go back to have her diploma, have her degree, have a job, and then she can do whatever she

wants. In the meantime I'm going to take care of Elif.' So there was a time when I grew up with my grandmother, and that was an interesting phase in my life because this house was full of fortune-telling, superstitions, evil-eye beads and folk culture. It's an important part of my storytelling.

Fast-forward to your book *The Bastard of Istanbul*. A huge bestseller, it propels you into the international arena. More so because the Turkish government attempts to punish you for being sufficiently bold (as a woman) to state facts euphemistically termed 'un-Turkish'. Did you not fear for your freedom?
Yes. It was quite unnerving. On the one hand, the book was distributed freely, was a big bestseller; I had amazing positive feedback from readers, particularly women. At the same time, I was put on trial for insulting Turkishness under Article 301, so there were demonstrations in the streets, ultra-nationalists burning my pictures, spitting at my pictures.

Was that accentuated because you are a woman?
Turkey's very patriarchal, very sexist, and the literary world is no different. For them to respect you, you have to … My goodness, you have to struggle a lot.

(previous page) Elif Shafak at La Fromagerie in Marylebone, where she sometimes writes in the mornings after shopping for her favourite cheeses. The world's most read Turkish female writer, she moved to London in 2011. 'I wasn't born in this city, but sometimes I think latecomers appreciate the beauties in a city much more,' she muses. 'I don't take it for granted'

But you became the most widely read female writer in Turkey.
I did. But they still look down on me. Recently I read a review that started by saying, 'Let's see what *kızımız – kızımız* means "our daughter" – has done this time.' And then he started to criticise me. I'm looking at this person; he's the same age as I am.

Never mind! With almost a million copies sold of the book, with a million and a half Twitter followers, you're a force to be reckoned with! How do you use that power to good effect?
I tweet in Turkish and English, and I have followers from different nationalities, different religions, different ethnicities. I like the way people can connect around stories, around storytelling. I took a decision early on in my life not to answer slander with slander, not to answer verbal attacks with another verbal attack, or gossip with gossip. I have so much respect for words, for a good cause. That good cause for me is stories. There are so many things I criticise, starting with gender discrimination, all these things I write about openly, but I don't attack people individually. We talk about ideas. And I do believe that creativity is contagious.

You talk about the multiplicity and plurality of voices. Is that a component of creativity? Can you have creativity in a society hidebound by tradition, religious or political control, dogma or fashion?
Where there's sameness, creativity withers away. Creativity thrives on difference, on differences. In this life, if we're going to learn anything, we're going to learn it from people who are different than us. I'm someone who celebrates cosmopolitanism. Turkey lost a lot by losing its cosmopolitan social fabric, by not appreciating it. I believe that where there is no diversity there can't be true democracy, there can't be true creativity, there can't be true art. The linguistic aspect is important for me because many words were taken out of the Turkish language because they were coming from Arabic or Persian. If you look at an Ottoman dictionary, it's this thick. If you look at a modern Turkish dictionary it is half the size. Up to 55 per cent of the vocabulary was taken out because it was not linguistically or ethnically 'pure', whatever that means. As a result we lost nuances. So, when I write in Turkish, I use lots of old words that were taken out. I put them back in. Why are we chasing the ethnic origin of words? It makes no sense to me.

Talking of lives, you've chosen London as your primary home. How much of the year do you spend here?
I spend most of the year here. My kids go to school here. I made the English language a home, not only London. I also love Istanbul. I think it's possible to love two people at the same time, two cities at the same time. I love Istanbul with my heart, but I have a huge love for London.

Has that love grown since you settled here?
It grew more and more. When I came here I didn't know a single soul because at the time, my main publisher was in New York, and the only editor that I worked with at Penguin UK had taken maternity leave and then quit. So I had to start everything all over again. London is beautiful, but it's not an easy city that opens up immediately, so it takes time to understand its spirit.

Describe your first wild moment of getting lost in London.
I got lost in St John's Wood; I got lost in Pimlico so many times; the beautiful markets, oh my goodness! Borough Market, I love that! I feel very comfortable when there are all kinds of fruits and vegetables and people selling. I'm not a shopping-mall person at all. I love life on the street.

While working, do you sketch certain scenes that then play themselves out?
I can work anywhere, everywhere. I don't need a beautiful room, a nice table. Actually I don't like nice and orderly tables, I don't like silence at all. There has to be noise, there has to be music, the children screaming, playing. When I was indoors I would always open the windows so that the sounds of the city could pour in. Usually in London I work in crowded cafés.

How many hours per day do you dedicate to writing?
I have an inner pendulum. When I'm inside a novel, that is the main thing I do in life, even though I give lots of talks and go to festivals. I love that, so there's a public persona. I'm an introvert by nature, so when I'm writing, I become more isolated. I go into my imaginary cocoon and I write day and night, usually at night when the children are sleeping. I can sleep during the day; I have to.

Do the children resent that?
It's tricky for any mother who is working, but maybe a bit trickier for writers because this is not a job, it's a lifestyle. It's not something you do 9.00 to 5.00 and then leave it outside the house. But at the same time the children enjoy it. Sometimes they question me, they criticise me. It has both sides.

Do you feel them to be more English than Turkish?
If they could learn the beauties of each culture and appreciate the democracy in the UK, understand its value, that's important. But I believe that we have to be at the same time global souls, world citizens. You can be from London and a world citizen at the same time.

Elif Shafak

You've observed that art 'needs conflict'. Can art change society? Does creativity flavour the temper, the tempo, the mood of a city? Does it inspire civility or otherwise?

Art, by its nature, asks questions. The answers are not as important as the questions. For example, I've observed lots of homophobic readers in Turkey. If you ask them, especially when they're with their friends, they will give you very homophobic answers. But when they're reading one of my books, they identify with a gay character; sometimes they love that character. I know because they tell me. Or someone who's very biased against Armenians or Jews or Alevis or Kurds connects with that minority character in a book. How does that work? I think the secret is in the art of storytelling. The novel is the loneliest art, the loneliest genre. The writer is alone when she is writing; the reader is alone when he is reading. As human beings, we're always less tolerant when we are in the company of other people. Fascism, totalitarianism, they're collectivistic diseases; they need masses. When we're alone, our chances of becoming more open-minded and open-hearted is bigger. The novel as a genre speaks to the person in that zone of loneliness.

In this zone of loneliness, this inner space of reflection, which one of your two favourite cities inspires you most?

One thing that strikes me is this difference between London and Istanbul: London is a city of memory, while Istanbul is a city of amnesia. Istanbul is based on urban amnesia; we constantly erase the past. It's easy to forget in Istanbul, whereas in London there's a sense of continuity. I like that.

Shafak, who has a habit of reading on her feet, in Paddington Street Gardens South (above), her Marylebone refuge. 'I love life on the streets,' she says. The writer's hand (opposite) rests on some of her own books in the basement of Daunt Books on Marylebone High Street

'London is beautiful, but it's not an easy city that opens up immediately, so it takes time to understand its spirit'

Shafak, lost among the shelves at Daunt's, one of London's best-stocked and most-frequented bookshops. 'As a writer, I have to be able to ask questions,' she explains. Built a hundred years ago, the antiquarian shop was bought and converted to its present cult status by James Daunt, an ex-banker doing good for London. 'I don't believe there's such a thing as old words; words live longer than us,' says Shafak

Peter Ackroyd
Novelist/Biographer/Poet
Clerkenwell

How did you end up here on the borders of Bloomsbury?
I was looking for an office and came across this and liked it, so I bought it.

Would it be fair to describe you as one of the most eminent writers on London?
I've written a lot about London, not only histories. Most of my fiction is engaged with the history of London too, whether it's *Hawksmoor*, *Chatterton* or *The Lambs of London*. It's been a constant theme in my work.

Is fiction easier to write than historical narrative?
No, they pose the same challenges and have the same rewards, but also of course they share similar difficulties. I don't change my habits of working or writing when I move from history to fiction. It's all the same process.

This love of fiction, of history, developed at quite an early age, I believe.
The love of history did. The love of fiction really only came when I left Cambridge.

I understand that you went on long walks around London with your grandmother.
That's right, and she showed me the sights, the bits she admired. But that was almost sixty years ago.

Where did your London life start?
In East Acton, which was a 1918 development. I suppose my earliest memories are concerned with that small neighbourhood.

Your early memories of reading apparently feature an encyclopaedia that you worked your way through from end to end.
Yes, Arthur Mee's *Children's Encyclopaedia*. I got it for a Christmas present when I was ten, I think.

You've said that you remember the shine of the pages, the photographs, the whole package. Was there an appeal there that drove you towards becoming a writer?
I don't think so; it was just an infantile experience. I don't ascribe particular meaning to it. The first book I read which had real meaning for me was by Karl Kraus, *Six German Thinkers* or something. No, it was Erich Heller, *The Disinherited Mind*. That caught my imagination. I thought, That's what I would like to do.

Your passion for writing apparently has a methodical side, in that you write a thousand words a day, starting exactly at 10.00 a.m. Or is this an urban myth?
I do write a thousand words a day if I can. It depends on the day.

So when you get an idea for a book, what happens?
It just happens. I don't know where it comes from. It could be anything.

And the next step is what?
The next step is to think about it, figure out the problems and difficulties. The period is important. I don't want to repeat myself, so for example I've done one late Victorian, Charles Dickens, and then chose another late Victorian, Wilkie Collins, to accompany it. I try to go backwards and forwards in specific time zones.

Do you only do one book at a time?
No, I do about three books at a time, but not of the same kind. One would be the long history of England I'm writing (in six volumes); one would be a short biography; one might be a different kind of study altogether; one might be a novel. You can juggle three or four books quite easily.

How do you manage that?
Habit and discipline.

Where did that discipline come from to begin with?
I suppose having to go through the rigmarole of exams and scholarships and grants, I taught myself that it was important to be disciplined in order to succeed.

How would you describe your family background?
Probably lower middle-class. I lived in a Council house with my grandmother and my mother.

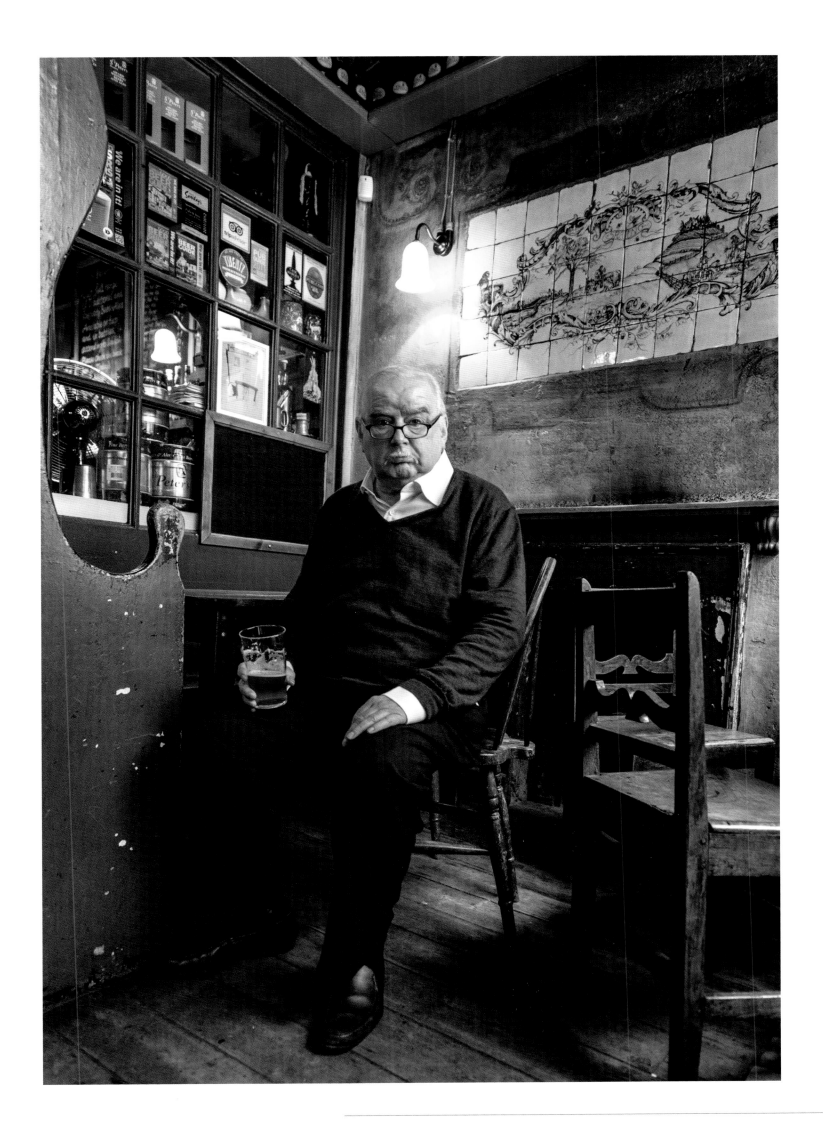

(previous page) Peter Ackroyd enjoys a pint of bitter at the Jerusalem Tavern in Clerkenwell, one of London's oldest drinking establishments. Known in the 1720s as St John's Gate Coffee House, it has been a gathering place for writers, businessmen, musicians and adventurers. Charles Dickens used to drink there, as did David Garrick and the young Handel. Quart bottles were famously known as 'Jerusalems' in the surrounding area. At one point, the place was owned by William Hogarth's father, and only Latin was spoken there

What role did luck play in your development as a writer?
Luck came into it a lot. It was only by luck I got into St Benedict's School; it was sort of luck that I got into Clare College, Cambridge. It was another kind of luck that got me a fellowship at Yale University. The biggest stroke of luck of all was when I came back to England after being at Yale. I wrote to every editor in London asking for employment. One of the letters was replied to by a man called George Gale, who was then editor of the *Spectator*. The luck was that his Literary Editor had just left. We had a short talk in a public house and he offered me the job of Literary Editor.

At twenty-three …
Yes. I was very young.

That was rather cheeky.
Yes, it was very cheeky, but it was lucky for me! I wasn't bad at the job and I stayed at it for a number of years. It introduced me to what you would call the world of letters.

What do you find especially fascinating about London? Because at one stage you described it as 'a harsh city, dark city, based upon money and upon power and upon the sacrifice of its citizens in the cause of capitalism'.
But it's still the landscape of my imagination. I like the dark aspects as well as the bright aspects.

Which do you prefer?
I sometimes admire the shadows of London as much as its public spaces.

Would you ever leave? What if somebody from Yale offered you a deal that you couldn't refuse?
No, I wouldn't go back. It's out of the question.

You've said that, once you've finished a book, you forget about it. How can that be possible?
I don't pay any attention to it any more. It just goes out of my head.

So if somebody reads a passage from one of your books to you, it takes you by surprise?
Yes. The other day, for example, I was looking at my life of Joseph Mallord William Turner, the artist, because I'd just heard about this film with Tim Spall in it. I read the first page and I was astonished! I said, 'I don't know!' And that's the truth. I didn't remember his father was a barber. Things like that just go from my head.

Of all the books you've written with London as their subject, which is your favourite?
London: The Biography would be my favourite in the sense that it's the most complete. But Thames I sort of like, *Thames: Sacred River* I think it's called. Because it's a bit quirky. I quite like *London Under London*, which is about the subterranean city.

What about the London characters you've written of?
Oh yes, there's plenty of them. There's Dan Leno, Dickens, Turner, Collins, Hitchcock, Chaplin, many more … Turner, I said him, didn't I? Newton I suppose could be called a Londoner; Milton, that's true; Blake, mustn't forget Blake. Of all those, whom do I prefer? Blake. It was the most interesting book to write, and also he was the most sympathetic of all the writers I've encountered. Oh, Thomas More is another one that I dealt with. And Dr Dee. Now that you've asked me about it, they suddenly start coming back to me in clouds. Charles Lamb was another one.

When you put down your pen, what follows in your daily routine?
I go on to the next project.

You don't go out for a drink or dinner?
No. I don't drink till I've finished.

Then work removes itself from your mind.
It's out of my mind by that stage. I just go and have a drink, or go to a restaurant and have a drink, more likely.

You've expressed the opinion that London is always the same no matter how much it might change. What did you mean?
The cliché is that London will never be the same again. In fact, it always is the same. If I was transported back to 1600, to Cornhill or to streets in the City, I would probably know where I was, and the atmosphere would be similar to the one that exists today. That wouldn't be true, of course, of many parts of London, but I mean the old centre; I would more or less figure out what was going on.

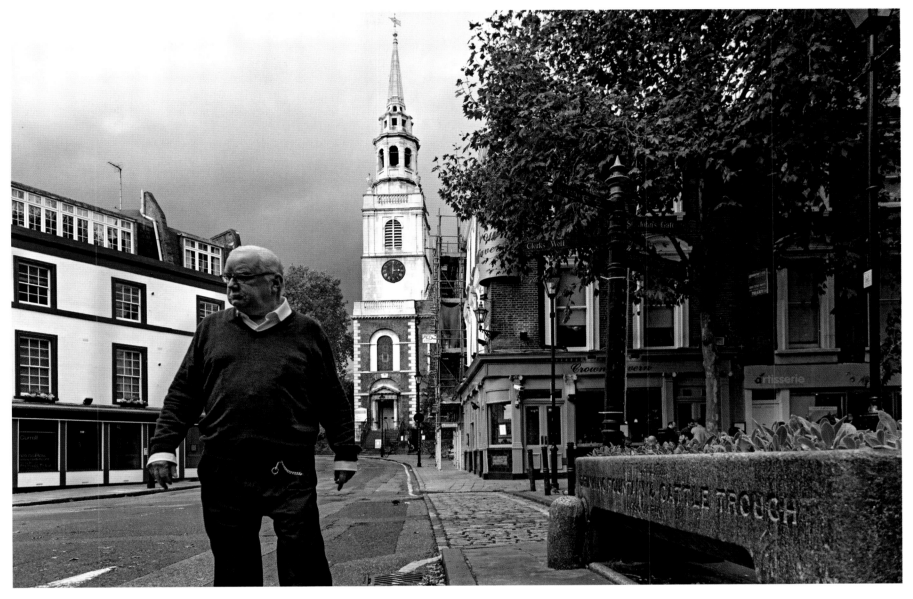

Ackroyd, facing up to history (opposite), overlooks the Cloister Garden of Clerkenwell Priory. Redolent of the Crusades, the area has been a nodal point for political agitation for several centuries. 'All radicalism took place in this square,' Ackroyd remarks (above) on Clerkenwell Green, where Wat Tyler's Peasants' Revolt began in 1381; where Lenin argued 'The Communist Manifesto', and where Karl Marx's daughter led a red-flag march to Trafalgar Square in 1887. It is also where William Morris' procession of the same year ended in what became known as 'Bloody Sunday', where the Tolpuddle Martyrs were hung, and where the Chartists' uprising began. Annual May Day marches still commence there. The Social Democratic Federation's Clerkenwell Green HQ became home in 1903 to Lenin's publication *Iskra* (The Spark); the site now houses the Marx Memorial Library

'I sometimes admire the shadows of London as much as its public spaces'

'I don't pay attention to my books' successes,' Ackroyd says dismissively of his global literary standing. In the prolific author's overcrowded study (above), his own numerous titles vie for space with favoured tomes. Ackroyd (far right) visits Charles Dickens' house; Dickens is one of many London literary greats about whom he has penned biographies. Ackroyd (right) at St John's Gate, the sixteenth-century southern entrance to the inner precincts of Clerkenwell Priory, home to the Knights Hospitallers of St John of Jerusalem, a religious order dating back to the eleventh century. 'Every road or square or crossing name has relevance in a historical context', Ackroyd notes at the entrance (opposite) to Passing Alley (a sanitised version of 'Pissing Alley'), a narrow passage close to St John's Gate

Speaking of this continuity-in-sameness, in our travels across London, we've seen nothing in parts of the city that even resembles what there was ten or twenty years ago …

It's a funny thing. London always changes, but it always stays the same. The areas that have changed most radically … I suppose the City has changed radically. Other areas have changed very much, like Smithfield and so forth, but the basic identity is still there, if you care to look for it.

And you can hardly find any Londoners, or English people, now in certain parts of the city.

Well, it was always like that. It was always well known for being populated by foreigners; there was always a lot of fuss about it. Mainly foreign merchants in those days. But it's always been very much a cosmopolitan, open city.

Is that a cause of its creativity, do you think?

Very much so. London owes a great deal more to its immigrant population than is generally recognised. I'm all in favour of immigration. It fertilises.

Even when it's Russian oligarchs or Arab sheikhs or Kazak thieves?

They're fine, let them come! They will soon be chastened by being in London and become Londoners. Within three generations, most immigrants become Londoners. Even the Russian oligarchs, if they stay, will become as much Londoners as a costermonger.

You've evoked another interesting concept, that of Cockney visionaries. What does that notion signify for you?

It's something I've tried to describe in various biographies and in a book called *Albion*, which was on the origins of the English imagination. It's to do with the nature of spectacle and the interesting crowds and large movements of the human spirit.

And a bit of naughtiness?

A bit of naughtiness, terrible pantomime and bad jokes.

Does that describe the quintessential Londoner in your opinion?

More or less. Dan Leno, for instance, was a music-hall star, but he had all the ingredients of a Cockney vigilante. What they do, as Blake said, is take a speck of sand and turn it into a universe, take a speck of London and turn it into a universe.

In the last century or two, which Londoner has been the most important in terms of seeding those specks of sand?

Probably Dickens.

Anybody who's still alive?

No.

Shifting from sand to landscape, you've said that the spirit of a place can live on in the most extraordinary ways.

Yes, it can. Territorial imperative, that's what I call it. It happens to be an observation I've made that people in the same sort of neighbourhood behave in the same sort of ways. For example, London radicalism has always had its centre on Clerkenwell Green, a tiny, tiny space of land. But from there all the great union meetings came, that's where Lenin was, that's where Marx was, that's where the May Day marches start from. All the manifestations of London radicalism have begun on Clerkenwell Green; it's the most extraordinary thing. When I first broached this theory, the guy who owns *The Big Issue* wrote to me saying, 'We've just moved to offices on Clerkenwell Green, but we didn't know its history of radicalism.' I don't know how it works, but it does.

Autumn Hues

Season of mist and mellow fruitfulness,
Close bosom friend of the maturing sun;
Conspiring with him how to load and bless
With fruit the vines that round the thatch-eves run
from John Keats, 'To Autumn'

In mid-October 2014, Regent's Park's autumnal hues begin to dress central London in seasonal colour changes. Seemingly deserted but for wildfowl, waders and a lone heron clutching its lookout at the very top of a tree's truncated glory, the spot is less than ten minutes' walk from the large, bustling tented enclosures of Frieze London, the UK's pre-eminent contemporary-art emporium, attended by forty thousand people. A few hundred feet from where international art aficionados are vying to outdo one another in purchasing works by fashionable artists for ridiculous sums, a group of crimson-clad tourists could be glimpsed among distant trees, hiking London's greenbelt.

London's parks are the ultimate gift of urban redemption to an increasingly crowded city, the result of a certain English inclusiveness as well as citizens' respect for manicured Nature. There are an awful lot of green spaces spread across the capital's boroughs, varying in size from small neighbourhood plots harnessed for children's playgrounds or exercising dogs to Regent's Park's 400 acres of rose gardens and arboretums. London's eight largest parks incorporate 5,000 acres of prime real estate scattered round the centre and suburbs; several are featured in seasonal panoramas in the pages of this volume. Managed by the Royal Parks, they ceased to be exclusive hunting grounds for royals and aristocrats as Britain's monarchs largely surrendered ownership through the Crown Lands Act of 1851.

Expropriated from the Catholic Church by Henry VIII in the sixteenth century, the treasure now known as Regent's Park became a hunting ground in Tudor times, with smallholdings farmed for hay and dairy until the Prince Regent commissioned architect John Nash to create a masterplan for the area in the early 1800s. The results of Nash's labours are evident in the elegant, and exclusive, terraced houses bordering the park, which land is still quixotically owned by the Crown Estate. Greenwich, 9 miles to the south-east, is another example of royal patronage turned to good public effect. One of the 'Royal Eight' parks and home to the Greenwich Observatory, Greenwich Park traces its history back to Roman times. Having dispossessed yet another abbey of its lands, Henry VIII had Greenwich converted into deer-hunting grounds in the sixteenth century. James I, the first Stuart monarch, was perhaps more boundary-conscious, enclosed the park with a 12-foot-high wall in the seventeenth century at a cost of £2,000. Another of Henry VIII's land-grabs from the Catholic Church was Hyde Park (this time from the Canons of Westminster Abbey, who had owned it since before the Norman Conquest). 'Acquired' in 1536, it was turned into yet more pig-sticking, deer-stalking territory for Henry's pleasure.

Other green spaces also make significant contributions as bountiful natural havens for Londoners of all persuasions, including Highgate and Brompton cemeteries (both featured in this book in remembrance of the capital's notable, weird and wonderful dead). Then there are the city's squares, more privileged enclaves fenced off (and locked) for the benefit of a select few residing around them. From Cadogan Square to Clapton Square, each of these represents an oasis of calm reflecting the range of London's neighbourhood moods as well as its social colourways. Safeguarded by the London Squares Preservation Act (1931), they are protected from development and lend the capital a range of reassuring aspects, from the rhythmic thonking of tennis balls on quiet summer afternoons to the wonder of leaves carpeting the greens in autumn.

Alidad Mahloudji
Interior designer
Fulham/Chelsea/Mayfair/Imperial Wharf

How did you end up in London?
I first went to Geneva when I left Iran, and then my parents decided that we should come to London. We loved Geneva; I still love anything Swiss. When I came here it was very difficult because I didn't speak good English, and then they have O-levels and A- levels and I was the wrong age. But actually that's what's made me because I had to really go for it.

Have you become an Anglophile in the intervening years? Where do you feel most at home?
I'm Anglophile. I feel at home everywhere and nowhere; I've learned how to blend in automatically. At the beginning when you come to this country, it's difficult because you don't understand what's going on. People are very polite, but you see them the following day and you have to start from square one. This, for foreigners, is incredibly difficult to cope with because you meet people, you've gone a couple of steps forward, and you expect one step back, not to suddenly find you're all the way back at the start. It takes a good four or five years to get into. And then, once you do, it's actually rather nice.

How would you define Englishness?
I like the fact that you're not bothered, you're allowed to live the way you want to. It's not that sort of claustrophobia that you get anywhere else. It's so removed here that sometimes you want a bit of action and reaction. That's why if I'm here more than two or three weeks I feel a bit strange. I need to go away, even if it's just for a weekend, to realise, No, no, I quite like this ... I'd like to come back to this. I could go on the street, I could cut my wrists, and nobody might come to help me, because they don't want to interfere. Sometimes you want some sort of reaction. I'm lucky because I'm always travelling.

You've spoken about being a traveller in mind and space. What does that type of travel involve?
It depends on where I've got jobs.

What's the most exotic place where you've done a job?
In Kiev, we've got a huge job that is on hold. But we've got a lot of those clients here too, so on a normal day, I have to switch 180 degrees just to say hello to somebody, not to say hello in a foreign language but to say hello according to who they are. Because how you deal with an Arab is very different from how you deal with an English person from the country ...

Is that ability to switch quickly the secret of your success?
I'm very faceted, and if I was only dealing with one facet of my character, I'd be very bored.

Faceted or compartmentalised?
Both. 'Facet' is on the surface, but obviously it goes deeper. It's just different things which I mute automatically. I know instinctively how to deal with an Arab and how to deal with a Continental and how to deal with an Englishman. I need to relate to the job before I can take it on, because when I take something on it's 1,000 per cent on, and I need to make sure that it's going to work. I get to know the client, because you can't bring in a vision that is not related to people. So the vision starts and I get to know the house.

In fact you're a kind of psychologist, aren't you?
I'm a psychologist before I'm anything else. I'm somebody who can calm things down. We deal with very privileged people quite often. The slightest thing can be a huge drama. I'm one of these people, when there's a huge drama, the moment I phone somebody, they hear my voice, everything's calm, everything's fine.

How long does your 'post-operative' responsibility last?
We're always there, except that normally after a few weeks it's fine. You go through three, four, five years of nightmares for that last day that people walk in with their luggage and there is a smile on their face. That makes me happy. But we never really go through that happiness because we've already gone to some other drama.

Getting back to your personal history, you went to University College and did Statistics and Computing! How did that happen?
As part of that difficult period of being here with not much English and having to do things quickly, the only thing I could do was mathematics. Maths opened my mind and gave it some logical way of going about things. I use that every minute of my life. I know what a 2-metre cube is, for example; I can visualise it. For me the scale of a room is the most important thing. Most decorators get the scale wrong.

Given your wide range of clients, is it a happy coincidence that London is the new HQ for the moneyed classes and many of the Russian oligarchs?
Yes.

You did a spell at Sotheby's, as Departmental Director of Islamic Art, didn't you?
Yup, a long time ago.

And the nature of your work is rather extravagant and exotic and grandiloquent ...
It doesn't have to be. I can do something relatively simple.

(previous page) Alidad
Mahloudji views a recent
project, the Saloon at
Buscot Park in Faringdon,
Oxfordshire. Presently
home to the 3rd Lord
Faringdon, whose great-
great-grandfather purchased
the property in 1889, Buscot
Park was bequeathed to
the National Trust in 1949.
The family continues to
reside on the estate among
Rembrandts and Rossettis

Alidad (above) in his
Mayfair study, decorated
to his exacting style; it
took him a quarter of a
century to complete his own
apartment. 'I'm my own worst
nightmarish client!' he says
of the experience

But the press is interested in the grand look. Which do you prefer yourself?

I like the fact that I've got a room like that myself 'cause it's London. On these grey, horrible, dark days, anybody needs a womb-like room, even in a modern house. I've been here since time began; my parents bought this flat for me. Three ceilings came down because of various floods; I still wouldn't move out. Anyway, in the end I did have to move out, to a very small flat on the King's Road, a sort of up-and-down thing, two bedrooms and a bathroom, a drawing room with a kitchen in it. I took 5 per cent of my clothes, no furniture because it was partly furnished, and I loved it. It was so easy and comfortable. When this flat was finally ready again, I didn't move back for four months, because I was happy there. It was like a village. Across the road was Megan's and I would go and have dinner there, and L'Antico was on the corner. I could live in a place like that quite happily.

But this timelessness, this outreach to times past, this grandeur, are those elements not intrinsic to your work?

Let's put it this way: If somebody wants grandeur, I can easily do it. It comes naturally. I like big scale and I like nice things.

Do you work with a big team or a small one?

A very small team. Can't have a big team. I'm a control freak. I'm hands-on with everything.

If you lived and worked somewhere other than London, would your work have a different aesthetic?

Interesting question. I think I would be the same person, character-wise, so all these ideas of timelessness and striving for perfection and detail-orientation and being mad about the tiniest little things, but having the ability to zoom and come out – this is so important in interior design. All these things would have been there, but the style might have been slightly different. I don't know. I was attracted at the beginning to the cosy, slightly worn-out look that you get in this country, that element of comfort. You only have to go to France, the nicest houses, they don't have comfortable sofas as such, or they didn't, it was always suites of furniture. Here there is that slight chaos. The way I started noticing this is that when I was on the Sotheby's course, before I got my job, they took us to a lot of country houses, and I was thinking, They are two chairs side by side, but they're not pairs. I hate pairs. My pairs are never pairs, but they occupy the same volume. A lot goes into making sure that they go with each other even though the shapes are different. That's what I learned from here: the element of comfort and the fact that it looks as if nothing matches, but the overall effect works.

Thinking back, what story did London tell you when you first arrived, and has it come true?

It's allowed me to find myself. London has changed so much since the '70s. London was sort of a village in those days, and in the past ten, fifteen years it's become something else. In the '70s, we used to go to Heathrow to have pea soup; it was the only restaurant open at 11.00 p.m.

So has the city lost its charm?

It's found other charms. What I love about London comes from my Middle Eastern background: that element of surprise. You can be in the most horrible area in London, and then you turn the corner and it's the most beautiful square, intact almost. I love that.

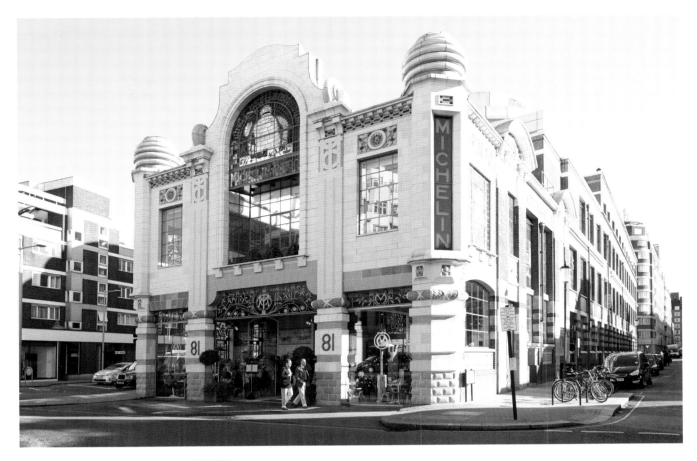

Alidad (above) on the roof of his studio building, the Old Gas Works at Imperial Wharf, with London's omnipresent gasometers as a backdrop. No longer in use, these giant tanks used to fill up every Friday to feed the city's domestic-gas grid during the week. Formerly a wasteland, the area's regeneration began in the 1980s; it is now prized for its nondescript modernist blocks of flats

The sought-after interior designer (right) playfully tries on a turban in his studio near Chelsea Harbour. His client base covers English aristocracy, Russian oligarchs and Middle Eastern potentates

Alidad and designer Paul Goulet (above) leave Bibendum in South Kensington. The restaurant is located in Michelin House, formerly the British HQ of the eponymous tyre company and one of London's more exotic Art Deco buildings

(following spread) Alidad, at the entrance to the Chelsea Arts Club, observes artist Tony Common finishing off the club's Christmas 2014 mural. A fixture on London's art scene since its inauguration in 1902, the club's exterior has been Common's experimental canvas since 2002

'I could go on the [London] street, I could cut my wrists, and nobody might come to help me, because they don't want to interfere'

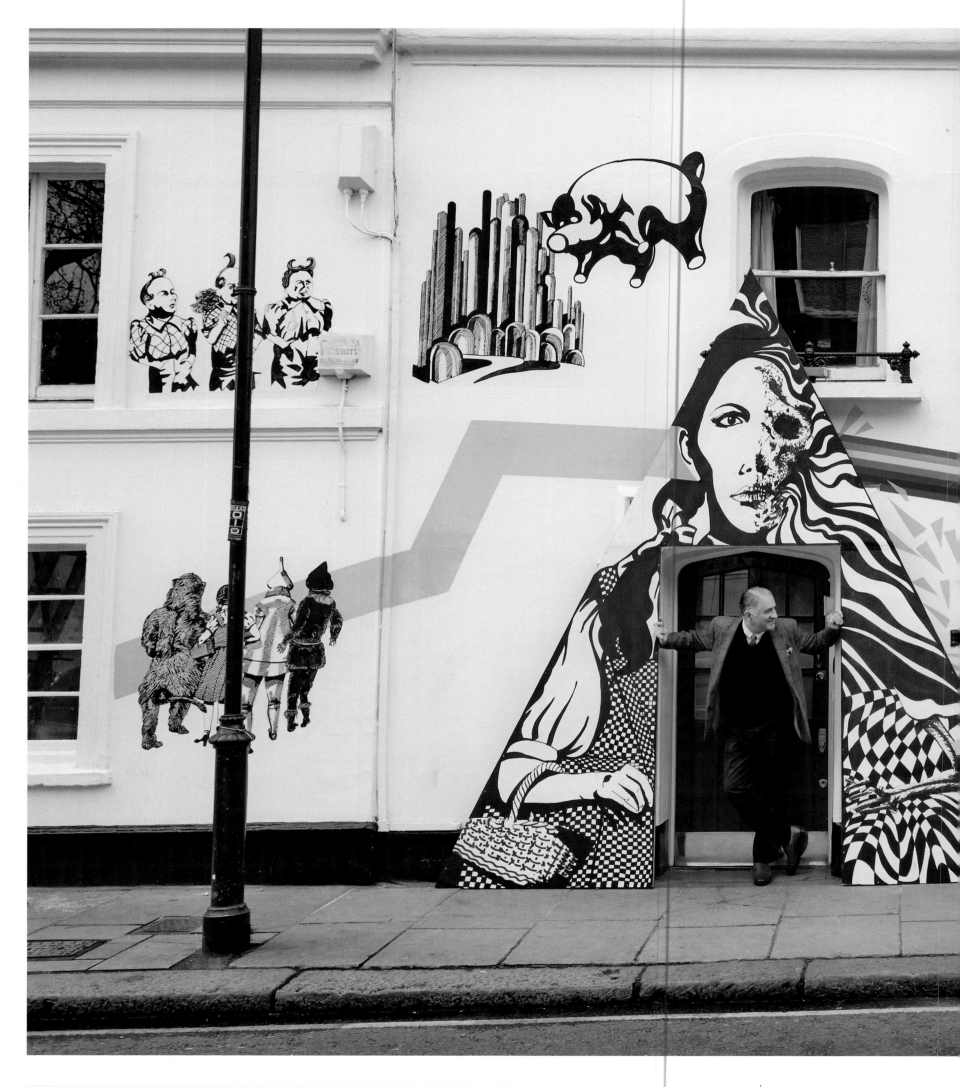

Alidad Mahloudji

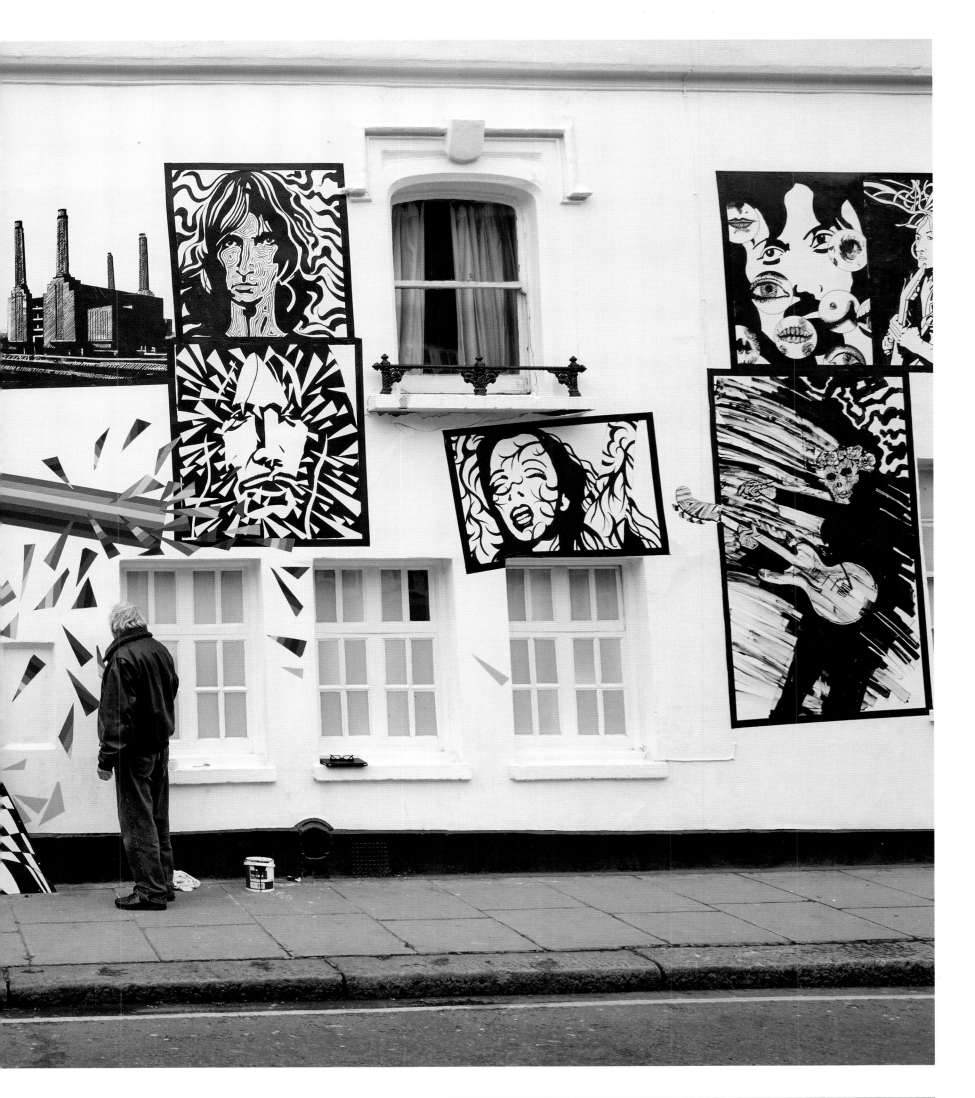

Raqib Shaw
Artist/Gardener/Apiarist
Peckham/Holland Park/Trafalgar Square

You've created a piece of Eden in Peckham, of all places …
What is lovely is that there is great stillness here. One can inhale
and exhale and have time to think when the pianist is here, with the
candlelight. I find it a very, very, very lucky situation to be here. You
know, I don't wake up in the morning and say, 'Oh, I'm going to paint
today' and then paint and then go to the pub and have a great time and
then plan my next holiday. What do you do to kill everything else in your
life and only have one focus, which is aesthetics? Each and every thing
here is about aesthetics.

**Are you dependent on this extravagant palette that hovers between
nature and aesthetic nurture?**
Of course, because I come from Kashmir and the Kashmir in my memory
doesn't exist any more.

Did it ever exist?
It's like Xanadu. It did exist in my mind, and it did exist before it was
ruined by terrorism.

**You seem to blame the Americans for intervening here, there and
everywhere, but surely the British have been more culpable in that
part of the world?**
Darling, one has to stay away from political things.

Would it be fair to say that you've become an alchemist in art?
I will not say that I have become an artist, but I definitely believe
in alchemy.

Does your alchemy derive this Kashmiri ideal that you talk about?
Oh no. It is doing something constantly and the drive for aesthetics, to
get things right. It doesn't stop. It has to be the bonsais, the flowers …
Absolutely everything has to be worked on and improvised.

What attracted you to colour in the first place?
I was born in colour. My parents were carpet merchants; they also used
to trade in gemstones.

**So you grew up in a magical garden, a garden of paradise, with the sun
shining every day, and you had a pampered childhood …**
I would not say I was pampered because my mother was manic depressive,
and at the tender age of six and a half I looked after the house. It was the
kind of household where you had people coming and going all the time.

(previous spread) Raqib Shaw plays his Bösendorfer in the rose-festooned salon of his home-*cum*-studio-*cum*-exotic garden. 'I shut myself off from the outside world because I don't want to lose my integrity!' he says of his self-imposed exile in Peckham; Shaw rarely leaves his compound Shaw (above) tends to his collection of rare (and expensive) bonsai trees. 'When I asked for the money,' he says, 'my accountant asked, "Raqib, what model is it?", thinking I was buying a Bentley!' The artist has a habit of playing Paganini to his trees to keep them in good trim. Shaw reviews progress on one of his artworks (top right), and discusses sculpture models with aides Marion, Max and Bridget (right) in the studio. 'There are hardly any good anatomy sculptors,' he laments; he once had a nude life model suspended from the ceiling during a collector's visit. Shaw (opposite) doing what he loves best: looking after his bees on his roof terrace. The colony is ruled, he believes, by three queen bees: Lady Josephine II, Lady Penelope and Lady Gertrude. Ironically, he himself is allergic to bee stings

So you were a caretaker?
Of course! Why do you think I don't have family and friends? It's because I refuse to spend my life looking after people's feelings.

Do you look after your own feelings?
I put my feelings in a lead box. But I do express them in my painting.

This incredible outpouring of colour and fantasy has a darker side as well, doesn't it?
It depends on what pieces you are talking about. When you dedicate yourself to something a hundred per cent, it transcends what you are doing and the object becomes something divine. For the object to become something divine, you have to give your liver, kidneys, heart, lungs, everything to it. No other focus, only one focus.

And this focus feeds you spiritually?
It is the only thing I can do.

Did you leave Kashmir suddenly?
When I left Kashmir it was because there was a civil war and everyone had to leave. I had no intention of leaving Kashmir. My family were very, very lucky because they could leave; other people had to stay and deal with the mess.

Your parents are Muslim, your teachers were Hindu scholars, you went to a Christian school, and historically Kashmir was Buddhist. That was a complicated context out of which to choose London. Why did you?
It is the fairest city in the world. You are not bullied.

You attended Central St Martins, didn't you?
Can you believe what they fucking did to St Martins!? Luxury hotels and flats!? It's tragic! When I was at St Martins, it was automatic that if you had a first for your BA, you went to the Royal College. I thought, Why the fuck should I go to the Royal College? Why would I want to go to Kensington? What do you do there? You go and see the Albert fucking Memorial. You are not next to Old Compton Street. And now, nothing. It's corporate. They ruined it.

Does being corporate degrade the notion of the aesthetic?
When you want to get rid of a college and build luxury apartments for extremely rich people, what do you do? It is very much like what is happening in Belgravia and Mayfair. There is hardly a community there. There are houses and people only live in them a few months a year.

In the twenty-odd years that you've been in London, how has the art scene been transformed?
Artists nowadays are interested in being celebrities, not artists. That's very sad. Would you believe at St Martins in first year they read business books, like who to sell to, who not to sell to, how to sell? It's unbelievable because as an artist you are supposed to not worry about commerce. If you worry about commerce, well, one should go to the stock market.

I just went to Frieze Week and it was like a corn exchange.
The only art fair I ever went to was the first Frieze, and I could not believe it. It was like a Sunday fête after church where you have everyone selling jam. Nothing ever really looks good at an art fair. I do think, though, that art fairs are quite important. Lots of people – curators, museum directors – do come.

So you survived Kashmir, you survived moving to London, and now you hide out in this luxurious garden in Peckham.
Darling, it's not luxurious. Can you imagine if you had a garden? You have to dead-head flowers in summer, it's a fucking full-time job. You have the worst nails, you have the worst physique in the whole world.

And you have Council flats all around you. This is not a high-end neighbourhood.
Oh darling, no. But it will be.

It will be, like everything else that gets consumed by money in London. What I'm saying is that this garden of yours is luxurious! Just one basket of these flowers costs the weekly pocket money of any of the tenement-dwellers here.
No, I get the flowers for a tenth of the price because I know where to get them from. I remember Geraldine saying to me, 'Raqib, the skips are burning with money,' because I used to spend £1.5 million on cut flowers.

In a year?
Yeah, back then, but not any more. It was perhaps a childish thing to do, but I was trying to mend my broken heart.

Broken by whom or what?
By missing Kashmir and nature. At my mother's house, you could see the Himalayas; it was absolutely beautiful. I used to live in a basement situation for many, many years. I didn't have any hot water, I didn't have a shower, six years of absolute poverty. That was the happiest time of my life.

And then in 2007, you sold the highest-priced painting by an Indian painter ever.
I did not get any money from it, darling. I really don't know what the fuck you are on about.

So we have this question of money, which seems to be paramount in present-day London. Everything about the art world is about money. Artists get stupendous prices for silly works.
Good for them and good for the economy.

But it doesn't trickle down into the economy. It's one class feeding themselves.
Well, good for them. And good for them that they are buying as many properties as they want. Historically artists were really, really poor, but now they are living the high life. Why not?

But there is a major divide in London between the super-rich, the rich and the majority. This is inevitably going to create political tensions.
Oh, come on! I really don't think that necessarily is the case.

Raqib Shaw

Shaw with his eleven-year-old Jack Russell Mr. C (left) in his exotic garden, where plants have to be grown in pots. 'The previous owner buried all his rubbish underground to avoid paying for skips', the artist complains. 'You dig a metre down and you hit a bathtub or WC!' Shaw (above) surveys the neighbourhood from atop his compound, a former sausage factory. 'Nobody needs a gym here, what with all this going up and down the stairs,' he jokes

What I'm asking is, when it comes to money and art, how much has London contributed to the current situation?

The reason I wanted to be here is that I wanted to be in the fairest city in the world. I wanted to be in a city that embraces art in all of its forms, and people as well. Apart from the Queen, I don't think there is much nationalism here when you compare it to places like New York. Post-9/11, New York lost its eccentricity. People became so tragically politically correct and absolutely, severely sterile. I was in New York for two days and three nights. I almost died. It was like steel, steel, glass, glass everywhere. Can you imagine if all your life was centred round this tiny patch called Central Park? London is brilliant. It has parks. Also, what I love is that you can see the influences of the Empire.

So you have this love of the city, but you keep yourself hidden in your own Garden of Eden.

Yes. When I was a student, one day a week I would walk around London, just walk and see and observe.

Did that inform your aesthetic?

Absolutely. In St Martin's in the Fields, next to the National Gallery, you would have the most incredible afternoon concerts, and you would pay by donation in a box that went around. I don't know if it still happens, but with the skylight and the sun, it was very spiritual.

You've been quoted as saying that the first chapter of the story of your life was painting, but the last chapter is going to be your fear. What are you afraid of?

I used to write a diary, and each and every painting is a page of my diary. Every time I look at a group of paintings, I know exactly what I was going through at that particular moment in time. Of course, it's highly coded, very, very metaphorical, but that's what it is.

A sort of *Satanic Verses*?

Oh, it's much more sophisticated than that.

'Why would I want to go to Kensington?
What do you do there?'

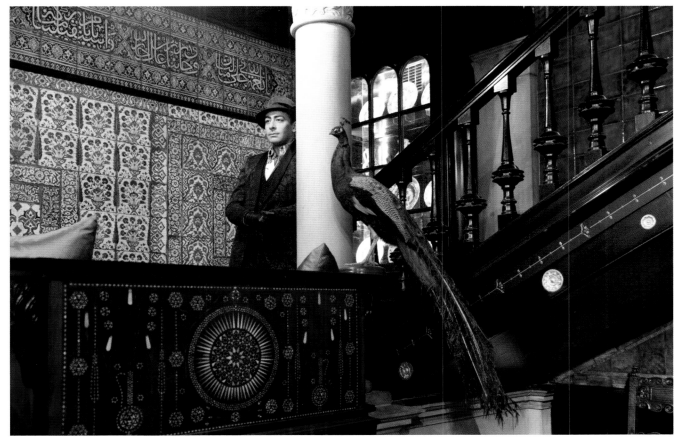

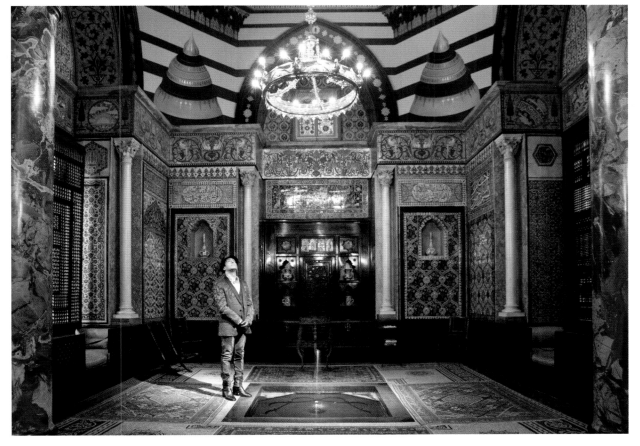

Part of the Paradise Lost series, one unfinished painting (opposite) has been in the works for the last thirteen years. 'If you knew how many paintings I could have made and sold instead!' Shaw laughs. 'I live in debt; this is a sort of anti-capitalist statement.' The artist on one of his rare outings (above & left), a pilgrimage to the Leighton House Museum in Holland Park, from which he derives inspiration. The museum was the personally designed home of the Victorian artist, traveller and eccentric Frederic, Lord Leighton, who lived there alone, occupying the only bedroom

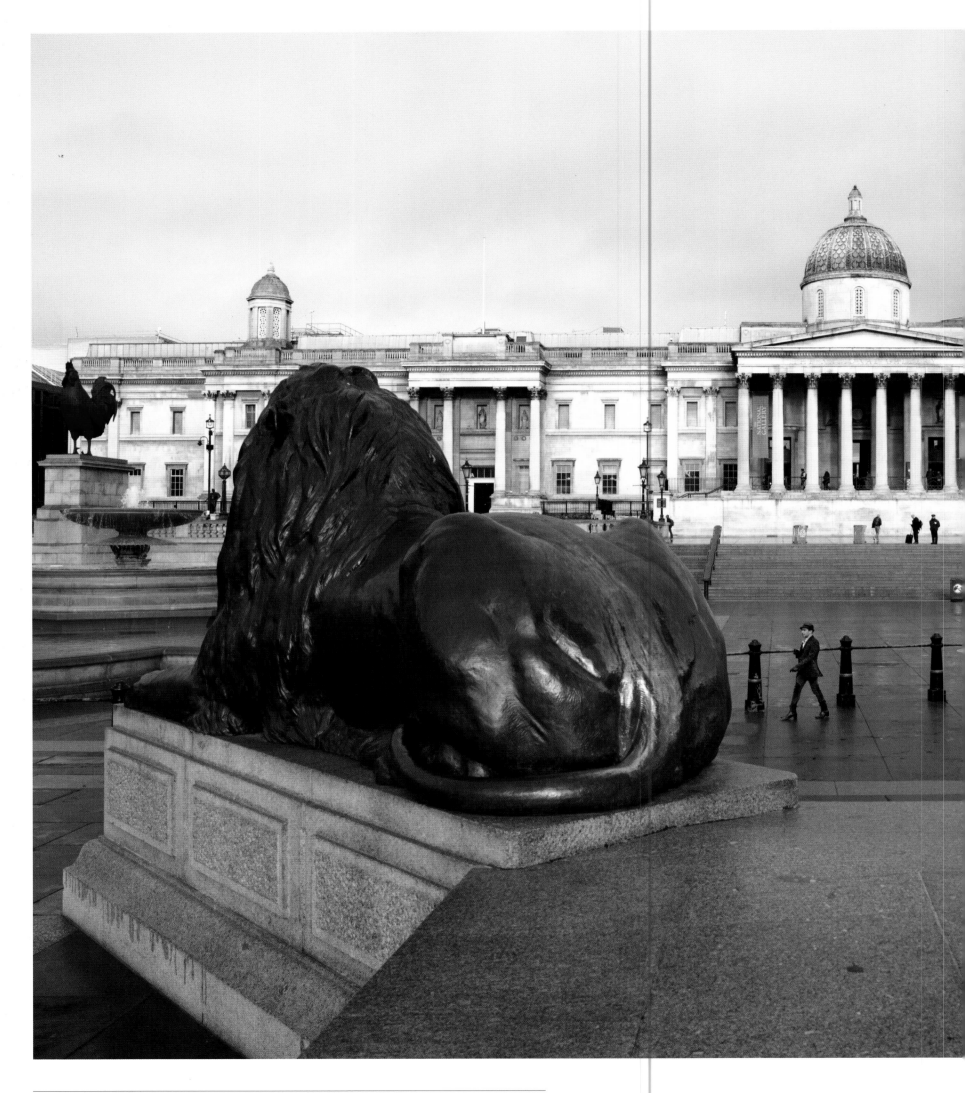

Raqib Shaw

Shaw in early-morning sunshine in a nearly empty Trafalgar Square, home to London's infamous pigeons, its most famous admiral, Lord Nelson, and the world-renowned National Gallery. 'The first time I came to the National Gallery was to see Holbein's *The Ambassadors*; that's when I decided I was going to be a painter,' Shaw remembers. The gallery, established by an Act of Parliament in 1831, was strategically located to facilitate access by visitors from both sides of the social divide

Azzi Glasser
Perfume designer
Camden/Hoxton/Seven Dials

The whole idea of a woman's scent, a man's scent, is a bit of a hocus-pocus, isn't it?
Well, everyone is different. That applies to scent, sense of style, personality. What someone smells like is so important. In terms of memory as well it's very strong; you never want to be with someone romantically if they don't smell good. How many times has someone said that to you? Smell is not a conscious sense; it's more of a subconscious sense.

But the olfactory sense is not subconscious, it's biological.
Yes, but you wouldn't necessarily walk through the day remembering all the smells that you smelled. Some people do it subconsciously, but they don't think about it, whereas I think about everything. I smell shower gel and say, 'Is it the same as yesterday morning?' I would start thinking about the different notes.

You talk about notes as if smells are musical intonations.
Perfumery language is the same as musical language; we talk about notes and chords. A fragrance can be made up of one chord, or many chords, and then it's got many notes. A note is one smell, and a chord is a mixture of notes, which make the accord. Then we fine-tune it.

You try to manipulate human emotions, then?
The way that I work in fragrance is different than many other perfumers. It is a bit like making a film. I decide what the story is and then I interpret that in terms of smell. I think of the main characters I'm going to put into the perfume. My main characters are the main ingredients. The heart of the fragrance is the core of the fragrance. Then I look at the supporting characters to make the fragrance tell that story. You have top notes – the heart notes – then you have base notes. The base notes are what give the fragrance long life on the skin.

This orchestra of smells that you evoke is almost an art form, isn't it?
It is an art form. The other thing that you must know about is molecules and how they work together, because smell is all about molecules. It's not about 'Oh how exciting, we've got these ingredients!' It's when the ingredients meet each other in the fragrance, in the compositions. When I'm composing a formula, I'm thinking of how (for example) the Queen of the Night smell will change when I add frankincense, myrrh and vetiver, and how that will make it richer, deeper, more sensual, more seductive. Then I think I want to leave that trail behind, that mystery. That woman walks past and God, she smells great.

This trail that you construct, it's as if you're creating a persona. Is that what you do?
Yes. You sort of personify the person.

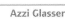

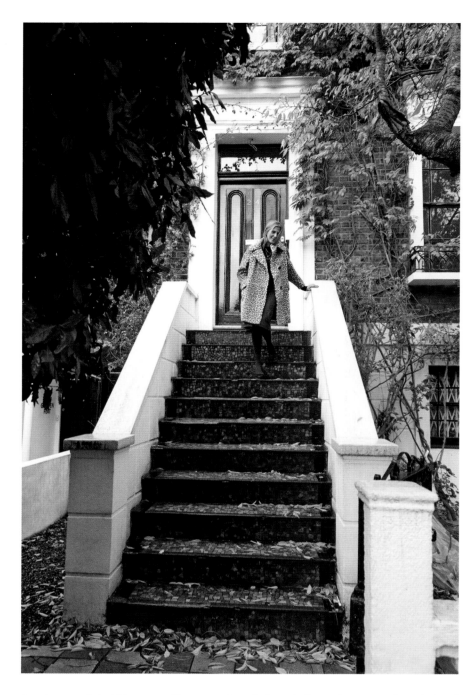

So it's a requirement that you are close to these people for a period of time?

Yes. Sometimes I get to know them immediately. So, like with Orlando Bloom, it was very quick. He was only in town for a certain period of time because he's living in LA and all over the place. He's got that tousled hair, and he's very handsome and extremely charming. He gave me a hug and a kiss and said, 'You smell great!' Suddenly we were having this conversation about smell and what it means. He was fascinated, probably because celebrities get so bored with the usual conversations they have. They like intelligence, really.

The last thing I would have associated with scent is intelligence, because we see this huge amount of advertising about perfumes as obtuse luxury items.

What I do is quite unique, because I'm the only perfumer who insists on working directly with designers or with the person that I'm doing it for: actor, artist, whoever. Whereas Gucci, Dior and all of those companies, they're owned by L'Oreal or Estee Lauder or P&G or Yves Saint Laurent, and it's all done by marketing. It's a different mind-set. I used to work that way. I came out of it because it didn't make a blind bit of sense to me. I was too creative for them, too unique. They wanted a safe fragrance. Now there's millions of safe fragrances out there; that's why they all smell similar, look similar, say the same story. But they don't tell the *actual* story.

What sets you apart from the rest of this crowded field you've mentioned?

I'm passionate about what I do, and I love the fact that I smell things before I see things. Maybe it's normal, maybe it's not normal; whatever it is, it's my world that I've grown up in. It takes a lot of money and time and knowledge to come up with a fragrance that is perfect. For me it has to personify that character, that brand. For Orlando Bloom's fragrance, I've got this tousled hair of a super-intelligent guy, and I wanted the smell of old books. You know when you go into an attic and you pick up a book and it falls apart and it smells really rich? There's a heritage feel about him. He loves old-world stuff, alchemy and everything else.

You are a cerebral perfume-maker, if you will. Are there others like you in England?

There are quite a few of us. Generally, they do their own brands. There are very few perfumers who do what I do. I've spent my life working with probably every single British fashion designer you can think of: Jasper Conran, Nicole Farhi, McQueen, Jack Wills, Bella Freud, Joseph Corré.

How much of the cost of a perfume is vanity, how much is marketing, and how much is actual production and perspiration?

That's a good question. With the big companies, the main thing you're paying for is: How much louder can we shout about this? It's the marketing, the advertising, the packaging, the distribution; it's all about selling, selling, selling, making money. Which is great, but is it going to make that fragrance iconic and have longevity? If you think about the fragrances that are still iconic today, they are all old ones. Chanel, you see, was one of the first fashion companies that does what I do in-house. Coco Chanel worked with Ernest Beaux, the perfumer, directly. There was nobody in between because nobody owned Chanel. Joy was one of the most expensive perfumes that came out post-war, from Jean Patou. It's those fragrances that have that unique quality. Something that is different and doesn't smell of everything else is what gives them that iconic status and longevity.

What would you do if you were commissioned to conceptualise a scent to capture the essence of creative London?

London is this mini-world of wondrous everything. There's nothing that you can't find in London. It was the heart and soul of intellectuality and it always will be because heritage just keeps going. And people love coming here because they want to feel the energy.

(previous page) Azzi Glasser, aka The London Nose, in her home studio in Camden. Arrays of her scents line the shelves; her secret green-cased formula book takes pride of place on her desk. 'I probably have the best portfolio around,' she says without a hint of modesty, 'because I have all the big names: Johnny Depp, Orlando Bloom, Kylie Minogue, Jude Law …'

Glasser (above) on the front steps of the house in which she has lived for ten years. 'I escape from the real world to go into my little fantasy world,' she muses. 'When you've got a strong sense of smell, you go through life slightly differently'

Your parentage is from India, and you were born in London. Where does your English nose come from, exactly?

I did this project for David Cameron, for his GREAT Britain campaign. They said, 'We want you to represent the smell of Britain, whatever you think that's going to be.' His concept was that he wanted to improve alliances with countries all over the world. So I thought, Whenever I speak to anyone around the world, whether it's Turkey or India or America, the first thing they say is, 'Is it raining over there?' They think, Grey, rainy old Britain, but that's just what we live with. Interestingly enough, I love this smell; it was one of my first memories of smell. It's the only natural smell that smells the same anywhere in the world, but Britain is the home of it.

How does scent work for celebrities? You've collaborated with Helena Bonham Carter and Johnny Depp, among others, creating individualised scents for them.

We get to know each other; we end up becoming good friends. They become their natural, normal selves. It's not about being in front of the camera. We go for dinner, we might go dancing, we might just hang out for a cup of tea. We have a chat. Some of them live here so I can spend more time with them.

But how would you distil that into a single fragrance?
It has so much to offer, London. It's difficult to describe it as one smell. I remember doing this project with Space NK where I had to do smells for different pockets of England. We did Bloomsbury, Columbia Road, Brighton Beach and the whole of the countryside. I couldn't say there's one smell that would do that. Well, you know what I would do? I'd create where you would not pick out one ingredient in it. You'd just smell it and not even know where to begin, because that is what London is about. It has everything that needs to be discovered, really.

Do you foresee London ever becoming a bigger centre of perfumery than, say, Paris?
Well, Paris has always been the home of perfumery. What I like particularly about Paris is the history and heritage of perfumery, not so much what it represents today. What it represents today is what the whole world represents in perfumery today. In the olden days they used to have kings and queens and courtesans and palaces … They'd hide the chemists underneath the palaces through these little secret passages where the laboratories would be. Nobody would know where they were. What's important about that is that I quite like the hiddenness. Some part of my business – the bespoke work and work I've done with actors and everything – we keep hidden. I have my little book of names and formulations. It's this tiny little place. We don't even have a website. What do I want a website for?

So you're still in a manner of speaking this alchemist hidden away in a corner. You come out to look at the moon from time to time but never show your face. But your smell precedes you.
Yes, because that's what it should be. That's the meaning of it.

Glasser (above) outside Floris on Jermyn Street, the quintessential London perfumers founded in 1730. 'You have all of London's history coming out of this place,' she observes, praising the sense of tradition and craftsmanship personified by the artisanal shop whose clients have ranged from Lord Nelson (who would stay in one of its rooms while visiting London) to

Winston Churchill, Eva Peron, Marilyn Monroe and even the fictional James Bond. Glasser (right) tries out new smells with Edward Bodenham, a descendant of the establishment's founder Juan Famenias Floris. Floris keep detailed records (below) of every scent produced for royalty, celebrities or ordinary seekers of distinctive personal auras

'London is this mini-world of wondrous everything. There's nothing that you can't find in London'

Glasser takes Mad Hatter's tea with Helena Bonham Carter in the actress' garden in north London; the perfumer has developed scents suited to personalities the actress has portrayed in different films. Bonham Carter refers to these as her 'protective shields … my secret weapon', explaining that the scents help her to better understand her characters. For example, when Bonham Carter starred as Miss Havisham in *Great Expectations*, Glasser produced a scent that smelled like old soap

Glasser with James Lavelle (right) at the 2014 launch of their collaboration on a new scent, Build & Destroy, at the Saatchi Gallery in Chelsea. Lavelle is an electronic musician and owner of the record label Mo'Wax, which marries contemporary music and art into merchandisable products

Adrien Victor Sauvage
Fashion designer

These days Adrien Victor Sauvage, who was a professional basketball player before becoming a personal stylist, is best known for his menswear designs. Born in Wandsworth in south London, Adrien lives in Islington. Of Ghanaian descent, he met Azzi Glasser through a mutual friend; the two went on to work together on scents. Glasser has remarked that she and Adrien have similar ways of approaching what they do. Adrien was just twenty when he started his company Untitled Muse, drawing clients from celebrity circles as well as wealthy individuals from the Middle East and Russia. He established his fashion house, A. Sauvage, in 2010 in partnership with TV presenter George Lamb. Of their collaboration Adrian says, 'When anybody works with a creative person, it's quite hard, and he definitely gets what I'm about.' The company has expanded to include made-to-measure, womenswear and leather goods.

Despite the fact that he had no formal training in fashion, Adrien developed a reputation for understated luxury and a no-nonsense approach to tailoring. Rather than follow the traditional fashion schedule, A. Sauvage adjusts to the needs of its customers, among whom are the Arctic Monkeys and the notoriously natty Bill Nighy. Collaborators have included Dr Martens, the Café Royal Hotel and Microsoft. 'My aim,' Adrien explains, 'is to get a balance of celebrities, working-class heroes and people who are not known.'

Adrien describes London as 'a bit of a trip', recalling getting on the Tube when he was still playing basketball for England, 'eyeing up people and being like "Where are these weirdos going?"' He explains his move into fashion by referencing his younger days when he 'was always wearing the newest thing'; meeting 'a girl who was interested in fashion' inspired him to sort out his wardrobe. The professional turning point came when he realised, as he puts it, that 'you're only as good as your last gig.' It was time for Adrien to start his own label. Interestingly, he speaks of tailoring as 'kind of a language' with which he began to think about communicating in a new way. He also started doing fashion photography and made a film that was picked up by the Sundance Film Festival.

London, Adrien believes, possesses 'a kind of anti-support that pushes you more' than, for instance, the unthinkingly enthusiastic reaction he usually gets in places such as the US. But the city demands constant vigilance and creative forward thinking: 'I always say that you only have six months in the limelight in London and then it's gone.' He likes Shoreditch, where he recently set up house, because of its sense of community. But his roots remain important. Describing himself as 'an Afropolitan', he evokes being brought up in a family 'who were always dressing up in traditional cloth ... For all of my fabrics or designs to have integrity, 30 per cent of the collection normally has parts of the kente updated, a modern take on tradition cloth'.

A.SAUVAGE

Adrien Victor Sauvage and Azzi Glasser, friends and collaborators (opposite), in Shoreditch near Sauvage's studio and showroom. Sauvage takes his sartorial ease, in the company of a stuffed friend (right), at his elegant desk. The bespoke maverick had no formal training. 'I moved from styling to tailoring when I realised men's sartorial needs were not being met,' he explains. His personal philosophy is 'Dress Easy', the idea behind his collection being, 'This is not a suit, it's a way of life.' Sauvage enjoys breaks at Dirty Coffee (downstairs from his studio) (below) beneath the watchful gaze of the Queen

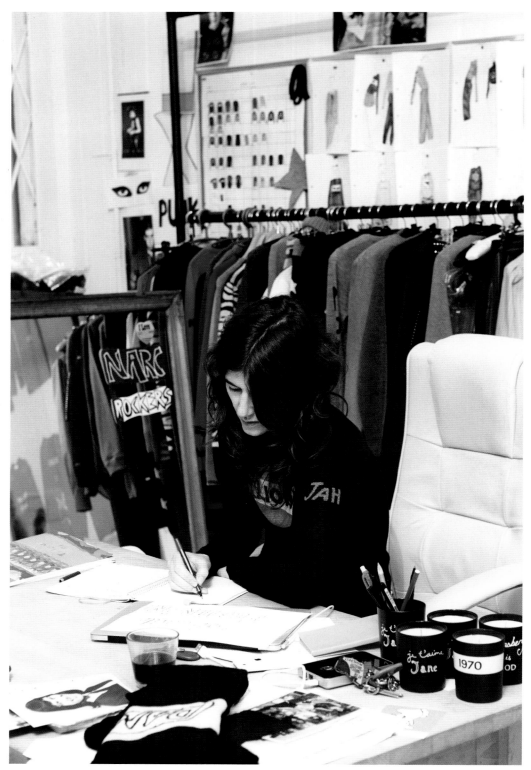

Bella Freud
Fashion designer

Together with Azzi Glasser, fashion designer/film-maker Bella Freud – daughter of Lucian Freud and great granddaughter of Sigmund Freud – launched a Bella Freud fragrance collection consisting of Je t'aime Jane, Ginsberg is GOD and 1970. Bella's logo was designed by her artist-father, to whom she became close as a young adult; her mother Bernardine Coverley was a writer and gardener. Having spent some of her childhood in Morocco, Bella left school at sixteen to work as shop assistant for Vivienne Westwood. She went on to be described by the *Telegraph* as 'the personification of London cool girl gone global'.

Bella launched her womenswear label in 1990, making her name with the Ginsberg is GOD line of jumpers. Since then she has purposefully kept her business small. After being named Most Innovative Designer at the London Fashion Awards in 1991, she went on to design and consult for Kangol, Jaeger, Barbour, Biba and Miss Selfridge. In 1999, to replace the traditional catwalk-show format, Bella co-wrote and produced three short films in collaboration with John Malkovich in order to showcase her collections: *Strap Hanging*, *Lady Behave* and *Hideous Man*. Other short films followed. Fans and friends include Jemima Khan, Alexa Chung, Kate Moss, Madonna, Jerry Hall and Courtney Love. Bella is also a trustee of, and major fundraiser for, the Hoping Foundation, a charity she co-founded in 2003 and which supports Palestinian refugees.

Bella's inspirations include 'galleries, landscapes, architecture, rubbish, old ladies', the 'suppressed-looking' style of the Edwardian period, and classic designers Coco Chanel, Yves Saint Laurent and, of course, Westwood. Remembering the London of her youth, she mourns the passing of the community feeling of Soho and the individuality of Portobello Road. 'Now,' she says, 'to have an authentic market is a really unusual thing. Everything has got paved-over and special areas for cafés, and then suddenly there's no identity … It's just suddenly dull.' Bella describes herself as being very much against what she calls 'a kind of tarring with this invisible brush, making everything the same as everywhere else, rather than strengthening what's already here'. Of the current primacy of British fashion, she cites the difficulty created by 'people in command seeing everything as a disadvantage and trying to show them that actually disadvantage is the *thing*. With British fashion that's exactly what's happened. Before, everyone complained and dismissed it as being chaotic, too creative, not enough industry. All they're doing now is seeing it as wonderfully unexpected, wildly creative. You never know what you're going to get here. These were the same things that were presented as a disadvantage; now it's the *it* thing'.

Bella Freud (opposite) at work in her North Kensington studio, and (right) outside her front door. 'I feel grounded here,' she says of Kensal Green, where she has lived and worked for seventeen years. Freud and Azzi Glasser (below) have collaborated on the latter's fragrances and perfumed candles. 'You can't get bored speaking to Bella,' the perfumer says of her friend. 'I love her intelligence'

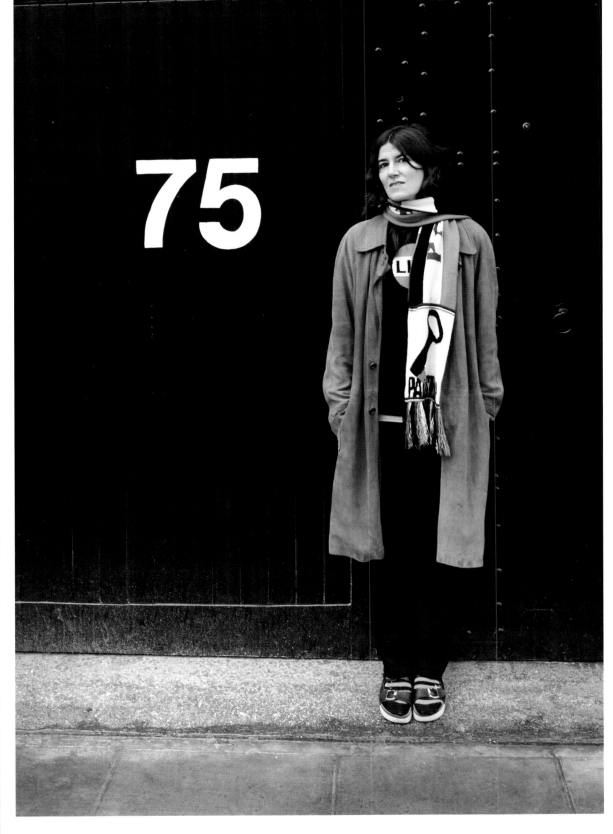

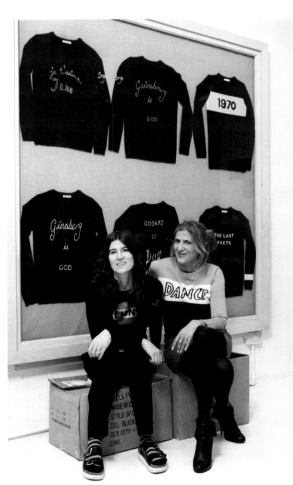

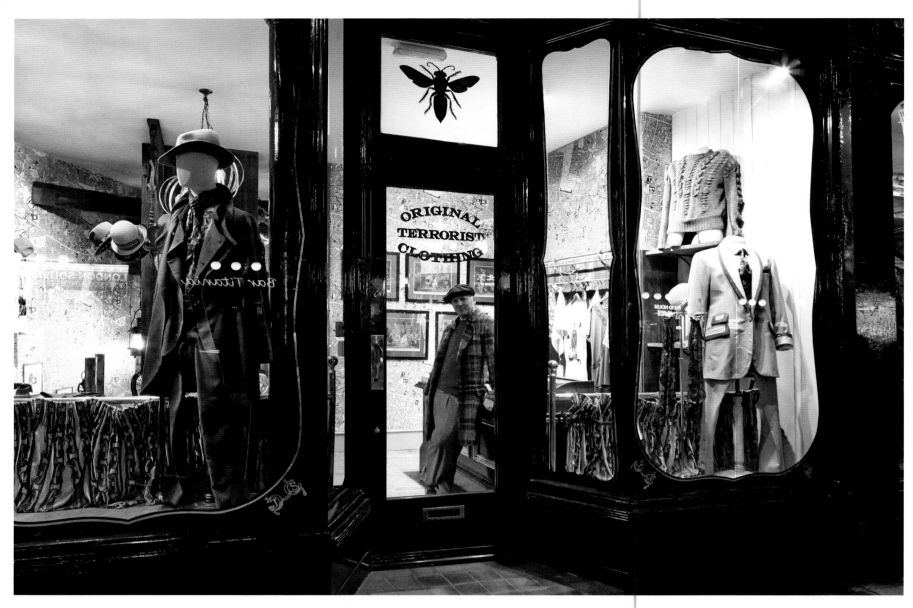

Joseph Corré
Entrepreneur

Azzi Glasser and Joseph Corré have known one another since they worked together on the first Agent Provocateur fragrance. The fragrance was insanely successful, hitting the market in the 1990s when a lot of companies were making perfumes that smelled very much alike. Glasser and Corré's, by contrast, was bold and stood out from the crowd. It was also unusual in being the first modern fragrance to be packaged in a porcelain bottle, which was humorously designed in the shape of a grenade.

Born in 1967 in London, Joseph is the son of Vivienne Westwood and Malcolm McLaren (the latter famously remarked that he was 'totally incapable of being a parent'). As a child during the punk revolution, Joseph was looked after by members of the Sex Pistols. A vivid boyhood memory is of hiding in the kitchen when National Front members shouted abuse through the family's letterbox and threw bricks through the front window, kids he had played with laughing alongside the racists. 'That's when I changed,' Joseph recalls. 'I became a lot more careful about who my mates were … From then on I never wanted to fit in with the norm.' Known for his left-wing politics, he famously decorated the window display of Agent Provocateur with scantily clad mannequins holding placards reading 'Weapons of Mass Distraction' and 'The Only Bush I Trust is My Own' to protest the Iraq War. Of his ideal customer back then, Joseph said, 'The Agent Provocateur woman exudes confidence and pure sexuality.'

After opening the first AP shop in Soho and expanding significantly in the decade that followed, Joseph sold up to private-equity firm 3i following his 2007 divorce. He now owns a shop in Shoreditch called A Child of the Jago and a menswear label, and has built up a cosmetics company, Illamasqua. He regularly channels funds to Reprieve, a legal-aid organisation for detainees in Guantánamo, and turned down an MBE with a public letter of protest signed 'Knickers Forever!' 'Human rights,' he observes, 'is the issue that businesses shy away from – because usually, at some stage along the chain, some businesses are making a lot of money from human-rights abuse.'

'I'm not your average businessman, am I?' Joseph laughs. 'All the so-called rules of business have always sounded like a load of old crap to me. "The customer's always right." Like fuck he is. In my experience, the customer is nearly always wrong.' His friend and collaborator Azzi Glasser describes Joseph as a 'genius', 'an 'information wizard' and 'a great pleasure to work with in every way', adding, 'What he did with Agent Provocateur as a lingerie company was incredible; it was the real buzz of London.'

Joseph Corré at his new boutique, A Child of the Jago (opposite), on Charing Cross Road. The Jago was a notorious eighteenth-century slum in Shoreditch, now known as Arnold Circus. Corré used the equally notorious eighteenth-century thief and escape artist Jack Sheppard (aka Jack-the-Lad) as the back-story for his shop. No newcomer to the London fashion scene (his mother is Vivienne Westwood), Corré co-founded Agent Provocateur in 1994. Jack Sheppard did not fare nearly as well. Having escaped from prison four times (despite being shackled to his cell floor), he became a much-loved public figure among the city's working classes and was hung at Tyburn in 1724 with a third of London's population on hand to bid him farewell

Corré (left) in front of the St Martin's Theatre, similarly witness to huge attendance figures, having shown Agatha Christie's *The Mousetrap* without interruption for the last forty years – the world's longest-running theatre presentation. Corré and Azzi Glasser (above) have together produced a hat trick or two in their time, the perfumer having created Agent Provocateur's signature scent in 2000

(following spread) The Tower of London on the night of 10 November 2014, its moat carpeted with ceramic poppies to mark the centenary of the start of World War I. 888,246 individual blooms formed *Blood Swept Lands and Seas of Red*, an installation by Paul Cummins and Tom Piper, each poppy representing a British fatality. The Tower itself, home to the Crown Jewels and one of London's chief tourist attractions, has its own ghoulish history. William the Conqueror chose its site as London's principal fortress, and it became a prison and place of torture during the reign of Henry VIII, two of whose wives were beheaded there

Josh Berger
President & Managing Director, Warner Bros. Entertainment UK, Ireland & Spain/
Governor, British Film Institute
Battersea/Westminster/Holborn/
Leicester Square/Leavesden

You've been an American in London since 1996. How did you come to live here, and what made you become a British citizen?
I basically wanted to move to Europe and learn languages, and fortunately met and worked for the head of Warner Bros. International Television in the 1980s, who made that dream a reality. I lived in Italy, France and Spain before moving to Britain. I never thought about citizenship until many years later, when the idea grew on me, more than I realised. Now I'm quite proud to be both an American and a British citizen.

But not every Brit-on-the-doorstep gets a CBE. How did that make you feel?
It was a nice acknowledgement of the work we do at Warner Bros. On the day, I mostly felt happy for my family from Los Angeles as they got a chance to dress up and go to Buckingham Palace.

Can you talk a bit about the importance of creativity in your job?
I was raised in a creative environment. I don't know at what point it happens, but when you're around the creative process, you see magic happen in music or film or television, which is where I saw it as a kid at Motown Records. It becomes part of your modus operandi, part of your sensibility. You respond to it when you see it and learn how to be part of it. For me, creativity has always flourished when working with people who have that certain chemistry which builds on a creative spark and turns it into something special.

Is the global-franchise success with *Harry Potter* a good example of this?
Definitely. A lot of people have been involved in turning *Harry Potter* into a massive success story. The initial creative spark in the mind of a writer – in this case the superlative J. K. Rowling – that's the purest form of creativity. That spark was then taken by a lot of other individuals who together turned it into much more: a movie series, theme parks, video games, among many other things – a massive creative and commercial endeavour.

(previous spread) Josh Berger outside the British Film Institute cinema on the South Bank. A BFI Governor, Berger was born in Los Angeles and has been a London resident for the past eighteen years. As President and Managing Director of Warner Bros. Entertainment UK, Ireland and Spain, Berger casts a big shadow across regional film-making and is a keen exponent of British cinema. The *Harry Potter* film series, made in the UK, has grown into the world's highest-grossing film franchise during his tenure, and Berger now manages the *Harry Potter* global franchise operation from London

Berger at home in Battersea (top left), evidence of two of his keenest interests, art and city-cycling, close to hand: Gerhard Richter's *Cage (6)* (2006) contends for attention with Berger's Brompton bike. 'This is one of my big places for inspiration,' he says of his home. 'Most precious to me are my kids Jake and Noah, and my partner, Danna. I'm pretty attached to my Brompton and my Richter too!' Berger (above) cycles past the Battersea Arts Centre shortly before the Victorian building was damaged by fire. A keen supporter, Berger describes the centre as a place 'where creativity happens'. The former town hall has hosted everything from radical political speeches to boxing matches to readings by Allen Ginsberg since its founding in 1893. Berger cycles in front of the Palace of Westminster (left) on his daily commute from Battersea to Holborn

You've said that you learned a lot about creativity from your father and your godfather. But then you went to Harvard. How did the two things connect up?

I learned a ton about creativity – by osmosis really – from hanging around the incredible artists my father and godfather worked with, people like Diana Ross, the Temptations, Smokey Robinson, the Jackson 5 and Marvin Gaye, among others. Then, after a heavy showbiz upbringing, I went back East for university to get a more general education. While at Harvard, I majored in English and American Literature and Language, which got me back into all kinds of creativity, let's say of a more classical nature: literature, poetry, literary theory. Years later, I went back to Harvard for a programme at the Business School, which has also been hugely helpful, and which showed me that creativity finds its way into everything, including business.

Who are the three greatest writers in English from the past in your opinion?

Somerset Maugham, Yeats, Shakespeare …

And what about the live sort?

Tricky one, that; I need to think. J. K. Rowling is definitely on the list. Michael Chabon. Philip Roth. Hard to choose … there are so many others.

In terms of creativity, and of London in particular, is there some kind of magic here that people come from other countries to touch, to be infused with, to contribute to?

The creative outsiders definitely add to the creative soup that is cooked here on a regular basis, and have done for quite some time. By the way, the reverse is true as well; the British are adding enormously to American creativity. That's part of the reason why both places are so vibrant, London and Hollywood. For creativity to flourish, you've got to take ideas from everywhere. You need to stir it up, you need to challenge it.

Are there any cultural spaces in London that especially demonstrate that vibrancy and creativity?

After years of living in the neighbourhood, I recently discovered the Battersea Arts Centre, which is an amazing space with some brilliant productions and events across dance, theatre and art. Further north, in Enfield, there's the fabulous Chickenshed Theatre, who've pioneered inclusive theatre, open to anyone, regardless of background or ability; I'm proud to support them as their Chairman. The South Bank of course has undergone a complete renaissance in the last few years – the Royal Festival Hall, the National Theatre, the BFI, Tate Modern and all the outside performers. It's a wonderful, lively, challenging, world-class creative hub.

How does London stack up in the film world?

London's been boxing above its weight in the film business for some years now. The *Harry Potter* series is the biggest film franchise in history, and the Bond film series is right behind it (both made here). As we speak, the new *Star Wars* trilogy is being produced here as well. This is not to mention other, more specifically British films like *The King's Speech*, *The Theory of Everything*, *The Imitation Game*, and on and on. Creatively, all of those films are at the top of their game, and their global appeal is unquestioned. Production has been growing dramatically, and, along with it, so have the critical and commercial successes.

What is the nature of the creative machinery that produces so many successful Brits in this field?

I don't have a perfect answer to that question, but I would love to figure it out! I watch what my kids get exposed to creatively, both in school and out, from such a young age, and that must have something to do with it. Add to that the artistic and literary history of this country, and the incredible institutions, like the National Gallery, the BBC, the National Theatre, not to mention regional theatre … All must contribute to it.

You are responsible for Warner's business and commercial success in the UK. How does that connect with the creative side of things?

Our business is fundamentally a creative business. It's about nurturing creative ideas and figuring out how to bring those ideas to an audience. That's why investing in the production, marketing and distribution of these creative assets – in games, TV, film – is key. Sometimes that all works, sometimes not. That's where commercial skills come in. It's all part of the same process: bringing a creative endeavour to market. It's hit-and-miss. We manage huge successes and sometimes productions that are not so successful; you won't get the successes unless you take risks.

Berger (above) chats with David Kosse, Director of Film4, and a colleague outside Channel 4's HQ in Westminster designed by Richard Rogers. Warner Bros. has a longstanding relationship with Channel 4. Berger describes Richard Rogers and his wife Ruthie as 'two of my dearest friends in London'.

You've helped to build Warner Bros. to become one of the biggest studios in the UK, stirring parts of the industry into life, creating many jobs, hence your CBE. You've lived in many cities; you're fluent in French, Spanish, Portuguese and Italian, and dabble in several other languages. So where do you go from here?

I'm going to keep doing what I'm doing, and hopefully do more of it. The future for me is always about growing, expanding, increasing the breadth and depth of what we do. I don't think I would have predicted five years ago some of the interesting things that have happened in this last chunk of time. I like entrepreneurial challenges; I like innovating, so hopefully we will continue to be involved in delivering great business and creative work.

If you had the choice of continuing with this expanding bag of creative tricks but only if you moved back to LA, would you do so, or is London particularly important to you?

London is important to me for personal and professional reasons. My kids, who mean everything to me, are here, as is my partner Danna (most of the time!). In a way, LA and London are the perfect combination of cities for me, and I would like to keep it that way. And I get to see enough of sunny LA to keep me sane in London.

What is the downside to London's creative explosion?

I am concerned about the city's growing exclusivity. The cost of housing has effectively priced out too many creative people who should be living in London's heart, particularly those who are younger and just starting out. If we're not careful, there'll be a moment when the next generation of creative talent won't be able to afford to live here, and we'll see a drain to other cities. We need to find a way to solve that problem, and fast.

You've been quoted as saying that 'creative people are different from other people, but so are businessmen, lawyers and accountants. Every one of these professions has its own language.' What did you mean?

What I've learned in business, and about creativity, is that each has its own way of expressing itself, its own mores. If you want to excel at one of them, you've got to learn its language. I learned this the first time I worked in television when I was in high school. I wanted to direct the show I worked on, but I started off as a cameraman. I realised that I had to learn every single one of the functions on the production, and learn the language of each one of them, and learn how to speak to each one of the crews. I realised that's how you manage to get the big job: you've got to learn the ins and outs. If you're going to be a leader and command the respect of the people you're leading, you've got to be credible.

On another subject entirely, you're a cyclist, right?

Yes, a dedicated London cyclist. It is my favourite pastime in London, and the only easy way to get around this marvellous city.

Do you derive inspiration from cycling around the city or find yourself becoming reflective?

I get inspiration from moving through the various London spaces. The light in this city is pretty incredible, in the day and at night too. I love the canals on the way to Camden, the hustle and bustle of riding through Soho, zigzagging in and out of cars along Piccadilly, riding along the river down on the South Bank, crossing Tower Bridge and heading over to Shoreditch. Going over Waterloo Bridge and the amazing views both west and east are always stunning – and a reminder of the amazing paintings created from just that vantage point by artists like Monet, for instance. I have seen wildly inspiring vistas riding in this city. St Paul's to the east, with all of the modern skyscrapers that are popping up around there … Richard Rogers, Norman Foster, Renzo Piano, what they've done to the London skyline is unbelievable. I'm incredibly lucky because every day I get to enjoy these wonderful sights from a bike saddle – and try not to get hit by a car in the process!

Instead of using a limousine with a chauffeur?

I much prefer my Brompton or, when I can, to take my Tesla for a ride around town.

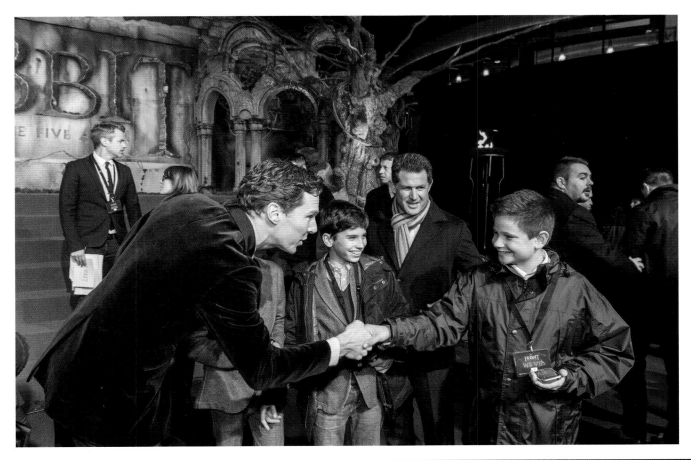

Superman (opposite) stands guard at Warner Bros. UK HQ in Holborn. Berger and his son Jake (left) with superstar Benedict Cumberbatch at the premiere of *The Hobbit: The Battle of the Five Armies* in Leicester Square, home to London's major cinema events. The area is no newcomer to celebrity or pageantry. Formerly known as Leicester Fields, it was the scene of many duels, and in 1760 George III was proclaimed King at Saville House nearby. Berger as Chair of the Chickenshed Theatre Company outside the Chelsea Theatre in World's End (below), and chatting with a Chickenshed Theatre troupe in rehearsals (below left)

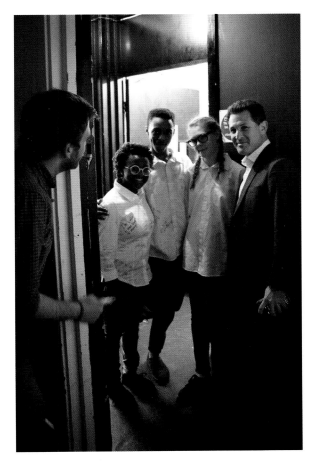

'That's part of the reason why both places are vibrant, London and Hollywood. You're not just sitting with your own potentially limited view creatively'

'I like where creativity meets the business bit,' Berger says of his job. 'The creative process is exciting when it goes from an idea to a script to a film set.' Berger joins director Guy Ritchie (above) for coffee at the Warner Bros. Studios in Leavesden in Hertfordshire. The site, first used as a film studio for the James Bond movie *GoldenEye*, went on to become the production home for the *Harry Potter* film series. Warner Bros. is the only Hollywood studio to own and operate a production facility in the UK, having invested more than £100 million in its redevelopment

The film set (opposite) for Guy Ritchie's new King Arthur epic at Warner Bros. Studios in Leavesden

Ruthie Rogers
Chef/Restaurateur
Chelsea/Hammersmith

You've been quoted as saying that politics is in your blood. What did you mean?
Politics is not how you vote. Politics is the way you treat people every day, the way you run your workplace, the way you share your wealth. At the River Café we treat our staff with respect. We treat them as people who need two days off every week and not to do more than six shifts a week. We teach them through hope rather than fear. We don't shout. We don't bully. We give money to charities. That's the kind of politics I'm talking about.

So you're a political cook in the sense that you are cooking with people's hearts in mind?
That's what a restaurant does. You want everybody who leaves your restaurant to feel better than when they arrived.

You were born in Woodstock, New York but settled here in the UK.
Yeah. I came here in 1969 for six months and I've been here ever since.

What brought you to London?
I'd been at university for a year and I wanted to take time off. I had quite a few friends who were leaving because of the draft. They weren't escaping; they had organised for further education. Coming here meant that they could be away from having to go to Vietnam.

So the political turmoil of the '60s affected you personally?
Hugely. I grew up in a generation where many of our leaders were assassinated, from Martin Luther King to JFK to Malcolm X to Bobby Kennedy. So we grew up with this tumultuous political situation in our country. It did affect my generation very deeply. In France you had '68, in Berlin you had '68, in America you had the Free Speech Movement, so it was a really interesting time.

Did you ever think of going into politics yourself?
Maybe if I had stayed in America, I would have. Here I couldn't; I was a foreigner.

But you don't feel a foreigner now, do you, after all these years?
I feel American. I feel connected to Britain – this is my home, it's where I've raised my children, it's my family, it's my work – but I do not feel British at all.

How does that work, London being this amalgam of people from all over the world who choose it as their home, yet feel that they remain separated from Englishness?
I can't say for other people, but I stayed because I fell in love with a man. Otherwise, I probably would have gone back. I didn't stay because I didn't want to be in America or particularly loved Britain.

And from that transformation in your personal life, what drove you to develop your own creativity, to build up the River Café?
Well, we lived in Paris during the whole of the Pompidou project. I started really cooking in Paris. I was working – I was a graphic designer – but living above a market influenced me hugely. I just wanted to cook all the time. You went out every day and saw what was in the market and decided what to cook. And Richard's family was from Florence; his mother, an amazing woman, was from Trieste and Florence. So we went to Italy. As much as I loved France and French food, I thought, This is the food that I really love to cook. I spent a lot of time with Richard's family in their kitchens in Florence. They taught me how to cook. So when the space became available to create the River Café, it was a great opportunity with Rose Gray to develop my passion.

Did you ever imagine that it would be so successful?
We were very ambitious. We didn't want to be just a little restaurant in Hammersmith and hang up our aprons at the end of the day and go home. But when you think about the future, you're just so busy doing what you do. I have so many problems to solve every day: whether the bread is fresh, or if a staff member is not working well, or if somebody needs an invoice …

You've been in business for twenty-seven years. That's a remarkable length of time for a restaurant to maintain itself.
It's probably because, unlike many restaurants, we only have one. Rose and I just always wanted one. Every time we thought about doing another, we would do a cookbook instead.

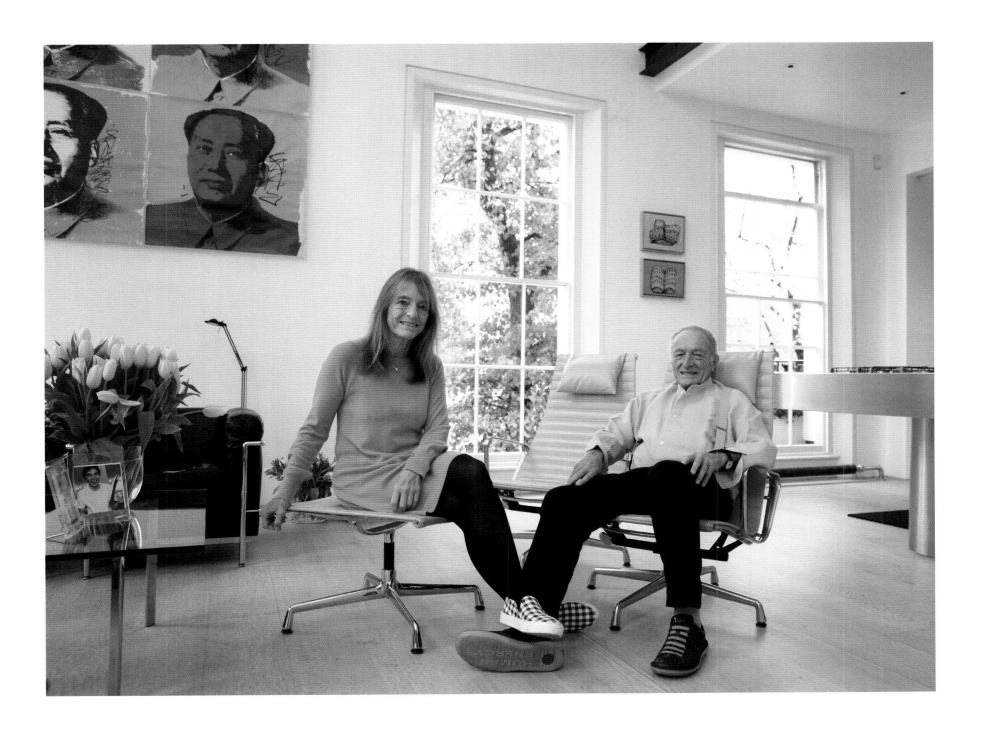

(previous page) Ruthie and Richard Rogers at home in Chelsea under the watchful eye of Mao Zedong. The Rogerses, who bought and converted two Georgian terrace houses in 1983, describe their living space as a 'piazza'; they designed it down to the last detail. Discerning collectors, their walls host works by Andy Warhol, Cy Twombly and Philip Guston

The Rogers family is a close-knit one, a fact Ruthie attributes to Richard's Italian background. Their 'piazza' gatherings are known for their mixing of London's creative classes. The couple (right) on their ground-floor staircase, punching bag at the ready. Hand-in-hand on Royal Avenue in Chelsea (below), a square they think of as particularly magical (and the fictional home of James Bond)

With the *River Café Cookbook*, you sold more than a million copies, didn't you? Have all your books had those sorts of sales numbers?
No. When we wrote the first cookbook, they only printed five thousand copies to begin with because we'd only been open five years, we were a small restaurant, and the only people who would potentially buy it would be people who had eaten in the restaurant, or staff. It was a revelation that it sold so many copies.

How would you explain the restaurant's continuing success in a single sentence?
I always find it hard to talk about my own success, but I would say, probably, that it is the attention to detail that we care so much about, and that I'm there every day. Everybody who knows that, who works there, knows that that's where I want to be, so I have a lot of commitment from the people who work for me. I hope that our customers feel that they're part of the River Café family, our regulars, that there is a sense that we are a warm restaurant. The fact that we have an open kitchen means that there's a kind of transparency. Also, people can know how clean your kitchen is. They can see if the staff is smiling or if they're hot and sweaty and shouting at each other.

Do you find the same kinds of daily markets in London as you enjoyed in Paris?
Farmers' markets are really changing. Rose and I always said in our books, 'Don't go to a shop or a market with a shopping list in your head because then you're exhausted! You're running all over trying to find that one asparagus spear. It's much better to go to the market, see what's there, and then come home and cook.' This idea of the weekly shop … obviously everybody has to do it. I do not expect working women, or men, to go shopping every day on their way home. You want to see your kids. But there's a way of thinking about what is in season, what is fresh. It's economical as well.

Mistress of her kitchens both at home and at the Michelin-starred River Café, Ruthie Rogers (right) by her restaurant oven on Thames Wharf in Hammersmith. Founded by her and the late Rose Gray in 1987, the River Café's rustic Italian cuisine has been a driving force behind London's transformation into a European culinary centre. 'I learned to cook to impress my Italian mother-in-law,' Rogers confesses. The River Café cookbooks have sold over a million copies, and the kitchen has turned out such famous young chefs as Jamie Oliver and April Bloomfield

In London fifty years ago, the food was pretty basic. What happened to change that?

I'd like to say that it was immigration. Probably cheap flights, because if people can fly to Rome for £80, they can have a fantastic meal, come back and want to cook the food that they ate there.

You've talked about the macho environment around male master chefs. In a matter of speaking, you broke that mould, you and Rose.

The macho chef is really old-fashioned, as is the macho anything. Those days are just over. And fortunately, they're not being put up with in any profession.

Yeah, but they still make good television.

I don't like it because it gives the wrong image of our profession. I don't like to talk about chefs as different from any other profession. It's not more stressful, it's not more difficult, it's not more intense. It's a performance: you have to get the food out. But there's absolutely no excuse for bullying or shouting.

I'm interested that you mention the word *performance*. Do you consider yourself an impresario of the kitchen?

There is a huge theatricality to restaurants, certainly to ours: the drama that used to take place behind closed doors in the hot, dramatic kitchen, or the drama between the chefs and the waiters, or the drama that takes place between the waiters and the customers, or the drama between customers. We've had people cry in the River Café, we've had people get divorced. You go to restaurants to admit to an affair or end your marriage or get fired. People do that because the restaurant is a safe environment. If you do it in the office, somebody could see you. If you do it at home, your husband might throw something at you. Restaurants are where private things are carried out in a very public space.

'Restaurants are where private things are carried out in a very public space'

Richard Rogers
Architect

Internationally renowned architect Richard Rogers came to England from Florence shortly before the outbreak of the Second World War. 'My parents always told me that nothing was impossible,' he remembers. 'They gave me warmth and confidence that seemed at odds with the ups and downs I went through.' He was thirty-six when he met and fell head over heels in love with the much younger Ruth Elias. 'Life is not worth living if Ruthie is not next to me,' he says today.

Richard had severe dyslexia as a child, and did not read until he was eleven. He remembers being beaten up at the age of six because he could not memorise a poem. A gregarious optimist and 'campaigning socialist', he says, simply, 'I don't know how to be alone.' Like his wife, he is known for running his firm like a family. The partnership has a 'collegiate' approach that includes, among other enlightened measures, a 20-per-cent profit-sharing scheme and significant contributions to charity.

Celebrated designs by the Richard Rogers Partnership (now Rogers Stirk Harbour + Partners) include the Centre Pompidou in Paris and London's Millennium Dome, Lloyd's building, so-called 'Cheesegrater', One Hyde Park and Heathrow Terminal 5. The first architect invited to give the BBC's Reith Lectures (1995), Richard chaired the Labour government's Urban Task Force concerned with the state of British cities (from 1998), going on to win the prestigious Pritzker Prize in 2009. He does have his high-visibility critics. Famously the Prince of Wales called him a designer of 'carbuncles', while architectural historian Gavin Stamp described One Hyde Park as 'a vulgar symbol of the hegemony of excessive wealth, an over-sized gated community for people with more money than sense, arrogantly plonked down in the heart of London'.

Richard cites as inspirations the energy of New York City, Pop ideas that began to emerge in London during the 1950s, and the warmth of the life he experienced as a child in Italy's urban centres. 'I was just blown away by New York,' he recalls. 'We'd left Southampton looking down on streets with men in cloth caps riding bicycles, and now we were looking up at these amazing buildings. We hadn't travelled as young people do today, so everything was new and utterly thrilling.' American optimism, he says, filled him with 'a kind of anything-goes energy. This was the era of giants like Lou Kahn and Eero Saarinen, and Mies van der Rohe's wonderful Seagram Building on Park Avenue had only recently been finished. There was nothing like this confidence in England.' London, of course, has changed radically in the intervening years, in Richard's view for the better. 'If you go to the City of London, it's pretty good,' he enthuses. 'I was coming out the other day from the Design Museum on the other side of Tower Bridge and I thought I was in New York, with all the towers and lights. I'm not saying that it's good or bad, but it's very exciting, it's very dynamic. It's something that was impossible before.' Global capitalism, he believes, 'does have its good side. It's broken down barriers – the Berlin Wall, the Soviet Union – it's raised a lot of people up economically, and for architects it has meant that we can work around the world'. In the broader context of global change, members of his profession, he believes, 'have to see ourselves as citizens'. The man who has changed the face of several cities spends most of his life talking about them, he admits. 'The design of cities does have an effect on your life. You're lucky if you can see trees out of your window and you have a square nearby, or a bar, a corner shop, a surgery. Then you're living well.'

Richard Rogers (opposite) at his window overlooking Burton Court, not far from the Royal Hospital Chelsea, home to the red-uniformed Pensioners. The Rogerses' house took many years to gut and rebuild; colleagues joked that they saw more plans for the stairwell than for the Lloyd's building Richard designed. 'I was looking for fantastic views when searching for a house,' he remembers. Another fantastic view, this time from the architect's office balcony (above) overlooking the Thames at Hammersmith. Situated next to the River Café, the Rogers Stirk Harbour + Partners building and the adjoining restaurant are undergoing redevelopment, with the architect's own studio relocated temporarily to the City. 'I hope she comes too,' Rogers says ruefully of his wife, 'because life is not worth living if Ruthie is not next to me'

Dylan Jones
Editor, *British GQ*
Mayfair/Soho

You are reputed to be one of the most important publishing personalities in Europe. Is that assessment correct?
That's not for me to say.

Well, how do you perceive yourself?
I've been lucky enough to work on lots of iconic titles over the last thirty years. I spent most of the '80s editing style magazines and most of the '90s working in newspapers and the last fifteen years back at Condé Nast. It's nice when people say flattering things.

***GQ*, prior to your taking the helm, was not a magazine of great import; now it has a huge impact. What's the circulation?**
The circulation is fantastic. Business is really good; our market is declining but we're going in the opposite direction. *GQ* was always a big brand, but it was never notable for its journalism. When I inherited the magazine, I thought the one thing we could do to change people's perception was to turn it into a vehicle for very, very good journalism and very, very good writing. It was already a yuppie bible, it was already a benchmark for a certain kind of man's lifestyle. I thought, We'll make this the best monthly magazine vehicle for journalism in the UK.

You used the term *yuppie* as against *laddish*. *GQ*'s a men's magazine, but not Playboy-style.
In the '90s, there was a huge surge of men's magazine publishing in the UK. You had all the lads' mags, like *Loaded* and *FHM* and *Maxim* and *Front*, all of these dreadful magazines. They did infect the market for a while; even magazines like *GQ* were susceptible. But we came out of it. All those magazines are dead and we're still going.

So this brand that you've developed by focusing on great journalism, what sort of content does it embrace?
Everything. All of the things that already existed in the magazine, all those areas, we decided to do them in a different way. So, whether we were talking about beauty or food or travel or cars or music or sport, we invested and got much better writers. For instance, the first car correspondent I hired was Boris Johnson, because he'd written some car review for the *Telegraph* and it was one of the funniest things I had ever read. We got Peter Mandelson to be our political writer. We got A. A. Gill to be our food writer. We picked the best people and brought them into the magazine. On top of that, we injected a lot more reportage, a lot more foreign reporting, a lot more politics. We wanted the magazine to be as renowned for its writing as it already was for its lifestyle tips.

You seem to have an ability to draw in, through networking or otherwise, leading political figures. How does that work?
It's always interesting when you make your brand world as big as possible. There's no reason why we can't have Jamie Oliver or Gordon Ramsey or Jason Atherton on food, or Lewis Hamilton on motor racing, or David Cameron, or Tom Ford.

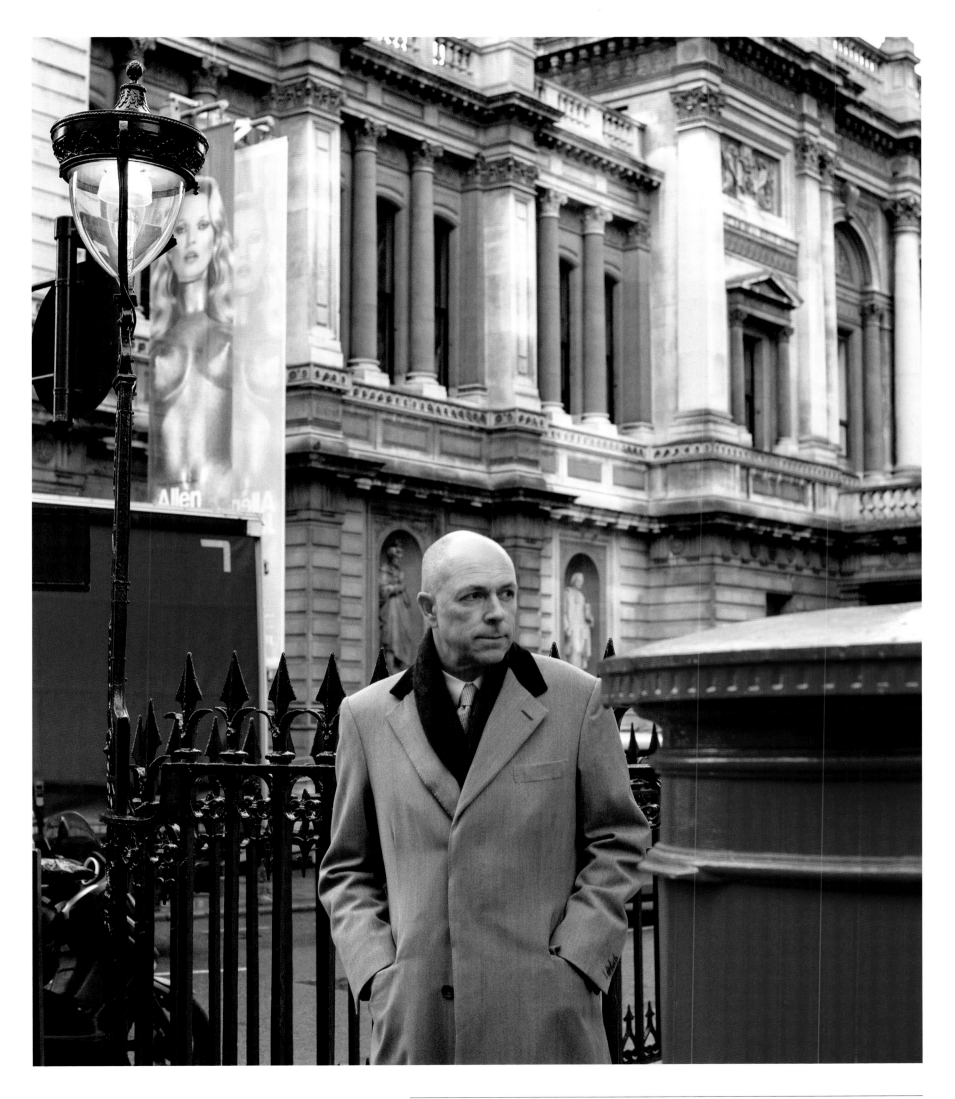

(previous page) Dylan Jones in front of Burlington House on one of his frequent walks between *GQ*'s Hanover Square offices and the Groucho Club in Soho, where he often lunches. Burlington House is home to the Royal Academy, here advertising British Pop artist Allen Jones' 2014 exhibition

The editor in his element: Jones at his desk (top), in front of recent *GQ* covers in the office lobby (opposite), and leaving London's Condé Nast HQ (right). Jones' otherwise spartan office is brightened up by various lookalikes (above) and select *GQ* photography

And do you give a leg up to new thinkers, or are they always established figures?

Not always. The important thing is to always see young people into the magazine. You can't grow older with your readership. I'm constantly on the lookout for young, good writers. Unfortunately, there are less of them than there used to be, because perhaps journalism and creative writing are not things that as many people want to pursue as they have done previously. Possibly because journalism doesn't look as financially rewarding as it perhaps did in previous decades. But yeah, you have to have young people working on your magazine. If you don't, you die.

You're what, fifty-four?, and you have a certain style which you've developed over the last however long. You seem always to have been interested in clothes.

Yeah, I think you have to be.

Let's go back to when you were sixteen or eighteen and had ten quid in your pocket. Did you invest in a shirt or tie?

When I was sixteen, I was at Chelsea School of Art. I was a punk. I had skinny jeans, spiky hair, a plastic leather jacket. That was 1977, so it was the apex of punk in London, which was enormous fun.

And also fundamental to the transformation of London as an artistic and cultural centre.

Yeah, completely. It was a dynamic time, one of the most important, I think, although I wasn't a catalyst; I was just involved in it.

Did you pick up on the themes that were developing then, or were you just having fun?

I was lucky to be in London during a time when there was huge cultural change. At first it was music, then it was nightclubs, then fashion, then people starting magazines, becoming video directors, opening clothes shops, becoming journalists, becoming photographers. It was our version of the swinging '60s.

And in the midst of all that, you dreamt of doing what?

I aimlessly went to Chelsea, and then to Saint Martin's. I was a very mediocre photographer. Then I left and basically went to nightclubs for two years and was a bit of a layabout. It was 1983. I literally spent my day getting up as late as possible, eating as late as possible. I only had one meal a day.

Because you didn't have money?

Yeah. I'd eat at about 4.00 or 5.00 o'clock, watch a bit of TV, and then get dressed and go out to a nightclub. You could get in free and have free drinks. It was a pretty desolate life. And then a friend rang me. He was a photographer, he was taking some pictures for *iD* magazine, and they needed someone to do the interviews. So I went over to interview all these people, typed it up and gave it in to the editor. And didn't think anything more of it. Then, about a week later, I didn't get a call, because I didn't have a telephone. I was staying at someone's house and this person eventually got a hold of me, and it was Terry Jones, the editor, and he said, 'Do you want a job?' Literally, like that. I said yes, and that was it. He not only gave me a job, he opened my eyes to a completely different world. As soon as I was in that environment, I realised that this was what I wanted to do.

So you just shed your punk image? No more nightclubs?

No. The whole lifestyle thing was important because I was going to all these places that the magazine was writing about. I was immersed in it. The important thing was that you weren't an outsider. You were an insider and you were writing about all these extraordinary things. What I was doing in my private life suddenly became my professional life.

But much more powerfully so.

Eventually, yeah.

Because carrying the imprimatur of any magazine gives you –

Yeah, but whenever we have work-experience people and they come and ask for advice, I always say, 'You need two things. You need to work harder than you've ever worked, and you need to be lucky.' I was lucky. You can't teach luck; you need a break. I got a break. I got a very big job very quickly; it was mad, really.

You have a reputation for toughness. Is that accurate?

I'm not a tough guy, and I'm not a disciplinarian. I just expect people to do their jobs properly. My policy is: You have a lot of freedom. If you want to fuck it up, that's up to you.

And how do you pick your people?

We pick everybody. Whenever we don't, it's a mistake. Sometimes you need someone who is really clever. Sometimes you need someone who has a bit of hustle about them. It's horses for courses.

We mentioned youth already; what about keeping your ear to the ground as to what is happening in new technology, new ideas? How do you manage to keep ahead?

A lot of it is common sense.

Give me an example.

I'm a very late adopter of Instagram, but I'm all over it now.

For what reason?

For amplifying what we do here. If I were a farmer in the middle of the country and I was retired, why would I be on Instagram? But for this world you need to be on Instagram. You need to be on everything. You need to be active and proactive and responsive. You need to be involved because that's what people do. I'm not a technological wizard, but we've been quite innovative at *GQ* on moving in that direction.

You mentioned several men's titles that have disappeared, some for their own reasons and others because of the challenges of online. How have you managed at *GQ* to keep abreast or ahead of this curve?
Well, (a) because of the content, and (b) because we're aware of the marketplace. We don't manufacture hardware, we don't develop software, we don't control the means of distribution, but we're very, very good at producing content. We make sure our content is as good as possible, we make sure that if you want it, you pay for it, and we're receptive to what's going on in the marketplace in terms of delivery and consumption. Which is why we have a phone app, a tablet app, a website, all forms of social-media feeds. Everyone does. I like to think that we're better than a lot of people at it.

And this 'being better' allows you to lead the flock? Do you feel you have to help to mould the ethos of today's London man?
I don't know. Your influence is not really in your control.

How many hours do you spend a day behind the desk or involved in work?
A lot. Because of the way we communicate, unless you're asleep, you're always working. I enjoy myself, I have downtime, but there's a sense now that you're always 'on'. I don't mind that. In fact, if I email or text someone at the weekend and they don't respond, I get kind of annoyed.

So if you were suddenly forced to, say, live like a retired farmer, do you think you'd manage it?
I'd get used to it. What's that cliché? If life gives you lemons, you make lemonade.

You've never made lemonade! You've always gone for a pink martini!
I'm sure I could learn!

Known as one of London's most stylish media personalities, Jones was made an OBE in 2013 for services to publishing and the British fashion industry. He shops (above & right) at Savile Row tailors Richard James. Home to English bespoke tailoring, Savile Row invented the bowler hat among other things

Jones (above) outside the Groucho Club, and (right) in front of a work by Ian Davenport in the club's Mary-Lou Room, named after the founder of the charity StreetSmart. The Groucho Club is a peculiarly English anti-Establishment institution peopled by creative types; founded in 1985, it caters to the media, publishing, arts and entertainment industries. Jones, who has been a member since the early days, observes that the Groucho has 'retained that sense of quirkiness ever since' then. 'It's a fantastic place', he adds

'Because of the way we communicate, unless you're asleep, you're always working'

India Hicks
Model/Entrepreneur
Hyde Park/Piccadilly/The Mall

You were born in London and lived in Albany in Piccadilly, am I correct?
We lived in the countryside. When I came to London we would be in Albany.

Given your choice to live in the Bahamas rather than the UK, what is your relationship to London now?
I am so removed from the London life that I had that when I come back I am virtually a tourist. But there is pride and a sense of place as well.

You left England at an early age, didn't you?
I left when I was nineteen. I went round the world for a year, and I lived in Boston, New York and Paris.

With or without the permission of your parents?
I didn't need permission; I was eighteen. I didn't really seek their blessing.

I'm trying to get at the idea that you were quite the rebel.
Rebel is a hard word. *Rebel* implies that you're a rule-breaker. I didn't consciously break rules; I just did what felt right.

We are talking about when, exactly?
1987? But again, none of it was conscious. I went round the world, which a lot of people did, and that to me was the greatest education. My eyes were opened to the way other cultures lived. If only more of us did that now, we would be a little more patient with one another, and perhaps the world would be a slightly more considerate place. We judge very harshly and very quickly without understanding other cultures.

How do you remember that time on reflection?
When I look back, I realise what a blessed year that was, to experience the plains of Africa where you don't see anybody but wildlife, to see the mass of India, and the colour and the vibrancy, and to smell the shit in the streets. And to go to Thailand and the north, where they'd never seen blonde hair and Coca Cola bottles cost so much that you were made to drink out of a plastic bag. Those sorts of experiences are very necessary when you come from a closeted background, and they opened my eyes to a lot. They also gave me a sense of adventure and travel. I was backpacking, staying in youth hostels for 69 cents, and then also, in India for example, staying in government houses. So I would get two very different perspectives on one country, which was equally important. The terrifying thing now is: Would I send my blonde, blue-eyed eighteen-year-old daughter to India on her own? I probably wouldn't.

Coming back to London, how many times do you return to the city each year?
A lot, actually, but now I try and sleep in the countryside. I am so not a city person that I find it oppressive to be in any city. But London is fundamentally a part of where I need to be. London is where you do your business, London is where you meet your appointments …

(previous page) India Hicks in Hyde Park, picking through London's glorious autumnal colours. Hicks, who used to go riding in the park as a child, enjoys revisiting familiar sites in one of the world's largest urban green spaces. Hyde Park, which was acquired by Henry VIII from the monks of Westminster Abbey in 1536, has served as the site of varied landmark events, from sheltering the capital's plague-ridden population in 1665, to serving as a home to William III, who bought Kensington Palace in 1689, to hosting the Great Exhibition in 1851 and massive pop concerts in more recent times. The park is also home to Hyde Park Barracks in Knightsbridge, headquarters of the Household Cavalry

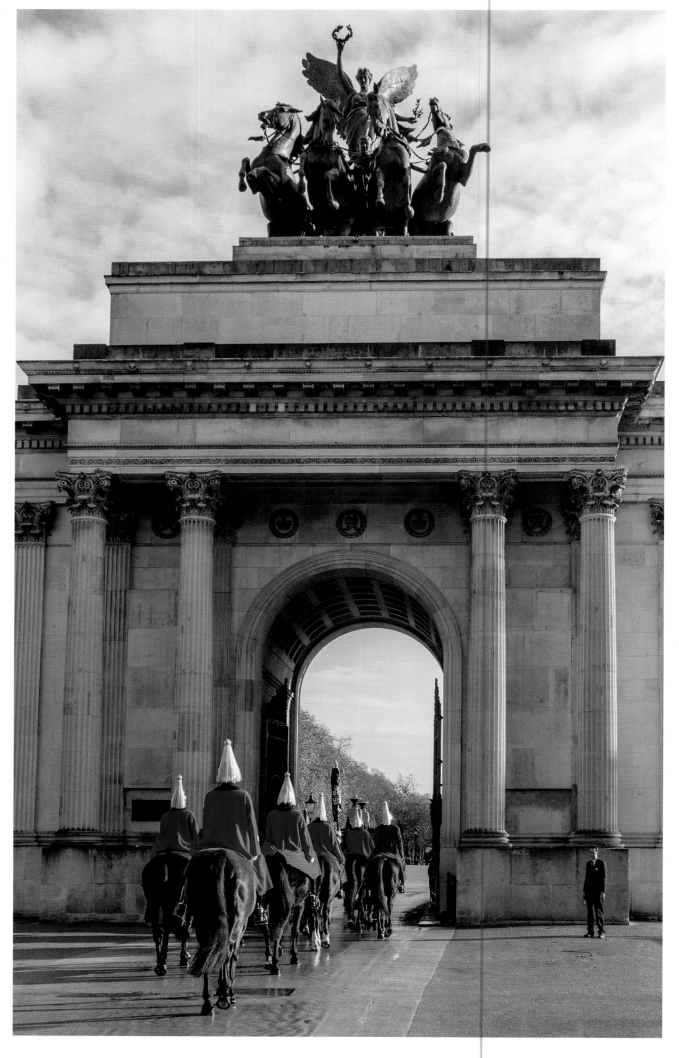

Your business being what?

What I have done for fifteen years is have a healthy career in licensing. I was a partner with Crabtree & Evelyn, a small but global boutique company.

Very English.

Actually not. It was started in 1970 in Woodstock, Connecticut; the big fallacy is that it is English. Isn't that incredible? Brilliant branding.

Did your association with the company have anything to do with its branding?

My association was to bring a more English side to it, but it was much more the island side that they loved. Obviously there was the British connection there too. I worked with them for nine years developing fragrances, and I did a couple of books on island life and beauty. Then I did jewellery, and then I did bedding with the Home Shopping Network, a big American corporation.

What's next?

About a year ago I met a brilliant financier who likes to channel women entrepreneurs. He said, 'There is more that you can do. Don't just work for other people, start something for yourself.' I thought, I'm geographically challenged because I live on a small island in the middle of nowhere, which is why the licensing suited me. Suddenly there was something in me that felt: This is the next step. Although at forty-seven it's a big thing to be starting a big company, so there's a fairly terrifying aspect to that. I'm not the business brain, I'm the creative force. And I have the ambition and drive to do it. So I went between New York and London meeting financial people, and I was surprised at the response. It's a terrifying thing going and saying, 'I have got an idea. Will you sponsor me?' And, as you know, structuring a financial deal and starting a company takes months and months.

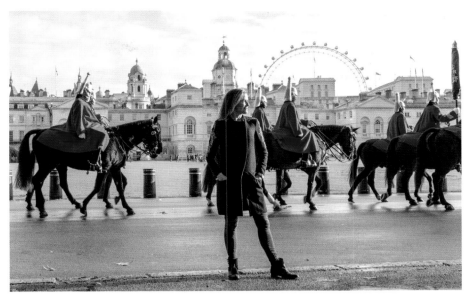

Speaking of creativity, your dad was David Hicks, the famous interior designer …

He was. He had a shop on Jermyn Street, opposite Albany.

Did you pick up anything from watching him work?

Absolutely. He was a tricky man because he was creative, cared passionately and woke the world with his designs. Until my father came along, the world, especially England, was happy to live in a dusty, flowery, chintzy way. My father brought the English drawing room alive with geometrics and shocking colours and a very different point of view. So much of what we see now is copied, or it's iterations of what's come before. My father was an original. There were aspects of our relationship that were definitely difficult, but would I have chosen a different father? Possibly not, because I wouldn't be the person I am today.

How much of your creative bent do you owe to him directly?

A lot. I decorate in a much quieter way. His was very loud and bold and strong. Mine's much more ineffective. But my audience is different to his.

Who is your audience?

The audience I sort of earned while working with Crabtree is made up of working mums. They are aspirational; they probably read magazines; they wouldn't be *Vogue* readers but would probably read *InStyle* or *Good Housekeeping*; they're probably aged thirty-five to fifty-five.

How do you relate to that demographic? Your background is entirely the opposite.

I chose a different life. I was probably expected to marry a duke, take a nice Sotheby's course and live in England. I'm unmarried and live on an island in the Bahamas with five children, one of whom is black. Now, whether I went out and sought it or whether it turned up and I saw an opportunity and grabbed it, I don't know.

From where do you draw your inspiration?

Very disappointing for you, I'm sure, but from nature, because I've lived on an island for eighteen years and, I think, having been when in England under the imposing eye of my father, with all that Englishness, the heritage and the expectations.

Hicks, who was a bridesmaid to Diana, Princess of Wales, remains a keen rider. As a minor member of the royal family, she likes to follow the Household Cavalry's Mounted Regiment in their daily Changing of the Guard in Horse Guards Parade. The troop (opposite) passes beneath the Wellington Arch, which commemorates Napoleon's defeat at Waterloo in 1815. They wind their way through Constitution Hill, past Buckingham Palace and the Mall, to Horse Guards Parade (above), where Hicks aligns herself with the statue of her late grandfather Earl Mountbatten of Burma (left). 'I remember watching the horses and my grandfather riding in the parade,' she says. 'It was the smell of all the horses, hot from marching around London, and the fresh carrots to feed them, and of course the Queen was there in the courtyard and we happened to be in a palace'

As a child, Hicks lived in the Albany on Piccadilly; her parents had a 'set' there. 'You would always say "a set", never "an apartment",' she explains. 'Otherwise it would immediately reveal you as an outsider.' Hicks revisits childhood haunts on Piccadilly, including Hatchards, London's oldest bookshop, established in 1797 (top); she holds a book about her late father the interior designer David Hicks (opposite left). Hicks Christmas-shopping at Fortnum & Mason (left), and exiting her partner's vintage E-Type Jaguar (above) in front of Mayfair's Arts Club. 'Fortnum was really our corner shop,' she remembers. 'We'd pop across the road for tea.' Former fashion model Hicks (opposite right) strikes a more pedestrian pose in Piccadilly Circus

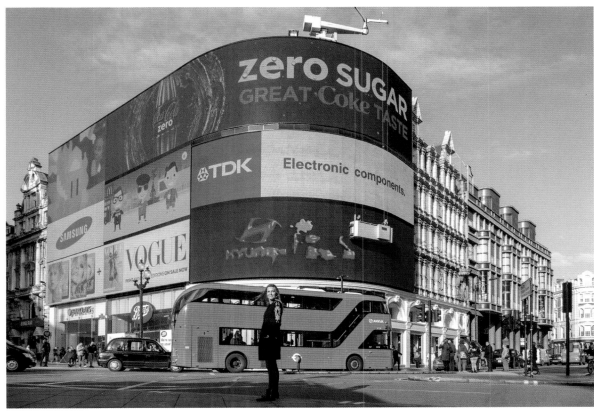

Was it stuffy?

No. My mother is a very free thinker, which is unique. My parents' eyes were open to anything, but because of the expectations (beyond them) of the life I was meant to lead or who I was meant to be, I took a degree in Photography, graduated with honours and went to art school. Once I got to Boston and was doing something away, it began to feel easier and easier. Then I fell onto the wrong side of the camera and started modelling, which again took me around the world. I was always on the move. And I met a team of people who I would never otherwise have met, some of whom have stayed my best friends. It wasn't that I was so passionate about modelling; I was just passionate about earning my own money. Once I got to the island, I suddenly could get back to being creative again. I wasn't modelling anymore, I was having children. I wasn't the daughter of anybody, I wasn't the goddaughter of anybody, I was just myself.

Someone with a ferociously organised temperament, or am I wrong?

Look, my grandfather was Admiral of the Fleet, he was the last Viceroy of India! *He* was organised; there must be some gene there. I am a Virgo, so I'm organised anyway.

And the Prince of Wales is your godfather. Has he influenced you in any way?

He is, I would say, an inspiration in the fact that he is doing an awful lot of good work that he is not recognised for necessarily. He has a point of view. He is in the unique position of having a mother who is still on the throne in her late eighties, with no intention of giving up that throne, so he still hasn't come into the job he's meant to have come into. So what he's done is he has carved out for himself a career while he is waiting. It must be a difficult position to be in, but he's become very passionate about it. He's a driving voice in so many areas now, for the better in England.

'I am so not a city person that I find it oppressive to be in any city. But London is fundamentally a part of where I need to be'

Olu Michael Odukoya
Publisher/Art director
Farringdon/Walthamstow

You're Nigerian, yet you were born in England.
I was born in England, but my parents are Nigerian. I'm English, but my heritage is very African.

How do you meld the two cultures?
Whenever I do a project, I always do it in a very African way. The attitude is very open, very warming, but maybe the aesthetics might look very British. But the soul is African in a way. It has that kind of resourceful, you know … when I do everything myself, where you throw everything in but the kitchen sink. Everything and anything always comes out. Then I find what is common in my other background to what is common in my new world. I always find similarities.

Is this process a kind of conscious assimilation or symbiosis?
Sometimes it's conscious. When I was growing up in Africa, the way I was brought up was very African, but I come from a middle-class family. So I was brought up to look into Western-world ideology or maybe pop culture. Over my years here, now that I'm part of that culture, I'm kind of looking back to Africa to collect that in reverse.

Is that a creative decision or a search for stories from the old homeland?
It's a creative decision of independence, non-dependence. I can't really change that; I've been so influenced by it. I've accepted it so I can find my other root influences.

Have you now grown away from the older pull that decides who you are depending on where you are at any given moment in time?
I've grown out of it. So now, the more I stay in Europe, the more African I become. Every time people ask me to go back to Africa to do a project, I never do it in 'African', because they always compare it to a project in Europe. It took me twenty-seven years to get out of that system to where now I create projects that are not based on comparing them to any standard. I'm coming out with my own standard.

You are a creative with a wide scope. You've been an advertising director for Yves Saint Laurent and then you've done various magazines.
I've relaunched *POP* magazine with Dasha Zhukova and Ashley Heath. I worked as a creative associate for a big advertising agency called Fallon.

Why did you leave the advertising industry?
When I started my magazine, I wanted to be an optometrist. I went to art school; I was training to be an optician, and my school was in Old Street. I thought that was the easiest way of getting into the system. Don't try to be individual, just get with the mainstream.

Was that you or your parents?
I did what was instilled into me. I've always been an artist, since I was a child. I've always been creative. Creativity is how I survive. I got by in class so as not to be bullied, because I can make nice artworks for everyone, you know? When I was here, I became more sensible. Art is the part of me that is natural. It's not sensible.

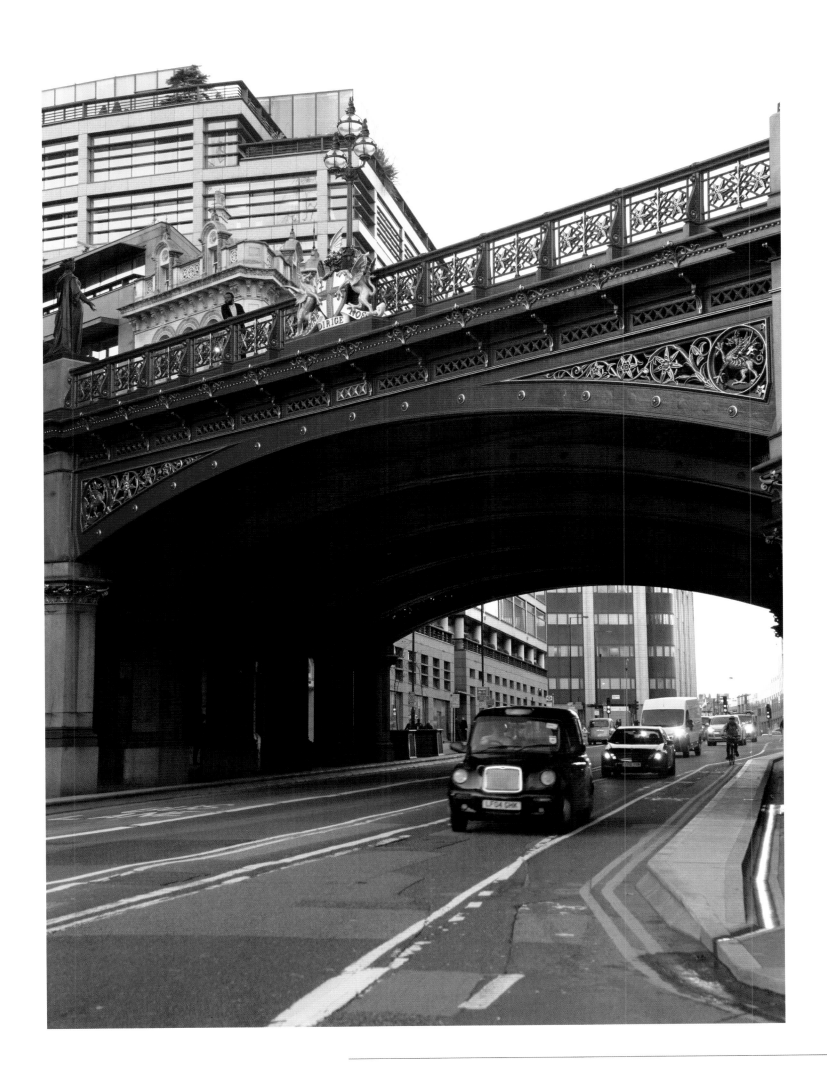

(previous page) Olu Odukoya views the terrain from atop Holborn Viaduct, a skew-bridge inaugurated by Queen Victoria in 1869 and intended to connect the City of London with the West End. St George and the dragon, alongside St Paul, the City's patron saint, adorn the bridge's coat of arms. The saint was popularised by the Crusaders as their emblem; the mythical George is traced back to a Christian soldier who refused to recant his faith under torture during the reign of the Roman Emperor Diocletian

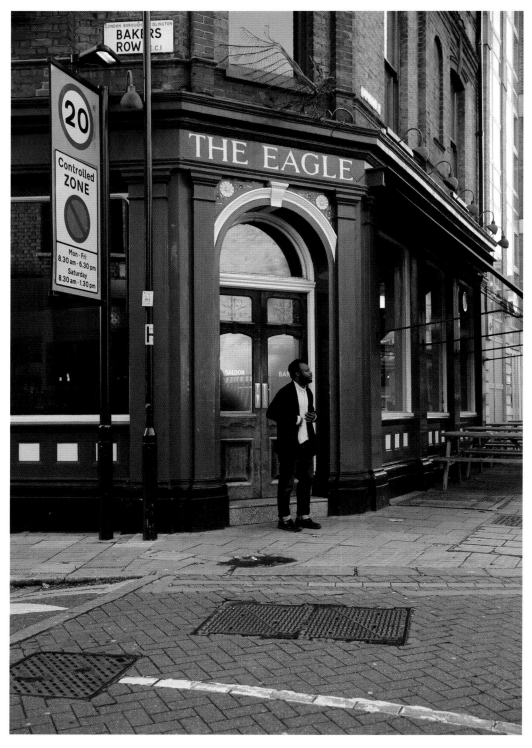

'London is very, very small. It's a little village where nobody cares what you do'

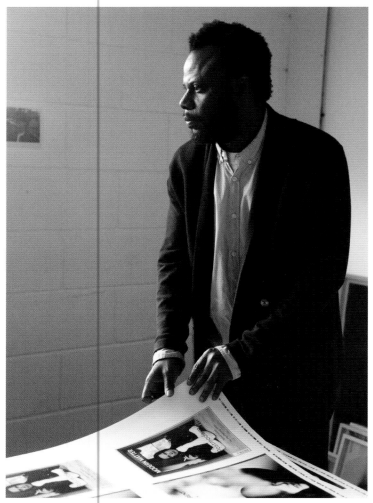

So when did you decide to become an artist?
I decided to choose clubbing and going out with my friends, being free.

What do you mean by 'free'? You use the word a lot.
It's an expression of freedom within myself, because I wasn't free. I've developed all my projects on my own. I've never really in my life worked for anybody.

Is that because you're a problematic creative, or were you just born a free spirit?
It's more because I was more ambitious than what anyone could give me. I think that's my luck. I never get more than I deserve. I always find my own path.

I understand that you work sixteen hours a day, seven days a week?
Yeah. I do everything for myself.

And there's no real money in doing that, is there?
There's no real money. I've always been blessed with money, in a way, because I know how to be resourceful. Like when I was doing my magazine, my printers were like, 'We're going to take your magazine to a conference, because we can't believe you can do the cheapest magazine in a luxury way!' I know about paper. With my magazine *Modern Matter*, I'm using the same paper that you get for photocopying. It is the most basic paper that you can buy. This paper interests me.

Coming back to the question of adaptation, you've been quoted as saying, 'Communication to me is a genuine art form.'
Yeah, just like a musician. For example, you don't write the lyrics, but you can sing it and you believe it. I know how to do that. I've never read my own magazine. People tell me that it's well written. I think the magazine is more like saying hello, or you have the cover to give you the surface of what it is and then you stop a bit and chat. That's why a lot of artists use it.

You've also said that creativity is largely about problem-solving. You don't survive on advertising, do you?
No, I don't survive on advertising. I survive on people buying my magazine.

That's a very rare thing.
Yeah. I knew one thing when I was doing *Kilimanjaro*: either I go for advertising, or I suffer a little bit, it takes me longer, and I do it the content way. And also, if I have a thousand people buying my magazine, I make the magazine for the thousand people who love what I want to do. So I was never chasing people that wouldn't listen anyway. I just took them out of the equation.

Tell me about those two magazines, *Kilimanjaro* and *Modern Matter*.
What was so clever about *Modern Matter* was when I started the magazine, I named it *Matter*. I wanted to stop *Kilimanjaro* and make a magazine that was actually easy. Somebody emailed me from New York, saying, 'Why do you want this name? We've registered that name. This name is so important?' I said, 'Look, I'm not attached to anything from yesterday. I'm always attached to things that I want now, what I want to do tomorrow.' So we changed the name from *Matter* to *Modern Matter*. And actually *Modern Matter* makes it like a work in progress because every time you say it, it still looks like something that is new. That process determines what I do in the magazine.

I've tried my hand at making magazines; I know how hard it is. Does it really matter what you do with these publications? Will they make a difference?
For me they always do. It's like writing history or documentation. Why should commerce control magazines? It's a very beautiful art form. I've been very influenced by it, so why should I give happiness a price? I think I have a responsibility. What you give out comes back to you. If your reward is wanting to sell the biggest copies, then you're in the wrong position. That is not my reward. My reward is that people have written about it for their dissertations. I've made great friends with brilliant people.

Why are you based in London?
I love London. In Africa, it's totally, really different.

What about another European or American city, like New York?
New York, no. I would prefer to go to LA because of the freedom. It's far away, I can have my space, I can be on my own, I like the weather. Even in London I've never been part of the cool system because I've always been independent.

Is that because the system doesn't accept you or because you rejected it?
I rejected it. It's about choices.

Would you have been able to do what you do somewhere else?
London was good because London is so punk, you know? London is so punk because nobody cares. London is so tough. I wouldn't do it in Berlin; it would be too easy for me. I need that struggle to get something out of it. I'll always choose London as a good school for me. It reminds me of Lagos. It's not all about aesthetics. It's about the message. It's about how you survive. London is very, very small. It's a little village where nobody cares what you do.

So the ideal of creativity is the creation of one's own culture within one's own community. Is that how you see it?
That's how I see it.

Given your growing reputation, have you transcended the bounds of your locale?
I think so. I've done that for me. I did a project in *Modern Matter* with a big Swiss sponsor; they never worked with a magazine before. The project was about Hans Josephsohn, the biggest sculptor/artist that has ever come out of Switzerland. I've never met him and everybody was like, 'Oh, you're going to do a project of somebody you don't know? You're not Swiss!' I said, 'I'm an artist. I tell stories.'

Odukoya, in his small Farringdon office (opposite right), works on the latest edition of *Modern Matter*, his arts magazine. Taking a break at The Eagle pub (opposite left), not far from the *Guardian*'s old offices on Farringdon Road, an area known historically for its textile industry. Odukoya, who lives in Walthamstow, often visits the William Morris Gallery (right) in nearby Lloyd Park. The gallery was opened in 1950 by the Labour Prime Minister Clement Attlee as a tribute to the eponymous poet, textile designer, novelist and social activist

Roksanda Ilincic
Fashion designer
Shoreditch/Cambridge Heath/Clapham

There is such a large congregation of creatives in Shoreditch now. How do you explain that?

Above all is the economic element, or how much the rent is; it is that simple. Shoreditch doesn't belong to 'the poor brother' anymore because it became attractive when creative people were here and building the creative way of life. They were going out, creating parties, creating shops. That's why this isn't a place that is out of the way anymore.

You mention creating parties. How much of that social scene is important to the development of a brand?

It depends on the brand. Some brands and the people who are creating them can be very driven with creating a social context and being people who are loved by everybody else. Others are very introverted and don't enjoy building and being part of a social group as much. I don't think that really matters. It's really what you are working on, how valued your work is, and how your work resonates in the culture and society that we live in.

You were born in Serbia, and you moved here about fifteen years ago. You've said in interviews that you fell in love with London when you were a young girl in Belgrade. Why would a girl in Belgrade be drawn to London?

London always had this incredible energy and incredible freedom. When I was a little girl I was browsing through the pages of *i-D* or *Face* or *Vogue* …

What were you doing browsing through *i-D*?

I was obsessed with fashion. Literally. As young as ten years old, or even younger, because I had an older cousin who lived nearby who was very much into fashion, plus my mum, and they were always together and had loads of dresses and fashion magazines. That's where all this is coming from. What I discovered in those magazines, and what drew me to London, was the incredible amount of individuality that people were expressing themselves with.

So your mother was a fashionista?

She loved fashion. In another life, she would also probably end up being a fashion designer. She was a pharmacist but worked in PR for pharmaceutical companies, so she had lots of functions and events to go to. I remember her travelling to Paris and coming back with beautiful Yves Saint Laurent dresses –

Which you cut up?

Exactly!

How did she react when you cut up her dresses?

She was really, really upset, but now she probably doesn't mind it so much. I'm more upset actually, because I wish that I had those beautiful pieces as they were, not destroyed.

So you came to London, you went to Central St Martins, and you seem to have had some sort of fascination with one of your teachers, Louise Wilson. How much of an influence can a teacher at an important institution have on a student's career?

Louise was incredible, not just as a tutor but as a person and as a support throughout my life. She was one of the people who encouraged me to start my collection. Also, with her individual approach to teaching, she was the epitome of what London is all about.

In what way?

To give you freedom and also to make you realise who you are. That was definitely the biggest strength that I took from college, because when I was living in Belgrade and studying fashion, I wanted to rebel against classical values, everything that was considered acceptable at the time.

You are much too elegant to be a revolutionary!

Exactly, but back then that is what was driving me forward. Then I went to London and joined Central St Martins, and the whole experience was so focused and so full of self-discovery.

Life-transforming?

Absolutely life-transforming. You are left to yourself, but you are pushed to give your best when the time for crits comes. You need to give not just 100 per cent but 200 per cent, and if you fail the consequences are huge. There was a certain way that Louise was teaching people that would strip you of who you thought you were, make you look into yourself and then almost rediscover yourself. That's what happened to me at St Martins.

(previous page) Roksanda Ilinic sheltering from the winter weather in front of Rivington Place, designed by David Adjaye. Rivington Place, which opened in 2007, is London's first purpose-built public gallery since the Hayward Gallery opened forty years ago on the South Bank. Adjaye, who is Ilinic's favourite architect, designed both her home and her Mount Street shop. Her own sculptural designs draw inspiration from 'open-plan architecture of the past', she says

Ilinic has a passion for colour and is inspired by urban sights, shapes and forms. The crane sculpture (below) featured in the first window display in her recently opened boutique. 'I prefer looks over comfort,' she says. 'I'm happy to sit on an uncomfortable chair all day as long as it looks beautiful' (far right). Ilinic walking (right) to an empty Bistrotheque Restaurant (bottom right), founded by Pablo Flack and David Waddington, and decorated with Christmas ornaments. The Bethnal Green-based Bistrotheque is favoured by East End creatives. The tall, elegant Ilinic, herself a former model, shows off her latest design (opposite) while propping up the ceiling of her studio. Her clothes are favoured by celebrities including Michelle Obama, Keira Knightley and the Duchess of Cambridge

How much of a cultural contrast was this compared to your upbringing in Belgrade, especially at a time when history was not being kind to the former Yugoslavia?

You know, I don't think it was that much of a contrast. At the end of the day, it's Europe, and it's a design thing. It's something quite ephemeral, something you can't pin down. It's very subjective as well. When I came to London and walked through the door at St Martins, I felt at home because the school looked very similar to where I had come from. The machinery looked old and run down, exactly the same as back home. But also, London was the place where everything was happening, and that was part of the reason I wanted to come here. I wanted to pursue my dreams and build my fashion career. I had to be where everything was starting.

Why didn't you go to New York and Parsons School of Design?

Oh no! London was the place where everything was literally being born and then it would resonate to other cities. Without sounding too pretentious, I still think that London is bringing in lots of new ideas.

You came here at what age?

Oh gosh, let's skip the age! I was young, but I'm not young anymore, fifteen years later!

What I'm trying to get at is whether you had to work nights in bars and restaurants to support yourself?

No. I wasn't working in bars and clubs for sure! I was lucky enough to be able to do a part-time modelling job which was bringing in quite a lot of money and which was another thing Louise encouraged me to do. Success has many facets, and one of them is definitely luck. I was lucky to be able to do modelling rather than working late, because we all worked late throughout the course.

What do you mean, you were lucky? They were lucky to have you! Did you model for magazines or catalogues?

I did some things with stores and then later with jeans. TV commercials brought me money so that I could start up my label later on.

So the combination of growing up in Belgrade, quite a cosmopolitan city, moving to London and having a person like Louise Wilson encouraging you culminated in your clothes being worn by the likes of Michelle Obama, Kate Middleton, Keira Knightley and Lady Gaga! How does that make you feel?

It's an incredible feeling because I always felt it was the ethos of my brand to design clothes that women would like. It's a very women-driven business, really. My belief is that a dress needs to empower a woman; it needs to make her feel happier and more positive. If women are not finding that in my designs, if they don't want to wear them or don't believe in them, I wouldn't feel like I was doing my job right. Seeing not only my customers but also very powerful women – I wouldn't call them celebrities, but strong, independent women in different parts of the world and cultures – wearing my designs, it's incredibly reassuring and gives me more energy to do what I do.

You are yourself a powerful, strong woman, aren't you?

I hope so. It takes a lot to achieve this sort of thing, particularly in a town like London that is attractive to many people like myself who all want to succeed and are extremely talented and ambitious. So yes, I guess I am.

You're drawn to a particular aesthetic that doesn't reveal much of the body.

Yes, covering quite a lot, for sure.

And your use of colour and cloth evokes traditional peasant clothing?

Yes. Colour is a medium which I find very, very attractive. I am not afraid of colour; I use it in a bold and intuitive way. That helped me to establish my DNA and to stand out and make people understand who I am. Colour brings happiness. It brings a point of difference; to me it brings only positive things.

Are things looking positive for you right now?

Absolutely! 2014 was an incredible year. I opened my first store, which is a huge achievement for somebody who started on her own without backers or investors. We just took on an investor; it's been a very organic and very slow process that was built by getting a couple of stores each season and building up relationships with my stockists and colourists. So let's jump and grow even more!

Ten or twenty years down the line, will you still be in London?

I think I will. I love London and everything about it. London is the centre of the universe for many reasons. The first is finance. There is a lot of good economy happening in London, which is driving everything else. Industries like mine are thriving on the good times.

'London was the place where everything was happening, and that was part of the reason I wanted to come here'

Studio Voltaire
Art centre

Having started out in 1994 as a collective of twelve artists headquartered in an abandoned tram shed in Clapham, Studio Voltaire morphed into artist-run spaces which commission major projects with international artists. Now a registered charity directed by Joe Scotland and located in Nelson's Row in the same neighbourhood, Studio Voltaire makes affordable space available to over forty-five artists. Two groups, ActionSpace and Intoart, both of which support artists with learning difficulties, are based there. Partners have included the Berlin Senate in Germany, the British Council, the philanthropic group Outset and the Royal College of Art.

Studio Voltaire's main goal is to support emerging practices and ideas through public programmes, by commissioning work that would not necessarily be possible to create within institutional or commercial frameworks. Exhibited artists have included such notable figures as Phyllida Barlow, Spartacus Chetwynd, Liam Gillick, Anthea Hamilton and Lawrence Weiner. Education programmes (begun in 2002) aim to widen participation with contemporary art, particularly among individuals and groups who do not have much access to it. As programming has developed, so of course have costs. But, instead of organising gala dinners or charity auctions, Studio Voltaire decided to create the unique House of Voltaire, a biennial temporary shop selling a range of artworks, limited-edition prints, and specially commissioned housewares, clothing and accessories by leading contemporary artists and designers. With proceeds going to support Studio Voltaire's gallery and education programmes, House of Voltaire has become a staple of the art- and fashion-world calendars. In 2014 House of Voltaire partnered with fashion great Chloé to produce a number of limited-edition bespoke pieces, including one designed by Roksanda Ilincic and artist Eva Rothschild. 'Organisations like Studio Voltaire play such an important role,' says Joe Scotland. 'We're able to give artists opportunities which they wouldn't normally have, and that's so vital to the art scene as a whole.'

Joe Scotland, Director of Studio Voltaire, at their exhibition space (opposite) in a desanctified Victorian Methodist church in Clapham. Set up as an artists' collective in search of affordable studio spaces, the organisation has grown through the help of such creative fundraisers as House of Voltaire. Designers including Roksanda Ilinic and Louise Gray (left & below) paired with visual artists to create limited-edition items in support of the south-west London group's twentieth anniversary

Grayson Perry
Artist
Barnsbury/Piccadilly

When did you first visit London from Essex?
I came here as a child, did the classic things, went to the British Museum, went to St Paul's. It's only a half hour on the train.

And when did you first aspire to leave Essex?
I never had aspirations until fairly recently.

What do you mean by 'fairly recently'? You're fifty-four!
In the last fifteen years, maybe I had aspirations. Before then, I just bumbled along. I'm always suspicious of people that want to become artists. I'd rather be interested in people that want to make art.

Are you more of a craftsperson yourself?
No, I'm an artist. But most artists have some craft ability. If you talk about art like it's creativity, a lot of them are gonna laugh because they just get on with it. *Creativity* is a word that people who aren't artists tend to use. Politicians are always talking about creativity, aren't they? Whereas you get a couple of artists together and they're going to say, 'Where did you get that paint?' or 'Shall we go down to the pub?' You think what you'd like to make and then you do it. It isn't framed as self-consciously being innovative. I think that's a disaster.

You seem to revel in the idea of not being a stereotypical modern artist.
What is a stereotypical modern artist, I'd like to know! I mean, painting is like a craft now. Painting is like, you know, basket-weaving. It's about as limited as that. It's such a crowded world, the history of painting, that it's very hard to be original in it.

So how do you find originality?
I don't search for it. If I happen to stumble upon it, I'm very lucky. The twentieth-century model of originality was all to do with form. It was about what you made and in what style you made it. Nowadays, it's about the social and political context of what you're doing. That's much more interesting.

So it's all, in a sense, just manufacturing.
That sounds like a cheap shot. It's just people try to be interesting for their times. You know, we're in the leisure industry, artists; we're trying to attract attention and entertain people. As an artist you've got a sense of what is interesting. That's your job: to take the temperature of society, to try to revive that flagging celebrity-money corpse of contemporary art.

Would you describe yourself as issue-orientated?
I have mixed motives. I sometimes need to make money, sometimes I need a bit of attention, and other times I make work about social issues that interest me.

Do you deliberately seek out controversy?
Controversy. Hmmm, that's one of those alarm-bell words, isn't it? It's not for me to decide what's controversial.

You've been quoted as saying, 'I'm sceptical of the idea that you can find an empirical way of judging quality, particularly in art.'
That's true. Price is good. It's the only empirical way of judging apart from popularity. The idea of the undiscovered genius is another one of these clichés that needs kicking into the weeds.

In the last few years, you've become a superstar, a television personality, a social commentator. Don't you also want to be a troublemaker?
Yeah, but you gotta do it like you're not trying to make trouble. It makes it much more interesting. 'Show not tell.' Classic line. It's the first thing they tell you on a creative-writing course.

So how does London figure in your personal scheme of things?
It's hugely important. I'm a local artist. The metropolitan and cultural life of one of the world's greatest cities, that's my local culture. As a visual artist, I've been incredibly fortunate that I've been in London in a time where it's gone mad. You see, when I came to London and you were working in contemporary art, it was like a backwater of culture –

This was when?
1983, and I was a squatter. There would have been maybe fifty contemporary-art galleries, maybe less. I don't know how many hundreds there are now.

What has caused this change?
It's a mix of things, isn't it? It's to do with the stability of the British political and social system. It's a safe place to dump money, you know, property. And it's an English-speaking access into Europe, so it joins Europe and America. It's also of course a hugely diverse international population. There is a natural sophistication that comes from being rubbed up against lots of different cultures.

Does any element of this natural sophistication have to do with Britain's imperial legacy?
Yeah. The initial waves of immigrants would have been coming to London because of colonialism. That got us used to the idea of having different people in the country. London is where it all happened. And of course you've got this British sensibility.

What is British sensibility exactly?
One of the central things is healthy scepticism. The catchphrase of your British person is 'Come off it!' There is a sort of respect and constant playfulness, humour, word play. English people are quite creative about the way that they talk because they want to enjoy it. People will joke and laugh and twist things around for fun. Everybody's playing with words the whole time. It's in our social DNA. The big thing that powers British creativity is the avoidance of embarrassment. We make jokes constantly to avoid the discomfort of certain feelings.

Does London fit comfortably into that spectrum or not?
There is an element of dog-eat-dog; it's incredibly competitive. You come to London because you want to up your game, meet other people, make networks, be influenced. If you can't stand the heat in the kitchen, then get out. It's a hard place.

When you came to London at an early age to visit the British Museum or whatever, were you enthralled or were you 'Can we go to the movies'?
I was probably more interested in watching *Thunderbirds* on telly.

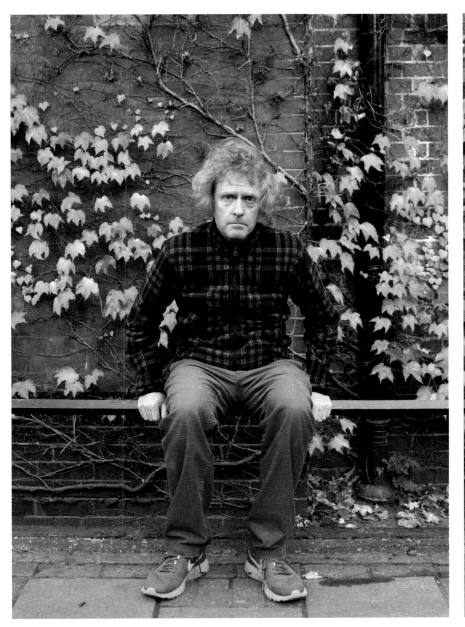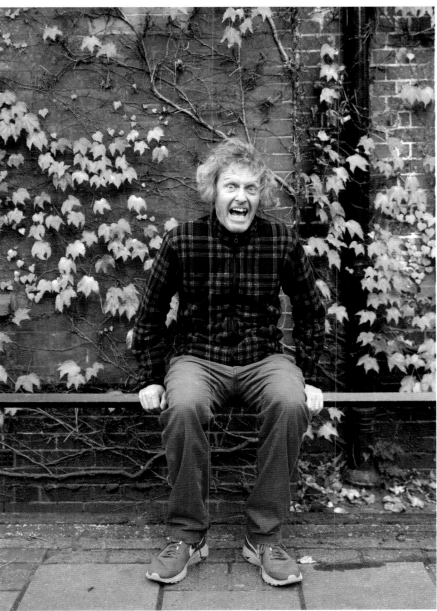

(previous page) Grayson Perry, outside his Islington studio, mocks the camera. 'As a transvestite,' he says, 'I find it quite tricky to do photo shoots'. Perry walked past the former watch factory for twenty years before he could afford to buy and convert it into a workspace. 'It's a rather YBA studio,' he adds, 'very perfect, white and industrial-feeling'

Perry in repose at his studio (top), copies of the *New Statesman* issue he guest-edited in 2014 to hand. The playful artist at play (above) with a remote-controlled model racing car he bought himself as a fortieth-birthday gift. 'I have working-class hobbies,' he jokes. 'I don't own a violin.' Perry does not own a car either, preferring his powerful pink Harley-Davidson.

An active mountain biker, he rides his equally colourful bicycle (left) to the local pub. 'I'm a post-rationalist,' the artist claims. 'I have the ideas after I've done the artwork … It's an organic process of one's imagination.' Perry's imagination knows no bounds, as witness his outlandish costumes (opposite) designed by students at Central Saint Martins

'I'm a local artist. The metropolitan and cultural life of one of the world's greatest cities, that's my local culture'

So when did it click that you were an artist?
I don't think necessarily that you suddenly get inspiration or that suddenly you become an artist. You put it on very slowly. It's also not just you that decides. To be an artist you need an audience and the wider art world to agree with you.

In declaring, or not declaring, yourself to be an artist, did you experience doubt?
Of course!

And do you still doubt yourself?
Of course!

Is that a good thing?
Yes! Very important. Hubris is very dangerous. When artists start feeling it, they lose touch with the fact that they can just print money. That's the worrying bit, when they think that everything they do is good.

What do you do to ground yourself?
Well, being married to a psychotherapist helps. We talk like any married couple about art, emotional states.

Talking of emotional states, you've often mentioned your fascination with pilgrimage. What does that exemplify for you?
In the digital age, you can find out about anything from Google, you can look up an image of anything on your phone, but you still need to get over there to see the thing. People want to physically move through space and go and visit the thing. So we're going to plot a route through Essex where people go to certain places and they can travel to it however they want to. I think it's very important.

Is there in fact some essential connection between religion and visual art?
Well, people like to believe stuff. The basic model of art in a way came from religion: going to a special place, seeing a special thing. The idea of art that we hang on to today probably developed around 1400.

Taking the imagery a bit further, do you consider yourself a kind of prophet?
Oh, no. I'm an experimental human. My job is to play around with the possibilities, and if other people take inspiration from it, well, great.

Does living in such a vast megalopolis affect your core inspiration?
What is great is that people still need to be in close proximity to each other. Geography is still king. House prices are still about proximity to where it's happening. I partly put my career success down to the fact that luckily, my wife had a house that was twenty minutes' walk to the West End. When I moved my studio from Walthamstow, it worked out about two hundred grand a mile to bring it nearer to the centre of London, if not more.

So what keeps your inner fires burning?
I just keep myself interested.

And what's psychotherapy got to do with that?
It's hugely important. It's given me a viewpoint on the world that I find constantly stimulating. It's a way of looking at yourself and the world that unpicks it a bit. All of our decision-making, whether we think we're being rational or not, is pretty well unconscious. Scientific studies show that when we make a decision, we've actually made the decision already; we're literally post-rationalising it most of the time. Like when people talk about the economy being very objective, it's not. They're doing it for completely animal reasons and laying pseudo-scientific stuff on top of it.

What about aesthetics?
What we find beautiful is entirely acculturated. People have a sensibility that they pick up in their cultural context.

And what about sex?
Well, sex is important because it powers a lot of the decision-making in the world.

Artistically, as well?
Of course. A lot of men, particularly, they're doing things that they think will impress women, to get them laid.

So it's all about getting laid in the end.
A lot of the time it must be, yeah. Just making loads of money and being famous in order to, at some unconscious level, make them more attractive. Like a big peacock's tail, isn't it?

You've been quoted as saying, 'For me, art is all about expectations.' What did you mean exactly?
Can't remember why I said that. Disappointment is more like the truth, because my imagination is always nicer than reality. It's all soft and fuzzy. The foetus of an idea is always much more beautiful than the sprawling and ungainly teenager when it finally gallops into the room. It's one thing having a lovely idea, which is one part of being an artist, I suppose. Bringing it into reality with all of its compromises, hard work and mistakes is a different thing.

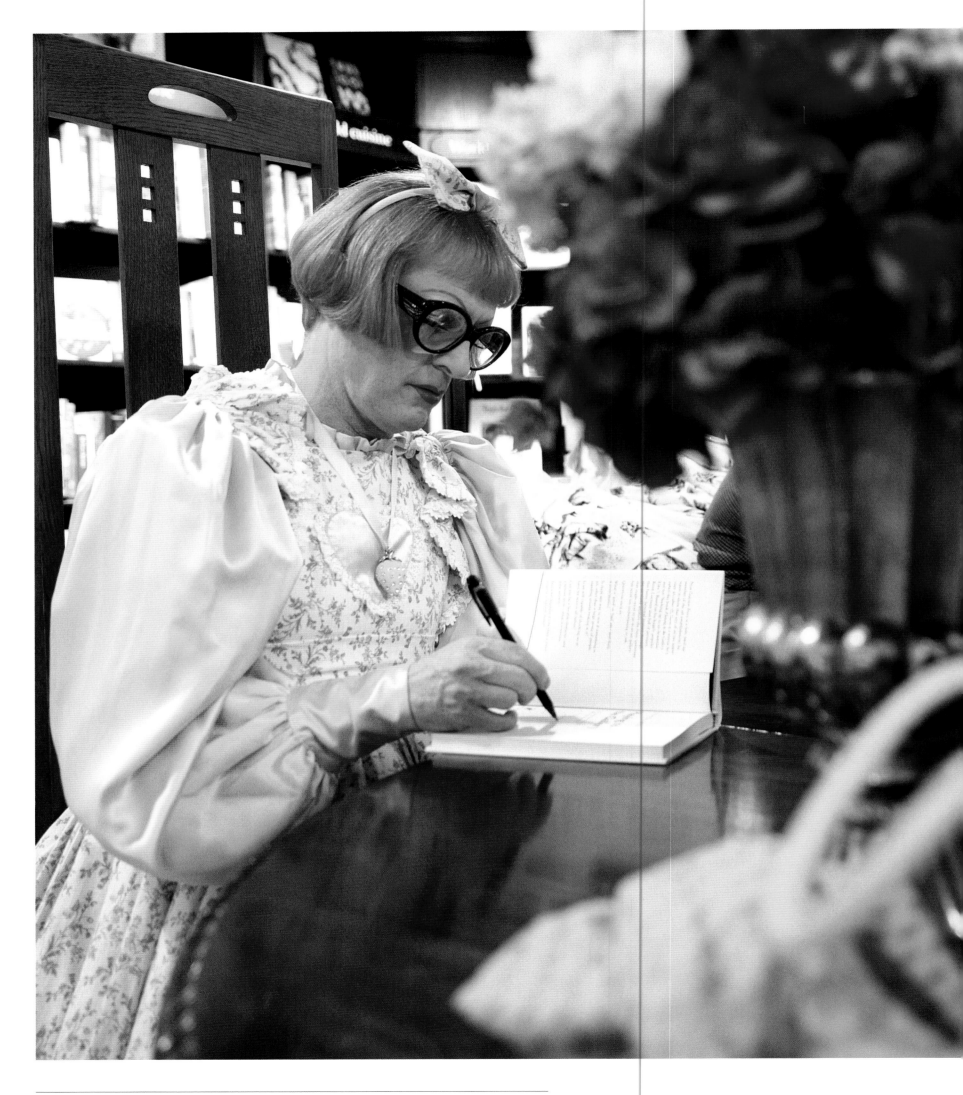

Perry in full regalia signs books at Hatchards in Piccadilly. Internationally respected, he has become a major cultural voice in Britain. The book, *Playing to the Gallery: Helping Contemporary Art in Its Struggle to Be Understood,* was published in 2014 to coincide with a major exhibition of Perry's work at the National Portrait Gallery. It controversially explores the boundaries and tensions at the heart of contemporary art

Munira Mirza
Deputy Mayor for Education & Culture of London
Shad Thames

Your parents were Pakistani, but you were born in Oldham. You escaped to London and now you're sitting at the top of the pile. How did you manage such a journey in such a short time?
A pivotal part of the journey was going to Oxford. Also the draw of London. I'd always known I wanted to come to London, from when I first understood what London was. I remember my first school trip to London; I must have been about eight?

Were you enthralled or intimidated?
It was enthralling. It was vast! I remember being amazed that Leicester Square was open after 8.00 or 9.00 at night. I had never seen anything like that. Seeing shops and restaurants open that late and people walking around, that was really exciting, feeling that this was a real metropolis. I was drawn to the sense of possibility. That's what big cities do. The celebrity of history, the idea that important and interesting things happened in this place, is very attractive. Maybe it's vain to say it, but I've always wanted to be part of that.

Was there a celebrity figure in Oldham or Manchester who grabbed your attention at a young age?
Lots of famous people came from Manchester and Oldham, but you have to remember that in the 1980s when I was growing up, the North was going through a recession. My dad was laid off; he took voluntary redundancy in the early '90s. Growing up, it didn't feel like there were lots of exciting things coming out of that area, certainly not that sense of history-making.

Which characters caught your attention in London?
I remember going to a Saatchi exhibition about 2001/2, and Damien Hirst's *Love Lost* was one of the pieces. There was something so funny and witty and moving about it. I started going to more museums. The great figures of London's creative scene are these institutions; the unsung heroes are the people who run the institutions.

'The celebrity of history, the idea that important
and interesting things happened in this place,
is very attractive'

(previous spread) Munira Mirza on the balcony of London's Living Room: City Hall's top floor overlooking Tower Bridge. Myth and archaeology both point in the direction of the bascule bridge (commissioned in 1876), sited near the first Roman bridgehead (built in AD 47) to span the Thames

Mirza hardly has time to stretch her legs, but her favourite neighbourhood remains Shad Thames (far left), where she has a home. Her workplace, City Hall, is a Norman Foster design located in Southwark (opposite) and affectionately referred to by locals as the 'glass testicle'. (The irony is that Charles Dickens referred to the area as one of 'the filthiest and strangest localities hidden in London'. The *Morning Star*, his newspaper, termed the district the 'Venice of Drains'.) Redeveloped in the 1980s, Southwark has been gentrified and is glorified for its tourist traffic, boasting a multitude of restaurants, bars and bistros while retaining iron bridges and goods gantries (above) linking former spice and tea warehouses. Shad Thames plays host (left) to the old Design Museum, a favourite haunt of the Deputy Mayor. 'London is a design capital,' she says, 'so it's important to have a public institution for it.' The new Design Museum will be located in Holland Park

'*What happens in London is that you have incredible dynamism and that tends to allow identities to flourish. But there are tensions*'

How can you reconcile the almost alien divide between Chelsea, Kensington and Mayfair on the one hand and what is out there in Poplar or Hackney?

People often talk about London being a different country to the rest of the UK, but actually there are different countries within London. Poplar is obviously much poorer than central London. But these are areas that have communities, too. They're very transient; the communities are international. Some of them do settle down and make roots. I was at a youth centre in Poplar which is just established; we partly helped facilitate that through some housing that we're doing in the area. There are people there who were volunteering with young kids and they've got a sense of community. Does Kensington and Chelsea have a sense of community? It's very international, too. It's very transient. The character of London is one of increasing internationalism, cosmopolitanism, which is a great thing. But people also feel the sense of change. The whole city is constantly renewing.

But what about that underclass, for lack of a better word, that seems unable to integrate?

You have contradictory forces. You have things being pushed out, people also being brought in. So, while you have increasing inequality or more people feeling that they're not able to partake in the wealth in London, you also have social mobility, you have people coming through the system and becoming part of the story. Over the long term people's circumstances are getting better.

Is there equality of opportunity out there in the city's hinterlands?

Compared to what it was like when I was growing up in Oldham, the cultural opportunities for young people in London are completely different. You're invited into galleries and theatres. There are programmes especially for schools to bring them in. There are issues in London about what cultural education people have access to and whether it's as empowering as it could be. There are more things we could do to give young people access to cultural capital.

So wouldn't it be opportune for City Hall to be pushing London education?

Well, we are. We have a programme called the London Curriculum, which is materials for teachers to use, a way into understanding what cultural resources exist in London. This is the best living classroom you can get. You walk around, you constantly are learning, you're constantly taking influences. It seems strange to me that so many young people could walk past St Paul's Cathedral and not understand why St Paul's Cathedral is an amazing building and why we protect the views of it.

So can you put your finger on why exactly London is roaring ahead in cultural terms?

There are some long-term trends: the higher-education institutions, the way in which creative courses have been well regarded, and then things like arts funding, Lottery funding. And you can't deny the way in which the city was transformed in the '80s through the reform of the economy. Deregulation, the rise of the financial sector, the wealth that came into London as a result of that, and that then started buying art. People coming from abroad feeling welcome here. This being a safe city compared to cities abroad, a feeling that this was a place that welcomed experimentation, freedom, free speech. Although I would argue that we can't be complacent about that. It's not as free as it could be.

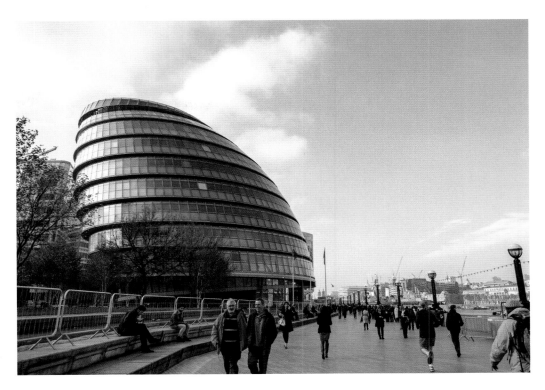

So is London a paradox, or a paradigm of unexpected futures?

What happens in London is that you have incredible dynamism and that tends to allow identities to flourish. But there are tensions. Some people can carry on ignoring those tensions and others can't. Broadly, London has been successful in integrating immigrants. There are isms, but there is also a strong identity in being from London and being a Londoner. It does have a lot to do with a sense that there is a future, a kind of exciting project to be a part of.

How does the system contribute to this bigger picture?

On the part of the system (if you mean by 'system' the authorities, government, local councils, charities), there is an amazing effort to try and engage with young people. There certainly have been cuts in the last few years, but the amount of funding and support that goes into that area has been sizeable. The problem is that it is not just about funding and resources. There is a cultural problem as well, which is that a lot of young people are searching for an identity, for something that they can identify with. And the traditional types of identity – political identity, ethnic identity, religious identity – have become much more fluid, much more dislocated. The growth of gangs is quite logical for some young people because this is a community where you earn respect. You're part of a tight-knit group of people who are loyal to you and you're loyal to them. There is status attached to it. There are rules and there is discipline. What we need to do is create alternatives for those types of things.

How do you see your contribution in this socio-political mix?

I'm an Enlightenment liberal. That's why I like the word *excellence*, because it's contested. We should have debates and discussions about what should be in the canon and what shouldn't be, what is knowledge and who has authority, but at the end of the day, you do need expertise, you need authority, and you need teachers to be able to say to their students, 'I know more than you and I can help you to access this incredible canon of knowledge and civilisation.' There is a strong democratic value in giving young people a belief that they can identify with civilisation. God, I'm using all these very deeply unfashionable words! It always takes the ethnic female from Oldham to say the deeply unfashionable words because nobody else wants to say them. I believe in them because my entire journey is about that access, the revelation of civilisation.

Mirza is a keen proponent of public spaces being developed to cater for their communities, one example being the Undercroft at the Southbank. The picturesque birthplace of British skateboarding (reputedly the world's oldest skateboarding space) was the subject of a major battle between commercial and public interests over the use of urban space, with the latter winning in this case

Mark Hix
Chef/Restaurateur/Food writer/Art collector
Shoreditch

You're a West Country boy. London must have come as quite a culture shock. What brought you here in the first place?
Well, in Dorset where I come from it's a bit sleepy. I had to come to the big city to make money.

When did your creative flair for food come into play?
In the fifth year of school I did cookery instead of metalwork. We just messed around. It got to the end of term and I was working in a pub washing up and helping out in the kitchen. Embarrassingly I won the school prize for Domestic Science. They said, 'Why don't you go to catering college?' I didn't have anything else to do so I went there and had a great teacher; he worked in London, always talked about London. I ended up getting a job in the staff canteen at the Hilton, my first job. I was eighteen. My friends were working up the road at Craven House and the Dorchester. My dad put me on the train, tried to give me ten quid. I said, 'No, that's alright.' I worked at the Hilton for about six months, then I did two years each, Dorchester and Craven House, and then I worked at a funny little restaurant just down the road called Mr Pontac's. I got a bit of a reputation for myself then. I stayed there for about four years, and then the job at Le Caprice came up; my fishmonger told me about it. I applied, had a few interviews with Chris Corbin and Jeremy King, and they gave me the job.

Thirty years on, you've done Le Caprice, you've done the Ivy …
You set up seven restaurants in less than four years, right?
There was Le Caprice, the Ivy, Scott's, Daphne's … that was it. Myself personally I had seven restaurants, yeah.

When was the Tramshed actually built as a tramshed, in the nineteenth century?
In the late 1800s. I think it closed in the early 1900s, whenever the trams stopped. A friend of mine who bought the building said, 'Do you want to do a restaurant?' So we did a cross between a gallery and a restaurant.

What is special about your menu, your approach?
Making good use of small producers, if you like. All the menus are very British and seasonal. All the books I've published have been about British food. It's quite a recent thing. Growers are growing nice things, farmers are growing proper chickens.

So you've put British food on the map of London?
I'm probably partly responsible.

But what exactly is English food?
That's a very good question. English food is probably quite close to Italian food in some ways. It's comfortable, usually good produce, not pretentious. It's just finding nice ingredients.

I understand your grandmother cooked well within the household budget. Was she an early influence?
Yeah, she cooked within her means, nothing fancy. Some of the food I do today is maybe slightly similar to what she used to do.

We're talking about food which has become a great attraction for the city's increasingly rich upper class. What were your other inspirations, or did you just experiment?
Sometimes when you're confronted with an ingredient, you make the best of it. For example, in Dorset I used to catch a lot of spider crabs. You catch them when you're fishing sometimes.

Did you go fishing by yourself?
Yeah, and with my mates from school. We used to fish for mackerel, for sea bass or for prawns with a net. It was part of the way of life, I suppose. I have a fish restaurant on the coast in Lyme Regis. Fish features quite heavily on most of the menus in my restaurants.

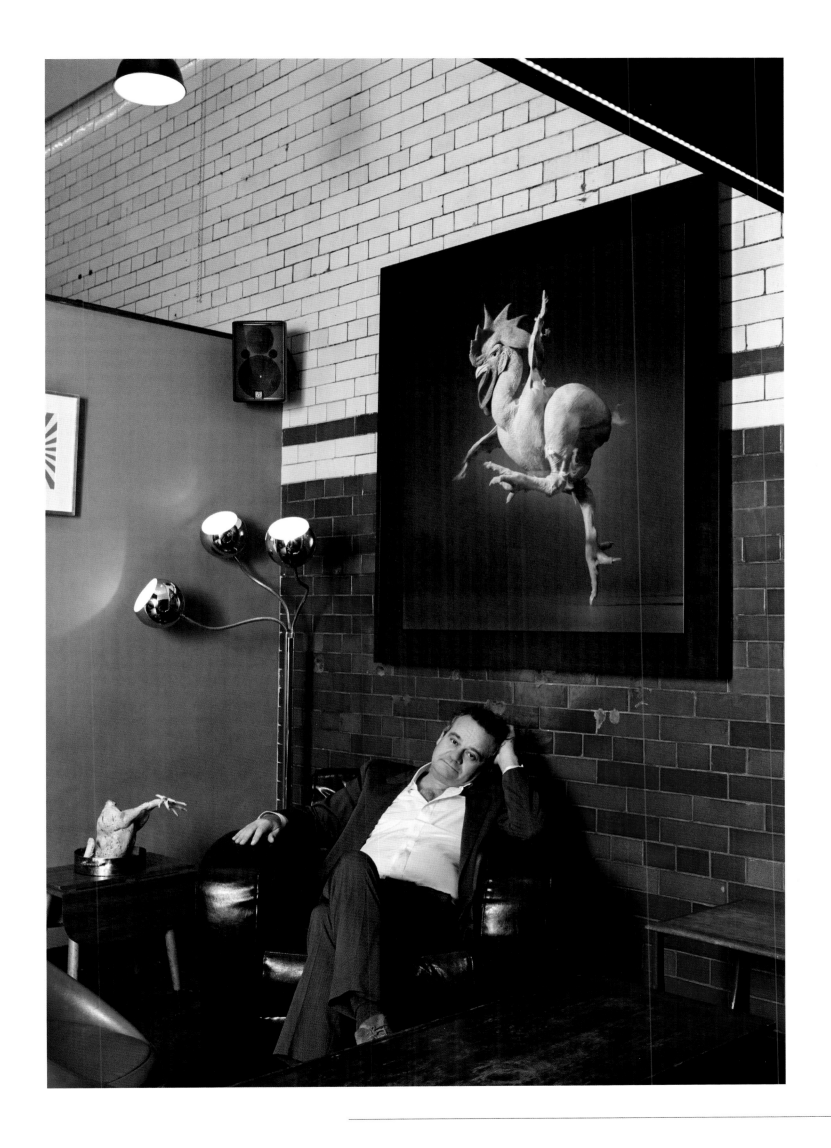

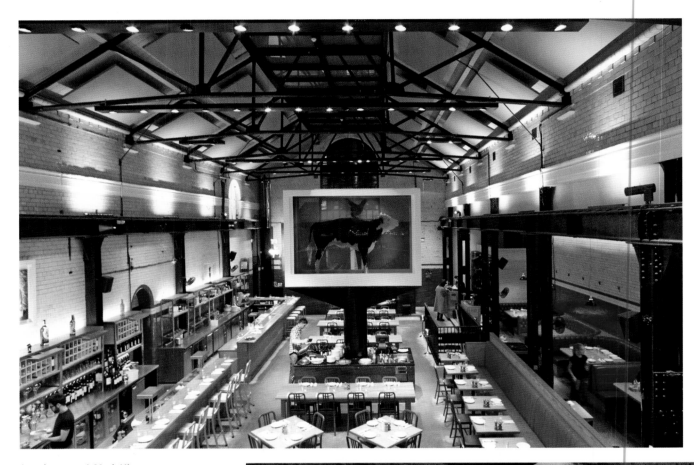

Tramshed (left) features *Cock and Bull* (2012), a giant Damien Hirst sculpture of a rooster standing on the back of a Hereford cow; both foul and friend are featured on the menu. Hix (below) chats with Gio, the manager of Hix's FishDog food truck, a 1971 Citroen H that delivers his famous fish-finger sandwiches around London. Hix is a connoisseur of fine wines, a few of which he produces in England under his own brand. The author of a series of successful cookbooks takes time out in Mark's Kitchen Library (opposite) in Tramshed, where he supervises menus down to the last detail

(previous page) Mark Hix at Tramshed in Shoreditch, looking rather henpecked. Hix's restaurants are adorned by works by such artists as Damien Hirst, Tracey Emin and Bridget Riley; behind him here is *Featherless Chicken* by Tim Flach. Describing himself as a 'Dorset lad', Hix has in the last decade pioneered a revival in English cooking, with eight eateries including Hix Soho, Hix Mayfair and Hixter in Bankside. Prior to that, he was Chef Director of Caprice Holdings, which owns such sought-after dining spots as the Ivy, Le Caprice and Scott's

Although you've said that you don't plan ahead, nevertheless you seem to have quite the little empire around you. How did that happen?
It's about having good ingredients, treating them simply. Also, creating an environment is important. Art features quite heavily in the restaurants.

How did that start?
Well, I lived in the East End and got to know a lot of the artists there twenty years ago. I used to go to parties with them, I used to host dinners for them, and I started to exchange work for art, starting collecting a bit. Then when I did my restaurants, I did the same thing. So we exchange work.

Do these exchanges result in ownership, or are they loans?
The artists get a tab so some of it is on loan. All the artworks in the restaurants, whether it's Soho or here, are because I have a relationship with the artists rather than just going shopping for art. The works are normally commissioned for the restaurants.

Did you grow up with a taste for art?
I suppose for me it's which artist do I like? Who will I spend time with, drinking or eating or on a weekend? I tend to get to know people as opposed to their work. I sometimes do what galleries don't do: I get new students or unknown artists that galleries aren't ready to take yet. We show them in the gallery downstairs and they might go on to better things. It's like a stepping-stone. I nearly always buy something from the show and I do the Hix Award, which is displayed above the bar downstairs. Art colleges submit their best students, a committee choose the best work, and the one with the best piece gets the Damien Hirst Award and a show in the gallery with the runners-up, who each get a tab for £500.

So you've become both a collector and a patron.
Yeah. I sit on the board at the Royal Academy Schools, and I'm a patron of the Chisenhale Gallery.

You've been sourcing new art, new talent; now you're sourcing good game and fresh produce. How do you go about doing that?
I know all of these producers. Also with drinks: all of my cocktail bars fly the flag for British producers. So whenever there is a new English gin or vodka, we make sure we have cocktails using these new products. Same with wine. On wine bottles I use some of the artists' images, like Mat Collishaw's here, so we have our own branded labels, and even cooker tonics, which is a Portuguese wine; Tracey Emin did the label for that one. It's not a financial thing, it's just a nice thing to do.

How has the restaurant scene in general changed in the last thirty years?
When I first came to London, everything was French. Now we have fantastic Italian restaurants, very, very good Indian restaurants, a lot of people doing good British food. Peruvian food is getting big now. You get more or less anything. If you go to Paris, it's very difficult to get anything other than French food.

Whereas you cater both to your local clientele and to a bigger audience. I saw a lot of Chinese groups coming here. You're on the tourist map ...
Yes. If you Google the Tramshed, the cow is the most photographed image in any restaurant.

That was a pretty clever branding idea, wasn't it?
You know, I didn't even think about it; that wasn't the incentive.

Having nice art on the walls, being nice to people, serving nice food – where do you go from here?
Who knows? Next year, I will probably have another restaurant or two. I quite like the idea of doing a restaurant with a hotel, a small one, in London. I'd also like to open something in New York and Paris. Imagine doing something like the Tramshed in Paris. Maybe wake them up!

How creative would you consider yourself to be, given that you've, in a manner of speaking, transformed English cooking but also adopted art as a culinary platform?
The two things go well together. In Berlin and Paris years ago, artists used to frequent restaurants, and their way of eating nice food and drinking was to exchange their work. A lot of artists' work is based on food. Look at Warhol and the soup tins.

And your last hurrah would be?
A good dinner party with some nice wine, with nice people.

'In Dorset where I come from it's a bit sleepy. I had to come to the big city to make money'

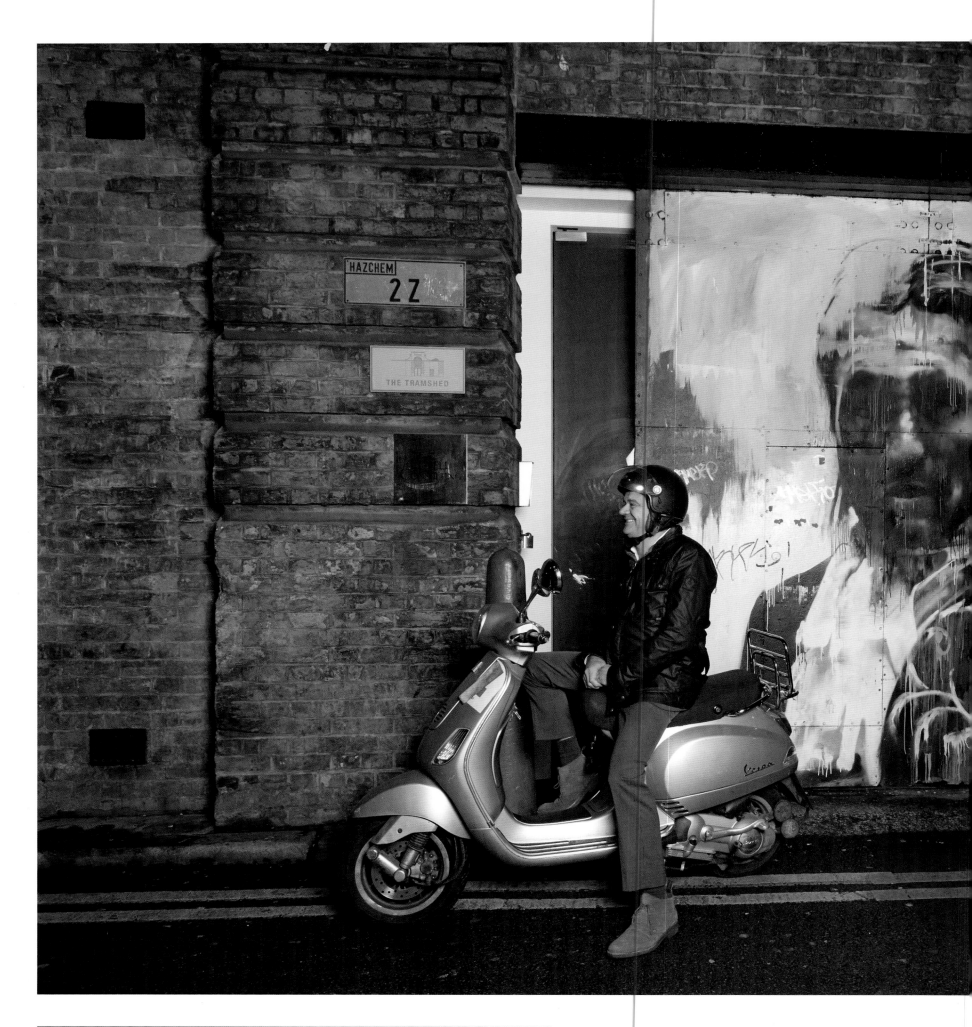

Mark Hix

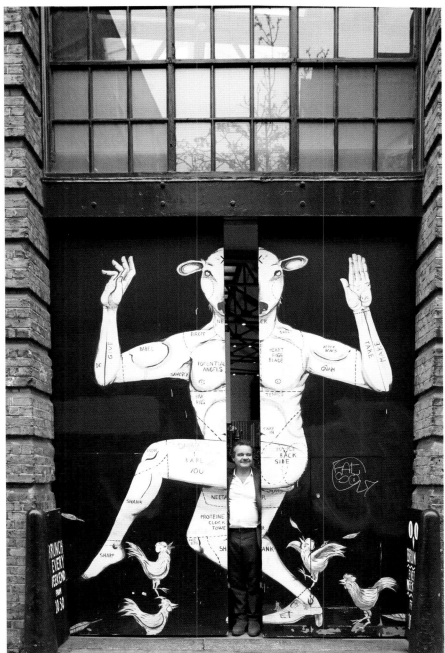

Hix (above) between the large painted doors of the Victorian tramshed he converted into a restaurant in 2012; they were decorated by RUN (aka Italian graffiti artist Giacomo Bufarini). The chef pulls over on his Vespa (left), en route home after a hard day; the mural is by Irish artist Conor Harrington

Peter Pilotto & Christopher de Vos
Fashion designers
De Beauvoir/Regent's Canal

I'm intrigued by the diversity of your backgrounds. Peter, you're half-Austrian, half-Italian; Christopher, you're half-Belgian, half-Peruvian. Anything else in the mix?
CdV: Well, I was born in Libya, and I grew up in South America and the Middle East.

Peter?
PP: I grew up in Austria, in the mountains. I moved to London when I was twenty and then to Antwerp when I was twenty-three.

Why to London?
PP: I always was excited about London; it's one of the most exciting places in Europe.
CdV: Peter's parents had a fashion shop. They were the first store selling Alaïa and all the big brands in Tyrol.

Did growing up in your parents' shop direct you towards a fashion career, Peter?
PP: Yeah. Fashion surrounded me. It's what I knew. I was doing collages with look books and thinking about studying graphic design. I knew it had to be something visual and artistic. I did a foundation course in London, at the Chelsea College of Arts. I tried different subjects and then realised that the fashion part was the best thing for me. And then I decided to apply to the Royal Academy of Fine Arts in Antwerp.

Why didn't you stay in London at that point?
PP: I worked at Vivienne Westwood; I did the shop windows and other things. I was fascinated by that, but I didn't find enough time to concentrate on myself and my studies. Antwerp was another place I always admired because of the designers.

Did doing windows inform your work later on?
PP: I don't know. I worked with some great people that helped me understand what I had to look out for, what made the scenes stronger. It was very, very interesting. That's the thing: it was too interesting. I realised that I would get stuck there unless I studied and explored and found myself.

Christopher, you two met at the Academy in Antwerp, didn't you?
CdV: Yeah, in 2000. Antwerp was great for studies because you could really concentrate and give it your all, but once you graduated you felt like, 'I don't want to stay here' because we were not from there. The natural thing was to go and work for big houses in Paris or New York or London or Milan. I moved to London, Peter joined me a year later, and we decided to join forces in 2007. Our first catwalk show together was in 2008.

What attracted you to each other's ideas?
CdV: In school it was always like a healthy competition, you know? We liked exactly the same things. It's funny, because sometimes we almost think in sync.
PP: That's scary!
CdV: Yeah, it's quite scary! So, moving to London was hard. Peter had lived here before, but we moved to East London, which we didn't know. It all a bit like, 'Oh my God, how do we do that? Where do we buy this?' Then we made friends with a couple of designers who told us, 'You have to do this and that.' Bit by bit we got to know people in the industry, relevant people like Sarah Mower …

It must have been a shock to come from idyllic Antwerp to the East End.
CdV: The first time Peter brought me to the East End, I was like, 'Why are we here? This is so ugly!' That was ten, fifteen years ago. It has changed so much.

Peter, you talk about this back-and-forth between you and Christopher. Is it just you two sitting down and saying, 'That's the colour, that's the mood, that's the style,' or are there other people involved?
PP: For many seasons it was just the two of us, but now we have a team. It's a dialogue between the two of us extended to the team.

How much team input do you encourage? Is it vital to your work as a sounding board?
CdV: Totally. I mean, we've grown so much in the last couple of years, and that's the whole point.

So how have things evolved since 2007 on other fronts?
CdV: We were in a studio with no heating. We were sharing, right?
PP: Yeah. It was an artist's studio.
CdV: We were not allowed to be there. Fashion is not considered art, so they were trying to kick us out.

I'm fascinated by that. We're talking about setting up in a pauper's yard and then, within seven years, finding yourselves on the front pages and sought after by the main fashion houses or distributors. Do you pinch yourself from time to time and think, How did we get here?
PP: It's so funny, fashion, because it's a constant race and this mountain to climb, so you just have to look ahead.

You don't feel the pressure? Or is it like skiing, something that comes naturally?
PP: I guess so. Except with skiing you have a cable car! With us it's more like hard climbing.

You mentioned Sarah Mower, and of course there's London Fashion Week and support for younger fashion designers. That, in a sense, is the cable car. How much of a pull did they bring to the table?
CdV: What London has in terms of support is amazing. There is no other city that has that.

Has that always been the case, or just recently?
CdV: I think it started with our generation, right?
PP: The support schemes started earlier. I don't know why, but our generation wanted to combine creativity and commercial success.

What role was played in that process by the Centre for Fashion Enterprise?
PP: That's one of the organisations that was so great for us. After being in that unheated artist's space, we got a studio from them for two years for free. It was so great being in a safe place and having all those facilities. It was inside the London College of Fashion so we had access to all of the machinery and everything. The BFC and the NEWGEN scheme are great as well, because that's how you get on the London Fashion Week calendar and have the opportunity to show your work to the world.

(previous page) Peter Pilotto and Christopher de Vos dream up designs at their studio in Hackney's De Beauvoir, by the Regent's Canal. The architect-designed space has a clean, industrial feel. 'It complements the bright, colourful and graphic nature of the brand's designs,' Pilotto explains

Pilotto and de Vos lunch (top left) at the Towpath café on the Regent's Canal near their studio. Open from March to November, the eatery operates out of four shallow concrete bunkers. 'There's something truly international about the place,' De Vos says. The duo (above) inspects the fit of a new collection on models. Known for their digital prints, which they design from scratch, they often return to the mill to recalibrate the machines if the designs are not vibrant enough. The two personally supervise (left) every aspect of their garments' production

Without that, Christopher, do you think you would be where you are now?

CdV: I don't think so. We would be somewhere else!

New York, perhaps, or Paris, or Milan?

CdV: That's the difference between London and New York. New York designers always come from a more commercial background. Maybe the support is just different in New York.

That's where the real money is, isn't it?

CdV: Yeah. But what's amazing about London is that you had the support, you had Fashion Week, you had the stores who were buying novelty and supporting designers and accepting their cash-flow issues. They were really supporting us financially in the beginning. It was the perfect combination. We still struggled with our cash flow, but we managed to get where we are now.

But that's not always been the case. London Fashion Week was a bit of a joke ten or twenty years ago.

CdV: The problem with London Fashion Week is that it was always about novelty. That's what Peter is trying to say. What happened in the heads of the new generation was that they needed to be creative and at the same time to have business understanding. They needed to know their customer. That's another thing. We got to know our customer in London. We got to meet all these amazing women that wear our dresses, at the same time buying our collections as supporting art or philanthropy. There is this whole circle of people in this city supporting the arts.

PP: Money you have in many places, but you don't have the same spirit that you have in London.

So this spirit, the London spirit, if you will … It's even apparent in the colour palette that you work with. London was known for being drab and dreary. How come it suddenly changed?

PP: There was always something colourful happening …

CdV: Go to Antwerp! It's much greyer!

PP: Somehow in London there was always so much energy for exploring the new.

But what about Belgium, Christopher? It's the most uninspired place in the world, isn't it? And yet, one of the richest and most efficacious in social terms.

CdV: It's always been a country of extremes. It's an insider's place. Once you know that, it feels really interesting.

But your products are very much 'outside' …

CdV: Yeah. Growing up in South America and the Middle East makes our point of view much more colourful. We both like to show our southern point of view, but the way we deal with the company is quite Nordic.

PP: We do so much colour, but we always try to have the colour engineered on the right place on the body, in control somehow.

Speaking of control, or engineering, you are very focused on digital design, am I correct?

PP: We did a lot of digital printing and still do, and yes, the computer is involved a lot in our design process. So it's a modern approach, but it's not exclusively digital. When we design textiles, we explore different possibilities – the print, the jacquard, the embroidery. But there's the garment as well, and of course that is very classically made, in the sense that it's partly corsetted or draped on the dummy.

CdV: Fashion has become such a fast-paced industry that you need to go digital. Also, we came at a time where there was a big trend for digital prints. We were part of instigating that trend. Now it's about how we move that forward.

Do you have in-house engineers or an outsourcing system to match your ideas and expectations?

CdV: We design everything. We do most of it inside. We work closely with the Italian mills to get our fabrics printed to the highest standards.

You're an expensive brand, aren't you?

PP: Well, it's a high-quality product, so a lot of steps go into it.

There are a lot of brands which are expensive and not that high-quality! Do you feel that your brand expresses a different mood or aspiration than the normal high-street purchase?

PP: Yeah. High-street is, anyway, a different price point. What's particular about our brand and about high fashion is that it's all about innovation. High-street is about copying trends. We set the trend. We try to look into the future constantly and do something new every season.

Christopher, you mentioned the women who wear your clothes. Who are they?

CdV: We do dress celebrities and are flattered when they wear our clothes. But when we design, we think more of women who are close to us, friends that love what we do but love fashion in general. They wear our clothes and we enjoy them wearing them.

What do you mean, you 'enjoy them wearing them'?

CdV: There's something so pleasurable about seeing a woman feeling confident and looking great wearing something, you know? It's what fashion gives you, that kick.

Peter, what does fashion give an ordinary Joe like me?

PP: It's hard to put into words. It's a visual and emotional thing. It can lift energy and tension. If somebody is really confident in wearing something, that gets translated into the situation. Clothing can change everything.

So when I see a beautiful woman dressed in beautiful colours and designs, it makes me happy?

CdV: It does.

PP: But it makes her happy, I guess, first of all. She feels at her best and therefore gives her best.

'The biggest struggle,' Peter has been quoted as saying, 'is handling very different mindsets. Design is one thing; business, and managing twenty, thirty people, are very different things.' Which one of you is the Nordic one, in that sense?

CdV: We have to wear different hats every day, and we've learned to wear those different hats. We have, so far, run the business ourselves, which has been a great and interesting path. We've grown organically, and it's important for us to keep that pace, the pace that relates to our lifestyle and what we're capable of doing.

'Money you have in many places, but you don't have the same spirit that you have in London'

Zac Goldsmith
Member of Parliament/Environmental activist/London mayoral candidate
Barnes/Westminster

Is there creativity in politics today?

There is. I'm cynical about how things work in Parliament, and I'm cynical about how little power people have to hold their MPs to account, but there is a dynamism here which I've never experienced anywhere else. It's the most disappointing place I've ever spent time in on some levels, but it is never boring.

Your father, Jimmy Goldsmith, had considerable influence and political ambition. But despite his wealth and personality, he was unable to affect political change. So clearly money doesn't count for everything.

Of course not. But he was probably the single biggest reason we didn't join the euro. He catapulted the issue of our relationship with the European Union to the top of the political agenda and it's been there ever since. So I don't believe that he was ineffective; he had a massive impact. I don't like big money in politics, and I think we should change the way politics is funded, but people sometimes exaggerate how easy it is for big money to purchase policy.

What drew you to politics yourself, given that your obsession, if you will, is the environment?

That was the main reason I wanted to get involved. I've campaigned on environmental issues outside of politics for years. I raised money, ran a magazine, set up campaigns, and I felt that, rather than bashing my head against the wall on the outside, it'd be worth trying to join Parliament and campaign on the inside. Being a local MP in the area that I grew up in – it's the only place that I would represent – is a privilege. There are times when it's infuriating, but on the whole it is an absolute pleasure.

What is the particular fascination of Barnes and Richmond, apart from the fact that you were born and lived there most of your life?

Well, that's it: it's the only place that I can really call home. When I was being selected, not that many people wanted to do it because it was considered a difficult seat to win (it was a Lib Dem seat). We were interviewed by an audience of four or five hundred people. I remember looking out in the hall and seeing all these familiar faces, and I thought it just made sense.

So have your ambitions, your dreams, your aspirations been realised?

Not even close. I've got millions of things I want to do in Parliament. I try and focus on things here that would not happen if I wasn't here. I have campaigns around industrial agriculture, antibiotics being used in farms; no-one else is interested in these issues. They are the most important issues in relation to our health and environment, and I'm able to put them on the agenda. Winning these campaigns is a nightmare; it takes a very long time.

If you weren't Jimmy Goldsmith's son, would you carry as much weight in the chamber as you do?

In Parliament, you're all equal from day one. David Beckham could be elected and people would be interested for a few hours and then he'd become just another MP. We all have the same mandate; my constituents are just as important as everyone else's.

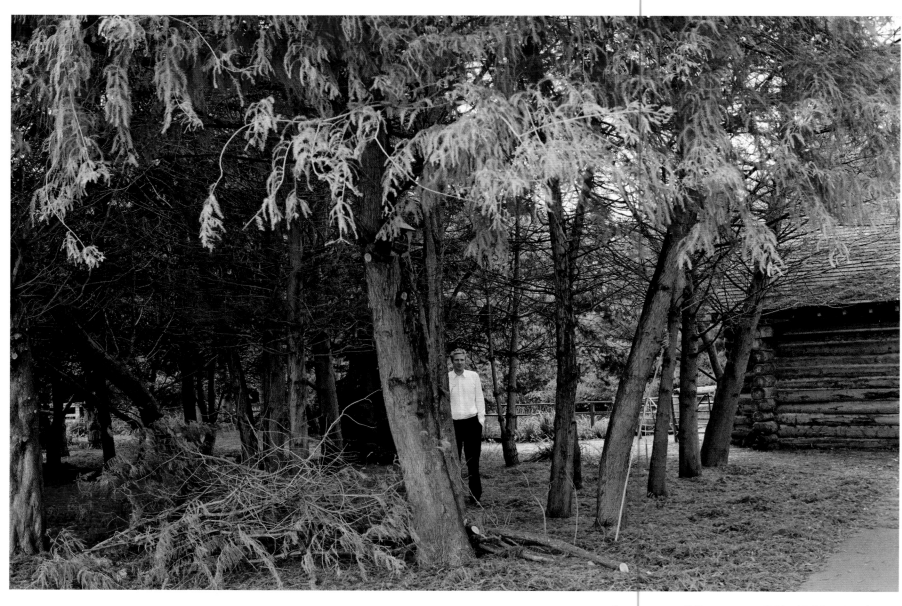

'In Parliament, you're all equal from day one. David Beckham could be elected and people would be interested for a few hours and then he'd become just another MP'

(previous spread) Zac Goldsmith in Barnes Village. Barnes Pond once served for the cleaning of horses and carts, and the site provided grain storage for Mortlake Manor. A long-time Barnes resident, Goldsmith relishes the local environment, both natural and political

Goldsmith (above) at the World Wildlife Trust's London Wetland Centre, where he married Alice Rothschild in 2013, and also the place where news of his appointment as his party's environmental-policy leader was announced. 'This is a nature haven developed from industrial wasteland,' Goldsmith says of the centre. 'I love that London's preserving its green spaces'

Would you ever have considered joining the Labour Party?
I don't think I would have done. I feel that I am a genuine Conservative. I draw a lot of inspiration from Edmund Burke, and there are plenty of things that have happened in the last four years which I don't regard as being Conservative. So there are times when I have to vote against my party. It doesn't mean I'm not Conservative; it means that the party's not Conservative at that moment.

Which creative personality in the history of Conservative politics would you feel comfortable dining with every night?
There are so many! Probably Burke. Everyone is drawn to Churchill, but there were times when he was not a particularly impressive MP. Disraeli. Robert Peel. Margaret Thatcher. I didn't agree with everything she stood for, but I like that she had directness, strength and the ability to follow her convictions. People always think the moment you become an MP you have a lobotomy. But you only have the lobotomy if you choose to be politically brain-dead.

Going back to the environment, at one point you set up an organic farm, didn't you?
Briefly, in Devon. I never was able to spend enough time there because I was always based here. There are parts of Devon on small farms where you still have hedgerows instead of fences. They're teeming with wildlife since people are running the land in more or less the same way they have for generations. It's extraordinary.

Can one survive as a farmer these days?
It's very difficult. You have massive subsidies for the wrong kind of farming. I would like to shift it completely in favour of the small farmer. Then our countryside would have a chance and we'd have food security and jobs in the countryside. But that's a taboo nowadays; we call that protectionism, which you're not allowed to believe in, but in relation to food I do.

The _Guardian_ once dubbed you the 'golden boy of British environmentalism and anti-capitalism'. In what ways are you anti-capitalist?
I'm not anti-capitalist. I believe in the markets; I just think the markets are blind to things that matter. But you can change that. If you have a situation where Google is worth more than the Amazon rainforest, you know that there's something wrong with the way you measure things. Google is a convenience; the Amazon is a source of much of our life. So there's a problem with the way markets recognise things. I have got a problem with unrestrained global capitalism, and unfortunately the default position of politics is corporatism. Big businesses have privileged access to decision-making, so you have policies churned out by the Department of the Environment, Farming and Rural Affairs which are clearly the consequence of lobbying. You can accept it and say, 'That's the way it is'; if that's your choice, then we're screwed, we're finished. Or you can try and change it.

Leaving politics to one side, which non-political personality has had the most influence on your thinking?
David Attenborough, more than anyone else in the world, has made people appreciate the magic of nature. He can make a puddle seem inspiring.

Speaking of nature, you at one point spent six months in Ladakh. Doing what exactly?
I was in charge of a tourist-education programme; I was only eighteen. Ladakh is a pre-industrial society, had never been colonised, was not part of the cash economy, and it operated in a completely different way to anything I'd ever seen before. There were aspects of it that were deeply inspiring. It made me wonder slightly about what we mean by progress. Modern man looks at a place like Ladakh and says, 'They need to be developed, you need to give them education, you need to pour money into subsidised flour and sugar and change their economy so they become more productive.' But I've seen pockets around the world that have done just that, and not one of them is in as good a position as Ladakh. 'Development' is a misnomer.

Director of _The Ecologist_ magazine, Goldsmith is London's most vociferous politician in support of the environment. The Conservative MP for Richmond Park since 2010, he can be relied on for his dissenting voice. The politician (above) encounters a constituent, Richmond's former Deputy Mayor Colin Yandle. 'I helped plant the tree,' Yandle offers. Goldsmith declared his candidacy to succeed Boris Johnson as Mayor in June 2015

Zac Goldsmith

The upcoming politician tackles the busy thoroughfares of politics: Goldsmith walks to the Central Lobby of the Houses of Parliament through St Stephen's Hall, surrounded by statues of British parliamentarians. The original Houses of Parliament were built by William II in the eleventh century to strike awe into the hearts of London's citizenry. The Palace of Westminster, no stranger to violent tempers, was the target of Guy Fawkes' Gunpowder Plot in 1605 and survived fourteen direct hits during the Blitz. It did not survive a raging inferno in 1834, however. The New Palace, built in 1840–70, encompasses the Great Hall, the only part of the structure in continuous existence since medieval times

Thomas Heatherwick
Designer/Sculptor/Architect/Urban planner
King's Cross/Temple

T

Have you always been someone who had big ideas, big dreams?
Ideas have a scale that goes with them. The thing that excited me was making a difference; in some instances that implies a scale. The goal isn't to be big for the sake of being big; the goal is an excitement about making things better.

But most of your work is big …
As I was growing up, I got more and more interested in the public, the part we share with each other, and seeing the world around us as the venue for cultural expression and as functional performance. I was drawn to things that you happened upon because you needed them or they were necessary for the communal dimension that a city is, rather than something in a gallery. The labelling of creativity as 'creativity' turns me off creativity somehow. I grew up at a time when Britain felt stuck. I was interested in ideas and inventions and engineering. My grandfather had books about the amazing people who had caused the Industrial Revolution to happen. Then, no-one was defined; you didn't say, 'Oh, they're an artist' or 'They're an engineer'. People who were doing engineering were thinking about aesthetic functionality at the same time as scientific performance, and that was exciting. In a way, my studio now is a better version of my bedroom when I was eight years old.

Is that what you meant when you used the phrase 'sliced-up ghettos of thought' a couple of years ago?
How we categorise at this point of history is probably very different than how we'll categorise in two, three hundred years. When I was little, I was fascinated by people who had invented ideas, but then I found that there was no degree course called 'Inventing'. So I tried to find a way through and how I would study that might be as true to myself as possible. There was a word called 'design' that seemed somehow in the middle. It seemed that you could design buildings, design jewellery, design food even. So I studied three-dimensional design. The course was called 'Wood, Metal, Ceramics, Glass and Plastics' – what most of the world is made from.

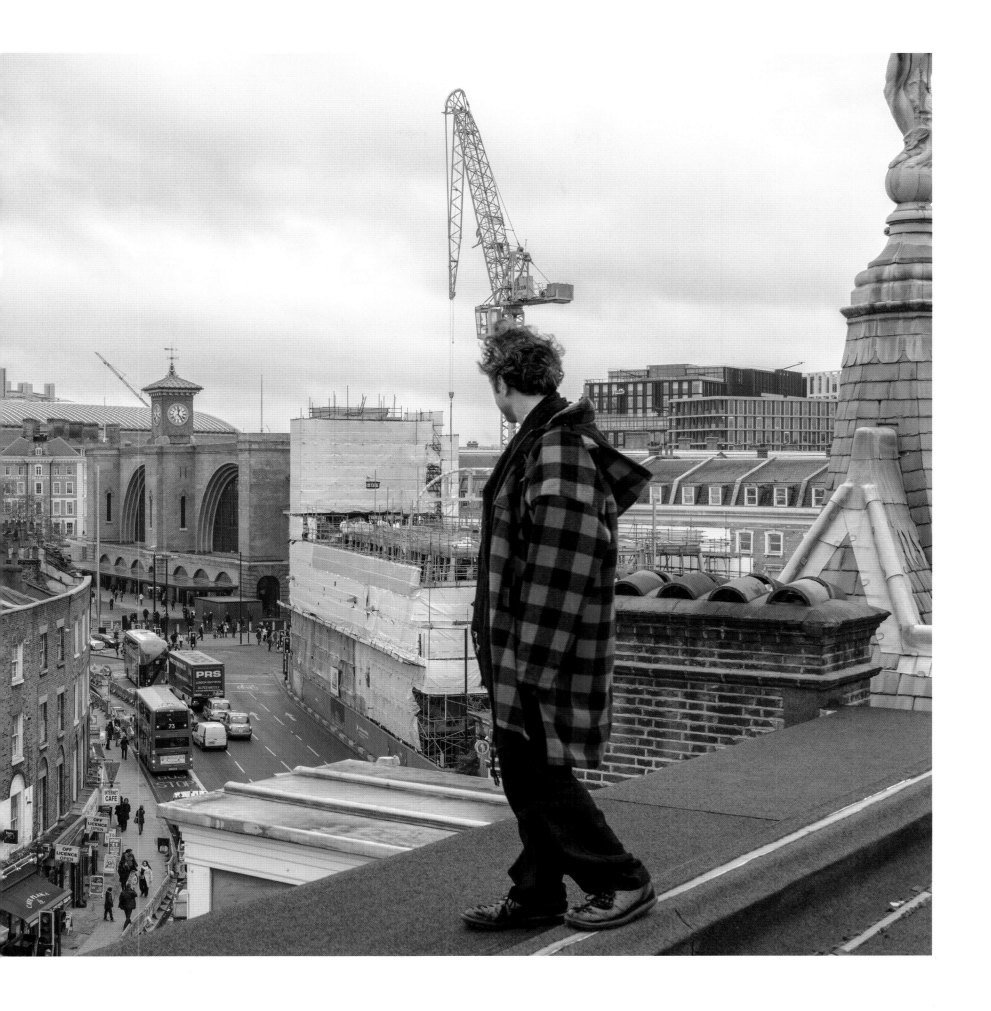

Heatherwick, with barely
a minute to spare, pauses
on the fire escape (above)
behind his bustling HQ.
The designer (left) visits
another studio/office
complex, where R&D is
carried out. His principal
studio (below), established
with fellow student Jonathan
Thomas in 1994, employs
160 international architects,
urban planners, designers
and strategic-development
specialists

(previous spread) Thomas
Heatherwick, on top of his
particular world, surveys
the transformation of King's
Cross. 'There is so much
possibility to make things
better everywhere,' he says.
The fast-changing area
was already populated in
Palaeolithic times; a thirty-
five-millennia-old hand axe
(now in the British Museum)
was found in excavations
beneath Gray's Inn Road,
where Heatherwick's main
studio is based. 'When
we read the papers, we're
interested in what the future
will be … The future is made
of ideas,' he muses. 'One
wonders what will remain
of the present period in five
hundred years from now'

As a child did you go looking for found objects to make things out of?
There used to be jumble sales in those days, and my grandfather had lived next to Inverness Street Market in Camden Town. He always bought things that he thought were interesting, even when they were broken or damaged. My mum used to collect lots of things, and I found myself drawn to physicality and craftsmanship. My mother also was involved in making things; to get to my parents' bedroom I had to walk through an enamelling workshop with quite toxic chemicals. So I suppose from the beginning I was questioning what a domestic environment should be like.

What did your father do?
His mother was a servant at Windsor Castle, and he was a very good pianist as a child; he won a big music prize, a sort of Young Musician of the Year, when he was fourteen. Music was a way for him to break out from an upbringing that was more limited. By joining the Royal Marines he could see the world, and he was also a talented boxer. My mother came from a more artistic background; her mother started the textile design studio of Marks & Spencer's in the 1950s. As to my father, I think music forces this incredible focus on excellence through practice, which is different than vast knowledge, so his influence on me was powerful because he was very good at challenging me and always throwing out new insight. It's frustrating as a child when your mother says, 'Well done! Wonderful drawing of a cat' and your father says, 'A cat doesn't look like that though, does it?' You know: 'Have another look; you're drawing your idea of a cat, you're not actually drawing what you see.' He's always done that for me and been someone who broadened my perspectives through lateral thought.

Given your family's creative genes, you had quite a heritage to live up to.
One thing I appreciated is that my family never asked me what I wanted to be when I grew up, and they never put any pressure; they just watched what I was interested in and supported that interest. If I was walking along the road and spending time thinking about cars, my father would, a week or so later, say, 'Why don't we go to the motor show at Olympia?' We'd go and *really* have a look at cars. He studied child development (he's got a Master's degree) so I'm his guinea pig. I was fortunate to have people who never treated me as a child; they treated me as an equal from the beginning.

Was that a contributing factor to your becoming empathetic with your environment? You want to serve rather than to shine, am I correct?
My grandfather was a Communist; he spent time going down the coalmines and felt a romantic attachment to the working man. But I've never been aware of any class judgement from my parents. My father was working-class, but his mind is forward-thinking and utopian. My mum had a shop on Portobello Road for twenty years with everyone coming in from crazy people on full-moon Fridays to Paul Smith when he was first starting out.

I'm trying to see the connection between this empathy with the common good, the bigger picture, the rights of man, if you will, and design for better living.
I've been influenced by people like Richard Rogers, the architect, and his humanistic line. It's something that's been growing more in me in recent years as we're getting chances to work on a more city scale. The chance to work on the London bus was thrilling because, as someone said the other day, the successful city is where rich people take public transport. That's when you know a city's working well. I love those moments when you're somewhere and there's a mix of everybody all together.

What project are you most proud of?
I couldn't say one thing that I'm more proud of – *proud* is a funny word. At the moment my mind is absorbed in trying to make an idea happen that isn't my idea, but that I believe in, which is for this new garden that connects north and south London. I love the levelling dimension of public space in a good city. The Garden Bridge project is an extension of social entrepreneurship.

Would you describe yourself as an environmental activist?
It's easy to blame the world for why things don't happen, so I've become interested in what it takes to make something happen. If you already have the view that the world ruins everything, then it will ruin everything. If we speak in two or three years, maybe I'll be bitter and twisted, but I'm trying to believe the best of us. I don't mind hard work, if that makes sense, and I don't know whether I'm a particularly good designer, but I know that I'm a determined person, and I know that to make things happen there's a determination level needed.

So your childhood bedroom in Wood Green is now a studio spread across several thousand square yards with 160 staff. How did that come to pass?
When I was studying, I was aware of the kinds of things that I was interested in and that my own lack of skill is that I couldn't do them by myself. I'm not a big social person, I'm not a mega leader, but I knew that I needed to work with people. So part of the process has been to invent an organisation and try to really be a team. I also was aware that I don't design by myself; it's through conversation that things come alive. The way we work is with reviews, so myself and the project team, we analyse, we look together, we push each other, we try and figure out what's wrong or what could be better, what's exciting, what needs testing or experimenting with. That's the true base of our work.

Heatherwick on St Chad's Place (above), where he frequently enjoys a meal. A derelict mechanic's workshop, the lively 06 St Chad's Place (colourful in the background) serves the local community daily from early to late and features live music events

Is this intense dialogue like a trial, a sort of baptism by fire?
Yeah. We've never done a project that was easy, because trying to push beyond the familiar tends to be a slightly painful process. In his little way my father did that with me when I was younger, pushed me to go beyond my comfort zone.

Wired **magazine has described your work almost like breathing out ideas. Does that description ring true?**
Everything has two scales to it. When you're thinking at city scale, there's a strategic, master-plan way of thinking, but that master plan means nothing if when you get up close it's dead and soulless and lacking meaning. So in all our projects it feels like you're having to step back to check that you've got the right philosophy for a project, but then also having to be able to zoom back to the smallest scale to give materiality and spirit somehow. That maybe sounds sentimental, but I feel strongly about that process. We do, as humans, run our hands along things if they interest us; we do end up holding a door handle and feeling whether it's cold or warm or fits into the ball of your hand or is interesting. I'm resistant to the idea of architectural environments being a collection of catalogue components put into a shape.

'The goal isn't to be big for the sake of being big; the goal is an excitement about making things better'

For how long have you been in your studio here in King's Cross?
I've been in King's Cross for fourteen years; before that I was in Camden Town for six years.

In that period, the transformation of London has been colossal, right? Particularly with King's Cross, which has been changed almost beyond recognition.
Back in the 1970s there were still bomb sites that would become car parks or just had hoardings round them, where they were left over from the war. As I came into adulthood you felt that those sites got used up and turned into buildings. I still find it funny that I was born only twenty-five years after the end of the war. It felt that you had to go to Paris or Barcelona to see a city daring to think of new heritage for itself. And there was a post-war licking of wounds happening in Britain. The post-war architecture was not really warmed to; it didn't quite work out.

Because the war sucked the life out of the country and the empire, essentially …
Yes, but then what got built was quite sterile and didn't actually make great places. There was fear of this thing called 'modernity' in city-making. We retreated into our heritage, and there was a strong thing about buildings having to be 'in keeping'. You'd go to Paris and see the Institut du Monde Arabe, which was people daring to think about culture going forwards in the built environment. It took a while for that to come back, for people to dare to build an office building in the shape of a gherkin or whatever, and the Shard and the London Eye, and to see the city as a thing that needs to be evolving, to see that new ideas can add a new sensitivity.

Known for his eccentric designs such as the UK Pavilion at Shanghai Expo 2010 and the Olympic cauldron for the 2012 London Games, Heatherwick also reimagined London's ubiquitous red buses (opposite) for the first time in fifty years. His inspiration: the world-famous Routemasters. 'However amazing your car is,' he says, 'you can't get a better view of London than at the top and front of a double-decker bus.' Heatherwick (left) at Temple on the Thames, the starting point for his proposed Garden Bridge. 'When I was seven or eight,' he remembers, 'I came to the river with our neighbours' little girl, who fell in and had to be rescued by my father.' The Thames has been a constant draw, finally leading him to design England's first river-spanning bridge with walkways and tree-filled gardens

Winter Blues

This City now doth, like a garment, wear
The beauty of the morning; silent, bare,
Ships, towers, domes, theatres, and temples lie
Open unto the fields, and to the sky …
from William Wordsworth, 'Composed upon Westminster Bridge,
September 3, 1802'

London's bridges, more than any of the city's other features, are representative benchmarks of its history. For six hundred years, London Bridge was the only throughway crossing the Thames in the city centre, until Swiss architect Charles Labeyle completed Westminster Bridge in 1750 (Putney Bridge had been built upstream in 1729). The idea of a bridge at Westminster, as ancient as political rivalries in the Houses of Parliament, had first been floated in 1644. Westminster Bridge was painted green to match the colour of the leather seats in the House of Commons; Lambeth Bridge, completed almost two hundred years later, was painted red to match the seats in the House of Lords.

Painted by Canaletto in 1746, Westminster Bridge was sagging under its political weight a century later, when it was redesigned in wrought iron by Thomas Page, with Gothic detailing by Charles Barry, the architect who designed the Palace of Westminster. Its completion set off a competitive flurry of bridge construction. The City of London, owners of London Bridge, expanded its thoroughfare while building Blackfriars Bridge, which opened in 1769. Spans at Battersea (1773) and Richmond (1777) followed.

London Bridge has been a constant thread in the weave of the capital's history. The current crossing opened to traffic in 1973, replacing a nineteenth-century stone-arched bridge, which had in turn superseded the medieval structure that had replaced various timber bridges dating back to the Romans' founding of Londinium in AD 47. Waterloo Bridge, seen here, a granite structure with nine arches each 120 feet tall, was designed by John Rennie and opened to toll traffic in 1817. Rebuilt in 1945, it is known as the Bridge of Sighs after an eighteenth-century poem by Thomas Hood about a prostitute's suicide. Sometimes called the 'Ladies' Bridge' because the workforce was reputedly all female during World War II, it was painted by both John Constable and Claude Monet, and was the only London bridge to be damaged in the Blitz. Tower Bridge, a late arrival in the bridging sweepstakes, was built in the late nineteenth century downstream from London Bridge, its faux medieval towers becoming the city's most recognisable symbol besides Big Ben.

The Thames has inspired some architectural madness over the years. In the 1800s Sir John Soane (who appears several times in these pages) proposed a triumphal bridge complete with a domed temple. Not to be outdone by history, the 1960s saw a proposal to build a multi-storey residential/pleasure bridge with its own skating rink and open-air theatre. It was French architect Antoine Grumbach who, as a competitive tease by the Royal Academy, first floated the idea of a garden bridge in 1996. Twenty years on, Thomas Heatherwick (also a denizen of these pages) won approval for just such a 'Hanging Gardens of Babylon' concept, to be built by the end of the decade.

Meanwhile the Thames itself has influenced every aspect of Londoners' lives. Apart from the threat of flooding, tamed in the 1970s with the construction of the Thames Barrier, the river has been to London what the Nile and Ganges have been to their respective cultures: a lifeline nurturing its populace by providing water, fish, eels and oysters, as well as passage to the seaways via the English Channel. London owes its longevity, its livelihood and a great deal of its character to its ever-flowing river.

Edmund de Waal
Artist/Author/Historian
West Norwood/Dulwich/Albertopolis

How would you describe the neighbourhood of West Norwood, where you have your studio?
Dull.

Is dull inspirational?
Dull is very good, because dull in a big factory next to a bus garage is about as anonymous as you can get. You can drive along a road and it's not here. So it's a place that you can absolutely escape to. You can open and close a door, and you can be wherever you want.

It's almost as if you need a Narnia cupboard to walk through.
A cupboard is a very interesting idea. Yes, you walk through a door and things change. It's all about thresholds, the liminal.

What form does your focus take while you're working?
Oh, it's a tunnel. I mean, it's all about movement isn't it? You move towards something. Whether or not you get there is not really important. Keeping moving is the significant thing. For instance, if you think spatially about the studio, I come in across this threshold, I can choose to go up into my library and write, or I can choose to make pots.

So when you exit this tunnel, you don't know which direction you're going in?
No.

And this happens every day?
Well, sometimes it does. Having said that, I have to finish a book to make an exhibition. What do I do? It's interesting for me (not for other people) because those things are hugely connected. Going upstairs, opening a book, beginning to write, beginning to look at things, beginning to try to trace a line of thinking in words. Or picking up clay, beginning to make something, beginning a line of thought which will end up in a vitrine.

To get to this tunnel of movement, do you take the bus, do you drive, or do you walk to work?
I live a mile and a half away, so when I can I walk with the dog or I cycle.

How important is the dog in your scheme of things?
Massively significant. The studio might be a white space, but it's not a minimal space. There's people coming and going all the time. You've got lots of conversation happening. Having a dog who's running around and meeting people, barking and needing walks, it's all part of the openness of normal life. It's not some hieratic, priestly, sacrosanct space. It's a real, living space.

With a dog yapping and a telephone snapping and people chatting, though, how do you manage to get any work done?
I'm very good at turning down the volume. This is partly about having children. But I can have lots of stuff happening around me and be able to write a book or make pots. And there are things that help you along the way. One is that I put on very, very loud music, Steve Reich or Philip Glass, and saturate the space with sound. The real thing is the training to be able to continue with your thinking no matter what's going on around you.

Let's go back to your childhood. Your father was Chancellor of Lincoln Cathedral and Dean of Canterbury. Is the sociology of religion embedded in the way that you exclude things from, or include them, in your work? I'm talking about method and discipline in spirit.
God, that's a tough question to be asked on a Friday morning! Genuine response is yes, it's very important. Actually, there's a real connection there between early experiences of church, of being around people who were involved in some kind of spiritual discipline, and my own path with clay.

What is it about clay in particular?
Well, clay does several things. It's grounding. It's about being on the Earth. Clay is the ur-material, the thing that defines you as a human being. It's the fact that you pick up clay and you make something out of it. But it's also the utter, ridiculous fragility of what you do. Nothing you do will survive. It will survive for a bit, but everything ends up as shards. Everything is broken. So you're involved in this art where everything is paused and poised, just for a bit intact in the world. You always end up, if you make things out of clay, like Job sitting on your pile of shards.

But the shards provide a reading of the history of humankind.
Exactly. Upstairs, there's all these twelfth-century broken bits of pot I found on a hillside in China. When you pick them up, you've got that pulse of someone else, eight hundred years ago, making something. And you've got the moment of fracture, the disruptive moment when something gets broken. And you've got this puzzle. You've got this extraordinary, dense, physical object which tells you something, but not everything, about what happened.

So you close your eyes and hold the piece of broken pottery and imagine?
Yes. You absolutely feel it. You know you can't get the whole thing.

You feel it? What do you mean?
Well, when you pick it up, you feel that this pot has been made very fast or very slowly. That it has taken attention, or if the person was thinking of something else. You can see how much it mattered to them. I've spent forty-five or fifty years making pots. You pick something up, you read it with your hands, you read it with your body.

You had, at age five, a key to the back door of the Deanery and managed to escape to some potter's shed where you swept up and did what was necessary to ingratiate yourself with the potter. Have you thought about how unusual that was for a small child?
Yes, I have. In some ways, you could say, why at five doesn't everyone want to be a potter? It's about play. It's about being in control of something and not being in control. It's about that wonderful moment of slipping in between, fluidity. You make something. And what is that about? It's about storytelling! You start to make a bowl and it ends up as a jug. And then the jug collapses and it's an ashtray for your mother.

(previous page) Edmund de Waal, splitting conceptual infinitives in several senses, looks through a Plexiglas vitrine containing some of his delicate porcelain vessels, of which only shadows are visible, leaving the viewer to imagine what the eye cannot make out

De Waal's studio in West Norwood (above) is a converted 1960s munitions warehouse which the artist had redesigned in 2013 by architects DSDHA into a light, airy space. A long-time Dulwich resident, De Waal could not imagine living anywhere else. 'Why would you be in any other city?' he asks. 'London is chaotic, febrile, utterly confusing and full of possibilities of encounter.' He discusses a day's work with his assistant (right) before disappearing into his self-contained workshop (opposite) to assess the fine details of his small trademark pieces

It's the story of everything, isn't it?
It's the story of all stories. You being somewhere else … you take it and it becomes something different. That's what clay does. It reads your thinking and how you pace what you're trying to say in different ways.

Surely that's not something you'd relate to young children, though.
Now, that's great at five, it's great when you're an adolescent, because you're trying to work out who you are and things keep changing. Then you have this great decision about how disciplined you want to be. You go into this long, dark tunnel of apprenticeship, and that takes however many years. You end up with skills with which you can then decide what kind of storytelling you want to be involved in.

Has your attitude towards clay changed over the years?
Of course. Clay changes all the time.

So, metaphorically speaking, clay matures in your hands?
Yes. If you choose to use a material, you don't decide at five and then that's that. You're in step with this process of self-discovery.

Who makes the decisions, you or the clay?
Well, that's the biblical question! I don't know, is the answer.

Do you think you are going to last longer than your work or the other way round?
Oh, I'll be gone. But what will happen is that there will be shards. And that, you see, is quite liberating. As an artist it's liberating because it's what you're trying to do. I do this ridiculous art form which is that I make things. And, even more ridiculously, I put them out and I say, 'That's my poem. That's how I want it to be. I want it to be in this particular frame, this particular vitrine. I want them to be in that order. I want them to have that kind of energy in those gaps. And I want this colour here.' But you know what? Some pots will be broken. They'll be moved. The collector who's just bought it might not like it. It will disappear, it will come back, and it will fall apart. That's absolutely fine.

You don't mind if the whole thing falls apart or breaks?
I don't mind, because the moment it leaves the studio, things change.

So you're not invested in ownership?
I'm not.

Looking closely at some of your work makes me think of music.
Good. Lots of things come out of scores and notation. I do this whole thing which very much came out of Bach, endlessly.

Are you good at maths?
No, I'm hopeless.

So this is your maths?
Yes. Scoring is one thing. It's intervals and repetitions. But there's also a lot of words, phrases and picking up of syllables.

Do they need interpretation?
No! Sod interpretation!

But that's what everyone in art does!
That's fine. I really don't care. I do quite a lot of reading and quite a lot of writing.

How many hours a day reading?
How long is the day?

I mean, you've got a dog, you've got children, you've got a wife, you've got pottery …
Yes, but I also have 3.00 in the morning when I'm reading books.

When do you sleep?
The next decade I'll sleep. That's fine.

Still, the interpretation thing is important given the immense intellectual and spiritual investment in time and effort, no?
You know, the interpretation thing is important because you give something you've made a name. The name, the title, is part of the poem. It's sometimes helpful and sometimes distracting. Sometimes it's a joke.

'You move towards something. Whether or not you get there is not really important. Keeping moving is the significant thing'

De Waal was a frequent visitor to the Victoria and Albert Museum (above) from an early age, taking inspiration from its ceramics collections, which are among the world's best. These days he acts as a V&A trustee, having created his own porcelain installation inside the building's dome. De Waal also frequents the National Art Library (right), which holds over a million items. The V&A, whose foundation stone was laid by Queen Victoria in 1899, is the world's leading craft and design museum, custodian to two thousand years' worth of art in virtually all media and from around the globe

Is the creation adopted, or is it a natural child? Because you mentioned things changing once a piece leaves your domain …
That's a good question. I don't know. If I was over-identified with all the things that I had done, I would spend my life anxious about all these children. As it is already, I have too many people trying to ask me stuff about what I have done. You make a child and the child walks off down the road. Of course, you're concerned because it's your child. But at a certain moment your child has to have its own life. You absolutely have to let go in order to have the room to make the next thing, to take that line of thought somewhere else.

You grew up in a well-to-do, left-wing, *Guardian*-reading, Anglican family. Is that the sort of upbringing that you can ever escape from?
No, never.

How did this environment affect or train your mind?
Lots and lots of argument all the time. Argumentative brothers, argumentative parents.

And from a potter you have become a celebrity. How has *that* affected you?
Well, it's ridiculous. I mean it's such a joke. A celebrity potter? Have you ever heard of such a thing?

But you're one of these guys with the big names and people chase you around. They do programmes about you on BBC and all that stuff.
Look, what it does is two things. It means that the projects that you really want to do have more chance of happening. You have more agency in the world. There were many decades of not getting published or not doing the projects that I wanted to do, so now that's great. I enjoy it.

What sustained you through these years? You weren't a starving artist exactly, or were you?
Actually I was for quite a long time. What sustains you is, you enjoy what you're doing. How good is it when you know what you want to do, and do it? That's an incredible privilege. You may not get paid for it, but come on! Paying for it is way down the line.

So, we have two naturally ordained disciples, Discipline and Passion. Is there any relationship between the passion of creativity and the discipline of religious faith?
The creative passion, the elemental passion, the absolute passion, is making something. When you make something yourself, you make something of the world around you change a little bit. What you do by making something with passion is, you're taking a bet on something. That's not insignificant.

Let's talk about inspiration. It's been said that a dinner conversation led to you writing your best-selling book, *The Hare with the Amber Eyes*. That can't be true, can it?
Well, of course I wanted to do it. The line between telling someone a story and then deciding to actually write it is an interesting one.

How long was the line in this instance?
That process was seven years, from dinner party to publication.

In writing a book, you can use language as a metaphor. Can you talk about the translation of language or thinking into a clay pot?
The only thing more simple than the word is a vessel. A vessel is something with an interior space. And each of those things, the word and a vessel, is a breath. When you're making something, you're making an internal space. It's pretty good to have a life to try and work out what that means. You can turn that into poems, you can turn it into installations, you can turn it into books, you can turn it into huge things in museums. But at the same time it's also, absolutely, just a pot and just a word.

De Waal (above), in the company of Julius Bryant, the V&A's Keeper of Word & Image, looks over an illuminated seventeenth-century Persian manuscript. 'I think of this room as the end of the line,' Bryant says of his office lined with priceless, ageless books. 'All the turmoil from revolutions to the ransacking of castles, monasteries and abbeys in Europe have ended up here.' Bryant likes to think of the room's contents (left) as 'an intellectual salvage' of European culture. 'Choosing a favourite book is like choosing a favourite child,' he confesses

DSDHA
Architects

Edmund de Waal's friends and collaborators David Hills and Deborah Saunt are the two halves of architecture firm DSDHA. The firm has recently been awarded projects for redevelopment in the West End, the aim being to upgrade the streets around the Royal Albert Hall and to transform the streetscape and create new parks around Tottenham Court Road, Gower Street, Euston Road and Shaftesbury Avenue. The intention is to cut back traffic and congestion and create wider pavements, cycle lanes and pedestrian crossing areas. Named by *The Times* as one of 'the new generation of architects', DSDHA was named Richard Feilden Architect of the Year in 2010.

'Modernism loves a stack. For us that's anathema,' explains Deborah, giving a clear indication of the breakaway quality of the firm's work. 'Too much architecture is self-referential; a more diverse range of people being involved in making it would improve the process and the end result.' About historic conservation and its effect on London's cityscape, she observes, 'It's an interesting dynamic. If you're naïve, you think it means, as a designer, 'Just keep everything the same.' But actually it's a way of making you interrogate the context as a designer, so you use it as a starting point for something new. We're well known for going into places like Mayfair on South Molton Street, looking down towards Claridges, making a new building that's incredibly modern.' The 'phallic'

towers being thrown up by developers all around the capital evoke a very different ethos for Deborah: 'A tower is a different typology to what you would find in a conservation area. So the City of London might have a historic grain, but it has also built a contemporary international centre. There are multiple readings you can make of that part of the city. If you go to Westminster, it has a limit of height, which does preserve a certain quality, in which case the conversations are about depth of façade. A lot of the time when buildings don't fit, they don't have that level of articulation.' Deborah also believes that the towers are, as she puts it, 'political instruments, because they are there to express the power of the mayor of the moment ... Height, scale, international global span – they want London to be a world city.' The downsides of this approach are obvious to both her and David. 'It's a real shame in the City of London that they've let this kind of riot happen,' he says. 'They have imported a modern city into the historic fabric and it's not done with great delicacy.'

On the vexed subject of London's multiculturalism, Deborah is clear in her thinking. 'You can't have a city without the notion of exchange,' she insists. 'People come together to do business, to share beliefs and culture, and that's what happens in London. So it's very tolerant, very diverse and welcoming.'

Edmund de Waal (opposite) with Deborah Saunt and David Hills, founders of DSDHA. The avant-garde duo are long-time friends of the artist, and designed both his previous and his present London studios. Known for their urbanism, DSDHA are responsible for redrawing city-renewal plans for Albertopolis and the Shaftesbury Avenue area. Saunt (right) with Hills, her partner in life and business (top right), at their 'concrete cottage', which they designed and built from scratch on a garden plot in Clapham. Known as Covert House or (to locals) the Bunker, the building has been the subject of national attention in architectural and design circles. The duo (far right) in their Vauxhall studio

Clara Farmer
Publishing Director

Edmund de Waal's editor Clara Farmer is Publishing Director of Chatto & Windus, an imprint of the Penguin Random House conglomerate. Her first year in charge saw the highest turnover in the imprint's 156-year history.

Having begun her career at Puffin in the children's book department, Clara then moved over to history, going on to co-conceptualise the Hogarth Shakespeare initiative, which commissions contemporary authors to retell Shakespeare's plays. Calling De Waal 'this most miraculous of writers,' she believes that his new book, *The White Book: A Journey through Porcelain*, will be his magnum opus.

Speaking about the publishing processes she oversees, Clara explains that 'anybody can bring an idea to the table, anyone can find an interesting writer … You don't have to be in a position of seniority for that … Everyone starts at the coalface, everyone learns how to make a book, everybody does their time. You work your way up the ladder ... You don't really get people who just arrive and are instantly publishing books. You need a deep understanding of the whole process.' She emphasises the importance of mentoring, saying, 'If you're lucky enough to have people who give you an opportunity or want to spend time teaching you things, who want to encourage you to edit books and engage with the writers and offer your ideas, you always have to be willing to do more than the job

description.' When asked about current corporate preoccupations with the bottom line, she replies, 'If you do cynical publishing, it's harder to sustain an ongoing life.'

Clara 'discovered' De Waal when she read a review of one of his exhibitions by biographer Fiona MacCarthy. The review mentioned that he was writing a memoir. Clara sent the potter an email, they met up for a cup of tea, and the rest is history. 'I suppose I wasn't creative,' she says modestly, 'but I poked a stick. I said, "Come on, you should do it!"' Of the author/editor relationship, she observes that each one is different: 'It depends what the writer needs from you. You're there to support them and help them. With Edmund, for instance … he knows the story he wants to tell; he knows the message he needs to get across about his relationship with porcelain. I was telling him that that message still needed to come through more clearly and asking him to explain what he wanted to say. So we try to find a way to unlock something to enable the writer to fully express what they need to say. I'm not necessarily with Edmund changing a line. We're talking about the voice, the mood, the energy in which something is told. For other writers who are less experienced than Edmund, say, or who want more help, we will do more work on the line. But Edmund has such a poetic style. He has his voice now.'

Clara Farmer (opposite) at her old desk in her office at Penguin Random House near Vauxhall. 'There is a ridiculous rumour that Virginia and Leonard Woolf, who ran the Hogarth Press in the 1930s, sat at this desk,' she explains. It was Farmer who 'discovered' Edmund de Waal and published his 2010 international bestselling autobiography (left), *The Hare with Amber Eyes*. Farmer (above) is a frequent visitor to one of London's quaintest independent bookshops, John Sandoe in Chelsea. The three floors of the eighteenth-century building are packed with twenty-five thousand books, from mass-market to out-of-print titles

Romilly Saumarez Smith
Jewellery designer

Now primarily a jewellery designer, Romilly Saumarez Smith approaches design across the board powered by a unique aesthetic. She and her husband Charles, who is Chief Executive of the Royal Academy of Arts, are old friends of Edmund de Waal. In 2013 Romilly worked with the potter on *Newfoundland*, a project that paired her jewellery and fragments of Roman and medieval metalwork with his pots. 'Romilly made an extraordinary body of work,' De Waal recalls, 'and we installed the jewellery as an installation. So you could hold it and pick it up. It was a journey through the space.'

Romilly co-founded the company Savage & Chong, which she runs from her house in Mile End. MS prevents her from making items herself, so she hires assistants to help execute her vision. 'Being brought up as a craftsperson, I was always thinking that you must make it yourself, but I understand now that the idea is the absolute crux of the whole piece,' she says. She and Charles bought their then-'derelict' house in 2000, having previously lived in Limehouse. Charles having encountered an acquaintance in Sainsbury's who had just moved to the Mile End Road, Romilly said that she couldn't imagine doing the same thing. Her mind was changed once she saw the space in question. 'The next day,' she remembers, 'I started negotiations with the Spitalfields Trust, who were handling the houses,

and after quite a long period, we got it … We had to do everything, which makes everything sort of perfect, really.' Responsibilities were shared during the renovation: 'I'm the person in the family who's very good at colour, and I love the way colours sing against each other, but he's very good at hanging pictures so I would defer to him.'

'It took me a long time after I got MS to be able to accept that I could work again through someone else,' Romilly says. 'The positive sides are that I've learned to enjoy working collaboratively, which I never did before. The other thing is, my head is full of my work all the time. I don't have to do anything else. I don't have to cook, buy food, clean the house. I get looked after twenty-four hours a day and I think about my work. I used to be very private in my work, and I was rather nervous of other people seeing what I was doing … Now I have no privacy at all except for total privacy in my head.' Interestingly, she adds, 'I don't think my work would have become what it is without what's happened to me. There are times when it's difficult and there are things I can't do, but I'm happy.' In praise of their collaboration, Edmund adds, 'There was a generosity in the conversation about how we work which was fantastic. Working with someone can be appalling, it can end friendships, but it was just glorious.'

Romilly Saumarez Smith
(opposite) by a window
of the Mile End home she
shares with her husband
Charles, Secretary and Chief
Executive of the Royal
Academy. The pair bought
the then derelict house in
2000 and have rebuilt it from
the ground up, transforming
it into a showcase for smart
East End living. 'It was an
artistic endeavour for us,'
she says of the refurb. Her
office (above) and drawing
room (right) present the
understated aesthetic for
which the creative jeweller
and bookbinder is known.
Saumarez Smith, who has MS,
chats with Edmund de Waal,
a family friend (top right)

The potter with Man's Best
Friend on a winter afternoon
in Dulwich Village: Edmund
de Waal walks Isla, his Grand
Basset Griffon Vendéen.
A picturesque reminder of
outer London's eighteenth-
and nineteenth-century
village life, Dulwich is known
for its 'rose cottages' dating
back to the 1920s. The mostly
bourgeois residents are
able to enjoy the Dulwich
Picture Gallery, the world's
first purpose-built public
gallery and one of London's
most highly regarded
arts institutions, on their
doorstep. Founded by Sir
Francis Bourgeois in 1811,
the gallery was designed
by Sir John Soane 'for the
inspection of public art'

Beeban Kidron
Film director/Founder, FILMCLUB
Islington

Since when have you lived in Islington?
Oh, about ten years now. Before that, Camden; before that, near Oxford Street; before that, New York; before that, LA. And before that, Camden. I'm a north Londoner. In fact, one of the things that I love about London is that south London is a foreign trip for me.

Why is that?
I don't know. Although there are connotations of different parts.

What do you mean?
Well, north London contains a liberal, arty, lovey persona, yeah? Although actually this borough is one of the poorest areas in the UK, as well as one of the richest. This is very evocative of London, the high and the low. What I was going to say about south and north is that the certainty that the river is going to be felt throughout the city is very important. That whatever the developers do, whatever the cultural community try and do, whatever history brings, there is something about the Thames that is determining. One of my favourite places is Waterloo Bridge. I like it when you can see both sides.

On which side do you put yourself politically?
That's a difficult question to answer straightforwardly because the division is not left and right. The division is rich and poor, entitled and left out. The other thing is that I'm a middle-class person who believes in class politics. I do not accept the idea that we live in a classless world. That's one of the lies of the last ten to twenty years. Class is more pronounced rather than less.

But in the '60s the class barriers came down …
Yes, but social mobility is at an all-time low; you can see that in London. That there are extremes. That there is an uber-rich class. There's a huge transfer of security, money, jobs … A lot of benefits are going from the poor to the rich.

What's the relationship between social mobility and creativity?
In the context of creativity, we have a problem about bringing fees into further education. What happens to creative industries which are by definition insecure and unknown? As a young person, you have to have remarkable confidence to suggest you're going to be able to make a living as, say, a writer. Writers get £5,000 a year on average in the UK. So, to put a financial barrier and say to someone, 'You're going to carry a debt of £50,000 into your future, but you can also be an artist' is a barrier to social mobility in the creative industries.

But isn't the model of free higher education wearing thin in the West?
That is just a random example. It is interesting that we have subsidised French and Chinese energy companies to provide our nuclear future, to the tune of billions of pounds. You tell me whether we're making the right choices. I don't think the model is broken. I think that the ideology has been shifted.

(previous spread) Baroness Kidron, bathed in sombre winter light, in the courtyard of the offices of her company Cross Street Films, next door to her Islington home. 'One of the things I love about London is, when the sun comes out, to watch the way bodies unfold,' she muses

Kidron (right) checks her laptop; the shelves are lined with files for projects she has filmed, as well as ideas biding their time. 'What defines human beings is to be able to make something out of nothing, to do the unnecessary because it is necessary,' she reflects. A social and political activist, Kidron is passionate about issues like immigration, social housing and her Islington neighbourhood, of which she says, 'You know every person in each house.' The director of *Bridget Jones: The Edge of Reason* (opposite) outside the King's Head Theatre Pub, which dates from Shakespearean times. Kidron (below) walks past the oldest taxidermy shop in London, appropriately called Get Stuffed, and (bottom) is tempted to 'get stuffed' herself in Paul Young's award-winning chocolate shop in Camden Passage

The fact that arts education is not free means that a lot of it is taken up by rich kids and foreigners now.
I hold nothing against rich kids or foreigners. But if you looked at our current crop of artists, designers, architects, film-makers etc and took out everyone who's not rich or foreign, it would be a travesty. Some of the best people crossed a social boundary, but it won't happen in the future. We left a job unfinished, which was to allow a broader group of people access, in deliberate and accidental ways, to the industry. We have an under-representation according to gender, class, colour, language etc in the country as a whole. We have not finished the job of integrating people, and now we put up barriers to keep them out. The point is that the direction of travel is wrong. It's not that some people won't leap. Some people always leap.

Would you have it that arts education should be free and other disciplines should be fee-paying, then?
No. I disagree with your assertion that it can't be free. It can be. And it should be. And it must be, for all.

Limited resources need prioritised distribution, even in education?
I don't recognise disciplines in binary opposition to each other. Interdisciplinary education is what we need. All of us need a broader technical understanding about how things can be made and distributed and consumed. In a world that is about artificial intelligence and the Internet and so on, it would be ludicrous to privilege arts education over science or science over art. Or creativity over history. If we don't understand our history, we don't understand anything. And if artists privilege art, not only do they seem ludicrous but they also miss out on the totality available to them.

But art is the privilege of the élite, the rich. Even the artists who populate London's art scene are members of the élite. Why would one not ask, say, Damien Hirst, who makes £X hundred million, to create a foundation to give something back?
Well, he should. That's a different question. You were asking about the position of the state.

But the state is made up of the people.

Absolutely. The thing is that everything is inter-related. Should we have more punitive tax on the super-wealthy? Probably. I do not want Damien Hirst to be individually responsible for whether some kid in northern Wales gets an arts education.

Isn't there a distinction between utility, the practicality of everyday living, and the need to spread finite resources, which may or may not nurture quantifiable talent?

I am amazed at this conversation, do you know why? Think about what is distinct about human beings. It is our desire and determination to take things beyond utility, using creativity, using beauty. How dare anyone suggest that we should not include, or require access for, any living human to that? Once you've got something on your plate to eat, there is the question of how you will cook it to make it delicious. People in the art world should think about it from that perspective, not from an individual talent perspective.

What about the role of the Internet in all of this?

It is the organising technology of our society. Neither the creative nor the education nor the political community has quite grasped the structural obstacles, problems, opportunities, benefits etc. We're behind the curve. My particular thing is I talk about the Internet and young people, and I do that for a couple of reasons. One is that young people know nothing else, so the issues are very pertinent around them. They don't have Old World skills and thinking. The other thing is we have a duty of care to young people.

To regulate and control new media?

A lot of the language of now is represented in digital, web-based technology, and I am concerned about two things. One is that if you leave it to engineers and you don't have the creative people in there, we will get the wrong technology. The second thing is that creative people do not understand the rhythm of science behind some of the opportunities that exist. I want to make a utilitarian point here, which is that everybody is a photographer, a publisher, a graphic designer, a writer. So, many of the things that we have held on to as markers against our creativity have been pushed to the lowest common denominator *or* are democratising forces of creativity. The battle for the creative community is to make damned sure that it is the democratising force, not the lowest common denominator, because it has the potential to be.

But it is, very evidently. With the loss of language skills, writing is a lost art.

Is it? And if it is, does it need to be? This is the front line of debates around creativity. It requires the artistic community to be engaged. There's a lot of our community where you start talking about the Internet and they think it's a Twitter feed. They do not understand either the full glory or the full implication of what's going on around us.

Leaving politics aside, can you say something about your own personal journey?

Neither of my parents, one of whom came from South Africa via Israel to England, and the other of whom came as a war baby, talked about their history. My father had a huge disappointment that Israel was not going to be a socialist state, so he made his world here. But much of his history is lost to me. My mother's parents lost much of their family during the war. In fact, her one cousin who was in a concentration camp always said, 'We have to assimilate so that it should never happen again.' So on the one hand I have this radical socialist father, and on the other side I have, also Jewish, this other family who are very, very tentative. Both my parents were ardent atheists, so it wasn't a religious question. It was a cultural question. They both left behind their religious heritage and they both left behind their country. They were middle-class, radical Londoners, and that was the world in which I was brought up. The absence of what they inherited is a certain sort of silence. It's only now that I can articulate what I think was in that silence. I don't think I even knew I was Jewish until I was well into my early teens. No-one was hiding it. It just wasn't up for discussion.

In light of your background and experience, personal and professional, how do you imagine London will be a quarter century from now?

Do you know, I got immediately upset when you said that. I see 'The Jetsons' (I don't know if you understand that reference), with automated cars and toasters that pop up – that vision of a world to serve our material needs and not our spiritual needs. And the other reference that came immediately into my head was that it would be like *The Beach*, or like *Brave New World*. My fear is that the growth/profit/transfer/consumerist vision that we are in, the vision of global capitalism … we're in the last piece of the rocket of that. And it's a pretty nasty vision. My more optimistic and passionate self says we will say no to it and look for a more sustainable and inclusive future. That is the challenge for the next generation. We actually do want a collective world. We do want a beautiful world. We do want a world that entertains and grows us. That will be the next era.

'Think about what is distinct about human beings. It is our desire and determination to take things beyond utility, using creativity, using beauty'

Beeban Kidron

Kidron is the founder of FILMCLUB, an organisation running weekly film screenings for a quarter of a million children. 'It's about community,' she explains as she walks past the hundred-year-old Screen on the Green on Upper Street in Islington. 'This is an indy cinema; it's really important that they exist'

Idris Khan & Annie Morris
Artists
Stoke Newington/Islington/Bloomsbury

What really distinguishes London's neighbourhoods, Idris? What determines that this is Stoke Newington as opposed to Islington, for example?

IK: I don't think it's a social divide. Islington's a borough that's definitely become more gentrified, more middle-class. But it wasn't when I first moved to Islington in 2002. It was very much an area that was changing. Islington was always an area where a lot of writers were, and artists …

The Bloomsbury of the twentieth century.

IK: Yeah. Now house prices have become ridiculous. London Fields has become much more gentrified. Now that's being pushed more towards Clapton. We always feel that artists actually create an area.
AM: You see pink hair and you know that's where you want to be.
IK: Kingsland Road really creates the shift between East London and Islington. Kingsland Road was always called Murder Mile, and it's not any more. Dalston is super-trendy.

Annie, where were you were born in London?

AM: I grew up in Chelsea, which was not like it is now, also. It was always a really beautiful area. There is such history there.
IK: Kings Road, the '60s, '70s …
AM: When I was fourteen, maybe even younger, around eleven, I had a stall on Portobello Road with my friend, which was a lot of fun, selling my parents' stuff, these really nice things … I would say, 'Oh, you don't need that and you don't need that.' People would bargain me down …

And your dad would come and scream, 'That was a so-and-so that cost a –

AM: – a fortune!'

Idris, are you a Londoner?

IK: I don't know what I am, actually. Yeah, I would probably class myself as a Londoner. I mean, I've been here twelve years now.

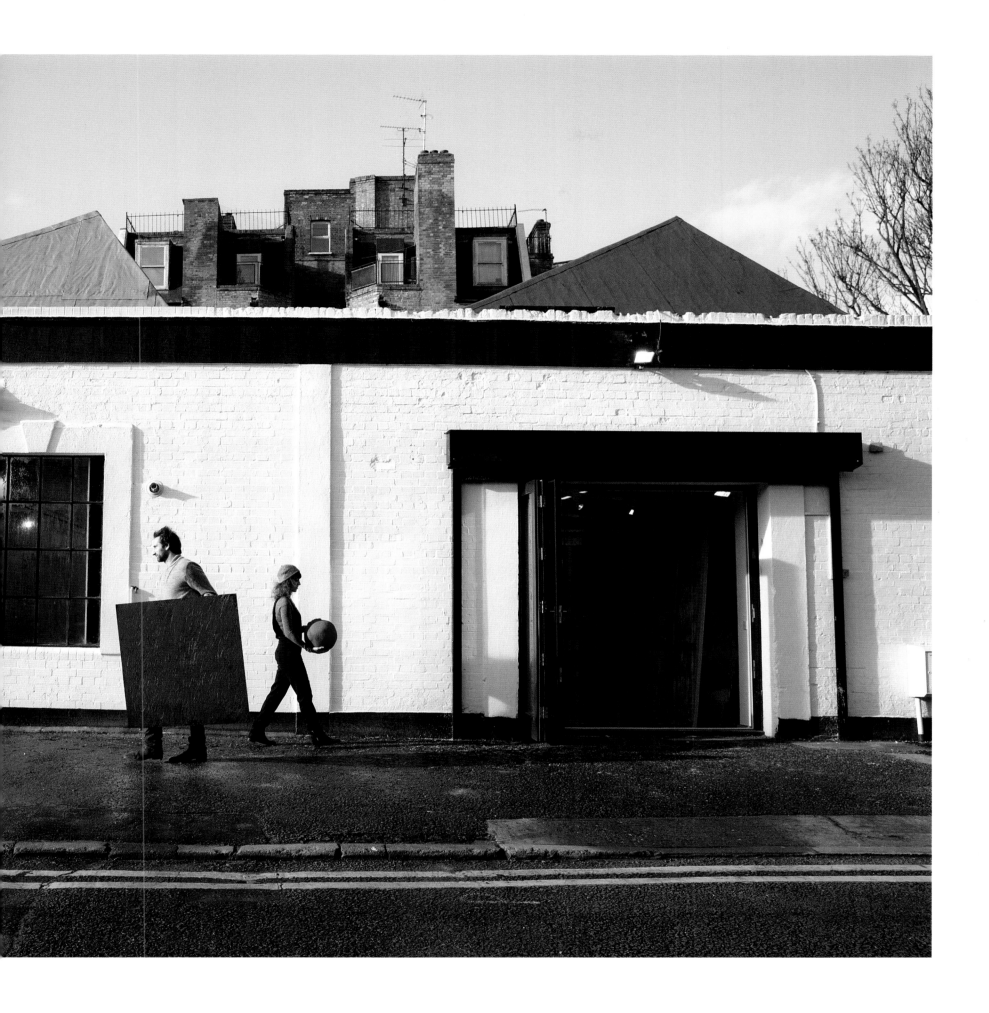

(previous spread) Husband and wife at an artistic crossroads: Idris Khan and Annie Morris outside their adjoining studios in Stoke Newington. 'We bought the studio for Annie from a lovely lady who made hummus for Harrods!' Khan explains

'We always feel that artists actually create an area … You see pink hair and you know that's where you want to be'

And you were born where?

IK: I was born just outside of Birmingham. There was no real cultural relevance there at all, in terms of art. Annie had everything on her doorstop. I'm not talking about the middle class, just about what's available to you in a city.

Where were your parents from?

IK: My father came from Pakistan and my mother was Welsh. They met in Cardiff.

And what's your background, Annie?

AM: My father's a businessman. My mother's …

… well-off, we could say.

AM: Yeah, and my brother's unbelievably clever. He was at Oxford; he was the Creative Manager of the Old Vic. He started there when he was twenty. So I grew up with a lot of creativity, in the sense that my godfather was Israel Horovitz, the playwright. My mother used to work in the theatre with him.

You are from a Jewish family, then.

AM: Yes.

So you two have the perfect relationship …

IK: Perfect. The wedding was very –

AM: We were married by Israel Horovitz!

IK: We were married by a faux rabbi, and my father was the faux mullah at our wedding.

What I'm trying to get at is the core of what makes this city or undoes it, if you will. This mixture of everything and everybody …

AM: But of course, Idris and I have art in common.

IK: I think that's what brought us together.

But art doesn't make you live together and have children.

AM: It's such a strong connection to have though.

IK: It's a starting point. Creativity is the starting point. It's the understanding. I don't think necessarily we make Islamic art or Jewish art. I've always said that my work has to stem from somewhere and you can't ignore your upbringing.

Well, why would you ignore it?

IK: It's not about ignoring, but I'd like to make a comment on it. I still have that ideology available to me, to make connections with.

I'm intrigued that you used the word *ideology*.

IK: Yeah, because it's something I understood from a very young age. But it's a difficult thing to express. It's not like I am a practising Muslim. Annie's not a practising Jew. We still do the holidays – something fun, it brings families together – but it's not like you are really brought up in that way, to understand that culture. You didn't always surround yourself with Jewish people, did you, Annie?

AM: No. I went to Westminster School, where there was no Jewish …

IK: You didn't go to Jewish schools, and I didn't go to Islamic schools. I think it's different now.

AM: I was pretty much the only Jewish student, maybe one other –

IK: And can I just say how outstanding that is? Because when a girl gets into Westminster, it can only happen in sixth form. It was her creative talent that got her in.

AM: On the subject of Westminster, because it was something spectacular, I would wake up and go to Westminster Abbey every morning. It was pretty amazing …

IK: … to see that. We have kids now, and we're in London. I look at their upbringing and future here and the things they're surrounded by. It's something that's unique to England.

AM: To London.

So, Idris, you made the pilgrimage to London …

IK: Yeah. I left Birmingham when I was eighteen and went up to Derby. People outside of London always see it as this massive metropolis; it's a difficult place to get into. London is great if you're doing really well, but it's a struggle if you're not. So it was always me thinking London was this place that's so far away. I never had the courage to apply to a London art school when I was eighteen, nineteen. So I went to Derby and studied Photography, and then all the tutors there said, 'You got this. Try at the Royal College.' I had a year out, and then I came to the Royal College, and that absolutely changed everything.

Did it change your own psychology?

IK: Absolutely. When I came to the Royal College there weren't many people from outside of London taken into the course. It was amazing to me to go to openings. Really as basic as that. You would open your eyes to this trendy East London world. You always used to go to the Vyner Street Gallery; now that's not really happening any more. You know, modern art came to town … It was so cool to see. I felt like I was in something for the very first time. It sort of opened my eyes.

Annie, when you were growing up, did you get the chance to go to galleries?

AM: I did a lot of that, a lot of staring at vitrines. I met an artist when I was about thirteen or fourteen called Ann Stokes, who was a potter. She lived in Hampstead. She was really important to me in the sense that she was so creative. She was self-taught. I used to spend a lot of time at her house. She taught me pottery, to make things.

IK: She was a very old-school artist, very Bloomsbury Group-esque.

Where did the spark of art come from in your case, Annie?

AM: I used to always make things. My concentration was a bit lacking; I had it when I was drawing or painting. From such an early age, I always wanted to do that. I used to leave drawings and paintings outside my parents' room, and they would wake up and look at them. I would spend hours drawing; my brother would always be reading. At the school I went to before Westminster, the art teacher took me under her wing. She told me that I shouldn't do any of the sciences, which I wasn't so good at, and just focus.

Khan and Morris at their Angel home (left); the house dates to 1760. 'It was actually a squat for twenty-five years,' Morris grimaces. The couple and their children, Maude and Jago (below), feed the ducks on New River Walk, a scenic manmade waterway in Islington from the early seventeenth century. In their studios, the duo (opposite) prepare for shows of their starkly differing oeuvres. Morris draws inspiration from such artists as Louise Bourgeois and Picasso, while Khan looks to figures like Mark Rothko and Richard Serra, incorporating his own writings inspired by Friedrich Nietzsche

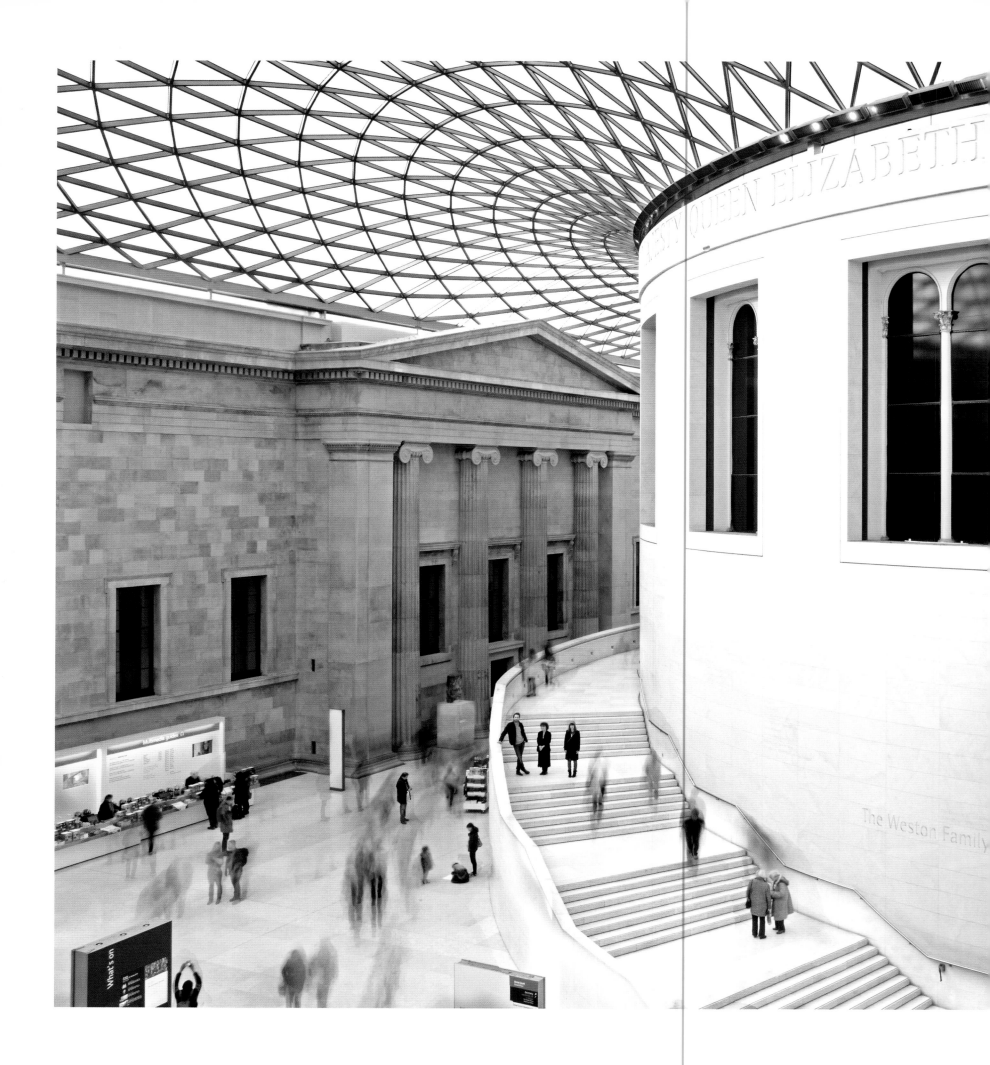

Idris Khan & Annie Morris

Teaching is so critical, isn't it? Somebody along the line picks you out …
AM: It's so important. When you find a teacher that nurtures you and sees something in you, you suddenly feel the way they see you.

And later you went to the Ecole des Beaux-Arts in Paris.
AM: I did. I started at Central St Martins. I wanted to go to Paris. I loved the idea of learning French. The school was so fantastic. But then I came back and went to the Slade.
IK: Actually if you don't go through art education in London, it's very hard to get back in afterwards. You finish at the Royal College, your work is out there.

Do you regret choosing Paris, Annie?
AM: I regret it a little. But I'm happy to speak French. It's cool to go to Paris when you're young.

So you're from different backgrounds, different cities. Do you influence each other's work?
AM: Yes.
IK: Actions speak louder than words. When I first met Annie, I was doing only photography. Since I met Annie, I've made sculptures, I've made paintings. I'm drawing now. It can't be an accident.

Let go back to the geopolitical lineage of your work, Idris. Today, the bulk, if not the vast majority, of the West believe that the Koran is the instrument of an indentured teaching of Islam. But you treat it in a benevolent, non-involved manner. You almost could be doing Shakespeare. Is that how you see it?
IK: I've never set out to make a political piece. I never say that I'm a political artist. The very nature of making something, of creating a piece of art, is to put it in front of viewers for people to then question their own political motives. So if I make a piece of work with Arabic and English on top of each other, it's poetic, it's beautiful; there is a translation there between English and Arabic, meeting them together. You might say, 'Actually, there is a political motive.' I don't think there is. But the fact that you're talking about a piece being political makes it political. So.

Do you believe that art as practised by people like yourselves can act as a means of discourse that transcends cultural differences?
AM: Maybe by seeing some beauty in a religion that is not violent.

Idris, if you were back in Pakistan, you'd be stabbed, quartered, shot in the face and anything else.
IK: I don't know whether I actually am doing anything sacrilegious by using Arabic and layering. I'm not making imagery from the Koran.

If I may push this angle a bit, I want to mix it in with what we were talking about earlier with Annie. Annie, would Idris's work resonate against your learned Jewish family background? How is it received in your extended family circle?
AM: That circle is very entwined in art. So it's seen in a more poetic, less aggressive, less political way.
IK: Can I step in? Are you asking if Jewish people collect my work?

I'm asking how it is received.
IK: I have so many Jewish collectors, it's unbelievable. Will they buy my Arabic works? I'm not sure. There is some way in which some people probably wouldn't want them on their wall. But it doesn't matter. It's not about the creator, it's not about the artist, it's about having an empathy towards a piece of work.

The British Museum is one of London's principal cultural and touristic draws. Opened to the public in 1753 by an Act of Parliament, the museum is an apparently endless repository of art and artefacts from earliest times to the present. Khan and Morris, frequent visitors, in the Great Court (left) among the crowds, alongside curator Venetia Porter, who commissioned Khan to create his installation *Seven Times* as part of the 2012 exhibition *Hajj: Journey to the Heart of Islam*

NTS Radio
Online radio station
Dalston

So, Femi Edmund Adeyemi and Sean McAuliffe, what is it that you do exactly?
FEA: We're a live radio station set up in 2011. We broadcast from Hackney to the rest of the world. We have listeners everywhere, from all over the States to Tokyo to Kazakhstan to Australia …

I've heard that you have fifty thousand listeners …
SM: It's more in the region of a quarter of a million regular listeners.

How do you survive financially?
FEA: There's various things we do. We work with partners. We've worked with Nike, with Red Bull, with Carhartt, with Converse …

Why are they interested in you, apart from your quarter of a million listeners?
FEA: We give them access to an audience that they might sometimes struggle to communicate with.

So what is your target demographic?
SM: It's generally people who want to make a little existential leap through music.

Big score, but how exactly do you give them that opportunity?
SM: You play music that they wouldn't usually hear on commercial stations or through automated-listening software platforms.

You're out there on the edge trying it on, aren't you?
SM: Yeah. We base our programming on heavily curated, carefully selected DJs and artists who take a lot of care with the music that they play. You could tune in one hour and be hearing music from the 1930s, like very obscure folk from the Deep South of America, and then the next hour you could hear music that hasn't come out yet, techno or house. So it crosses genres, but it all filters through the same system of music curation.

Do you think of yourselves as champions of the underdog?
FEA: In a way. There's not a lot of radio stations that'll open up to anyone who isn't an established name. That's one thing we try and do.

And where were you born?
FEA: I was born in Nigeria. I moved here when I was three, then back to Lagos, then settled in London when I was thirteen.

Heard it said you didn't like school much.
FEA: After secondary school I didn't, but I've got African parents so I had to go to school, to college and to uni.

And you had to become a doctor or a scientist?
FEA: I was pretty good at maths and science but ended up doing marketing and advertising.

How did you fall into radio?
FEA: I've known Sean for almost ten years. I'm surrounded by people who love music. That's a Nigerian thing. Nigerians are able to survive anywhere. Nigerians are very enterprising.

(previous spread) Femi
Edmund Adeyemi and Sean
McAuliffe, NTS Radio's
founder and Managing
Director, in their modest
office/broadcasting studio in
Dalston's Gillett Square. 'The
only reason we stay here,'
Adeyemi says, 'is that there
is something special about
this location.' Jazz bars,
cafés and a United Nations-
worth of food outlets liven
up the area. 'The language
of music is universal,'
McAuliffe observes to an NTS
fan (below). From modest
beginnings in a shack, NTS
has gone on to become a
go-to broadcasting vehicle
along the lines of the pirate
stations of the 1960s that
changed the face of British
musical culture. 'We're
broadcasting on a global
level,' McAuliffe boasts.
'We could have listeners
on Mars for all we know!'

And what about you, Sean?

SM: I grew up in London, in Soho, and I'm of Irish-Jewish descent. In regards to NTS, I think Femi was about to say that a lot of the inspiration came from Plastic People, a club in London that recently closed down. It was set up in 1994 on Oxford Street by a guy called Ade Fakile, who's Nigerian, and moved to Curtain Road in 1999. That was not only an amazing room, it was the best small-club sound system in the world. You could go there and dance to jazz with no drums, just like a choir singing, and then straight after that an electronic tune would come on, and then a hip-hop tune, and then an African tune.

FEA: When we first started the station, a lot of the DJs were friends from Plastic People. We all had different tastes in music but a similar approach.

It seems like a great deal of new music coming out of London in the last twenty-odd years has come out of these rave rooms, for instance Boiler Room …

SM: Boiler Room is like NTS, a platform that promotes new music. With the Internet, anyone around the world can link into it. Like Boiler Room, what we've done is shine a light on what happens in London. Subsequently it grew to a world-wide thing, 'cause we do broadcasting from New York, and we were in Tokyo a few weeks ago, and from Paris … We go and do broadcasting from there with artists from there.

Have Ofcom not come knocking at your door asking what you were up to?

FEA: They have, but they've just tried to understand how they can work with us, 'cause this is a new thing for them. Online radio isn't new necessarily; what's new is an online radio station that is established and recognised and has a huge audience. This is a serious thing, actually in competition with FM stations. You can have a business out of it.

SM: From the roster of regular DJs on NTS, a lot of them have been offered the chance to play on the BBC and on large-scale FM stations, but they choose to play on NTS because they prefer the freedom and the audience.

FEA: When we first set up, we had a few DJs who we knew would probably get poached by other stations. But nowadays there's a huge migration of younger listeners from FM to the Internet. A lot of people just use the Internet for everything.

SM: Of sixteen- to twenty-five-year-olds, only 1 per cent listen to FM radio. The rest who do listen to radio, it's all online. Anybody who's knowledgeable in the radio industry realises that FM will be extinct within a decade.

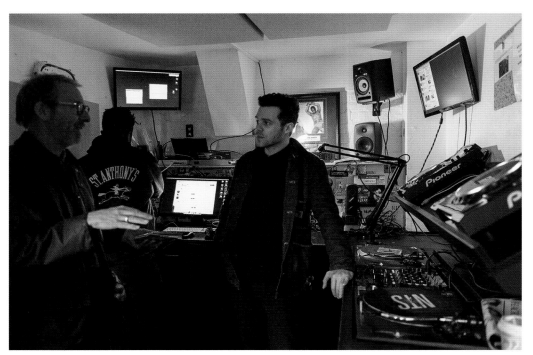

It'll go the same way as vinyl?

SM: It will always exist, just like how vinyl exists, but in a niche way. FM will probably be treated as just a broadcast thing for the emergency services. No-one's going to listen to FM because you've only got a choice of ten radio stations, while on the Internet you've got a choice of thousands.

You've referenced London's diversity in other contexts as being one of the city's attractions. Why is that?

FEA: It's definitely an asset. You could walk up the street and one area's Vietnamese, one area's African, one area's Turkish, and then there's everyone from Europe, and a lot of Americans as well. When we first started the station, there was people coming and doing shows in Turkish, German and Japanese.

So the station is community-based?

SM: It started as a community-based project, but it's dramatically changed. We've kind of outgrown that, to be honest.

If I came along tomorrow and give you two apartment blocks in Knightsbridge and Chelsea, would you move out?

SM: We'd sell them immediately and buy six apartment blocks in Dalston!

What I'm asking is: Would you lose the sense of place if you moved?

FEA: This is a debate we have constantly; we've outgrown the studio, for instance.

But you wouldn't migrate to the West End …

SM: The only reason we stay here, really, is that there's something special about this location. That has to do with the fact that it's an open window into a public space, Gillett Square. So even though the studio is tiny, it gives a sense of space. There's not many places like that around London.

Dalston has become one of London's hippest districts, populated by young people moving out to the periphery. Adeyemi and McAuliffe do the tour of their vibrant multicultural landscape: outside the Art Deco Rio Cinema on Kingsland High Street (opposite top), and taking in the sights in Gillett Square (left & above)

'The only reason we stay here, really, is that there's something special about this location. That has to do with the fact that it's an open window into a public space'

Laura Oldfield Ford
Artist
Barking

Having been born in Halifax in West Yorkshire, you moved to London when?
About twenty years ago.

Why did you come to London?
Well, I was squatting, and I was involved in a free-party scene, so I was living a nomadic lifestyle. I'd been living in Leeds and Bradford, and then I came to London and continued to have a nomadic lifestyle but within the metropolis. I've probably had about fifty different addresses since I've lived in London.

In between which you attended the Slade and the Royal College of Art.
Yeah.

What drew you into art in the first place?
I've always been obsessed with drawing and writing, but I didn't really consider a career in art when I was growing up; it just wasn't a viable option. I remember going to see the careers adviser at school when I was about fifteen. I said I wanted to be an artist so they sent me on my work experience to a stationer's selling pens, right? That was as close as I was going to get to the art world. It was made pretty clear quite early on that those lines of separation were in place, that you couldn't really expect to transcend them. So I came to my art education via a convoluted route. I was involved, like I said, in squatting, and I was politically active as well, so I was making 'zines and doing fly-posting; I was in bands; I was involved with music producers, putting on parties … that kind of culture – well, sub-culture. It was having the time and space to develop my skills as an artist and to formulate ideas, to spend time walking, drifting.

How did you earn a living?
I was on the dole. I was in this group of people where nobody was in education, no-one was employed. But we were able to sign on and we were squatting, so we had that space to develop our skills, which is gone now, really.

So what you're saying is that the London of the '90s has been sanitised?
Yeah. Zone 2 has become increasingly privatised and locked down. Those spaces that used to exist for experimentation, for considerations of other uses, of other ways of living, seem to have been gated off. One example would be the Lower Lea Valley, which was very important for a lot of people, particularly people living in the East End, as there were a lot of empty post-industrial buildings that could be occupied for parties. That was, through the process of a corporate land-grab, turned into the Olympic Park.

Would you rather have had that area remain as it was?
Of course. I'd rather have Tarkovsky's Zone than sanitised telly-tubby land.

But can you stand in the way of progress?
It depends on who's defining progress and who it's serving. If it's serving the interests of multinational corporations, I don't call that progress.

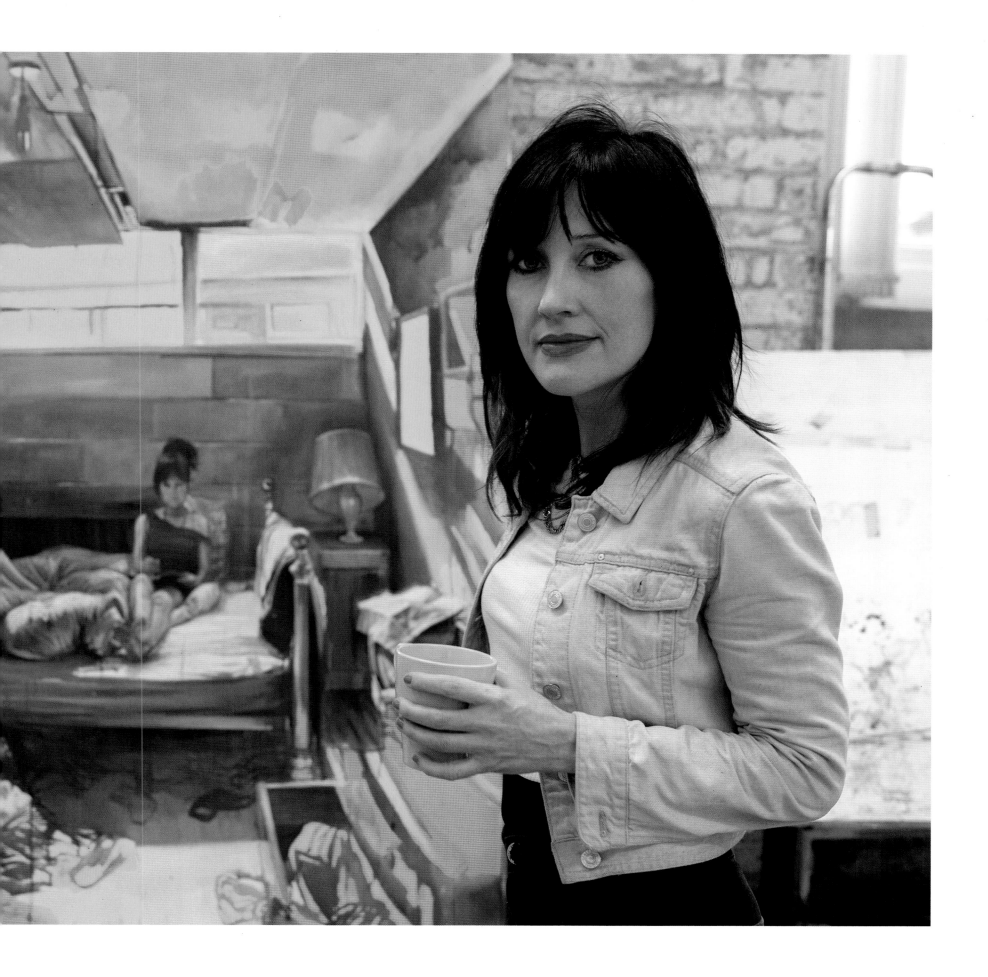

(previous spread) Laura Oldfield Ford in her temporary studio in Barking, with one of her large oil-and-acrylic paintings, *Tweed House, Teviot Street* (2012), acting as a permanent reminder of the squat living she experienced during years of political activism and social engagement

A former member of London's punk and anarchist scenes, Oldfield Ford is highly critical of the influx of wealth transforming the city's liminal spaces into one giant luxury housing project (opposite). Living on Commercial Road, she bemoans the fact that friends and colleagues are being pushed out to the suburbs; 'I used to have loads of people to call on,' she remembers. The artist in protest mood (above) in front of Goodman's Fields in Whitechapel, an empty block of flats destined for redevelopment as luxury apartments. Oldfield Ford normally walks 10 miles in a day in her high heels, mapping ruined spaces and derelict industrial sites to find 'space for drifting, for thinking'. Curator Catherine Lampert, a keen supporter (right), chats with the artist in her studio

Where else in the universe is there a city as important as London that would have been frozen in time to service what you call free expression?
I'm not sure. There are possibilities and potentials in London itself now; it's just that they are being pushed to the periphery. These more liminal or peripheral zones are crackling with potential. But that's because central London's become locked down, like I said. The phenomena of world cities and global brands are a concern because they mean that we get a similar situation with gentrification in all major urban centres. The actual political territory is very much stigmatised, if you like, whereas the sanitised version of it is exalted for its heritage.

What is the outcome of the heritage industry that you're speaking of, in practical terms?
It's like sanitised psycho-geography. It's about a selective history, isn't it? It's about saying which bits should be preserved and which parts should be discarded, and the unassimilated aspects of multiculturalism and historical moments are being erased. I guess that's what my project's about: coaxing out those hidden narratives and flashpoints of contestation and radical history, and allowing them to be conjured as revenants rather than being displaced by this more accessible or easily assimilated version. I'm plotting the lines of social antagonism, not cohesion. I'm talking about the way that territory becomes imbued with moments of cataclysm, if you like.

What would be an example?
The riots of 1991 in Brixton, Broadwater Farm in 1985, the Poll Tax Riots in 1990, the anti-capitalist protests of the late '90s, the student protests of 2010–11, the uprisings of 2011 ...

Which of those were you engaged directly in?
Pretty much all of them. But to finish answering your other question: The reason that I would evoke and conjure those moments is a way of making them present again. To not allow them to become erased or to be rewritten, to talk about them as a constellation of moments, in the sense of looking to the past and future simultaneously.

Are you saying that you want more riots and burnings and destruction?
In a sense, because there's a point where people reach a collective malaise and despondency. There's going to be moments of rupture because you can't have that level of despondency indefinitely. And if those moments are channelled into creating something that sets up an alternative to late capitalism, that's a good thing as far as I'm concerned.

About these walkabouts that you do, exploring your psycho-geography: You obviously don't have any predetermined ideas when you set out on them, or do you?
No. The theory of the *dérive*, or of psycho-geography, is that it's about a sort of emotional mapping of the city, about plotting the lines of the territory, I guess. It's not about getting from A to B in the most efficient way, it's not about the most accurate form of cartography, it's about understanding the city according to your own emotional engagement with it but offering a critique of urbanism as well.

And you both write about these experiences and paint them ...
Yeah.

Which do you feel has had more impact, writing or painting?
I see it all as coming from the same central force, so I'm not sure.

Is this lyrical, poetic narrative driven by your own curiosity or by the history of urban social and structural conflict?
Well, the paintings are based on real architectural spaces. They're places that I've spent time in, places that I've occupied. Often I talk about architecture as being imbued with a certain charge that has emerged as a consequence of a radical reuse of that space, often in those cataclysmic moments that I was talking about before. There's something uncanny and haunting, I think, about structures that have become obsolete. I often talk about the abandoned shopping arcades of the '70s and '80s as being a future that was promised but never fully delivered. So I talk a lot about lost futures, in a way.

Are you at all concerned with the commercial aspects of making art?
I'm not sure. Class politics don't sit comfortably with a certain constituency that are buying fine art, unfortunately.

But you reap what you sow in all aspects of life, isn't that correct?
My politics are deeply felt, well researched. I do have a very militant, very stringent political analysis, and that isn't easily assimilated into the narrative of the *enfant terrible* and the London art world.

What would you do if your pieces start fetching huge amounts of money?
If the money started rolling in, it would be brilliant, but it wouldn't be about me conforming to any requirements. I wouldn't be compromising anything.

Going back to London as a city, from what I understand you have a dystopian view of the city's future ...
Not really. Other possibilities are emerging, other currents, at those points of rupture that I mentioned before. There are new political discourses fermenting, a sort of matrix of possibility; there's this idea that potentials will be unlocked at certain points. That's a recurrent theme in my work.

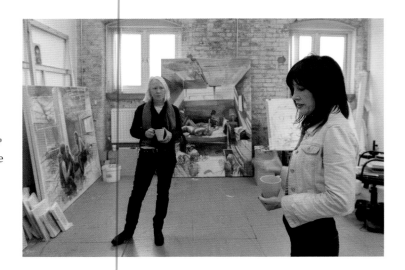

You've been quoted as saying that, for you, 'the street is always the most important place.' How so?

Because it's individualised suffering, individualised hallucinatory states, individualised intoxication. Public spaces are being privatised, so places that would have been sites of congregation, gathering, protest, demonstration, exchange, drinking, whatever, have become private shopping malls. People aren't socialising in the same way that they used to. Instead of going to the pub, they'll buy supermarket lager and stay in and watch flat-screen TVs. Things have become so much more difficult in terms not only of the privatisation of space but also of the privatisation of time. The tyranny of the phone just means that time has become a sort of always-presence. Marc Augé talked about non-places; I think we can talk about non-time as well now.

Given all that you've said about London, would you ever consider moving to another city?

I've been able to carve out my own networks here; it would be quite difficult. I don't want to give up on London either. I mean, it's a matter of pride, you know? I just sort of refuse to be driven out.

'People aren't socialising in the same way that they used to. Instead of going to the pub, they'll buy supermarket lager and stay in and watch flat-screen TVs'

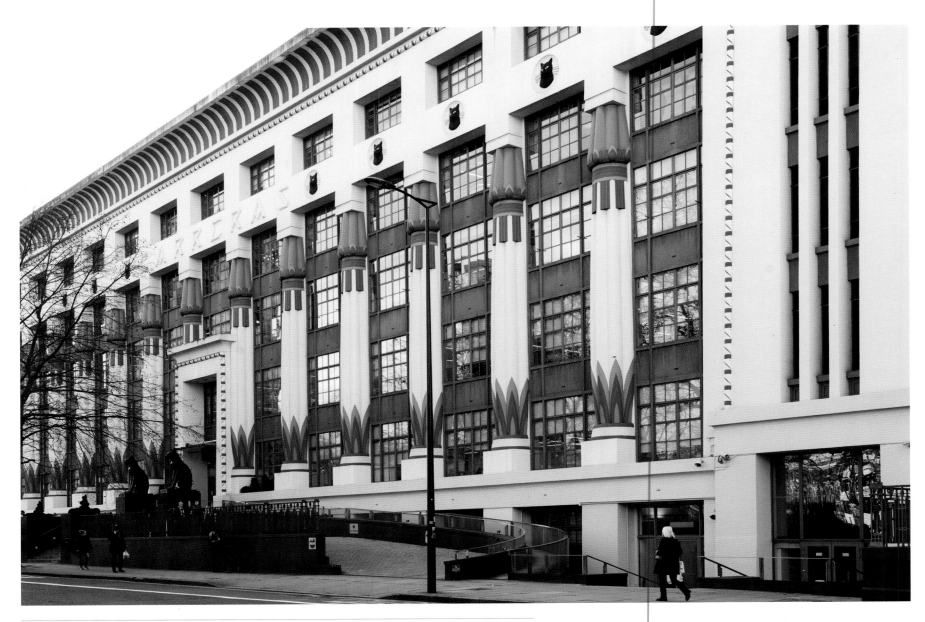

Catherine Lampert
Author/Curator

Freelance curator and former Director of the Whitechapel Gallery Catherine Lampert established a strong relationship early on with several important British modern artists including Lucian Freud and Frank Auerbach. Catherine still sits weekly for Auerbach, an arrangement she describes as 'not just social ... It's proper work'. Of the painter's strong individuality, she notes that he does not invite people to his studio: 'There are lots of artists who just can't cope with that. Some artists are brilliant at working between the interfaces of one culture and another, but not every artist has to do that. You can sell work without spending a lot of time with people who buy your work.'

Charged with looking after a scholarship fund following the death of Valerie Beston of the Marlborough Gallery (after whom the fund was named), Catherine met Laura Oldfield Ford in the course of a search for deserving young artists. Describing Ford's work as 'poetic', Catherine adds that she and Pilar Ordovas, the other scholarship judge, 'had the same common feeling that Laura was really special. After we looked through all the studio displays, we narrowed it down to two or three, and we chatted with her for a moment. We were even more convinced because she just

had such a sense of what she wanted from her art and what her subject matter was; it's something you can't put your finger on. It's not didactic art that fits a recipe or formula. It belongs to her and it has a strong political commitment'.

Catherine was a student at Brown University in Rhode Island when some friends of hers decided to go to Paris to spend a year abroad. 'I'm very bad at foreign languages,' she says, 'so I thought, No, I can't do that. And anyway I wanted to go to London – you know, swinging London at the end of the '60s. So I applied to University College at the Slade and went there. I just liked London a lot.' In 1971–6 she squatted in her first husband Robert Mason's studio; it was during that period that she held the post of Senior Curator at the Hayward Gallery.

Catherine's many publications include the catalogue raisonné of the paintings of Euan Uglow and *The Mystery of Appearance: British Figurative Painting 1950s–70s*. Her other posts and affiliations, past and present, give a sense of her range of interests: Visiting Professor at the University of the Arts, London; the Charles Wallace India Trust; the Art Fund and ICOM (International Council of Museums).

Catherine Lampert (below & right) in Mornington Crescent, and (opposite) in front of the Art Deco Carreras Cigarette Factory on her weekly visit to painter Frank Auerbach's studio, she has been a sitter for him for over thirty-five years. The two are close friends; Lampert is curating Auerbach's 2015 show at Tate Britain; her new book is entitled *Frank Auerbach: Speaking and Painting*. Lampert (above) revisits the Columbia Road squat where she lived for five years with her then husband, artist Robert Mason

Lynette Yiadom-Boakye
Artist
Number 319 bus route

You were born in London, but your parents are from Ghana. When did they come to the UK?
In the '60s, at a time of post-war regeneration. They were encouraged to come over and do jobs that nobody wanted to do here.

We've just had a journey on the 319 bus from Streatham Hill in south London to Sloane Square. Is this a journey that you make often?
Fairly often.

Why do you waste forty or fifty minutes riding a bus?
It's something I just always did. I loved getting the bus; I loved the time it gave me to think. There were practical reasons initially; you could get a bus pass for just a few pounds when I was younger. There used to be a bus route from near where I lived in south London all the way to Trafalgar Square. I liked that route because it went via interesting places, through Brixton, Kennington, Westminster and then over the bridge to Whitehall.

Were those spots points of inspiration?
Maybe in some ways. My mind used to travel with the journey, if you know what I mean. It was a good way to think. It was also a way of getting to know London.

Was it helpful in terms of your art?
Not directly when I was still at school.

When did your mind fully open to a visual take on life that would be translated into art?
That time was probably formative in the sense that there are things you store up and maybe use later. I didn't know what I was going to do with my life. I had no plans for this.

Having lived most of your life in south London, do you feel that the Thames acts as a kind of social barrier?
I don't know. Each area is so mixed, or has been in the past; each area has been a combination of social classes. That's less and less the case because pricing is pushing people out of London. In the London I grew up in, you had pockets of different social groups in every area. It always felt like you could wander anywhere. Everywhere was mixed.

No neighbourhood was closed off socially?
Not really. There were areas that were more attractive than others to spend time in, but I never felt like anywhere was particularly off limits. I don't know about now. I suppose over time it has gotten more and more divided.

Has London changed beyond recognition, do you think?
There's something of that mixture that gets lost, something of that social identity, particularly in terms of housing.

So who owns London now?
I still feel like I own a part of it. It's home for me; it's always going to be.

Has the fact that your parents are African and that you are a born Londoner made a palpable difference to your way of seeing?
I heard it put nicely recently in a programme on August Wilson, who said something about what he called 'blood memory' – which is about how everything about your life experience, including your heritage, where you've come from, who's raised you, how you were raised – all of those things influence the way that you think about everything. You don't necessarily need to identify with one thing or another; it's just there.

So even if you weren't born in a particular town or village, the genes carry a sense of origins in some form or other?
I believe so. I like this idea of blood memory being the thing. I think it was really about people being lazy sometimes in the way that they want to position you. It does get quite frustrating because you can be more than one thing, think about more than one thing, talk about more than one thing.

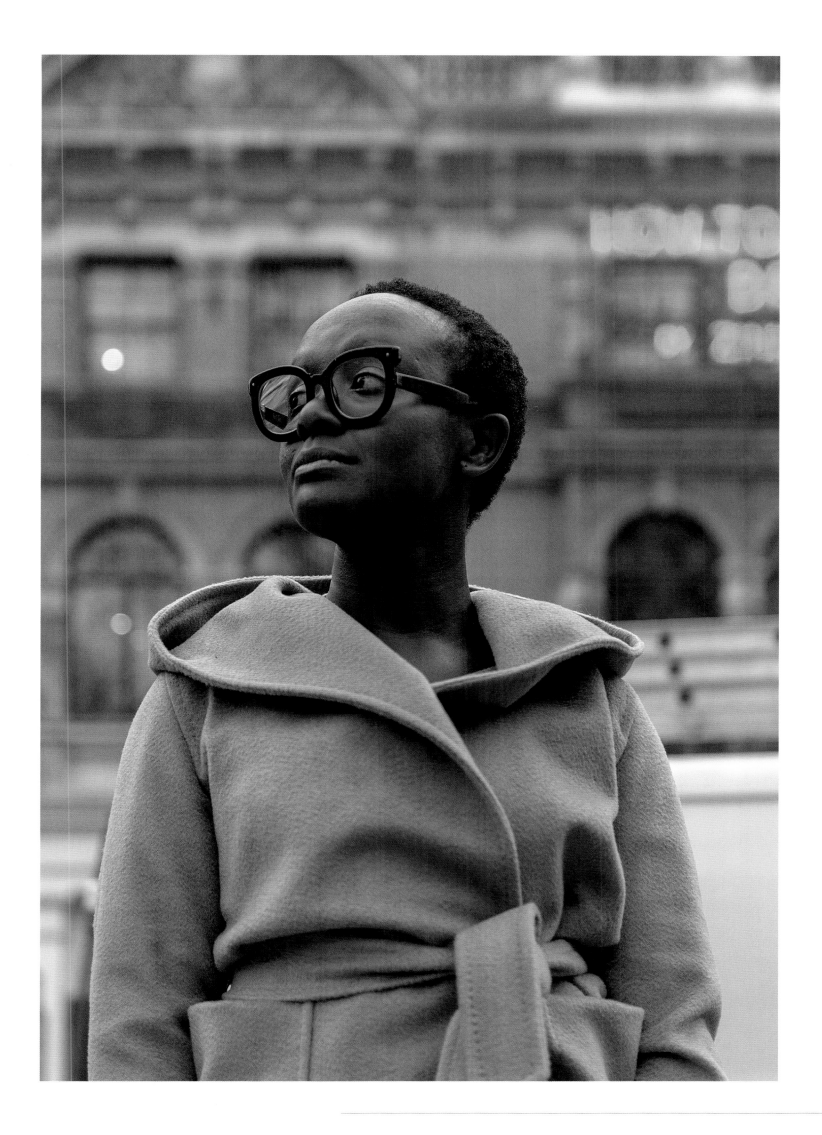

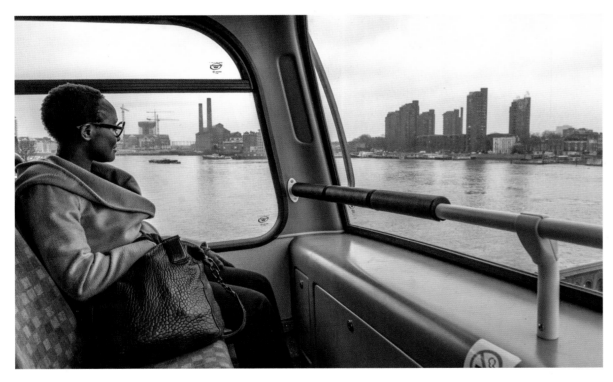

(previous page) Lynette Yiadom-Boakye at the pit-stop of the 319 bus route, in front of the Royal Court Theatre in Sloane Square, once described by the *New York Times* as 'the most important theatre in Europe'. The 319's route starts at the Arriva depot in Streatham Hill (top & above). The artist, who has travelled the same route since childhood, enjoys sitting on the bus and doing 'a lot of thinking', she says. Coming into central London, she crosses Battersea Bridge into Chelsea (left)

'In the London I grew up in, you had pockets of different social groups in every area. It always felt like you could wander anywhere. Everywhere was mixed'

How did you decide to live where you do now?
When I was looking for my flat, Streatham was one of the only places I could afford in London. I wanted to be south and close to my family. There was a funny moment when I realised that there was this little triangular area where my mum used to get off one bus, change and then get on the 319. I don't know if that held a sort of significance somehow. Plus there were all these other bus routes going through there that were significant to places where my parents worked or where my cousin used to work. There were all these funny little associations I had with different bus routes going to different places. The 319 became, strangely, an important one because I was working on the King's Road and used to get that bus everyday. Different jobs I have had all seem to be on that route somewhere.

Could you give an example of the route's significance with reference to the work that you did?
There was the sports shop on the King's Road, and around that time I worked with a children's art group which had many sites around Wandsworth, Clapham and Balham. The 319 was the route I used to take to some of those sites. I find the route beautiful, but I don't expect anyone else to. I find it beautiful because of the personal associations I have with it.

When the bus stops at Sloane Square and you get off, do you sense a difference in place, or atmosphere, or ambience, or social tenor?
Oh yeah. But a lot of people will have come from places along the route and they get off at Sloane Square too. It's not like one type of person gets on at the beginning and then gets off before they get to Sloane Square. I often wonder where people are going to get off. It's just another one of my nerdy bus things! I often think about following someone's route …

Have you ever turned that idea into a piece of writing?
I have. But again, these are the types of thoughts I have on the bus. You aren't necessarily watching people, but you become aware of people.

You become a sort of social wanderer …
Yeah. And then you get surprised sometimes when you see someone getting off. You think, Oh! I didn't think they were going there, doesn't look like their kind of place.

The red bus is so emblematic of London. With the way it courses through the veins of the city, it's representative of the full range of urban social, physical, mental, emotional and psychological life, isn't it? Sometimes of violence as well. Does that analogy work for London, do you think?
Yeah. If you think of the routes as veins, and of life-blood going through them, those things that are keeping everything moving and alive somehow … Whenever I'm away, I miss them. It's an amazing service. You can cover the whole city by bus.

It's a very egalitarian construct.
Definitely. I know people who won't travel any other way, and I know people who won't get on the bus. For me it's always felt very comforting.

Yiadom-Boakye at work in her small Bethnal Green studio. 'I generally get to my studio on the train or Tube, but if I get on a bus, it's a treat,' she confesses. Her oeuvre is all to do with ordinary people doing ordinary things – like taking the bus

Alan Yentob
Creative Director, BBC
Portland Place/Ladbroke Grove/
Shepherd's Bush/Golborne Road

Were you born in London?

Yes. At a very early age, we moved to Manchester because my family was in the textile trade. We came back to London when I was twelve or thirteen years old. At that stage, because I suppose I had a privileged upbringing, I lived in a block of flats on Park Lane. When Park Lane was two-way, it was very noisy. I had to do my homework facing heavy traffic, so it wasn't quite as blissful as you might imagine.

How did you get interested in the BBC?

I've been at the BBC since I was twenty years old. Every year I go to some of the Proms. My parents lived in Albert Hall Mansions, which was built around 1887, just a few years after the Albert Hall went up. So their front room was on the park. That was a space I visited a lot. A lot of people like Mel Brooks and Arthur Miller used to come to Saturday lunch with my mother in that apartment.

Why was that?

Because she was a good cook!

Where did you end up living yourself?

I moved to St John's Wood, which is not an area that I particularly felt at home in. I moved to Notting Hill in the late '60s. Of course, that's changed. What I liked about that part of London was the mix of social classes. A lot of immigrants came to Notting Hill. The Notting Hill Carnival, the riots, all those things took place in that environment. There was always the juxtaposition of the better-off and the less well-off, and that created tensions but also created a piece of society which was, in some way, integrated.

How have things changed in London since the '60s and '70s?

Once upon a time, you could never sit outside in London, and also it was very divided. Mainly it was sort of male, you know? Women went shopping, but men were in the pubs. I was never comfortable in either of those two worlds uniquely. What I love about London now is that you can sit outside no matter the time of year. The sense of confidence, the sense of it being a European city, the sense of conviviality, food of course, all so much better, and the diversity, the multi-culturalism.

Where do you go that has more or less survived the upwardly mobile change washing across the city?

The space that hasn't been spoiled is Golborne Road, at the north end of Ladbroke Grove. The mix is so vivid and so interesting. There's Mexican food, there is a Danish restaurant, there is Moroccan. There is a place called John Doe, which is a smokehouse, and which sells venison burgers and sausages. You can smell it as soon as you walk in. Lots of food stalls, fish, kebab any time of the day or night. As you move up Ladbroke Grove, with the Crossrail coming, I see all of that being developed much more. So that's one bit of Notting Hill that I really like.

Anywhere else?

I also know Shoreditch because my father's business had a building on Shoreditch High Street; it was the other end of their Manchester business, a wholesale warehouse. Now, of course, that whole side of London has been transformed, Brick Lane and all the rest of it.

You've just described in a nutshell the transformation of London in the last fifty years. What do you think has driven that transformation?

Well, I think it's a mixture of economics and prosperity coming and development and people thinking about what a city should be. It's a destination for tourism, of course. There are a number of other things that have happened side by side with that. One is lots of restaurants, cafés, a sense of city life on the streets. The other thing that has been very remarkable in London is investment in infrastructure for culture. Tate Modern has made a huge difference. Exhibition Road was a place where I first discovered museums and galleries. The reinvention of these places has been a big part of what's happened in the past thirty years in London. Then if you move to the other side – Hoxton, Shoreditch – that is where you find a lot of artists of a particular generation. That's made it hip. It's East London transformed near the City.

The artists have been a tease, but the fundamental movers have been the developers.

That's absolutely right. The story of developers in London is a big one. It's done well in some places and less well in others. The river, which is such an incredible asset, seems still not to have fared as well as it might have. Some places we could be proud of. I'm talking about pleasures that are not necessarily known about, like the London canals. I live off Ladbroke Grove, and there have been times when I've taken a dingy, blown it up, walked down the steps of the bridge on Ladbroke Grove, got into the dingy and made my way to north London and back. The other thing I do is cycle a lot in London. I like the unexpected views you get. For instance, you could be in Hyde Park, go along past the Serpentine and see Renzo Piano's new building. It's miles away if you were to go there, and yet somehow it seems really close. Another building I love is the Lloyd's building. The other thing I think is important about that bit of London where there's various towers is how old and new can sit next to each other.

How do you rate the Dubai-esque development that's ongoing in the City?

Well, I'm not very keen on Dubai. First of all, it's not cultural, it's an economic model.

Exactly. My point is that if you're travelling through the east of London and the City, you see more cranes than you can count …

That's true, but then London is a place with lots of villages. If you go to Hampstead or Belsize Park, that's a very different model. The City is one thing; there are many other parts of London which haven't been developed in quite that way. I actually don't mind the City of London.

(previous page) Alan Yentob at the heart of the BBC's offices at Broadcasting House, Britain's largest creative hub. 'This is where all the different elements of the BBC interact,' he explains. 'You've got the World Service, you've got the news, the drama people, the radio, all the networks …' The warren of cubicles in the background is a reflection of the organisation's attempt to keep pace with the spatial needs of its multitude of staff. 'We have six thousand people working here, which is far more than we intended,' Yentob confesses. 'How we organise the space is critical'

Yentob observes Yentob (right): the Creative Director's cluttered desk beneath the watchful gaze of a lookalike. Yentob, in front of All Souls Church on Langham Street (below), chats with musician Paul Simonon. Outside Broadcasting House's original grand building (bottom right), completed in 1932, Eric Gill's statue depicting characters from Shakespeare's *Tempest* stands guard against creative adulteration. Yentob chats with Ceri Thomas, Editor of *Panorama*, the BBC's investigative news programme

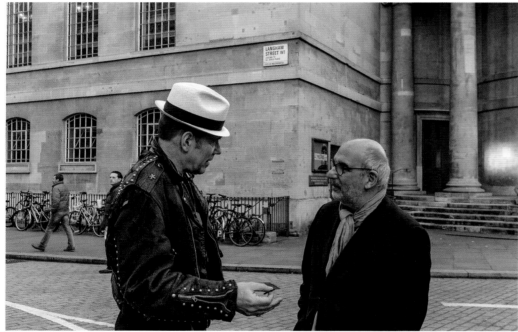

'From very early on, when I was running the Arts Department at the BBC in the early '80s, I believed there needed to be a conversation about what our city should be like'

I was comparing the hectic pace of reconstruction that is going on to Dubai's SimCity video-game building boom ...
In London there is a huge amount of building. That's good and bad. I'm not a believer that things shouldn't change. But clearly, regulations (rather than ad-hoc building) are very important.

You've worked out of some landmark London buildings yourself.
I've always worked in iconic buildings. Whether you like them or don't like them, they've made their mark. I started in Bush House, which was a 24/7 building before the phrase '24/7' was even invented. People from the World Service were working day and night. Since then we've moved, and I'm now talking to people about what will happen to Television Centre and White City. I've brought Nick Jones from SoHo House into Television Centre, so that will become a media centre; BBC Worldwide, our commercial body, is going to stay there. I'm very committed to seeing that the legacy of Television Centre remains in some way, though it's got to be married with its commercial future, which is tied up in housing.

How much of an effect does your built work environment have on your creative output?
I have always been a believer that cities, communities, buildings, your working environment make a great difference. Anyone who's spent a lot of their childhood going to Italy for the holidays knows that the idea that these things don't really matter is ridiculous. The built environment is absolutely critical, and more people need to be aware that it makes a difference. This is not just about whether it's tall or it's low but also about the quality of the work that's being done. From very early on, when I was running the Arts Department at the BBC in the early '80s, I believed there needed to be a conversation about what our city should be like. That conversation has been more effective in Britain than elsewhere, and it's been helped by Lottery money to make sure that public spaces were an important part of the development of cities. We've got the infrastructure. We need to make sure that it can be sustained, with the economy as it is.

How much of a role has the BBC played in mediating this dialogue?
I don't want to make too many claims, but I believe that the BBC is the foremost cultural institution in the UK. We've not tended to be as good at partnering people in the past as we are now. Now that Tony Hall is here with me, we are determined to be a major force for good in supporting and partnering arts institutions across Britain. The BBC, through radio and television and online, is able to bring people together in a way that very few other organisations can do. It sits not just in every household but on every mobile phone. You can get BBC Arts on your iPad or your iPhone.

In what other ways have the Internet and the development of digital technology changed the BBC?
We've had to deal with very significant funding cuts. So we've had to run ourselves more effectively, more efficiently. We've had to stop doing certain things. The balance between what you invest in technology and what you invest in content is a delicate one today.

Do you think the Beeb has cracked it?
The BBC was online before just about any other organisation. Its news service went online very rapidly. We saw that if we were to have a future, we would have to find ways to learn about, and invest in, this new technology and pace it.

Give me an example?
The iPlayer, for instance, is the BBC's invention. Freeview has allowed people who don't have the means to purchase a Sky or Virgin or BT service to get dozens of channels which they don't pay more for than their first payment. That would not have happened if it wasn't for the leadership at the BBC. But the BBC can't be complacent about how it continues to deliver first-class content, particularly to people that pay the license fee in the UK. It isn't an élitist structure. The BBC is in the home of just about everyone in the UK. Actually, I believe the BBC underpins the creative societies of Britain. We're not unique in entertainment. In information and news, we are a formidable force.

And everyone owns a piece of it. And they can come down and knock at your gates. The public, I mean.
Sure. Well, we're going to try make it more easy for them. We talk about 'our BBC'. We're trying to develop a much more personalised BBC that will give people access to material. We can customise it to what you want, what you need, wherever you are. And we can do this in a way that does not compromise your personal data, that does not exploit who you are. It's all built on trust. It has to be.

Let's go back to when you first came to the BBC. What sort of dreams did you have at that time?
I had no dreams at all. I was lucky!

Come on! You must have had ideas, dreams, a sense of purpose ...
My dream was to have a fulfilling life, to allow my curiosity to continue. I didn't think that I would ever be this old, you know?

And how do you see your own future?
My ambitions are personal; they're not about status. They are to continue to do interesting things, to probably carry on making programmes, which I love doing. The truth is, being an enabler of a creative organisation, understanding what that means, creating an environment where you nurture people, where they can thrive and succeed, even in a huge, much scrutinised bureaucracy, discovering new talent, listening as well as telling – that's an incredible thing to be able to do. To make something as important as the BBC work even better.

Are you a touchy-feely type of guy or a cerebral doer?
I'm a very intuitive person. I mean, I obviously have a level of intelligence, otherwise I would have been found out long ago. I still suspect I might be found out!

Yentob reads in his Notting Hill garden in winter sun (left). 'There are lots of parts of London that have their own zeitgeist,' he notes. 'That's more than any other city, which is what makes it pleasing and different.' Yentob revels in the area's multicultural vibrancy. 'This is where there is a lot of social housing cheek-to-jowl with more prosperous middle-class houses. It is also where the race riots happened and where we have the Notting Hill Carnival.' Yentob out shopping (below) at a Saturday street market beneath the Westway

Alan Yentob

Yentob on his Brompton bike (left), the Brutalist Trellick Tower in the background. Nicknamed 'The Tower of Terror', it was built in 1972 as a social-housing experiment by Ernő Goldfinger. 'It's the one landmark left from that era,' notes Yentob. 'Everything else has been pulled down.' Yentob on Golborne Road (below) with a close friend, English film director and businessman Franc Roddam, creator of *MasterChef*, an international television phenomenon that originated at the BBC. 'Its about multiculturalism,' Yentob enthuses as he searches for a place to have a meal. 'There's Moroccan, Persian, Danish, Austrian … Everything is here'

And you come from a family of Jewish immigrants. Why has the Jewish community produced so many successful personalities in the arts, do you think?

Well, that's a big question. A friend of mine, actually it was Charles Saatchi, said to me once, 'Why don't you do a programme called "A World Without Jews" and see where it would get to?' It's also, remember, about the traditions of Judaism. Most of the Jews I know are secular Jews, they're not religious Jews at all, so we don't have the problems that, if you like, the Muslim communities have. I've done a lot of programmes around these themes. I've just done a couple of programmes with Philip Roth. I just did a programme about the Jews who invented the Broadway musicals, about which Cameron Mackintosh said to me, 'That's the best programme on music I have ever seen in my life.' So I'm wrapped up in those traditions. But I can't tell you the answer to that question. I don't know the answer.

Where would you have found yourself if not in London, had your life taken a different course?

While I was in England, I was always going to be in London. I like the city. I have a place in the country, but I'm a city person. The BBC partly kept me here. The cultural dynamic, the city, my friendships. London is a big city, but the creative community is much more connected. London is quite interactive. The only places I might at some point have been seduced by might have been New York and Los Angeles, mainly because of the business I'm in, and opportunities which were offered.

You apparently have a family testing mechanism called 'Uncle Isaac's Test' that has to do with excellence. How does it work?

Uncle Isaac was in the textile business. Whether it was television or fabric, he knew what was good instinctively, at least he thought he did. So I apply Uncle Isaac's Test: Is it good or isn't it good; what do you think? There are some guidelines, but there are no absolute rules. You always have to be open to new things, and use your intuition, use your eyes, use your ears.

Charlotte Olympia Dellal
Founder, Charlotte Olympia
Mayfair/North Kensington

You were born in Cape Town, I believe.
Yeah. My mother's Brazilian and my father's English, originally Iraqi-Israeli.

Which part is the most important, out of that mix?
I feel more Brazilian when I'm in London and more English when I'm in Brazil.

What language do you dream in?
I dream in English, definitely.

And do you think in English?
I think in English. But there are certain things that are in Portuguese. I speak to my kids in Portuguese. I've met people who appear to be more English than I am. But what is English? Everyone's from everywhere now. I'm not a unique case. I feel like I'm more from London than from England.

So what is your idea of a London person?
Well, anyone can be a London person. London is a mix. I can go to all the little shops on one street where I know I can buy my Iranian food because there's a whole Iranian community, or I can go north of where I live and buy all my Brazilian food.

The Iranian connection is via your husband?
Yeah. My mother-in-law is Iranian. 'Persian', I like to say; it sounds more romantic.

In fact, romance figures in your product, your style.
I think so. I always used to think that romance was just about love, but I would say I'm a romantic person because I'm also a nostalgic person. I romanticise things, I guess. When I design a collection, a lot of the time I'm inspired by places I've never been to, so it's more an idea or a fantasy.

Have you been a bit of a dreamer since childhood?
Probably. I like creating environments. I like extremes. I could never go to a pink restaurant and not wear pink. It's part of the fun. I love those parts of life where things are more of an occasion. I love occasions. It's a bit old-fashioned as well. I like to dress up and do my hair. It's that nostalgic element of when women were women. I mean, women can still be women, but I hark back; I like reminiscing about the good old days. I wasn't there so I can romanticise them. I love the glamour of the '40s and the playfulness of the '50s.

What was your first impression of the '40s and '50s?
My grandmother Zehava came from that era. She was a very glamorous woman. She would never leave the house without her hair done and her red lipstick. She looked like a movie star. She was very feminine but a strong woman; she wasn't girly. And she was classic … that's what drew me to that even more. Also I used to watch old movies from a young age.

Which movie was your favourite?
Gilda. I love Rita Hayworth. When I started dressing the way I do, I dyed my hair red because of Rita. That almost made a caricature of myself. That's when I started to wear red lipstick, and I guess it became a lifestyle. Does that make sense?

Not everybody can pull that sort of thing off, right?
I don't think that's true. When it becomes something that's innate within you, like a lifestyle, you can because it's dress-up. There are some girls who look amazing, fantastic, out of the shower with nothing on, and that's like their look and beauty, and there are some that try to dress it up a bit. I like that element of dressing up. It's half the reason I do what I do. I fell in love with doing fashion. I always thought I wanted to be an actress when I was younger, but what I wanted to be was a movie star. It wasn't about the acting, it was just that look. That got me into the love of glamour. And glamour got me into fashion.

But glamour doesn't really exist anymore, does it?
Not as much as it should. I haven't worn them for a while, maybe because motherhood has made things more realistic, but I love to wear a hat to go out. I make handbags, and all the handbags come with a matching pair of gloves. It's old-fashioned femininity that I love.

So it's part fantasy, part commerce.
I guess so.

What about shoes?
I never wanted to do shoes. I always wanted to do ready-to-wear, to be a fashion designer. When I did my foundation course, I was designing outfits, but I would always design a different hat, bag, shoes to go with them rather than just focusing on the ready-to-wear. So my tutor said, 'You're focusing a lot on the accessories. Have you ever thought about doing accessories?' I never thought that's how you did it; I thought that you specialised in doing bags or shoes. For me it was always about a look, I guess. But when I think about it, the accessories *are* the look.

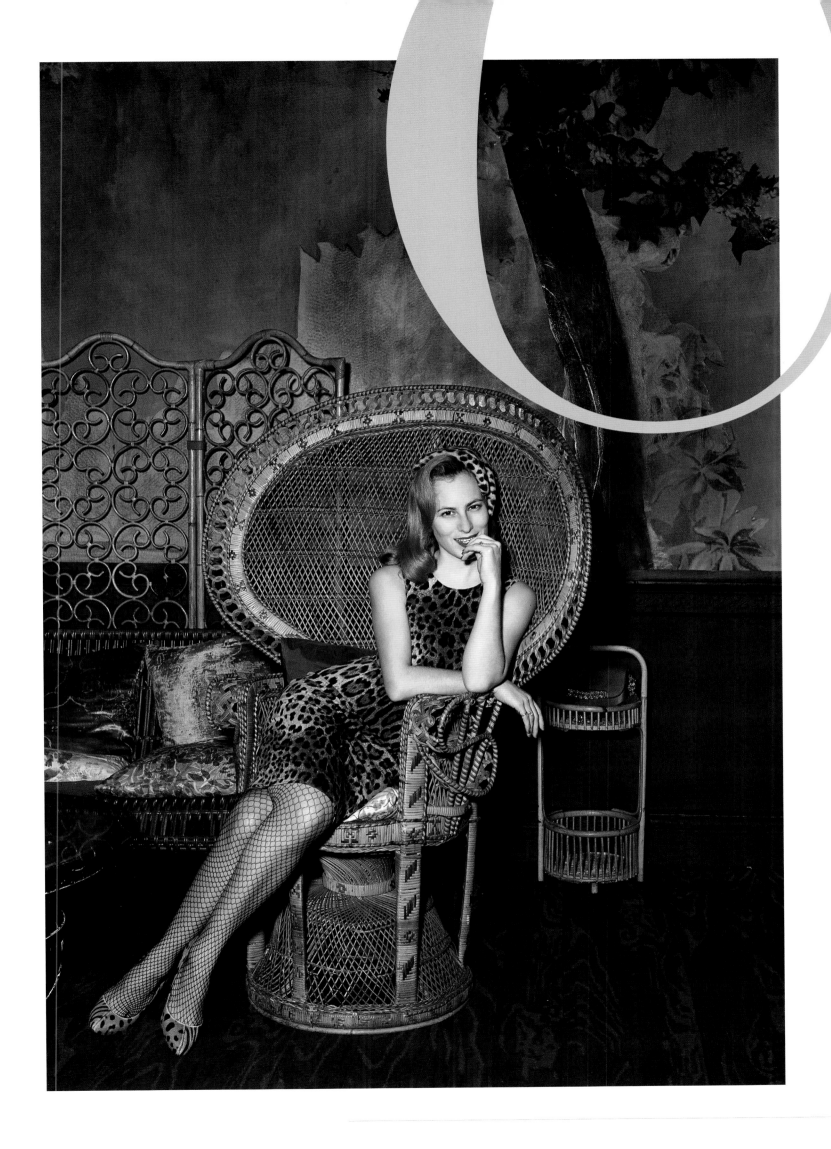

(previous page) Charlotte Olympia Dellal channels Rita Hayworth at Sketch in Mayfair, one of her favourite London restaurants. 'I don't just design and dream it,' Dellal says of her global shoe and accessories brand, which she founded in 2007. 'I try to live it a bit and wear it a bit. You know, head-to-toe leopard prints – why not?' Her designs are influenced by Hollywood glamour, pin-ups and movie stars of the '40s and '50s

Dellal (top left) window-shops outside the Charlotte Olympia store on Maddox Street in Mayfair; her trademark spider insignia, inspired by her favourite childhood read, E. B. White's *Charlotte's Web*, is on display both above the shop entrance and on each of her signature pieces. Dellal searches for inspiration (left) at Les Couilles du Chien on Golborne Road, a shop that specialises in design classics and baroque extravagance (above & opposite). 'When I design, I think about everything from colours to textures and mood,' Dellal says

That approach doesn't reflect a specifically London mood, though, does it? It's more global …
I guess so. It's the silver screen, but it definitely comes from London as well. Women can be very elegant in London. What I love about London is that it has four seasons. You can wear the hats and gloves and the bags and the big coats, and then you can be a bit more playful and wear watermelon baskets and prance around parks.

How would you describe London glamour in the '40s and '50s as opposed to that of Hollywood?
I guess it was a bit dark. You go to places like Claridge's and it's a different kind of glamour. It's a bit more grown-up. That's why I always wanted to have a shop on Bond Street. I love Mayfair for those clichéd reasons. I'm a big cliché! I love things for what they are. There's no deep meaning for things. And I love where I live because it's the complete opposite.

And where is that?
North of Ladbroke Grove.

Let's back up a bit now. You were born into a wealthy family …
I had a very fortunate upbringing, travelled the world when I was younger. For my business, I borrowed some money from my father. In fact, when I told him I wanted to be a fashion designer, the first thing he asked me was 'Is it a hobby or is it a business?' I said, 'A business!' and he said, 'Where's the business plan?' So it's always been in tandem. I like to design shoes, but I've always wanted to have a brand. It wasn't just about designing shoes. I wanted to sell them.

Are you still working to the same template with which you started out?
I grow things organically. I take opportunities when they arise if I can, and if it's right for the business at the time. There are many shops I would love to open, but it might not be the right time to do it. It's about growing my own luxury brand in my way.

Does Coco Chanel figure in your imagination at all?
Oh, I love Coco Chanel!

Do you think you're in some ways similar to her?
No. I'd probably be aesthetically very different. My designs are more playful. She was a bit more classic and elegant. I try to be elegant, but it's a different aesthetic. If we're going to talk about women who inspire me from a different era, Elsa Schiaparelli is a favourite. I admire her aesthetic. She was glamorous and colourful and feminine but had a sense of humour. Carmen Miranda's another woman that I absolutely love. I love these strong, colourful women for different reasons.

What do you have in common with them?
My husband would say I have a strong personality, but I have a strong aesthetic that I live by as well as incorporate into my designs. It's in my work life, but I try to live it as well.

'Everyone's from everywhere now. I'm not a unique case. I feel like I'm more from London than from England'

'I never used to like pink until I had three boys; now I absolutely love it': Dellal resplendent in pink in the Gallery at Sketch, which was designed by India Mahdavi. Artist David Shrigley's transformation of the space is intended as a long-term programme of artistically conceived restaurants; 239 of his own sketches line the walls, and he designed the tableware. 'To be English in London does not mean you have to be 100-per-cent British,' Dellal says, referencing her own mixed lineage. 'You don't have to have English heritage to be English in this town'

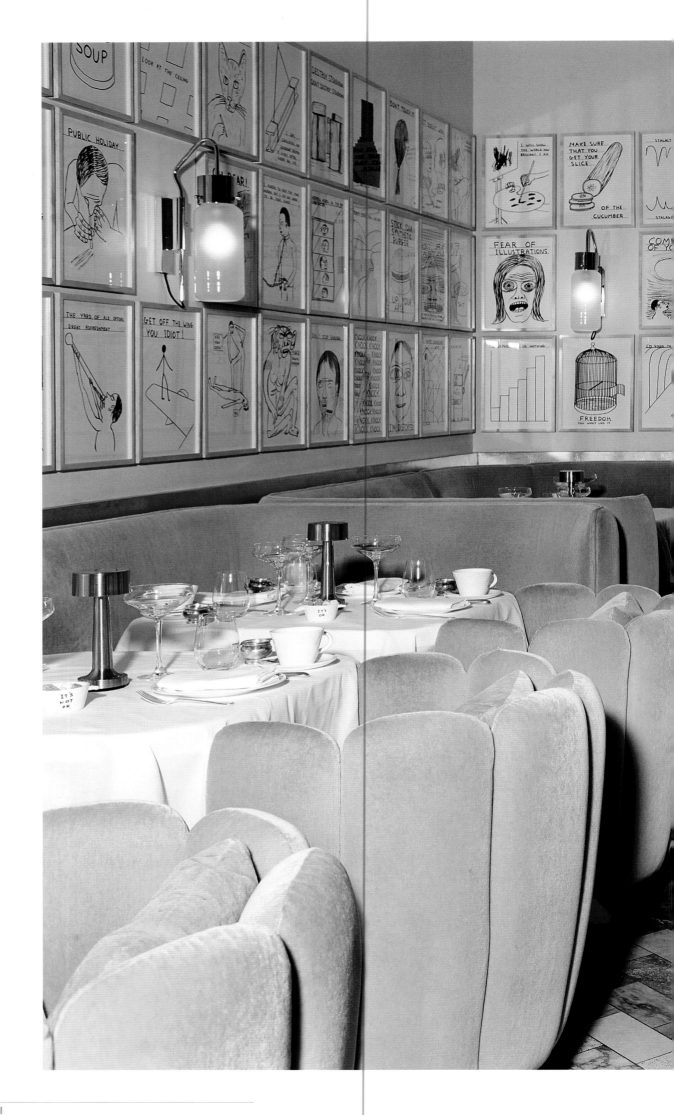

Charlotte Olympia Dellal

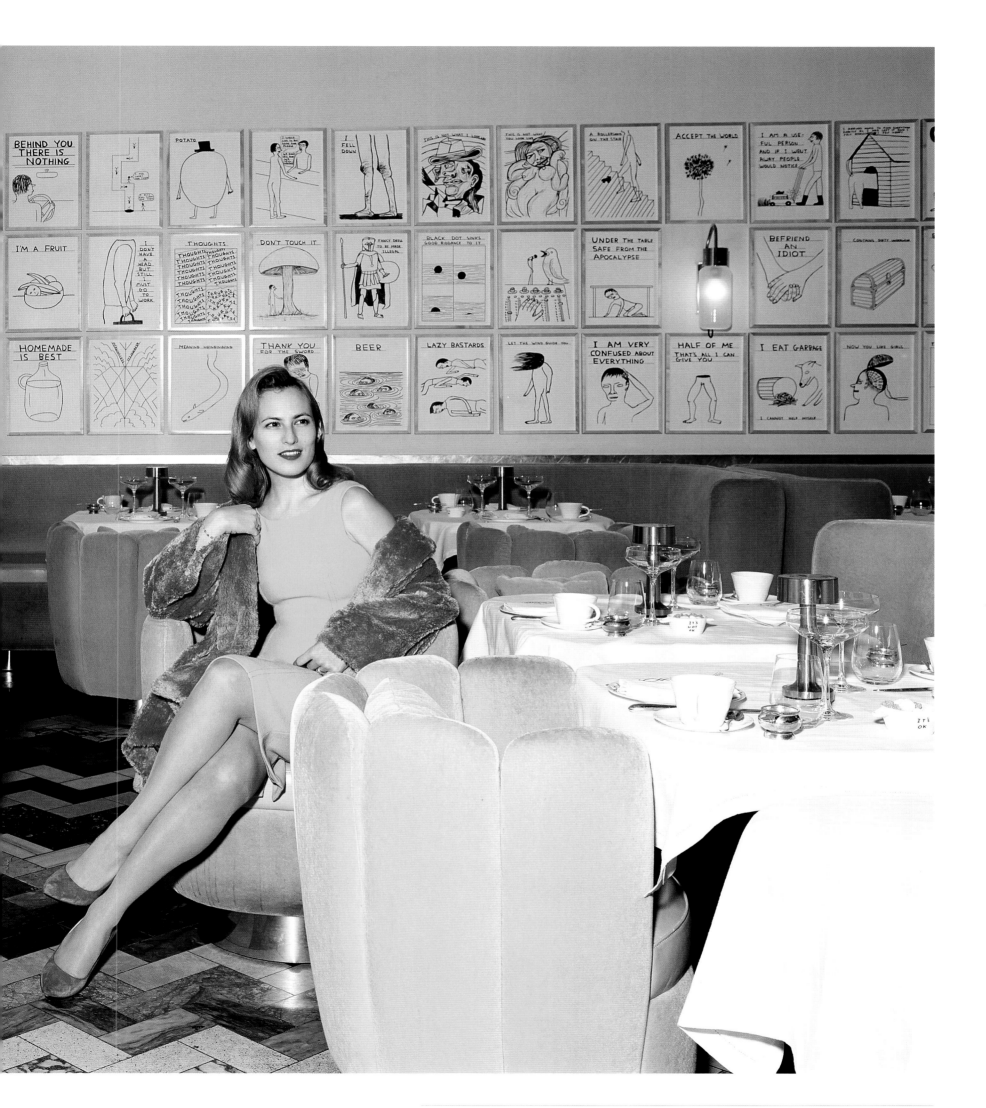

Tinie Tempah
Musician
Chiswick/Hammersmith

How did you choose the stage name Tinie Tempah?
Well, at twelve years old I decided I wanted to do music. I remember being in school and I said, 'Okay, I'm going to take this seriously now. I need a cool name.' I flicked through a thesaurus and saw 'anger' and, underneath that, 'temper'. I said, 'I like "temper", but I need something to soften it.' I put 'tinie' in front of it, and that was it.

You didn't have anger issues, or did you?
No, not at all! Quite the opposite. Especially within the sort of work I do, it's nice to have patience, because it's easy to lose yourself sometimes.

Where does that patience come from?
I think it came from my parents, from the way that they raised me. I've always been advised to work as hard as I could and be able to do everything by myself. Whatever anyone's able to do for me, I'm always grateful, 'cause I don't expect anything.

Does that have anything to do with the fact that you're a second-generation immigrant?
I think so.

Your parents moved here from Nigeria in what year?
In '86 or '87.

What kind of life did they lead out in Nigeria?
My father's dad was the superintendent of police. His mom was a teacher, and my mom was a bit more working-class, if you could even call it that. Her parents were more like farmers.

You've talked about visiting your grandmother in Nigeria and having to go and fetch water.
Yes, things that you never think about doing in England. But it was nice. It was very, very humbling.

It seems that you have a touch of humility about you.
I need to. When I have children, I need to find a way to put that in them. It's important.

When did you first engage seriously with music?
I engaged with music around maybe fifteen years old. I'm from south London, but there was this whole thing in East London called 'grime'. It was like hip-hop, but very underground and niche. Being from south London, I found it difficult to penetrate that scene. There were no barriers or security in the rail station called North Woolwich near my house. I'd go to North Woolwich and then to Stratford and climb over the barriers there. I researched a lot of artists and would go to radio stations and find out where they were. After a year, I started to have lots of friends that were doing that kind of music from East London. I was able to record with them, and that's how I started making music. It was like being in an old boys' club or going to a particular school, like you couldn't get in if you weren't part of this thing. I had to almost disguise myself and sneak in through the back way.

When did you get your big break?
I got my first job as a tele-sales guy. I saved up £800 and shot a music video in 2006. I put it on an independent DIY TV channel and it got a big reaction. That started getting me shows. Finally I was making money from music. That's how I was able to attract my manager, who is my cousin. He saw that video and then we met at a family gathering. So lots of good things started happening off the back of that song.

You were how old?
I was sixteen. My actual big break was in 2010, when I made a song called 'Pass Out'. That went to Number 1 in the UK charts and was the biggest-selling song of that year.

So you achieved success in a very short period.
It depends on how you look at it. Aside from education, I literally woke up and went to bed to make music. From the age of fifteen, I was only working so I would be able to fund making music.

So would you call yourself obsessive or just committed?
When it comes to music, I'm obsessive *and* committed. I love it like it's a person.

(previous page) Patrick Chukwuemeka Okogwu, better know as Tinie Tempah, in contemplative mood in the light well at Metropolis Studios in Hammersmith, where nearly half of the UK's Top 40 chart entrants are recorded, mixed or creatively mastered. 'What I'm trying to reflect back is … it doesn't matter whether you're privileged or not,' the rapper confides. 'You've got all the opportunities in the world'

Tempah on the up-and-up outside the Hammersmith Apollo (left), an Art Deco entertainment venue built in 1932. The Apollo has hosted some of the greatest musical talents of modern times, including Duke Ellington, the Beatles, The Who, Elton John and The Clash. Tinie Tempah himself performed a sell-out show there in 2011. The rapper (below) pays homage to some of the great names in jazz, pop and rock 'n' roll while propping up the recording studio's vinyl collection. 'I'm just ultimately trying to leave my own legacy,' he says with modest humour

'I came from a place where there are hoodies and gangs, but I'm not a hoodie and I'm not in a gang'

The whole business of music is rather mad, isn't it?
It *is* mad, exactly.

How do you deal with the backstabbing and all that stuff?
When I started, you could argue that being naïve and optimistic made me overlook all those kinds of things. There are loads of different types of musicians, but you have some characters who're not necessarily thinking about the money when they're making music, and I was definitely one of those people. However, I came into success where a lot of money was being made. Once you start to concern yourself with those issues, that's when you start to notice the bullshit and the politics. And the fact that some of the dynamics of relationships in music are not very balanced, they're not correct. Basically, the music industry (or any industry that is creative) is designed not to be fair, or not to benefit the artist. You live and die by your every move, and it's only you that lives and dies by it. All the people who say that they created you, if anything bad happens to you tomorrow, they could just be like, 'Oh, that's a shame. That was sad.' But you have to go through the physical thing, the mental thing. The artist suffers the most.

Other artists talk about feeling imprisoned once they have contracts with big corporate entities because everybody takes a piece. But you can't do without the business side, unless you're a busker on the Underground, or am I wrong?
You need the industry. You need the Establishment as much as they need you, essentially. However, it's not designed to be fair.

Let's go back to the beginning. Give me a little background on the Aylesbury Estate, where you grew up.
It's a massive tower block. Massive. When my parents first came over, that's where they lived. My mum was always super-driven. She was the one who taught me, showed me about a side-hustle. That if you follow the structure, the way Western society is designed, and you get your qualifications and you fall into work, you're always going to have to work for somebody. Which is not a bad thing, but if you don't try and build your own dreams, you're just going to end up building someone else's.

What did your mother do?
She worked in the NHS, in human resources. And she would trade, so she would go to Switzerland and buy fabrics and bring them over here. That's how she saved up for a mortgage. I was like, 'What's a mortgage?' and she's like, 'We can't rent. We need to get a house and then another house and then another house.'

So you moved to Woolwich.
Yeah, to Plumstead. That was the first time I had a semi-detached house on the ground floor. I remember that being quite a surreal thing. I wasn't even interested in the house, I just ran out to the garden: 'There are trees here and grass!' I tried to make a tree house straight away.

A lot of kids from your kind of background end up in crime or permanent underachievement or gangs. What made it possible for you to escape that pattern?
My upbringing. Like I said, my mum was overly ambitious, overly optimistic. I had the stability of my parents staying together. But I started to realise that the system was not going to get me to where I wanted to be. So I almost had to make up my own rules. By the time I'm thirty, thirty-five, I can create a system that will work for people who have come from a similar situation …

So you're planning to give back.
Of course. Because identity is so key, knowing that there are people who have gone before you. In England we celebrate Winston Churchill and all these people who were so great in our nation and who make us believe we can do this.

So you are saying that you feel totally British, totally a Londoner?
Exactly. But London, now more than ever, doesn't have one picture. I reflect an aspect of England.

Are you a reflection or a product of London's diversity?
I'm a product. But now I'm at the point, because of my success, that I'm starting to reflect an image of England that isn't constantly reinforced. I came from a place where there are hoodies and gangs, but I'm not a hoodie and I'm not in a gang, so there must be other kids who are not hoodies and who are not in a gang. I want to be a positive reflection for those people who have maybe lost their way and are trying to get back.

In fact, you're the epitome of success. *GQ* has described you as one of the best-dressed people in the music industry. Is that something you've done consciously, or do you just love clothes?
It's a natural thing. I didn't know you could be an ambassador for the British Fashion Council. I didn't know there *was* a British Fashion Council when I first started to get into clothes. I've always loved fashion. Like I said, my mum was bringing back all these different fabrics. Even now, I'm the same age as some of the people who are in my crowd. So I'm always like, 'How can I stand out? How can I be a bit different?'

So you're turning the abnormal into the norm?
Why does it have to be abnormal? If I go on the plane and I'm in a tracksuit, why would somebody be like, 'Are you in music?' I could be a brain surgeon! You don't have to be an older guy with grey hair and a suit. We have to change these constraints because they're not relevant anymore.

You've said that you want to get to a point where you have consolidated what you called your 'position in British culture'. Are you at that point?
That has never been for me to say. I just want to work for as long as I can and as hard as I can.

Here's another intriguing quote: 'Music has no race. It appeals to everybody.' What did you mean when you said that?
I remember the days when my producer would talk to me about people going to jungle raves, where there would be a white DJ, a black DJ, an Asian DJ. The music was the common denominator; it wouldn't matter who was in the club. I wouldn't say there are more successful black artists or white artists; I'd say it's the effect of the music that I think is colourless.

Learning from language and history, Tempah (above) sits at the studio console, coffee in hand, *Roget's Thesaurus* at the ready. The rapper chose his stage name from that volume at the age of twelve while looking for synonyms for 'anger'

Simone Rocha
Fashion designer
De Beauvoir/Mayfair

Is it a coincidence that a lot of major designers are located here in De Beauvoir?
For me, it's a complete coincidence. I moved to London five years ago and lived in the flat above my parents' shop on Dover Street. I went to college in Soho. I've been based in East London ever since. It was originally because my one friend in London lived here, and it took an hour and ten minutes on the number 38 bus to have a cup of tea in her house. So I decided to move out this way.

Your father, John Rocha, is quite a famous designer in his own right. I understand also that your mother has been a partner in his business.
Yes, and she's my partner today.

Where were you born?
I was born in Ireland. My dad is Chinese; my mother's Irish. I have a big family in Hong Kong; I go once a year to see them and really love the place.

Has fashion become a sort of globalised force, unity in diversity, where eventually all ideas meld into each other regardless of where you actually come from?
The thing about fashion that everyone relates to is that everyone has to wear clothes, otherwise we'd all be walking around naked. So someone might not think about music or might not think about art, but fashion has a function: it is there to clothe people. In that way it can run through a lot of different disciplines.

Taking that one step further, why is there this human aspiration to be dressed better than everybody else? Where does that come from?
That is because it's personal; it's the way clothes make somebody feel. I think it's a very selfish thing, and that's why things come in waves. When people haven't been wearing something for a while, it feels new again. It's very emotional and personal.

But if you are wearing a particular brand, you are more noticed, you are somehow separated from the masses, aren't you?
For me, it's about making work that people feel they can be part of. I want people to see my clothes, be able to wear them and integrate them into their personal styles. They don't have to be a certain type of woman.

But why are people prepared to pay a lot more for one brand when they can spend a lot less on another brand, say in H&M, to keep cozy in the cold or keep the sun off their back in summer?
For me as a designer, it's about creating something where I feel that I've thought of something that I can translate into clothes for someone to wear. At a place like H&M, it is not as individual. What I do is bespoke and personal, and people want to buy into that world.

So you individualise fashion. You create fashion to appeal to a strictly limited group, an élite if you will. Is this your preference, or would you rather that your clothes were off the peg, sold at lower prices and used by the masses?
If I wanted my clothes to be used by the masses, I would work for a company like H&M. It is not the path that I have chosen. I want to make something really special because I feel that I can translate work into garments that people can wear day to day. It is a special kind of person: someone who can appreciate it, someone who can see what has gone into it.

(previous spread) Simone Rocha looks through her signature tulle fabrics in the cutting room of her De Beauvoir Crescent studio overlooking the Regent's Canal. 'Fabrics are very important to me,' she says. 'My process always includes throwing in something wrong or off-kilter just to keep people on their toes … to keep *me* on *my* toes!'

Rocha (right), on the terrace of a suite at Claridge's, with the Mayfair skyline behind her, and (below) pausing for a snack in her bedroom while considering some designs. Her father John Rocha, the Portuguese-Chinese fashion designer who resides in Ireland, used to have his shows in the hotel's ballroom. 'Before I moved to London,' Simone recalls, 'we used to stay with my dad at Claridge's all the time. It feels like home.' The hotel has been a watering hole for royalty, celebrities and heads of state since 1856

'I like to be in uncomfortable situations that make you think about who you are and how you feel'

And the price tag makes that distinction?
No. The price tag is because of all the levels you have to go through to make that garment. You don't make something and then whack a price tag on it to be élitist. I have no interest in being élitist.

Do you add value to women's sense of self, do you think?
I hope that when people buy something, they feel that it is a special piece, and that when they wear it they feel special. I'd like it if they felt something from it that they wouldn't get if it was just off the rack and there were thousands of them.

Tell me about your design process.
I get inspired by everything around me, by being a person in touch with the world today. Anything that I feel something from – which usually tends to be something quite personal to me, because I'm not mass-market – it's how I can translate that into clothes.

And the next step is sitting in your office and making mock-ups?
Yeah. Me and my team, we do mock-ups on the stand, toile fittings on a model. It's not like a big machine, it's very organic the way that we work, thinking of what I'm inspired by that is relevant to make clothes out of, like whether it inspires fabrics or silhouettes. Then I start thinking about the next show and listening to music, thinking about where it's going to be and the feelings I want people to feel when they are sat there.

So, from the National College of Art and Design in Dublin to St Martins in London, to Claridge's and Dover Street and Bond Street, you have become quite successful, quite recognised. Do you still find time to float on the wind, to garner inspiration from all four corners of the universe?
I've always done a lot of travelling. I don't get to move around as much now, but I still go to a lot of interesting places.

Did you ever feel overwhelmed by your father's success, or a need to separate your name and style from his?
I came to London rather than settle down in Ireland like he did. He said that if I wanted to do this, I needed to find my own feet; that's why I came here to do the MA. But it's an absolute privilege; I have a wonderful family who really support me.

With the little experience I have of the fashion world, I've noticed that the sense of competition is always there, but that sometimes it veers towards the nasty. Is that correct?
Well, I'm very private and I don't get that involved with anything outside of our work that we do here. So, personally, I have a very pleasant experience. But it is what you make it. I've been going to shows since I was zero. I've been around people like this for such a long time that I try to take it all with a pinch of salt.

How much do you attribute your success to the attention young British designers are receiving these days?
For me the big thing was that England had the best education for fashion design, worldwide. That's why I wanted to come here. Louise Wilson, who sadly passed away last year, was the pioneer of fashion education in England. As part of the education here, for the MA, it was like being in the industry. The British Fashion Council are very supportive when designers come out. If they see promise in designers they will support them, and I was lucky to be one of them. At the time it was a shock. I didn't realise that I would be in that position so early. I was part of a designer collective called Fashion East, and it kind of all rolled from there.

The principals involved in this field – the likes of Lulu Kennedy and Sarah Mower – became very important in propagating British fashion.
Big-time! Lulu approached me after the graduate show. I had never met her; I was just off the boat from Ireland; I didn't know about NEWGEN or the BFC; it was all totally different in my dad's time. So I didn't have a clue. She said that she saw something she really liked in my work and asked if I would show under the Fashion East umbrella. I owe a lot of this to her.

So they gave you infrastructure, gave you access –
They let you on the schedule for free. Now it's really expensive!

How important is the work as such, as set against the publicity and promotion that go with it?
I don't advertise, first of all.

But people like Jean Paul Gaultier, Valentino, Dolce & Gabbana are outgoing personalities, very loud and visible. You seem to be the opposite.
I would definitely be more reserved both as a person and as a designer. For me, it's always been about the work that I make. A big part of the success that is happening now is that at the beginning I got a lot of support from my stockists before I got support from the press. Dover Street Market offered me my own shop within their shop, which was 100-per-cent inspiring because I respect the Covent Garden shop and everything that the label does. To have my own space there, in London, is really what started to cement it. That was my way of advertising the brand.

As you grow, how do you deal with the success that comes with it?
It's wonderful! Sometimes I have to step back and make sure that I appreciate everything that is happening because I get so busy. For me, every show has to be as good as the last, and that's what I focus on every season. Everything else is a bonus.

How much have the demands of the business changed you as a person?
No-one keeps you grounded like family. I work with my mum, so –

You seem to have an affinity for powerful women. This strength of purpose and feminine commitment, from where do you draw them?
I've always been attracted to things that have femininity, strength and humour.

But you have described yourself as a tomboy.
Yeah. I'm not a girly girl. I'm very much a realist. When I was in primary school in Ireland, there were thirteen boys and three girls in my class, so you had to be a tomboy. I think that's why my work never turns into satire; it always has to have a boyish slant to it. That's what makes it interesting and not super-sweet.

So would you say you are rebellious?
I was. If you ask my mother, until around four years ago she would say that I was wild. I really tried to live my life and not be in a glass box. I like to be in uncomfortable situations that make you think about who you are and how you feel.

Another nostalgic venue: Dover Street Market (above), where Rocha hosts a shop-in-shop. The Georgian building is the former home of the Institute of Contemporary Arts. When Rocha first moved to London, her father had a small flat above his own shop on Dover Street

André Balazs
Hotelier/Creative entrepreneur
Marylebone

You've been living in London since when, the 1980s?
No, no. I've been coming to London for a lot longer. This project began four, five years ago.

This project being the Chiltern Firehouse ...
And it's the first project I've done here, so although I've been looking to do something for easily a decade, and have put in bids to buy buildings at least three times before, I always got outbid. This happened to be a unique property that I discovered with a friend, because I was just in the neighbourhood. I love to discover the back alleys of the city that way. You end up seeing things differently on foot or jogging. Anyway, it was a dilapidated firehouse that had been empty for fifteen years, the façade had been torn off …

How were you able to see its potential on the trot?
It's just one of the things I like to do. I love architecture and unusual places, and I loved all aspects of this particular corner. I love Marylebone; I love its proximity to Mayfair, but it's not really Mayfair; I like the street because it's a dead end so it becomes village-like. I started coming here aggressively when we started the project because it took about a year and a half just to get permission to convert it to commercial use. It's complicated 'cause if you take some building in Westminster out of circulation for one use, you have to provide alternate space for the same use.

How does someone like you deal with that level of bureaucracy?
Every aspect of the process becomes interesting to me as long as it's different. I'm an entrepreneur at heart, and what fascinates me is solving problems. I get bored when there's repetition.

But bureaucracy is an ugly challenge to creative aspirations.
It's not fun, and it can be frustrating, but every place we've ever done has been full of challenges. I don't think we've done a project that hasn't been in either a restricted neighbourhood, a landmark neighbourhood (or a landmark building) or a residential area. What I like to think we do is provide real estate-based entertainment. We go through a process that is like creating a movie: casting it, coming up with the concept, the narrative. Having an asset-based form of entertainment puts it in a different league than pure film, which is more ephemeral.

You're very much a details man; you're hands-on in all aspects of your work. Having studied at Columbia and Cornell, you set up a business called Biomatrix, is that correct?
It's a biotech company, yeah. When I was in high school, I wanted to be a sculptor, but I became frustrated by the fact that no-one back then understood the language of three-dimensional design. It was like being a poet in a language that nobody read. So I became interested in architecture and things that people could appreciate more.

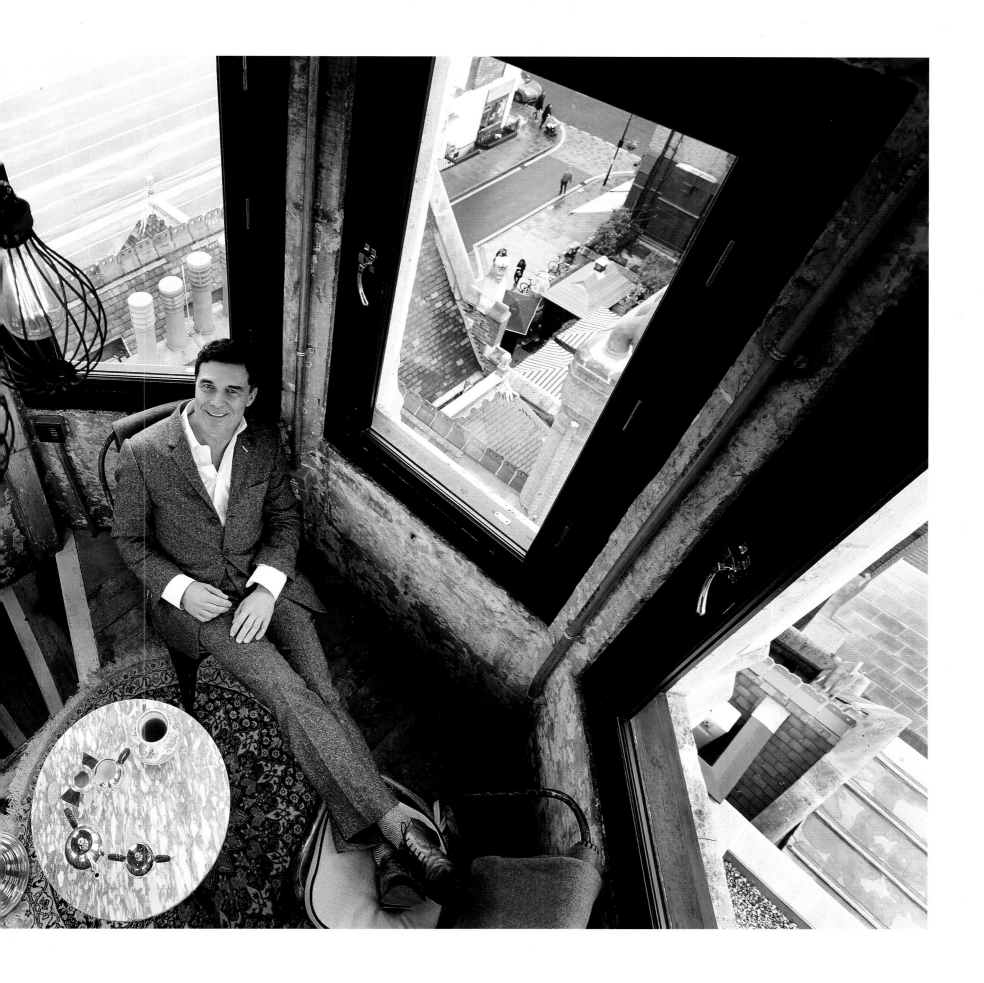

How did you end up being interested in so many different things?

I was interested in three-dimensional design, and then I became interested in journalism, in narrative, in storytelling, something so immediate and understandable compared to sculpture. And I briefly worked in politics. Then I wanted to start a company again. The idea of creating something from nothing, whether it's a business, a property, whatever, is fascinating to me. I like the fact that it's iterative and non-repetitious; you're always moving forward even if it's not in a direct line. What I wanted to do was start a business when biotech was being funded for the first time. My father, who was a researcher and an MD, had specialised in the intracellular matrix, so we started a company to find medical applications for work that he had been pioneering throughout his career.

Do you believe that the playground of life provides better training than academic matriculation?

It depends on what kind of education you're talking about. There's no substitute for clear thinking, and that is a direct result of education.

Both your parents are professors. Where did you grow up?

I was born in Boston, grew up in Cambridge, Massachusetts, and moved to New York after school.

In academia, one wouldn't expect to find someone with verve, panache, a sense of class and enough creative nerve to go out and undo the standards of the hospitality business, though.

That's exactly why I left Boston.

Isn't the hospitality business the biggest GDP component in the world in terms of revenue and employment?

If you throw in all aspects of travel, it's probably one of the biggest, yeah. And it's growing. At the same time that social networking is increasing, the demand for face-time is also increasing. In fact, when people are in an urban environment, specifically an environment where they have chance encounters and intimate relationships, those factors foster creativity. There's a reason why companies like Google are moving their offices out of suburban campuses into the centres of cities. There's an aspect of urban life that is compelling, and it's becoming more obvious how it's more productive.

Can you give me an example of how urban cultural friction leads to creative overspill?

If, say, someone files a patent for a component of a jet engine, then surrounding, related patents blossom. Creativity is like a virus; it's contagious. If people have a good idea, they have a coffee, they meet face-to-face.

(previous spread) 'What makes success? I think it's just attention to detail': André Balazs in the Gothic Revival tower of his Chiltern Firehouse hotel and restaurant. The tower of the decommissioned Marylebone landmark was originally used for fire-spotting

An aesthete with a string of international hotels and restaurant ventures behind him, Balazs is always on the lookout for a city's creative heartbeat, in this case the Howarth of London specialist woodwind shop on Chiltern Street (below), one of the world's finest oboe-makers. The entrepreneur takes calls in the Firehouse's cobbled courtyard (top right), and takes in the view from the roof overlooking Marylebone (opposite). 'For better or for worse,' he observes, 'our hotels have completely transformed neighbourhoods'

But there are also bad urban viruses, for instance huge hotel chains. I can go to any of them in any city and not know where I am.

Most of the big hotel chains are changing, but in the forty years after the war they were all American. Hilton International actually had investment from the CIA because they were looking for ways to transport the message of America's open society. At the same time, people thought that the world was a dangerous place. So they would have slogans like these on big hotel chains: 'It's a home away from home' or 'Where the best surprise is no surprise'. That has changed completely. The big chains are the opposite of where most people want to be now.

Why is travel so important in our modern world?

One of the greatest luxuries in life is travel. You can sit at home and consume anything at all on your laptop, but in order to experience something you have to go somewhere. With that comes the idea that if you go to a hotel in a new city, what's the point of being there unless, when you're in that hotel, you feel like you're in that city, in that neighbourhood and in that building in particular?

What significance does London have for you?

London is in an incredible moment in its history. Having lived in New York before and after 9/11, I not only saw the insane exuberance of the city at its best, at its most hopeful, its most dynamic, but then, over the last decade, a complete collapse of that, and an inward-looking-ness. I love New York, but right now in London, because of the banking laws, the tax laws, the acceleration of wealth and mobility around the world, the fact that they're converging through London, there's an optimism that is vital for creativity. That fuels everything else. It's not necessarily about money, it's the psychology behind it. I'm aware that this is a city of small villages, but that village aspect is being overwhelmed. It's also triggering the best of English qualities.

What role has money played in previous cycles through which London went starting in the 1950s?

In every city in the world, commerce has always fuelled the arts, or whatever you want to call it, however you define creativity. Look at Florence, look at Rome, look at Athens. Any city at the convergence of the flow of commerce is always where the arts flourish. If New York had not been America's premier economic city for so long, it would not also have developed as its premier intellectual and cultural centre. When I moved to New York, you could still go from kindergarten through graduate school all paid for by the city. So New York had a massive infrastructure based on its wealth in education. In comparison, London has the infrastructure to sustain it as a great city while New York is losing it. Virtually everything interesting in New York is being done through either private enterprise or volunteerism or philanthropy, which makes it more haphazard, more limited in scope and less game-changing.

What are you planning to do next? You've got this big hotel chain, The Standard, cropping up all over America. Are you planning a Standard in London?

Yes. We're working on one in Camden. I was at St Pancras visiting a friend and noticed this building that I liked, which was for sale: the former town hall. It's a kind of 1970s architecture that many people think is ugly right now, but in ten years' time they'll think it's iconic. I'll make sure they think it's iconic!

The role of a creative developer like yourself, a creative entrepreneur, is pretty crucial to a city's transformation, isn't it?

That's why I wouldn't separate commerce from creativity.

On the other hand, you see these ugly outcrops going up all over London ...

The economics of the development business are: Build it as cheaply as you can, then sell it for as much as you can. Unless someone has a passion to create something good, it tends not to produce memorable work.

Do you ever regret, having luxuriated in your success, that by transforming neighbourhoods, you change them beyond recognition, often putting them beyond the means of the general population?

I have mixed feelings about it.

'I'm an entrepreneur at heart, and what fascinates me is solving problems. I get bored when there's repetition'

Chloe Aridjis
Writer
Angel/Bloomsbury

You were born in New York, grew up in Holland, lived in Mexico and Berlin. Your father was from Smyrna, your mother's family was from Lithuania. You studied at Harvard, did a PhD at Oxford. How do you define personal identity within a mix like that?
One thing I've come to realise is that it's a very fluid identity. It's been liberating to not be easily classified culturally.

Liberating for whom?
For myself. It can also be confusing sometimes, and overwhelming, but it gives you that degree of distance from everything. You never belong entirely to one society or culture.

Do you feel different from other people in London when you go, say, to the market?
Less so at this point, because you all inhabit similar urban landscapes, but also rhythms, expectations from a city.

So you can pick and choose, you can go cherry-picking round the world. Is that the bottom line?
To some extent. Being a writer, you're not anchored anywhere. It's just me and my cat, so we can go wherever.

But you have this amorphous idea of magic realism in your writing that you carry around with you, don't you?
I'm interested in the element of the fantastical in quotidian settings, so nineteenth-century German Romanticism and some twentieth-century writing and music and painting …

Nothing out of Latin America?
Juan Rulfo, for instance, a twentieth-century Mexican writer who only wrote two books. Since my father's a writer and writes in Spanish, my interests have tended to be more Eurocentric. I grew up bilingual, but I was always interested in French and German literature and in Russia and Eastern Europe, although I don't read those languages. It's always the lure of what's different.

And so you've chosen to anchor yourself in a safe, civilised city like London …
Well, Berlin was a very, very powerful chapter in my life. If I sit down to write a story or think of a character, I almost immediately have this dystopian perspective towards Berlin. I was worried when I left Berlin that something would be lost, that the strangeness and inspiration or stimulation I had from the city would be difficult to find in London.

Surely London is more layered and has more history than Berlin …
Well, it's less in your face sometimes. I find it less present. Part of the reason I love Bloomsbury is that there is a sense of travelling in time.

You're a bit of a time-traveller, aren't you? A romantic, literary persona somewhat lost in the present?
Yeah, I think I was born in the wrong century.

(previous spread) Chloe Aridjis at home in Angel. The Mexican writer, who grew up in Holland, has lived in Mexico City, Berlin and Oxford. 'My new novel is set in Mexico with an ancient Greek element,' she says, compounding her aura of mystery and magic

So where do you see yourself rooted intellectually? It seems to me that you are more tied to your French literary roots than to any English ones.
Of the writers who have been most important to me, almost all are French or German, but English is my language. I write in English.

Do you switch characters when you speak?
Well, it's strange. The new novel is set in Mexico. Writing in English feels very odd, and I'm still trying to decide what to do about that. It's strange narrating a character's life in a language that's different from its own.

So you sit in a bohemian *quartier* of London, a gentrified, yuppified area of the city, and you travel via the Google of your imagination to Mexico … Or do you actually go there to do research?
I go twice a year to Mexico and spend time with my family. But with this new novel, since it's set in the late '80s, a lot of the places don't exist anymore. I don't want to rewrite over the memories I have, so that's something else I'm trying to decide, whether to go back to Zipolite, to the beach where a lot of the important events of the book take place.

Your first book, *Book of Clouds*, how long did that take you to write?
It's hard to say, probably four years.

And within those four years, how many notebooks did you fill?
I don't know, eight or nine or ten.

And each one was revisited time and time again?
What I usually do is, I transcribe my notes onto the computer and then elaborate and slowly find a structure.

You've described yourself as feeling 'increasingly nomadic'. You hold dual citizenship, Mexican and American, yet you live in England. What is it about England, about London specifically, that keeps you here?
It's a city that gives a lot in return, but I could imagine later in life living outside London. I will probably stay in England for the rest of my life with all these long stays in Mexico, and I'd love to spend long periods in Berlin as well. I've given an enormous amount of thought to why one chooses to live in a certain city, if one has the freedom to choose. For me, the conflict was magnified when I was trying to decide whether to move back to London or stay in Berlin. I realised that living in a foreign language, culture and society all fed into the book I was writing; those two or three degrees of detachment were very beneficial. After a while, one chooses also in terms of personal happiness. I have important friendships in Berlin, but I have more here, and here I feel much more of a community. And it is my language. I feel one's literary personalities are often halved in another language.

Relate to me your sense of belonging as you walk through any particular space in London. Do you hold to a single identity or do you need to, as you might put it yourself, roam?
Very much to roam.

Do you observe faces? People?
Yeah, a lot.

Deeply?
It depends. If I'm preoccupied, I don't look up.

What preoccupies you in the everyday context of the city?
Often banal, prosaic things. In December I had to apply for indefinite leave to remain, so for two months I was anxious about that. I had to take an exam. So often it's very concrete.

Let's talk about that exam, about being tested to qualify for remaining in a place …
This is an exam for permanent residency, but you need to take it also for citizenship.

How did you feel about being subjected to such a banal test? Did it piss you off in a way?
Well, it was so absurd. Because it's not even about knowledge, it's about memorisation of the contents of a booklet that was apparently revised under Michael Gove. It's all about illustrious history, kings and queens, a whole section on Thatcher. I took it with a bit of humour. It was something very abstract up until that point of my life here. Suddenly it seemed very tenuous, and I realised that I was here on other terms from all my friends. There was of course a large level of anxiety, but I tried to be humorous about that too. I became extremely aware that I was foreign, that at any moment my living here could be taken away.

Did you feel like an interloper at all?
Not really. I mean, everything here is so expensive that, with things like the NHS, I feel I'm entitled to them because I pay so much for everything else …

You've lived in London for a total of ten years. Within that period, how have you seen the city change, and what differences do you notice in its sociology?
Unfortunately, it's losing character everywhere, on almost every high street in every neighbourhood. Islington used to have a community bookshop; now there's just one Waterstones. Upper Street is just one real-estate agent after another, many chain restaurants. Essex Road still has a bit of the past, old record shops and second-hand … I can think of very little that's positive. Even in East London, people are being pushed out. And down the road, the Packington Estate, social housing, older generations that have been living there for decades are being pushed out and having to find new homes at age seventy or eighty.

Do you feel any kind of crusading urge on their account?
The only activism I've ever done is animal activism, protesting outside the Japanese embassy against the dolphin slaughter in Taiji. That's something that keeps me awake at night. I feel there are people who would do better than me. I'm not English; that's somewhere I do feel foreign.

Even in this cosmopolitan city?
Yeah. I know there's nothing stopping me, but I feel inhibited to be more politically or socially active. Maybe in the future.

Chloe Aridjis

Aridjis often walks down to Bloomsbury, historic home of the Bloomsbury Group and her favourite part of her adopted city. 'When you're walking here, London allows you to be almost disassociated from its various components,' she reflects. 'How many languages you pass on the street, how many colours, shapes and faces!' The writer (opposite) proves her point outside a multicultural, multi-choice funeral parlour. The Swedenborg Society on Bloomsbury Way (top right) is currently presided over by her father, Mexican poet, author, diplomat and former PEN President Homero Aridjis. As in the spirit world, so in real life: Aridjis happens upon the London Review Bookshop's window display (above) just as the word *Mexico* is being stencilled on the glass. Located on Bury Place, the shop is a classic example of London's unfading charms. Arriving at her final destination, Aridjis takes intellectual refuge in the British Museum's Enlightenment Gallery (right), where thousands of objects are exhibited as they would have been in the eighteenth century. Aridjis holds this place sacred above all others in London

'It's a city that gives a lot in return, but I could imagine later in life living outside London'

Matthew Freud
Founder, Freud Communications
Primrose Hill/Tottenham Court Road

Can you say something about your lineage before we move on to other things?
My uncle Lucian had a German accent until the day he died, and my father didn't. My grandfather was an architect on the fringes of the midcentury Modernist movement. My great-grandfather came in 1938, maybe '39; he made it out of Vienna because one of his patients was Marie Bonaparte.

You're talking about Sigmund Freud ...
He settled in Maresfield Gardens, which is now the Sigmund Freud Museum, and his daughter Anna, who lived with him, set up the Anna Freud Centre and the Tavistock Centre. So the origins of modern psychoanalysis in this country are based around Swiss Cottage. We lived in Boundary Road and out on Primrose Hill, so I grew up belonging to this new tribe of north London intellectual, creative, entertainment types.

Was there a pre-existing bohemian tradition in north London?
The '20s and '30s saw a primarily East European Jewish community settle around north London. Commerce went to Golders Green, and intellect stayed closer to Regent's Park.

With which identity did you grow up yourself?
I grew up as part of this new generation who weren't part of the class system, which was beginning to unravel in the '60s. My dad was a journalist, a club owner and a restaurateur. He had a club in Sloane Square, which is where Peter Cooke, Dudley Moore, David Frost and what we call the 'New Establishment' would hang out. I never left London. I mean, I left once for a few days. I was sent to work in a kebab shop in Michigan when I was sixteen. They were trying to get me out of trouble, I think.

This new generation you speak of, what triggered its rise?
Something started around 1963 that was this extraordinary catalyst for interesting, challenging, in some cases difficult cultural expression. Punk was born of this city, Freud and Bacon and Auerbach and Hockney, Lucian's excursions in the East End …

So which inspired which, the social friction or the artistic scene?
I don't know. One Establishment has run the UK since 1066. There's never been a revolution. You know, Prince Charles still owns Devon and Cornwall. Not because he's got some titular right; he actually has the deeds. Five people own Scotland. London is still primarily owned by three families who had farms here. I went to school at Westminster, and every morning I'd go to prayers in Westminster Abbey, which is a thousand years old, a Norman building. I didn't really look at it at the time. I've been back since. God!

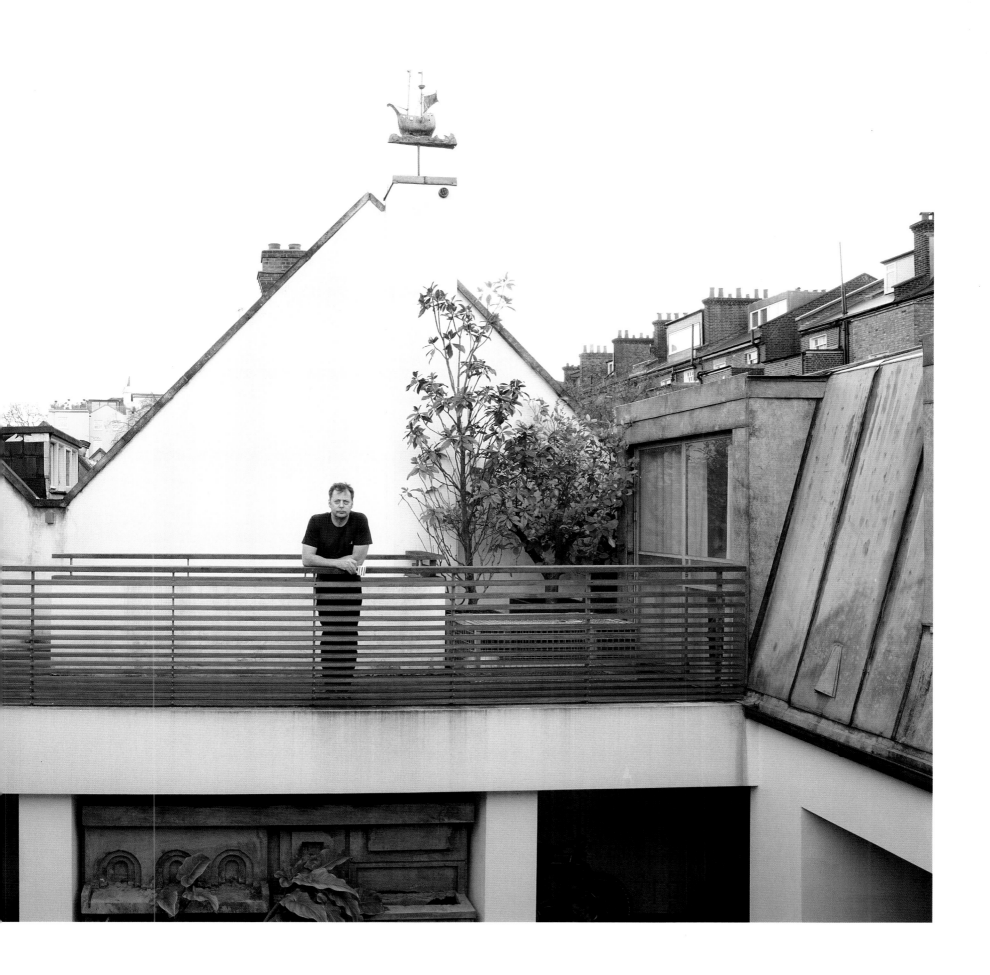

'London is still primarily owned by three families who had farms here. I went to school at Westminster, and every morning I'd go into prayers in Westminster Abbey, which is a thousand years old'

(previous spread) Matthew Freud on the balcony of his Primrose Hill home, formerly the site of a greetings-card factory, which he and his ex-wife Elisabeth Murdoch redeveloped to include a pool, guesthouse, offices and gym. Next door are the Primrose Hill Studios (built in the 1870s), where such artists as Joseph Wolfson, Patrick Caulfield and Sir Henry Wood lived and worked in more modest surroundings

Was that a kind of culture shock, coming down from Hampstead to face a very traditional Englishness?

No, because I grew up at the tail-end of the thousand-year-old Establishment. You could write people's obituary on the day they were born with a reasonable degree of confidence up until 1940, maybe even in the '50s. If everywhere you walk, you see thousand-year-old buildings, the same rooflines, a couple of buildings missing from the war, that's a good way of keeping people in their place. You knew, with this relentless messaging, architecturally and culturally and socio-economically, that this was not an open society. It was dominated by a political class, by a rigid class structure around what school you went to, by whether your family was in *Debrett's*, by how many generations of your family had worked at this bank or lived in this house. At school I was a vague honorary member of a famous-surname club. It dawned on me that the Gettys, the Rothschilds, the Rockefellers and the Westminsters set up bigger trust funds, that their heritage was vocational and profoundly social. I came from a non-practising Jewish father, a Roman Catholic middle-class mother. This was not a celebrated birth certificate.

How did name recognition affect you as you were growing up?

At the time, fame was an unusual commodity, and people didn't like Jews so much. Psychoanalysis wasn't a popular movement. There were only about ten famous people in the whole world when Sigmund Freud was alive. Because media were so slow, by the time you became renowned on a couple of continents, either you were long dead or you were head of state or a general. So my father – growing up as a famous person's grandson – and Lucian were immensely irritated by the fact that people would point and say, 'That's Freud's grandson.' My dad became famous as a television presenter at the point when people, through the media and television, were suddenly appearing in twenty million lounges or front rooms every night.

People like Lucian and your father broke the mould, didn't they?

Fame as a commodity seemed to act as an antidote to the Establishment hierarchy. Very rich Americans were occasionally allowed into English society, but they did clever things with them where for instance the names of great houses were pronounced differently to how they were spelt. So when people would say, 'Oh, it's lovely to be here at Althorp,' the Earl Spencer could turn around and go, 'It's *Althrop*, actually.' What happened with the social mobility that fame and media allowed was that suddenly it didn't matter where you had gone to school or what your family was. Lucian, you know, slept his way through most of the wives of the aristocracy. He was welcomed into their houses and repaid their hospitality with paintings and sexual favours.

And then what happened?

The '70s gave way to the social unrest that began to emerge after the '60s, where suddenly the police and the Establishment were aware of the impending threat, the behaviour and entitlement of people who had forgotten their place. The police presence in London in the '70s was palpable, partly because the IRA were active. It's odd now that we look at conflict zones and think how terrible it must be to live in such places. I used to sell badges at Westminster that said, 'No future'. All the boys at Westminster, their futures were fine. But I did a very good trade.

So you dared to be different from the start.

London suddenly challenged people to be different. Look at the mistakes that were made. All over the city you can see these massive architectural errors where apparently the rulebook had been abandoned. So for my generation, the rulebook was not about whether you could get into the right club or what kind of building you built or whether you went into the City; it challenged you to express yourself. And there was a recession, the economic catastrophe of the '70s, where there was a property crash. Many buildings were derelict and squatters moved in. We lived in a lovely, big townhouse with a garden in St Johns Wood, but next door there were eight drug dealers, this kind of hippie commune.

And what about the '80s?

What happened around the '80s and '90s led to the creative-entrepreneur boom. When I started my company in 1985, it wasn't because I thought it was the most fantastic opportunity, because there weren't many opportunities and there wasn't much downside.

What broke the camel's back, in your opinion?

Thatcher's last stand against the unions, the Poll Tax Riots. The closest we've come to civil unrest in this country without getting to revolution was running battles. It's not even a term you hear anymore, but there was a thing called 'Generation X'. That was the 50 per cent of Britain about which Thatcher just went, 'Fuck it,' dismantled the benefit system and made it very, very, very tough for the bottom of society by breaking collective bargaining and by inspiring more people to break away from the working class and own their own council homes, television and clothes washers on credit. Collective bargaining only works if everyone sticks together.

Freud attends to messages at home (opposite) surrounded by contemporary art. A passionate collector, he displays pieces by Warhol, Hirst, Banksy, Gilbert & George and Francis Bacon in his offices. 'I never like to set foot outside of my domains,' he remarks. 'I go to my house, my office, the country house and the restaurants that I either own or like. I never go anywhere which is not under my direct control, something I'm working on with my analyst' – a revealing joke from Sigmund Freud's grandson. The communications supremo oversees his son Samson's homework (left), his Labrador Vincent by his side, and (above) prepares a cookout at the Dirty Burger shack he had installed in his courtyard

Freud's new offices in Tottenham Court Road, where visitors are greeted by artworks on the premises (right), including Shepard Fairey's portrait of Barack Obama and Damien Hirst's desk (below) from the now defunct Pharmacy restaurant in Notting Hill (Freud helped Hirst launch Pharmacy in 1998). 'Creativity is our only naturally recurring resource in this country,' Freud observes. 'We don't have oil, we don't have gas; we have people'

'We have KPIs that show that economically we're the number-one city, that culturally we're the number-one city. We have the number-one language. London is the centre of the world'

Nevertheless, in that same period the state maintained the class that became the YBAs. From big names like Antony Gormley to lesser folk, they all went through the squat system and benefits racket.
Yes. It's interesting … Now there's a renaissance of the old Establishment, and the vast majority of creative achievement is coming from Eton and Harrow.

How do you explain that?
It's cyclical. There's a nature/nurture argument about whether this is genetic fight-back, but certainly the majority of social mobility using fame, celebrity and creativity came from the working class throughout the '60s. These days the only way a member of the aristocracy is going to get into Jay Jopling's front room is if he can paint, act or write. There's a new creative hierarchy in London, the greatest city on earth. We have KPIs that show that economically we're the number-one city, that culturally we're the number-one city. We have the number-one language. London is the centre of the world.

What about LA, New York or other creative centres?
No, no, no, no! Not even close. If I think of the world growing up, the map had the Atlantic in the middle. America was the centre of the world and England was off to the side. The world's turned. You barely see America on a map now. The world is about Europe, about Asia, about the former Soviet Union.

Will London always be your home? What about Vienna, for example?
In some cases, where you're from is not where your parents are born, or where you are born, and not where you live; it's where you are accepted. I go to Vienna and I feel nothing. I don't feel home anywhere other than here.

Getting back to personal, as opposed to urban, dynamics, your name has always driven your brand, right?
Not intentionally. My name was more famous than I wanted it to be when I was born. I've probably failed in diminishing it. If you're born with a surname that's so much more interesting than your Christian name, it definitely gets a bit weird. So if you have a name, but without a trust fund and without a family bank to join, the first thing you try to do is establish your Christian name over your surname.

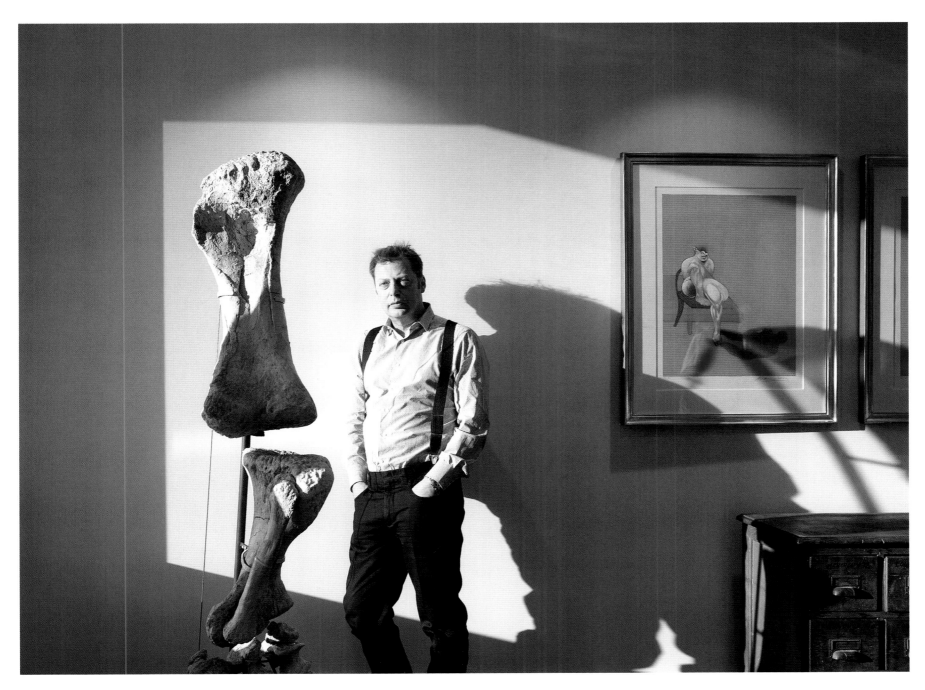

Leaving names to one side, to what would you attribute your success in public relations?

There's this vague rule in my family that you try and do something that no-one else has done. My great-uncle invented public relations, but I didn't know that when I started. I was the youngest child of the youngest child of the youngest child. The youngest always goes off in a slightly different direction than the previous generation.

But you capitalised on the riches of your family background, no?

You neither want to live it down nor have to live up to it. An intellectual dynasty is a fairly unusual thing because normally dynasties have financial and vocational substance. Whereas, in our case, we just had a dysfunctional family and a prominent surname.

Was that what prompted you to outsmart your surname?

You don't have to come from an unusual family to have some aspiration to achieve, to leave some mark. Ambition is not the preserve of the children of the ambitious or the successful. In common with a lot of people of my generation, the motivation was as much psychological as anything else. I remember having a long, long conversation with a group of people, all of whom had incredibly successful fathers. As it turned out, every single person's father was a son of a bitch. We came up with a conclusion along the lines that the pursuit of greatness was the consolation prize for a lack of unconditional love.

To what, then, do you attribute your own success?

If I was going to overanalyse, I'd say that, if there is some genetic ability that has reoccurred in my family, it's been analytical. It's been about how certain members of this one gene pool have looked at something and seen it in a different way. I can't paint, I can't write particularly well, and I definitely can't design anything or play any instruments, but I'm quite good with stories, with narratives. I'm more a curator than a creator.

Freud compares bone structures (above) with bits of an Ankylosaurus, a fifty-million-year-old dinosaur. 'PR is storytelling,' he confesses. 'It's trying to find a way of making something interesting enough so you don't have to pay people to listen.' Matthew Freud Associates was set up when the PR guru was just twenty-one years old; today Freud Communications is one of the UK's largest PR companies

(following spread) A view from Primrose Hill towards London's crisp winter cityscape, with Freud at an open window. 'I don't think I'm a product of my family,' he says ruefully. 'I'm a product of my city'

Matthew Freud

Duro Olowu
Fashion designer
St James's/Masons Yard

Would you call yourself a gentleman-tailor?
I think I am best referred to as a designer.

St James's for the longest time has been representative of English chic. The word *designer* never figured in earlier days, did it?
It did for a while. But 'designer' also refers to the fact that I design clothes for women, not just men. You have to be more general as a description of what you do. I design furniture, furniture fabrics, clothes …

You were born in Lagos. At what age did you move to London?
My mother is Jamaican, so we were coming here on holiday all the time because she had family here, since the early '70s. Then when I was fifteen, I moved. I went to school and university here, and then I moved back for five years and did my national service etc. And came back to England, to Europe, permanently.

When you make a shift of that nature, is there any culture shock involved?
Not really. The culture shock was going back to live for a few years fulltime as opposed to being here. It was a culture shock of how much the cultural life had deteriorated. In the '70s, early '80s, Nigeria was the centre of culture and commerce. You had the FESTAC festival, which was huge, but you also had incredible members of the art and literature intelligentsia, worldwide, visiting. By the end of the '80s it had all disintegrated because of oil and corruption. That was my culture shock.

You live between New York and London, don't you?
Yes. My wife and I have a place in Harlem, and then I live here in Ladbroke Grove. I've lived in Notting Hill for almost twenty years.

Why New York?
The reality is that travel is much easier than it used to be. You can decide at 4.00 that you need to be in New York, get on a plane at 6.00 and be in New York in the afternoon.

Is that one of the things that makes London what it is today?
Well, as far as a central point for what I do, I show in London and then I go to Paris during the collections. I go to Milan; I have a lot of manufacturing in England and in Italy, so I go to Italy a lot. Then my wife and I live in New York. So as a central focus point, London's great. If I need to fly to Lagos to see my family, it's quick. But also, I've always maintained that there is a creative freedom in London that is not quite the same anywhere else …

Even in New York?
Oh yes. In fashion for sure. There's a certain freedom to do what you want. Of course the difference with me is that my biggest market is in America. I get huge support in America from press and such, but you have to deliver. London does have the ideas, and somehow you're freer about them. You don't feel constrained by trends, or mood boards, or colour – whatever everybody else is doing. Also, I love that London is so international; I thrive on that. I went to school with people from all over the world, some of whom are still good friends. Only in London could you have such a diverse cultural and professional milieu.

What about snobbism? Up until the '60s, London was the epitome of snobbery and class barriers.
Kind of. The reality of London is that people from other countries are very confident. They do not feel that they can't walk into a certain store because they're not rich. That's why England, London particularly, is so great. That's why you get this concentration of people who do things and mix. Snobbery is in the heads of those who feel they're being snubbed. (A lot of the time it's not; people are busy sometimes!) I would love to think that snobbery, like racism, or like sexism, or like homophobia, or like xenophobia, just occurred to people because somebody else told them. The reality is that for all the multiculturalism and great artistic merit it brings to the mix, we're sort of existing alongside of that. So it's a volatile and exciting mélange.

If push came to shove, would you ever move to New York?
My wife is a museum director, and I respect and love what she does. She has curated some great shows. She can't move. The same opportunities are not here in the same way. I wouldn't expect my wife to give everything up, and vice versa. A week every month, it's expensive, but it works.

When did you start wearing clothes to be fashionable?
That really started in the '70s because we used to come here and to Geneva for the summer. My father used to take us to Portobello Road because we were obsessed with Jimi Hendrix. Visually, records were very much a fashion statement for me, and also my parents loved clothes. But not in a showy way. They always said, 'Instead of getting five mediocre things, get one great thing.'

Your mother favoured Yves Saint Laurent, I believe …
Yes. She used to mix Saint Laurent with Nigerian clothes, with Jaeger – whatever. My father came from a sort of royal kind of a family, so he was meticulous in how he saw fashion. My mother would mix it, which is reflective of what I do. I'm very close to my parents.

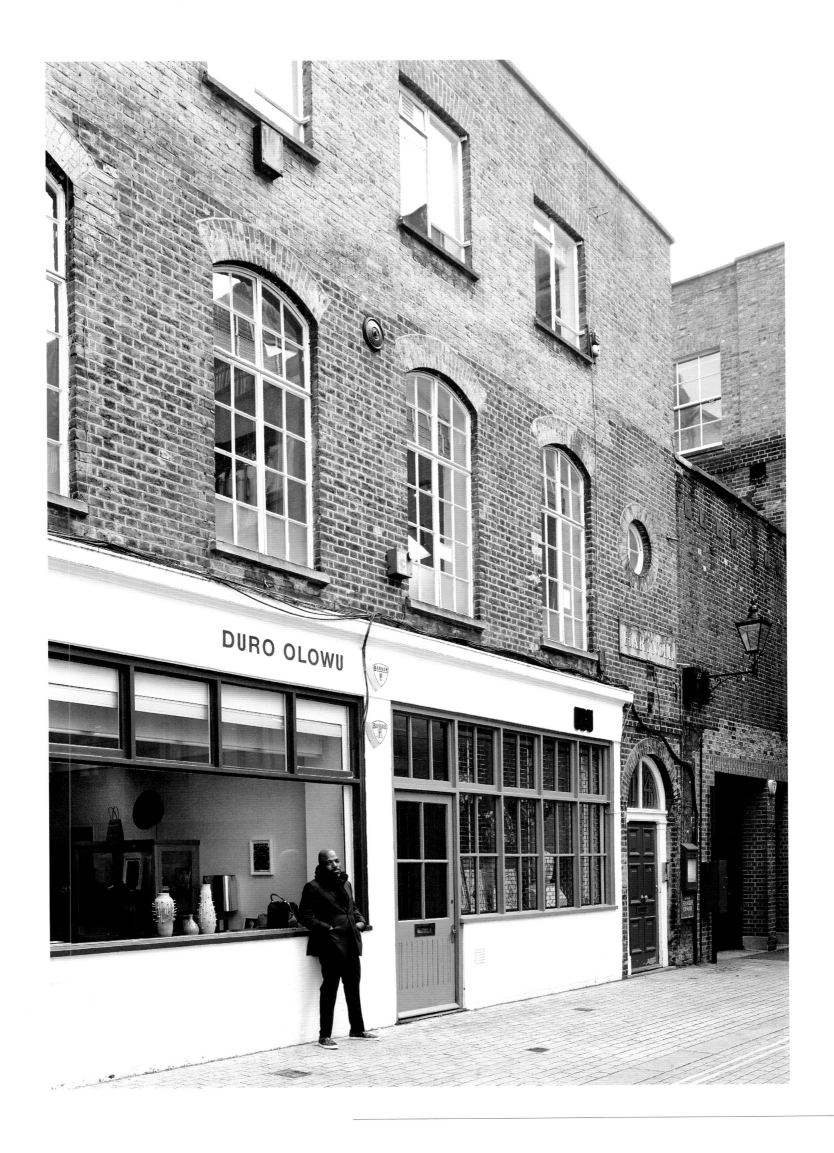

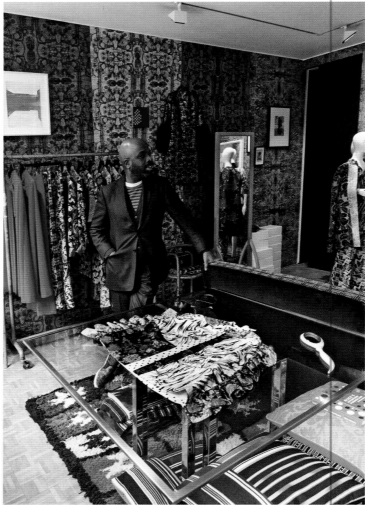

Olowu (far left) walks to work past White Cube; the minimalist structure is a former electricity substation. A keen collector and sometime curator, Olowu (left) is surrounded by his extravagant designs and small artworks in his boutique. 'You just want that one pattern or one shape to relate to someone,' he says of his work. Martine d'Angeljan-Chatillon, art dealer, fashionista and partner at Thomas Dane Gallery, contemporary-art specialists also based in St James's, is a fan. Wearing one of her favourite designs, she breakfasts with Olowu (opposite) on oysters and champagne at Wiltons. George William Wilton started his career selling cockles and mussels from a stall in Haymarket in the eighteenth century. Moving up in the world, the shellfish-monger's restaurant received a Royal Warrant in 1884. It is considered one of the last London bastions of the English aristocracy

(previous page) Duro Olowu outside his boutique in Masons Yard in St James's. The motto of the Nigerian-born designer, who launched his fashion label in 2004, is 'Stick to what you love, and you have to have some integrity!' Originally built as stables, Masons Yard is home to White Cube, a principal force behind the YBAs' rise to prominence in the 1980s

So you didn't follow the Savile Row route yourself …
No. I trained as a lawyer. When I was growing up, Saint Martin's wasn't an option. In the '80s, they thought fashion was a career – but was it a career that you could rely on? So it was like, 'Just get a degree and then you can choose …' But you know what? It sort of saved me, because everything I am now is based on not conforming and not believing that I can't cut something in one way or mix things in another way. That's the benefit of being self-taught and then having the experience of working. When I talk in schools or colleges, the kids say, 'How do put this with this?' You realise that hanging on to that naïveté, that childlike thing where you just mix things, is your greatest option.

You're playing!
You're playing, but in a very emotional way, a very relatable way. I sketch a lot, but I see or design a fabric and that's where it starts. My outlook was always international because that's how I grew up. A lot of the prints are my designs or vintage couture prints from Abraham of Switzerland, which is one of the great couture houses. The aesthetic is clearly Afro-Jamaican, which is to say Afro Chic, but in a very international way.

And you have dressed some important women.
Yes, thankfully.

For example? Give me some names.
I never name people! You know that.

Not even Michelle Obama?
Well, yes, Mrs Obama wears my things quite a bit and has for a while. I'm very honoured because she is a wonderful role model, a wonderful person and inspiring to women of all ages. But I have girls that are eighteen and women who wear my things who are ninety-five. When people talk about who wears what, they say eighteen to twenty-five, but my demographic is wide. The people that tend to buy my things regularly are not followers of fashion. They're discerning and it's not about money.

But your clothes are not cheap!
No, they aren't, but it's not about that. There are very few things of this quality; I don't make a lot of everything. The factory where I have things made in Italy, they make for four houses and it costs a fortune, but the quality is second to none. So I stick with them.

Talking of quality, class, discernment and distinction, are these words that describe the potpourri that is London today?
I think yes. Quality is dying, as you know. Look at Savile Row, look at St James's. Burlington Arcade has been replaced by big-brand cosmetic shops. All those old-school tailors and menswear shops, where people would come from all over London to get their shirts or suits – they are all going. But what London has is a real idea and understanding of different tastes. And that's what I love. It's all here. Sometimes you have to look for it, but it's here. In one journey, the people you see, the diversity, the architecture, the parks, it's incredible. But London also reflects a kind of va-va-voom that New York has more of but in a different way.

But isn't London all about money these days?
It is about money if you look at the art world and the fashion world, but not really. You can exist and enjoy beautiful things.

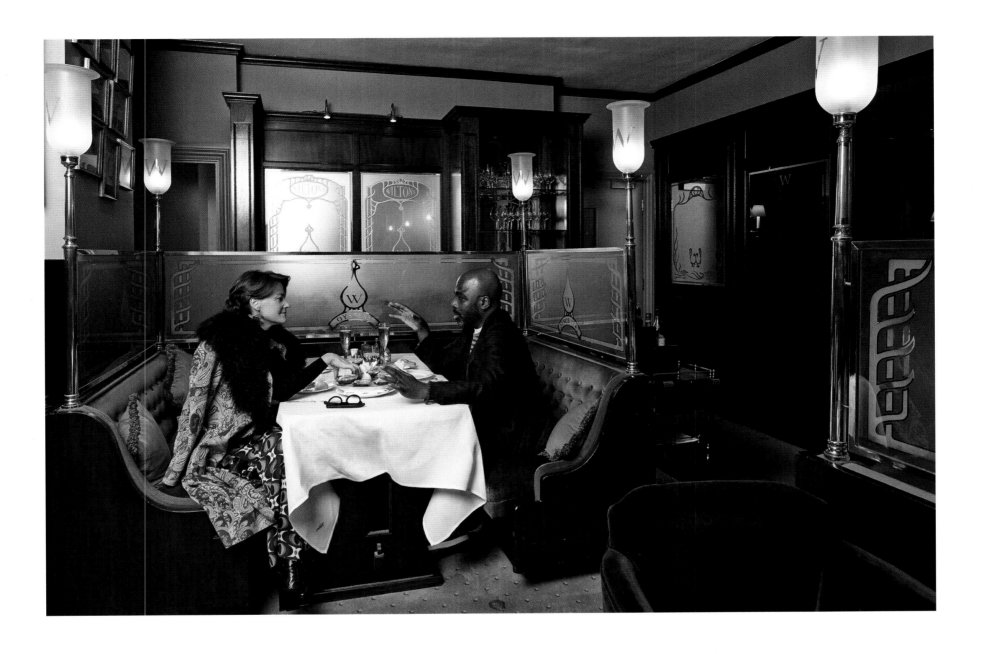

'The reality of London is that people from other countries are very confident. They do not feel that they can't walk into a certain store because they're not rich. That's why England, London particularly, is so great'

Julie Verhoeven
Fashion illustrator/Designer/Artist/
Creative director
Walworth/Elephant & Castle

What is the attraction of Walworth for you?
Originally it was cheap, and I like it because it's a bit of a hidden gem.
People don't appreciate how close it is to town, and I love it for its bus
routes. And I like the colour, in all aspects.

How would you describe the neighbourhood?
Colourful characters, colourful people; there's a lot of damaged people,
'cause there's a lot of poverty. On the east side of Walworth it's semi-posh
but not very posh, and then it's predominantly working-class estates,
people that have been here for generations. They're non-judgemental. I
find it much easier to live here than anywhere else. I remember arriving at
Elephant & Castle twenty-five years ago and feeling intimidated as soon as
I got out of the Tube, full of fear but excited. I felt like I was in New York!

Can you describe the street life?
There are a lot of regular characters that I see around; I've probably
morphed into one of them! There's one lady, she must be in her late fifties,
early sixties, and she's in proper Dolly Parton attire, proper cowboy boots,
and always fully made up; it's fabulous. There's another one that sort of
hits people on the street; she wears dayglo leg warmers, and again she
must be in her sixties.

Does this inspire you, this sort of company?
Yeah, I love it. It makes me feel alive. And I love the noise of the street.
My studio is set right back, so I have that solitude, that area of calm,
but I come out onto the street and it's all back in your face again.

**Twenty-five years ago when you arrived in Elephant & Castle, what
was the makeup of the local population?**
There was a huge black community, so that was great, and a giant
Colombian community …

Is the area still mixed, or is that aspect of south London disappearing?
I think it will just become bland, and only one type of person will be able
to afford to live here. Everyone's going to have to move out to Kent, aren't
they? So for now the diversity's nice.

What influence has this diversity had on your creative process?
It's bizarre: I'm beginning to see it now that I'm more confident and
comfortable in what I'm doing, understanding more what I'm doing. I'm
beginning to look like the area; I've realised that all the dirt and grit that
I like is coming out in the work. It's like osmosis. I can't see me going
anywhere else in the work; it's going to become more and more like my
environment, I think.

So if they took you from here and plonked you down, say, in Pimlico or Chelsea, what would happen?
I'm not happy in Chelsea. I'd struggle because there are so few pound shops in the posher areas.

Is that where you pick up your materials?
Where I buy all my rubbish, yeah.

You make art out of rubbish?
Yeah. It's shameful, isn't it?

How did that start?
I always seem to have a million deadlines, so there's always this sort of speed thing. In an ideal world, I would like to make something beautiful and spend time and enjoy that process, but it just doesn't work like that for me. A lot of the time it's like shortcuts; it's low-budget or whatever. All these pound shops, it's just fabulous, and then finding ones that are more obscure, that have the weirder stuff that never sells – it's a constant adventure.

So when you visit galleries, say, in Soho or the West End, is that daunting?
It definitely makes me jealous; that's a nasty trait, isn't it? I'd love to do a Jeff Koons; that would be good, wouldn't it? One of those giant balloon dogs. I'd also like having the balls to present one beautiful object. I try and do that and can't; I just have to layer. There's a thing about layering and collage and when do you stop. I love that.

What was the first piece that took you to another level?
I don't know; it's been a slow burner. It's a bit like my drawing. I always draw, draw, draw, and I didn't realise that actually the most beautiful thing is the initial drawing. It took me ages to realise that that initial gesture *as such* was what it should be. It's the same now with this 3D work. I realise when I just do it (without consciously thinking about what I'm doing) and I'm in that moment, that's far better. If it takes five minutes, so be it. Rather than labouring over things.

(previous page) Julie Verhoeven on the lookout for lookalikes in the Julia Knows Beauty hair and cosmetics shop (one of thirty such shops known for their wigs and hair extensions) on the Walworth Road, the route she takes each morning between her home and her studio in Elephant & Castle. The eccentric artist, designer and creative entrepreneur has collaborated with Vuitton, Versace and Mulberry, among other big brands

Verhoeven's home is colourfully bedecked to match her clothes sense (left). 'It's a mishmash of everyone's work including mine,' she explains, likening her interiors to a constantly evolving sketchbook

You've worked through various levels, haven't you? You've been an assistant to John Galliano, for example. So you took yourself out of that world, didn't you?
Again, it's been gradual. I still work within the fashion world.

But you would prefer not to, right?
I'd rather just do art.

But isn't fashion art?
Definitely not.

But it is creative …
Absolutely, but clothes have to function, and then it's just product, and I love it for that as well.

Why does your current work have such a close focus on women? Is it about actual sexuality or a tease referencing what sexuality is meant to be?
I don't know. It's something I've always been fascinated by, and now I feel less shame in being fascinated by it.

Well, hopefully we're all fascinated by it; we just don't express it so loudly. What allowed you to break the bounds? Is there courage involved, or is it about being blasé?
I suppose I was much more careful in the past. I like the comedic part of sex that doesn't get discussed. It is such an absurd act, really. The female thing started because I've always been fascinated with female beauty and what an amazing tool it is. If you have it, you can do anything. I was like, 'Oh man, what am I going to do, 'cause I want to be seen but I can't play those sexual games!'

In the quarter century you've lived in south London, how much have sexual attitudes changed?
I don't know. I mean, the more of it that is out there, on the Internet and everything, it makes me sort of sad because then there's no mystery, is there?

You certainly break down any mystery barriers in your work!
I hope I'm being warm with it. I hope I'm not being nasty.

Maybe you get away with it because you're a woman. If a man were to do it, do you think it would have that warmth?
I don't know. I just like bodies, and what you do with a body. Living and breathing, yeah.

What's happened as you've got older?
I've become quite pessimistic. Is that about age? I don't know. My work becomes more sing-y and dance-y, but I get sadder, if that makes any sense.

Can you explain why?
Life's moving too fast. I'm not happy being nearly forty-six. I think, How many years have I got left to say something? I've only realised now what I want to do, and I'm like, 'Oh man, I've got to move fast!' It's quite funny 'cause when I'm teaching fashion, I'm a real stickler. It has to be correctly sewn, it needs to be well executed. Then, when I get to my own stuff, I make it really badly. But I'm loving that. It's really amusing me how shit it can be.

Yet you are paid to teach … And where do you do that?
Central Saint Martins.

Which is not exactly a spoof operation! It's a major international institution, and they regard you highly, they pay you to teach there, and yet you doubt your own –
Yeah, but that's normal, isn't it? Otherwise you'd be a really arrogant sod. You have to always keep doubting yourself, don't you?

The artist on walkabout (left) around Elephant & Castle, and (bottom left) with her designer friend, muse and model Sarah Easom, who appears in many of Verhoeven's videos. Verhoeven at an angle in the Elephant & Castle pedestrian underpass (below), to which she is drawn by colours and patterns commissioned in the 1990s to reflect the area's multiculturalism

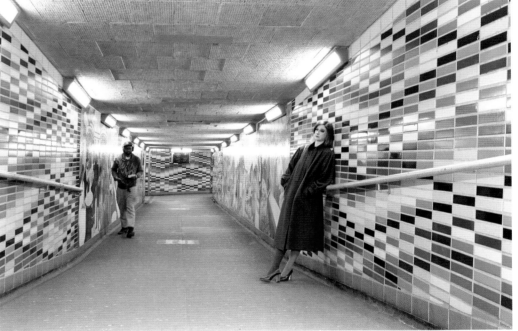

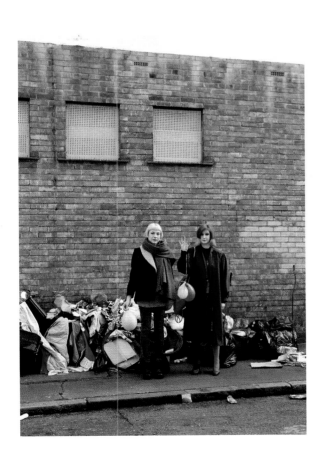

'Colourful characters, colourful people; there's a lot of damaged people, 'cause there's a lot of poverty'

Charlie Siem
Violinist
Kensington Gore

You're a bit of a wonder-boy, right? I mean, you've got it all: family, brains, good looks. Where does that leave you when it comes to competing in real life?

People look other people's lives and imagine they are a certain way. On paper, you're right; I'm a very privileged person. But everybody has struggles and challenges within themselves that might not be clear from the outside.

Is there some kind of magic, some godly or devilish attribute, to your talent?

To a certain extent. With the violin, with any kind of virtuoso playing, there is this slightly mysterious, magical element to be able to create something that sounds like it's on fire. When you hear a great performance, it feels like it's charged with electricity. That's more than discipline and hard work and achievement. There's something unquantifiable about taking the risk, going onstage, going a bit further than you ever went when you were preparing for that moment. You're going into the unknown. Your fingers are doing something that you never thought they could do. It doesn't always happen that way, in a live situation. But that is the magic, the fire, the electricity.

So you reinterpret Mozart, Bach or whomever, but those guys have been played a million times.

Yeah. You're not changing the notes, but you're reinterpreting every time you do it. Even if you have played a piece by Mozart or Brahms many times before, it's important to stay stimulated and inspired. Every time you decide, 'I'm going to play that Mozart concerto again,' you take it out of the cupboard and look at it and say, 'Right, I've never seen this before and I imagine it's never been played before. How can I create a completely blank canvas in my approach to interpreting it?'

Isn't it a little like reciting great poetry?

Well, no. Music is a living art form. When Brahms writes a piece of music, he writes down little dots on paper and puts it in a book and leaves it there. He doesn't know how long for; he's hoping many people in the future will come along, open the book and create music from it. It's like buying a table at Ikea that has not been assembled. You get an instruction booklet that tells you, 'This is how you put the table together.' You use a bit of the instruction booklet, but then you use a bit of your own ingenuity too. It's essentially the same material everyone will be using, but maybe you will put it together a bit differently. The notes aren't the truth; the notes are pointing you in the direction of what the truth is.

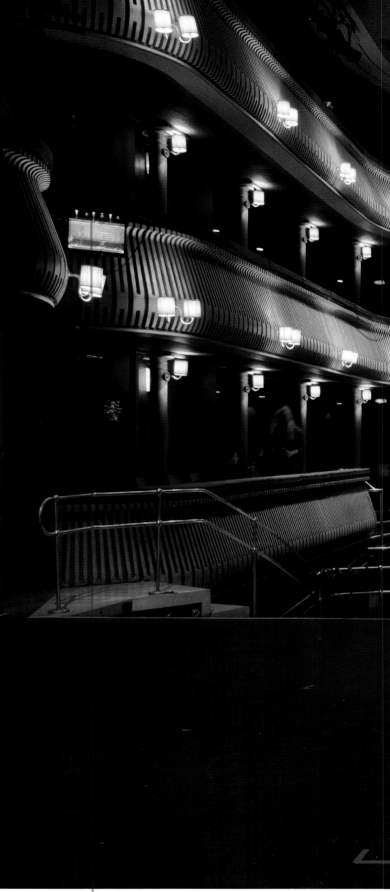

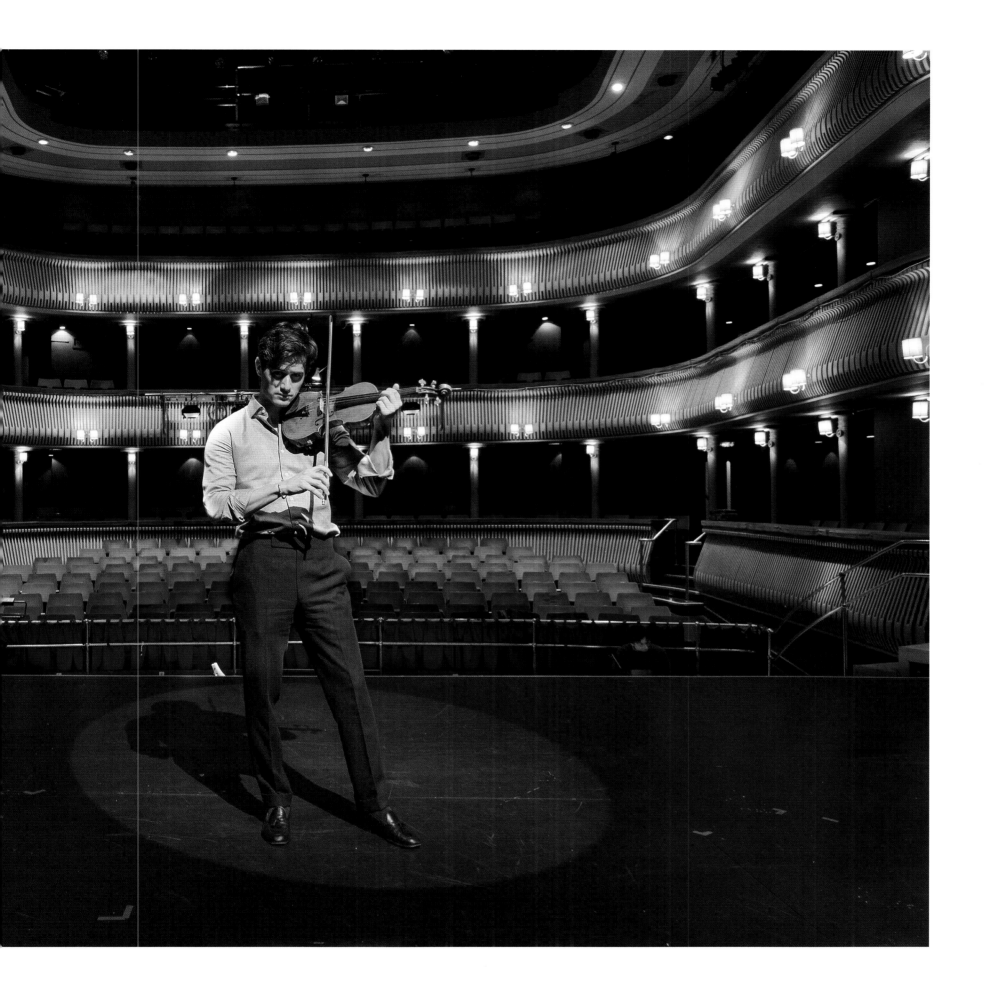

(previous spread) Charlie Siem plays his 1735 Guarneri violin, known as the 'D'Egville', for audiences past in the Britten Theatre at the Royal College of Music. Although Siem never formally attended the RCM, he has been practising there since childhood. 'It's the transcendence of everyday life' is how he defines music. 'Maybe people just need to live a few more lifetimes to transcend the everyday – the null life.' The college, founded in 1882 by the Prince of Wales (later Edward VII), trained some of the most important figures in the music world, including Benjamin Britten

Siem is dwarfed by the RCM's red-brick façade (right), designed in the Flemish Mannerist style in tune with the Royal Albert Hall across the road, which was built around the same time. The young musician (below) practises with Itzhak Rashkovsky, Professor of Violin at the RCM and his teacher and mentor. 'I taught him between the ages of one and seventeen, when Charlie left for university,' Rashkovsky remembers. 'We now play as friends more than as teacher and student … Now I want to impress him rather than the other way round!'

'At the end of the day, it is the player that makes the sound'

When your fingers start doing something magical, where does the feeling come from?
It's a combination of intuitive practice and a prepared, worked-on facility when you work at something in an almost scientific way, to try and understand how each finger relates to the next and how you can programme the coordination between your brain and the spaces between your fingers. When you are able to do the greatest things that you ever do playing-wise, it's usually an intuitive freedom where you release yourself from this mathematical approach to playing the instrument.

Why did you choose music as a career?
My parents didn't have a musical background. They wouldn't have encouraged having a life in music. But in a limited way, they would allow us kids to have access to classical music because they, like a lot of people, thought it was good for the development of a child's brain. That was the fashionable thing at the time. That's how I had access to music. It triggered something within me.

Can you remember a specific trigger point?
I can. I remember being enormously inspired listening to music and feeling a strong urge to want to engage with it. I remember when I first had the chance to pick up a violin, which was in a music therapist's home, because my mum didn't know about violin teachers. She had seen an advert in the newspaper for a music therapist who lived close to us and who had many instruments. And she wanted to see what was best for her child. As soon as I picked up the violin, it was a physical connection with the instrument. It felt very, very comfortable. It was something that came naturally.

You were at school in London, and then you went on to Eton and Cambridge, right?
Yeah.

And then you studied at the Royal College of Music?
I didn't, actually. I went to the Junior Department of the Royal College for a year when I was ten; it is a Saturday school where a lot of young kids go.

So you're a Londoner, born and bred. And you haven't chosen to go to Vienna or wherever else the world of music would take you. You hang out with some pretty big names, teachers or violinists of international importance. And you play an instrument equivalent to ten people's houses in value. Is the noise that comes out of that instrument more resonant than what comes out of an ordinary instrument played by Joe Violin?

It is. At the end of the day, it is the player that makes the sound. There are some people that make incredible sounds on mediocre instruments. But the great Strads and Guarneris typically have an edge to their sound, a character of sound that distinguishes them from modern instruments or even from lesser makers of the eighteenth and nineteenth centuries. But one can't generalise. I've played Strads that don't have a sound that is great.

Does having ownership or the use of such an instrument itself unlock the doors to some musical mysteries?

No.

But you pick up a brand new instrument and it requires a hell of a lot of playing, doesn't it?

It could be a year and the violin could open up and it could be ready to play. Sound-wise you can get a great quality and wonderful tone from a modern instrument. But you're part of a tradition as well. If you love the violin and you've lived your whole life within the world of the violin, of course the sound is great on those instruments. But also, you're engaging with the tradition and the history of being a violinist. It's sort of a spiritual pact you make with the instrument to be part of this Strad-and-Guarneri thing.

You talk about an instrument being played and then suddenly it opens up. What does that mean?

It's to do with the way the instrument resonates and vibrates. When it's just been made, there's a tightness that doesn't allow the sound waves and reverberations to be as open as they will be once it's been played and those waves have made it more flexible within the seams of the instrument, allowed them to give a little bit. Then the sound can come out.

You've played with some of the best and biggest orchestras in the world; you've also played with some modern singers. Which do you prefer?

I've never liked saying, 'classical music vs pop music' because it's putting it in a box somehow. The music of Beethoven, Mozart, Bach, Brahms opens my soul. It speaks to me directly. I enjoy listening to pop music every now and again, but it doesn't have the depth of impact that Mahler has.

It's entertainment against reflection.

You can be entertained by classical music as well, but yes, exactly. There's a complexity in the way that classical music is written. And there's a sort of spirituality. If you think about Mozart, it's the most entertaining music to listen to. There's lightness – it's like champagne almost – there's brightness, there's joy. The genius of Mozart is that underneath that, he manages to also have this sense of tragedy. So it's layered. The challenge of playing that repertoire is so much more rewarding than playing pop music.

And now you're a professor in Leeds. The track that you have made for your life, or that has been made for you because of your various talents and attributes, where will that take you? Will you always be based in London?

I don't know. London is the centre of world culture, I think.

Why is that?

Every great artist has spent time in London at some point, and they've been inspired by London. They've drawn something from the place. It's an ultimate destination and has been for hundreds of years.

What greater art form is there than music?

It's a difficult question, that. People always argue about what is the most effective or the most insightful art form. I always say it's music. You're limited when you look at a painting because it's within the material world. There's canvas, there's paint, and then you've just got the moment when you look at it and take it in and that's it. Music is far more abstract. It seems more likely that it would be talking to the intangible nature of your soul because you're talking about sound waves that you can't see. You sort of feel and hear them.

It's almost a sonar emotion.

Exactly. And it's stretched out over time, so it's time/sound waves. It's so abstract; it's in a sphere beyond the physical reality we're in now. I've always been convinced that music is the highest art form, but that is my perception. What speaks to you is what counts.

In the past you've spoken about the complexities of being human, saying that it's only through those complexities that we develop as people. In terms of questioning the human condition, does your instrument, your personal vitality, bring that to bear every time you perform? Or is it by way of a daily chore?

I wouldn't call it a chore; it's a daily challenge. Again, music is all about inspiration. It's the pinnacle of human achievement in that it's not grounded in our everyday physical needs but an expression of where we want to go. It's a human goal, a human yearning. That's what all the arts represent.

Siem (below) on his daily walk passes the Albert Memorial, with the Royal Albert Hall in the background. 'I feel like I'm back in the eighteenth century when I'm walking here,' he laughs

Rizzle Kicks
Musicians/Actors
Kensal Green/Arsenal

Is today's wired, frenzied rap and pop music scene a bit of a showman's con?

Jordan Stephens: It depends how you look at it. I don't think anyone's consciously trying to fool anyone. The state of music has been accelerated and maybe diluted by the fact that everything's instantly available, so there's a lot less time spent honing skill. Like if I did a rap for you guys and you filmed it and put it on YouTube, that would be what the world thinks is my best work. But maybe it's not my best work. So then you've got to do another, and what you identify with as your maximum potential kind of isn't 'cause you didn't spend an extra hour.

Harley, fifty years ago do you think you would have had as much success as quickly?

Harley Alexander-Sule: No. Back in those times, you had to graft, and a lot of it was word of mouth. The impression I get, it was either really, really difficult or really, really simple; there was no middle ground. People would graft and graft and do all the clubs, or there would be someone at a record label who'd hear it and then they'd just pay off all the radio DJs and it would be like, 'Now you've got a hit record!'

JS: Also, rap wasn't in the picture fifty years ago.

Do you think of yourselves as pathfinders? Do you have to break the rules constantly to keep ahead of the pack?

HA-S: To keep relevant? Well, when we first started, we did something that no-one had done before, or we brought back something that hadn't been done for a long time. We touched on this area of hip-hop which was popular in the late '80s, early '90s. We took influence from that and then it became quite a big thing. We also used a lot of brass; no-one did that for a long time. We did it and it became popular again. It's very rare that someone comes along and blows everyone away with a new genre of music. It's impossible to do that anymore because every chord sequence has been done.

Do you have to be tuned in 24/7 to stay in play?

HA-S: The last six, seven months, we've taken our heads away from the pop world; it felt like we've grown up a little bit. When we first came out, there were like fucking T-shirts with our face on, and people were saying, 'I want to be the next Rizzle Kicks' on *X-Factor*, which you don't have time to process when it's going on; it's just mad. That's the rollercoaster and you've just got to carry on. Our intentions were always pure. What we brought to the market was accessible rap, basically, and hip-hop.

On this question of the violence and stereotyping that is common in hip-hop, you've spoken of the misogynist attitude it seems to promote.

JS: We've never been accepted into the world of hip-hop, apart from friends who took me under their wing while we were on the come-up. Recently I've fallen out of love with rap anyway. In terms of why rappers talk about what they talk about, there are a few points. Firstly, becoming successful in America as a young black man is nigh on impossible. Secondly, it's escapism, it's a fairy tale. The aspirations are twisted. And there's this weird ego. We get respect from some areas of hip-hop actually, on the basis that we don't care. What they perceive as not caring is like not understanding what they care about. Like they care about some shit that I don't even get. It seems there's a deficiency of love.

How can such violent, sexist themes flow out of today's music, with lyrics beating people over the head and everybody begging for more? It's like paying money to be abused, like white kids pretending to be black …

JS: Because it's cool. What is also fascinating for Harley and I is us being working- to middle-class in our values. We've experienced both sides – the toffs, the Chelseas, and the rude boys, the bad boys – and I'll tell you what: They both want the same thing, but from a different angle. The posh kids have got the money, but they want to be cool. The cool kids are poor and want the money. We'll go out with kids who are from rich parents, and they all consider us the coolest fuckers ever. They'll be saying things like, 'Oh, d'you want some weed, bro?' and we're like, 'I don't know.' They'll just swerve us because they're scared; they don't understand black people. Any rap video, any music video with dance, if you're on a label and you want a cool video, put black people in it.

We're talking social branding on a massive scale through music, about power beyond anybody's imagination. Since black musicians like Nat King Cole led the charge, how has music turned society on its head?

JS: Where's the new Nat King Cole? I don't know.

(previous page) Jordan Stephens (left) and Harley Alexander-Sule contemplate the moon at Parlour restaurant and bar, where they go to hang out or to work on their song-writing and poetry. Childhood friends, the two Brighton boys first met while living in north London

Stephens and Alexander-Sule (above) practise a new tune in the former's Kensal Green flat, a collection of trainers the only tidy display in otherwise untidy surroundings. Playing on themes of instant fame (which they experienced themselves at an early age), money, reality TV and the self-absorption of technology, the intellectually confident duo studied media and theatre, training which has stood them in good stead. 'I wanted to be an archaeologist,' Stephens explains. 'But I've never gotten along with the academic system.' Skipping school, the duo indulge in popcorn (right) at the Lexi Cinema, the UK's first independent social-enterprise boutique digital cinema, which donates 100 per cent of its profits to charity

'We've experienced both sides – the toffs, the Chelseas, and the rude boys, the bad boys – and I'll tell you what: They both want the same thing, but from a different angle'

Okay, then where are we going with all these extremes?

JS: I'm conditioned to not be a pessimist, but hip-hop and rap is the worst it's ever been. London's grasp on hip-hop with a particular scene of rappers from 2003 to 2008, that was the most underrated rap scene ever; I'm talking Task Force, Chester P. The difference between London and America was that the Americans were all rapping about being rich and the Londoners all took pride in talking about how poor they were. It's only recently that that's balanced and switched again. All the drug dealers have started rapping now, and they're talking about having money. And all those old backpackers are like, 'What, is it not cool to be poor anymore?'

HA-S: You wanted to be cool and live in a squat!

JS: We were brought up in Brighton under the premise of respecting the art of rapping. That's what always fascinated me: multi-syllabic rhymes. That's why Eminem's the best rapper that's ever lived in my opinion; his manipulation of the English language is second to none. But other people are in it for other things; some rappers can just say four words and deliver it on a certain beat, and everyone's like, 'Whoa!'

Have you guys known each other since year zero, or what?

HA-S: Since four, five years old. Jordan's auntie and my stepdad worked at a record label in London. We didn't see each other for many years and then we moved to Brighton at the same time.

Why did your parents move you out to the sticks?

HA-S: I lived in Haringey, Wood Green; it was just awful. My perception of Brighton was that it was posh and middle-class, so I hated the idea, but it was probably the best thing that could have happened to me, moving to Brighton.

JS: If you want to talk about creative space, what it feels like at the age of ten, eleven, twelve, when you're forming your ideas and starting to have opinions, London is a fucking minefield. I used to get bullied in London for being smart by dumb kids. These kids would have to use their strength on the basis that they didn't hone any intelligence they had. But why would you try and beat down the intelligent one in your community? What my mum noticed was that Brighton was a place where, if you have an idea, you're not gonna get told to shut up. We went to AudioActive, this hip-hop workshop; it was the scariest thing in the fucking world, trying to rap or freestyle, but it was a nice environment. In London, you get to about thirteen, when it's socially acceptable to get beaten up by older kids, and if you embarrass any older kid, you just get shunned. I understand, believe me, how difficult it is being a minority in the capital, but the way some of these guys talk about going into drug dealing or surviving, whatever, it's like, 'School's free, bro!' If you go to some kid whose mum is a drug addict and dad's a gambler, don't say, 'Hey, come and run a corner for me!' Go like, 'Why don't you read a book?' Innit?

The Rizzle Kicks (above) outside the house in Holloway that they shared when they first moved to London. Using rappers' sign language, the friends test their horse sense against two equally jovial members of London's Mounted Police, a force founded in 1760 to protect the capital's main roads from highwaymen

Rizzle Kicks

You came back to London at what age?
HA-S: Eighteen?
JS: Yeah, we got signed. We got the record deal.

Would either of you have been as successful if you'd stayed and dribbled a football with your mates in London?
HA-S: I don't think so.

So Brighton was a metaphor for –
JS: More like a gateway.

Where do you reckon you'll be in another six years?
HA-S: We've got plans; it depends how those plans unravel, I suppose. If you said to me five years ago that I would be sitting in Jordan's house that he's bought in Kensal Rise and we've had hit records, I would have been like, 'I didn't exactly know that was going to happen!'

And what's the sell-by date for musicians of your genre?
JS: There isn't one anymore. You can do anything. For me, asking anything about the future is a complete mystery. In these months when we haven't had any obligations or professional requirements, I feel like I've started to catch up on things that I was supposed to have done. Bear in mind, we got famous at what, eighteen, nineteen, and it's like nineteen, twenty, twenty-one, twenty-two were a complete fucking whirlwind. I used my espresso machine for the first time two months ago; I don't know when I got it! Just shit like that, just little fucking things of existing. I feel profoundly happy just with existing as usual for a little bit, you know? I'm reading non-fiction books and shit at the moment …

What are you reading?
JS: This book called *The Field*, about the next stage of human evolution in terms of the mind. I'm doing an online screenwriting course, and Harley's wanted to do an Open University English Literature course. In six years, I would like to have achieved another milestone, even if it's a third and fourth album that we're really fucking happy with. Also I'd like to tick another thing, like maybe writing a television show. Maybe Harley will star in another film.

And all of this will be centred around London, right?
HA-S: It depends.
JS: People get driven out of London now. All the cool kids are fucking off.
HA-S: It's so expensive.
JS: They're all in Peckham already; they're going to end up in Croydon soon. Brighton's the next stop. I typed in 'flats for sale' this morning and the first thing that comes up is in Brighton. That's all I'm saying.

Everybody's being pushed out of the city, then?
JS: I read this article the other day which was like, 'If you were a creative in the '70s, you were getting a little flat in Marylebone with your mates for a laugh.' A flat in Marylebone! You can't get near central London now.
HA-S: You'd be squatting.
JS: Yeah, but who's getting into central London now? You can't get a consistently paying job and get a flat in London. That just blows my fucking mind. And all these fucking places have been bought by people who don't even live in London! They're just storing their money in fucking flats, and you know it because down the road there's like two hundred new homes being built, but where's the new school? 'Cause they don't care, they're not living there. Like retirement homes, there's no transitional stage for people to go in. You're telling me two hundred new people are just going to be walking around Kensal Rise? Doing what? There's no new jobs, there's no new built facility. It just drives me mad. But yeah, they're driving the guys out of London.

No highwaymen themselves, the Rizzle Kicks are highly vocal supporters of Arsenal Football Club. They enjoy a photo opportunity with young Arsenal fans excited by their surprise celebrity encounter before a match against Liverpool. Formed by a gaggle of Woolwich Arsenal Armament Factory workers in 1881, Arsenal has become one of the two most successful football teams in football-mad London, the other being Chelsea

Second Awakening

December days were brief and chill,
The winds of March were wild and drear,
And, nearing and receding still,
Spring never would, we thought, be here.
from Arthur Hugh Clough, 'In a London Square'

Spring may come but once a year, but in making *London Burning: Portraits from a Creative City*, another spring has blossomed at journey's end. The unfolding of seasons in the capital has allowed our cameras to indulge in London's perennial visual feast, the glorious cover story that her inhabitants often take for granted. There are many cities that can claim similar seasonal tonalities, but none can cloak themselves in the multiple bounties afforded a Londoner.

A common sight in most London parks (as here), the canvas deckchair with its bright stripes evokes lazy feelings of nostalgia, real or imagined – nostalgia for a bygone era with a measured pace of living unlike today's frantic grind and cycle. The sight of someone snoozing in a deckchair bathed in spring sunshine brings one to stillness, perhaps to reflect on lost time.

Although its provenance is disputed, the lowly deckchair was most definitely an Englishman's invention; John Thomas Moore took out a patent for an adjustable chair in 1886. Americans call it the 'Yankee hammock', the French a *'chaise transatlantique'*. Before cultural tempers ignite, we should remember that the ancient Egyptians, Greeks and Romans also laid claim to this most simple of inventions.

The clash of cultures, the claims and counterclaims of history, and evidence of today's realities have been the informing markers on our journey while making this book. Deckchairs seem a fitting tribute to civilised continuity, a hallmark of London's multifarious charms. Between one spring and another, we've captured most of London's moods, seasonal tones and natural colours to reflect contemporary and historical nuance within each profile narrative, in a way attempting the impossible. The purpose of this book was always beyond the strict logic of publishing; reverse engineering of sorts was required to craft a tome to fit a niche to fulfill an idea (or ideal) of Place. *London Burning* is more or less a creative urge predicated on a whim: to fashion something unique and special out of the billion pieces of the puzzle that go to make up London. A jigsaw of people mapped against environments of their choice and the necessities of life, individuals' sense of location, of locale, mapped against the ideas that drive their presence in the urban bustle, everyone chasing the zeitgeist of a singular twenty-first-century megapolis.

Having walked its streets, crossed its bridges, waded through glorious and inane architecture alike, and explored its parks and green spaces with pleasure for half a century, I have come to this point in my own journey of London. Whimsical, perhaps, but not fanciful, wanting to represent personal aesthetics by piecing together enough bits of the city's creative culture to represent its essence, a moment in time's continuum fostered by the urban adventure called London. Conundrums we've faced aplenty. Who to feature, how to focus, what not to include? It simply wouldn't have been possible to trace-engineer London's habits and habitats according to any creative master plan at the start of such a journey. It was always going to be a difficult proposition, and an easy way of breeching this conceptual conundrum was to let London speak for itself. To allow the city room to breathe, instinctual filters set to their own metered shuttering, allowing hand-eye movements to find its aesthetic markings. The wonder of creativity, after all, is that you hardly ever know what you're going to end up with.

Xiaolu Guo
Writer
Mare Street/Hackney Marshes

What's the title of your new novel?
It's called *London Mauve*. It's about artists, bohemians and immigrants around East London; they're quite fucked up and remain hopeful.

You yourself moved to Hackney from a Chinese village, almost tore yourself away, separated yourself from your origins. Yet you seem to have blended in quite nicely.
No. I don't feel nicely. I feel very uneasily. Very.

Is *London Mauve* a reflection of the uneasiness or the niceness?
This will be my first novel focused on the London bohemian.

What themes are you exploring?
I think even Indians find it agreeable living in Britain. But we're Chinese; for us India is the West. Because of our Communist ideology, I find it difficult to live in the West, even if I speak English. I describe myself as a rootless global peasant. 'Chinese' means 'peasant'; our population was 95 per cent peasant; now 77 per cent are peasants. That is our tradition. Does a peasant become an artist or intellectual? We come from an agricultural society, unlike Britain, which is a mercantile society.

But the Brits were agriculturally based until the Industrial Revolution …
But it's different. The last three hundred years of colonial history made everybody a kind of explorer in the world. But Chinese are totally inwards; even now the way they deal with the world is ideologically inwards. I have no intention of conquering the world or becoming an international artist, so I don't feel rooted here. My root is an agricultural tradition; I despise the industrial tradition. So I'm a romantic artist. Most modern artists I actually despise. In Western language, 'romantic' is an impossible state. But if you're Chinese, you're by nature earthy and romantic. I wake up in the morning and I don't give a fuck who's the emperor or the queen because I grow all my little sugar cane or my little rice. By three months later, big tree, big fields, and I can sing with my birds. It's a kind of Buddhist idea. The only relationship I have is with nature. So, by nature I'm not an urban person, but I do it. We can only live in the urban in the future. There's no more so-called 'nature' and 'countryside'. They're all dead. Urban is the only space, but it doesn't mean that I'm an urban person or I feel comfortable in the urban world. I feel every day a disaster.

How do you cope with those disasters?
I grumble and then I try to make my film or write my novel.

So you need that fuel of angst and anger?
I think so. A lot of European artists think, Oh yeah, that's cool, I can play with that idea. When I hear such a sentence, I have a murderous impulse to kill that person! Because I never think, That's a cool idea, I can play with it. For me, the first impulse is, 'Fuck! This is such awful human condition!' And, 'Fuck! I have to put some political ideas or vision!'

But this is an extraordinary contradiction. Your father spent fifteen years in a labour camp, you yourself were at odds with Chinese law, your brother was an activist. You reject Communism entirely, yet you think communistically.
I am nihilistic by reaction, but that is in my blood. When you are a post-Maoist kid, you reject the ideology you were given, but you are

so ideological that the rejection becomes a political status. I try to make sense of what we're supposed to believe. Lots of people think, How can you be a post-Marxist living here? Fuck, I *AM*. I am something which I value. Human society is largely made of mediocre reality composed by a bunch of normal people who want to get on with life.

In isolation?
In isolation. In East Asia it's a more collective society; in the West, of course, it's individualistic. We say 'isolation', but no-one is really isolated from another. We're all part of this society in which we try to find identity, which is superficial identity. We have to belong to some kind of artificial identity to make sense of our daily life.

So how do you identify with hectic Hackney, with consumer-mad London?
I don't at all.

What about receptions promoting your books and people all over the world looking up to you as this grand visionary?
I never felt that way. I always felt very alone at any party, apart from my own Chinese-dumpling food party in my own house, you know what I mean?

Do you actively try to make that point?
I used to. I learned there is no use to be a radical reactionary in the West. The best way is to get them to read my novels and watch my films and listen to my talks.

Let's backtrack here. You were born in China in 1973, and you moved to the UK in 2002, right?
I came here and went to Beaconsfield for two years, which is the National Film and Television School.

Where you got a scholarship?
Exactly. I was in this advanced lab called Documentary Direction. After that I went to Paris because I got this film residency. I loved it. My Chinese intellectual culture is very close to French literature and cinema. So that's my intellectual home in a way. After that I got another year residency in a monastery next to the Gare du Nord. I felt rather lonely, so I wrote *You Are Very Nice*. So that's two years in France, and I decided to come back to London.

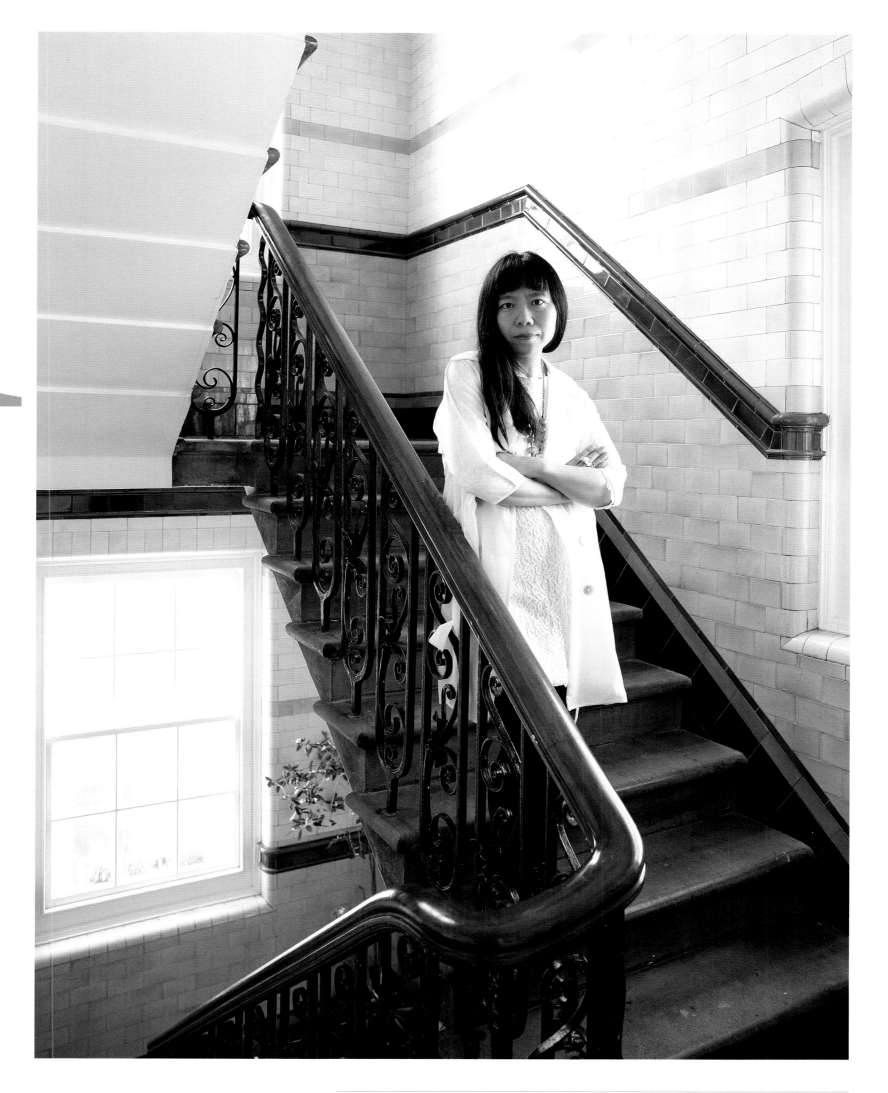

Because you married an Englishman?
We're not married; we're boyfriend and girlfriend. I don't feel any love towards London; I'm just a lodger in this city.

Don't the English admire utopian, exotic extremists who are exceedingly clever, in fact?
They never feel I'm exotic. Maybe for France they feel I'm exotic. Sometimes offending. They find that I'm very hostile.

But you are. Your language is hostile. Your tone is hostile. You almost seem intent on hostility, no?
Probably. But the intention is to say, 'Look! Listen!' I don't feel my role as some sort of writer or professional film-maker; I am a public intellectual. The problem is that I cannot survive as a public intellectual in this culture because, sorry, this culture doesn't respect that.

But it respects success; it respects good work; it respects a novel that becomes a bestseller, a film that is given critical acclaim.
But that respect is superficial because it depends on success. If someone has a truly great interior landscape but has no success, they're just a loser; they're squatting next door. The rule of capitalist society.

But isn't that what you came to this country for?
I came from that culture which means that no-one is singular, a genius-god. Everyone is a product of that history and a limitation of that regime. We often think that if you're successful, you get respect. But that's not the core of the artist, is it? I mean, I like Jeff Koons and all that, but I don't respect. Fine, he's successful, but it says nothing about his values.

'I am nihilistic by reaction, but that is in my blood. When you are a post-Maoist kid, you reject the ideology you were given, but you are so ideological that the rejection becomes a political status'

Are you seeking answers to the Big Question?
Because we are crazy human beings, we try to make a big work, not only a comment on the food you ate yesterday or what kind of lover you had last week. You want your work to talk to many people or many societies, many cultures.

You're ambitious, if nothing else, and your ambitions extend beyond Hackney. What has caused you to stay here?
There is no mystery; just by accident. It's a very, very practical matter. I write in my second language, which is English. When I write in English in Paris, I feel this discontinuity because I'm thinking in Chinese. But that's like psycho-language, not verbal language.

So is the English language an impediment or fertile ground for your thinking?
It's a necessary tool. An artist commits to one tool. I cannot imagine that I would write my second language in a third-language country. Plus I never went to any English school. It's self-taught in the last ten years.

You've talked about the idea that the English language is more welcoming, and noted a 'world becoming smaller' as well as the increasing mixing of lifestyles. Isn't that London in a nutshell?
It is. So I always think, If I have to live in Europe, the last capital of Europe would be London, whether it's my style or not. It's not my choice.

You've been described as the 'voice of modern China'. Would you accept that?
I don't think your nationality defines a writer. If you're a great writer, if I don't tell you my name, they would think, Oh, she's probably Japanese or Russian. Because the nationality reduces your potentiality. You know, I'm British right now. From the technical point of view, I'm not Chinese.

But people like yourself extend the boundaries and reach at least some, if not total, freedom.
But it's not freedom, because in China you would be in prison if you possessed more than one identity. The Chinese embassy cut my Chinese passport, so I have fucking no choice. I have to use one passport, which is the Britain one. So it's nothing posh or freedom.

Then what defines who you are?
My view, my work, not a piece of paper. That is like dictatorship; that's really reductionist.

So you never go back to China, or do you?
Yeah, but on a tourist visa. I only have maximum three weeks. I don't do public events, I'm not allowed. I need to be very obedient in China or I could never enter.

You talk about capitalist restrictions on censorship, and here you are going back to your Communist model, yet accepting the censorship!
But that's just limitation of a certain thing. The story that I want to tell you is that I was just in Beijing. In London, street sellers, restaurants, cannot open in the street. So for you there may be enough street life, but for me it's dead. I love this Latin American street life where I come from, because everywhere you go, all the streets are celebrating food and selling and people, and they don't need any license to be there.

You love the disorder of all that.
Exactly! I was like, 'Oh, I really miss this!' Because everywhere you walk is humanity celebrating life. Here in London it's 'License, license, license!' 'You're not allowed to be sitting here!' 'You're not allowed to drink anything anywhere!' I really miss that permissive reality; you can stand in the sun and just celebrate.

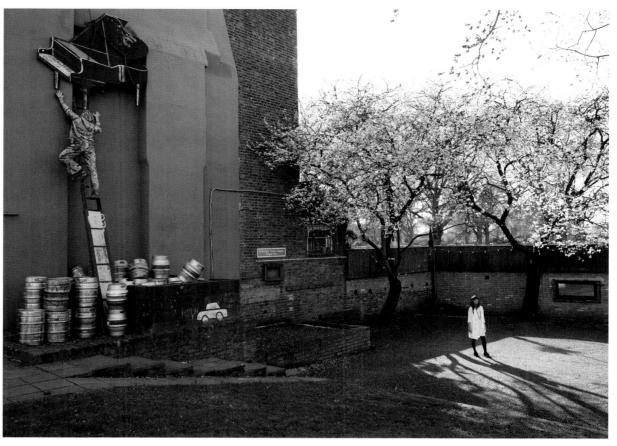

Guo (left) outside the Hackney Empire in Mare Street. Built in 1901 with then state-of-the-art technology (electric lighting, central heating and a built-in projection box), the legendary venue hosted Charlie Chaplin and Louis Armstrong, among many entertainment greats

Guo (above) basks in the spring sunshine outside the Pub on the Park, a busy Hackney watering hole. London's railway arches are a characterful feature of the cityscape (below). Traditionally home to garages, lockups and artisanal enterprises, they are increasingly being used as hip cafés and restaurants, breweries, rock-climbing facilities, gyms, cinemas, high-end fashion boutiques and contemporary-art spaces, the upcoming Hackney Fashion Hub being a case in point

But you've also said, 'My father's generation died for the ideological struggle. I hate that struggle because I never feel free.' Do you feel un-free right now, sitting here talking to me?

I feel freer, for sure. At least I can say what I want to say without making lots of metaphors and hints. But again, this is only a degree of freedom. My mind is free because you can't see it, you can't sense it, but my body is rigidly imprisoned. In the cold weather, in the urban space which is quite ugly, I miss the hot sun and the sea, humanity everywhere, eating in the streets, spitting. What kind of freedom do I really want? I don't want a life in prison, although my mind can voyage everywhere … Physical freedom is the most important thing.

Xiaolu Guo

Guo in her element in Hackney Marshes. 'My parents were kicked out from their land,' the writer remembers. 'For generations they were growing plants; now they have nowhere to plant.' One of London's largest common areas, Hackney Marshes were drained in medieval times. Today they are wildlife havens, with the Middlesex Filter Beds, built in the mid-1800s, hosting sixty different species – proof that nature can flourish even in the most urban of areas. 'Physical freedom is so strong in the sense of how you feel living in London,' Guo says

Guy Ritchie
Film director
Fitzrovia/Watford Gap

What keeps you in London?
I've been farting around central London, creatively, for the last twenty-five years, I suppose, and I've seen it change. I live just north of Soho. I'm excited about the creative aspect of London because, for the first time in my experience, it feels like the centre of the film-making world.

That's a big ask.
Look, I leave my house in the morning, thirty minutes later I'm at the studio, where I have the best facilities in the world. My editor is thirty seconds away. Every movie that's being made here is a vast production. As you walk along the corridors, you have pirates, you have Martians, you have knights in shining armour. It's the quintessential idea of what a studio was like in the '50s, in the golden age of cinema.

The era of Pinewood?
It's infinitely bigger than that.

Why is Soho dying on its feet, then?
From my point of view it's not dying; it's the antithesis of that. I lived on Wardour Street twenty years ago; it's infinitely more exciting to me now than it was then. All our films are made basically in Soho, the last two *Sherlocks*, all of the *Harry Potters* …

I'm not talking about creativity dying, I'm talking about the nature of the place fading away.
But you can get a better coffee in Soho now than you ever got before! Just to go back to Leavesden for a minute … I have a screening room where they project dailies. I don't know how many movies I've made, but there was never a version of me seeing projected dailies; it's like old-school Hollywood. I'm living that fantasy, and I adore it. I have to do twenty meetings a week in post-production facilities in Soho; it takes me two minutes on my bicycle. My office is somewhere in between, so I've got my home, my office and the hub of creativity in Soho. To me, Soho's never been better. The dirty Soho I knew twenty years ago is still there, just smaller.

Would you ever leave all of this behind and move out to LA?
No fucking chance! I adore London, and the older I get the more I adore it. It's too creatively vibrant, but it's not just that. There are so many good hotels in London now; they seem to open up every other week. And the guys who are in charge of those hotels, they're clever guys, creative guys. Those hotels don't feel like corporate hotels, they feel like interesting hotels. The food's interesting, the way they manage them is interesting, the service is fantastic.

Why is all this happening to London now?
I don't know. I love the weather, that's another thing. Compare it to New York weather – who would want *that*?! Here it's very temperate.

Were you born in London?
Yes.

Did you get into a lot of trouble as a lad?
Do you know, I've managed to avoid being in trouble. I worked from fifteen onwards. I was an unskilled labourer for the first five years, working on building sites or as a barman. I was a removals man for a long time. All in the West End. At the time, Soho was filthy. There's always been that argument about the balance of being gritty and interesting and filthy and despicable. I like the character, but you get bored of the filth. Now it's still got enough character, and I don't see it being washed out.

Give me an example of Soho's new vitality.
We went for a walk on Sunday morning, started at 9.00 o'clock, by 11.30 it was packed. We bought a couple of nice pairs of shoes down Meard Street, very good-value handmade shoes. We love the building; you've got all those lovely Queen Anne buildings down there. They showed us the basement, we checked out the stairs; it was built in 1720, so just post-Queen Anne. It's almost undisturbed. We tried to get breakfast in Nick Jones' gaff, the Dean Street Café – fucking packed, couldn't get in. Then we crept around a couple of other gaffs before we could get in anywhere! We thought we were going to be the only people on Sunday morning in Soho! We ended up in this lovely coffee shop which used to be small a couple of years ago; it's now twice the size it was.

Twenty-five years ago, nothing like this would have happened, right?
Ten years ago, fifteen years ago, I used to come out of my flat above Mezzo or whatever it's called on Wardour Street, and I would have to navigate through homeless people in the doorway to get out. When I first went to Soho, I was very charitable. I'm telling you, after six months fifteen years ago, you didn't feel so positive about homeless people. I couldn't go out on Friday or Saturday night about 6.00 o'clock because of the amount of violence on the streets in Soho. You'd end up in a fight, it was so volatile. Maybe when you're twenty-five that's a laugh; when you're forty-five it ain't.

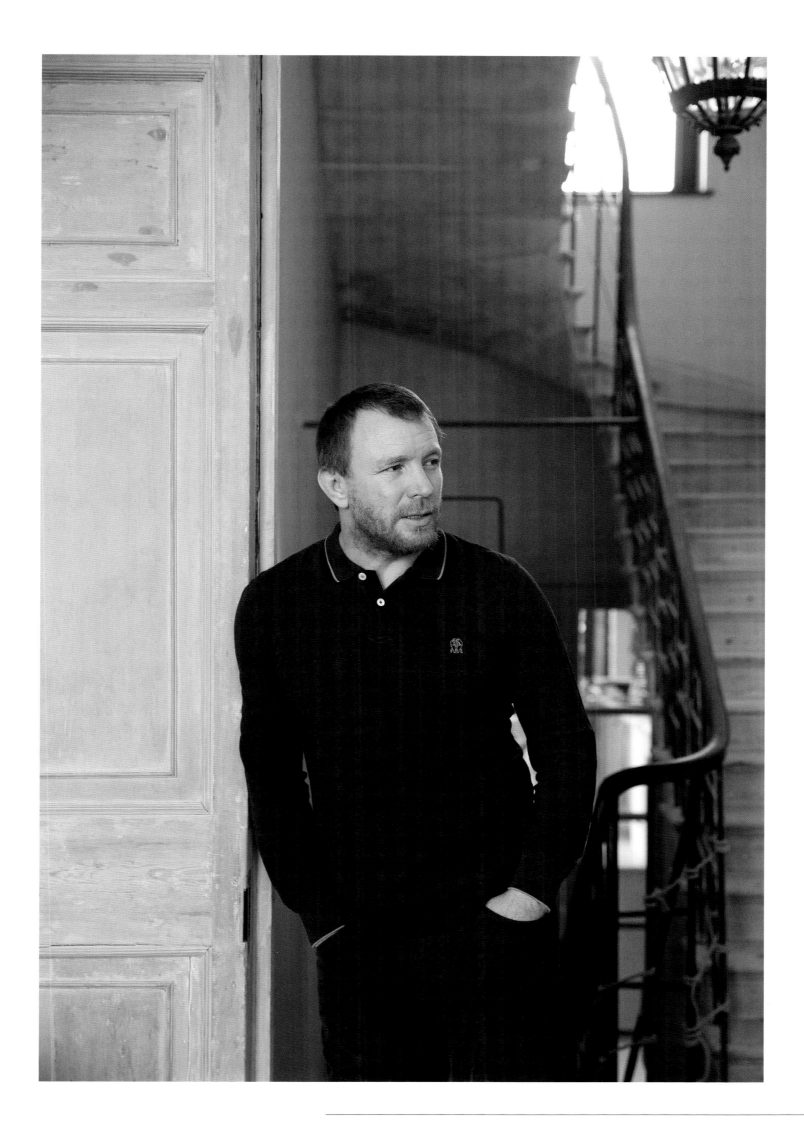

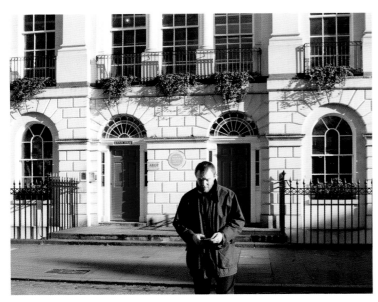

Ritchie takes in his neighbourhood outside Robert Adam's house on Fitzroy Square (left); Adam was the eighteenth-century Scottish architect and interior designer whose creations include Kenwood House on Hampstead Heath. A film director with a tough reputation, Ritchie walks past the alleyway where he lived for three years. He recounts how graffiti artist Banksy painted an image on the building wall beside the tunnel (below), but 'the local council had it painted over!'

(previous page) Guy Ritchie at home in Fitzrovia. Far removed from the London gangster scenes that feature in his early movies, he decorated his Georgian house himself. 'I've been on the streets of London since I left school at fifteen,' he says of his education in the school of life. 'I still love the London streets.' Fitzrovia was named after the Fitzroy Tavern on Charlotte Street, which was frequented by a group of 1930s bohemian writers reputed to have engaged in regular pub-crawls from Soho to the tavern's door. In a geographical coincidence, Ritchie's father worked at Collett Dickenson Pearce, also based on Charlotte Street and regarded as one of the finest advertising agencies in the world during the 1970s. 'I used to go there when I was a teenager and take in the scene,' Ritchie recounts, 'being caught by the creative worm'

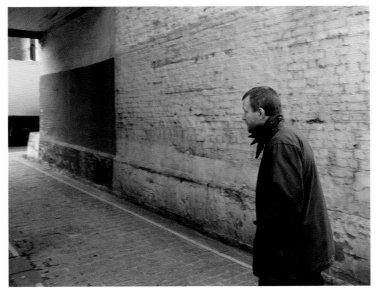

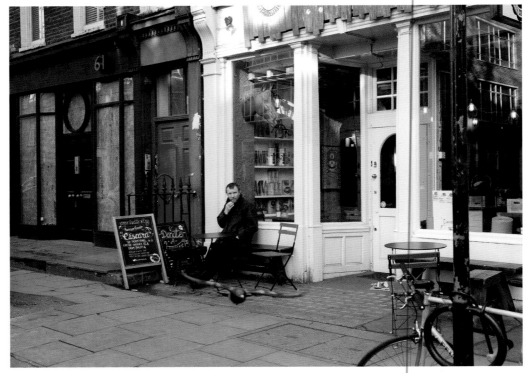

Back to the question of creativity in London generally. In your twenty-five-year expanse of experience, what has been the elemental change that has made London one of the world's principal film centres?
It's tax incentives, I imagine, is really what's pumped it in. What's happened is, it's become a self-fulfilling prophecy. Big films, starting with *Harry Potter*, suddenly caused a market for the infrastructure, so we needed better post-production. Then it became a tax break. The point is, you had government support for film. Then *Harry Potter* put the industry on a scale that it had never been on before; it put literally hundreds if not thousands of people to work in different skills.

Who created the architecture of this support base, the infrastructure you talk about? There was always talent in English film-making, whether it was exported abroad or not.
I'd like to know what the statistics are on English directors, but I imagine they're pretty impressive, never mind English actors. The entire infrastructure is British, and there's no-one here on this set at Warner Bros. that's been unemployed for years. And this used to be the case, right? There was permanent unemployment within the industry.

So it's all to play for, then.
Yeah, as long as you're prepared to crack on. You must remember that my experience is relative only to me; I can only tell you from my point of view. London creatively, and in terms of being employed, and in terms of me seeing the shift in the industry that I'm in, is vast. There could not be a greater shift from my point of view in a more positive way than has happened in the last decade.

Is it going to be sustained, do you think?
Who knows? I have no crystal ball for that.

What do you have in your imagination's box of tricks right now?
Creatively? Lots. More than I can handle.

Watching the world go by as he waits for his latte on Tottenham Street (left), Ritchie turns the conversation back to his native city: 'I've been banging on about London for a decade. It's an exciting place to be, but some of the architecture is shit.' Ritchie himself would not have minded being an architect if it had not been for the attraction of film: 'I fancied it, but I wouldn't go to school'

Ritchie feeds the fire (right) in his caravan parked outside Warner Bros. Studios in Leavesden, a wooden relic he uses when filming; his current project is an epic about King Arthur scheduled for release in 2016. 'Everything I like is old,' Ritchie remarks. 'I like classical things like Georgian architecture and London's squares, and I collect antique furniture.' He was a removals man in a different life, 'moving stuff from some toff's gaff and like, so I took a course at Christie's and learned to pick up odd things here and there and sell them for a profit'. It was when he came back from boarding school to live in London that Ritchie 'got interested in the conspiracy of all expressions of creativity'

Your ambitions aren't just national, they're global, right?
Yeah, but I'm not sure if it is a London thing; it feels international. It's curious that all the actors I'm working with, lots of them live in LA but they're all English. But now they spend more time here than they do in LA. And everyone's moving back to the UK, actually; it would make more sense for everyone to be in the UK. And everyone's around where I live.

When you take your working cap off, what do you do?
It's just me and the kids and the wife. I've got a place in the country; the English countryside and a townhouse are, if you ask me, an unbeatable combination. It's unbeatable as long as we remain commercially competitive and there are incentives to keep this industry (I'm being specific here) alive. By default or by active decision, it's happened that way; I just happen to be the recipient of seeing it become manifest.

Would you have made it if you had been in another city, do you think?
Not that I'm aware of. I'm not aware of any other city that seems to be as vibrant as London right now. Unless maybe in China, but I don't know anything about China.

If you were to compare LA, for instance, as the heart, the birthplace, of cinema and London as a more studied version of theatre and dramatic acting, what would be the great differentiator in terms of feeding your craft?
I'm not sure, is the answer to that. I spend more time thinking about European cities than I do about American cities. It's funny, this morning we were talking about … sorry, do you mind if I talk about Paris? We were thinking of Paris as the Gisele Bündchen of cities, the supermodel of cities. It looks absolutely spectacular, but it's not particularly practical. What's rather good about England, or London specifically, is that you have all the benefits of the culture, you still have some of the architecture (although it's not on the level that Paris has), but she's a very practical lady, is London. She's a bit beaten up, she's got a few pounds on her, she doesn't look like Paris, but she works, and she cracks on. She endures. To me London's a much more exciting city. No matter how brilliant Paris looks, I'd much rather live here. It's filthy in a good way.

'I'm excited about the creative aspect of London because, for the first time in my experience, it feels like the centre of the film-making world'

Daisy Jacobs
Animated film-maker
Marylebone/Bermondsey

You're only twenty-seven years old, you've got yourself a BAFTA, and you've been nominated for an Oscar. How did it feel to go over to Hollywood for the ceremony?
It wasn't something I ever thought might happen, or something I aimed for. I just felt accepted, I suppose.

Do you think of yourself more as a Londoner or as a country girl?
I'm a mixture of both. I absolutely love London; I don't think there's anywhere quite like London. But I like it back home as well.

Why do you think there's no place like London?
There's something understated and quite stylish, quite interesting, very layered about London that I really like.

As if it doesn't need to shout?
It definitely doesn't need to shout. If you live here for a while, you realise there's more to things, there's places that you've never been to before.

For how long have you lived in Marylebone?
For two years; I've lived in London for about nine. I was at Saint Martin's for five years, and then I went to film school for two.

Straight out of country life?
Yes, straight out of A-levels. It was a big culture shock initially; London felt very big in comparison to where I'd come from and also had a much faster pace. And I was aware of other people being very good at things as well. I always was one of the best ones at my school, especially at art. And then it was suddenly, 'Oh! A lot of people are good at art! You've just been in a small pond!' So it was the opening up to the big pond, which obviously was really healthy.

How come you didn't drown?
I did initially drown a little bit. I fought through by sticking at what I liked doing and always challenging myself for my own sake, not veering off course just because I could get a job.

Is your artwork a place of refuge for you?
Yeah. If I don't paint, or if I'm not actively doing something towards a film, or if I leave it for too long, I start to feel really, really depressed. I think it's very much linked to my sense of self. And painting is obviously therapeutic.

So you're an animator, a film-maker, primarily, but painting seems to underlie the whole …
I enjoy writing and storyboarding. The idea of the sequential, of images and storytelling within pictures, was always a thing that I was most interested in.

Where did you pick up the storytelling? Did you like being read to as a child?
My mum read to me every single night until I was about twelve. I'm an only child, so I was constantly reading. Between about twelve and fifteen, all I did was read and draw.

When did you make the move from reading to painting?
Well, I would always paint because my whole family paints. My uncle's an artist, and my granddad and my aunt. And my gran. Having a studio at the bottom of the garden and having paints around was very normal. I would copy what my uncle was doing when I was little. And I would also sit with my gran and we'd go over my art homework as though it was quite important.

Tell me about your gran. She seems to have been a very important figure in your life.
She was a resourceful, creative person. She very much supported the idea of doing art and the idea of always working hard and achieving what you wanted to. She was definitely the matriarch of our household. I grew up in an extended household with my aunt, my uncle, my grandparents all in the same house. My gran was very much the centre of everything. My first film is about how she died and what that caused as a family. The second one is about how we're moving on as a family, which is essentially slightly drifting apart. As soon as she went, some of the relationships didn't seem the same.

So, you've taken this difficult personal journey and turning it into art …
For most of my life, my gran had Parkinson's and I was aware of her getting worse. But she still was able to go on holiday and paint. It was really those last three years, where she was disabled – that's what the film's about.

Did it work out that making the films was a therapeutic exercise for you?
Yes, it did. The main thing, which was obviously quite strange for me, was that I was trying to keep her alive. Because when I left the space where I was working, animating, that's when I felt really sad. I cried for about a week.

You had already come to London by then. Did she see the work?
She saw my first experiment with life-sized technique.

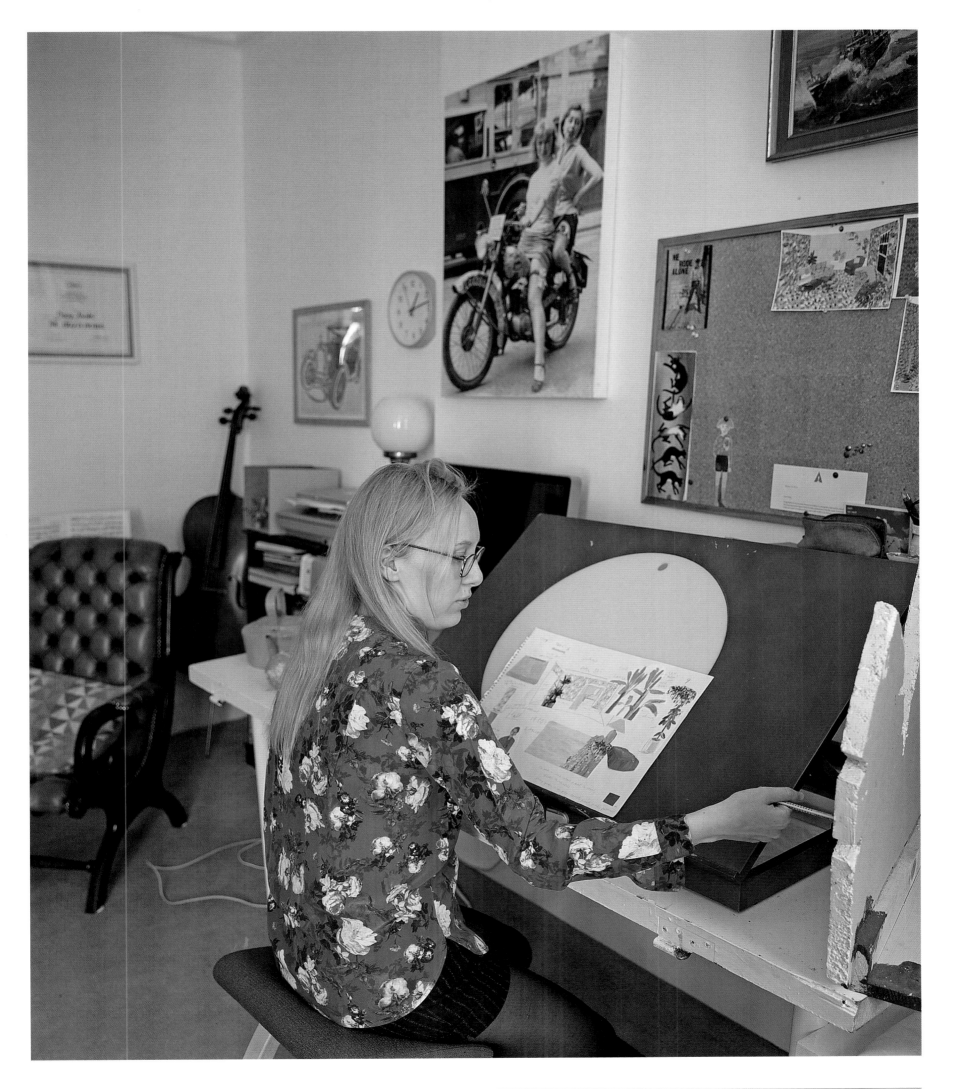

(previous page) Daisy Jacobs at work in her studio/flat in Marylebone. 'There's something about painting that is very therapeutic', the twenty-seven-year-old Oscar nominee says, 'even in illustration.' Jacobs won a BAFTA in 2015 for *The Bigger Picture*, her first-ever film, an animation scripted around the death of her grandmother Eileen, pictured on the wall above Jacobs' desk astride her BSA Bantam motorcycle with a friend

Jacobs (below) enjoys a springtime walk in Regent's Park, and waits patiently in Baker Street Tube station (bottom right). Sir Arthur Conan Doyle's character Sherlock Holmes resided at 221B Baker Street, which claim to fame still fuels tourist traffic in the area (right). Home to such raffish entertainments as bear-baiting and bare-knuckle prize fighting in the 1700s, Marylebone has had its fair share of larger-than-life residents, from Benedict Arnold to H. G. Wells and John Lennon

'There's something understated and quite stylish, quite interesting, very layered about London that I really like'

And now you've raised something like 23,000 quid on Kickstarter, is that right?
The 23,000 is for my next film. I've made quite a bit of money at festivals as well from winning things, so I've got a fairly good budget.

So you're an independent ...
For this next film, definitely.

How many people are on the production team?
The core is twelve. There's a lot of other people that have asked to be involved.

When you started out, did you work alone?
On The Bigger Picture I had a team of about eight. Today, I design, I write, I storyboard, and then I animate, but I have a co-animator, Christopher, and we also have production designers, a photographer, an editor, a sound designer and a composer.

Has success changed you substantially, or has it just given you more room to be yourself?
I feel supported and encouraged, definitely. I don't think there's been a change in myself. I was always quite confident of my own abilities; I knew what I was capable of. I still feel that way.

In painting?
Yeah, and in film-making, in writing. These are all aspects that I feel I'm good at and enjoy doing. I enjoy all the different stages, and for things that I'm not strong at, I have a crew member that's really good at them.

You strike me as somebody who's very gentle, very subdued, rather understated. But in the film world, you have to kick ass! How do you deal with that sort of situation?
I'm quite assertive. I think I may appear to be more gentle than I actually am.

Elsewhere you've mentioned two people whom you respect, Wes Anderson and David Hockney. You've spoken about Hockney's lavish use of colour, but what about Anderson?
He represents the type of film that I'm interested in. Pretending to be a documentary film-maker is not for me. I feel strongly about things that are surreal, out of the ordinary, if you like, with an underpinning of something very true. There's something about the way Anderson frames things that's animation-like, almost like a comic. It's that element that I like, the way it's a real world, very choppy. It reminds me of how I storyboard.

There's no allowance for emotion, repartee or breakout. You've said yourself that with animation, you're showing, not telling.
Yes.

Is that manner perhaps reflective of your own emotional makeup? Don't you like things to be very structured, peaceable almost, but totally under control?
Yes, I think so. I am very, very controlled in everything. There's an expression about being orderly and controlled in your life so you can be violent and original in your work. I like that idea of being clear when I'm working. You can get inspiration from sitting and working. Maybe the first two hours, there's nothing there, but after the third hour, you get into it. It's like a door opens, eventually. If you don't work at it, you don't get to the door. It's not going to just come to you.

So the idea of the creative genius is not for you.
I believe in risk-taking; I don't think it's all plodding. But the main thing is hard work.

Your first film addresses decline, family dysfunction and disease. The new one talks about breakups, the catastrophe of divorce. These are not gentle subjects.
No. They're universal subjects, though. I don't see the point in making films aimed at a small group of people that have an obscure message. I'm aware of the audience, but I'm also aware of what I want to make. I'm not interested in pretentiousness.

You've spoken of your friend Tristan Oliver, who has been a cinematographer for nearly twenty-five years. In what ways has he been your mentor?
Tristan is important because he was quite involved in my first film. We possibly do have slightly different tastes, but that hasn't stopped us becoming friends. Also, he's made me think more about cinematography, which wasn't, coming from a drawing background, something that I'd had to use before or understood at all. I couldn't believe how different something looks when it's lit correctly. It's how you light it that can make something really interesting, and how the production design and the cinematography work together. And how you throw things in front of the camera or how you take them out. I find that fascinating because it is in a way a type of painting – painting with light, painting with shadows. Tristan's obviously exceptional at that. It's nice to have someone who is exceptional at something that you aren't good at that you're friends with.

Jacobs lunches at Casse-Croûte in Bermondsey (above) with her friend and mentor Tristan Oliver, a Hollywood cinematographer involved in the making of such animated hits as Chicken Run and The Fantastic Mr Fox. Bermondsey has witnessed massive gentrification, with the formerly derelict riverside and leather-trades district transformed into a hip neighbourhood anchored by White Cube's huge new gallery and high-end restaurants. The two friends on Morocco Street (top left) among former warehouses converted into lofts and luxury apartments

Paul Simonon
Musician/Artist
Paddington/Westway

You've been called the coolest man in town. What's that about?
I've got no idea. All I know is that I've been fortunate to do what I wanted to do on my terms, throughout my life. What I mean is that when I left school, I got a job at John Lewis and couldn't handle being told what to do. So I left. Then by chance I managed to get a scholarship to an art college. I'd gone to school in Ladbroke Grove, and none of us had much of a chance to achieve O-levels or qualifications because the school was a feeding system for the factories and what was around that area. You worked in the bookie's or down Portobello Market, or you joined a band.

We're talking about the '60s, right?
The early '70s.

So how long did you hang around school?
I stayed on as long as possible. But because it was a tough inner-London school, you had no stable teachers. So the structure of the school lessened.

Your dad was an amateur painter and a card-carrying Communist, wasn't he?
He was. When you're a member of the Communist Party, you have to go out and leaflet at certain periods of the year. So he gave me the leaflets and I would have to go to everybody in Ladbroke Grove and put these things through their door. Whereas my father, Stalin, was indoors watching television.

But he had a huge influence on you, didn't he?
Well, I had an interesting background. I grew up in Ladbroke Grove and Brixton. They're areas where you can live cheaply, and it was the time of *Windrush*, which was when they invited people from the Caribbean to work in the UK. I went to school with the children of these people, and this is how I started to get an interest in reggae. And also to be aware of another culture.

Was Stalin still around at that time?
My parents separated. My dad went off travelling and my mum's boyfriend moved in. He was a musician. In 1966 he won a scholarship to study in Italy, so suddenly the family was transported to Siena and Rome. That was mind-blowing because there was pasta, melons, Parmesan, things you didn't get in England. In school in Italy at my age then, you had to wear this smock with a big bow. I said to my mum, 'I'm not wearing that! We're from Brixton, Mum!' She understood. So I didn't go to school. Most of the time, me and my brother were just roaming the streets. And then we moved back to England, and it was grey, cloudy; the food was rubbish. It was quite depressing.

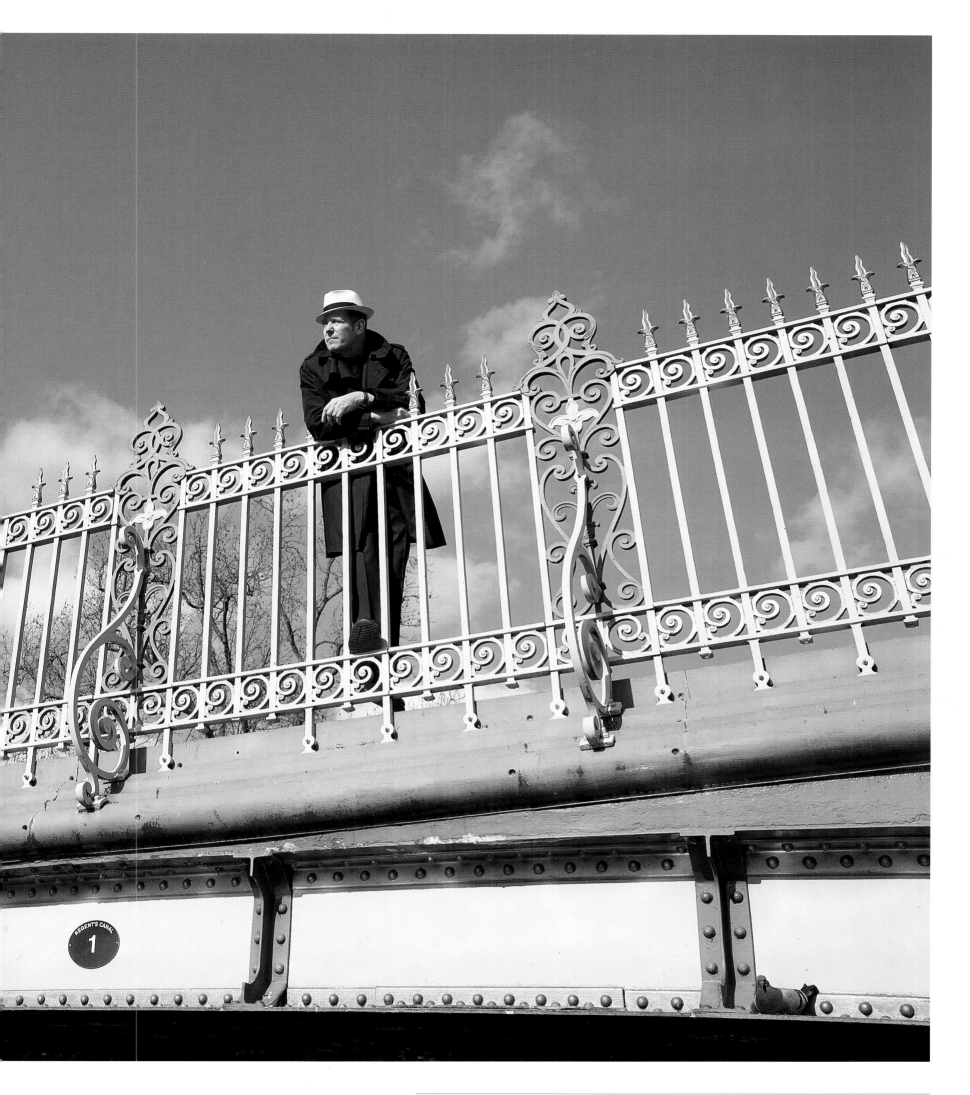

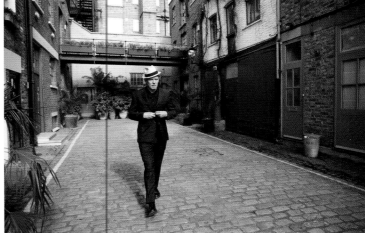

(previous spread) Paul Simonon strikes an old pose on a bridge in Little Venice. 'I've got memories of being in this area even though I mostly grew up in Ladbroke Grove and Brixton,' he says of his days before fame and fortune. Many of the grander buildings in the neighbourhood were designed by John Nash, while Little Venice itself is thought to have been named by Lord Byron, who did not care for the area being referred to as Paddington

Simonon in his studio, former stables in a mews in Paddington (above), which derives its name from that of an Anglo-Saxon chieftain. Anglo chieftain Winston Churchill once lived in the area, as did lesser warlord Tony Blair. Tyburn Tree, London's principal execution platform from the 1300s until 1783, stood at the junction of the Bayswater and Edgware roads. Simonon was a bit of a bad boy by his own admission, his leather jacket collection attesting to restless roots. 'Being savvy to visuals and an awareness of everything is important to me as an artist,' he says of his later self. Simonon walks the cobbles (above right), looking more dapper than in the days when he bought second-hand clothing on the Portobello Road. 'London Calling', The Clash's greatest hit, was themed around social and political issues such as displacement, unemployment, racial conflict and drug abuse. *Plus ça change …*

What about your artwork?
That came from my father; he was a Sunday painter because the rest of the time he was looking for work. When my parents were together, his room where he would paint would be my bedroom as well. He used to go to the libraries in Brixton and get books and tear pages out and put them on the wall. So I grew up looking at all these paintings. It was like the history of art, really. And because I was quite good at drawing, and I had all this knowledge about art, I thought, This is going to be my job.

From art to music – that was quite a leap.
The music thing kicked in when I was a teenager. That was the height of the skinhead period in Britain. The music we listened to, which was their chosen music, was reggae. The skinheads were the opposite of everybody because everybody had long hair and flares. In that period skinheads were pro-black music. When reggae bands came over to the UK, skinheads would be their security.

Which tribe did you join up with?
In the early days of The Clash, we were like mods; we had straight-legged trousers and jackets. That's what you could get from the second-hand stores; the normal shops had flares.

So your style was predicated on a lack of money.
Yeah. Style was really important. But of course later we became known as punk rockers.

What happened to the art part of you then?
I went away from art college after a year and a half because they were on an agenda where they didn't think life drawing was important.

You said something earlier about doing things the way you wanted to. Was there some sort of creative imperative that caused you to leave art college?
I just think that it was my life. Put it this way: When I was living with my mum and stepfather, I got in a lot of trouble. Criminal damage, maybe, and maybe stealing something. Nothing that extreme, just bored-teenager stuff. There were times where the police would come up to the house looking for me and I'm not there. In the end, my mum was like, 'You're going to have to go and live with your father.' And I was going, 'That sounds really good!' So I arrived at my father's in Ladbroke Grove and I had this trunk with all my stuff in. He saw all these things that I'd saved up, posters and stuff, and he went, 'We're not having that rubbish in this house!' It was like the prison doors just went 'Clink'. That's probably why I had this thing like, 'I want to do what I want to do!' Once I left, I did whatever I wanted to do.

When did you get a place of your own?
When I went to art college, I shared an attic with a guy from Wales, in Chiswick. It had these big cupboards taking so much space. We were saying, 'Can we not have these? 'Cause we ain't got much clothes,' and the landlord said, 'No, they got to stay.' So I got my one and tipped it on its side and pushed it up against the wall. Then I could open it up and put my paintings in there. That was my first place.

So how did the switch to music happen?
When the college thing was not working out, I ran into Mick Jones. He had this band called London SS, and I went along with a friend of mine who was a drummer. The drummer didn't get the gig, but the guy sitting in the corner was Bernie Rhodes, who became The Clash's manager. He said to Mick Jones, 'Get rid of your group and start a new group with him' – meaning me. I'd never played an instrument in my life. Bernie liked the idea of having a musician working with a non-musician.

'There are so many artists named *Paul*,' says Paul. 'Peter Paul Rubens, Paul Gauguin, Paul Uccello …' Paul is inscribed on his guitar (below), one of the rare survivors from his time with The Clash, having escaped being smashed onstage. Atoning for his sins, Simonon has a smoke outside St Mary's on Paddington Green (right). Apart from its tombstones and topiaries, the church is home to monuments to local luminaries, including a sculptor, a lexicographer and an actress – but no rock-band artists as yet. The punk-rock star, remembering his own motorcycling days, references the 1960s vicar of St Mary's, The Revd Bill Shergold, who turned his parish into a refuge in 1964 in order to bring 'hoodlums and bikers' under one church roof. By 1965, the 59 Club had seven thousand members from every corner of the country

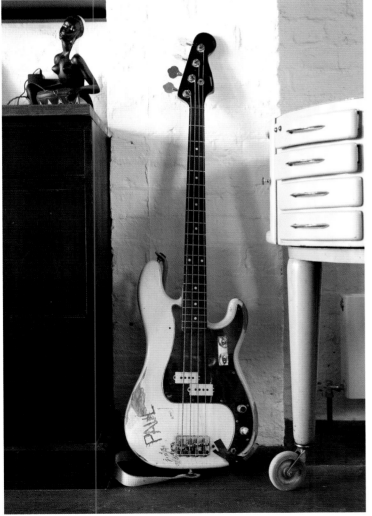

'In school in Italy at my age then, you had to wear this smock with a big bow. I said to my mum, "I'm not wearing that! We're from Brixton, Mum!" She understood. So I didn't go to school'

529

Simonon strolls along the Regent's Canal, photographing the colourful houseboats lining the waterway to Paddington (left). 'I got interested in music when I was hanging out with a friend who came from the Caribbean,' the musician confides. 'It was a total lifestyle and attitude ... You breathed it, you smoked it.' Simonon retraces memories (bottom left) alongside the Westway Overpass, mentioned in one of The Clash's songs. He crosses into Paddington Green, one of the oldest parts of Paddington, referred to in the song 'Pretty Polly Perkins from Paddington Green'. The rocker on Paddington Station's platform 1 (opposite), from which he often takes the overnight train to Cornwall in order to paint the clear blue Atlantic skies. Designed by Isambard Kingdom Brunel, Paddington opened in 1838 and is presently the site of massive redevelopment

What was he trying to create?

It was just trying to lay down ideas. We had a lot of conversations, political and social, and I had to try and learn how to play.

How long did that take?

Well, it's still happening now. I practised a lot. I didn't want to be stuck in one room painting; I wanted to live. Music seemed like a good option. After a few months, we saw Joe Strummer in his band called the 101ers. He was really good onstage. Then Joe did a show with the Sex Pistols and looked at his band and thought they were old hat. So when me and Mick approached him to join our band, he said yes. That's when The Clash was started.

Was there money at that time, or just girls and noise?

There was just nothing. I wasn't even on the dole.

When did that change?

Probably a year later, about 1977; that's when our first record came out.

How did that feel?

It felt really good. Somebody said, 'Look, you should get a mortgage, and there's a place in Ladbroke Grove, a basement flat. It was £11,000. So, with £1,000 I got a mortgage, and suddenly I had my own place. I could paint the walls black, blue or whatever, and take a big cupboard out when I wanted and have whatever I wanted in there. It gave me stability. It meant that I didn't have to sleep on people's floors anymore.

When did you get into the big money?

That came later. But it wasn't for very long. The way I like to put it is that we had our feet on the ground and our head in the clouds. We didn't take it that seriously, the big success. Otherwise, you're just away with the fairies. The point when it got really extreme was probably about 1982, when the records were in the charts in America. We were doing shows with The Who, so it was getting very big-time. The thing that was disturbing was that you went into a room and you wanted to leave with your guitar. Somebody would say, 'No, it's okay! He's hired to take your guitar for you. He's hired to get you a sandwich or whatever you want. Just ask him and he'll get it for you.' So slowly you got the idea that you were losing control of everything around you. One thing we learned from Bo Diddley was: Always carry your own guitar.

What led to the breakup of the band?

Eventually, there was sort of an internal issue. '84 is probably the year that we guitarists were out. That was Mick, who I had started the band with. He was a difficult person to work with. Me and Joe asked him to leave the band, which we knew was going to be trouble because he had come up with a lot of the music.

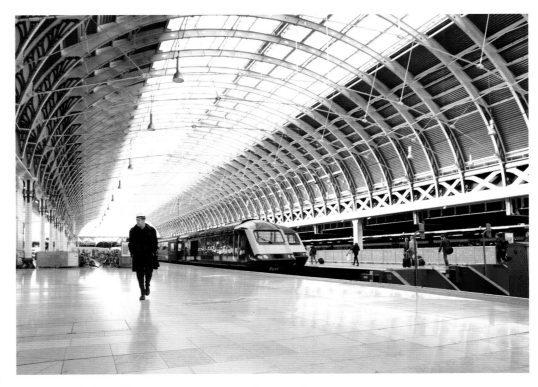

You've talked about The Clash as having been like a family. In what ways?

That's right. We didn't have the money, so we couldn't go to Vivienne and Malcolm McLaren's shop because they were too expensive. And if we did, we'd look like the Sex Pistols. So what we wore in the street, we'd wear onstage. We lived and breathed everything together.

How did you make your own trip back into art?

Art was still relevant in terms of visuals within the band. In the beginning of The Clash there was a bright pink speaker. I had our equipment painted that colour. In 1977, everything that was pink, people would go, 'Ugh, that's really gay!' I was thinking, Actually, it's a rock-'n'-roll colour. Elvis Presley had a pink suit. The good thing is, nobody wanted to nick our stuff. So there were practical reasons too. If you see a band, they come onstage and they look amazing, you want to know what they've got to say. I didn't dress everybody in the band, but I possibly did lead the way in the style thing. That was creative, I suppose …

Ilse Crawford
Interior designer/Editor/Author
Bermondsey/Rotherhithe

How did you end up in Bermondsey?
I chose it purposefully. I live in Borough, just down from Tate Modern. The studio used to be right next to my apartment. In fact, it more or less was *in* my apartment, but there came a point when the only space that was clear of stuff was my bed. So we had to move, reluctantly.

So you had people working for you at the time?
Yes. The studio was based above my apartment. But of course it overlapped, as it always does in this profession. We had meetings in my flat. Clients came to lunch in my flat. It became that overlay of life and work, because there isn't really a difference when you do what I do for a living. However, it did come to a point where the whole floor became a mountain of samples.

Why stay in this area?
Southwark is my favourite area in London. It's got real character. It was the last industrial area of London; it has that feeling still.

You grew up in Notting Hill, right?
I was born in Notting Hill, but we lived in Shepherd's Bush.

And your love affair with south London started when?
I've always lived in central London. Before Borough I lived in Holborn. I like the working parts of London, if you like. When I started the studio, I needed to find space that had light. It's about finding the kinds of buildings where you can function because making interior spaces is exactly that. You need to have your materials at your fingertips, and you need to have space to spread things out.

You've emphasised your love of light ...
Yeah. It's partly personal, partly practical. The practical side is if you are working with materials and colours, you need to have light for as long as you can. In Holborn, you could really only work with materials and colours until 2.00 in the afternoon because you had a window at the back and a window in the front. What we're doing here is making new realities; making interior spaces is a sensorial process, so all the senses need to be engaged. You need the space and light for that. But on another level, I need headspace. I like to have a bit of sky.

What do you mean by 'making new realities'?
We believe that our environments affect the way we behave and feel, and we endeavour to make what we call a 'frame for life'. We look at how to put human experience at the core of everything we do. As we describe it, 'Warm values in a cold system', particularly when we're working on commercial projects. When we're making interior spaces, it's less about the way they look and more about the way they feel and affect behaviour.

Is this a relatively new concept?
The insides of buildings are where we've always lived. What happened in the latter part of the twentieth century is that developers and architects started to work together, and the insides of buildings received relatively little attention. Now, for example, we might work for a company that wants to reposition itself and is looking at a behaviour change for their staff, shifting from selling to wellbeing. That has to be built from the ground up.

Which elements factor into that sort of change?
We spend at least two to three months working on the strategy of a project before we ever design its look. So we will work with a client based on the context. Why are they doing the space? What's it for? Who's it for? What will the life of that space be after we've left? You can't operate in silos. You can't have a space that is speaking to us in one way and then a staff who is trained in another or a vision for the company that's completely other and that has to be integrated in some way. It's through the physical experience of a place that you can differentiate yourself.

Interesting that you mention the notion of connection. In previous times, how would humans have felt in particular spaces, for example in Victorian factories?
Control is very much a function of the industrialising world. If you think about it, the office is a twentieth-century construct; it's the white-collar factor. All of that control, clocking in and clocking out ... the measurable things. Whereas what I'm interested in is the immeasurable things, the things we all feel. Trust is one, and beauty. We recognise those immeasurable things instantaneously. We're humans; they're primal.

And you feel that a sense of wellbeing increases productivity?
For me, wellbeing is critical. Obviously that's part of what I do.

(previous page) Ilse Crawford is all smiles at the STUDIOILSE offices in a former tannery complex in Bermondsey. 'I like living in the working area of a city because that's the lively bit,' she explains. 'It's messy and I like places where things go on during the day'

Crawford visits Neale Brown (below) at the Rotherhithe Film Library at Sands Films Studios. One of London's few remaining independent film-production studios as well as internationally renowned costumiers, Sands Films was recently threatened with closure and redevelopment into flats along with a Starbucks and Tesco. The studios bought the building instead, via Kickstarter and a crowdfunding initiative. 'That's the amazing thing about the digital world: that it can keep this place alive,' Crawford says

Give me a contemporary example of this sense of wellbeing.
Airbnb is a wellbeing project, if you think about it – the use of an idle resource, the reconnecting of people. We have got locked into these silos where sometimes we ignore the obvious. I heard yesterday about an old people's home that's in a town in the Netherlands where there's a shortage of student accommodation. They're renting rooms to students and it's proved to be a tremendous hit.

Do we all need to own a home in a huge city like London?
Home is very important to our psychological wellbeing; the feeling of being *at home* is profoundly important, that sense of feeling safe, of feeling connected, not feeling vulnerable. Because so much space is inhospitable, it makes us feel unsafe.

A huge amount of new London space is pretty inhospitable and almost dormitory-like, cut off from the flow of human interaction. Is that deliberate, do you think? There appears to be this paradox where on the one hand, you have London's huge surge in redevelopment while on the other hand, you're losing the sense of neighbourhood.
It's a huge pity. Where I grew up in Shepherd's Bush, I remember strongly that feeling of neighbourhood. We had a city farm; we had a mobile library; there were Catholics round the corner who had a television. It was a very diverse area. We were connected, we were aware of each other. You knew the rag-and-bone man. As kids we were exposed to all sorts of people. My parents were Canadian and Danish living in London. I met people from all financial backgrounds, of all ages. It was normal. Today, not at all. I was on the bus or the Tube aged five or six on my own. There was never the thought that anything would happen to me. Today, we are protecting every child from being exposed to reality, which basically means that we are all living in bubbles. Which isn't human, and is actually quite bad for us.

Is interior design in the sense you've described trying to compensate for this social evolution to the next stage of city life, to urban dwellings that are totally impersonal?
For sure you can't compensate, but there's no question that certain guidelines are more likely to create better social relationships. You can't make it, but you can certainly nudge it along the way. That's why we talk about a frame for life. You can create the conditions.

The philosophy behind social housing that started in the '60s in London has led to terrible results, hasn't it?
Not always. In Amsterdam, for example, social housing works very well.

But in effect you have two societies in London. One is feral, almost, inbreeding in an enclosed estate environment, and the other is a fancy, glorified, new humanistic design catering to people who can't actually afford it.
We don't work in the UK; our clients are foreign. To be honest, I think many projects that use design in London are really interested in gift-wrapping. It's a short-term thing. The financial gains have been so huge, I think they see design as the cherry on the cake. You need an enlightened client; none of our projects would have been possible without courageous clients. There always needs to be a human being behind the process because only human beings can create change. The system is an Excel system; it looks at numbers, it looks at measurable things, and fundamentally it looks at profit. The individual can project forwards.

So what is it going to take – major riots? – for the government to think seriously about trying to extend this subtle space for human interface?
It's going to take a number of things. We have noticed recently that more local people have started to come and talk to us than ever before. I think it's the beginning of a realisation. You always need a crisis of some sort, don't you? I think that things are changing, that we're in a period of accelerated change. Big companies that we never thought would be in trouble are in trouble. If I was in a big company right now, I would be looking at the evidence. You can never afford to be complacent; just look at the facts. And if you look at the facts right now, it really is time for change before it comes and bites you. There is a real desire for something that has, as you say, more embedded values of humanity, of neighbourhood, in London. The rapid gentrification of London has meant that people have focused on shorter-term goals. I had a conversation with an estate agent not long ago, and she said she was struggling to sell those apartments, but whenever council housing came up, there was a queue round the block because they were built better. It's true there were issues in London around council housing, but it you look at the comparative quality of what was built in the '60s and '70s and what's being built now, they were far better built.

Structurally, they may well have been; I was thinking more of the social engineering behind council housing.
They often put the wrong sorts of people in the mix. You need a diverse community in order for it to work. Where as they tended to put monocultures together, that didn't really work.

How do you plough new social fields to grow more diversity in terms of social-housing stock?
It is a question of prioritising. The Danes, for example, have prioritised wellbeing in the way that the city is constructed. London is a very different animal. It's a more short-term, money-driven city.

Yet you've chosen to live in there.
The great thing about London is that it's part of Europe even though sometimes one wonders whether it is. So it's a fantastic base. You can get everywhere from London. I lived in New York for a while, and when I decided to come back to London, it was less about coming back to London as such and more coming back to Europe. The thing about London that of course is so great is that culturally it is so rich. I look at the people in my studio; I think I've got at least ten different nationalities. It's such a cosmopolitan city, and that is so unusual.

The designer looks out towards Execution Dock in Wapping (below), opened by the Admiralty in the 1400s for the execution of pirates. The designer is concerned about the present-day piratical exploits of the super-developers transforming London's skyline. 'The Shard is wrapping paper,' she says condescendingly. 'People say it has created jobs, but people come in, they work, they go away. It's a slice off the surface. Borough Market has now become a food court for the Shard, but it's been a neighbourhood market for a thousand years.' One wonders what the Shard will look like in another millennium

Crawford visits one of her favourite public spaces, a bandstand in Southwark Park (above). 'This is the area Dickens wrote about,' she notes. 'It was polluted with lots of illness, and one of the things made to balance this out was the park.' Crawford frequents the railway arches in Maltby Street Market (Ropewalk) in Bermondsey (below), a public space transformed into a thriving market by Anita le Roy, a friend to whom she refers as a 'benign dictator'

'I think many projects that use design in London are really interested in gift-wrapping. It's a short-term thing. The financial gains have been so huge, I think they see design as the cherry on the cake'

Alan Rusbridger
Chair, The Scott Trust/Former Editor-in-Chief, *The Guardian*/Writer
King's Cross/Fleet Street

Would you agree that you've made a big mark for yourself, a big difference in the world, in the last twenty-odd years?
Well, I hope so. Many people are drawn into journalism in order to make a difference. The *Guardian* was born out of an instinct to make an influence on the world, and I think it always has. If you were being purist about the newspaper, you would say that the first duty is to bear witness and keep a record, and that the act of recording things is itself influential, because we know of parts of the world where that is difficult, and what the consequences of the absence of that is. But it's possible to go beyond that and into things where you're not simply a neutral observer; you're having an influence beyond the act of observation.

Precisely, because merely being a newspaper of record does not suffice to make that much of a difference. In the last few years, you've had WikiLeaks, the *News of the World* hacking scandal and then the mother of them all, Edward Snowden. In each of those cases, the consequences went well beyond the boundaries of London.
But in a sense they all began with reporting. The phone-hacking story spiralled and spiralled and spiralled and had a huge influence, but it was all based on a reporter asking questions and writing what they knew. With Snowden, we had a lot of documents which we looked very carefully through in order to reveal what was there. Sometimes the story has a life that you can't predict when you start.

If I had a pot of gold information-wise, why would I go to the *Guardian* as opposed to another newspaper?
You would have to believe that we have the independence and the courage to run things. One of the reasons Snowden didn't go to the *New York Times* was that they hadn't used material like his in the past. He obviously thought the *Guardian* probably would. So the reputation you develop for how you do your journalism and the decisions you take obviously has a reinforcing effect.

Would you describe yourself as a crusading spirit?
Sometimes. On the phone hacking, we published something and other people reacted very badly to it. News International attacked us, the police did nothing, the regulator blamed us. So you think, Well, this is going to need more than reporting. We're going to have to do this in a determined way, maybe for years. That feels like a campaign, but at the heart of it, it's reporting. The thing we're doing on climate change at the moment is an overt campaign. So there are things we do from this building that are subtly different.

At what point does a story transform itself into a journey with a challenge? Does that worry you, getting yourselves into trouble?
Well, I don't enjoy getting into trouble. Often the best thing is to just look at the words on the page. You could begin with Edward Snowden by saying, 'Who is he? What's his motive?' Or you could just say, 'Look, here are these documents. What do they tell us? What is the public interest in this?' Every day we take decisions about what we consider the public interest in publication to be. That's almost the only question you need to ask: Is it true, and is it in the public interest?

How much of a say do the lawyers have in all this?
Quite a lot. Anything that looks at all tricky we'll show to them before we publish.

You mentioned Snowden. Were his intentions ever questioned?
Well, I did send a reporter to Hong Kong to meet him and to try and evaluate him. He rang back and said, 'My judgement is that he is who he says he is; his motives are what he claims.' Now, if I'd been terribly suspicious about him and thought, Well, is he really a spy?, I could have spent more time, though it's in the nature of espionage that you'd never really be sure. You can debate Snowden for the rest of your life, in which case you'd never publish any stories because you'd be too anxious about who he was.

Is there anyone outside the editorial room that you consult on these matters?
Depending on what the story is. There are six hundred colleagues out there. I'll consult them; I'll consult senior columnists; I may consult the Scott Trust, which owns the *Guardian*. Sometimes you go to people outside who are experts. Snowden brought in foreign relations, the law, cryptology, things that you can't be expert in. So you find the people you think you can trust and you have multiple conversations which help you as Editor to decide, Well, I'm now satisfied that we can publish in this way.

You were born in what was then Northern Rhodesia and came to the UK at the age of five. Describe your beginnings as a journalist.
I began very modestly on a local paper …

That was the *Cambridge Evening News* …
I started writing wedding and funeral reports. I didn't think there was anything there that was going to change the world. Then you climb your way up the ladder …

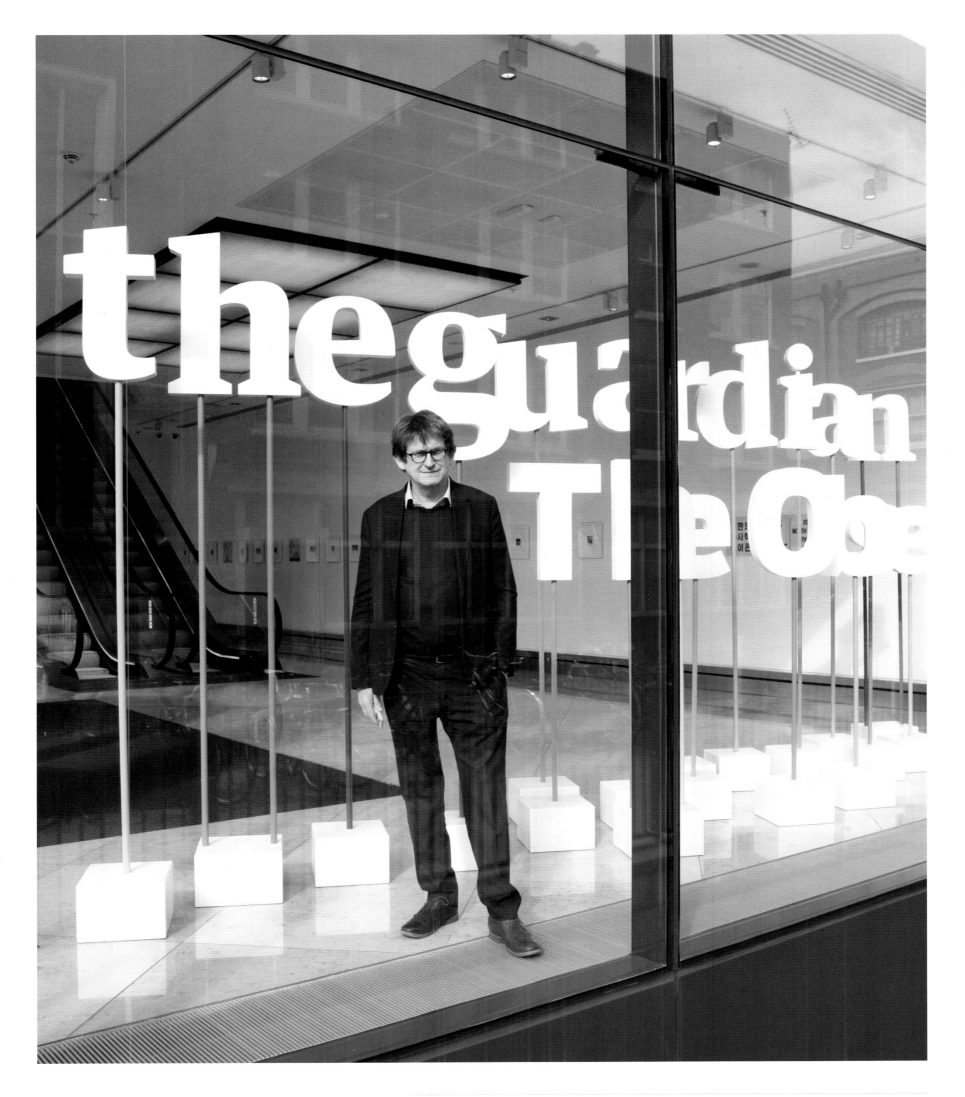

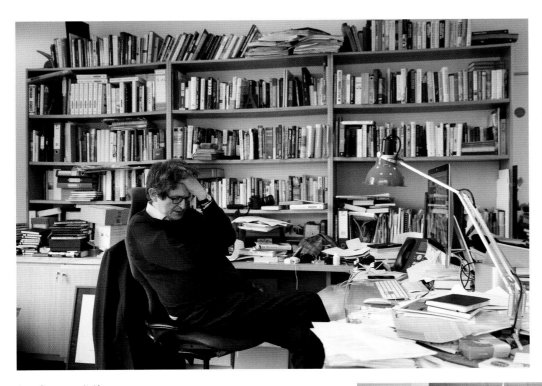

(previous page) Alan Rusbridger at the *Guardian*'s HQ at Kings Place, a bat-friendly roof proof of the newspaper's progressive take on eco-issues. The paper's former Editor does not like being thought of as anything more 'high-flown' than a reporter

Rusbridger keeps his head above water in troubled times (above), and considers his options (above left) at his cluttered desk. Under his direction, the *Guardian* was responsible for the Wikileaks and Edward Snowden exposés, stories that shook the very fabric of the body politic. 'As a society, we tend to respect whistle-blowers,' he asserts. Wandering the corridors of power (left), this time his own, the 'reporter' surveys the workstations of the *Guardian*'s six hundred employees

'… *If we went through another phase of cuts, the danger that you'd destroy this amazingly stable and flourishing art scene in London is a bit worrying*'

An accomplished pianist, singer, photographer and all-round man of letters, Rusbridger's passion (when he can spare the time) is indulged in dingy bookshop basements (left), investigating old printed matter and musical scores. Not content with settling political scores (the Jonathan Aitken and *News of the World* phone-tapping scandals, among others), the aesthete rummages through detritus at the Archive Bookstore on Bell Street, one of London's best-kept musicians' secrets. Taking his new secrets with him, Rusbridger (below) makes his escape, shadowed by seasonal blossoms

I'm trying to find that pivotal moment when you veered off in the direction that took you to where you are now.
I know what you're talking about, and I do see colleagues who from quite a young age want to be the editor of this or that or want to run the world or whatever. I don't think I ever was like that. My career advanced in incremental steps. Up to the point of becoming Editor, I was a writer, a columnist, a feature writer, a foreign correspondent, a section editor, another section editor, a commentator, Deputy Editor. At no point, until about six months before I got the job as Editor, did I think, I'm going to be running the *Guardian* one day.

So either you're quite brilliant, or fortune favours you, or you've got a secret admirer. Which one of those …
All three!

And now you've left, to don a don's gown … in Oxford.
At Lady Margaret Hall, and I'm Chair of the Scott Trust. I was very keen to be Chair of the trust because I'd been conscious as Editor of how much I valued having the protection of the trust behind me.

So you've become the guardian of the *Guardian*?
I've become the guardian of the *Guardian*. I wanted to have a life that allowed me to write a bit. I was approached about the Oxford job and I thought, *That* sounds a bit like *this*: a community of six hundred very clever people. *That* feels like an interesting place to be. It's interesting to wake up and know that you're going to spend the day with incredibly talented, clever people.

You seem to be a rather modest chap. We talked about crusading; you're not going to make any big changes in Oxford, are you?
I'm not going to make any changes. You have a framework that Oxford has to operate. You have the health and welfare of the students, and, on top of that, Oxford has the same thing that a newspaper has, which is a great power to convene interesting debates and arguments. There's a journalism school there; they're interested in the Internet, I'm interested in the Internet; I've become very interested in climate change, there's a climate-change institute there. So there are a lot of opportunities in Oxford to do the kinds of things that we were doing at the *Guardian*, but in a slightly different way.

Imagine you are now at the college, and you discover that MI5 or MI6 are trying to recruit staff. Would you permit it?

I'm not against MI5 and MI6; they perform a useful service. Countries need intelligence agencies. If you mean Snowden, he was revealing a huge pattern of systemised collection, storage, researching of millions of records; he was pointing out that that technological capability is very dangerous if not properly …

But who is he to judge? If somebody at the *Guardian* was to go and write the inside story of things not meant to be public about the organisation, would you feel comfortable?

I suppose it comes back to the same thing as in journalism: What is the public interest in the revelation?

On another subject entirely, I understand that you are a keen pianist. Do you see that as a kind of respite? Does it give you clarity and sustenance?

Well, it's two things. Since a very young age I've had a musical life, singing, or playing the piano or the clarinet or in orchestras, or just listening to music. So the deep need for creative expression and fulfilment is of itself fulfilling. Separately, I think in a very high-pressured job, finding escape is quite important.

The media in progressive countries comprise a central force when it comes to stirring a creative soup. At the *Guardian*, how have you tried to not only sustain but to develop that influence on a national level?

We've done it on a national *and* an international level. We have a great many writers, critics, editors, people working in audio, in film, writing about culture, from low culture to the highest culture, and it's a very well-visited bit of the newspaper and its website. On Saturday we have everything that's in the *Guide*, which is popular culture, right through to the *Saturday Review*, which is very high culture.

And your audience, you hope, extends beyond the literati. Have you ever wanted to capture the *Mail*-ians, the *Mirror*-types or the *Sun*-worshippers?

The print circulation of the *Guardian* has always been quite small, but in digital it's now the biggest English-language newspaper website in the world. Bigger than the *New York Times*, not including the *Daily Mail*, but of the newspapers that are trying to do serious coverage. Six or seven million a day come to the *Guardian*. That's huge, and I expect that it will double over the next X years. So in terms of doing justice to something like culture, you're not just addressing what pejoratively would have been known as *Guardian* readers. It is the biggest source of news after the BBC in the UK. So that's a very broad thing we're managing.

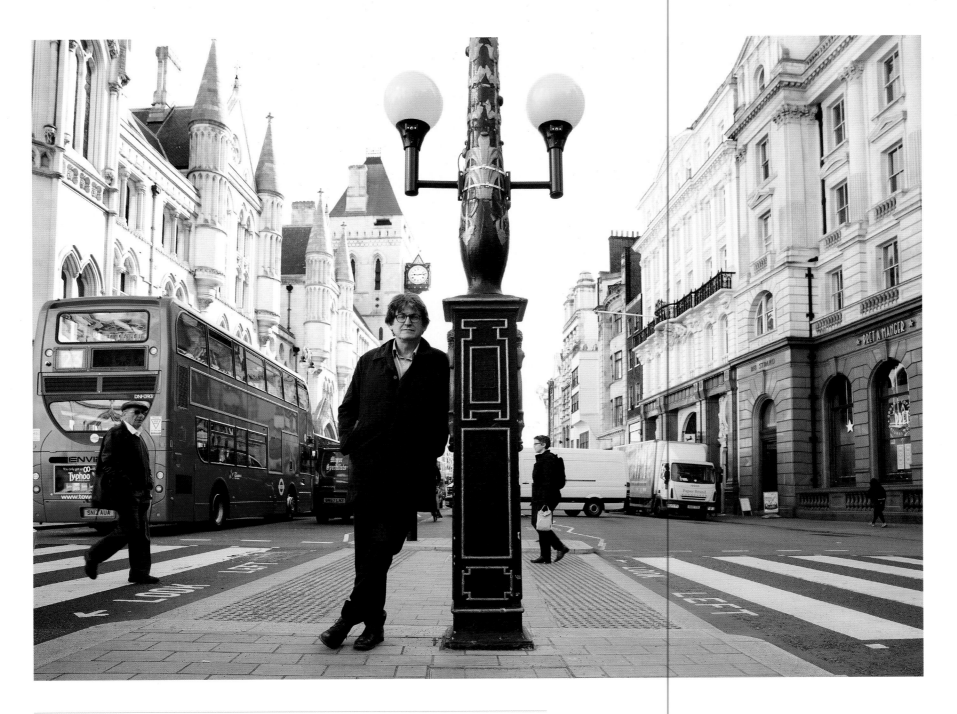

Alan Rusbridger

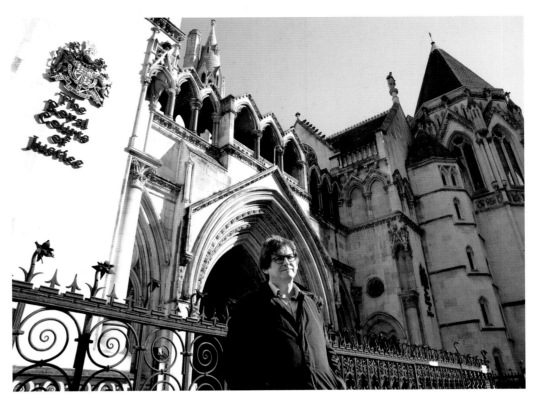

You moved to King's Cross in 2008, when the area was being transformed. The physical, financial transformation of London was the precursor of the creative spurt that has positioned it where it is today, as, some would claim, the world's leading creative city. What role has money played in this creative explosion?

The last ten years have been the most glorious phase in London. There's state subsidy of the arts, which is incredibly important. Ten years ago, twenty years ago, half of these institutions were in crisis. The Royal Opera House was tearing itself apart; ENO was in crisis. At the moment, the Tate Gallery, the Royal Opera House, the National Gallery, the National Portrait Gallery, Tate Modern, the various symphony orchestras, the Southbank, the Barbican, they're all flourishing, the ICA, the Whitechapel. I do fear the withdrawal of money, so if we went through another phase of cuts, the danger that you'd destroy this amazingly stable and flourishing art scene in London is a bit worrying.

How does a newspaper like yours make a difference in that arena?

In the end, it's really between the voters and the government and the Department of Culture. With free museum entrance, the access for ordinary people to art is staggering. It would be terribly short-sighted to put that in jeopardy.

On a personal note, you seem to be a bit of a workaholic, aren't you?

Yeah, that's probably right.

Have you always been one?

I don't know if I was a workaholic at university, but you can't do a job like this and not work incredibly hard. You just can't do it.

Have you accomplished what you set out to do in your life, or is there more to come?

Well, I've been editing the *Guardian* for twenty years and I am handing it over in strong shape, having done some things that I'm very proud of. It's not all that I want to accomplish; I've got family life, I've got a creative life, I'm not yet dead, and I've got another career coming up, so there's lots still to achieve. There's books still to be written, pieces of music still to be played, so I wouldn't want to sit back and say, 'This is a life achieved' yet. It's not a life achieved.

Rusbridger recalls former times on Fleet Street (opposite), propping up the Establishment on the Strand, and taking on the powers that be (above) at the Royal Courts of Justice, a venue he has visited more times than he cares to remember. 'Several times in my life I've been up there in trials, and they are always incredibly intense experiences ... very nerve-racking and very forbidding,' he remembers. The Gothic Revival building, opened by Queen Victoria in 1882, serves as the home of the High Court and Court of Appeals

'The last ten years have been the most glorious phase in London. There's state subsidy of the arts, which is incredibly important. Ten years ago, twenty years ago, half of these institutions were in crisis'

Gemma Arterton
Actress
Battersea/Bankside/The Cut/
The Strand/Vauxhall

It's a long way from a council estate to becoming a Bond girl, a high-flying Hollywood star.

Yeah. I never thought I'd end up there, to be honest with you. It's not necessarily a case I was particularly comfortable with either. I grew up on a council estate, and when you grow up somewhere like that, it's hard to shake it off. Even when you're placed in über-glamorous circumstances, you can't quite fit in. I'm so very grateful to have come from that, because I can see the disparities between the two!

How do you cope with those disparities?

Well, to me the glamorous side is not real at all. I enjoy going to film festivals, I enjoy going out for nice dinners and living the nouveau-riche life, because that's what I am, nouveau-riche. Yet it's not where I feel comfortable. I guess that's why I live in south London still. Even though I live in a nice place, I still can be five minutes down the road and I'm in Brixton or wherever. I don't think I could ever live anywhere that was manicured because I'd find it very uncomfortable.

Can you say something about your upbringing?

My mum's a cleaner and my dad's a welder. They work five or six days a week and have done their whole lives. My mum earns twelve grand a year and my dad earns about twenty-five. They work harder than most people. I got my first job when I was fourteen and I was happy to work.

Where was your first job?

How weird is this: the Warner Bros. shop! And then I ended up working on Warner Bros. films. I made my first film when I was twenty-two.

Did you find the irony a little –

It's not ironic, it just felt like something that happened. I remember one day I was serving a guy that was James Bond's stunt double in the shop, and he was boasting to everyone. And then, five years on, you're working on the same thing. It's weird. Life is full of things like that.

Life is not full of things like that, absolutely not, for the vast majority of girls who come from a working-class background …

That's true. I do count myself very, very, very lucky because I didn't have any connections to the acting industry whatsoever.

So how do you account for your success?

If you talk to my mum about what she's most proud of with her daughters, she'll say it's their independence, the fact that we're both doing what we love for a living and earning money, being able to support ourselves.

Your mum was on her own when she was raising two girls, wasn't she, and having to work, at how many jobs?

At one point she had three jobs.

So she would hardly have been able to tend to you guys.

She did that as well. She's an amazing woman. I was raised by a woman who struggled to raise her kids but did it, and did it well. For me it's been a huge inspiration in terms of the way I live my life, because I'm proud to say that I can do anything off my own back. I've got my own production company now, I can make my own films, any theatre I want to do I can do, and I'm so immensely proud of that. Which is hard for a woman coming from the working class. There's not many working-class female actresses that are doing queens, duchesses, leading female roles; usually they are playing the wench, or *EastEnders*. When I was doing the Bond film, I remember somebody said to me, 'You need to change your accent, Gemma. Otherwise you'll only play the maid.' And I said to him, 'You can fuck off. I can change my accent for the part. I will not be changing it for my life, because I'm proud of where I come from.'

You've described yourself as being passionate, fiery, impulsive and fickle. How so? You seem hard-core, determined.

Yeah, but I change my mind every day. Not my opinions, but I change my tastes a lot.

Does acting necessitate an essential character shift that can happen in an instant, or do you have to grow into each role?

In film, you have to be much more instantaneous because you're jumping from place to place while shooting. So you'll start with the end sometimes and you just have to become that then. Whereas with a play, you grow into it. I always want people to come and see plays in the second half of the run because in the first half you're just getting used to it, you're not quite there. Although there is something to be said about the first time you ever do something probably being the most interesting because it's all on impulse and instinct, and you're grappling with things like you would in real life.

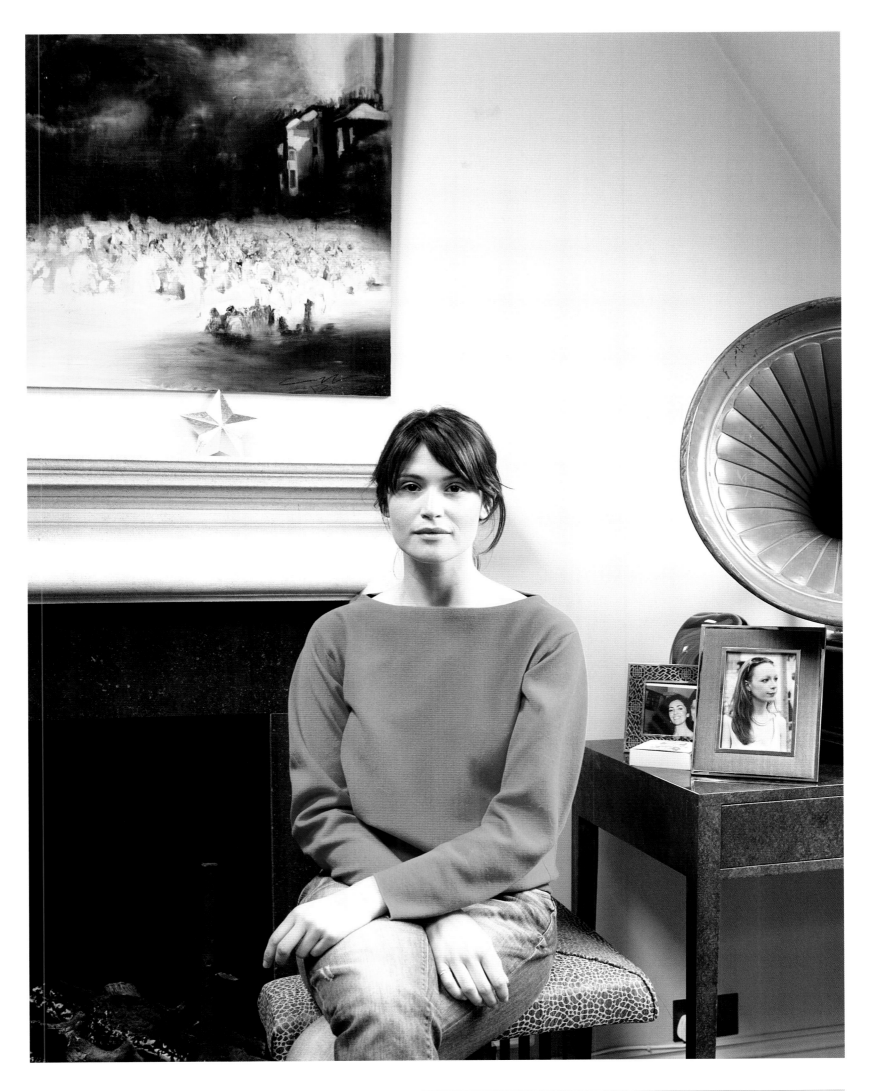

Flowing in and out of a character, where did you learn that?
You learn it as you go along. I went to RADA; I did three years of technique. A good actor doesn't need technique; they can just do it. But technique often helps you to be able to have range. For me, there are some characters that you feel instantly you can identify with. You choose them for a particular reason because it's a way of exploring that aspect of yourself. Other things take a bit of work. I did this film called *The Disappearance of Alice Creed*, and it was very, very, very intense, very dark. Afterwards for three weeks I was really ill and depressed. I couldn't get rid of this feeling because I'd battered myself emotionally.

You're a very determined woman, and you also seem to have a great aptitude for learning. Apparently you wanted to learn French, and did it in a year, fluently. That's hardly something that everybody would do.
I've always been like that, ever since I was a kid. The French thing is that combined with the graft thing that my dad is always so proud to say that he instilled in us.

***Graft* is a very London word isn't it?**
Yeah, East London. They are from East London, my dad's family, so that's a natural side of me. I enjoy working hard, but also I enjoy broadening my horizons. Where I grew up, no-one spoke another language unless your parents were from somewhere else. I always loved travel and other cultures. It's a shame that in the UK it's not the done thing. You can speak English in most countries, and I hate that. I've got a musical ear, just get on with it and do it, and I'm so proud of myself for learning French. It's opened up a whole new world. I'm now doing more French films, and it's a different world over there. In terms of cinema, they're much more artistic than we are here.

(previous page) Gemma Arterton beside her old gramophone at home in Battersea. 'I would never feel comfortable in the posh London neighbourhoods. I'm a working girl at heart,' she says

Arterton (above), on the roof of her apartment complex, peeks over at Lavender Hill, with south London's skyline stretching to the horizon. She likes the area's 'no-man's-land' atmosphere, saying, 'It feels like a sanctuary; nobody bothers me here.' Lavender Hill was named after the herbs cultivated around Clapham Junction and Battersea in pre-industrial times. The actress (right) in the forecourt of her block of flats, a former school

Gemma Arterton

Arterton dies onstage as the Duchess of Malfi (right), a character she portrayed at the Sam Wanamaker Playhouse, a replica Jacobean theatre, in 2014. 'Every night I had to lie there acting dead for twenty minutes,' she remembers. The intricately crafted theatre is named after the American who single-handedly campaigned for the resurrection of Shakespeare's Globe, which was rebuilt near its original site in 1997. (The Bard's own Globe, home to his company The Lord Chamberlain's Men, had been built in 1599, destroyed by fire in 1613, rebuilt in 1614 and closed in 1642.) Arterton's first theatrical role, straight out of RADA, was in Shakespeare's *Love's Labour's Lost*. 'Even if I had not made my debut here,' she says, 'the Globe's a special place. There's magic here!' Arterton (below) chats with Wills, who has been magicking sets for the Globe for the past seventeen years

'Even though I live in a nice place, I still can be five minutes down the road and I'm in Brixton or wherever. I don't think I could ever live anywhere that was manicured because I'd find it very uncomfortable'

Arterton outside The Duke of Sussex (above), a pub next to the Old Vic in The Cut, where she worked as a barmaid and karaoke performer at the age of seventeen. 'It was real down and dirty,' she grimaces. 'Sometimes a scary mobster-type clientele would inhabit the place.' Mobsters are unlikely to turn up at the Savoy (right), where the actress sometimes dines with friends when performing at the Adelphi Theatre nearby. Britain's first luxury hotel, the Savoy celebrated its 125th anniversary in 2014, having been acquired by Arab interests (like many of London's top hotels) in 2005 and undergone extensive renovations

So you do some singing, you have a theatre career, you have Hollywood, you have a career in independent film. What will you be doing next?

It's all independent, the next four films I'm doing: two French and then two British films.

I was asking about your other interests …

Producing and directing, eventually. I want to do something that I've written myself, something very personal. There's a director I admire called Andrea Arnold who is from Gravesend, where I grew up. Her films have always moved me; they're very simple and very beautiful, about working-class people. Her first film *Wasp*, which won an Oscar, is about women on a council estate, a young single mum on a council estate. She films the beauty of that, and that's what I have to show to the world as well. But I think I'd start out directing theatre because I'm more experienced there and understand how to do it.

You've spoken of the inequality of women in Hollywood and of how your views are exploited, more so than those of men.

Yeah. That's a fact.

How so?

If you put a picture of a girl on a poster, usually you have to make her boobs bigger and her waist smaller. You're sexualised even if it's not a sexual part. The parts for women are usually the accessory to a man. Usually, I'd say 90 per cent of the time, they're the girlfriend, or the secretary, or the lover, or the wife. They're never usually the main part. And when there *is* a main part, a woman that is the central part, there's about six hundred actresses that want that part because those parts are so rare.

And they would kill for it.

Yeah.

But you wouldn't.

No, I'd fight for it. That's why I started my production company. My production company is about creating work for telling stories that are female-centric. That's not excluding men or saying that it's not going to be directed by men or written by men or with interesting parts for men. In the theatre world, there are so many brilliant plays about women written by men like Ibsen or Chekhov. But in film, women are not celebrated in the right way, and I don't know why that is. Especially because now Hollywood has got a lot of women running it. Isn't it interesting that even Angelina Jolie is making masculine films? I'm like, 'Really?! Angelina Jolie? Come on! You can make anything and you made that war movie, *Unbroken*?!'

Despite all this grafting and feminist determination you exude, wouldn't you still call yourself a bit of a romantic?

I don't know … What does that mean? My dad and my step-mum, they've been together for twenty-five years. For me, they're just in love, and of course they've worked for it and they've gone through horrible times and hard times. As a culture we are so quick to say, 'Oh, it's not working.' And I know I'm like that: 'Oh, it's not working, life's too short, go on to the next one, the next show.' But as I'm getting older, I'm thinking, No. You've got to work harder if you really believe in something, the right thing. I am a romantic in that sense. Yeah.

The brassy actress reprises her 2015 role in the stage adaptation of *Made in Dagenham* at the Adelphi (above), and, revisiting old stomping grounds in the world of espionage, pauses in front of the MI6 building in Vauxhall (left). Arterton's breakthrough role was in the James Bond film *Quantum of Solace* opposite Daniel Craig. 'I always wanted to do theatre,' she says; she remembers visiting the Adelphi as a child. 'I love film too, but when I'm onstage you can't really beat the feeling.' Her *Made in Dagenham* role as Rita O'Grady, a working mother who turns union activist to fight for equal pay for women at Ford's Dagenham works, is true to life in more ways than one. 'It's about working-class women I could identify with,' she notes. Arterton, whose mother was a seamstress, has set up her own film-production company to address women's issues

Deyan Sudjic
Director, Design Museum/Writer/Broadcaster
Holland Park/Kensington High Street

What defines a Londoner?
London, of course, has existed for a lot longer than anything that could be described as England. And London is the prototypical cosmopolitan city. Successful cities offer their inhabitants the things they need, the choices they want to make, and also the choice to be ignored. London offers that range of energy if you want it, the things you need from it, and anonymity should you require it.

The question of anonymity, of choosing to be in the heart of the city yet curtained off in your own little world, how does that work?
With England having invented the industrial city in the eighteenth and nineteenth centuries, it triggered a kind of moral panic among the English/British; they were horrified by what they'd done. So there's been an enthusiasm for a rural ideal since then. My family came from a small village on the coast of Montenegro, a place that doesn't offer choices; it's not a place to be different. A city offers that ability to be different.

Does that remain true in the twenty-first century?
Privacy is being transformed by technology, and anonymity is difficult in the age of digital culture. The fact that the world knows where your iPhone is at any moment changes the way we understand the city, the fact that Transport for London's data is available in real time on an app. It's a complete transformation of understanding how the city works.

Before, you had to do the footwork yourself …
And you got to understand the city slowly, gradually. I got to understand London on a bicycle, on Tube trains, on buses, on foot; it gives you a sense of how geography links up. But you never really get there, because on foot London is an extremely large place. So you're always finding that you don't understand how bits of it work together. I was born in W8, and over the next ten years I went east of Leicester Square four or five times; London's geography was confined to that part of the city which was within my reach as a child. It's now a very different place, but the way that you grow up in a city does implant a kind of mental map, and you tend to see other cities in the same terms.

You mentioned digital transformation, which is effectively eradicating the high street. Is that how you see the future?
Human beings have a natural desire for marking out their lives with their possessions. In the digital world, people still want to make books, still want to make print magazines. They want to record music on vinyl, they're fascinated by the Polaroid camera … It's interesting that you're wearing a watch, which is of course not the best way to tell the time and not the most value for money. But it clings on as a symbol of who we are, something that we might pass on to our nearest and dearest. It requires a lot of advertising from the Swiss watch industry to make us want to still invest in watches.

Is just being functional a realistic measure of city life today?
I've always been interested in looking at *why* things happen as well as *how*. There is a sort of alibi for most human phenomena that rests in the word *function*. But *function* is a slippery word. Yes, you want shelter, you don't want to get wet if you can avoid it, you want to keep warm. But beyond that we have other needs which could be seen as functional but that are emotional. They are about understanding what there is beyond the material world.

But the material world pretty much rules the equation, no?
If you take an optimistic view, a city is an effective machine for turning the very poor into the not so poor. That's why the ambitious and the dispossessed flock to cities the world over. We're in the midst of a transformation from the world being majority rural to majority urban. Not all cities have the same pulling power. London in the last decade has had an astonishing attraction. Most northern European cities were in decline; they were losing population to the suburbs. That's turned round. London's been growing in the last few years and will continue to grow, but it has only just reached where it was before World War II.

How does an urban native define their sense of identity?
If we look at what constitutes the city, what makes people feel like they belong to a place, it's what football team they support, it's what newspapers they read, it's how they get to work, it's where they work. You could argue that London spreads all the way from Bournemouth to Ipswich, in terms of what it does to the cost of where people live and transport patterns. What we think of an idyllic Cotswold village is actually an outer suburb of London. If you go to places in the Cotswolds, it's like Fulham: the same people, the same prices. They might look like rural enclaves, but they aren't.

What about the fact that the mass of so-called professional blue-collar workers are increasingly unable to find affordable housing in the city?
It's the single most damaging thing that's happened to London, the fact that the very things that make it attractive and desirable are being hollowed out by its inability to house people affordably.

(previous page) Deyan Sudjic takes ownership of the new Design Museum in model form. The actual building in Holland Park formerly housed the Commonwealth Institute: proof, if it were needed, that post-imperial power has less resonance in today's world than design and new ideas. Ironically, the previous Design Museum was housed in a former banana warehouse at Butler's Wharf

Sudjic on Kensington High Street (right), across from the new Design Museum's site. The pyramid of the Grade II listed building designed by Robert Matthew (its new interiors have been designed by John Pawson) is dwarfed by several high-end apartment blocks, trade-offs between the owners of the Commonwealth Institute building and the Royal Borough of Kensington & Chelsea, the richest borough in the country, if not the world. The owners have their cake by granting a lease on the property in exchange for planning permission for the redevelopment, and London gets to eat a new £80-million design centre. On which radical makeover Sudjic is emphatic in both principle and print, as witness the board behind him (below) in his temporary offices

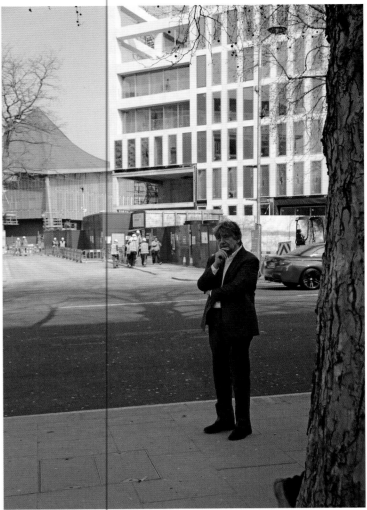

'London offers that range of energy if you want it, the things you need from it, and anonymity should you require it'

And there really is no ready solution, is there?

Well, these solutions don't happen as instant answers. One thing you have to say about London is that in terms of transport, it's got things right in the last two decades. Transport for London is a model for other large city transport systems. It's navigable, it's efficient, the way that London Transport's taken control of the over-ground system using lines from the nineteenth century. That's opened whole parts of London which were almost inaccessible. If we could apply the same connective thinking to housing policy, we would be in good shape. As it is, London attracts bright, gifted people, but they can't afford to live here. We're in serious trouble. The Wellcome Institute is building a centre for post-doctoral medical research next to St Pancras. They attempted to buy the Olympic Village; it was bought by the Qatari government for reasons best known to the powers that be.

Those reasons mostly came down to money.

But there is such a thing as enlightened self-interest. Sometimes London doesn't show that. Enlightened self-interest means that you don't necessarily always go for the highest price.

Land's always been the principal catalyst of capitalism, though. Art and culture are mere afterthoughts, a means of centring political focus and cultural value, aren't they?

A city is not a work of art; a city is never finished. We are now in an era where there are many cities in the world that are larger than many countries. What is it that keeps a city an entity? What makes people believe they are part of a city? That's in a way a creative idea. It's about the marks that people use to show where they belong, so accents, voices, how people sound and speak, the transport network … London's underground system is what gives a sense of belonging. The Tube map from the 1930s is a fascinating example; it's a logo for London.

And London's demographics are similarly in a state of flux.
Ethnic mixing has always been an aspect of city life. Alexandria in the era of Christ had its Greek community, its Arab community, its Persians. Successful cities have always been ethnically mixed. Britain has been pretty good at understanding that national identity is not a fixed thing. It fluctuates.

And of course this is good for creativity.
Absolutely.

But in what sense?
Understanding that there are layers of identity within a place is the modern condition. Not to have that is to be parochial.

But a lot of ethnic communities are almost enclaves, ghettoes, non-penetrative.
We are at a moment where identity and belonging are being interrogated once more; there is no one answer. We need to live together, to find ways of doing that. People who say that Britain should leave the European Union because it will allow Britain to self-determine its destiny don't understand the way the world works. We believed that new communications and technologies would allow the world to become more decentralised; it seems to be becoming more centralised in fact. Nineteenth-century Britain had not just London but Manchester, Birmingham, Newcastle, Liverpool, Glasgow, Edinburgh. These were all cities with their own energy, their own stock market, their own newspaper, their own constitution. That has been threatened by increasing centralisation. If you want to be a film-maker, you need to go to California. If you want to be in digital technology, you go to California again. If you want to be banking, it's London or New York, possibly Tokyo. On one level, things are centralising more and more. On the other hand there is this distribution of abilities and possibilities.

You've said that you 'live in a house in north London with tattoo parlours and vomit on one side of the street and Nash's sublime Regent's Park five minutes away'. Is this proximity a cause for social eruptions? Are we not storing up trouble down the line with such gritty diversity?
London was having riots in the eighteenth century; they were religiously oriented. It was no town to be Catholic.

So it all boils down to tribal issues …
Yeah. And you hope that a city would actually help to defuse tribalism.

So what's happened to social equality and integration and a sense of national identity?
Certainly London is, and Britain is, a vastly more tolerant place than it was.

Is there a future for London as a centre of design as compared to the great design centres like Milan and Paris?
London is the present as well as the future, the place to which young people come and learn. They'd like to be able to live and work here afterwards. That's the problem. They can't afford to stay.

You've been quoted as saying that London 'has come through an astonishing period of insane growth'. Are we on the cusp of change beyond which London will never be recognizable again as its old self?
As I said earlier, cities are never finished. We have in our minds an idea that London is a conservative place that doesn't warm to change, but if you look at the skyline and the way it's shifting so quickly, it's ruthless. It's the nearest thing in Europe to Shanghai. And that makes one ask the question: Will it be destroyed by its success?

Sudjic (above) enjoys the spring blossom in Holland Park (his new museum in the background), taking a break from worrying about delays and cost overruns. 'This city, which produced Alexander McQueen, Zaha Hadid, Richard Rogers, Norman Foster and Anish Kapoor, is pretty hard to beat creatively,' he exclaims. Holland Park, a 22-hectare jewel in the heart of Kensington, is located on the site of Cope Castle, a Jacobean mansion built by Sir Walter Cope in 1605. Inherited by Cope's son-in-law Henry Rich, 1st Earl of Holland, the mansion was renovated by Inigo Jones in the 1600s, only to be firebombed in the 1900s

Charlotte Tilbury
Makeup artist/Entrepreneur
Notting Hill

You're an island girl, right? In the sense of the Mediterranean, of Ibiza, I mean. How would you describe life there?
Exotic, sexy, dramatic, flamboyant, wild, passionate …

Does that describe you as well, would you say?
It does, actually. I am all those things. I'm definitely more Latin in the way that I express myself than I am British. I'm a mixture of both because of my heritage. My grandparents, my parents, it was almost like being in the Raj … That colonial behaviour never really changed. At the same time there was the difference between England, where children are seen and not heard, and countries where children are included in daily life. When you go out, they're up till 10.00 at night; you go out to dinner with your family, whereas in England you're very much excluded. And, because you were more included living in Ibiza, you got a chance to view things and be involved in things that you wouldn't normally be involved in. And the sunshine, the beach, the parties …

Were your parents extravagant people, then?
Very expressive people. They are colonial, and then totally extrovert, completely extravagant and Bohemian. They're quite traditional, but then they were avant-garde for their time. They helped start that nightclub Amnesia. There were writers, painters, actors; they were pioneers of the Ibiza set.

And your mother was involved with the creative world as well?
She was a producer, so she would do films and fashion. We worked together for a while, with the photographers Mert & Marcus. She would do Gucci campaigns and Louis Vuitton campaigns and *Vogue*.

How did you come up with the idea that you were going to be a super-support person to celebrities?
I was always fascinated by the power of beauty. Why does a certain woman when she walks into a room command so much attention? What is it about beauty that the human race is beguiled by? They're slaves to it; they're immediately drawn to it. And I'm a very aesthetic person; my family is very aesthetic. When you're creative, your aesthetics matter more than to other people. Everyone has the power to be beautiful; some people don't make the most of themselves. We think that what is symmetrical is more beautiful, but sometimes a bit more character in someone's face is a good thing.

But aesthetic surgery is a huge business, particularly for women, but more and more men are getting into it as well.
People should celebrate who they are. If you want to have surgery, it's fine, but you can do a lot for yourself with makeup.

But what we have today is a kind of aesthetic standardisation, with the big magazines pushing an image that is internationally sought after: the thin looks, the tall bearing, the made-up ingénue. Isn't it rather sad, everybody wanting to become the same?
Homogenised, in a way … But that's my point. Everybody should celebrate their beauty and be who they want to be through makeup. Fifty per cent of women in this country don't engage with makeup because they don't know what to choose.

They say that the last item in any recession that is cut is women's makeup …
The 'lipstick index' … that's absolutely right. Women would almost rather starve than go without cosmetics. We think of makeup as being frivolous, but it's quite serious. If you look in the mirror and think, Oh my God!, or when you look in the mirror and feel tired, makeup can mask all of that. Then you look in the mirror and you go, 'Oh! I look great, I look healthy, I look alive, I feel awake, and my eyes look sexy!' Whatever it is that you then feel gives you confidence, the world reacts, and you get a lot of compliments. Then your confidence, your happiness, grows.

But what happens to spirituality in that mix? Shouldn't one feel good inside rather than concentrate on the exterior?
We're completely ridiculous to think that you can turn into something that you only feel inside and are not affected by what happens around you.

When did you first take pen to face, so to speak?
I suppose I started really doing it at thirteen. I went to boarding school, and that's when I started experimenting more with makeup. I would take girls and be like, 'Let's get rid of your plait and do this to your hair and put this makeup on you and get rid of that kilt' and restyle someone to look completely different.

So you saw the power of the makeover. What was your school like?
It was a traditional English boarding school with an amazing lake; it was absolutely magical. I had a fabulous boarding house.

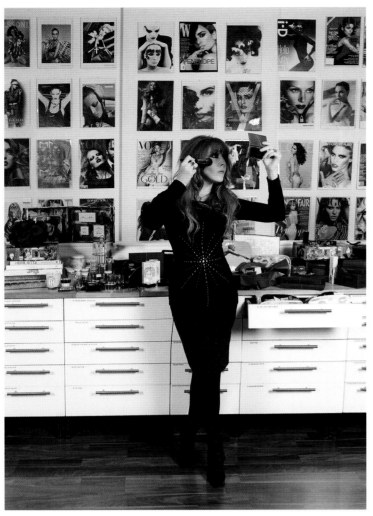

Tilbury (left) in her Queen's Park office, a wall of glossy magazine covers whose subjects she has 'done' behind her, the power of 'creative visualisation' evident in the transformation of their faces. 'I'm someone who thinks out of the box, who does things differently,' she exclaims. 'I believe in "NO is Yes"!' Tilbury, who launched her own makeup line in 2013, has helped to create campaigns for brands including Tom Ford, Stella McCartney and Burberry. 'My father was a painter; that's why I like to "paint" faces,' she says. No need for paint here (below): Tilbury in her living room, enjoying the style to which she has become accustomed. 'I love being who I am,' she confesses. Who she is has always been a woman in control, as witness her (opposite) stopping traffic

(previous page) Charlotte Tilbury vies with nature on the balcony overlooking the garden of the Notting Hill home she shares with film producer George Waud and their son Valentine. 'I believe in the power of creative visualisation,' she asserts. 'I'm dealing in the psychology of makeup; I can steal DNA as an artist ... I'm an alchemist'. The psychologist at work (right) transforming super-model Cara Delevingne

So, the school of life and the school of makeup: how do you equate the two in the experiential sense of making, or being made, over? Do you ever feel that you're papering over people's internal cracks?
Absolutely. We live in a world where everyone is exhausted. We are trying to race against the computer; we can't work fast enough. What makeup does is so powerful, the psychology of it and how it can affect somebody.

How does it feel to be a celebrity dealing with celebrities?
I kind of hate the word *celebrity*. The point is, you are in a privileged position. You get to be with people in places or times that not even their families sometimes or their best friends would share, because the only time that someone gets that close to your face is if they're your lover. So it's an incredibly intimate job, and you do become very involved. For me it's about aura. You feel someone's feelings, you pick all of that up. So yes, it's the nature of the job. You do become close.

Do your clients unburden themselves during these intimate close-ups?
There's a certain healing that goes on with makeup, when you put on their makeup, that whole kind of moment –

Do you remain silent?
No, I chat. We have fun, we laugh, we enjoy. You do become close friends, but you try and make it a pleasurable, fun moment, or as fun as it can be. In life you have to be more than just brilliant at what you do; you have to be light, you have to be fun. If I was just a brilliant artist and not fun to be around, I don't think I would be as successful as I am. It's the package that makes you who you are. It's a discipline. I'm professional, I'm hard-working, but I like to have fun and I'm good at what I do.

From a young age you admired people like Helena Rubinstein ...
I feel like Rubinstein's on my shoulder all the time.

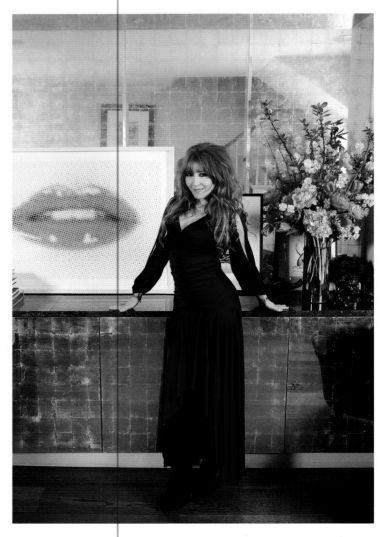

'We've had a huge influence on the world, this tiny little island. London has been a huge influence on me; I think it is the most exciting city in the world'

But she was a dumpy, grumpy, dictatorial woman.

She was. But she was also visionary, brilliant and very quick. She had an amazing artistic sensibility, a great eye. She pioneered the African art market. She got Dalí to design some of her packaging. She had great vision; she was tireless. Sometimes her exhaustion led her to be grumpy; I don't think she was always a grumpy woman. She was a bit shy sometimes. When I read about Helena Rubinstein, Coco Chanel or Estée Lauder, I'm not them – I'm different – but I do see similar character traits, and with some of the things they say, I'm like, 'That's the kind of thing I would say.'

And in this world of makeover, makeup, London is your central inspirational force, right?

Yeah.

Is it where you want to continue to be?

Yes. From a very young age I visualised, imagined, created my own destiny. It hasn't happened to me by accident.

But if you had stuck it out in Ibiza, or gone to Madrid or Barcelona, would you have been as successful?

But that was never what I was going to do. I literally was saying to my parents, 'When am I going to boarding school?' I was that girl. I was a very strong character from a very early age.

How did London specifically figure in all of that, though?

There was a big English crowd in Ibiza, so we hung out with English people all the time, and we'd always come back here; it felt it was like a second home. When you're brought up on an island, if you want to really do anything, you have to do it in a city.

Has London changed in terms of its importance in the world of cosmetics?

London has become a lot more cosmopolitan. London's always created trends. Now you have more celebrities living here than ever before, you have more business being conducted here than ever before. It has become one of the biggest airports in the world. It has become this Mecca of cosmopolitanism. Before, maybe you had the Rolling Stones, David Bailey, Twiggy, Chelsea … We invented the miniskirt. We've had a huge influence on the world, this tiny little island. London has been a huge influence on me; I think it is the most exciting city in the world. I can live so many different things in one night; I can hang out with so many different types of people. I find that truly exciting because I hate to just be in one world. I like to mix it all up.

What sort of person would you have been in the '60s?

I would have been having a bit of fun. I would have been a Biba girl, a Mary Quant girl. I would have my parents regale me with stories of Granny Takes a Trip, and going down the King's Road, and the Pheasantry and all those different places they used to hang out. It sounds so exciting and so fun and so wild and so free. What I really hate about today is the politically correct world that we live in. I feel like we are almost becoming hypocritical, like our voices are being shut.

Does that include the creative classes?

I feel that you're not allowed to express yourself because everyone's becoming fearful of being politically incorrect. I think it's wonderful, political correctness, to stand up for minorities, and for people not to abuse people, but it's gone to an extreme where people are becoming fearful to say anything. They're in total fear of flux. I find that sad because expression does affect how you creatively feel and flow. Who knows whether there will be some sort of backlash.

Speaking of backlash, here you are with red hair, with Celtic blood in you somewhere. Do you think of yourself as a sort of Boudicca-figure who got badly burnt but who aspired to greatness?

She did aspire, exactly. When you have red hair, it comes with a price. You are never forgotten, and that can be good and bad because you can never fly under the radar. You are always a presence. There's also my personality type: I feel like a force of nature.

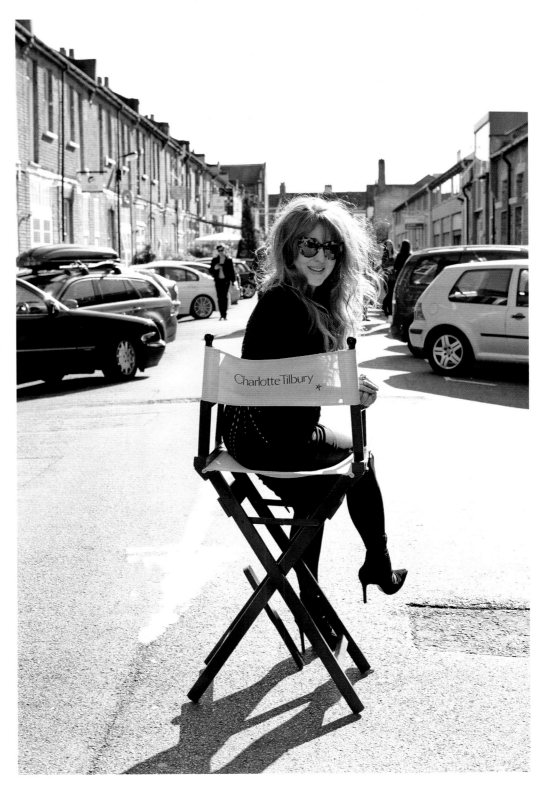

Tom Hooper
Film director
Soho/Chinatown/Leicester Square

What is Soho's particular significance for you?
From the very beginning, when I fell in love with film, Soho was the destination I needed to go to. From about the age of twelve, I have strong memories of getting on the Northern Line, going into Soho by myself, walking up and down Wardour Street, and going into shops and production companies and saying, 'I want to make films. What equipment can you give me for free?' I started making films on film, and you needed to load the film into the film camera in a changing bag that was light-proof. I didn't have a changing bag. So I would walk down Wardour Street, find out who sold changing bags and then go, 'I really need a changing bag. I don't have any money. Would you be kind enough to give me one?' The incredible thing was the kindness and generosity and supportiveness that I experienced. So this was the incredible place where I could find everything I needed to make films. I was lucky enough to be born in London so it was a Tube ride away.

How old were you when you first were attracted to film?
Like many people, it all started with an amazing teacher. I was at Highgate School and there was a teacher called Roger Mortimer who taught English and Drama. Every year he put on a play, and two years running he put on a musical. I acted in both. In *The Beggar's Opera* I was part of *MacHeath's* gang, and in the second year I played a military officer in a Gilbert and Sullivan musical. I completely fell in love with acting and theatre and drama; Mortimer opened my mind up to this whole world. So I knew from ten, eleven, when I began to act, that this was, in a broad sense, my world.

Did you grow this skin, or did you walk into a skin that was waiting for you?
Initially I fell in love with acting, and, like a lot of people, I thought maybe I should be an actor. But at the age of twelve, I remember thinking, Okay, I'm in a school of three hundred and I'm not getting the lead parts; that probably means I'm not good enough to be a professional actor. So I should give up this dream now. At the same time, I was drawn to directing, to stage lighting. I became the lighting designer of all my school plays, right up to seventeen. Then I found, in the assembly hall, a book lying on the piano; it was a library book about how film and television were made. I basically stole it, put it in my bag, took it home, read it that night cover to cover, and that was it. I was hooked. I spent a year reading every book I could get my hands on. I read a great book called *On Camera*

by Harris Watts which was the BBC manual for graduate trainees to teach them how to direct. I obviously bought the book in Soho. I was going to buy a second-hand Super 8 camera, and then I discovered my uncle had a clockwork Bolex 16mm camera from the '60s in his attic; he had briefly got obsessed with amateur film-making. So I borrowed his old camera and started making films. I used to physically cut the film with white cotton gloves on a splicer, so it was very old-school training.

Meanwhile, what was happening with your schooling?
I'd love to say I became a great rebel, but I was always quite hard-working and academic. What's interesting is that I never told anyone at school for a few years that this was what I did. It was a secret world.

So nobody knew?
My family knew.

Were they supportive?
Yeah. My mother was a bit wary; she worried that it was difficult to become a director. My father was more of an enthusiast. My family starred in my films. My first film, *Runaway Dog*, was a comedy about a dog that kept running away. Then I found my political conscience. My second film, *Countryside*, was about the fallout from a nuclear war, and my third film, *Bomber Jacket*, was based on my grandfather, who was a bomber-navigator killed in the Second World War.

You've spoken of getting your drive and focus from your father, and your bravery and ability to inhabit uncertainty or think laterally from your mother. Would you still say that?
Yes. My mother has an amazing lateral mind. I'll always ask her advice because to this day, I still can't predict what her advice will be. She's published over seventy books, so she's always been a great sounding board when I've talked about story construction. My family always see the first edits of my movies before anyone else; my brother and my parents are always my first critics. They've seen every film I've done, and they're pretty tough.

Going back to the Bolex camera you mentioned earlier, how much of directing is mechanical, technical interpretation rather than a creative exercise?
That's a good question. David Lean once said that directing is 90 per cent practical, 10 per cent wandering through the woods for inspiration. A lot of directing is practical problem-solving because you have limited resources, you never have enough time, and you never have enough money. A lot of getting through your shooting day and staying on schedule is to do with practical problem-solving. It can be something as silly and simple as you've laid down boards on the floor for the camera to track over on a dolly, and you go for the first take and the boards are creaking, and it's ruining the dialogue. You go, 'How do we get rid of the creak?' One person has one view, another person has another view. If you can come up with a solution there and then, you can carry on, but if it takes ten minutes, you've lost ten minutes. I remember shooting a commercial where that happened and thinking, 'Is this really my job? Do I really need to worry about a creaking board?'

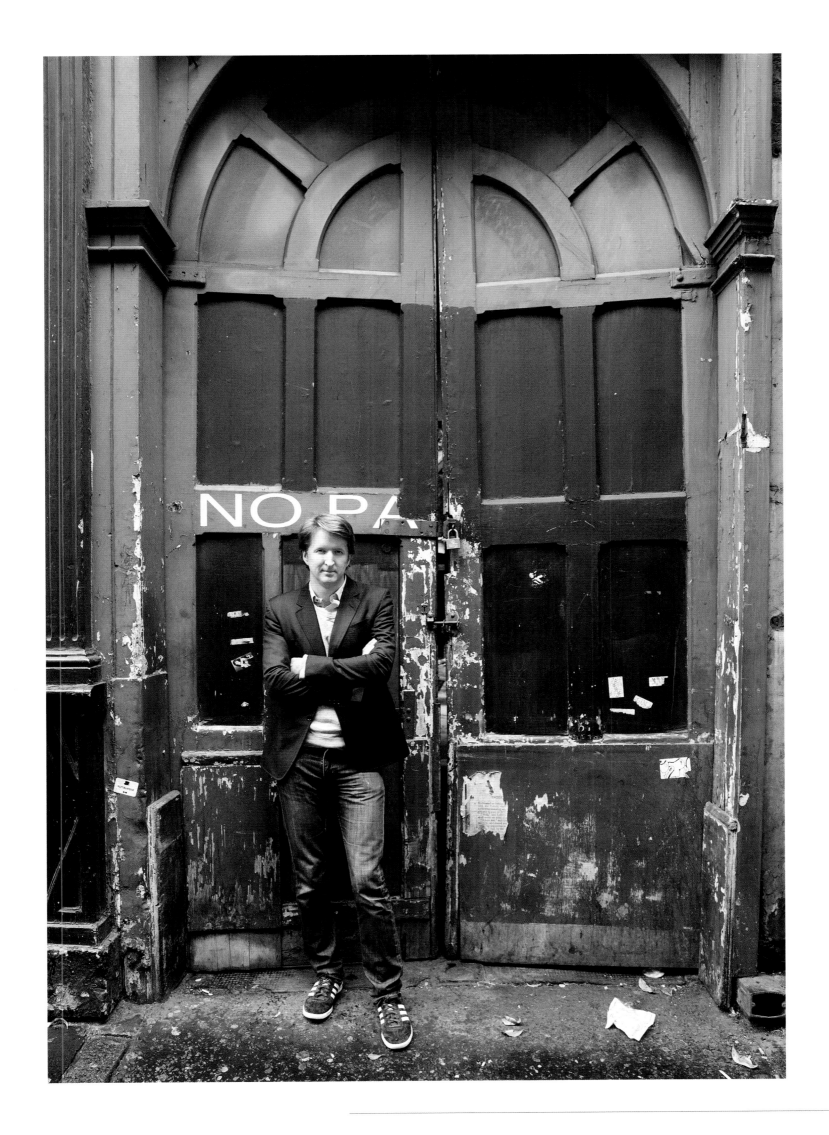

(previous page) Oscar-winning director Tom Hooper takes refuge from the hectic pace of Soho's redevelopment at the entrance to a derelict building on Lexington Street. Soho has been on Hooper's radar since he was twelve. 'I used to walk down the street and see the film companies and the posters of the films they made,' he remembers with nostalgia. Lined with late nineteenth- and early twentieth-century warehouses, Lexington and Wardour streets are home to the British film industry. Sadly, the neighbourhood is rapidly losing its charm in the face of frantic redevelopment

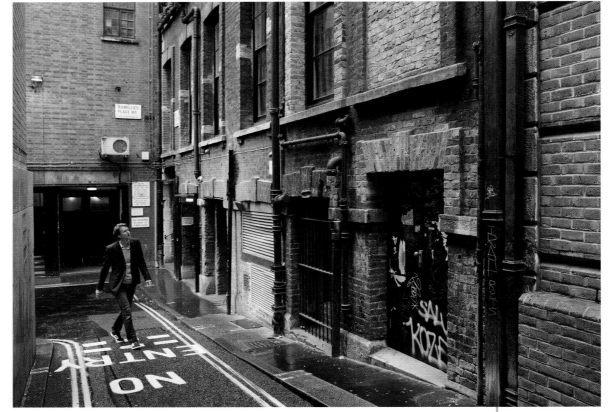

Hooper at work in one of Goldcrest Films' post-production suites on Lexington Street (top left), editing his latest movie, *The Danish Girl*. 'This is where we do the grading of colours, the sound ... We did a lot of *Les Misérables* here,' he explains. Hooper (above) with Melanie Oliver, editor on *The Danish Girl*, a drama about the first man to undergo a transgender operation. 'Marginalised stories that could not have been financed or would have found it difficult to get financing can now be told. That's a great thing,' the director explains. He and Oliver have worked together on several productions, among them *Les Mis*, *The Damned United* and *John Adams*

Hooper (left) walks down memory lane: the Soho alleyway where he shot his first film at the age of twelve. 'I knew it was probably one of the hardest things I could set my heart on because there are so few feature-film directors in the world,' he recalls

Hooper (left) retraces his boyhood dreams in Leicester Square, site of Britain's two major cinemas, the Empire and the Odeon. The Oscar winner moves through the characterful passageways of Soho, once the hub of London's sex trade. Walker's Court (below), described by the *Independent* as 'a suppurating alleyway of sexual half promises', is poised for a £45-million redevelopment. The Box, known to put on the capital's most explicit stage acts, is currently based here in place of the equally notorious Raymond Revuebar

What has been the impact of changing technologies on your particular role?

I was trained shooting film on a clockwork camera, cutting and splicing. My iPhone can shoot much higher quality, and it's got sync sound built in to it. This would have been a dream for me as a kid. *Les Misérables* was the last one I shot on film. I shot *The Danish Girl* on digital; we edit on digital. The world's changed, the technology will always change, but storytelling remains the art at the centre that doesn't change very much. What a great story is has remained the same for centuries.

So what's happened to the grand scenes of thousands of people being moved around and the director acting as God?

There's a famous call sheet of Richard Attenborough's *Gandhi* that calls, I think, for 1.1 million extras. On the biggest scene on *Les Mis* I think we had four hundred extras, and the other ten thousand were done digitally. We've got to the point where you will never do a film where you'll have two thousand, five thousand, ten thousand extras.

It doesn't feel the same somehow.

You're right, and there's some loss of romance in the fact that, in the old days, if you wanted scale you had to do it in camera, and now if you want scale you do a bit of it in camera and the rest through digital. I feel lucky that I'm young enough to have done film-making before the digital revolution; I had to do some big things for real. I'm lucky that we're still building sets for real, because one day we may build little sets and it might be all digital.

Will you still want to work?

The Danish Girl was a low-budget film. Everything is in camera; there are no digital effects. It's still the cheapest way to make a film; digital effects are expensive. So there will always be a place for doing things for real, because it's cheaper.

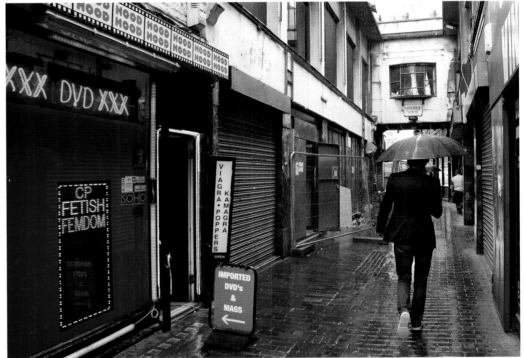

When you're ending up with all these blockbusters that are fine-tuned in some studio, isn't the romance gone?

The romance of knowing that a massive scene actually happened is gone.

Russell Crowe, whom you directed in *Les Mis*, has described you as a 'tough guy'. You don't seem to me like someone who would be out there punching and kicking.

I don't think I've ever shouted at anyone or lost my temper. I suppose all directors have a part of them that is going to fight hard to protect their vision; maybe that's what Russell was referring to. There's a part of every director that's tough as nails because they have to fight for what they believe in, and there's a core of a movie, a heart of a movie, that you can't compromise on. There are lots of compromises you can make around the edges, but you have to fight for the centre, the heart.

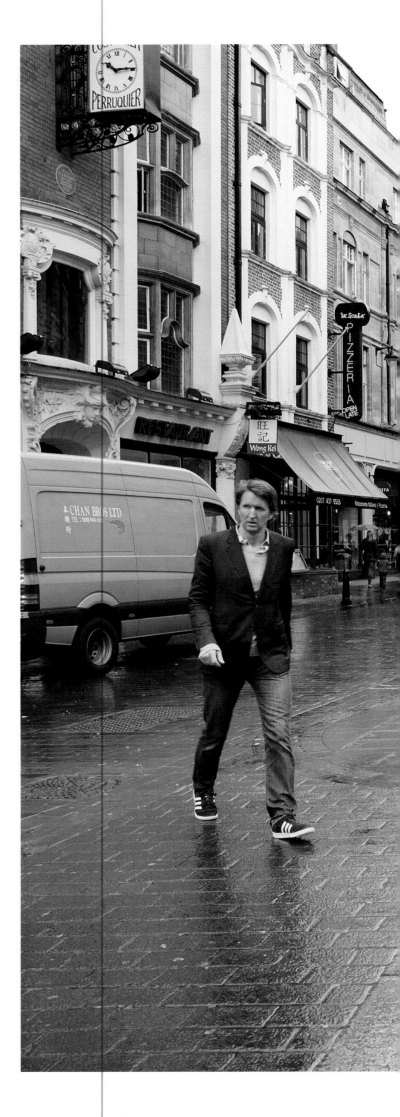

'I taught myself through reading about how to be a director,' Hooper remembers. 'I thought, I don't want to be one of these people who talks about being a film-maker; I need to make films.' He crosses Gerrard Street into Chinatown, bright hoardings in the background advertising *Les Mis*, the world's longest-running musical, at the Queen's Theatre in Soho. Home to descendants of Chinese immigrants brought in by the East India Company in the eighteenth century to work the Limehouse docks, Chinatown saw another influx of workers from Hong Kong in the 1960s, some of whom still only speak Mandarin

You were quite precocious as a kid, presuming one day to be on the credits of a major release, no?

I had a ritual that I did both at the Odeon Leicester Square and the Empire Leicester Square, which was, as the credits rolled for a movie, as I walked out the double doors into the foyer, that I'd look back and stare at the screen and commit myself to having a film on that screen one day. Then I'd turn and go. It was a great moment when, with *The King's Speech*, I did the premiere at the Odeon Leicester Square and could see a film of mine playing on that screen. Then, on *Les Mis*, we had a double premiere where we had both the Empire Leicester Square and the Odeon Leicester Square and I introduced them. I thought, now I've got the dream on both the biggest screens in London.

So what did you tell your twelve-year-old self?

That he could relax.

Back to reality now. You've been walking the streets of Soho for thirty years. How has the area changed?

I shot a film called *Single Sax* about a beautiful woman who plays the saxophone and tricks men to give her money. It turns out she's using a hidden hi-fi and isn't able to play the saxophone at all. In the introduction I weave through various London streets, including an alleyway in Soho that is still a bit of a shithole. My memory is that it was grungy, there was prostitution, the red-light district was everywhere. The film industry went there because it was cheap, because no-one wanted to be there because it was filthy and where the sex trade happened. What I find amazing is the gentrification. It's almost got too expensive for film to be there. In the next few years, film will start to move out. Ham Yard used to be a dead-end alleyway with a derelict warehouse; suddenly it's incredibly trendy.

Is this all good or not?

We've lived through an incredible revolution in London. When I was a teenager, the expectation was that you had to move to America. What I'm proud about is there's no pressure to go anymore. You get the feeling that it is okay as a film director making hopefully global films with London as your home. I think I'm right in saying that this year, there are more films shooting in London than in LA. I feel lucky that I've lived at a time in London's rebirth. The laboratory that processed my films was in Colville Road in Notting Hill. I was scared going down Colville Road at thirteen years old. It was edgy. Now it's all £10-million mansions. It's like New York. New York has lost an edge and a romance and has become gentrified, but it's also gained. Overall, London has gained.

But what about the crucible of creativity that needs seedy, prostitution-ridden alleyways and all that?

That's a good question. Seediness will always find its home somewhere.

'From about the age of twelve, I have strong memories of getting on the Northern Line, going into Soho by myself, walking up and down Wardour Street, and going into shops and production companies and saying, "I want to make films. What equipment can you give me for free?"'

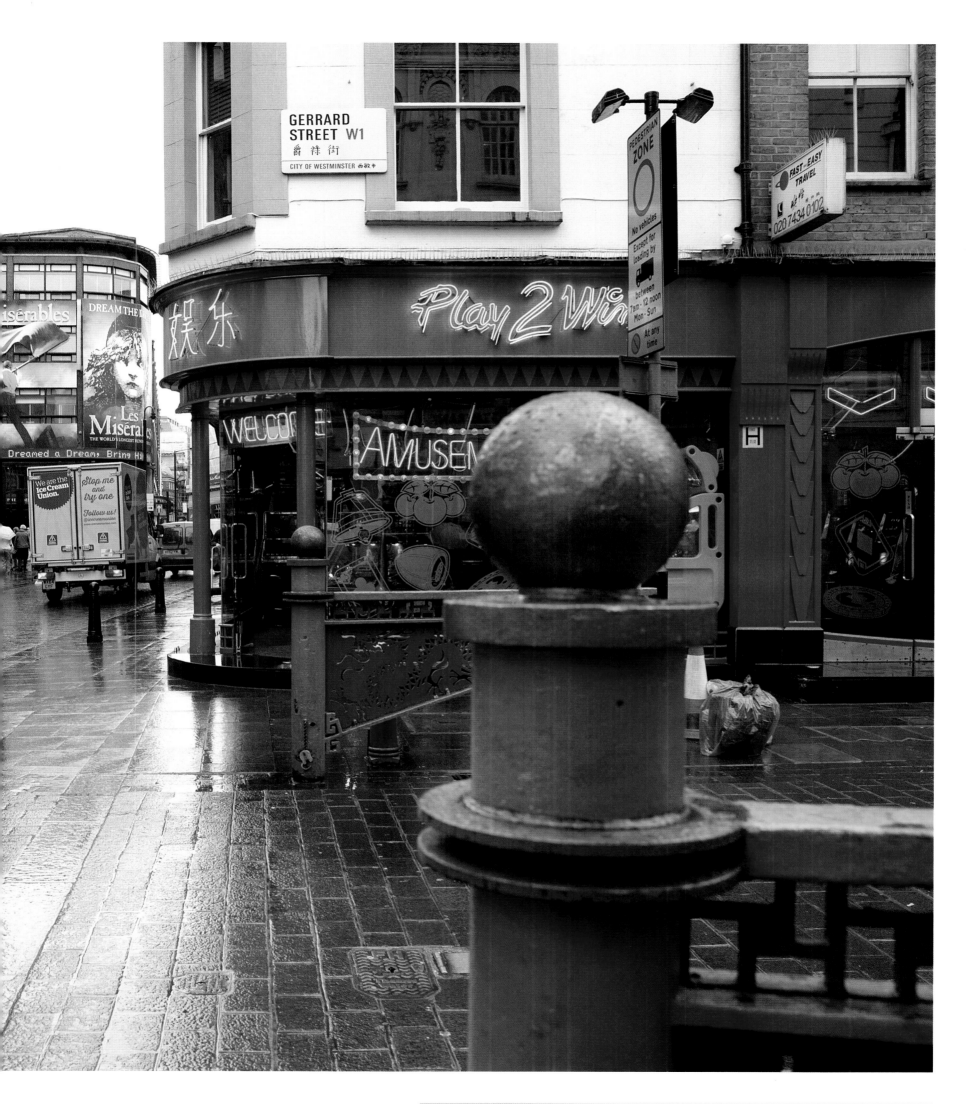

David Chipperfield
Architect
Waterloo/Southbank

Which project do you think of as the high point of your career?
In architecture the battles are ongoing; there's never a point of victory.
What's important is that, like all artists, on the one hand you're doing
singular pieces, but on the other hand you're trying to build a body of
work. You like your work to add up. But you want me to say which is my
most important piece … The Neues Museum was the most complex and
the most engaged, the project that had the most dialogue with a place and
the people of that place.

Why was that?
Well, it was embedded within the culture; it was a ruin for sixty years.
Berlin is in a continuous state of description and re-description, always
trying to reinvent itself. It was a strategically placed city, so from its
inception it has always been somewhat artificial, always trying to assume
itself somehow. It has no great wealth – there's no industry and no financial
centre. Hitler had his own vision for the city, then the war transformed it,
and when the Wall came down in '89 it went through a new stage of this
process. The Neues project was an important part of that self-description.
It became a seminal project in terms of how to rebuild a shattered city.

**So here we have the paradox of the British and the Americans being
responsible for the destruction of Berlin, Norman Foster rebuilding
the Reichstag, and you making another important landmark. How
does that feel?**
The Germans, Berliners especially, have been very open to foreign
contributions, certainly in architecture, and especially since Reunification.
They have a very fair competition system, and they open it up to
international architects. Norman Foster and I both benefitted from
that generosity.

**You've been heard to complain about what's happening in London
as far as redevelopment is concerned. It's the opposite of what's
happening in Berlin, where public money is supporting costly
non-commercial ventures. In London, everything has been built
by the private sector looking to make a fast buck.**
There's a different mentality in Germany, which still looks towards the
state. England after Thatcher became rather different. One must admit
that the free market and a certain level of deregulation have their
advantages. London has certainly benefitted financially. Other European
cities have been looking at London in the last fifteen years and saying,
'Why is London attracting all this investment?'

And why is it?
Because there is a greater degree of financial deregulation, and it has
allowed investment in a way that other cities haven't.

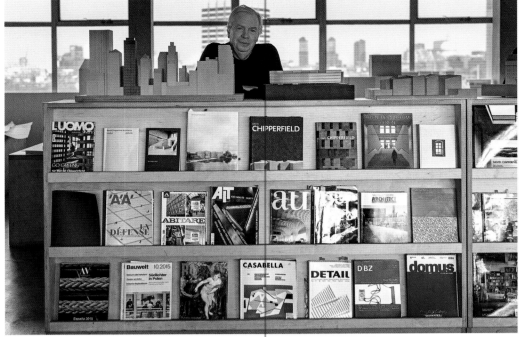

(previous spread) David Chipperfield in enigmatic mood in his Waterloo offices, whose building he has been commissioned to redesign. The architect/designer maintains offices in London, Berlin, Milan and Shanghai. A radical thinker in urban planning, he is a vociferous critic of what the capital is becoming. 'Without Lottery Funding,' he says, 'it would be nearly impossible to imagine any of the public infrastructure projects happening in London. Is this a fair system? Is it the correct one? I'm not sure'

Chipperfield (above) looks chirpy behind a rack in his office displaying books and magazines featuring his work. The architect on a walk from his soon-to-be-redeveloped office complex (left) towards the Thames, with old London mirrored by the new (below). Chipperfield's offices are next to Waterloo Station, London's principal rail terminus serving south-east England, named after the battle that turned the tide of European history

'Does the creative person sit against things or with things? In other words, how do you create an independent position in society that has some relevance?'

And how has London become this powerhouse of creativity, not only sucking sustenance from billionaires parking their money here but helping to transform thinking, to regenerate ideas?
We're certainly building a lot; that's not necessarily the same as creating. We have embraced the free market, and from a cultural standpoint there are some enormous bonuses and there are some negatives. The biggest bonus is that there are always things going on. Money demands a kind of creativity and produces a condition, I suppose.

There's a lot of money in Moscow; it doesn't spark much creativity.
The question you have to discuss is to what degree a strong financial climate stimulates creativity. Was London in the '60s a strong financial climate? Possibly not, but it was incredibly creative. London's always been quite creative.

What I'm after is cause and effect …
The question is: Does the creative person sit *against* things or *with* things? In other words, how do you create an independent position in society that has some relevance? The strange thing is of course that the moment when London felt like it was creatively at the forefront was with the Young British Artists; that was a flowering, if you like. And what produced that flowering? Margaret Thatcher. A strange idea, that this rather hostile cultural environment … I mean, Thatcher had no interest in society, let alone the arts.

She sustained it by allowing –
By suppressing people, yes! She introduced fees for foreign students, which was a negative thing; she introduced paid entry to museums, which was destructive. So you couldn't describe her as sympathetic. I would acknowledge that there's a paradox in this whole discussion, that Damien Hirst and Tracey Emin are Thatcher's children. Why? Because in a climate where it was absolutely clear that culture was isolated, these guys had to become much cleverer, just as the music business did before them.

So the more pressure there is, the more restrictive the environment, economically or otherwise, the more creativity flowers?
Let's look at it in terms of where creativity can sit. It either has patronage from the state or from wealth, or it sits in the cracks between and tries to find a place for itself. London has always been quite good at the cracks. I worked for Dolce & Gabbana in the '90s, and they thought London was the greatest place for fashion. They didn't say London had the greatest fashion houses …

So are you saying that London has become the stage, the platform …
What I'm trying to say is that if you take the music business of the '60s, or its fashion scene, the creativity was all coming from below. It wasn't coming from state patronage; it never has. The history of London since the '60s has always had a certain subversiveness about it. It's always happened *in spite of*. But students from the Royal College couldn't work here (apart from Paul Smith and Vivienne Westwood); there were no jobs for them. So they went to Milan, to Paris …

The more the state tries to *cause* creativity, to fund this underclass waiting to burst through the cracks, the less they get. People just leave.
It's a dangerous thing to start extrapolating from, because one's conclusion would be to starve the arts and foster creativity that way. This is a discussion about the relationship between subsidy, patronage and creativity. The problem is, of course, that – while you can start a band, find a place to play and establish a following – it's difficult to make buildings on your own. While architecture makes streets, it doesn't *come from* the street.

Looking more closely at the helter-skelter nature of London's new architecture, Nine Elms has been described as Dubai-on-Thames. What is that about?
Investment.

What is the process that's allowing for the flowering of these sort of …
We want money to be invested in London, and buildings are the best places for it to be kept.

Is this a conjuring trick of some kind, a pyramid scheme of sorts?
It's an unusual situation, because cities have historically grown in a more organic way. And the relationship between architecture and society was slightly closer. Once, things happened because the city *needed* them to happen; now things happen because an individual *wants* them to happen.

So a Qatari person, an Abu Dhabi person –
Well, maybe they're English. You can't just blame foreigners. We are part of a global market, and what we are seeing is money being parked in buildings. The city has become a way of harvesting money. It's a crop, like potatoes.

So when the weather turns, for ecological, political, financial reasons, what will happen then?
We'll turn around and say, 'Does this city look more beautiful now?'

And will it?
No. It's a shocking mess! London is certainly booming, but the question is: What gives shape to these things, and how do you resist it or impose order? If one were sitting in a city devoid of investment, you'd look at London and say, 'Can't we have some of that?' So there's no right or wrong. But we should be learning something from all this.

Will political change help to determine the economics of this peculiarly London phenomenon?
You mean, will it all collapse? I doubt it. Will the market be as volatile as it is now? Will money want to be here? I think so, until there's an alternative. The construction industry needs money, and money wants to locate itself in the ground because we're worried about non-tangible assets. While this conspiracy works, so will London. Again, I wouldn't necessarily say it's a negative thing – why should it be bad to invest in a city and build? But once you've embraced this monster – the free market – it's difficult to introduce a small amount of control.

If you were in control, what would you do?
There should be a city plan defining where we do and do not want to see development. But how can a free-market ideology embrace such a thing? You can embrace it if you have a social democracy. In Zurich, I can take you to a huge room where there's a model of the city. When a project is proposed, it is placed within this model and the City Architect and planning officials examine it in context. So every building is seen within 'the idea of' Zurich.

In London you had ordinances in the '60s, and it ended up being a wasteland.
No. There was a huge amount of investment, and that was a huge period of property speculation.

And it collapsed in the '70s.

Absolutely. I'm agreeing with you that it's difficult to have a semi-restricted free market. European cities have maintained an element of state control; there is respect for some sort of governing order. In London, we used to call planning 'urban design'. Now it's called 'development control'. All you can do as a planner (a profession more hated than even architects) is to try and stop the worst happening, try and put some sort of handbrake on.

Certainly Boris Johnson has allowed this, that and the other to proceed …

Well, Ken Livingston, who was a socialist mayor, did achieve two important things in terms of regulation. First, he invented the congestion charge. The success of this scheme contradicts everything I've been saying about taming the free market. It shows that if you've got the courage to do it, you can do it. The second thing he introduced was affordable housing, so that every time someone builds an expensive tower, they have to also supply affordable housing.

That's causing a lot of social friction.

As soon as you take diversity out of a city, both in terms of physical fabric and social texture, the city is no longer an interesting place. I mean, we can all walk through Mayfair and it's very pleasant but boring as hell! It's lovely, but is it interesting? Is that what cities are?

You believe in values that represent the culture, the heritage and the history of a place, don't you?

Most architects believe that they contribute to society because we are responsible for decisions that affect all of us. The difficulty is – and we've come back to the same point – how to be market-friendly and also autonomous. This is the predicament of the creative spirit. It's interesting to see that as consumerism becomes more pervasive, that distance becomes more difficult to achieve. To look at how today's design objects evolve, the designer must look firmly towards the market. The whole idea of design is to locate itself in something that will be sellable.

Does it not also have to be functional?

Not necessarily. The question is: Can you take a piece of raw material and leverage its value through design; can you affect a Midas-like transformation?

Can you brand it, in other words.

Brand it, leverage it and take it from the material world into an abstract one.

Is that also true of architecture?

Yes. Design has become a tool for leveraging value. With that realisation, how can you achieve an autonomous position? George Elliott didn't write *Middlemarch* in order to sell as many copies as possible, but at the same time she did want people to read her book. A creative mind does want to make things which are liked. But today, the only criterion is that they are consumed in enormous numbers. That becomes the measure of everything. It puts design in a very uncomfortable place, and it makes it more difficult for us as designers to find autonomy. It's easier for an artist who can paint things and take them to the gallery and just say, 'What do you think?' The artist can maintain a degree of autonomy. In practice, he's probably got one eye on what's going to sell, or his gallery might be saying, 'Useless! Give us more of the old stuff!'

I think we have to accept that we are trapped by history, conditioned by history, and that that's part of the richness of culture. Is that cultural heritage, that richness, being lost through what is happening in London?

I think it is. It would be much easier if we could be completely free of memory and familiarity.

But architecture doesn't allow you to be. And architecture is there to immortalise memory or prestige or power.

But that's the problem: it still sits there. Even in some kind of *Space Odyssey* environment, the truth is, we would still go to Florence or Rome or Oxford and walk down streets and say, 'Oh, isn't this wonderful! Look at that!' Most of the objects we deal with still look roughly like they did a hundred years ago.

We're creatures of habit, conditioned by evolutionary logic …

So when it comes to architecture, we may think that everything is free. Painters have the same issue, writers … All creative efforts have to deal with both freedom and restriction. It's how you play with, how you express, freedoms and ideas.

David Chipperfield

Chipperfield at the Southbank Centre (opposite). A long-time supporter, the architect believes in the philosophy that has always driven the place, the idea that the arts have the power to transform lives – in his case through architecture designed to serve the public interest. Chipperfield strolls down towards the river (above), and traverses the tunnel leading to Festival Pier, a principal riverboat stop (right)

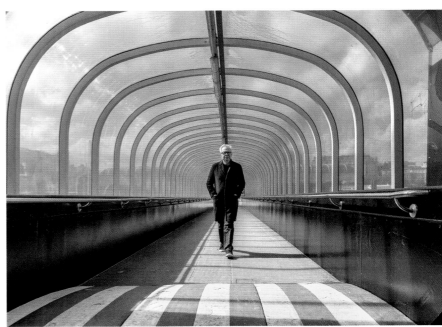

Wayne McGregor
Artistic Director, Random Dance/
Resident Choreographer, The Royal Ballet
Bankside/The Mall

You were born in Stockport in Cheshire. What inspired you to become a choreographer?
I grew up in the '70s, so it was all *Saturday Night Fever, Grease,* John Travolta, disco. That was my vibe.

When did you see *Saturday Night Fever*?
When I was ten or eleven? I loved the whole attitude of it, the look of it, the energy of it. I loved people communicating with their bodies, although maybe I didn't understand what that was at the time. I wanted to be him; I wanted to do that.

Communicating with bodies seems to be a reoccurring theme in your oeuvre. You're pretty expert in technology; in fact, you're a Research Fellow in the Department of Experimental Psychology at Cambridge. Do all of these elements go into creating communication through the figurations of dance?
I think so. They're all about the body. Actually that's three questions in one. The first one is to do with bodies and expertise. I've spent my life being with bodies in the studio eight, nine hours a day, so I recognise really quickly people's physical signature. You have a physical signature. The way you're sitting, the way you're relating to me right now tells me something about how my conversation is going with you. That's the same with all of us. Our life is an inter-relational act. It's about a transaction of energy and focus and position and physicality. That's why bodies are interesting to me. Normal bodies are interesting to me, bodies that haven't done lots of dancing or aren't experts, but also, on the other end of the scale, I'm interested in those refined instruments that have developed techniques, that are able to do incredible things that perhaps normal bodies can't do.

Going back in time, would a Neanderthal sitting at the table here have had different body language?
Of course, partly because they were primed for hunting. Their bodies were stripped of fat; there was no sugar in their diet. They were like running, fighting machines. Because of the circumstances in which they were living, they had honed their physical skill to be able to live in that survival aspect. As we got fatter and more indulged in our lives, our bodies often became more sedentary, less activated. It's no coincidence, I don't think,

that the increase in technological development has come with an increase in homeopathy, in ideas where bodies want to get back into understanding self, embodiment, in a clear way. It's the same in élite sports. If you've got this instrument that you can push to capacity and you want to explore it, if that is your paintbrush, if that is your clay, how can you push that materiality to a point where you are doing something that is really astonishing? That's what I mean about the technology of the body. I'm interested in exploring the technology of the body to see how far one can do unfamiliar things in a really interesting way.

And this interest of yours was triggered at an early age, also the interest in technology, in computers, wasn't it?
Well, I was one of the first generations to have a computer at home. Those early Texas Instruments computers, the early BBC computer, Spectrum … We used to spend, me and my friends, hours and hours coding. We would put a series of numbers into the computer and a little word would go across the bottom of the screen after about three hours, or we would play table tennis with little joysticks. More recently I've been at the university in San Diego and did a cognitive version of that, where I could wear a brain scanner and sit opposite you and you would get your own scanner. We had a table tennis game and I would think 'up' and be able to move my bat up, and I would think 'down' and could move my bat down. But I had to have had the experience of feeling 'up' before my brain understood how to do it. I had to have the experience or feeling of 'down', of what it is to have gravity and weight in your body, to be able to move it down. So there is a clear relationship between technology and embodiment. And all of that is connected to the fact that we think that dance is a non-verbal means of communication.

How do you differentiate between those types of communication?
I'm talking to you about it, and I talk to dancers about it all the time. I have a little voice on my shoulder; there's a running narrative in my head when I'm making things. So the cognitive capacity, the mental act of making, is as important as the physical act. Dance isn't just about instinct. That's a big misconception that we're working hard to move away from. There's a physiological and communicative aspect of moving which must have been as primal in Paleolithic man as it is today.

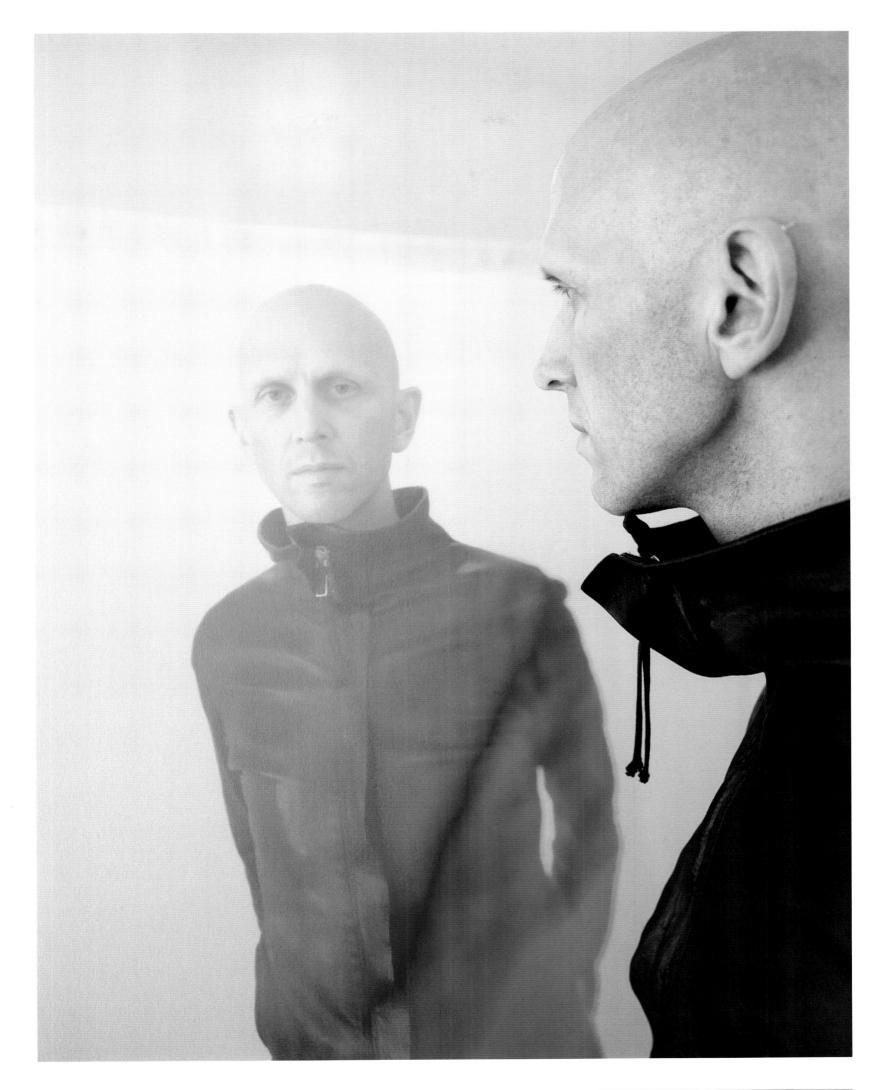

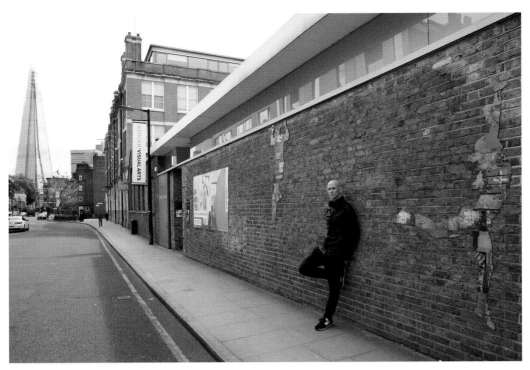

Yeah, art in motion. So it could be like a Mondrian moving. That's as valid as if I'm emoting something and giving a feeling of myself to you. The language that we talk about in dance so often is the emotive one. What we're looking for often is, 'Is this dance communicating something to me on an emotional level?' That's a shame. I think there's a much broader range. I love it when the hierarchies of dance are changed as well. For me, dance is not just the description of music; music is just one of the potentials that it can be in collaboration with. I don't want the audience to be neutral; I don't want them to sit there and go, 'Oh yeah, that was nice.' I want to take a position around it that demands that the audience come with an aspiration to see a piece of work and ask questions of it, not just to come and enjoy it as a piece of entertainment.

To ask questions of you or of themselves?
Themselves, mainly. We forget that it's so easy to come to a performance with your own filters and your own framework of the world. It's actually very difficult to be open because the job of the brain is to create meaning from things, and your meaning is informed by past meaning. Your meanings are a palimpsest of the things you've seen and experienced. You bring all of that to bear on my performance. Often what happens is that you look for evidence of what you think you know already about me in that show, and then those things become more heightened. It's very hard to sit there and go, 'What is in front of me?' and let meaning emerge, let it touch you in different ways. If you do that, you get a richer experience.

Is that what you meant when you once described yourself as trying to 'provide a problem for the body to solve'?
I like to provide a problem for dancers to solve with me, because it's not just me making up steps and giving them to you and you just doing them. There are so many other things involved when that happens. That transaction can be much richer when you both have an idea that you want to solve, a physical problem.

And from this emergence of idea into physicality, the audience can take what they want, right?
How could it be any other way? I always feel like I can only make a thing that I feel passionate about at the time. Sometimes that connects phenomenally well with a broad range of audience. Sometimes it doesn't quite connect to that moment. I noticed that quite a lot of the pieces that I made eight or nine years ago are now much more connecting with audiences for whatever reasons, whether it's familiarity with the language or because times have changed. Sometimes you can be out of sync. But I never think of how I can make a piece for a particular audience. I just don't think you can.

(previous page) Wayne McGregor reflected in a mirrored panel, part of Scandinavian artist Olafur Eliasson's backdrop for the choreographer's new production *Tree of Codes*, a collaboration with the Paris Opera Ballet and the Manchester International Festival

McGregor (above) outside the Jerwood Space, opened in 1998 as the Jerwood Foundation's first major capital initiative, and now admired as one of the country's best dance and theatre rehearsal spaces. 'When the Jerwood opened, I was resident there, so I have this connection with it,' McGregor remembers. 'What I love is that it's about artists from different disciplines working together in studios but also having collective spaces where you can eat and talk and exchange ... It's built into the machine.' Studio Wayne McGregor is the first cultural organisation at Here East, a new centre of innovation and enterprise being built at the Olympic Park in Stratford to serve East London. 'It's the collision of technology and art that we are interested in exploring there,' the choreographer explains. McGregor takes a walk in Bankside (right), where the Jerwood is located. The area is one of Britain's oldest settlements, dating back six millennia, and in Tudor times was the site of the Rose, Swan, Globe and Hope playhouses

Is this physiological expression of movement an impression of self or more about modes of survival?
It's part of the same spectrum, the pedestrian, prosaic language that our bodies do to survive. Then there's the language we've ritualised, which is culture-specific. And then there's an extension of that, where you push it. That might be in something like a dervish who achieves ecstasy through dancing in a particular way that gives you brain states. Now we're doing that in relationship to robotics or cognitive neural networks or biometrics. I'm very interested at the moment in biometrics, in what happens inside the body, in how you can bodily broadcast the signals of your interior. Wouldn't it be interesting be able to read bodily states that you can't lie about, that actually in some way are expressed? Wouldn't it be interesting to see how that might drive technology?

Has dance in its socio-biological sense been a motivation for physical transformation, then, in human history?
I think it has. Visualisation techniques have allowed us to expose the body so that we have been able to see and learn from it and understand how we might be able to do things differently. That is how it's been throughout history. Vesalius and his anatomical drawings gave us an insight into the body that we'd never had before. During the first surgeries where you were able to open up the ribcage, people saw all of a sudden that there was a heart, that the soul didn't fly out. You started to understand that there was blood flow, that there was a biological aspect to bodies. There's something about humans' aspiration to understand this thing that they carry, both from an interior point of view and an exterior point of view, that has fascinated us throughout existence. Technology is allowing us insight into things that we had no idea about. Insight provokes imagination, and hopefully imagination provokes innovation. So these things are very, very important to expose and use.

Do you then think of dance as a journey of discovery so that the viewer can see within themselves?
Well, hopefully. Hopefully there is something about the dance that you watch that has a visceral impact on you. I make dances that in some way sit inside the viewer's body. That's what I'm directly trying to do, but I don't think that always has to be through emotion. Always saying that dance has to be emotional is denying the fact that dance could also be purely graphic. It could be purely physical. It could be purely about lines and spaces.

So you're a leader and others will follow you until somebody else comes and supersedes you.

Yeah, I'm sure that will happen. It should be like that. Also, I don't think of myself as a leader. I think of myself as someone who's doing what they really want to do. I'm lucky enough to have a lot of opportunities to be able to do it in a range of contexts. One of the brilliant things about dance is its diversity; one of the brilliant things about bodies is our differences. That's why dance is such a rich territory to play with. It's even richer when it's in collaboration with other art forms and people outside the art world. That's why I'm interested in scientists and anthropologists and geographers.

What about economists?

Why not? What they do all the time is data streaming. That data is rich. How they find shape and meaning in numbers is fascinating to me.

In the culture of dance today, is there a political element at all?

There can be. Dance is political in that, for example, if I'm making a piece in Moscow or St Petersburg, those organisations are state-run. Many of the major lyric-opera houses are a context for political meetings. The cultural forces around the work itself are such that you often can use them as a –

As a tool? As a vehicle for political PR?

I don't think it's political PR. I think it's about questions. One of the great things that dance-making does is discuss things about collaboration, about cooperation, about discussion, about openness, about differences of ideas, about representing different types of bodies on stage. All of these things have political dimensions, and they're important.

And what about creativity? Is it the same seeding process everywhere, or are cultural milieus, economic circumstances, technological parameters also in play?

In my experience of working with young people, creativity is everywhere. What is really important, I think, is that there are techniques of creativity. There is a technique of creativity that you can teach. We've all heard this trope that it takes ten thousand hours to be in expert in something. In dance, you spend ten thousand hours at least *plié*-ing and doing curving and training this instrument, but we don't spend ten thousand hours on the techniques of being creative. I think you can shift attention in the brain. You can work between visual images, acoustic images, kinesthetic images. You can train people to move their attention outside of themselves, inside of themselves, behind themselves, into this corner of their imagination, to look at something from this point of view, to understand all of these strategies by which you can interrogate, and something rich can come out of it creatively. When you share those, when you can have those as a palette to work from, you can then divert from them. You can then invent your own. They give you a kind of scaffolding from which to be more and more creative. Creativity isn't always this kind of mystical, magical thing. In some way, it's just not understood. There are certain attributes of it that can be taught and shared.

You've also spoken about your body being an instrument. Is that really how you view it?

I think so, yeah. I'm not playing the piano, I'm not picking up a brush. I just have my own instrument. We talk about that when we think about training. How is it that you provide music? How do you get yourself a range of techniques, not just classical techniques but somatic techniques, feeling techniques, imaginative techniques, creative techniques, to be able to not only create language and stimulate language but also to be able to think physically? Physical thinking is phenomenal for a dancer. It's what we do really, really well. If I were to pick up a pair of glasses, it would be a version of physical thinking. I would know already how far those glasses were from my hand, how much effort I would need to pick them up, and I would know what I would need to do to be able to rotate them. That's physical thinking. That's all we do all the time in dance but with other bodies. I have a guy there, I know how heavy he is, and I know what effort I'm going to have to take to be able to pick him up and rotate him. This is an example of physical thinking. What dance does is attune your instrument to become better at physical thinking.

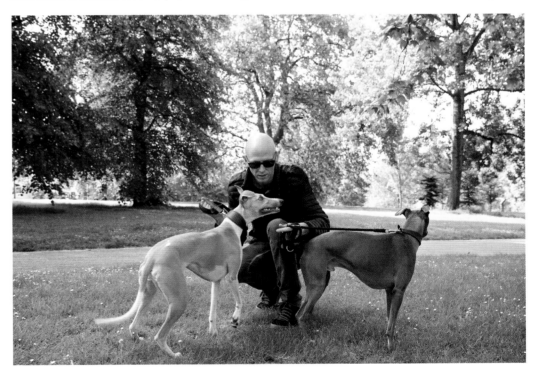

McGregor walks his whippets Freud and Mies (named after the artist and architect, respectively) in St James's Park (below). 'I walk a lot,' the choreographer says of his routines. 'It's the only time I have on my own when I'm able to do real thinking'

'Creativity isn't always this kind of mystical, magical thing. In some way, it's just not understood. There are certain attributes of it that can be taught and shared'

Bodies in motion: McGregor works his own troupe together with dancers from the Paris Opera Ballet in rehearsal for *Tree of Codes*, a refashioning of Jonathan Safran Foer's book of the same name. In addition to art director Olafur Eliasson, who is responsible for the sets, backdrops and costumes, Mercury Prize-winning producer Jamie xx is also part of the team

Johnny Coca
Creative Director, Mulberry
Kew/Covent Garden/Chancery Lane/
King's Cross/Regent Street

Having been born in Seville, what do you most enjoy when you go back to Spain?

I love the attitude of the Spanish people, their openness. It really does make everything lighter. People do talk to each other. Anywhere I go, people talk to me like they know me. You can be somebody or nobody. It makes no difference.

So you can be anonymous or you can be famous. Which do you consider yourself to be?

Anonymous.

But you are famous!

I don't think of myself as famous. I have a job that's in the public eye but really I am one of a team, all working hard to make things.

What is it then that you love about being famously anonymous?

It creates opportunity. Having this job means I get to meet some of the most talented and interesting people in the industry. I'm obsessed with the creativity of others. It's exhilarating to be around talent, and to discover new talent.

What I'm trying to reconcile is the fashion industry, which is hard-driving and money-minded, and your wanting to be anonymous and enjoy a leisurely pace of life.

Fashion is all about style and desirability. But what I really love and enjoy in life is very simple. When I'm sitting on a terrace and looking at the people in the street, I just want to make beautiful things for them. It's my obsession, as well as what I do for a living.

Fashion is a crowded field, and you've worked with a lot of brands, including Louis Vuitton, Céline... What defines a good product in your opinion?

A lot of designers tend to make things more complicated than is necessary. When you try too hard you lose the clarity of your vision. I focus on the construction. You can always embellish it, add different layers of attitude, but the silhouette, the style is everything. While I was studying architecture, I understood that the most important thing to achieve was function through structure, and getting the right proportions of a silhouette.

But if you strip it down to its basic elements, a handbag is merely something to carry things in. So why is it necessary to pay thousands of euros for a bag that has a brand on it?

A bag, a coat, a dress, a pair of pumps, a necklace…all accessories are like dreams that you wear. It is the care and the craftsmanship, the quality and attention to detail: these things are the essence of each creation.

You are an expert in working leather, and you know your industry inside out. Is that because you love your work or because you're basically auto-focused?

I love the technical. I love to understand how things are made and function. The more you know, the easier you can make things. I started with industrial design. When designing boats and cars, it's crucial to know all about the techniques and materials. When I was younger I enjoyed mathematics so much, as a pure and rational means of communication, to assemble ideas and solve problems.

(previous spread) Johnny Coca enjoys his elevenses in the Oscar Wilde Bar (formerly the Grill Room) at the Café Royale, a hotel he frequents on his London visits. Established in 1865, the Grade II listed interior was a haunt of the eponymous nineteenth-century Irish playwright, poet and satirist, who sometimes drank himself senseless on absinthe in its bar, a favoured haunt of bohemian intellects of the time. The hotel, true to the tradition of marketing dead personalities, now features an 'absinthe journey' in its Green Bar, where a traditional fountain trickles water laced with the anise-flavoured drink and filtered through a sugar cube

Coca on the hunt for inspiration in Kew Gardens, a place he holds in high regard as a quintessentially English institution and as somewhere he can contemplate nature uninterrupted. 'I love nature; I love how it is methodical and organised,' he explains with measured passion. 'The mix of nature, the elements and creativity offers a good combination.' Coca (above right) amid late spring flowers by the Treetop Walkway. Walking past a mulberry tree (right) being tended by gardener Alex Little (the tree one of thirteen thousand species at Kew), he (above) finds his way to the Palm House, the world's most important surviving Victorian iron-and-glass structure and home to tropical plants and palms

The paradox is that you're talking about mathematics and engineering, yet here you are, one of the most famous brand developers of women's fashion in Europe. How did that happen?
I have always been in love with fashion. It's a fascinating creative process, a ferocious industry, and part of our life and society now.

And to what do you attribute your success?
Lots of work, patience, and taking one step at a time. I've had to build knowledge and understand the variety of structures within a business. If you want to achieve something, you have to work very hard to know to perfection what you do as well as the context in which you are developing. To create is liberating, to be able to dream and to create something unexpected. Design must be intrinsically linked with our emotions. Otherwise it's pointless.

Can you walk me through your creative process, starting when you're in a café, watching people go by in the street?
I memorise everything. I never take notes. When I'm lying in bed at night, I start to think about all the things I saw during the day, analysing and combining them. As soon as I design something in my head, it's done.

What was your first great achievement as a designer?
Probably when I started at Louis Vuitton, at first I designed window concepts and then moved onto bags for women and men, as well as special projects for celebrities, the brand ambassadors. I enjoyed seeing my creations out in the streets, in real life.

And now you're moving to London to redesign an international brand that has an English rather than a French air about it. Do you feel uneasy at all?
I feel international. I travel constantly, and have lived in different cities. There are so many exciting references in British culture. Everybody around the world takes elements from British culture and London. To work for a British brand is a privilege. Britishness is quintessentially cool. British culture is so relevant, so exciting and contemporary. That's what appeals to me.

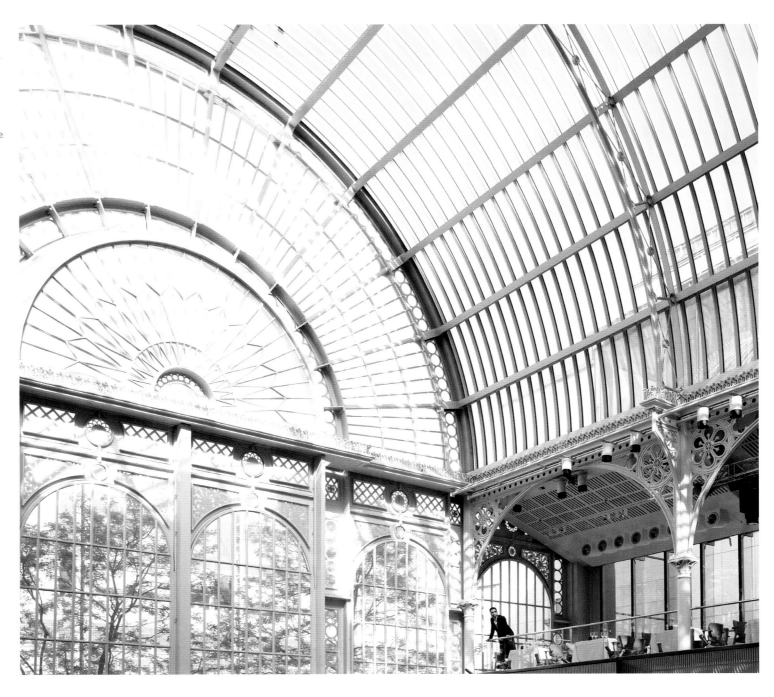

From one creative hothouse to another: Coca at the Royal Opera House in Covent Garden (right), where he goes for both emotional replenishment and physical inspiration. 'For me as a designer, creativity can be demonstrated not only by the product but by the body … the passion of movement in dance,' he says. 'I love art, I love dance, I love movement … Opera touches me every single time'

Does it worry you that London is not the fashion equivalent of Paris or Milan?

I wouldn't compare. In London it's more about owning your personal style. I see it just walking around, and when I'm at Central Saint Martins, this very particular British attitude to fashion and style.

How do you see the future of fashion in London?

Fashion and the industry is becoming increasingly more important in London. There is something unique about the creativity that drives the city right now.

Why do you think that is?

There is unprecedented talent. People take more risks in London. There are more free spirits. There is a great energy. There is so much heart, so much fun here. This is the start of another great fashion era for the city. You can feel it.

'To work for a British brand is a privilege. Britishness is quintessentially cool'

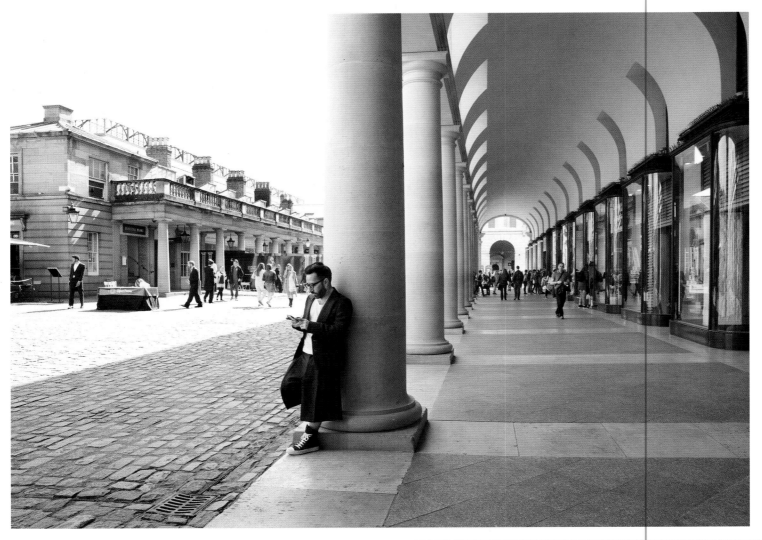

Coca checks his messages (above) in Covent Garden, home to the Theatre Royal as well as the Royal Opera House. Inigo Jones designed the Italianate square in the mid-seventeenth century along the lines of the piazza in Livorno, Italy. Covent Garden's illustrious but chequered history has been a contest between style and privilege on the one hand, and, on the other, everyday commerce and enterprise – one day dressed to the nines, the next day dressed as Eliza Doolittle hawking flowers

The designer (right) admires fine English craftsmanship at I. Franks in the Silver Vaults in Chancery Lane. Opened in 1876 as a safe-deposit store, the Silver Vaults today house thirty specialist retailers dealing in mostly English antique silverware and objects of virtu. Coca believes that a lot of valuable craft skills have been lost: 'You cannot produce these pieces today in the manner they were handcrafted before'

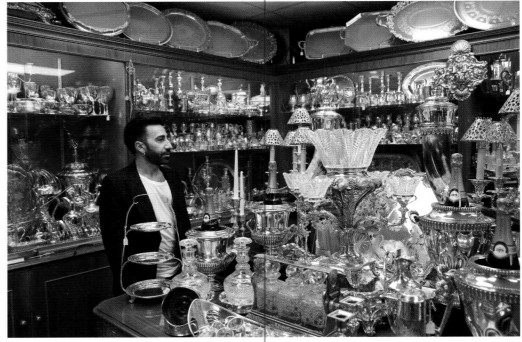

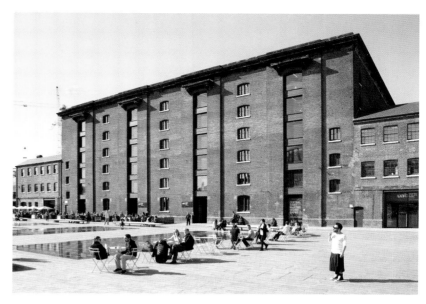

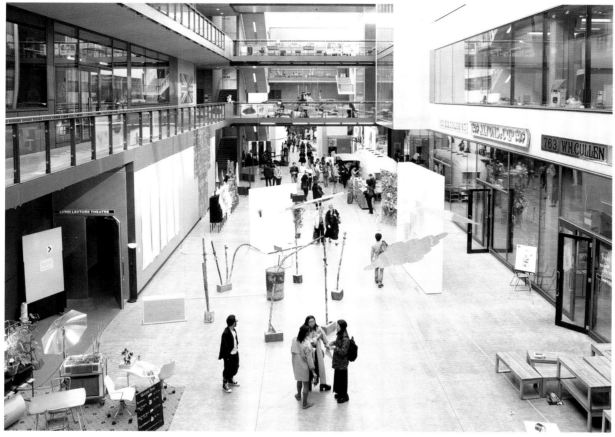

Coca (top) takes a break from teaching in the courtyard of Central Saint Martins' King's Cross building. The designer, who tutors the accessories projects of second-year Fashion and Design Marketing students, relishes interacting with young talent. 'We know that a lot of creative directors come out of this place. Why is that?' he asks rhetorically. 'Because there is freedom in creativity, and the school focuses on pure creation.' Coca walks the 'street' (above), Central Saint Martins' exhibition and student work display areas. 'What I love most is the mix of people from many countries … It's the strongest and most popular fashion school in the world,' he enthuses. He reviews second-year students' work (left) with Rosemary Wallin, the researcher/lecturer who assists him in class. 'To be the one who can drive a company, it is important to be able to develop a brand while working with new people,' Coca explains. 'One big responsibility of mine is to support artists from the visual arts, music, design … by helping to keep them in the country and to seek their own creative vision.' He himself has designed some of the most iconic handbags of the last few years (following spread) Johnny Coca at work and play, strikingly attired in keeping with the fantastic colours and contours of Central Saint Martins' 2015 end-of-year graduate press show: students not included in the main displays featured on the catwalk indoors enjoy their moment in the sun. The parade was dubbed by the press as a guerrilla-style semi-protest by young designers who had not made the cut. 'This is why I love London,' Coca enthuses while reviewing the vibrant creative outburst

Johnny Coca

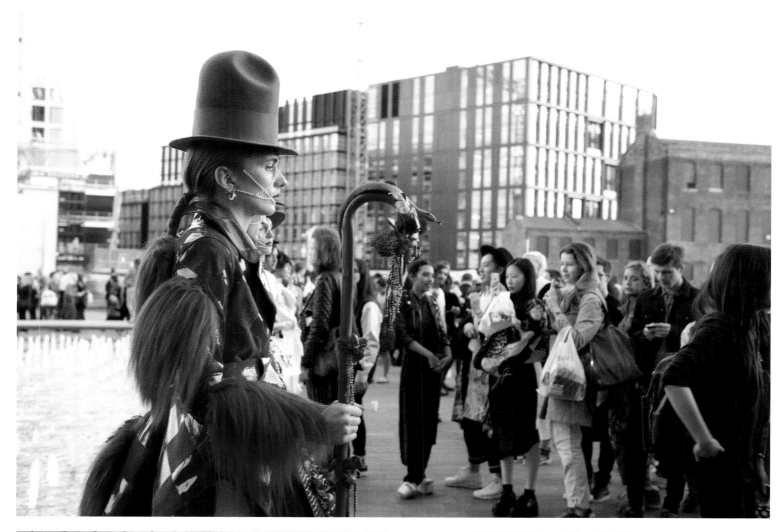

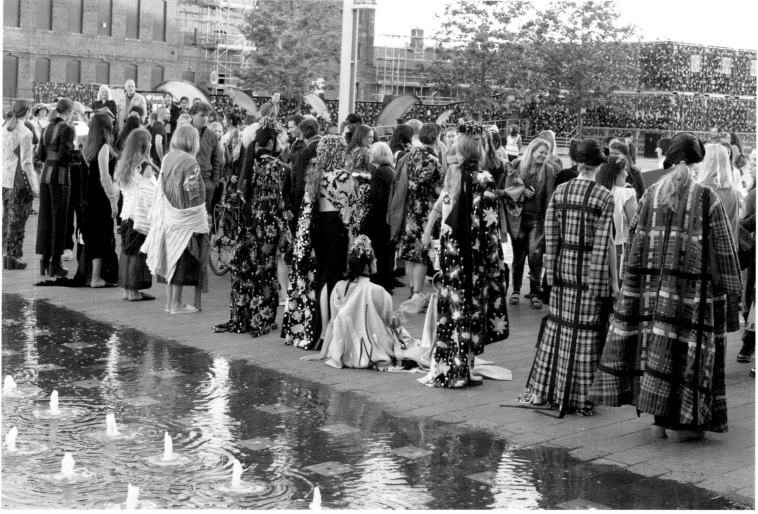

Lauren Cuthbertson
Principal, The Royal Ballet
Covent Garden

You started dancing at the age of three, is that correct?
Yeah. I was sent at the age of three because my mum was anxious that I would start school without enough discipline and social skills. I didn't want to go, but then it felt like the most natural thing for me to do.

Like a swimmer taking to water …
Literally. And then it was never a question of 'Shall I continue?' It was always 'What's next?' Always.

Was that reflective of your character, or was it that you had the bones, the mind-set?
I think both. With ballet you have to be intelligent and quick, but it's a very different thing to academia.

Is a dancer's intelligence a type of instinctual intelligence, then?
Yes. Sometimes I can watch a performance, and even though I like to be able to be articulate about what I'm watching, the words can never really convey what I've seen in the movement, what I've learned, and how I want to put that into my own dancing.

I understand that while you're watching television, what you're actually doing is choreographing moves in your head. Is that true?
Well, sometimes I'll be at home and watching a film with my family, but in my head I'm going through some of the moves I've done that day and preparing things for maybe the next month.

Do you never get any mental rest, then?
Not too much, because if you're not doing it, you're thinking about it or recovering from it or preparing for it.

Are you inspired by the movements of people walking in the street, or animals, or plants?
The other day I watched Sylvie Guillem, and the way her hand moved in line with someone else reminded me of a flock of birds and the shape that they move in. You have imagery like that or ways that you're thinking, and that helps it become much more poetic. I'm not very good with words, but I sometimes feel like movement can say so much more than the voice can.

Apparently so, because people pay a lot of money to travel across the Atlantic to watch your performances. How does that make you feel?
It's amazing. It becomes one of those things that, once people latch onto it, it hits something in them. They're not just watching me doing my steps, and they're not evaluating me; it's how I'm making them feel.

What about the dangers you seem to face on a daily basis in your work?
Of all the ballerinas I know, I've had one of the roughest roads with illness and injury. People would say to me, 'Oh! You're coming back again?' Unless you said to me, 'There is no hope in hell that you can do it', why wouldn't I try, why wouldn't I come back? Everything heals, and then I'd be the artist I was and am.

My goodness! I mean, everything heals? What kinds of injuries are we talking about?
Recently I took a horrible impact onstage, in a big slide with Carlos Acosta. My foot got stuck and it just kept going. So the front and back of my foot, the tendons, either tore or overstretched. For sixteen weeks I didn't walk, and I was on my other leg so much that I tore a muscle in my bum.

What did you do during that period?
Nothing, actually.

Are you ever afraid of not healing?
Maybe I'm insane … I always have this belief that it's going to be fine.

So what you do is engage with that timeframe of recovery. How do you do that exactly?
I met my current boyfriend just before I got injured. He lives in Copenhagen, so I was able to convalesce a bit in Copenhagen, which was amazing. I live round the corner from the theatre, a two-minute walk in Covent Garden, and being around here, waking up every day in Theatreland, in the midst of everything that I love and live for, I found really, really hard. What was so amazing was to be away with him and in a different city. That was my saviour.

So it was calming …
Completely. Sometimes he would go to work and come back and I would still be in bed. And the days would go by, and then luckily the weeks went by, and then I was able to gently start.

Did you keep up a pretence of physical fitness within that period of convalescence?
I didn't really.

So you let all of your muscles go?
This time I did; other times I've been determined to keep even the small muscles going. I learned a lot from being off. You can't cheat biology. I think my perspective to dance is different to other dancers. Once I was in bed for six months, unable to walk.

How many times have you been off in total?
Three. Three big times, and the others were for a year and a half.

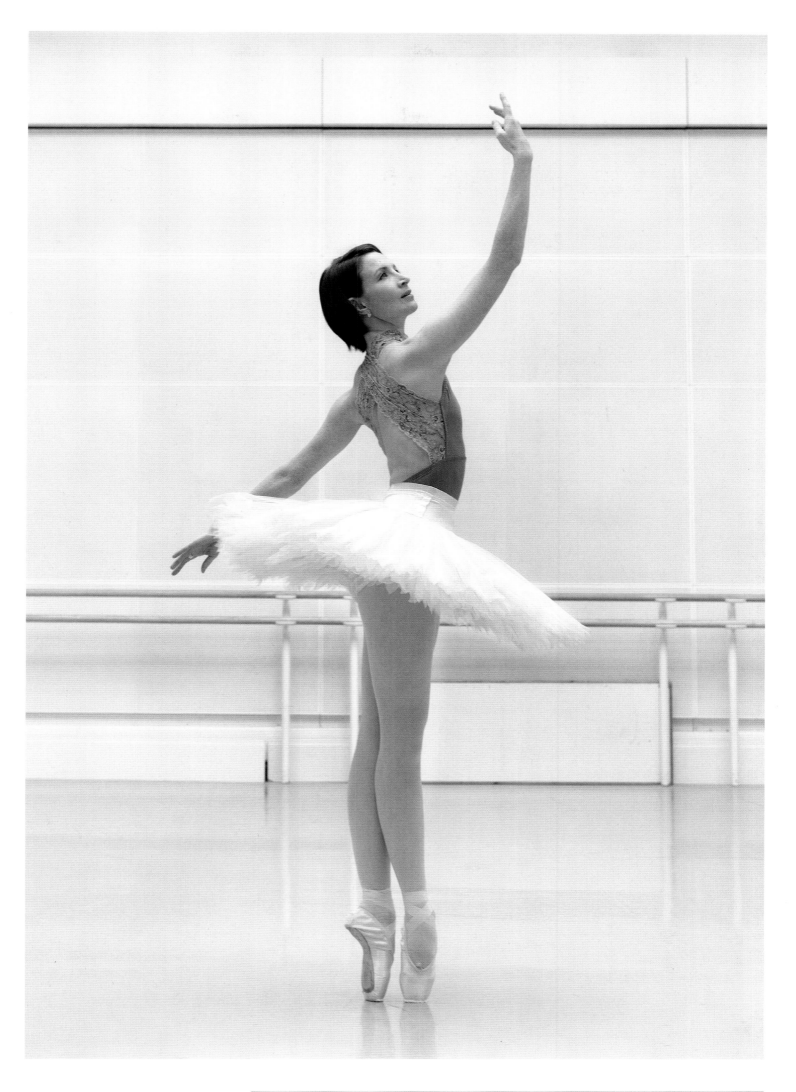

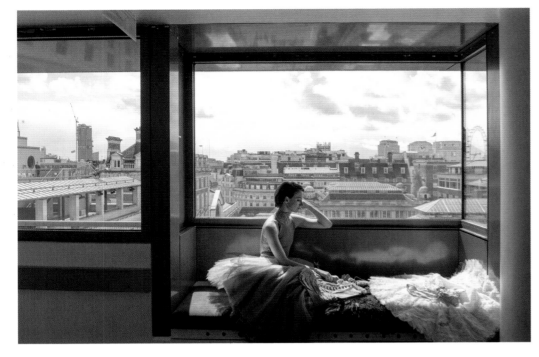

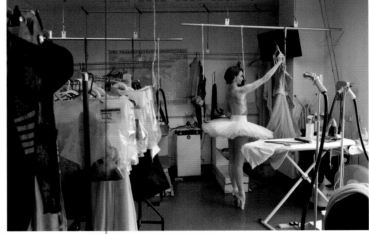

(previous page) Lauren
Cuthbertson, perfectly
poised, rehearses in the
Fonteyn Studio for the Royal
Ballet's 2015 American tour.
The studio is named after her
idol, prima ballerina absolute
Dame Margot Fonteyn. A
butcher's daughter from
Devon, Cuthbertson is the
Royal Ballet's only British
female principal

Cuthbertson, London's
skyline her backdrop (above),
contemplates her costumes.
She wore the purple dress,
her favourite, while dancing
in *Alice's Adventures in
Wonderland*, created for her
by choreographer Christopher
Wheeldon. In the costume
room, the prima ballerina
(above right) checks for
alterations. Cuthbertson
does her stretches (right)
following a mid-foot injury
that took six months to heal.
She buys Hello Kitty slippers
(below) in bulk whenever she
visits Japan

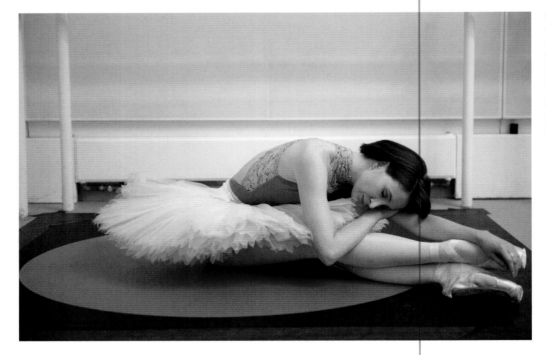

Cuthbertson is so devoted
to her job that she lives
a mere walk away from
work – 'dangerously close',
she jokes. 'I've even walked
home in a leotard, tights
and Hello Kitty slippers.
Then again, anything goes
in Covent Garden.' She
strolls (opposite) past Enzo
Plazzotta's *Young Dancer*,
next to the Royal Opera
House, also home to the
Royal Ballet

And you're how old?
Thirty. You're baffled! You don't understand, do you?

I'm totally baffled. It's almost like a fanatical dedication.
Yeah, I've invested my life. I went away from home, I grew up with a phone relationship with my parents. I don't have that family day-to-day thing; this is everything. At the same time you have to engage in outside life and understand everything that goes on there. You explore it and go AWOL and come back in order to be able to put more into what you do, if that makes any sense.

Is what you do principally for yourself or for the pleasure that you give to others?
I definitely started for the pleasure it gave me.

So you've kind of been in military training for nearly your entire life.
I started doing my once-a-month training with the Royal Ballet when I was eight, then I went to a summer course, and I knew I was going to go at the age of eleven to White Lodge, the Royal Ballet's lower school.

You knew you were already chosen, didn't you?
Yeah. You get chosen the season before.

Doesn't that process take you out of the normal currency of life? You don't get to mix with the ordinary kids in the neighbourhood, to hang out with different people.
A little, yeah, but you're mixing with your friends and colleagues, I suppose.

But that's rather incestuous. You talk the same talk, you drink the same drinks, you can't do things that they can't do.
I think that you think it is quite extreme, what we do. But often if people are going to achieve something, they have their minds set on it quite early. There are lots of people, especially in a city, who are driven by something, inspired by something, excited by something, and who give their everything to something. Even if it's something completely different to what you do, you can relate. I relate to people who want to do something really well, to people who want to make something beautiful.

Give me an example.
I can relate to a really good golfer. I can see that they strive. To someone who doesn't play golf or like golf or know anything about it, it's just hitting a ball around a green course with holes in it. But if you try golf, you realise that it is technique: I need to learn this, I need to learn that, and if I go here … It's a whole world. I can see why some people get captured by that and do that their whole life. It just happens that golf is much more popular than ballet.

And much higher-paying.
And much higher-paying! If you're good.

Even if you are good, ballet is not a high-paying profession.
You can have a nice life, but it's not lucrative.

Which adds to that element of necessary dedication. You've been quoted as saying, 'There's nothing quite like putting on those pink tights and whacking through a three-hour ballet.' Does putting on your tights actually physically revive you?
Oh yeah. The adrenaline, the challenge …

You must be an adrenaline junkie, then.
I have a love/hate relationship with adrenaline. It's like someone who has drugs and then they have the comedown. For days afterwards, I'm not myself.

If that's the case, what will happen when you finally hang up your tutu?
I don't know. I think I'd put all my heart into family.

You won't be like the swan who withers?
No, because I want to be alive all the time.

But part of you will have died, no?
I think that's it. Huge grief.

'*There are lots of people, especially in a city, who are driven by something, inspired by something, excited by something, and who give their everything to something*'

Kevin O'Hare
Director, The Royal Ballet

Born in 1966 in Yorkshire, Kevin O'Hare, like Lauren Cuthbertson, trained at the Royal Ballet School (White Lodge) from the age of eleven. After retiring from the stage in 2000, he turned his focus to management, becoming Company Director of the Birmingham Royal Ballet in 2001 and, in 2012, Director of the Royal Ballet, whose artistic development he is responsible for driving. The following year he was appointed to the Board of Dance UK.

Like many dancers, Kevin claims to have no life outside of ballet, attending performances most nights of the week. Leading figures he worked with included Ninette de Valois, Frederick Ashton and Kenneth MacMillan. 'I'm probably the last generation who knew those people, really,' he muses. Having himself started to dance at an early age, he remembers boys getting teased, but the study and discipline came easily to him. 'It was quite cool that I was on television and films,' he recalls. Fast-forward to the present, where he has 'the top three choreographers in the world today' working for him. His ambition? 'I want to create the classics of the future. It's my job to balance that with the classic works that we all know and love.' Having retired at thirty-five, going into management was not an obvious choice, however. 'Somebody said to me, "Are you living the dream?" I was like, 'This was never the dream!" You just go from one thing to the other. I love being in the centre of it

all. I love trying to make things happen.' Being in the centre involves accounting for the lives of roughly a thousand employees, organising tours and making sure everyone gets paid. No mean feat.

Kevin has a clear sense of how he wants to lure his audience into what can seem like an intimidating environment. 'It is this imposing building, that's what it is, but it's something to be celebrated and enjoyed by everyone,' he says. 'It's a creative building. That's what we want to try and get across … In the old days, in Margot Fonteyn's day, everything was kept more behind closed doors. People now are so interested in what it takes to be a dancer, how you put it together.' An enormous budget – some might say absurdly enormous – makes it all possible; the contrast with local libraries, say, being closed down due to lack of funding could not be more clear. Kevin is adamant that the Royal Ballet provides value for money. 'We have a programme called "Chance to Dance" where we go to schools across London and tell them about dance, engage them in dance. They do workshops, they create their own little company, and then they do performances. You see these children that would never have access to anything like that. Next we're going to do it digitally across the country.' Citing the potential health benefits for kids, he sneaks in a half-joke: 'We might find the next Carlos Acosta in there as well!'

Kevin O'Hare, the Royal Ballet's Director, in the Royal Opera House's Paul Hamlyn Hall (opposite). He and Lauren Cuthbertson, who attended the same ballet school as children (left), share a joke in the studio. O'Hare has been the ballet's Director since 2012. In the wings (above), the sets for five operas (including *La Traviata* and *La Bohème*) and two ballets are stored. The nine-storey opera house boasts endless corridors surrounding the stage, where Manager Stefanie Cliffe (above) often finds herself. The imposing Grade II listed interior houses the most beautiful auditorium in Britain, originally designed in 1857 by Edward M Barry

Henry Hudson
Satirist/Artist
The Rake's Progress

Born in Bath in 1982, Henry Hudson lives above his Roman Road studio in East London. His father is the artist Richard Hudson, known for his 'matinee-idol looks', and his mother is American. Henry's grandmother worked with Alan Turing as a code-breaker during World War II. She was also a model-maker. 'After the war she got married, became a farmer's wife, but she carried on making replicas of houses,' Henry explains. 'She did Highgrove for Prince Charles and Diana when they got married. When he asked how much it was, she charged him 50 quid or something. It took her two years to make, because it was an exact copy, the inside and everything. She's done the Dulwich Picture Gallery, so if you go to the Dulwich Picture Gallery, in the foyer you'll see a balsa-wood replica. My grandmother was very artistic; I think I can see that lineage. And my dad's a sculptor. And, you know, I developed that.' Of his parents' marriage Henry says, 'I can just remember it. After that it was divorce and a lot of moving around, punctuated by bits of boarding school.' After school he attended Central Saint Martins and Chelsea College of Art; his history of solo exhibitions stretches back to 2006. Fellow artist Marc Quinn has described Henry as aligning himself 'with an irreverent and eccentric British tradition in art that is really the saviour of it … It's a lineage of nonconformity yet quintessential Britishness'.

Henry's artistic journey started when, as a young boy, he was taken to the National Gallery and saw Henri Rousseau's *Surprised!* Having asked to be bought a postcard, Henry took it home and copied it. His father not only encouraged him to draw but took him along on Soho drinking sessions during which the young Henry met Lucian Freud, among other artists, and made drawings on tablecloths. 'It was good because it's one of the reasons I'm able to navigate London socially,' he says. 'I enjoy it. I love people, I love stories.' For the past several years, his primary medium has been Plasticine, which he uses to create 'sculpted paintings'. 'Plasticine is cheap, it's oil-based, so you can mix the colours like paint, and it's only 69p a bar,' the artist explains. 'I've always loved the impasto painters: Leon Kossoff, Frank Auerbach, anyone a bit gloopy. So Plasticine felt like something I could run with … It's got all the essential elements of painting, sculpture and colour.' His interest in the work of the eighteenth-century satirical cartoonist William Hogarth grew out of people's observations about his own work, that it was, as he puts it, 'very theatrical, very English'. Henry's studio at the time was in the City of London, where Hogarth grew up. Immersing himself in the famous cartoonist's world, Henry 'started noticing parallels: friends who'd inherited money squandering it on drugs or gambling or fine dining. The costumes are different, but the stories are the same. Art school was difficult for me because I didn't form strong relationships with any of the tutors. So in a way Hogarth became my tutor'.

Henry moved studios frequently in the early days. For one in Smithfield, in a building that was taken over by Crossrail, he and his friends paid a nominal sum. 'It was an amazing deal,' he remembers, 'because they had already bought the location. The deal was, they would kick you out within three days, but you had to go immediately because they were going to start demolishing it. There was about 5,000 square feet, so we really lucked out. We had great parties.' Other studios 'were windowless. There were places with no toilets. I remember at one point I had six heaters all stacked on my art books, with a snotty nose, trying to just get to the canvas'. Having to move frequently had its upside, however. 'It was important to live and move as I did, twice a year,' the artist believes. 'You get into the veins and tributaries of London, and you get to live in lots of different areas. I had a group, and some of us would leave and some of

us would go. That enabled us to pay the rents, which weren't very high. My budget was £50 per week, so quite often we were knocking on doors of warehouses. I met all sorts of dodgy characters; I've got all sorts of funny stories of people I've met in East London who have written me off, who've stolen artworks. I got a phone call the other night from someone who's clearly dodgy, saying, "Oh yeah, I'm just wondering how much your paintings were." It's because they've read about it in the newspaper or something. Someone's trying to flog it on to one of their mates.'

About the current shortage of space in central London and artists being forced out to the periphery, Henry says, 'We're living longer and there are more people. We need more space and more room. If the Black Death came back and knocked a couple of million off, we'd all have nice 5,000-square-foot studios. In truth, if you're a collector, you'd probably go to Brighton. Keith Tyson's got a suite down in Brighton. He's got a nice life, he can go on a nice walk and come back to a quiet studio, whereas I'm still in the hustle and bustle with London prices and a tiny little space.' But London has its advantages. 'I remember the other day I was struggling,' Henry muses. 'I got halfway through a painting and I said, "Scrap it, scrap it! We've got to start again!" And everyone said, "You're crazy! We've got a timeline!" I said, "Well, it's not working." I needed a new composition because it didn't work, and I couldn't get it. It was really frustrating me, so I just left and was in the National Gallery in twenty minutes. I lucked out from the bus to the Tube, but I ran in there. You couldn't do that if you were, I don't know, anywhere really. I had access to some of the best paintings in the world. Within fifteen minutes I'd found something in the composition that I was looking for.' Despite his somewhat precarious existence, Henry does not feel that London's current overdevelopment affects artists he knows all that much. And, in the midst of it all, his own goals remain firm. 'I'm thirty-three,' he says. 'My friends from my past, they're married with two children. I want to get the art, my baby, up and running first.'

Henry Hudson at a garden party all his own (right). The young artist, who has won over the art world with his sculpted paintings made out of Plasticine, is best known for his satirical series The Rise and Fall of Young Sen. Parodying William Hogarth's eighteenth-century *The Rake's Progress* in a contemporary setting, Hudson was asked to conceptually integrate the two journeys for this book. The resulting shoots (as well as the cover image) are centred on London's Life of Bling. 'I like the theatricality of Hogarth,' Hudson explains, 'the satire, the parallels with our own time.' His friends, workmates, colleagues and collaborators featured in the series include Jackson Boxer (chef), Philip Colbert (fashion designer/artist), Isamaya Ffrench (makeup artist), Nimrod Kamer (satirist/writer), Gerald Mak (artist), Idina Moncreiffe (model), Molly Parkin (artist/writer), Marina Ruiz Colomer (gallerist), Valentina Salmeri (gallery manager), Katie Shaw (artist), Pierre Smith-Stewart (artist), Joe Sweeney (artist), Fru Tholstrup (gallery director), Alexandra Wilk (artist) and Viktor Wynd (artist/curator)

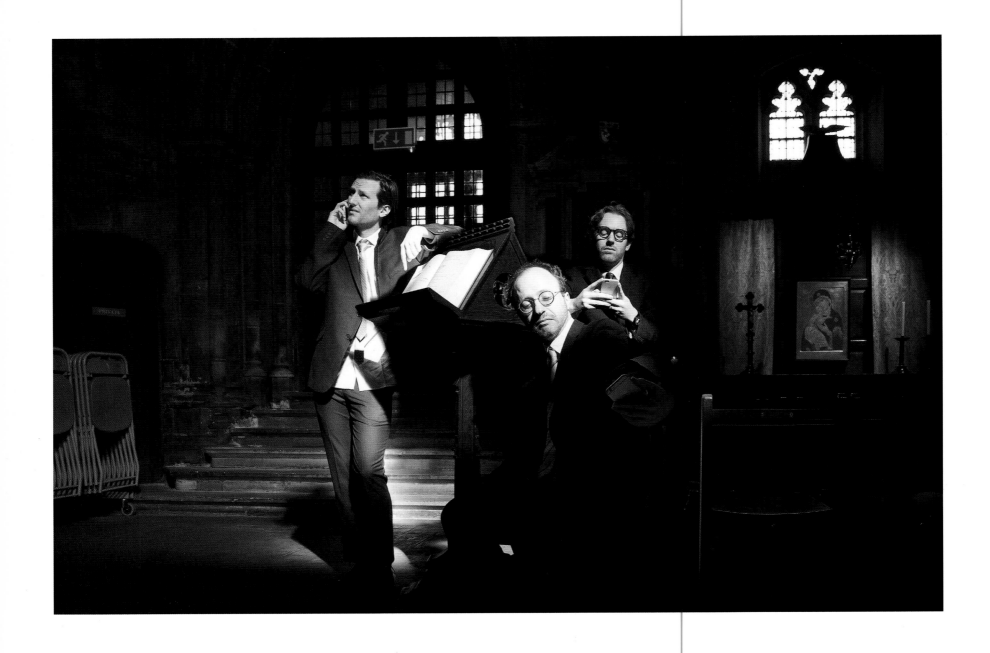

Henry Hudson (left) and two fellow time-travellers, Philip Colbert (right) and Nimrod Kamer (middle), at St Bartholomew-the-Great in West Smithfield, where William Hogarth was baptised in 1697. Built by Henry I, William the Conqueror's son, London's oldest church survived the Great Fire (1666) and World War II only to be desecrated by Young Sen's buddies. Retracing Hogarth's footsteps, Young Sen sets out to repaint the town in a final salute to his mentor, whose series of eight paintings, *The Rake's Progress*, was completed in 1733

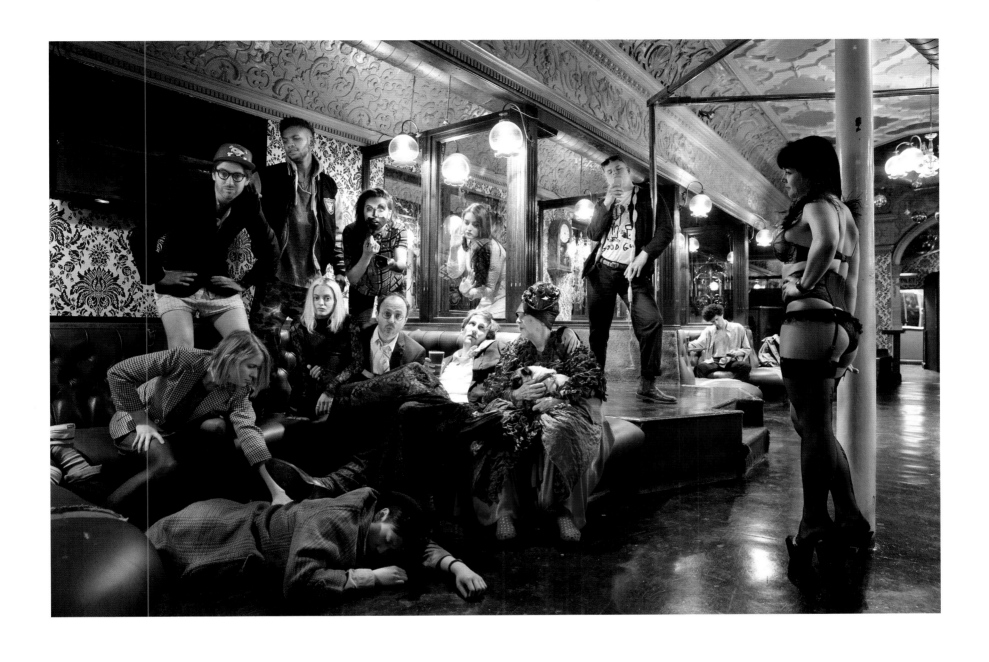

Ye Olde Axe in Shoreditch, one of London's oldest strip clubs and reputedly a haunt of Sweeney Todd (skeletal remains, along with scissors, were unearthed there in 1979), is where Young Sen goes for his own baptism, celebrated by his friends, Hogarthians and a neighbourhood stripper. Molly Parkin (with dog), painter, novelist and journalist, is a legend in her own right, known for her erotic Soho adventures and the bohemian company she has kept in her eighty-three years, including artist Francis Bacon, with whom she smoked and drank the nights away at the Colony Club (clockwise from man on floor: Gerald Mak, Alexandra Wilk, Philip Colbert, Pierre Smith-Stewart, Idina Moncreiffe, Isamaya Ffrench, Nimrod Kamer, Katie Shaw, Henry Hudson, Molly Parkin, Joe Sweeney)

Spring is in the air: the *Sun* newspaper, together with Young Sen, celebrates the royal household's fecundity atop a double-decker bus as a new Princess-of-Whatnot is born to William (not to be confused with the Conqueror or Hogarth) (left to right: Nimrod Kamer, Philip Colbert, Henry Hudson, tourists)

Young Sen's buddies retire to the Last Tuesday Society on Mare Street in Hackney, an institution dedicated to 'subverting life and boredom'. Viktor Wynd (owner) is a full-time eccentric and part-time artist, curator and culture buff (left to right: Viktor Wynd, Henry Hudson, Harriet Verney, Nimrod Kamer, Philip Colbert)

Filthy lucre: Young Sen, drunk on success, argues the take with Fru Tholstrup, Director of Sotheby's S2 Gallery in Mayfair, after the close of his 2015 show, *The Rise and Fall of Young Sen –*
The Contemporary Artist's Progress **(left to right: gallery visitors, Marina Ruiz Colomer, Philip Colbert, Nimrod Kamer, Henry Hudson, Valentina Salmeri, Fru Tholstrup)**

Henry Hudson

Young Sen blows his mind at Brunswick House in Vauxhall, pigging out with chef/owner Jackson Boxer, who's serving Hogarth's vintage baptism wine, discovered in the basement of John Dawson's 1758 building (left to right: waitress, Henry Hudson, Jackson Boxer)

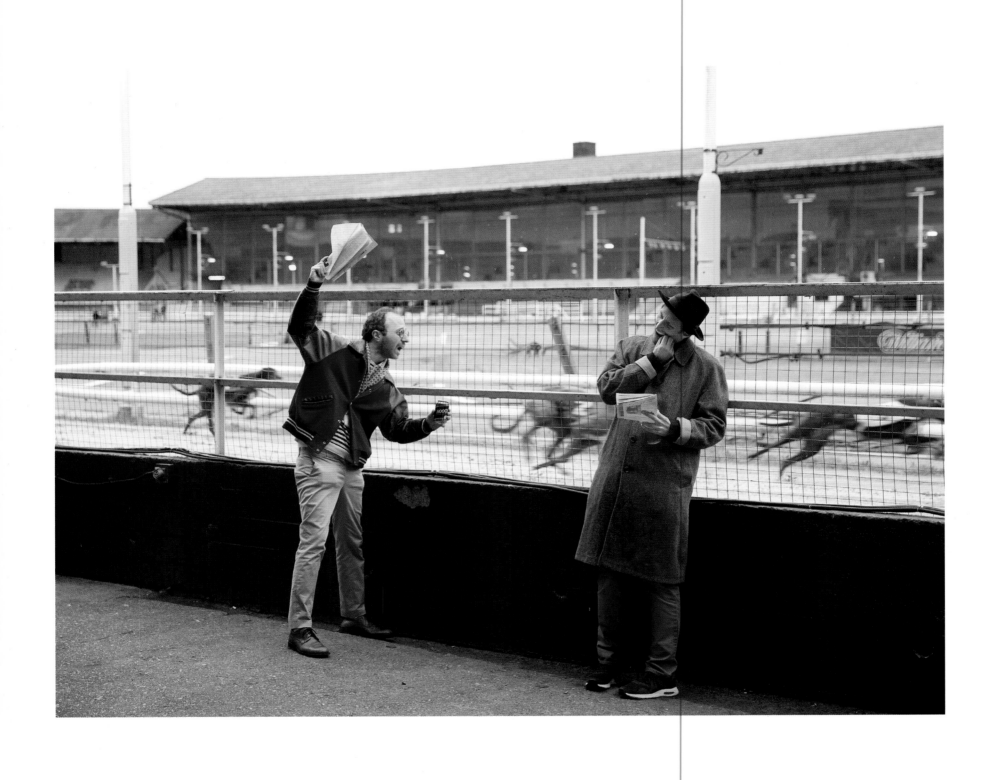

· Short of cash again, Young Sen goes to the dogs at Wimbledon Greyhound Stadium and loses his shirt, and his cool, after being rejected by the Retired Greyhound Trust, which looks after the nine thousand canines (and a few itinerant artists) who get dumped on their doorstep every year (left to right: Nimrod Kamer, Henry Hudson)

　Henry Hudson

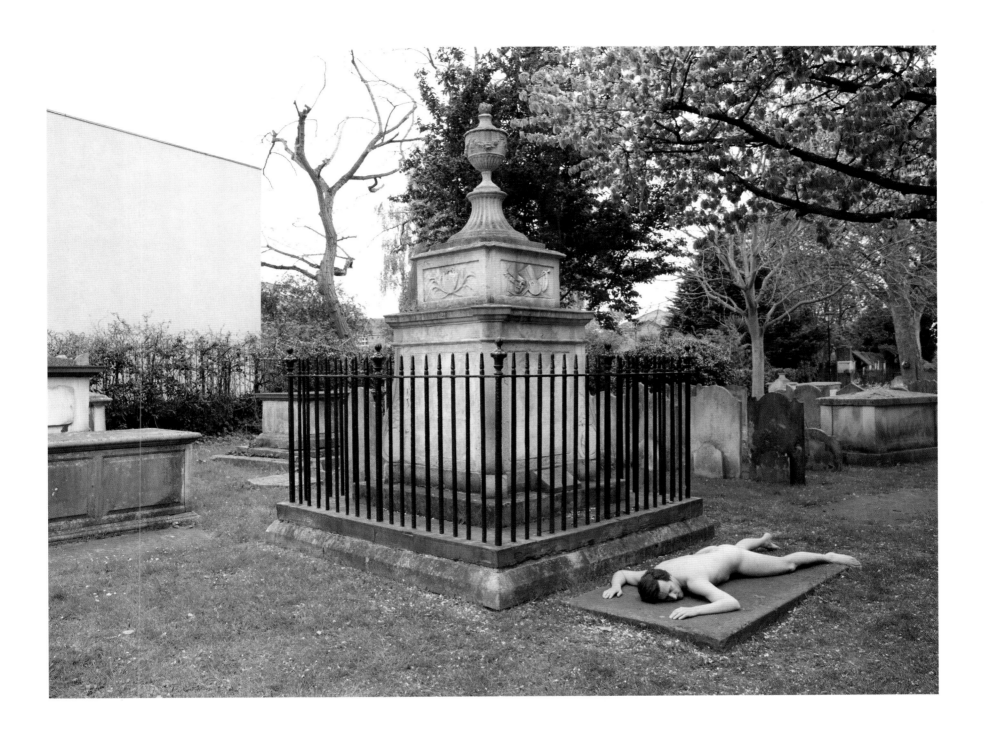

Young Sen ends up dead (or dead drunk) next to Hogarth's grave in the churchyard of St Nicholas in Chiswick, having inscribed 'Farewell, great painter of mankind' on his tombstone –
a suitable motorway exit out of London life, you might say (Henry Hudson)

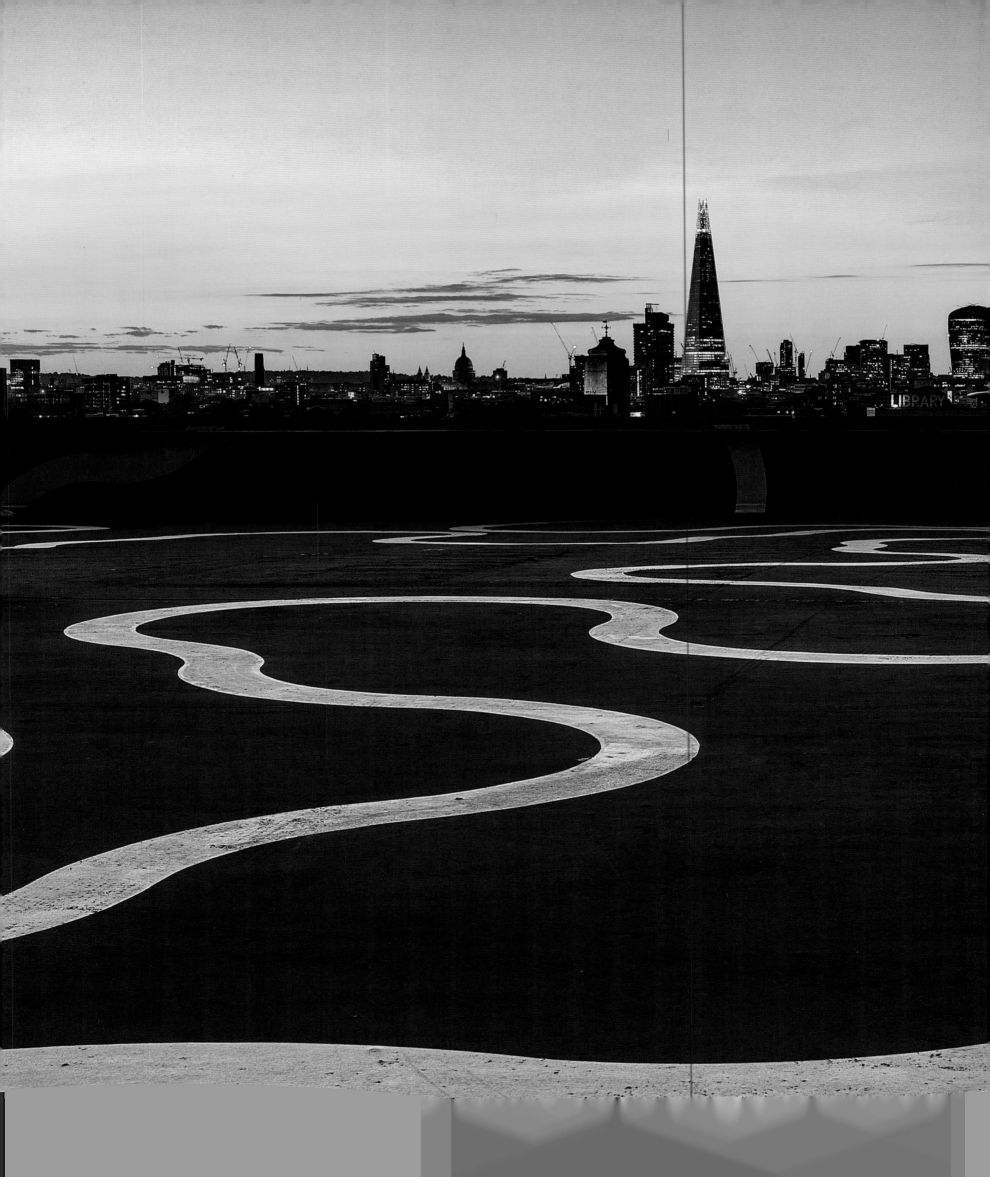

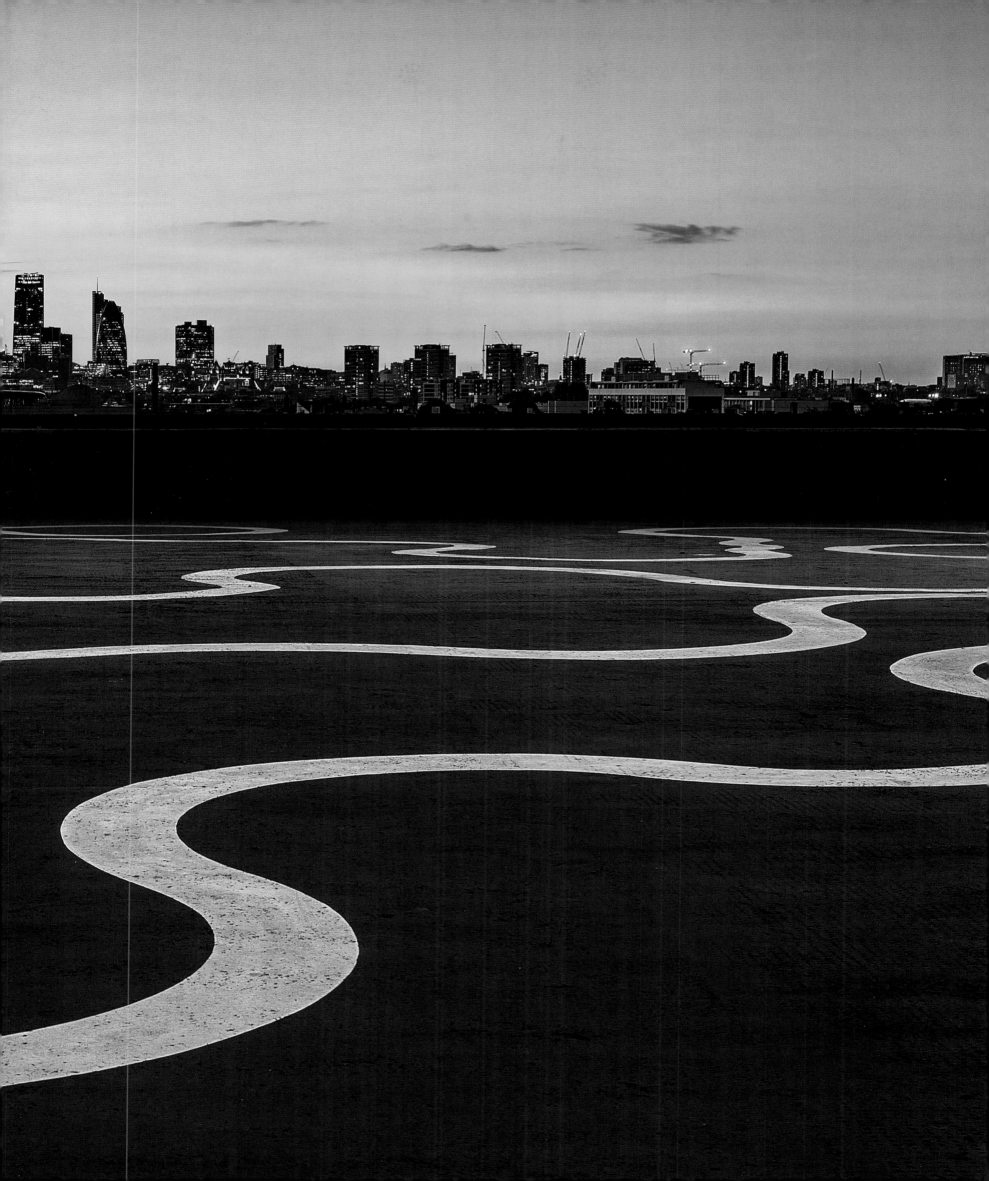

Acknowledgements

'Lord, what a diff'rence a day makes': so goes the song. Made famous by Dinah Washington in the late '50s, its lyrics best describe some of the energy packed into making *London Burning*. Remixed by a hundred successful artists since Dinah, the song describes some of the sentiments and emotions endured in the course of a love affair. Well, the same emotions can apply to one's love/hate relationship with the city one inhabits (or the books one reads, for that matter). London, more than any other urban environment I know of, has the habit of conjuring up such emotional conundrums. Yet its paramours have woefully neglected it. So little printed matter exists in colour that is worthy of the place. No book I know of gives full throat to its charms.

This book's romance with London is hard-headed, though. Florid and vivid it may be in terms of visual detail, but it is gritty, emotional and hard-hitting in its investigative content. And there is no middle ground when it comes to its creation; to praise the team that has helped make this tome is a somewhat tricky exercise. Leaving aside egos and expectations (bruised and battered by gruelling schedules, demanding directives and morphing creative scenarios), I've pushed and pulled, bullied and cajoled with much dis/temper to make the book as near to the idea it began with, which frankly just amounted to a title and a mental outline. What it has become, just one day before our press deadline, is unique and challenging, demanding, querulous and quarrelsome – and just plain beautiful.

Praise there must be for everyone involved, starting with Maryam Eisler. Without her, this book could not have been made in time, or as well. Maryam's many talents extend beyond her superb executive editorial abilities, her people skills and her aesthetic sensibilities, all utilised to the full here: she simply did not take no for an answer. Andrea Belloli, my Managing Editor, is the steady editorial han d behind my creative eclecticism, so praise for her sanitising skills in more ways than just editorial. To Roger Fawcett-Tang, my creative doppelgänger, is owed huge gratitude for fortitude under the machine-gun fire of changing ideas, differing compositions and creative dispositions. Not to mention long days and nights sweating over the keyboard.

Robin Friend, one of the book's three principal photographers, is a tried and tested veteran of TransGlobe's creative adventures. His wonderful output matches his ability to function under firestorms of big personalities, restrictive shoot environments and ever-present time constraints. Andrea Hamilton, a new addition to TransGlobe's talent pool, has acquitted herself remarkably well given the aforementioned circumstances; for someone who never worked on such a demanding project, her masterly ability to switch from landscape to portrait photography speaks for itself. A relentless drive found her in the most unlikely places at all hours, and in any weather conditions. Kate Martin, another newcomer to the fold, has had to master the challenges of working guerilla-style to meet our demands outside her normal arena of fashion and glamour photography, so all praise to her for producing such vibrant imagery. Anne Field, our long-time Project Coordinator, has suffered more than most on this book; she's had to bear the brunt of day-to-day organising while conducting research and much more. Dorian May has assisted in styling our fashion and music shoots, her happy humour a welcome addition to the mix.

As always in these books, our highest praise and deepest gratitude are reserved for our participating profilees, for their generosity in giving time to the book by inviting us into their homes and workplaces, allowing us to accompany them on individual journeys through their special parts of London. They endured what at times was intrusive photography while helping us to unravel some of the principal threads in the creative weave of London's history, and they helped us to understand the momentum that has led the city to its present moment – the taxonomy of ideas, important or otherwise, which go to make up today's London.

Gregor Muir deserves particular thanks for helping to brainstorm ideas and profile selections from the outset, his quick creative intellect a most valuable sounding board during the course of making the book. Special thanks are also due to those who assisted in our searches for London's creative talent or helped in other ways, including Hannah Barry, Josh Berger, May Calil, Johnny Coca, Georgina Cohen, Mat Collishaw, Lord Mervyn Davies, Peter Fleissig, Mathew Freud, Azzi Glasser, Idris Khan, Catherine Lampert, Munira Mirza, Alison Myners, Paige Nelson, Hayat Palumbo, Lauren Prakke, Guy Ritchie, Julie Phillips, Alia Al-Senussi, Sir Nicholas Serota, Alexandra Shulman, Polly Staple, Abdullah Al-Turki, Nazy Vassegh, Edmund de Waal and Alan Yentob. More special thanks are reserved for Mulberry and their efficient team for their contribution to the project. Not to forget the ICA crew, especially Elizabeth Davies, along with Gillian da Costa, Katherine Stout and Rosalie Doubal; Elizabeth was always there to lend a helping hand. Praise be to my co-publishers Thames & Hudson, ever-present, ever-enduring; many thanks are due to Jamie Camplin, Natalie Evans and Rachel Dewhirst. Also to Eric Ladd at XY Digital; Kate Burvill, our press officer; Caroline Campkin, the production supervisor; and Julia Smith and Françoise Vaslin at IMAGO.

Thanks are also due to our researchers, transcribers, photography assistants and others, including Andrea Algueró, Jaime Bako, Victoria de Botton Dreesmann, Lauren Nicole Collins, Giovanna Coppola, Rosie Duca, Tasos Gaitanos, Camilla Greenwell, Rebecca Gremmo, Karen Hotopp, Jen MacLachlan, Quintin Lake, Emelie Matutina, Marta Muntasell, Tamsin Osler, Nastassja Salem, Isabelle Scott, Celina Teague and Laura Valles. Special thanks are due to Molly Bondy and Catriona Montgomery, as well as Maryam Al-Thani, who has proven a particular and selfless gem.

Then there is the myriad of personalities absent in name but forever embedded in the book's bones and structure. We're deeply indebted to all of the various profilees' representative offices, studios, principals and staff for supporting our ambitious project: Sonia Adamczak, Alan Aldridge, Arabella Angell, Melanie Arnold, Piers Atkinson, Polina Bacon, James Balmforth, Stephen Barker, Liz Barrett, Georgia Bateman, Clara Beauchamp, Flora Beaumont, Jessica Belgrave, Rose Bellingham, Anna Biles, Emma Bishop, Sophie Blackman, Philippa Bloomfield, Natty Bo, Edward Bodenham, Marta Bogna, Suzanne Boguzas, Liz Bonelli, Helena Bonham Carter, Sussan Booth, Alex Borkowski, Celia Bosch Torres, Sarah Boughardt, Jackson Boxer, Danny Boyle, Victoria Boyle, James Bridle, Hilary Broadhurst, Emily Bromfield, Juliet Brooke, Beverley Brown, Neale Brown, Alexandra Brownsell, Julius Bryant, Lia Buddle, Sam Butler, Bruce Cameron, James Capper, Cheryl Carty, Aaron Cezar, Nick Chapman, Samantha Charles, Rosannah Clarence, Bodenham Clerkin, Stefanie Cliffe, Charlotte Colbert, Philip Colbert, Malcolm Colin-Stokes, Tony Common, Kitty Cooper, Diana Córdoba Barrios, Robert Coucher, Tom Coupe, Charlotte Cox, Benedict Cumberbatch, Averil Curci, Camilla Currey, Martine d'Anglejan Chatillon, Tim d'Offay, Gillian Da Costa, Jan Dalley, Will Dallimore, Marianna Davis, Will Davis, Shezad Dawood, Adam de Cruz, Ilaria De Virgiliis, Abigail Desch, Phil Dirtbox, Conor Donlon, Chloe Dorigan, Karenza Doughty, James Dunbar, Sarah Easom, Parisa Ebrahimi, Shirley Elghanian, Jeannettsy Enriquez Borges, Emma Farah, Clara Farmer, Hani Farsi, Isamaya Ffrench, Tara Ffrench-Mullen, Jonathan Franks, Daniel Furniss, Ragnhild Furuseth, Stephen Galton, Ana Garcia, Lily Gatehouse, Susie Gault, Jennifer Gill, Keziah Goudsmit, Paul Goulet, Angela Green, Louise Grey, Patricia Grey, Sophie Harriott, Alicia Harrop, Athena May Hasiotis, Natalie Hayes, Margot Heller, Margot Henderson, Orla Hickey, Rosie Hoare, Joanne Hodson, Bethan Holt, Alex Hornby, Emilie Hossard, Amy Houmoller, Larissa Howells, Polly Hunt, Sophie Hussey, Alison Ignacio, Lyndsey Ingram, Nina Jackson, Robert James, Tim Jefferies, Barry Jenkins, Talita Jenman, Jemima Johnson, Andy Jones, Rachael Jones, Kitty Joseph, Amanda Joy, Nimrod Kamer, Alex Katz, Sophie Kelk, Gareth King, Georgia Kirsop, David Kosse, Christian Krajewski, Marie-Louise Laband, Quintin Lake, Hannah Lambert, Clodagh Latimer, James Lavelle, Keren Levy, Jordan Lewis, Laura May Lewis, Pinky Lilani, Deborah Lincoln, Bip Ling, David Linley, Sally Long-Innes, Vanessa Lunt, Samantha Lusher, Kate Lynas, Laura Macfarlane, Ian Maine, Gerald Mak, Peter Maniam, Roberta Marcaccio, Jennifer Marcotti, Siobhan Mareuse, Ed Marler, Krissy Martin, Rachael Matherson-Frederick, Gaz Mayall, Leila McAlister, Shaun McDowell, Louisa McGillicuddy, Lucy McIntyre, Lauren Meek, Emily Meredith, Chris Millard, Arsalan Mohammmad, Idina Moncreiffe, Annabelle Morell-Coll, Polly Morgan, Guillaume Morisset, Clare Jane Morris, Jo Murray, Simina Neagu, Layla Nemazee, Ioanna Nitsou, Kevin O'Hare, Alice O'Reilly, Kelly Okogwu, Junior Okoli, Melanie Oliver, Sarah Oliver, Tristan Oliver, Elena Olivero, Jo Ortmans, Lauren Park, Molly Parkin, Charlotte Pearson, Giorgina Penco, Jessica Pennachetti, Kate Perutz, Alexandra Pilch, Isabella Charlotta Poppius, Verity Portas, Horatio Portas Rickey, Venetia Porter, Princess Julia, Claire Ptak, Maya Rasamny, Simon Raw, Grace Reid, Zandra Rhodes, Claire Richards, Mary-Jean Riley, Franc Roddam, Amy Rowe, Marina Ruiz Colomer, Bethany Russell, Edward Sahakian, Valentina Salmeri, Charles Saumarez Smith, Joe Scotland, Katie Shaw, Lesley Shearer, Victoria Sin, Elba Slamecka, Colette Smith, Luke Smith, Georgie Smith, Pierre Smith-Stewart, Heather Sprout, Camilla St Aubyn, Venetia Stanley, Evelyn Stern, Jenny Stewart, Alison Stoecker, Tabitha Stoecker, Robert Suss, Thomas Sutton, Joe Sweeney, Nerissa Taysom, Adam Teskey, Alice Thill, Fru Tholstrup, Ceri Thomas, Isobel Thomas, Rachel Todd, Jacqueline Townsend, Sam Trenerry, Jayne Trotman, Jenkin Van Zyl, Preeya Varsani, Martin Vedel, Johnny Vercoutre, Harriet Verney, Charlotte Wakeling Green, Lizzie Walker, Rosemary Wallin, Oscar Wanless, Jane Warham, Naoki Watanabe, Nicola White, Alexandra Wilk, Emily Williams, Jacqui Wills, A.N. Wilson, Kate Windsor, Daphne Wloch, Ashley Woodfield, Robin Woodhead, Viktor Wynd, Yu Yigang, Tom York, Roxane Zand and Alfie, Jenelle, Moshood and TK from Urban Academy.

Hossein Amirsadeghi
London, June 2015

(previous spread) London's burning sunset as seen from the roof of Peckham Multi-story Car Park. Richard Wentworth's 2015 installation *Agora* winds its way into the future in search of interactions between spatial conditions and the social realities of the metropolis (courtesy of Bold Tendencies)

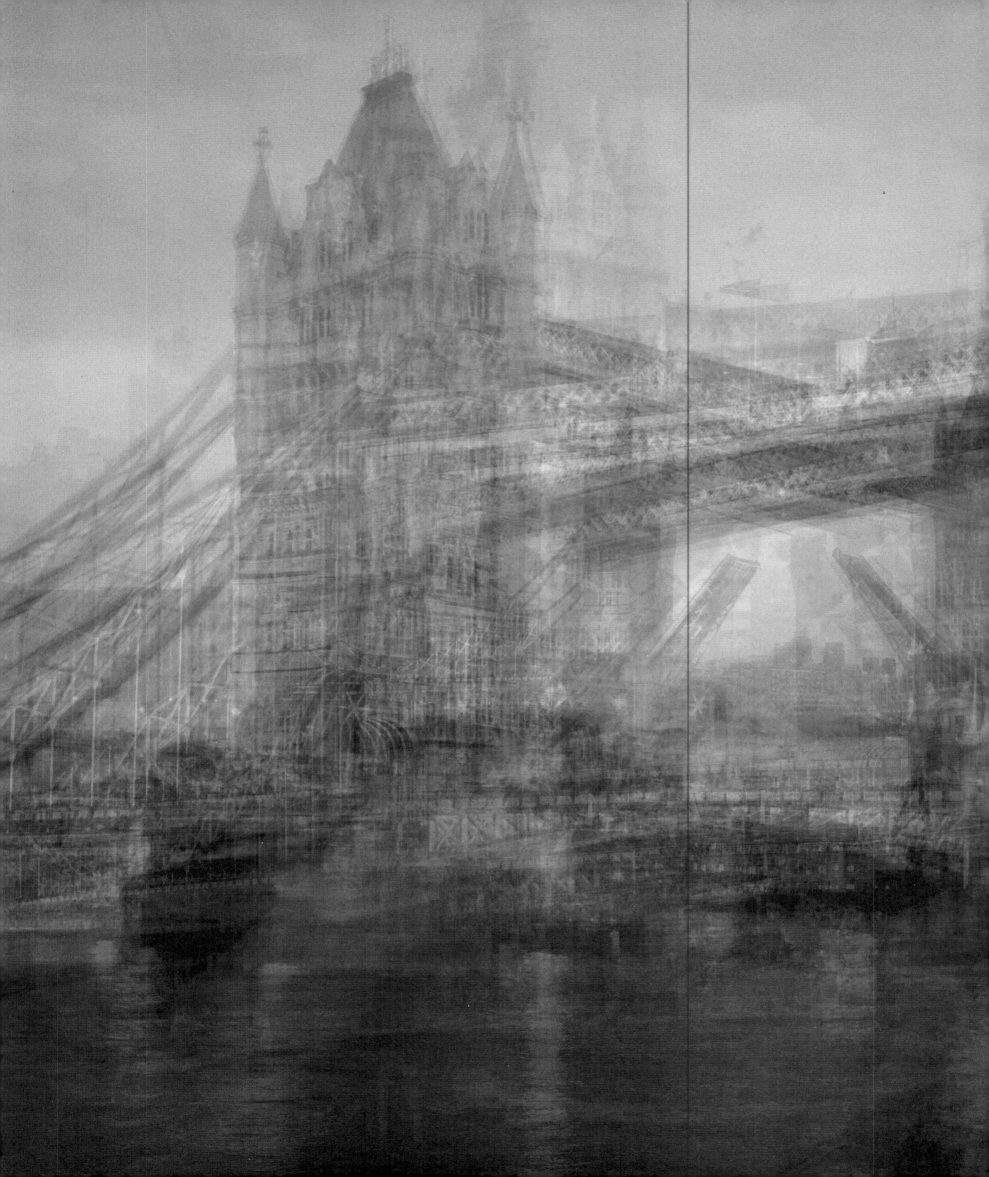